Nineteenth-Century European Art

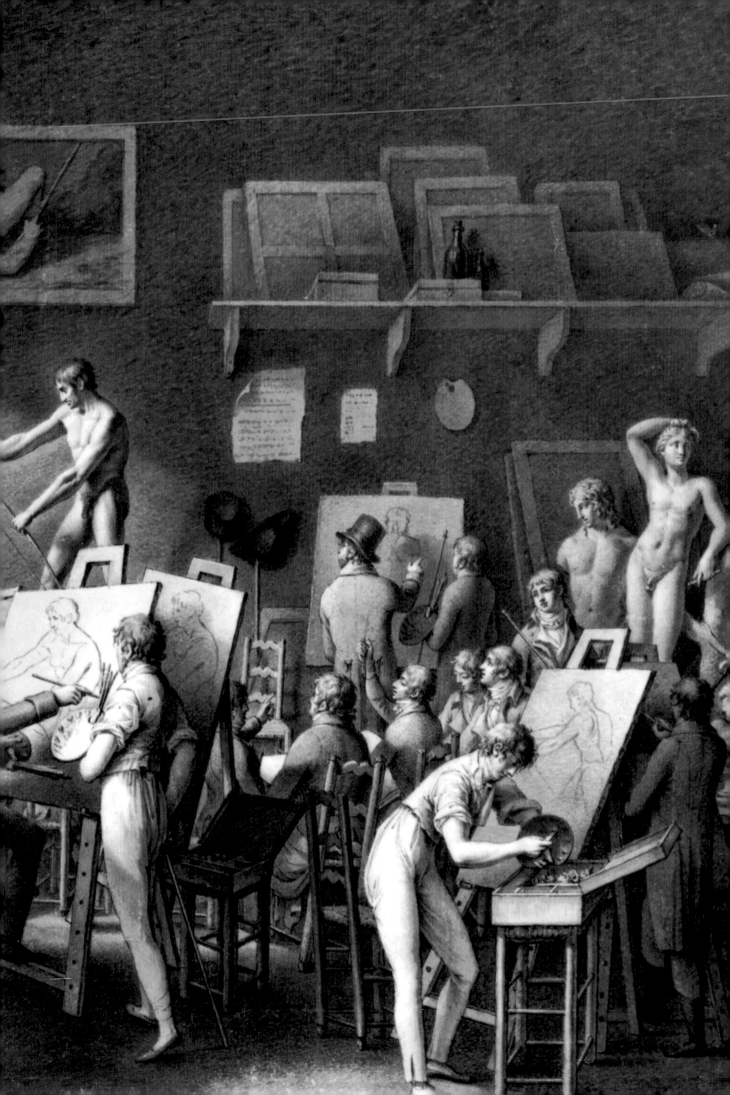

Nineteenth-Century European Art

Petra ten-Doesschate Chu

Senior Editor: Samantha Gray
Commissioning Editor: Kara Hattersley-Smith
Picture research: Peter Kent
Design and typesetting: Karen Stafford
Harry N. Abrams Project Editor: Holly Jennings

Library of Congress Cataloging-in-Publication Data

Chu, Petra ten-Doesschate.
 Nineteenth-century European art / by Petra ten-Doesschate Chu.
 p. cm.
Includes bibliographical references and index.
 ISBN 0-8109-3588-0
 1. Art, European--19th century. I. Title.
 N6757 .C484 2002
 709'.034--dc21

 2002016421

Printed and bound in China
10 9 8 7 6 5 4 3 2 1

This book was designed and produced
by Laurence King Publishing Ltd
www. laurenceking.co.uk

Every effort has been made to contact the copyright holders, but should
there be any errors or omissions, Laurence King Publishing Ltd would be
pleased to insert the appropriate acknowledgment in any subsequent
printing of this publication.

Harry N. Abrams, Inc.
100 Fifth Avenue
New York, N.Y. 10011
www.abramsbooks.com

Abrams is a subsidiary of

 LA MARTINIÈRE
G R O U P E

FRONTISPIECE: Jean-Henri Cless, *The Studio of David*, p.130.

CHAPTER OPENERS, DETAILS OF: 2. Angelica Kauffman, *Zeuxis Selecting Models for his Painting of Helen of Troy*, p. 52; 3. John Singleton Copley, *Death of the Earl of Chatham*, p. 87; 4. Jacques-Louis David, *Death of Marat*, p.100; 5. Jacques-Louis David, *Coronation of Napoleon in the Cathedral of Notre Dame*, p. 119; 6. Francisco Goya, *Family of Carlos IV*, p. 146; 7. Philipp Otto Runge, *Morning*, p. 166; 8. J.M.W. Turner, *Salisbury Cathedral from the Cloister*, p. 184; 9. Théodore Géricault, *Charging Chasseurr*, p. 201; 10. Horace Vernet, *The Duc d'Orleans on his way to the Hôtel-de-Ville, 31 July 1830*, p. 221; 11. Gustave Courbet, *A Burial at Ornans*, p. 250; 12. Rosa Bonheur, *Plowing in the Nivernais Region*, p. 277; 13. Adolph Menzel, *The Flute Concert of Frederick the Great at Sansoucci*, p. 303; 14. Richard Dadd, *Fairy Feller's Master Stroke*, p. 318; 15. Jean-Baptiste Krantz and Frédéric Le Play, *Exhibition Building and Pavilions*, p. 357; 16. Frédéric Bazille, *The Family Gathering*, p. 386; 17. Pierre-Auguste Renoir, *Children's Afternoon at Wargemont*, p. 412; 18. Max Liebermann, *Amsterdam Orphan Girls*, p. 441; 19. Paul Gauguin, *Vision after the Sermon*, p. 462; 20. Joaquin Sorolla y Bastida, *Sewing the Sail*, p. 509.

CONTENTS

10 • THE POPULARIZATION OF ART AND VISUAL CULTURE IN FRANCE DURING THE JULY MONARCHY (1830–1848) 217

11 • THE REVOLUTION OF 1848 AND THE EMERGENCE OF REALISM IN FRANCE 247

12 • PROGRESS, MODERNITY, AND MODERNISM—FRENCH VISUAL CULTURE DURING THE SECOND EMPIRE, 1852–1870 259

Acknowledgments

This book would not have seen the light without the invaluable help of two remarkable women. Hsiao-Yun Chu has spent countless hours, even days reading and commenting on the text in order to make it more concise and accessible. Her feedback and encouragement have been essential and extremely meaningful to me. Leanne Zalewski has done the time-consuming and exacting work of preparing the list of illustrations and the bibliography. I greatly appreciate her exemplary dedication and attention to this task. To both of these women I owe a large debt of gratitude.

Because of the long time spent to complete this book, I have worked with several editors, all of whom have been kind, considerate, and patient: Julia Moore, Katherine Doyle, and Holly Jennings, at Harry N. Abrams, Inc.; Bud Therien at Prentice Hall; and Kara Hattersley-Smith and Samantha Gray at Laurence King Publishing. My thanks go to them as well to the production staff at Laurence King: designer Karen Stafford, copy editors Delia Gaze and Mary Davis, and, especially Peter Kent, who has done a yeoman's job ordering hundreds of pictures in record time.

A sabbatical leave from Seton Hall University has allowed me the time to write this book. The university's generous sabbatical policy is something all faculty deeply appreciate. I am grateful to Dr. Mel Shay, Provost of Seton Hall, who granted me special funds to hire a research assistant. Dr. Robert Hallissey also deserves my thanks for pleading my case. Most of my work was done in my study carrel in the Walsh Library. I feel obliged to the many donors of this library, especially Frank E. Walsh and Thomas Sharkey and their families—who endowed the library in general and my carrel in particular. Thanks go as well to the staff of the library for their ever efficient and ever courteous assistance.

Many people have provided advice, information, and assistance. The following deserve special mention and thanks: Dr. Peter Ahr, Dr. Laurie Dahlberg, Anne van der Jagt, Dr. Jürgen Heinrichs, Dr. Sura Levine, Dr. Judith Stark, Dr. Gabriel Weisberg, Yvonne Weisberg, and Dr. Julius Zsako.

Apologies are due to my family and friends for, at times, making this book a priority over spending time with them. I intend to make up for it!

This book is dedicated to my children and present and future grandchildren, as well as to my students of past and future years.

Introduction

The Story of Nineteenth-Century Art

This book tells the story of nineteenth-century art. Like all "true" stories, it is manufactured from the raw material of historic facts. To develop a narrative, the storyteller, of necessity, will take a selective approach to those facts, giving more weight to some than to others and leaving many out altogether. Of course, the choice of what to include or leave out is not just the storyteller's own. Time itself has already acted like a sieve, retaining certain elements while letting others slip into oblivion. Moreover, as the story has been told and retold, a certain consensus has developed as to what is essential and what is secondary; who are the stars and who are the extras; which events make up the story's turning points and which just keep it going. Even with these points of consensus, the story will continue to evolve over time as each generation brings new expectations to it.

Time Frame and Context

History, whether political or cultural, cannot be packaged neatly in century-long periods. Historic periodization follows its own rhythm, which rarely coincides with man-made calendars. Thus, to tell properly the story of nineteenth-century art, we must begin nearly forty years before 1800, during the third quarter of the eighteenth century. At that time, many thinkers in both Europe and America believed that the world was undergoing a tremendous ideological and cultural upheaval. In 1759 the French philosopher and mathematician Jean d'Alembert wrote:

A most remarkable change in our ideas is taking place, one of such rapidity that it seems to promise a greater change still to come. It will be for the future to decide the aim, the nature, and the limits of this revolution, the drawbacks and disadvantages of which posterity will be able to judge better than we can.

D'Alembert's sense of his own time was very acute: exactly twenty years after he wrote down his prophetic words, the French Revolution broke out, ending a monarchy that had lasted for nearly nine hundred years and setting in motion, first in France, then elsewhere in Europe, a slow but steady process of democratization. Three years earlier, in 1776, the American colonies had declared their independence from British imperial rule in a document

so far reaching that to this day it contains the underlying principles of the political and moral organization of the free, democratic world.

While these political upheavals went on, the Industrial Revolution was also gaining momentum. In 1769 the British inventor James Watt patented the first efficient steam engine. Together with an unending stream of further inventions, it caused the mechanization of manufacturing, which led to a vast increase in the production of consumer goods. The unprecedented supply of commodities and the markets that needed to be developed to sell them encouraged the full flowering of capitalism.

From the early nineteenth century onwards, the steam engine also led to the development of steamboats and trains, which enabled a growing mobility of people and goods. Communications advanced through the improvement of the mail delivery system as well as the invention of the electric telegraph in the 1830s. It was important not only for sending personal messages but also for the rapid travel of news from one place to another. Nineteenth-century newspapers thus could report more immediately and accurately on events happening throughout the world.

The nineteenth century reaped both the blessings and the curses of the political, economic, and communications revolutions that had begun in the latter part of the eighteenth century. The gradual democratization of Europe was attended by continual political unrest. A major European-wide revolution marked the year 1848; smaller national or local uprisings occurred in various parts of Europe, throughout the nineteenth and well into the twentieth century.

The Industrial Revolution, while improving the standard of living of an ever-growing middle class or "bourgeoisie," created an urban proletariat that lived in squalid poverty. Charles Dickens's *Oliver Twist* (1838) and Victor Hugo's *Les Misérables* (1862), though fictional accounts, are among the more memorable books to address the problem of poverty, particularly as it manifested itself in London and Paris. But poverty was not just an urban condition. Although agriculture was slowly modernized, the fate of most peasants barely improved over the course of the eighteenth and nineteenth centuries. In fact, some aspects of this modernization, notably agricultural capitalism (whereby the land is owned by an agricultural investor who cultivates it with the help of hired labor), actually created a rural underclass that was just as miserable as their urban counterparts.

By 1750 the outlines of the five continents were largely mapped, thanks to the great sea voyages of the sixteenth and seventeenth centuries. Yet many of the inland parts of the world remained unexplored, at least by Western travelers. The American West, most of central Africa and Australia, and considerable parts of central Asia, were blank spaces on the eighteenth-century map. By the end of the nineteenth century, these territories had not only been mapped but many of them had been made accessible by roads or railways.

Increased mobility and communications helped several European nations to extend their grip over the rest of the world, leading to the colonization of substantial parts of Africa and South Asia. Although highly profitable for Europe, colonization seriously destabilized the world and set the stage for many of the political and economic problems that plague us even in the twenty-first century.

People's lives changed greatly during the period under discussion. Thanks to dramatic improvements in medical science, notably in the area of infant care, the world population nearly doubled, from about 800 million in 1750 to 1,550 million in 1900. In Europe during this time the population almost tripled, increasing from 140 to 390 million, and in Britain it increased more than five-fold, from 6 million in 1750 to 33 million in 1900. Moreover, due to better nutrition, men and women grew taller, notably in Europe and America where the average size increased by several centimeters.

Radical changes took place in people's daily living. In the eighteenth century candles and oil lamps were the only modes of illumination available, both inside the house and on the streets. By 1900 gas lighting was widely used and electrical light, though not common, was certainly an option for those who could afford it. In many homes, cast-iron stoves had replaced open fireplaces and the rich even had central (coal) heating. Nonetheless, as late as 1900 most homes were still sparsely heated and people wore heavy clothing, even in their parlors and bedrooms.

In 1750 a man's suit or woman's dress was entirely handmade, from the spinning of the yarn to the weaving of the cloth; and from the dyeing and printing of the fabric to the stitching of the seams and hems. Only the wealthy could afford a wardrobe of more than a few garments. Ordinary people usually had one or two outfits which they would wear for a lifetime and then, if they were not threadbare, would pass on to their children. In contrast, by 1900, men and women bought mass-produced clothes in department stores; fashions, especially for women, changed regularly (as our study of late nineteenth-century painting will clearly demonstrate). Clothes were worn for a few years, then discarded. Such "consumerism" was the result of the development of the mechanized production of cloth, as well as the invention of the sewing machine, both of which made it possible to mass-produce clothes at affordable prices.

In 1750 ordinary people had no input whatsoever into how and by whom they were governed. By 1900, in most Western European countries as well as the United States, adult males had the right to vote in national and local elections, without regard for their social and economic status. The social position of women, before 1750 in all respects inferior to that of men, slowly improved during the nineteenth century, largely through increased access to education. By 1900, however, women still lacked most of the rights and privileges of men. Despite a long and fierce struggle, women's suffrage was the exception rather than the rule, and women continued to be excluded from public office and many jobs.

In 1750 serfdom was a common condition of most peasants in eastern Europe, and remained so until 1861, when it was officially abolished. Concurrently, in North America, slavery was an accepted practice; workers imported from Africa formed a cheap and reliable labor force in the Southern tobacco plantations. While objections were raised against slavery from the mid-eighteenth century, the number of slaves actually increased over the next hundred years, as tobacco was supplanted by cotton, which required an ever-larger supply of workers. By the outbreak of the American Civil War in 1861 some four million men, women, and children lived in slavery. Although they were granted freedom by the Thirteenth Constitutional Amendment of 1865, their social and economic condition, like that of the serfs in Russia, had not greatly improved by 1900.

Labeling

In history, the period under discussion is considered a part of the so-called modern period. Historians distinguish between early modern, beginning with the Renaissance in the sixteenth century and ending about 1750; and modern proper, which begins in the middle of the eighteenth century and ends with World War II. Early modern is associated with the birth of "modern" science, the beginnings of capitalism, and the ascent of the middle class. Modern proper is known for expanding technology and the mechanization of production processes, the triumph of capitalism and the middle class, and the rise of democracy. Yet perhaps the modern period's most important characteristic is a powerful belief in progress, a sense that, with the help of science and technology, humankind has the power continually to improve the world.

In art history, although the term "modern" is widely used, its significance in terms of time boundaries is less precise. "Modern" art has been said to have begun in the early, the mid-, as well as the late nineteenth century and some even place its birth in the early twentieth century. Its end has been assigned with equal vagueness somewhere between the end of World War II and the year 2000.

The problem lies with the use of the term "modern" in the language of the arts, which is quite different from its application to history. First heard as an artistic term in the seventeenth century, "modern" meant the opposite of "classic." While "classic" referred to an art that was bound by the artistic rules and absolute criteria of beauty that had been established in ancient Greece and Rome, "modern" signified a relative (though by no means complete) freedom from these canonical precepts. In the late eighteenth and early nineteenth centuries "modern" came to be associated with the art of the Christian Middle Ages (as opposed to

"pagan" antiquity), which, in its disregard of naturalism and its lack of a single aesthetic ideal, was felt to embody the freedom and sentiment that Classical art lacked.

A new meaning of "modern" developed by the mid-nineteenth century, when the term came to mean both "at odds with tradition, free of rules" and "of its own time." A freshly coined noun, "modernity," came to signify the desire to be different not only from anything that had come before, but also from the norms set by middle-class taste. Modernity suggested the celebration of originality and rebellion against established values. It also came to be associated with the ever-increasing pace of change in the nineteenth century, which made the period, to those who lived in it, seem impermanent and in flux. The French poet Charles Baudelaire (1821–1867), who was in large measure responsible for introducing the term "modernity," wrote:

> Modernity is the transitory, the fugitive, the contingent. The half of art, of which the other half is the eternal and immutable…Woe unto him who seeks in antiquity anything other than pure art, logic, and general method. By plunging too deeply in the past, he loses sight of the present; he renounces the values and privileges provided by circumstances, for almost all our originality comes from the stamp that time imprints upon our feelings.

To be "modern" in the Baudelairean sense was to be original by being completely in and of one's own time.

If one defines modernity in art broadly as the desire to break with the artistic past, then "modernism," a term coined at the end of the nineteenth century, is a trend marked by the urge to forge ahead into uncharted artistic territory. Modernism thus is the art of the *avant-garde*, the front line of artists, who consider themselves the "soldiers" of the new, forever exploring unbeaten paths.

It has been claimed by some that modernism began in the late eighteenth century, when the Neoclassical artists dissented from the earlier art of the Rococo period. However, Neoclassical art recalled the art of Classical antiquity, which itself was the antithesis of the notion of modern. Romanticism, the next major phase in nineteenth-century art, has a greater claim to modernity, since it not only rose against the art of the previous generation but also was inherently anti-Classical. Baudelaire called Romantic art "modern," associating it with "intimacy, spirituality, color, aspiration toward the infinite, expressed by all means available to the arts." Yet in spite of these seemingly modernist and certainly anti-Classical tendencies, many Romantic artists professedly sought inspiration in the art of the past, and their subject matter, more often than not, was derived from history, the Bible, or historical literature.

The next generation of artists, the so-called Realists, are seen by many contemporary art historians as the first truly modern artists. Their leader, Gustave Courbet (1819–1877), who was a close friend of Baudelaire, wrote: "The true artists are those who pick up their age exactly at the point to which it has been carried by previous times. To go backward is to do nothing, to waste effort, to have neither understood nor profited from the lessons of the past. Courbet refused to paint historic, mythological, or religious subject matter, claiming that he could not paint an angel because he had never seen one. And he felt it was an artist's duty "always to begin working afresh, always in the present."

The painter Edouard Manet (1832–1883), thirteen years younger than Courbet, took the latter's ideas one step further. Not only did he reject traditional subject matter, he also flouted the notion that a work of art should present a credible illusion of reality. Acknowledging the fact that a painting or a sculpture is an artificial "construct" that can at best only approximate reality, he claimed that artists should create paintings and sculptures according to their own rules rather than those sanctioned by century-old conventions ostensibly aimed at "imitating nature." Manet set into motion a trend away from "make-believe" in art that, by 1910, would culminate in the total rejection by artists of any "recognizable" forms, in paintings and sculptures that we now call "abstract" or "non-objective." Of course, the gap between Manet's art, which still presents a convincing image of reality, and the completely non-objective works of a Vasili Kandinsky or Piet Mondrian was not closed easily. The bridge between them was

built by Manet's followers—the Impressionists and the Post-Impressionists. They gradually advanced the idea that a work of art is an autonomous entity that may refer to reality but that is first and foremost an object "created" by an artist. Or, as the late-nineteenth-century artist Maurice Denis put it: "It is well to remember that a picture—before being a battle horse, a nude woman, or some anecdote—is essentially a plane surface covered with colors in a certain order."

Plots and Subplots

The gradual shift from an art aimed at the imitation of nature to an art asserting its character of "artifice" is an important plot of the story of nineteenth-century art but it is by no means the only one. As we shall see in the following chapters, there are many parallel as well as subplots. These include: the changing ideas about the function of art and, relatedly, about the appropriate choice of subject matter; the changing relation between the artist and his public; the evolution of artists' attitudes towards nature; Western fascination with non-Western art forms in the wake of expanding trade and colonization; and the impact on art of new technologies (glass and iron in architecture, paint in tubes, gaslight in the studio, etc.). Together these various plots and subplots make for a multi-threaded story line, which, in turn, is enriched by the interweaving of the stories of individual artists' lives. It is this richly textured story that is told in the following pages.

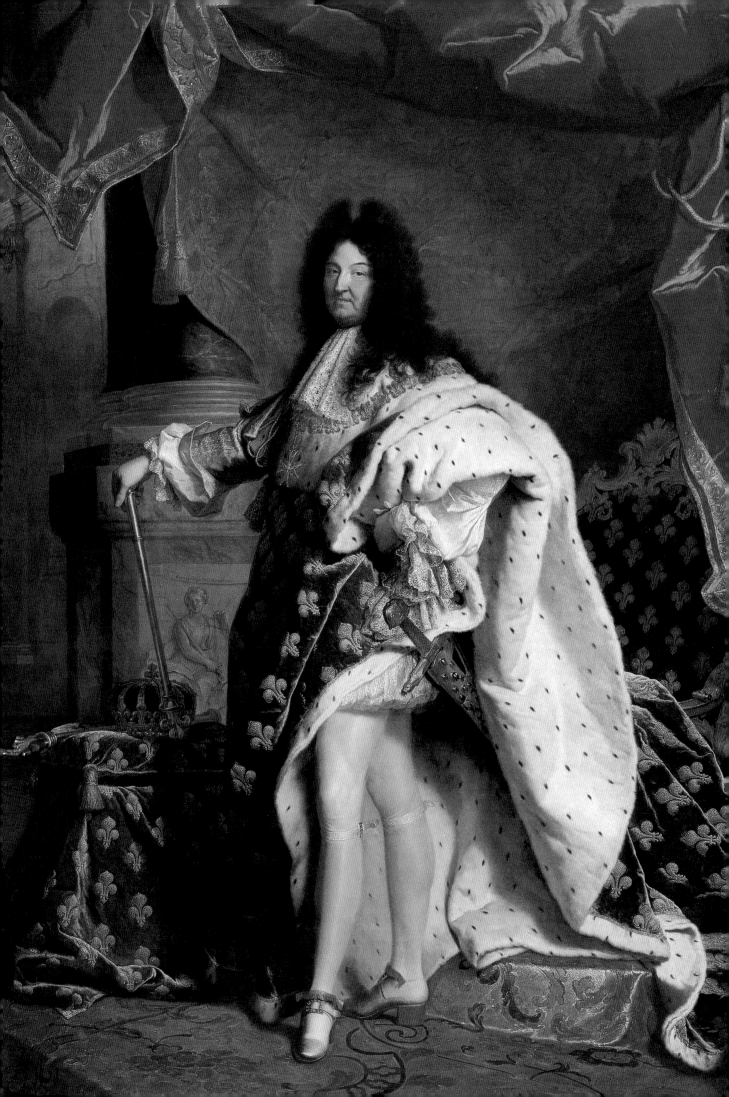

Chapter One

Rococo, Enlightenment, and the Call for a New Art in the Mid-Eighteenth Century

The death of Louis XIV (FIG. 1-1) in 1715 marked the end of an era in France. The "Sun King" had epitomized absolutism, a system of government in which all power—legislative, judicial, and financial—is concentrated in the hands of a single ruler (see *Absolutism*, right). In his famous maxim, "L'état, c'est moi" (The State, it is I), Louis had equated the monarch with the body of state.

Although Louis's death did not abolish the absolute monarchy, it did end the rigid, even stifling control that he had exerted over the cultural and intellectual life of his time. This offered his subjects a chance to question the philosophical and religious principles on which absolutism was based. In time, such questioning would lead to the demise of monarchic rule at the hands of the revolutionaries of 1789.

Louis XV and the Emergence of the Rococo Interior

During the lengthy reign of Louis XV (1715–74), the French upper class experienced a new social and intellectual freedom. Aristocrats and wealthy bourgeois (members of the bourgeoisie, or middle classes) focused on play and pleasure. Grace and wit were prized in social interactions.

1-1 **Hyacinthe Rigaud,** *Portrait of Louis XIV,* 1701. Oil on canvas, 9'2" x 7'10" (2.79 x 2.4 m). Musée du Louvre, Paris.

Absolutism

As strange as political absolutism may seem to us today, in the seventeenth and much of the eighteenth century it was justified on both religious and pragmatic grounds. Monarchs were believed to derive their authority from God, who had ordained them as executors of his divine will on earth. Their absolute rule was seen as a guarantee of order and security and the best safeguard against chaos and anarchy. Absolutism was the norm not only in France but also in Spain, Russia, and many of the Germanic states, such as Prussia and Saxony. Even in England, where it was tempered by the English constitution, the power of the king was sacrosanct.

Philosophically, absolutism fitted perfectly into the understanding of the universe as the "Great Chain of Being." Following this concept, all forms of life were linked in a hierarchic fashion, beginning with God, the "Supreme Being," and ending with the lowest microscopic creatures. If any class of beings were to exert undue pressure, the chain might break and chaos would reign. The poet Alexander Pope (1688–1744), in his *Essay on Man* (1732–3), expressed the idea most concisely:

Vast chain of being! Which from God began,
Natures ethereal, human, angel, man,
Beast, bird, fish, insect, what no eye can see,
No [magnifying] glass can reach; . . .
Where, one step broken, the great scale's destroyed:
From Nature's chain whatever link you strike,
Tenth, or ten thousandth, breaks the chain alike.

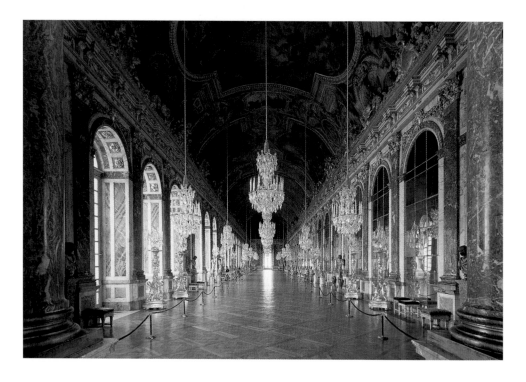

A new intellectual curiosity gave rise to a healthy scepticism towards well-worn truths.

The cultural differences between the reigns of Louis XIV and Louis XV are clearly expressed in the spaces in which the social life of the aristocracy took place. The great palace that Louis XIV had built at Versailles (FIG. 1-2), outside Paris, was the center of court life in the late seventeenth century. The grandiose Baroque structure, with its tall arches and heavy columns, was meant to overwhelm the French people and foreign visitors alike. At the heart of the palace sprawled a vast ballroom (FIG. 1-3), 239 feet long and 34 feet wide (two-and-a-half times the length of a basketball court). One of its walls had seventeen tall windows, overlooking the palace gardens; the other had seventeen mirrors, which made the hall look twice as wide. The opulent décor of this "Gallery of Mirrors"—ceiling, paintings, statues, tapestries, and chandeliers (it took some 3000 candles to light the room)—made it a perfect setting for the rigidly orchestrated receptions and formal balls that took place here during the heyday of Louis XIV's reign.

1-3 **Jules Hardouin-Mansart,** Gallery of Mirrors, Palace of Versailles, 1678–84. Versailles, France.

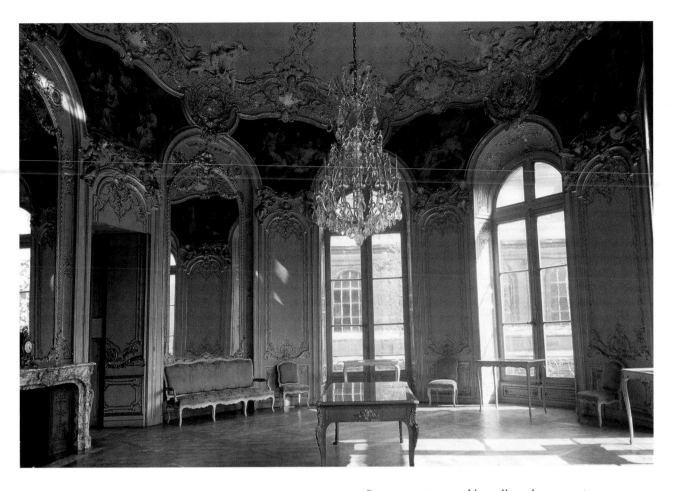

1-4 **Germain Boffrand,** Salon de la Princesse, Hôtel de
Soubise (currently National Archives), 1732. Paris.

1-5 Ceiling decoration of the Salon de la Princesse, Hôtel de
Soubise (currently National Archives), 1732. Stucco, detail. Paris.

By comparison to Versailles, the reception rooms or
"salons" of the eighteenth-century Hôtel de Soubise
(FIG. 1-4) are modestly scaled. This Parisian *hôtel* or man-
sion belonged to one of France's leading princely families.
It was refurbished after Louis XIV's death, when the
aristocracy, happy to leave the "golden cage" of Versailles,
moved back to Paris. Designed by Germain Boffrand
(1667–1754), the interiors of the Hôtel de Soubise have
a light and playful character quite different from the
imposing splendor of the interiors of Versailles. These
rooms, designed for informal social gatherings, tend to be
intimate rather than grandiloquent. Frequently oval or
round in shape, their walls are decorated with elegantly
carved wood paneling, punctuated by encased paintings
and mirrors. Fancy stucco decorations articulate the curved
ceilings. Both the woodcarvings and the stucco work (see
FIG. 1-5) display organic, winding forms, reminiscent of
vines, unfurling leaves, shells, or fantastic rock formations.
"Rococo," the term used to describe the decorative and
the fine arts during the reign of Louis XV, comes from the
French word *rocaille*, which refers to the rockeries in con-
temporary gardens that presumably inspired these decorations.

Some of the leading artists of the time contributed to
the interior decoration of the Hôtel de Soubise. The
Gracious Shepherd (FIG. 1-6) by François Boucher (1703–1770)
is characteristic of the paintings that grace its interiors. A
young shepherd presents a shepherdess with a little bird

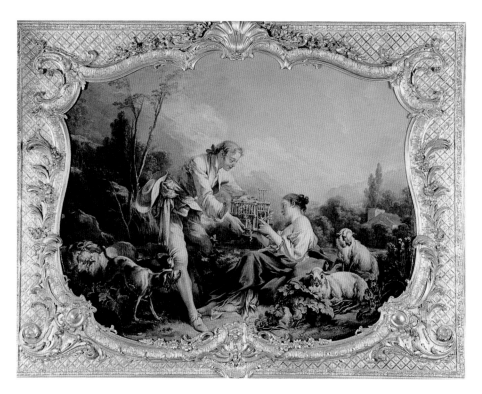

1-6 **François Boucher,** *Gracious Shepherd,* 1736–9. Oil on canvas, 49 x 65¹³/₁₆″ (1.25 x 1.67 m). Salon de la Princesse, Hôtel de Soubise (currently National Archives), Stateroom (Chambre de Parade). Paris.

1-7 **François Boucher,** *Mars and Venus Surprised by Vulcan,* 1754. Oil on canvas, 64¹/₂ x 28″ (1.64 m x 71 cm). Wallace Collection, London.

in a cage, the first phase in a courtship that will, no doubt, lead to her own capture by love. Given the social realities of the eighteenth century, it is obvious that these fashionably coiffeured and fancily dressed young people are not really shepherds. Instead, Boucher's idyllic pastoral scene is an escapist fantasy, meant to evoke nostalgia for the simple pleasures of country life.

Rococo Decoration: Paintings, Sculptures, and Porcelains

Boucher was the most famous decorative painter during the reign of Louis XV. In addition to pastoral idylls, he produced numerous mythological scenes in which nymphs and goddesses, all young, gorgeous, and brazenly nude, abandon themselves to sexual pleasure. Venus, the Roman goddess of love, figures prominently in Boucher's work. In the painting reproduced in FIG. 1-7, her husband Vulcan finds her in bed with her lover Mars, a development that, in her ecstasy, she fails to notice. Characteristic of Boucher's work, the scene is quite contrived: an undulating mattress is suspended in a forest, while fluttering putti (cupids) flutter around with enormous satin bed sheets.

The work of Boucher's younger colleague Jean-Honoré Fragonard (1732–1806) shows another aspect of Rococo decorative painting. This artist was especially drawn to the playful lives and loves of the aristocratic youth of his day. *The Secret Meeting* (FIG. 1-8) is one of four decorative panels commissioned by Madame du Barry, the last of Louis XV's many mistresses. In it, a young man has found a ladder to scale the wall surrounding the estate of his

1-8 **Jean-Honoré Fragonard,** *The Secret Meeting,* from
The Progress of Love series, 1771–3. Oil on canvas, 10'5" x 8'
(3.17 x 2.44 m). Frick Collection, New York.

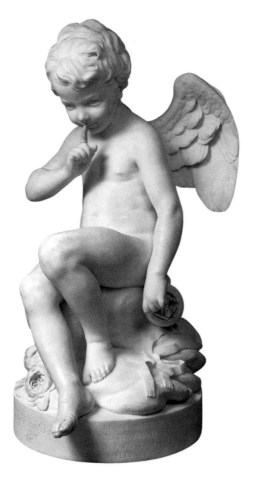

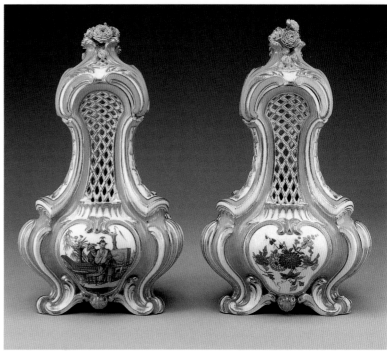

1-9 **Etienne-Maurice Falconet,** *Seated Cupid,* 1757. Marble, height 35" (90 cm). Musée du Louvre, Paris.

1-10 *Sèvres Manufactory, A pair of potpourri vases with lids,* 1761. Soft-paste porcelain, height 11½" (29.2 cm). Decorations painted by Charles-Nicholas Dodin (1734–1803). Detroit Institute of Arts.

sweetheart's parents. The girl, who has agreed to a secret rendezvous, looks anxiously around, suspecting that someone has followed her. Although Fragonard's painting deals with a contemporary theme, it presents no less a fantasy than the works of Boucher. The contrived eagerness of the two lovers and their charming "love nest," guarded by a statue of Venus and Cupid, all form a highly pleasing artifice.

Decorative statues such as the one depicted in Fragonard's painting abounded during the Rococo era. Venus and Cupid were favored subjects, as were shepherds and shepherdesses. *Seated Cupid* (FIG. 1-9), by Etienne-Maurice Falconet (1716–1791), was destined for the Parisian residence of Louis XV's mistress Madame de Pompadour. (The building now serves as the French Presidential Palace.) It shows Cupid holding his finger to his lips as he quietly pulls an arrow from his quiver. The statue engages the viewer by making him or her an accomplice in Cupid's furtive attack on an invisible "victim." Who could refuse to participate in his little game, which ultimately leads to sweet love?

No French eighteenth-century room would have been complete without the presence of some porcelain vases, candlesticks, or figurines. Although porcelain had been made in China since the eighth century CE. European manufacturers did not master it until the eighteenth. The most luxurious porcelains were produced in Sèvres, near Paris, in a factory that was controlled by Louis XV's Royal Administration. A pair of potpourri vases (FIG. 1-10), made to contain fragrant flowers and spices, exemplifies the originality of eighteenth-century Sèvres porcelains. Their playful forms, outlined by a succession of inward and outward curves, are enhanced by both three-dimensional and painted decorations. A delicately molded bunch of flowers on the lid of each vase is matched by a painted bouquet on one side. On the other, a fanciful scene of Chinese life shows the eighteenth-century love of *chinoiseries,* exotic fantasies informed by the scarce knowledge that Europeans had of China.

The Enlightenment

With their lighthearted paintings, charming sculptures, and playful, delicate porcelains, Rococo interiors served as a perfect backdrop for the intimate gatherings that were fashionable among eighteenth-century high society. The well-known hostesses of the day knew that the success of their "salons" depended on sparkling, quick-witted conversation. Thus they were eager to include among their guests some of the leading intellectuals of the day. Fortunately, there was no shortage of brilliant minds in Paris. The playful, libertine spirit of the age stimulated a new freedom of thought, and a willingness to challenge the convictions of the past.

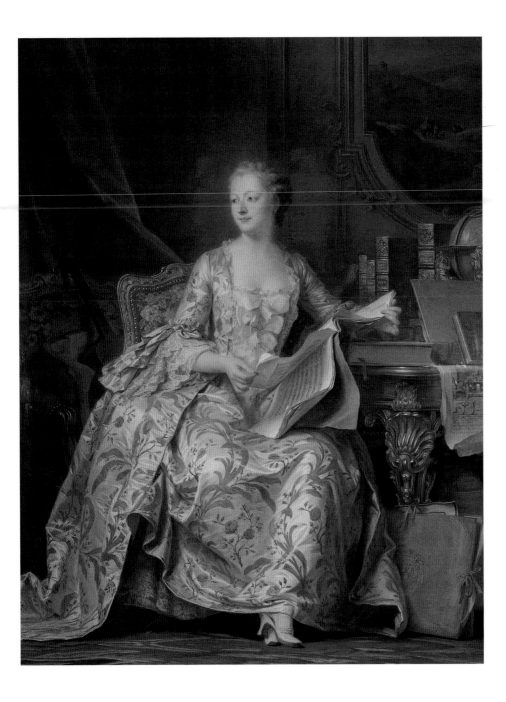

1-11 **Maurice Quentin de la Tour,** *Portrait of Madame de Pompadour,* Salon of 1755. Pastel, 69 x 50⁷⁄₁₆" (1.75 x 1.28 m). Musée du Louvre, Paris.

This was the period of the Enlightenment, an intellectual movement that had originated in seventeenth-century England but culminated with the French *philosophes* of the eighteenth century. Men such as François-Marie Arouet, better known as Voltaire (1694–1778), Denis Diderot (1713–1784), and Jean d'Alembert (1717–1783) had an unfailing belief in the power of reason. Reason, they felt, could explain all natural phenomena. It was also the basis for a rational moral code by which all men could abide. Challenging such ingrained beliefs as the Great Chain of Being and the Divine Right of Kings (see *Absolutism,* page 19), the *philosophes* even called the existence of God into question.

Among the great eighteenth-century hostesses to entertain the likes of Voltaire and Diderot was Jeanne Antoinette Poisson (1721–1764). Her contemporaries knew her as the Marquise de Pompadour, a title she received from Louis XV after becoming his leading mistress in 1745. Beautiful, clever and talented, she was a refined patron of literature and the arts and an arbiter of "good taste." Her famous pastel portrait (FIG. 1-11) by Maurice-Quentin de la Tour (1704–1788) shows the royal mistress seated at a table piled with books, a globe, and sheet music. A portfolio stuffed with drawings and prints leans against the table leg. Dressed in a white satin dress embroidered with sprigs of roses, she exudes worldliness and sophistication.

Madame de Pompadour became the special protector of one of the great intellectual undertakings of the eighteenth century, the *Encyclopédie,* a multi-volume illustrated encyclopedia that encompassed all contemporary

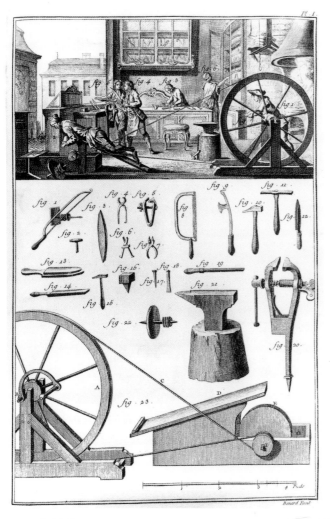

had already refuted the Divine Right of Kings and declared that political power was justified only if it served the public good—an idea that would greatly influence the American Constitution.

Locke also asserted that knowledge is derived from sensual experience, as opposed to being innate. This idea was the essence of a philosophical system called Empiricism, and it affected early eighteenth-century art theory by inverting the relative importance attached to different art forms. Previously, literature had been held in highest esteem because it appealed to the intellect. Now the fine arts and music were given priority, because these were experienced directly by the senses. Influenced by Locke, the French theorist Jean-Baptiste Dubos (1670–1742) praised pictures over poems because they "act upon us directly through the organ of sight; and the painter does not employ artificial signs to convey his effect . . . the pleasure we derive from art is a physical pleasure."

The Rococo outside France

Dubos's notion that art provides physical pleasure is central to the Rococo aesthetic. This aesthetic not only governed the interiors of the Parisian homes of the French aristocracy, but also eighteenth-century churches and monasteries in central and southern Europe. That religious architecture thrived during the eighteenth century may at first seem strange, in view of the religious scepticism of the period. This scepticism, however, had little impact outside the small circles of British Enlightenment philosophers and French *philosophes*. Throughout most of the eighteenth century, religion remained the undisputed mainstay of society at large.

A small but perfect example of Rococo religious architecture is the Wieskirche or "Church of the Meadow," built by Dominikus Zimmermann (1685–1766). Located in southern Germany, in the Bavarian countryside, the modest white exterior of this oval-shaped pilgrimage church gives no hint of the exuberance of its interior (FIG. 1-13). Inside, one is immediately drawn to the altar, which stands before an elaborate backdrop of architectural, sculptural, and painted decorations. Light streaming in through large windows glints off the gilded decorative stucco work all around the church. Looking up, one sees a large, exuberant ceiling painting. The interior's dominant colors, white, pink, and gold, lend a sense of lightness and airiness to the building despite the elaborateness of its decorations. Like Boffrand's salons in France, Zimmermann's church interior was meant to evoke sensual delight, yet its purpose was not to provide erotic excitement but rather to bring the soul closer to God.

Among the striking aspects of Rococo architecture is the contrast between the clarity and simplicity of its basic structures and the richness of its ornamentation. The great

1-12 *Cutler's Shop.* Illustration in Diderot's *Encyclopédie,* 1762–77 (plate volumes). Engraving. Private Collection, London.

knowledge, from philosophy and literature to astronomy and technology. Protection was something the *Encyclopédie* much needed since, from the beginning, the undertaking was attacked by the Roman Catholic Church for its progressive tone and the irreligious bent of many of its articles.

The chief editors of the *Encyclopédie* were philosopher-writer-critic Diderot and the mathematician D'Alembert, who engaged an army of contemporary scholars, scientists, and artists to write articles and draw illustrations. The *Cutler's Shop* (FIG. 1-12), one of many plates depicting contemporary trades, shows in detail the entire manufacturing process of cutlery, including the workshop and the tools of the trade. The image reveals the eighteenth-century passion for rational order and systematization. It also speaks of a new fascination with technology that would soon give rise to the Industrial Revolution.

The *Encyclopédie* drew heavily on earlier examples, notably the English *Cyclopaedia* of Ephraim Chambers (c.1680–1740), published as early as 1728. As mentioned, the British were really the main initiators of Enlightenment thought. At the end of the seventeenth century, John Locke (1632–1704)

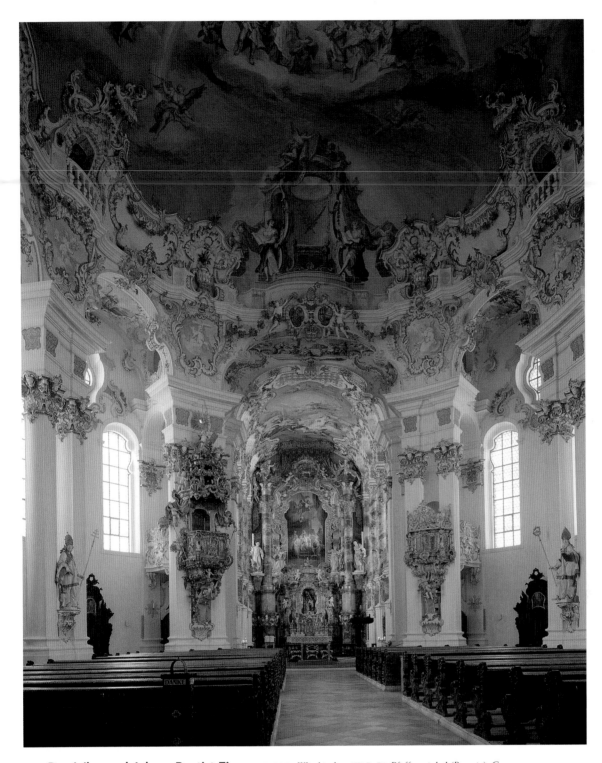

1-13 **Dominikus and Johann Baptist Zimmermann,** Wieskirche, 1745–54. Pfaffenwinkel (Bavaria), Germany.

architectural historian Nikolaus Pevsner (1902–1983) drew a parallel with the music of the time. He found in the works of Johann Sebastian Bach (1685–1750) and George Frederick Handel (1685–1759) an analogous use of a basic structure that is embellished and heightened by grace notes and trills. Bach and his contemporaries did not write these "embellishments" into the music, but left it up to the performers to improvise them. In the same way, Rococo architects designed only the main structure and left the painting, carving, and stucco work to local craftsmen, who could show off their imagination and virtuosity through intricate ornamental work.

Few Rococo craftsmen were well known. Yet some decorative painters, such as Boucher and Fragonard, achieved national reputations. Even more famous was the Venetian painter Giovanni Battista Tiepolo (1696–1770), who

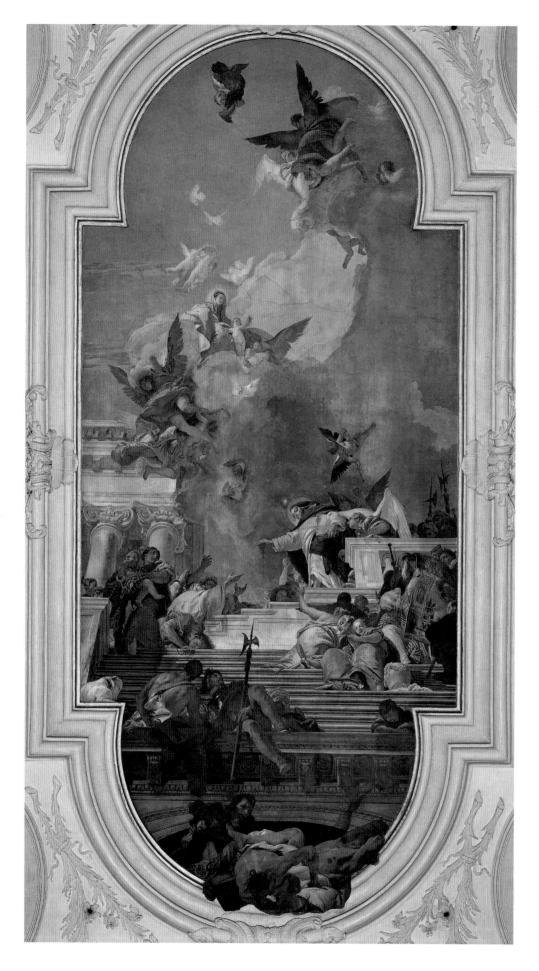

1-14 Giovanni Battista Tiepolo, *The Institution of the Rosary,* 1738–9. Ceiling fresco, 45'11" x 14'9" (14 x 4.5 m). Venice, Santa Maria del Rosario, Church of the Gesuati.

decorated churches and palaces throughout central and southern Europe. Tiepolo's *Institution of the Rosary* (FIG. 1-14) in the vault of the church of Santa Maria del Rosario in Venice is a breathtaking example of his work. The painting gives viewers the illusion that, through an opening in the ceiling, they are looking up into another space, beyond our earthly realm. In that space, a monumental staircase leads up to a huge building. At the top of the stairs St Dominic hands over the rosary to mankind. Beyond him, we see the Virgin Mary and the Christ child hovering on light-filled clouds, with angels fluttering around them.

Tiepolo has composed the scene so that our eye is guided in zigzag fashion from the bottom of the fresco, which "spills over" the frame into the space of the church, to the group of angels at the top. (To create the "spill-over" effect, a piece of carefully shaped canvas has been attached to the fresco to overlap the stucco edge.) The movement of the eye becomes a metaphor for the transport of the soul, guided by religion, from earth into heaven. This transport is likewise suggested by the color scheme, which moves from dark, earthly colors to light pastel tones. Tiepolo's art marries Rococo sensuality and Enlightenment reason. In this painting, the emotions of religious ecstasy are invoked by the methodical manipulation of perspective, composition, and color.

Portrait Painting in Britain

While Rococo decoration flourished in central and southern Europe, it failed to take root in the North. In countries such as Britain, Scandinavia, the Netherlands, and the northern German states, the demand for art was largely confined to easel paintings, that is, paintings that were done on an easel, framed, and hung on a wall.

In Britain, the most powerful nation in northern Europe, wealthy nobles decorated their homes with old master paintings. Contemporary artists were employed almost exclusively to paint family portraits, for which there was great demand. The *Portrait of Mary, Countess Howe* (FIG. 1-15) by Thomas Gainsborough (1727–1788) is but one example of the many portraits of the nobility that were produced in eighteenth-century Britain. Painted around 1763, it shows a life-size portrait of the countess taking an evening stroll. Her high heels and pink lacy dress are hardly suited for this activity, and she must lift her lace apron to prevent it from catching on a thistle. The incongruity of her situation reminds us that the painting is nothing like a modern snapshot, capturing the countess in an unguarded moment. Instead, the portrait is carefully engineered to illustrate her station in life. The landscape background marks her as a member of the nobility, for she, like other landed aristocrats, owed her wealth and social status to the land. The costly silks, laces, and pearls signify her family's financial well-being.

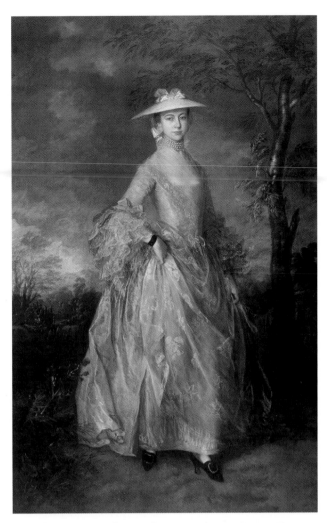

1-15 **Thomas Gainsborough,** *Portrait of Mary, Countess Howe,* c.1760. Oil on canvas, 8 x 5' (2.44 x 1.52 m). Kenwood, Iveagh Bequest, London.

In spite of all its contrivances, Gainsborough has managed to give the portrait a sense of spontaneity. The countess's bouncy step and pretty face, with a hint of a smile, suggest an intelligent woman with an independent spirit. The portrait is painted in a loose, free manner that belies the constraints of its composition. The virtuoso rendering of the silk and lace, and the freely sketched landscape background, tie Gainsborough's art to Rococo painting on the European mainland.

The Eighteenth-Century Artist: Between Patronage and the Art Market

Tiepolo and Boucher, perhaps the best-known artists of the first half of the eighteenth century, were "fine art entrepreneurs." Tiepolo travelled around Europe with an army of assistants to execute huge decorative ensembles for princely palaces and religious buildings. Boucher, whose activities remained largely confined to France, was an

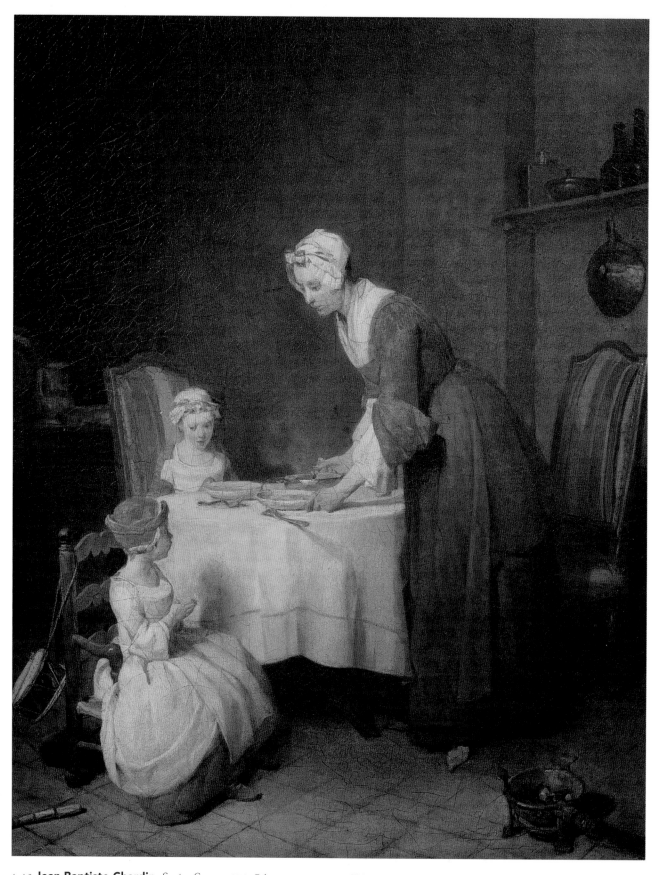

1-16 **Jean-Baptiste Chardin,** *Saying Grace,* c.1740. Oil on canvas, 19 x 15⅛″ (49.5 x 38.5 cm). Musée du Louvre, Paris.

entrepreneur of a different kind. In addition to painting decorative ensembles, he provided numerous designs for manufacturers of luxury goods, such as the Sèvres porcelain factory and the Gobelin tapestry manufactory. Both artists worked almost exclusively on commission and commanded substantial fees. Boucher is known to have earned some 50,000 *livres* a year, compared to a Paris university professor, who made about 1,900 *livres*.

Of the many artists who made their reputations and their fortunes as portrait painters, Gainsborough at the height of his career charged 30 guineas for a head, 60 for a half-length, and 100 guineas for a full-length portrait. He could easily earn £1,000 a year, allowing him to keep his own coach and to assemble a small collection of paintings. In France, La Tour demanded, and was paid, the unprecedented sum of 48,000 *livres* for his pastel portrait of *Madame de Pompadour* (see FIG. 1-11).

While decorators such as Boucher and portraitists such as Gainsborough depended on wealthy patrons (kings, nobles, religious institutions, and the like) for a living, a small but growing number of eighteenth-century artists produced directly for the art market. They painted pictures without commissions but in the hope that collectors would buy them. These artists generally turned away from mythological or religious scenes to focus instead on "lesser" subjects such as genre (scenes from daily life), landscape, and still life.

In France, Jean-Baptiste Chardin (1699–1779) sold still lifes and genre pictures to art connoisseurs who appreciated the quiet charm of his subjects, the subtlety of his compositions, and the tactility of his paint surfaces. His painting *Saying Grace* (FIG. 1-16) shows a sober middle-class interior with a mother bending over the dinner table. Two children, an older girl and a younger boy (little boys wore skirts until the early twentieth century), are seated opposite her. As in all paintings by Chardin, action and narrative are limited: the mother watches the little boy say his prayers as she places the dishes on the table.

Like many independent artists, Chardin made a steady second income through the sale of print reproductions of his paintings to a middle-class clientele (see *Reproducing Works of Art*, page 32). To increase their market appeal, these prints were frequently sold in series, with verses appended to the bottom of each print. The caption of a print after *Saying Grace* (FIG. 1-17) reads: "The sister slyly laughs at her little brother who hems and haws through

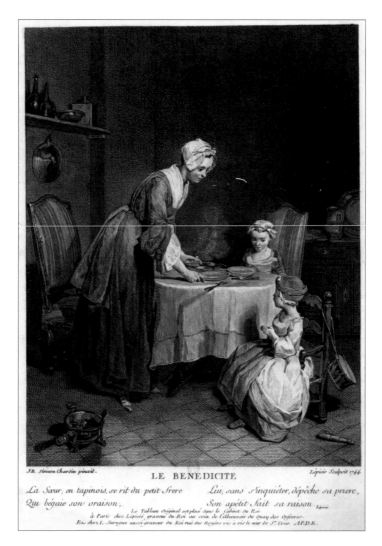

1-17 **Bernard Lépicié,** Reproduction of Chardin's *Saying Grace*, 1744. Engraving, 12³/₄ x 10″ (32.3 x 25.2 cm). Bibliothèque Nationale, Département des estampes et de la photographie, Paris.

Reproducing Works of Art

Today reproductions of works of art are so plentiful and ubiquitous that we can hardly imagine a time when they were coveted by collectors and sold for substantial prices. For most of the history of art, reproducing a work of art meant literally to re-produce it, that is, to copy it by hand. Such copies were frequently made by the artist himself on the request of a patron or collector. It took the invention of printing to allow for the manufacture of multiple reproductions, on paper and usually in reduced format.

Since the sixteenth century, the print technique most frequently used to reproduce art was engraving. To make a reproductive engraving, the engraver drew, on paper, a reduced copy of the painting or sculpture to be reproduced. He then engraved a copy of the drawing into the copper plate. From this plate, with the help of a bottle of ink and a printing press, several dozens or even hundreds of reproductions could be printed. Because of the way they were made, engravings generally reproduced works of art in reverse. In addition, they lacked color and were restricted to line. None of this hindered the demand for reproductive prints, which was the more widespread since, before the institution of museums at the end of the eighteenth century, public access to art was limited.

Reproductive engravings became especially popular in the eighteenth century, when new technical inventions, including color printing, made it possible to make reproductive engravings that came increasingly close to the original. In addition, print publishers thought of ever new ways of marketing prints, as they "packaged" them in print albums, with explanatory texts written by experts; or sold them as "furniture" prints, ready to be framed and hung on the wall.

Reproductive prints generally show the names of two artists, below the image. On the left is the name of the author of the original work, often in combination with the Latin word *pinxit* (painted) or *delineavit* (drew). On the right is the name of the printmaker, generally before the Latin *sculpsit* (engraved).

1-18 **William Hogarth,** *The Death of the Countess,* from *The Marriage-à-la-Mode* series, 1743–5. Oil on canvas, 27 x 35″ (68.6 x 88.9 cm). National Gallery, London.

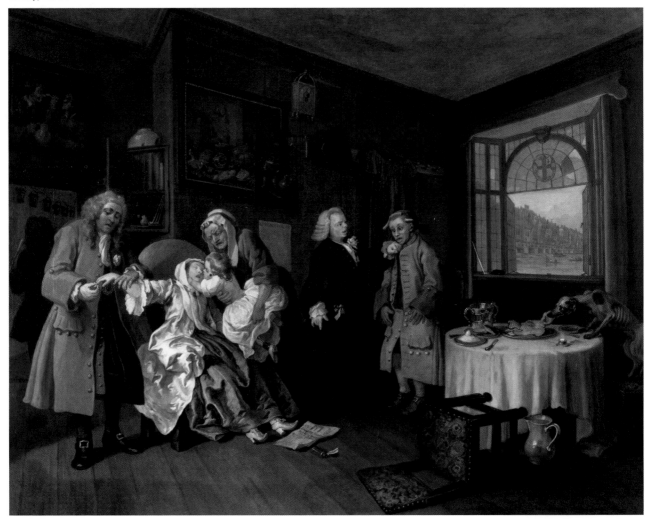

his prayer. He does not care but hurries on, spurred on by his appetite." The text "enlarges" the narrative content of the image by developing the characters of the children (the sly girl and the greedy little boy) and analyzing their motivations (the boy's hunger). By offering the viewers a "canned" interpretation, captions added to the popularity and marketability of prints.

Prints were so lucrative that some artists painted with the print market foremost in mind. The English artist William Hogarth (1697–1764), to this end, painted several series of pictures that were the eighteenth-century painted equivalents of modern soap operas. One of the best known is *Marriage-à-la-mode* or (*Fashionable Marriage*). This series of six paintings follows the sad course of an arranged marriage between the daughter of a rich bourgeois merchant and the son of an impoverished aristocratic family. As the betrothed pursue their private pleasures, the earl contracts venereal disease and his wife gets caught with her lover; the marriage ends with his death and her suicide. It is this tragic end that is represented in the final painting (FIG. 1-18), in which the unfaithful wife has collapsed in a chair after taking an overdose of laudanum. While the doctor feels her pulse, an old nurse brings over her little child for a final farewell kiss.

Hogarth announced the print series after his paintings in the *London Daily Post* of 1743: "MR. HOGARTH intends to publish by Subscription, SIX PRINTS from Copper-Plates, engrav'd by the best Masters in Paris, after his own Paintings; representing a variety of Modern Occurrences in High-Life and called MARRIAGE-A-LA-MODE." The series was quite successful among a well-to-do middle-class public that apparently framed these prints and hung them in the parlors of their houses.

The Education of the Artist and the Academy

Eighteenth-century art education for the most part followed the age-old model that had developed in the context of the medieval guilds. An aspiring young artist, often no more than fourteen years old, was apprenticed to an established master to learn the trade "from the bottom up." This system allowed young artists to learn the practical aspects of their chosen craft—painters would learn how to mix colors, and sculptors would learn to carve marble. When it came to the "higher" aspects of art, such as its history, theory, and aesthetics, however, apprenticeships did not always suffice.

Partly in response to this shortcoming, an alternative model of art education gained ground during the eighteenth century. As early as 1648, the French Council of State had approved the foundation of the Royal Academy of Painting and Sculpture, which was to serve as a school of figure drawing. Here, young artists, under the supervision of an academy member, could draw from casts of classical sculptures and live models. The purpose of the academy was not to replace apprenticeships, but rather to supplement their practical training with exposure to Greek and Roman sculptures, which were seen as the fountainhead of the Western artistic tradition.

The French Academy, though especially influential in Europe, was not the first institution of its kind. It had been preceded by several smaller academies in Italy, some dating as far back as the sixteenth century. As a national, government-sanctioned institution, however, the French Academy set an important example that, in the eighteenth century, was followed everywhere. Academies were founded in Vienna (1692), Madrid (1744), Copenhagen (1754), St Petersburg (1757), and London (1768), to mention only a few.

Eighteenth-century academies had two other missions besides teaching. First, they had to uphold artistic standards; second, they had to secure due respect for the visual arts within the broader cultural realm. To uphold artistic standards, academies developed reward systems that encouraged artistic competition. In most countries, the highest reward was membership in the academy itself, an honor that was reserved for well-established artists. (The British Royal Academy, from its foundation until the present, has never had more than forty members, according to its original statutes.) Academies also organized competitions for young artists. In France, the winners of the most prestigious art contest were given the funds for a trip to Rome, where they could study Classical and Renaissance art first hand. To this end, the French Academy even established an academy in Rome where winners of the Prix de Rome or Rome Prize could live and work for four years.

Academy Exhibitions

To secure for the visual arts a place of dignity in the cultural realm, academies organized periodic art exhibitions showing works by the membership and other artists approved by a member-appointed jury. The French initiated this practice. At first, academy exhibitions were at irregular intervals, but after 1737 they became annual or biannual. Held in the Louvre, the unused royal palace in Paris, they were called "salons" after the large square reception room, the so-called Salon Carré, in which the works were displayed. Other academies followed the French example. In England, for example, the Royal Academy began organizing annual exhibitions in 1768 and has continued to do so ever since.

It is impossible to overrate the importance of these exhibitions. On the one hand, they allowed the general public to experience the art of their time. Academy exhibitions were thus a major force in the gradual democratization of the arts that took place in the course of the late eighteenth and nineteenth centuries. On the other, they gave artists

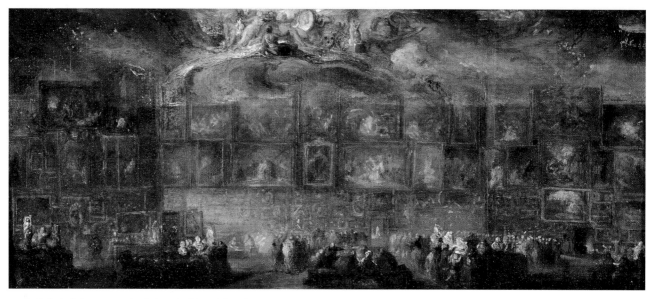

1-19 **Gabriel Jacques de Saint Aubin,** *Salon of 1767.* Watercolor and gouache, 9⁷/₈ x 18⁷/₈" (25 x 48 cm). Private Collection.

the opportunity to show their works in public. Since there were no commercial galleries in the eighteenth century, these exhibitions were essential for artists to make a name. Although academy exhibitions gave artists public exposure, they did not allow them to sell their works. Such transactions were arranged privately, between artist and patron. Artists received prospective clients in their studios to show paintings and negotiate sales. Only in rare instances did they involve a dealer. Generally, eighteenth-century art dealers avoided contemporary art, which was considered risky; they preferred to sell older works of art.

A watercolor of the Salon of 1767 (FIG. 1-19) by Gabriel-Jacques de Saint-Aubin (1724–1780) suggests what the French Academy exhibitions looked like in the eighteenth century. The walls of the Salon are crammed with paintings. Close to the ceiling are the large history paintings, which were considered the highest form of painting by academic standards. Below these hang portraits, landscapes, genre pictures, and still lifes. In the center of the room, on large tables, sculptures of nude gods and goddesses, portrait busts, and reliefs are displayed. Visitors mill around the room, scrutinizing and discussing the works. The visual effect of the Salon must have been dazzling, with the sea of colors on the walls and the swirls of people milling about below. Add to this the din of voices and the midsummer heat and it is clear that a visit to the Salon must have been quite overwhelming.

Salon Critics and the Call for a New Art in France

According to one eighteenth-century French official, academy exhibitions rendered a "sort of accounting" to the public of the academy's work. In the exhibitions, contemporary art was submitted to public scrutiny, leading, before long, to written critiques that were published in pamphlets and periodicals. From the mid-eighteenth century onwards, art criticism became a widely read and appreciated form of journalism. Critics were the middlemen between artists and public. As taste makers, they were both influential and powerful, since they could make or break artists' careers.

In 1747 a self-styled critic by the name of La Font de Saint-Yenne (1711–1769) published a lengthy pamphlet that is often seen as the first example of modern art criticism. Entitled *Réflexions sur quelques causes de l'état présent de la peinture en France* (Reflections on Some Causes of the Current State of Painting in France), it contains a lengthy review of the Salon of 1746, in which the critic laments the decadence of contemporary art. La Font's pamphlet enraged academic artists, who were not used to having their work so scrutinized. He was ridiculed, both in writing and in caricatures. In a print (FIG. 1-20) by Claude-Henri Watelet (1718–1786) he was portrayed as a blind man, complete with dog and cane—the ultimate offense to a critic of visual art. The attacks on La Font were so virulent that he felt compelled to defend himself in an open letter, published that same year. "It is only in the mouth of those firm and equitable men who compose the Public, [and] who have no links whatever with the artists, . . . that we can find the language of truth," he wrote. Thus he expressed the powerful idea that public exhibitions and impartial criticism would counterbalance the degeneration of art caused by artists' elitism and self-satisfaction.

To counter what he perceived as the decadence of art, La Font advocated that painters should abandon the frivolous, erotic subjects of Rococo painting for more noble themes. He suggested that they tone down their lively, asymmetric compositions, sensuous colors, and virtuoso

brushwork. La Font cited as examples the works of several sixteenth- and seventeenth-century artists who had found inspiration in Classical Greek and Roman art. He also proposed the foundation of a public museum where young artists could study, admire, and learn from the great masters of the Renaissance and the Baroque. This was a novel idea at the time, since most significant artworks of the past were in royal and aristocratic collections, which were generally inaccessible to the public.

La Font's infamous review of the Salon of 1746 was followed by a flood of salon critiques and other writings on contemporary art. Many of them repeated the call for a new art that was to be noble, edifying, and imbued with sentiment. That idea was expressed most eloquently by Denis Diderot, one of the editors of the *Encyclopédie*, who was also an insightful art critic. Between 1759 and 1771 he regularly reviewed the salons, and in so doing developed a blueprint for the direction into which eighteenth-century art should be moving. Diderot condemned Rococo

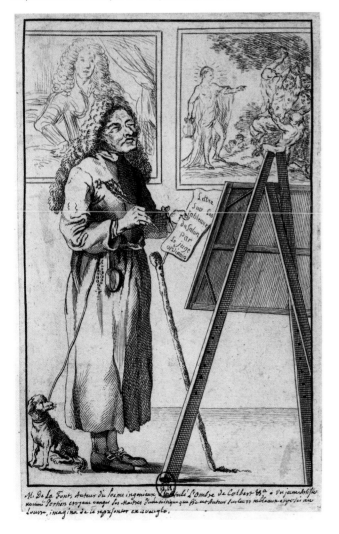

1-20 **Claude-Henri Watelet,** Caricature of La Font de Saint-Yenne. Etching after a drawing by Portien. Bibliothèque Nationale, Département des estampes et de la photographie, Paris.

decorative painting and lashed out against the work of Boucher, whose example he found ruinous for young painters. He criticized Boucher's pastoral scenes, "all dolled up with sheep and shepherds," as well as his mythological love scenes with their excesses of sensuality and nudity. Such works, to Diderot, could only issue from a depraved mind, the "imagination of a man who passes his life with the lowest-class prostitutes." (Ironically, Diderot's sharpest criticism against Boucher coincided with the artist's greatest public success, his appointment as "First Painter to the King" in 1765 and his appointment as director of the Academy in 1767.)

Diderot much preferred the work of Jean-Baptiste Chardin (see FIG. 1-16), since for him Chardin painted "nature and truth." He also praised the sentimental and edifying themes of Jean-Baptiste Greuze (1725–1805), who was by far his favorite artist. Greuze's *Filial Piety* (FIG. 1-21), shown at the Salon of 1763, drew his unconditional admiration: "this painting is beautiful and very beautiful." *Filial Piety* shows an old man, paralyzed by a stroke, surrounded by his caring family. Diderot admired the way in which Greuze's figures demonstrated their love for the old man. The blanket wrapped around his legs and the freshly washed sheet drying over the banister, to him, were moving evidence of filial care.

Greuze's paintings paralleled Diderot's own efforts to write a new kind of play, the *drame bourgeois* (bourgeois drama), that focused on contemporary middle-class life and its problems. Greuze, in fact, delivered what Diderot advocated: an art that dealt with contemporary realities, that showed genuine sentiment, and that presented virtuous examples.

> Oh, how beneficial would it be for mankind if all the arts of imitation set themselves a common goal and join hands with the laws to make us love virtue and hate vice! It is up to the philosopher to encourage them to do so; it is up to him to address himself to the poet, the painter, the musician, and to cry out to them in a loud voice: Men of genius, why has heaven endowed you? If he is understood, soon the walls of our palaces will no longer be covered with images of debauch; out voices will no longer be the organs of crime; and taste and social behavior will gain by it.

Count d'Angiviller and the Promotion of Virtuous Art

The mid-eighteenth-century call for a morally uplifting art has often been seen as the reaction of a hardworking middle class against the moral excesses of a bored and debauched aristocracy. Although there is some truth to this assertion, it simplifies a situation that was, in fact, highly nuanced. After all, the moralistic paintings of Chardin

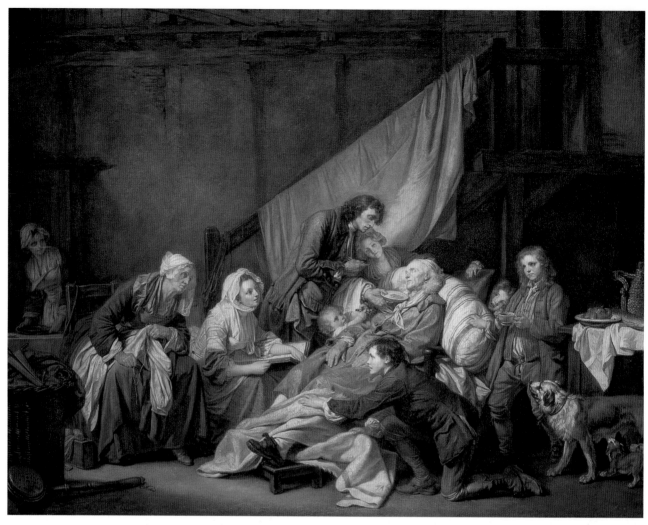

1-21 Jean-Baptiste Greuze, *Filial Piety* (*The Paralytic*), 1763. Oil on canvas, 43 x 57" (1.15 x 1.46 m). The State Hermitage Museum, St Petersburg.

and Greuze were collected by aristocratic patrons, including the king, while prints after the "debauched" paintings of Boucher and Fragonard sold well among the middle class. It is worth remembering as well that Madame de Pompadour, Louis XV's mistress, was the main protector of the *Encyclopédie*, in which many of the new ideas about the social function of art were expounded. By the same token, Diderot, that fierce critic of Rococo decorative painting, had himself portrayed by Fragonard!

Most importantly, the change in the arts that eventually came about was not initiated by the bourgeoisie but it was due to several initiatives of the office of the Director-General of Buildings, Gardens, Arts, Academies, and Royal Manufactories of the King. This office was responsible for the Academy and Salon exhibitions, as well as for all royal commissions for buildings, sculptures, and paintings. In the years between 1750 and 1790, this office was charged with the creation of a public art museum in the royal Luxembourg Palace in Paris, where, following La Font's advice, artists could study the old masters. It also encouraged a revival of history painting through commissions and acquisitions of serious works.

The latter initiative is associated in particular with Count Charles-Claude d'Angiviller (1730–1809), Director-General of Buildings under Louis XVI, who had succeeded his grandfather, Louis XV, in 1774. Shortly after taking office, D'Angiviller wrote a letter to the director of the Academy in which he declared that art's highest purpose was to promote virtue and to combat vice. To achieve this, he proposed to commission historical paintings with a strong moral impact. For the Salon of 1777, he awarded eight painting commissions for scenes from Greco-Roman and French history. It was specified that the paintings treat themes of religious piety, generosity, hard work, heroic resolve, respect for virtue, and respect for morality. A painting by the now forgotten artist Nicolas-Guy Brenet (1728–1792), a one-time student of Boucher, is an example of the works that resulted from d'Angiviller's dictate. Brenet's *Death of Du Guesclin* (FIG. 1-22) represents a scene from the Hundred Years' War between France and England (1337–1453). The

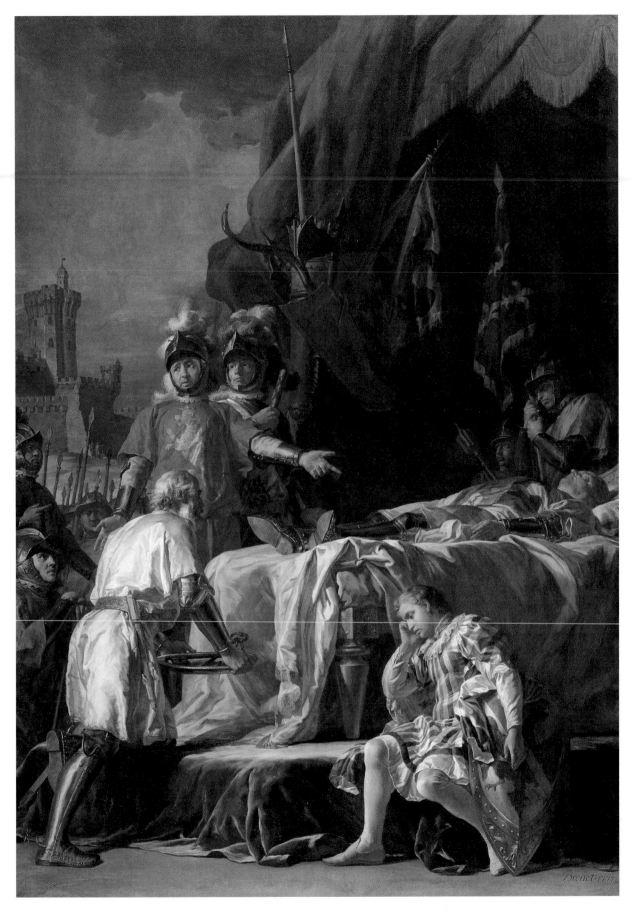

1-22 **Nicolas-Guy Brenet,** *Death of Du Guesclin,* 1777. Oil on canvas, 10'5" x 7'4" (3.17 x 2.24 m). Musée National du Château de Versailles, Versailles.

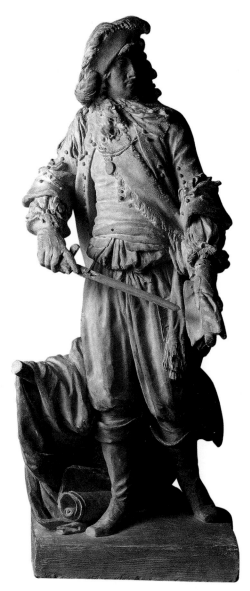

1-23 **Jean-Antoine Houdon,** *Admiral de Tourville,* 1781. Marble, over life-size. Musée National du Château de Versailles, Versailles.

painting's complex composition, the light colors, and the sensuous, cascading draperies connect it to the art of Boucher and Fragonard. It would take a younger generation of artists completely to sever the link with the Rococo style.

D'Angiviller also tried to redirect eighteenth-century sculpture by commissioning a series of monumental full-length portraits of the "great men of France." On the one hand, it was hoped that these effigies of men of high character would inspire greater virtue and intellectual achievement in French youth. On the other, by reminding Frenchmen of their hallowed history, the sculptures were expected to instill pride and patriotism. *Admiral de Tourville* (FIG. 1-23) by Jean-Antoine Houdon (1741–1828) was one of the statues in the series of "great men of France." It represents a well-known admiral from the time of Louis XIV who had won a series of naval battles before falling to the English fleet in the notorious battle of La Hogue (1692). For his courage and determination in that ill-fated battle, he was made Marshall of France. Like the history paintings commissioned by D'Angiviller, the statues of "great men" are marked by historic authenticity. D'Angiviller had no use for statues that depicted French heroes as nude gods or heroes. Through details of dress and attributes, each sculpture is clearly situated in a specific period of French history. That way, the ensemble of sculptures took the viewer through the entire annals of France.

Reynolds and the Call for a New Art in Britain

The call for a more serious, noble, and moral art was also heard in other countries, notably in Britain. Joshua Reynolds (1723–1792), first president of the British Royal Academy, set forth a new philosophy of art in a series of lectures, presented over a period of twenty years, at the openings of the academy exhibitions. In his so-called *Discourses on Art,* Reynolds called for the return to a "grand" or "great" style of painting, based on the art of Michelangelo (1475–1564) and Raphael (1483–1520), who were then considered the two supreme Renaissance masters. Reynolds's definition of "grand style" pertained to both form and subject matter. Formally, art had to be simple, natural, and "beautiful," according to the aesthetic criteria of Classical antiquity. Its subjects had to be noble and edifying, or, to use Reynolds's own terms ("Third Discourse"):

> Beauty and simplicity have so great a share in the
> composition of a great stile, that he who has
> acquired himself with them has little else to learn.
> It must not, indeed, be forgotten that there is a
> nobleness of conception, which goes beyond any
> thing in the mere exhibition even of perfect form;
> there is an art of animating and dignifying the
> figures with intellectual grandeur, of impressing
> the appearance of philosophick wisdom, or

virtuous French constable Du Guesclin had died while trying to win back a city occupied by the English. They had promised him that they would surrender if they did not receive help by a certain date. Even though the constable died, they kept their promise. In Brenet's painting the English commander kneels by Du Guesclin's deathbed and lays down the keys of the city. On either side of the bed, friends and fellow soldiers mourn the constable's death. His companion in arms points to Du Guesclin, as if to call attention to his courage and virtue.

Brenet's *Death of Du Guesclin* presents a radical departure from the lighthearted subjects of Boucher and Fragonard. Not only does it deal with a serious, moralistic theme, but it also shows great respect for historical accuracy. Brenet carefully studied medieval images to render the setting and costume of Du Guesclin's time accurately. Still, he did not turn his back on the Rococo completely. The

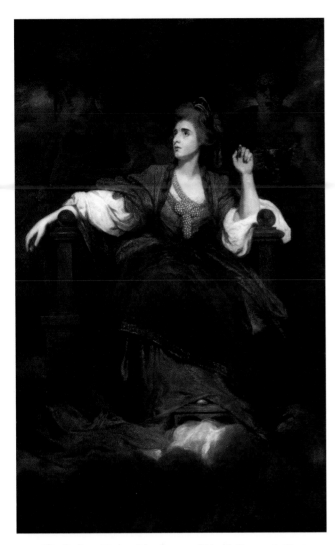

1-24 **Sir Joshua Reynolds,** *Portrait of Mrs. Siddons as the Tragic Muse,* 1789. Oil on canvas, 7'11" x 4'10" (2.4 x 1.48 m). Dulwich Picture Gallery, London.

heroick virtue. This can only be acquired by him that enlarges the sphere of his understanding by a variety of knowledge, and warms his imagination with the best productions of ancient and modern poetry.

Like progressive academicians in France, Reynolds advocated history painting as the highest form of art. Yet he himself painted only a few such works. History painting required a huge investment of time and materials, and painters would embark on it only to make an impression at the academy exhibitions or to fulfil a commission. In eighteenth-century Britain, however, government commissions were limited, and large-scale history paintings were difficult to sell to private patrons. Since there was little incentive for history painting, Reynolds, like most British artists, made his living painting portraits, for which there was always a healthy market. At times, though, he would try to graft his ideas for a grand style of painting onto portraiture. In some portraits, particularly those of women, he dressed his models as Greek goddesses or muses and placed them in a historical context. In others, he transformed his sitters into allegorical figures such as Nature, Poetry, or Tragedy. His *Portrait of Mrs. Siddons as the Tragic Muse* (FIG. 1-24) may serve as an example of the grand style in portraiture. The great actress, well known for her tragic roles (she was a favorite as Lady Macbeth), appears here as a muse enthroned between Pity (left) and Terror (right). The composition is directly inspired by one of the prophets in Michelangelo's ceiling painting in the Sistine chapel in Rome. This is not surprising, since Michelangelo was Reynolds's great hero: a "truly divine man" whom, in his *Discourses*, he recommended as the ultimate model for all artists.

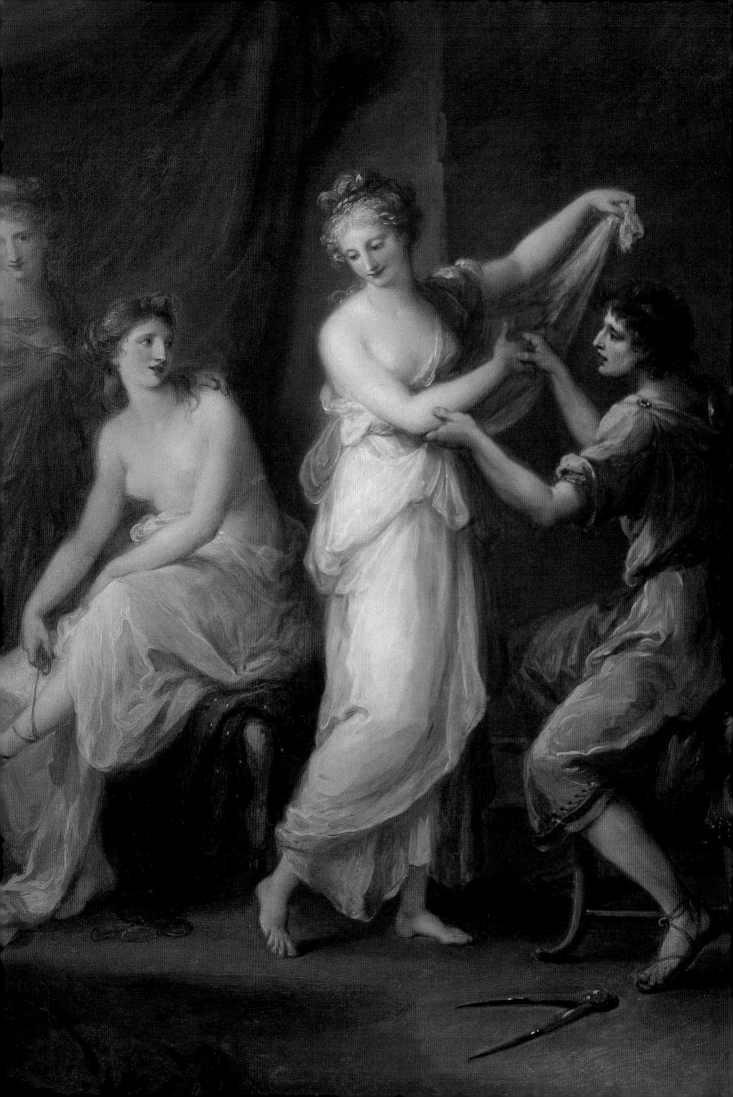

The Classical Paradigm

In order to counter the apparent decadence of contemporary art and culture, La Font de Saint-Yenne in France and Joshua Reynolds in England encouraged young artists to look at the art of the past. There, they believed, could be found the models of a new, noble, and edifying art that could strengthen, even repair the moral fabric of their nations. La Font, who advocated the creation of a public art museum for this purpose, cited the paintings of such seventeenth-century French history painters as Charles Lebrun (1619–1690), Eustache Le Sueur (1616–1655), and Nicolas Poussin (1594?–1665) as eminent models. Reynolds singled out the Italian Renaissance artists Michelangelo and Raphael as masters for young art students to emulate. These artists, they felt, had created great works by starting out with significant subjects and eloquent conceptions and realizing them with masterful compositions and perfect execution.

If there was a common denominator between the artistic role models proposed by La Font de Saint-Yenne and Reynolds, it was their common roots in the art of Classical antiquity. It was clearly understood, in the eighteenth century, that both Michelangelo and Raphael in the sixteenth century and Lebrun and Poussin in the seventeenth had looked at Classical art for inspiration. Reynolds, for one, felt that the study of Classical sculpture was as important as that of Renaissance painting. As the eighteenth century progressed, artists increasingly went beyond seventeenth- and even sixteenth-century painting to find, in antiquity,

the models for a "new art." Indeed, by the third quarter of the eighteenth century, it was Classical art rather than Renaissance or Baroque painting that came to be seen as the chief paradigm for the renewal of art.

Winckelmann and *Reflections on the Imitation of Greek Works in Painting and Sculpture*

The importance of Classical art, especially sculpture, as a pre-eminent model for contemporary artists was most forcefully argued by Johann Joachim Winckelmann (1717–1768), a German literary scholar. In 1755 Winckelmann published a short pamphlet entitled *Gedanken über die Nachahmung der Griechischen Werke in der Malerey und Bildhauerkunst* (*Reflections on the Imitation of Greek Works in Painting and Sculpture*, second edition, 1756; see FIG. 2-1). In it, Winckelmann pointed to Classical sculpture as a model not only for the improvement of painting and sculpture but of society as a whole. While recognizing that the perfect human forms found in Classical sculpture were "idealized" representations of reality, he nonetheless believed that they were fairly true representations of the ancient Greeks, whose lifestyle he held up as an inspiration for modern man. Inspired by his readings of Homer, Plato, and other ancient Greek authors, Winckelmann had formed a utopian idea of life in ancient Greece, where "from their earliest youth, the happy inhabitants were devoted to mirth

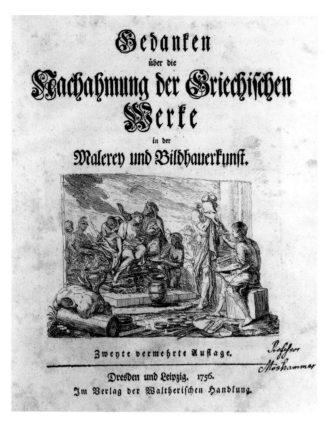

2-1 Title page of Johann Joachim Winckelmann, *Gedanken über die Nachahmung der Griechischen Wercke in der Mahlerey und Bildhauerkunst*, second edition (Dresden and Leipzich, 1756). Cambridge, Massachusetts, Harvard University Libraries.

Classical Art and Idealism

To Winckelmann and his contemporaries, Classical art exemplified ideal beauty, or what the French called *le beau idéal*. The notion of ideal beauty rested on the belief that nature, no matter how pleasing it may appear to the observer, is always imperfect. The ancient Greek philosopher Plato had first introduced the concept of an "imperfect nature." He suggested that the Creator or *Demiurgos* had conceived an "Idea"—a conceptual and invisible prototype of all things. This inherently perfect and absolutely beautiful Idea was realized on earth in an infinite number of forms, always falling somewhat short of the Idea itself. For example, the Creator had formed a generic and universal Idea of a "tree." However, all trees past, present, and future are but imperfect realizations of this ideal tree.

Classical Greek artists aimed at uncovering the "Idea" in the particularized forms of nature in order to approximate its supreme perfection in their works. Their sculptures (the art form for which they are best known) present male and female bodies, supremely proportioned and without the slightest blemish or deformity. Facial features of great regularity and calm expressions complete the effect of absolute beauty as the Greeks imagined it (see FIG. 2-5).

Idealism in art is that search for perfection in nature that was initiated by the Greeks and periodically revived—first in the Renaissance of the fifteenth and early sixteenth centuries, then in the works of some seventeenth-century artists, such as Annibale Carracci (1560–1609) in Italy and Nicholas Poussin in France, and, for the third time, in the period under discussion, from about 1760 to 1815. "By the ideal," wrote Anton Raphael Mengs (1728–1779), a German painter and theorist, "I mean that which one sees only with the imagination, and not with the eyes; thus an ideal in painting depends upon selection of the most beautiful things in nature purified of every imperfection."

Revealing the ideal in nature was considered a difficult task, requiring a special insight, often equated with "genius," as well as a great deal of practice and study. The study of Classical sculpture, in which the art of ennobling natural forms had been perfected, was considered especially important. As Reynolds stated in his *Discourses*:

> But the investigation of this [ideal] form, I grant, is painful and I know of but one method of shortening the road; this is, by a careful study of the ancient sculptors; who, being indefatigable in the school of nature, have left models of that perfect form behind them.

Contour

The eighteenth-century search for the ideal was closely bound to a preoccupation with outline or contour.

and pleasure [and] where narrow-spirited formality never restrained the liberty of manners." The Greeks, according to Winckelmann, lived simply, ate a healthy diet, and exercised regularly. This lifestyle contrasted sharply with that of the eighteenth century, when overeating and lack of exercise were the norm among the upper class. He also praised the loose clothes of the Greeks, as opposed to the confining, corseted fashions of the Rococo. Winckelmann suggested that the Greeks' sensible, natural lifestyle engendered healthy minds and high moral standards.

While Winckelmann's ultimate dream may have been to recreate ancient Greece in modern Europe, the aims he set in his pamphlet were more modest, confined as they were to the imitation of Greek art in modern painting and sculpture. "The only way," he wrote, "for us to become great or, if this be possible, inimitable, is to imitate the ancients." He noted that Michelangelo, Raphael, and Poussin had turned to Classical art for inspiration and he advised the artists of his own time to do the same. From the ancient artists, modern artists could learn to draw the perfect body contour, to model drapery gently around the human form, and, more generally, to extract the ideal from the real. A true understanding of Classical art, moreover, would help them to imbue their figures with that "noble simplicity and quiet grandeur" that Winckelmann admired above all in Greek art.

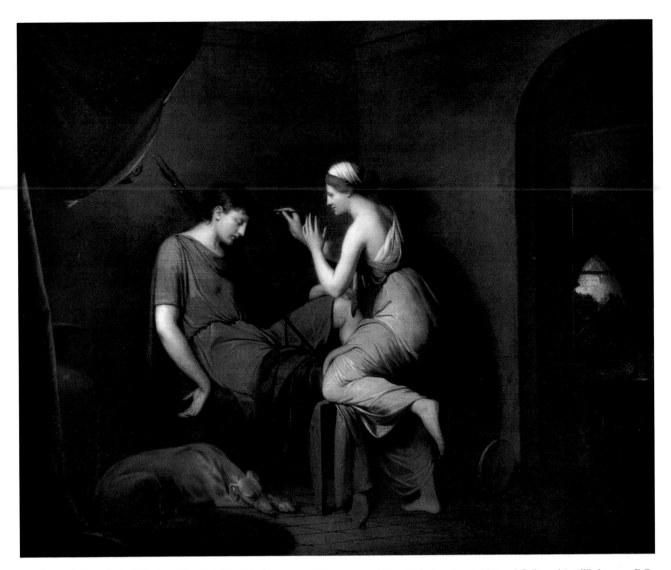

2-2 **Joseph Wright of Derby,** *The Corinthian Maid,* c.1782–5. Oil on canvas, 41⁷/₈ x 51" (1.06 x 1.3 m). National Gallery of Art, Washington, DC.

Recognizing its absence in nature (there are no black outlines around clouds, trees, or the human body), Winckelmann saw contour as the royal road to the ideal and the supreme means of artistic expression. Contour enabled the artist to purify reality by purging it from all physical particularities and reduce it to its formal essence—the highest beauty human beings could achieve. Winckelmann's celebration of contour was shared by many of his contemporaries. The Dutch philosopher Frans Hemsterhuis (1721–1790) even went so far as to attach an almost religious significance to contour. In his *Lettre sur la sculpture (Letter on Sculpture)*, published in 1769, he spoke of the sacred essence of line and the divine mission of drawing.

The renewed emphasis on outline during the eighteenth century led to a revival of interest in the Classical legend of the origin of art. According to the Roman writer Pliny the Elder (died CE 79), the first drawing in history was made by a Greek maid from Corinth who, saddened by the imminent departure of her lover, traced the shadow cast by his face on the wall. The story, which established contour drawing as the beginning of all art, was retold numerous times and even made its way into Diderot's *Encyclopédie*. It was also a favorite subject of late eighteenth-century artists such as the English painter Joseph Wright of Derby (1734–1797), whose painting, reproduced in FIG. 2-2, shows the Corinthian maid tracing the shadow of her sleeping lover.

Archaeology and the Discovery of Pompeii and Herculaneum

The mid-eighteenth-century preoccupation with the aesthetics (qualities of sensual experience) of Classical art coincided with a renewed scholarly interest in Classical culture. Enlightenment curiosity about the origins of mankind led to the birth of archaeology. Because of its accessibility and its rich past, Italy was the preferred

terrain for archaeological digs. Excavations along the west coast of Italy unearthed a number of ancient Etruscan tombs dating from the eighth century BCE, before the Etruscans were absorbed into the Roman Empire. Among the most exciting finds in these tombs were painted vessels of various shapes. Although archaeologists originally assumed that these vases were Etruscan, they eventually realized that the Etruscans had bought them from the Greeks. The earliest form of Western art known at the time, Greek vases seemed to take the viewer back to art's very origins. Because their painted decorations were based on strong contour lines, these vases confirmed the theory that the contour represented the earliest beginnings of art.

Greek or "Etruscan" vases, as they were known, were widely collected in the eighteenth century. By far the most important collection was that of William Hamilton (1730–1803), the British ambassador to the Kingdom of Naples, who assembled two important collections (the first one was sold to the British Museum in 1772), both of which were widely known by means of lavishly illustrated catalogues (see FIG. 2-3). In his preface to the second catalogue, Hamilton asserted the importance of these vases to contemporary art, claiming: "There are no monuments of antiquity that should excite the attention of modern artists more than the slight drawings on the most excellent of these vases; they may from them form a just idea of the spirit of the ancient Greek artists."

Of all the treasures unearthed by eighteenth-century excavations in Italy, none was more spectacular than the discovery, from 1738 onwards, of the ancient Roman cities of Pompeii and Herculaneum. These cities had been destroyed in the first century CE by an eruption of Mount Vesuvius, a volcano near the city of Naples in modern-day Italy. Very well preserved, Pompeii and Herculaneum

2-4 Large Garden Room, House of the Vettii, CE 62. Pompeii, Italy.

2-3 Reproduction of an image painted on a Greek vase. Illustration in Pierre-François-Hughes d'Harcanville, *Antiquités étrusques, grecques, et romaines tirées du cabinet de M. Hamilton* (vol. 4, pl. 43), 1766–77. Handcolored engraving. Private Collection.

gave a convincing representation of life in Classical times. Visitors could walk through the ancient squares and streets, enter temples, theatres, and homes, and admire a wide variety of Roman artefacts and utensils.

Perhaps the most brilliant treasures found in Pompeii and Herculaneum were a number of well-preserved, colorful paintings discovered on the interior walls of the large town houses. Some of these were purely decorative, others representational (FIG. 2-4). Until then very little was known about Classical painting since, with the exception of the small decorative paintings found on Greek vases, most of it seemed to have perished. Suddenly, a substantial body of Classical murals was available and this was to have a powerful effect on scholarship as well as the arts.

Winckelmann's *History of Ancient Art*

While the discovery of the Pompeian wall paintings caused great excitement, it also brought disappointment. To many connoisseurs it seemed that these paintings, frequently trivial in content and poorly executed, did not live up to

2-5 *Apollo Belvedere* (as the statue looked in the eighteenth century, before removal of restored hands and forearm). Roman copy of a Greek original of the late fourth century BCE, attributed to Leochares. Marble, height 7'4" (2.24 m). Vatican Museum, Rome.

an analogy to trace the history of Classical art. Just as life begins with birth, progresses through adulthood, and ends in old age and death, so Classical art (and by extension all major artistic traditions, according to Winckelmann) had an origin, a period of growth and maturity, and an eventual decline.

To Winckelmann, the cradle of Classical art had been not Rome but Greece, where the birth and the glorious peak of Greek art (during the so-called Classic phase of the fifth and fourth centuries BCE) had occurred. Winckelmann saw later Greek art, produced after Greece had been subsumed into the Roman Empire, as well as Roman art itself, as manifesting a decline. By focusing scholarly attention on Greece rather than Rome, he caused a major reorientation in the study of Classical art and culture, which until that time had favored Rome.

Winckelmann's contribution went beyond merely bringing new attention to Classical Greek art. His writings had an enormous impact, both during and after his lifetime, because of his unusual ability to engage the reader. Translated into many languages and frequently reprinted, his *History of Ancient Art* was widely read not only by scholars but also by artists, collectors, art lovers, and tourists, who came to Italy to admire the works of Classical antiquity. These lay people found excitement, not in Winckelmann's tight scholarly arguments, but in his wonderfully lively descriptions of Classical sculptures. Winckelmann showed his readers that these old marble statues were actually supremely beautiful images of human figures, pulsating with life, sensuous, and even sexually arousing. At the same time, he emphasized their "ideal" quality by pointing to the noble simplicity and calm grandeur of Classical sculpture. His description of the *Apollo Belvedere* (FIG. 2-5), one of the most famous Classical Greek sculptures in Rome (we now know that it is a Roman copy but in the eighteenth century it was considered a Greek original), speaks of his dual emphasis on the sensual and ideal qualities of Greek sculpture:

> Among all the works of antiquity, which have escaped destruction, the statue of Apollo is the highest ideal of art His stature is loftier than that of man and his attitude speaks of the greatness with which he is filled. An eternal spring . . . clothes with the charms of youth the graceful manliness of ripened years and plays with softness and tenderness about the proud shape of his limbs. . . . Neither blood vessels nor sinews heat and stir this body, but a heavenly essence, diffusing itself like a gentle stream, seems to fill the contour of the figure. . . . His lofty look, filled with a consciousness of power, seems to rise far above . . ., and to gaze into infinity. . . . The soft hair plays around the divine head as if agitated by a gentle breeze, like the slender waving tendrils of

the aesthetic standards of Classical sculpture. It was suggested that they represented a late phase in the development of Classical art, a phase in which that art was showing a decline. That, of course, implied that Classical art had undergone some kind of evolution, that it had a beginning, middle, and end.

This idea was further developed by Winckelmann. Attracted by the archaeological activity in Italy, this German scholar had moved to Rome in 1855 (the same year in which he wrote his *Reflections on the Imitation of Greek Works*). Appointed curator of the collection of antiquities owned by Cardinal Alessandro Albani (1692–1779), Winckelmann wrote several major books on Classical art, most importantly *Geschichte der Kunst des Altertums* (*The History of Ancient Art*), published in Germany in 1764. In this book, Winckelmann used the biological life cycle as

the noble vine; it seems to be anointed with the oil of the gods, and tied by the graces with pleasing display on the crown of his head. . . . In the presence of this miracle of art, I forget all else . . . My breast seems to enlarge and swell with reverence, . . . and I feel myself transported to Dells and into the Lycaean groves—places that Apollo honored by his presence . . .

Greece and Rome

Surprisingly, although Winckelmann drew attention to ancient Greek art, he never visited Greece. In the eighteenth century, travel to Greece was difficult and hazardous. Unlike Italy, which had been a tourist attraction from at least the seventeenth century, Greece was largely unknown territory. Admirers of Greek art had ample opportunity to view it in Italy; southern Italy had long been a Greek colony, and one could find many Classical Greek temples and sculptures there. In addition, the Romans, as well as the Etruscans before them, had widely collected and copied Classical Greek sculptures, vases, and coins, many of which were preserved in various public and private collections in Rome.

If Winckelmann never set foot in Greece, however, others, more adventurous, did feel the urge to study Greek art at its fountainhead. In 1751 the London Society of Dilettanti, a dining (and drinking) club of gentlemen who had made the Grand Tour of Italy (and thus become enamored of Classical art and archaeology) sponsored an expedition of two young architects, James Stuart (1713–1788) and Nicholas Revett (1720–1804), to Greece. Stuart and Revett were expected to study, measure, and draw ancient Greek architectural monuments. Seven years after their return to London in 1755, they began the publication of their research in a monumental, four-volume work entitled *The Antiquities of Athens* (1762–1816).

The Elgin Marbles

When Western European visitors such as Stuart and Revett came to explore the antiquities of Greece, the country was still a part of the Ottoman-Turkish Empire. The Turkish rulers of Greece had little interest in Classical Greek art and culture, which was entirely foreign to their own. This explains how it was possible for visitors to Greece to remove all sorts and sizes of Classical fragments and take them home. The most extreme case of archaeological "theft" was the removal of the decorative sculptures of the famous Athenian temple, the Parthenon, by the British aristocrat the 7th Earl of Elgin. Elgin had the sculptures shipped to London to be displayed in the British Museum (FIG. 2.1-1), where, despite the strong and continued objections of the Greeks, they may be found to this day. As unacceptable as was Elgin's deed, the display of the so-called Elgin Marbles in London contributed greatly to the revival of interest in Classical Greek sculpture in western Europe and America. Moreover, it may well have saved the sculptures from damage, even destruction.

2.1-1 **Archibald Archer,** *The Temporary Elgin Room,* 1819. Oil on canvas, 30 x 50" (76.2 cm x 1.27 m). British Museum, London.

It contains precise descriptions, careful measurements, and large folio-size engravings after Stuart's and Revett's on-the-spot drawings of Athenian temples—their plans, their elevations, and various architectural details (FIG. 2-6). These plates and the accompanying text encouraged a new understanding of Classical architecture that would influence architects far into the nineteenth century.

While Stuart's and Revett's *Antiquities* were both symptom and catalyst of the Greek revival promoted by Winckelmann, there was at the same time a counter movement aimed at advancing the artistic importance of Roman art and culture. The main proponent of this movement was the Italian printmaker, archaeologist, art dealer, and architect Giovanni Battista Piranesi (1720–1779). Piranesi opposed Winckelmann's view that Roman art was merely a derivative of Greek art and represented the decline of Classical art. He argued that the Romans were quite original, tracing their artistic origins back not to the Greeks but to the Etruscans. The Romans, Piranesi claimed, had created by far the greatest architectural monuments of Classical antiquity, superior to those of the Greeks in form, in size, and in engineering. To support his argument, Piranesi published his *Della magnificenza ed architettura de' Romani* (On the Greatness and the Architecture of the Romans) in 1761. This work combined an argumentative essay on the superiority of Roman architecture with a set of thirty-eight etched illustrations, both by Piranesi himself. While rooted in his careful archaeological studies, these plates, like all Piranesi's etchings of Rome, were intended to flaunt the grandeur of Roman architecture. His rendering of the Aqua Marcia Aqueduct (FIG. 2-7) emphasizes the enormous size of the ruined structure, both

2-6 **James Stuart and Nicholas Revett,** *The Ionic Order from the Erechtheum.* Illustration in *Antiquities of Athens* (vol. 2, ch. 2, pl. 8), 1787. Engraving. Private Collection, London.

2-7 **Giovanni Battista Piranesi,** *Aqua Marcia Aqueduct.* Illustration in *Della magnificenza dell'architettura dei Romani* (pl. xxvi), 1765. Etching, 7 x 11″ (19 x 29 cm). Private Collection, London.

by exaggerating the perspective view and by juxtaposing the monument with tiny human figures, who are clearly dwarfed by its dimensions.

While the battle about the relative importance of Greek and Roman art raged fiercely among archaeologists and theorists of the eighteenth century, it does not seem to have had a great impact on most artists. With some notable exceptions, most artists seem to have followed Piranesi's advice that artists should not feel bound to a single artistic model (such as the Greek one) but should explore all forms of Classical art.

The Beginnings of Neoclassicism

Winckelmann's advice to artists to imitate the art of antiquity was first adopted in the 1760s by a number of painters from different European countries who were either working in Rome or had spent some time studying there. Rome by then had become a magnet for young artists, who flocked to the city to study the ancient monuments as well as the works of the great Renaissance masters, most notably Michelangelo and Raphael. Many of these artists entered Winckelmann's orbit and were influenced by his idea that the imitation of Classical art would foster the renewal of modern art.

The works that they produced are generally referred to as Neoclassical, in reference to their Classical inspiration. It must be noted, however, that the terms Neoclassical and Neoclassicism were not coined until the 1880s and certainly were not used during the eighteenth century. "Neoclassicism," like "Rococo," is itself a broad umbrella term that covers a wide variety of works whose content and form depended on artists' individual temperaments and convictions as well as on their cultural and national backgrounds. Indeed, Classical art itself meant many things to many people, not only because it manifested itself in so many different ways (Greek sculpture, Roman architecture, Pompeian wall paintings, etc.) but also because it contained so many historical associations. To the German Winckelmann, Classical sculpture was a manifestation of a utopian past, a sort of golden age of physical and moral perfection. By contrast, to an Italian artist such as Piranesi, Roman architecture was a source of national pride. To French and British artists, whose knowledge of Classical art was often preceded by that of ancient history and literature, Greek and Roman art were often seen in the context of historical events that they either admired or despised.

The first important example of Neoclassical painting was done by Winckelmann's close friend, the German painter Anton Raphael Mengs. No matter how bland it may look to us today, his fresco *Parnassus* (FIG. 2-8),

2-8 **Anton Raphael Mengs,** *Parnassus,* 1760–61. Fresco, 10 x 20' (3 x 6 m). Villa Albani, Rome.

2-9 **Joseph-Marie Vien,** *Seller of Cupids,* 1763. Oil on canvas, 37 x 46⅞" (95 cm x 1.19 m). Musée National du Château de Fontainebleau, Fontainebleau.

representing Apollo and the Muses on Mount Parnassus, was, in its time, a revolutionary statement of a new art, conceived and painted in accordance with Winckelmann's precepts. The fresco was commissioned by Winckelmann's employer, Cardinal Albani, to decorate the ceiling of the reception room in his new villa in Rome. There it was seen by numerous visitors who came to the villa to admire the cardinal's outstanding collection of antiquities.

It is instructive to compare Mengs's ceiling fresco with the one by Tiepolo in the vault of Santa Maria del Rosario in Venice (see FIG. 1-14), done some twenty years earlier. While Tiepolo had mustered all his technical skill to create the illusion of an aperture in the roof that offers a view all the way up into heaven, Mengs conceived of his ceiling painting as if it were a mural. Rather than negating the ceiling, Mengs affirmed it. Instead of the infinite space suggested by Tiepolo's bravura perspective tricks, visual depth is understated in Mengs's painting. The figures occupy a shallow rectangular area, defined by a screen of trees in the back and the Castalian spring (the mythical source of artistic inspiration) in the foreground. Unlike the asymmetric "zigzag" composition of Tiepolo's ceiling painting, Mengs's *Parnassus* shows a strictly symmetrical

arrangement. While Tiepolo's painting, with its gesticulating figures and fluttering angels, is dynamic, Mengs's is static, its figures seemingly frozen in time.

Mengs's ambitious intention in the *Parnassus* fresco was to break free from Rococo decorative painting in order to create a new, grand, and noble style of architectural painting. To do so, he looked at the ancients (his *Apollo* is a painted version, in reverse, of the *Apollo Belvedere*) as well as the Italian Renaissance masters (his composition recalls Raphael's *School of Athens* in the Vatican Palace). This dual reliance on Classical sculpture for individual figures and Renaissance painting for composition characterizes much of Neoclassical painting and was strongly advocated by Mengs. Indeed, in the conclusion to his *Gedanken über die Schönheit und den Geschmack in der Malerei* (Thoughts on Beauty and Taste in Painting) of 1771 he advised painters to study Classical art so as to acquire a taste for beauty, and Raphael, Correggio (c.1489–1534), and Titian (c.1485–1576), in order to acquire a taste for expression, harmony, and coloristic truth.

More directly and exclusively inspired by Classical art was the *Seller of Cupids* (FIG. 2–9) by Joseph-Marie Vien (1716–1809), which was painted only two years after

2-10 **Carlo Nolli,** *Seller of Cupids.* Illustration of *Le Antichità di Ercolano* (vol. III, pl. vii), 1762. Engraving, 9 x 12⅝" (23 x 32 cm). Private Collection, London.

Mengs's fresco. A recipient of the Rome Prize Vien had studied in Rome from 1744 to 1750, just at the time when the excitement about the excavations of Pompeii and Herculaneum had reached a peak. His *Seller of Cupids,* exhibited at the Paris Salon of 1763, was based on an engraving in a multi-volume book devoted to these excavations that had appeared in 1762 (FIG. 2-10). The painting presents a mirror image of the engraving (which itself is a mirror image of the Roman wall painting), though its composition is not quite as austere; Vien added various interior furnishings and replaced the Classical cage by an eighteenth-century basket. Comparing the painting with the *Gracious Shepherd* by Vien's teacher Boucher (see FIG. 1-6), however, the *Seller of Cupids* seems sober and restrained. While the compositional lead lines in Boucher's painting are for the most part diagonal, Vien's composition is dominated by horizontals and verticals, which gives it a static rather than a dynamic feeling. Moreover, in Boucher's painting the figures are placed in a landscape that suggests infinite depth, while in Vien's *Seller of Cupids* the figures are placed in a shallow space, closed off at the back by an austere, windowless wall. In Vien's painting the figures are crisply set off against the neutral gray wall,

while in Boucher's work the figures seem to blend into the landscape background.

Contemporary observers sensed something new in Vien's painting. One critic, aware of the artist's interest in Classical art, appreciated what Vien had gained by

2-11 **Benjamin West,** *Agrippina Landing at Brundisium with the Ashes of Germanicus,* 1768. Oil on canvas, 5' 5" x 7' 10" (1.64 x 2.4 m). New Haven, Yale University Art Gallery.

2-12 **Benjamin West,** *Detail of the Frieze from the Ara Pacis Augustae,* 1763?. Black chalk, heightened with white, on paper, 8 x 10" (20.3 x 26.7 cm). Philadelphia Museum of Art.

studying it: "a great simplicity in the positions of the figures, which are nearly straight and without movement; . . . very few and generally rather thin, lifeless draperies, which cling to the bodies; . . . [and] a severe sobriety in ornamental accessories." Vien, this critic felt, had learnt a valuable lesson in austerity from Classical art, which would enhance the future of French painting. Yet while some observers admired the painting for its simplicity and sobriety, others criticized it for its immoral content. The critic Diderot, who had been arguing for a new art of moral edification, condemned the painting for its erotic subject matter. In terms of content, he felt that Vien's painting was no different from Rococo painting. In fact, Vien's theme of the sale of love to rich Roman ladies was more blatantly erotic and perhaps even more wicked than the themes of most of Boucher's paintings. Diderot was particularly indignant about the obscene gesture of the central cupid, who, marking off an arm's length with his right hand, shows the lady "the size of the pleasure he promises."

Vien's painting brought a new form, but retained the immoral content of much of Rococo painting. Conversely, *Agrippina Landing at Brundisium with the Ashes of Germanicus* (FIG. 2-11) of 1768 by Benjamin West (1738–1820), was new in content but only partially innovative in form. Based on a passage in the *Annals* by the Roman historian Tacitus, the painting depicts the moment when Agrippina, the young wife of the Roman general Germanicus, returns to Italy with the cremated remains of her husband (rumored to have been murdered in the colony of Syria, by order of the Emperor Tiberius himself). The painting was commissioned by the Archbishop of York from West, a young American painter who had studied for three years in Rome before settling in England in 1763. Unlike Vien's immoral *Seller of Cupids,* Agrippina is an *exemplum virtutis* (example of virtue). In honoring her husband, this good widow gives a positive moral example to her children (note the

presence of the son and daughter at her side). She is also a heroine, having traveled all the way to Syria to fetch the remains of her husband so they might be buried in Roman ground. It was for that reason that, on landing in the southern Italian harbor of Brundisium (Brindisi), Agrippina was welcomed by a crowd of sympathizers, who came both to mourn the death of her husband and to celebrate her courage and virtue.

West's composition is centered around the brightly-lit procession of Agrippina and her companions, dressed in white (the Classical color of mourning), and set off against a dark architectural background. With its figures placed in a shallow plane and their heads and feet set on two horizontal lines, this group resembles a Classical marble relief of the kind that West might have admired during his stay in Rome. Indeed, the arrangement of the figures bears a striking resemblance to an earlier drawing by West of a group of patrician men depicted in the relief on the famous Ara Pacis or Altar of Peace in Rome, erected on the initiative of Emperor Augustus (FIGS. 2-12, 2-13).

Yet, while the central group has much of the Classically inspired simplicity and austerity found in Vien's *Seller of Cupids,* the crowd of mourners on the left suggests the Rococo style in its drama and complexity. Grouped along two crossing diagonal lines, dramatically lit (some brightly illuminated, others in darkness), and colorfully dressed, they contrast with the procession of women, as do the dramatically posed boatmen on the right. By juxtaposing the new Neoclassical idiom with the old worn-out formulas of the Rococo, West heightens the difference between the virtuous Agrippina with her faithful followers and the ordinary mortals in the crowd.

2-13 South side of the Ara Pacis, 13–9 BCE. Marble, height 61" (1.55 m). Rome.

2-14 **Angelica Kauffman,** *Portrait of Johann Joachim Winckelmann,* 1764. Kunsthaus, Zürich.

2-15 **Angelica Kauffman,** *Zeuxis Selecting Models for his Painting of Helen of Troy,* c.1778. Oil on canvas, 31 x 43″ (80.6 cm x 1.11 m). Providence, Rhode Island, Brown University Library, AnnMary Brown Memorial Collection.

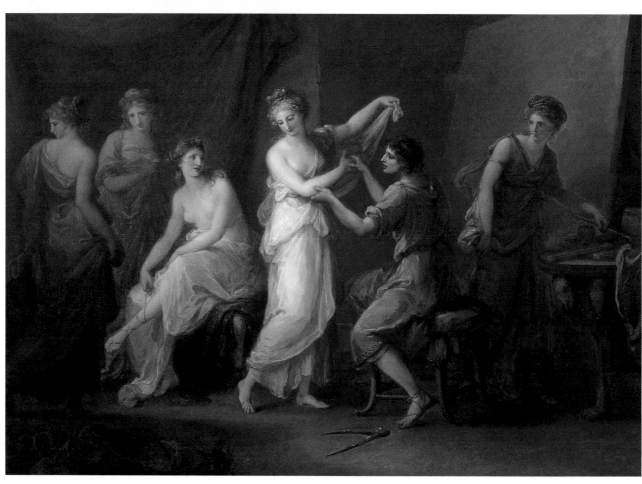

Eighteenth-century Neoclassicism was centered in Rome, but its proponents came from all over Europe and its colonies, creating a truly cosmopolitan climate. Mengs and Winckelmann were from Germany; Vien came from France; and West from the British colonies in North America (he was born in Pennsylvania). A fourth major early Neoclassical artist, Angelica Kauffman (1741–1807), was born in Switzerland. The daughter of a painter, she spent much of her youth in Italy, where her father urged her to study Classical sculpture and the works of the Renaissance masters. While in Rome, in her early twenties, she befriended Winckelmann and painted his portrait (FIG. 2-14). She subsequently moved to England, where she made her career as an artist, but frequently returned to Italy for prolonged visits. Kauffman's paintings, while often representing Classical subject matter, rarely show the radical innovations found in the works of Mengs or Vien.

Zeuxis Selecting Models for his Painting of Helen of Troy (FIG. 2-15) is a case in point. The painting depicts a scene central to the theory and practice of idealism. According to the Roman writer Pliny the Elder, the ancient Greek painter Zeuxis was asked to paint a picture of the legendary Helen of Troy, paradigm of female beauty. To do so, he chose five beautiful virgins as models. From this group, he selected the most beautiful parts (nose, breasts, feet, etc.) of each, and amalgamated them into one ideal figure. (It was precisely this process of "selective naturalism" that was advocated by Mengs in his theoretical writings.) Yet while the subject of Kauffman's painting touches the heart of Neoclassical art theory, its execution falls short of the noble austerity that Winckelmann was looking for in art. Though the figures do occupy a relatively shallow space, Kauffman has exaggerated the *chiaroscuro* (light and dark contrast) of the painting to counteract their frieze-like arrangement. Rather than the crisp contours found in the works of Mengs and Vien, her figures have fuzzy, *sfumato* outlines akin to the works of sixteenth-century Italian painters such as Leonardo da Vinci (1452–1519) and Antonio Allegri da Correggio (1494?–1534). It is true that Kauffman's choice of subject matter, namely historical painting, was squarely "masculine"—as opposed to portrait and still life, which were considered more "feminine" subjects. Yet, the subdued outlines and svelte forms of her figures, according to a critic of the day, clearly reflected the "softness natural to her sex."

David

Perhaps the first artist successfully to join the high-minded subject matter advocated by La Font de Saint-Yenne and Diderot with the sober, classicizing forms promoted by Winckelmann was Jacques-Louis David (1748–1825). A student of Vien, David shared the ambition of most young artists of his time to study in Rome. Competing for the Rome Prize in four consecutive years, he finally won it in 1774. In 1775 he left for Rome together with Vien, who had just been appointed director of the French Academy in Rome.

Initially, David was more interested in the great Renaissance and Baroque masters (Michelangelo, Raphael, the Carracci, and Poussin) to be found in Rome than in Classical art. "The Antique will not seduce me, it lacks action and does not move me," he is supposed to have told a fellow artist, Charles-Nicolas Cochin (1715–1790), upon his departure for Rome. Once there, however, he became interested in Winckelmann's ideas about the purity and power of the contour in classical sculpture and he began to draw assiduously from antique statuary. His drawing of Classical statues in the Vatican (FIG. 2-16) shows his desire to capture the simple, flowing outlines of Classical sculptures that Winckelmann praised. The figures are first lightly sketched in pencil, then carefully traced with a pen in order to create strong, unbroken contours. A few brushstrokes of diluted ink ("washes") are added to suggest volume and shade.

In his paintings, David's interest in expressive contour is first seen in *Andromache Mourning Hector* (FIG. 2-17). David executed this piece three years after his return to Paris from Rome in 1780, with the intention of presenting it to the Academy. At the time, artists wishing to join the Academy were expected to submit a major work to prove themselves worthy of that honor. These reception pieces (*morceaux de réception*) were generally exhibited at the Salon so that the general public could form an idea of the standards that the Academy set for its members.

David's *Andromache* was inspired by Homer's *Iliad*, an epic poem that experienced a revival of interest in the late eighteenth century, when it came to be seen as the primordial Classical text. The painting depicts Andromache's wake for her husband Hector, the young

2-16 **Jacques-Louis David,** *Classical Statues in the Vatican,* 1780. Pen and Indian ink wash on paper, 6 x 8" (15.2 x 21 cm). Musée du Louvre, Département des arts graphiques, Paris.

2-17 **Jacques-Louis David,** *Andromache Mourning Hector,* 1780. Oil on canvas, 9′ x 6′8″ (2.75 x 2.03 m). École Nationale Supérieure des Beaux-Arts, Paris.

54 *The Classical Paradigm*

2-18 **Jacques-Louis David,** *The Oath of the Horatii,* 1785. Oil on canvas, 10'10" x 13'11" (3.3 x 4.25 m). Musée du Louvre, Paris.

Trojan hero, killed by his Greek adversary Achilles. Hector's naked body, loosely covered by a red shroud, lies on a richly carved bed. The contours of his face and chest stand out boldly against the dark-green drapery in the background. Seated next to the bed, his wife Andromache turns her tear-stained face away from him, looking upwards as if to implore the gods in heaven. Her left hand clutches the arm of her son, Astyanax, while her right arm stretches out toward Hector, in a gesture that draws attention to his heroic courage and his tragic death as a victim of war.

Like Benjamin West's *Agrippina, Andromache Mourning Hector* is an *exemplum virtutis.* Here, too, a mournful widow is faced with the death of her husband (and the father of her child). In Homer's *Iliad* Hector is described as the consummate family man: a good son, husband, and father as well as a heroic soldier and an excellent friend. It is the tragedy of this great man, killed in the prime of his life, that David wished to communicate. Hence the contrast between the powerful physique and the deadly stillness of Hector's body, reminding the viewer that, in war, death strikes even the noblest and the strongest.

Compared with the eloquence of Hector's body, the figure of Andromache seems almost trite. She has all the theatricality of the late Baroque era, in which emotion is conveyed through dramatic gesture and facial expression. Expressive heads (*têtes d'expression*) were greatly valued in the Academy. One of its founders, Charles Lebrun, had published an important book on the subject in 1698 and the Academy itself had instituted a special competition for expressive heads, which David had won in 1773. The figure of Andromache was most certainly conceived with David's academic judges in mind.

Once he had become a full-fledged member of the Academy, David qualified for a studio in the Louvre where he could begin to accept students. In 1784 he received his first royal commission for a painting depicting a subject from Roman history. The resulting work, *The Oath of the Horatii* (FIG. 2-18), became a turning point in his career and earned him lasting and international fame. The painting was executed in Rome during a second stay in the city in 1784–5. When it was finished, in July 1785, David opened his studio in Rome to visitors. The painting was an

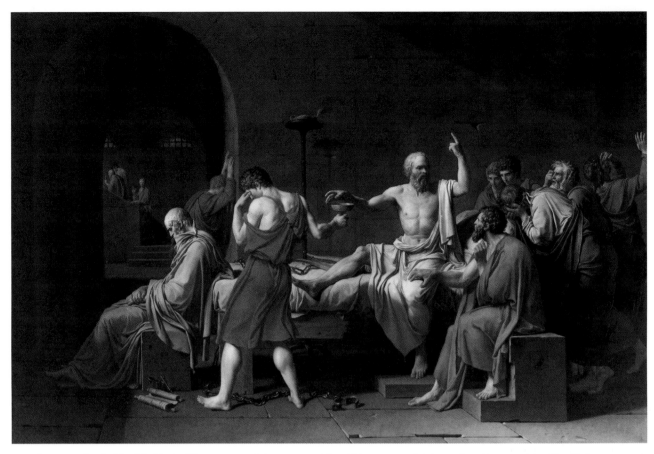

2-19 **Jacques-Louis David,** *Death of Socrates*, 1787. Oil on canvas, 4'3" x 6'5" (1.3 x 1.96 m). Metropolitan Museum of Art, New York.

international sensation, widely admired by Italians and foreigners alike. The German painter Johann Heinrich Tischbein (1751–1829) wrote a lengthy review of the work for a German newspaper, in which he told his readers that "in the history of art we read of no painting that might have awakened more uproar upon its appearance than this one."

The *Oath of the Horatii* was inspired by an event in early Roman history that was recounted by several Roman historians, including Livy and Plutarch. During the seventh century BCE, the kingdom of Rome had a border dispute with the neighboring kingdom of Alba. Rather than going to war, the parties agreed to resolve the conflict by means of a sword fight between three Roman warriors and three Albans. To fight this triple duel, the Romans selected three brothels, the so-called Horatii; the Albans picked the three Curatii brothers. As fate would have it, however, one of the Horatii was married to Sabina, a sister of the Curatii, while one of the Curatii was engaged to Camilla, a sister of the Horatii. Thus, no matter how the duel ended, one of the women would experience a tragic loss. As it turned out, after a bloody hand-to-hand battle, only one of the six men, Horatius, survived and was proclaimed victor. As he returned home, however, he was cursed by his sister Camilla, whose fiancé had died in the duel. Enraged by her reaction, Horatius killed her.

It was this dramatic moment (also one of the high points of a famous French seventeenth-century drama, *Horace*, by Pierre Corneille) that David was to paint for the king. Just before departing for Rome, however, he requested permission to paint another scene, showing the Horatii taking an oath on their swords, swearing that they will either win or die. This event was not recorded in Roman historical literature or in any later writings. It was a theme of David's own invention, inspired perhaps by one of several contemporary paintings by French and British artists, representing patriotic oaths. Certainly, the theme of such an oath met the demand for an art that could improve public morality and strengthen the nation. Yet, to David it also offered the opportunity to construct a picture with a minimum of action and a maximum of drama.

The scene is set in a bare stone hall, its rear wall pierced by three simple arches. Inside this austere setting, the solemn oath takes place. In the center, the elder Horatius holds up his sons' swords, their blades glittering in the light that sweeps down from an invisible window high up in the left wall. On the left, the triplets stand squarely, arms stretched out toward the swords. Their oath is silent and their lips are closed, but their eyes are intently focused on the weapons upon which their lives and their country's honor will depend. Three women occupy the right side

of the painting. In contrast to the vigorous, erect bodies of the Horatii, they slump down on their chairs. Camilla, on the right, rests her head on the shoulder of her sister-in-law Sabina, who is seated in the center. A nurse embraces two children, trying to hide the awesome scene from their eyes. But the eldest child, a boy, removes her fingers to peek.

In the *Oath of the Horatii* David seems to have absorbed fully the lessons of Classical sculpture, insofar as it was viewed in the eighteenth century. The painting exemplifies Winckelmann's ideal of "noble simplicity and quiet grandeur." Rather than tear-stained faces or declamatory gestures, the drama of the scene is contained within the bodies themselves—the vigorous, muscular, tanned bodies of the Horatii, and the lethargic, soft bodies of the women. The contrasts between them not only show the different roles of men and women in society, but, more importantly, the two faces of war: glory and triumph on the one hand, loss and despair on the other.

David's painting is revolutionary in its powerful distillation of a complex moral question into a single, sober image. To be exact, is an individual's duty in the first instance to the public or to the private, to the nation or to the family? David has clearly articulated the Horatii's choice in their resolute poses and determined facial expressions. By adding the women and children, however, he has ensured that we realize at what emotional expense that choice is made.

At the Salon of 1787 David exhibited the *Death of Socrates* (FIG. 2-19). This painting of the Greek philosopher, dying for an ideal of society that was perceived as a threat by the ruling powers, is often thought to anticipate the sacrifices of the French revolutionaries of 1789. Such a "hindsight" interpretation, however, can easily distort the meaning the work held for its contemporaries. The *Death of Socrates*, in fact, was commissioned by Charles-Michel de Trudaine (1766–1794), a member of the French aristocracy and an important art patron of the time. Trudaine came from an educated, literary milieu, and his choice of the subject of death probably had more to do with his interest in Classical philosophy than with his ambitions to subvert the status quo, even though, in 1789, he would be supportive of the Revolution.

In David's painting, Socrates is shown in his cold, bare prison cell at the moment of his execution. Surrounded by his disciples he is still teaching as, almost absentmindedly, he accepts the cup of hemlock, the instrument of his death. Socrates' disciples, meanwhile, are overcome by sadness and fear. Some are crying, hiding their heads in their hands, while others raise their hands in despair. The contrast between Socrates' stoic acceptance of death and the sorrow of his disciples exemplifies the philosopher's belief in the duality of mind and body. While Socrates stands for the immortality of the soul, the disciples represent the painful mortality of the flesh.

David's painting may have been inspired by Diderot who, in his *Discours de la poésie dramatique* (Treatise on Dramatic Poetry) of 1758, had proposed that the death of Socrates would be a perfect subject for a dramatic pantomime or play without words. He even went so far as to sketch out a pantomime in a text that could almost be a caption for David's picture. Diderot's description of the grieving disciples may serve as an example: "Some wrapped themselves in their cloaks. Crito had got up and he wandered about the prison, groaning. Others, motionless and standing, watched Socrates in mournful silence while tears poured down their cheeks."

David's reliance on Diderot may explain why in the *Death of Socrates* he emphasized gesture and facial expression more than in the *Oath of the Horatii*. Even in this painting, however, the body plays an important role in showing emotion. Note, for example, how David contrasts the clothed bodies of the disciples with the semi-nude body of Socrates, covered only from the waist down in what is presumably to be his burial shroud. Though Socrates was more than 70 years of age when he died, David gives him a powerful torso and muscular arms, an eloquent expression of his moral strength and fortitude.

Sculpture

Because Neoclassicism was centered on Classical sculpture, one might expect great changes in this field. In reality, the Classical influence came relatively late to sculpture. The two most important Neoclassical sculptors of the eighteenth century, the English John Flaxman (1755–1826) and the Italian Antonio Canova (1757–1822), were both a generation younger than Mengs, Vien, and West. Even David, the youngest of the early Neoclassical painters, was their senior by almost a decade. One reason for the slow acceptance of Neoclassicism was, no doubt, the general conservatism of sculpture in the eighteenth and nineteenth centuries. This was largely due to the high cost of the materials, which caused sculptors to be heavily dependent on commissions and less free than painters to experiment on their own. Another reason was the considerable challenge that sculptors faced to create works that were both classical in form and modern in spirit. On the one hand, when representing Classical subjects (Greek gods, heroes, historical figures), the challenge was to create sculptures that possessed the ideal beauty of the antique, yet could clearly be distinguished from Classical sculpture. On the other, when depicting modern subjects (portrait busts and commemorative or funeral monuments), it was difficult to achieve likeness and idealism all at once.

The sculptors successful in reconciling idealism and realism did so not by imitating Classical sculpture but by capturing its spirit—by imbuing their works with the calm grandeur seen at the time as its highest achievement.

and antiques dealer Gavin Hamilton (1723–1798), who introduced him to Classical art. Thus inspired, he created his first major sculpture, *Theseus and the Minotaur* (FIG. 2-20). This is a life-size work representing the Greek hero Theseus having slain the Minotaur, a mythical monster with a man's body and a bull's head. Canova represents the aftermath of battle rather than the battle itself, as Baroque and Rococo artists would have done. Theseus sits upon the monster in a quiet moment of reflection.

With courage and righteousness he has triumphed over the beast, but the victory has exacted a price: in killing the killer, Theseus has lost his innocence, and is forced to ponder his moral choice.

Although *Theseus and the Minotaur* was commissioned by a private collector and not publicly exhibited, it soon became widely known and admired. In its time, it was seen as the first true resurrection of antiquity. It is also, of all of Canova's works, the one most easily mistaken for a Classical sculpture, illustrating the difficulty of creating a work that was at once classical and modern. In years to come, Canova became increasingly successful in marrying the two. Essentially, his mature works are closer to the eighteenth-century perception of Classical sculpture than to Classical sculpture itself. That perception was conditioned by the writings of Winckelmann, whose sensual descriptions of Classical sculpture had, as we have seen, a great impact at the time.

Canova

Foremost among Neoclassical sculptors was the Italian Antonio Canova, who was in fact the most famous artist of the late eighteenth and early nineteenth centuries. Indeed, Canova may be called one of the first "stars" in the artistic world, a sculptor of international fame whose career was widely discussed in newspapers and journals. Interestingly, Canova was also the only Italian artist truly to excel during the second half of the eighteenth century, at a time when Rome was perceived as the center of the European art world.

Born in the Republic of Venice (Italy did not become a unified state until 1870), Canova first came to Rome in 1779. Here he entered the circle of the Scottish painter

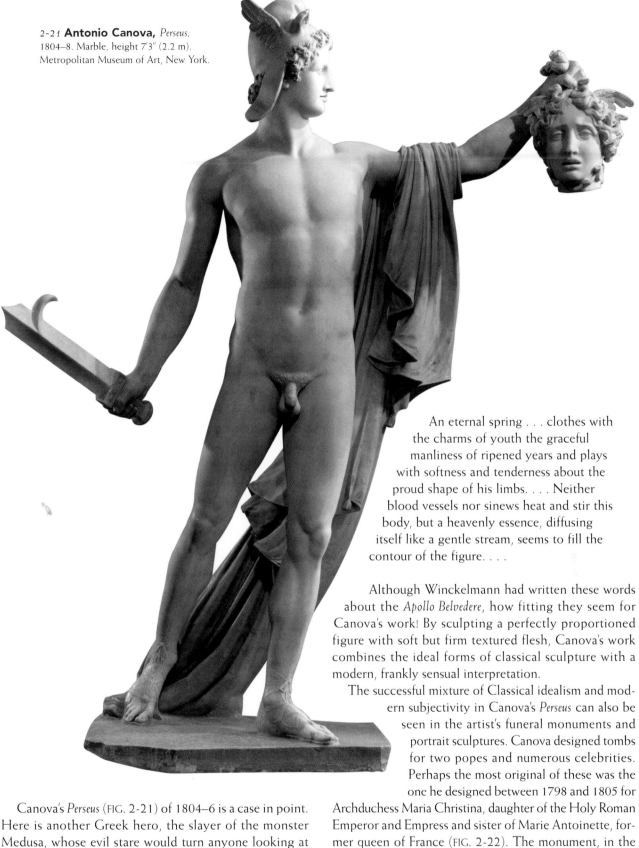

2-21 **Antonio Canova,** *Perseus,*
1804–8. Marble, height 7'3" (2.2 m).
Metropolitan Museum of Art, New York.

An eternal spring . . . clothes with the charms of youth the graceful manliness of ripened years and plays with softness and tenderness about the proud shape of his limbs. . . . Neither blood vessels nor sinews heat and stir this body, but a heavenly essence, diffusing itself like a gentle stream, seems to fill the contour of the figure. . . .

Although Winckelmann had written these words about the *Apollo Belvedere,* how fitting they seem for Canova's work! By sculpting a perfectly proportioned figure with soft but firm textured flesh, Canova's work combines the ideal forms of classical sculpture with a modern, frankly sensual interpretation.

The successful mixture of Classical idealism and modern subjectivity in Canova's *Perseus* can also be seen in the artist's funeral monuments and portrait sculptures. Canova designed tombs for two popes and numerous celebrities. Perhaps the most original of these was the one he designed between 1798 and 1805 for Archduchess Maria Christina, daughter of the Holy Roman Emperor and Empress and sister of Marie Antoinette, former queen of France (FIG. 2-22). The monument, in the Augustinerkirche in Vienna, takes the form of a pyramid set against the church's wall. Near the top of the pyramid, a female deity and a putto hold up a small oval medallion bearing Maria Christina's portrait. Down below, a funeral

Canova's *Perseus* (FIG. 2-21) of 1804–6 is a case in point. Here is another Greek hero, the slayer of the monster Medusa, whose evil stare would turn anyone looking at her into stone. Sword in hand, Perseus steps before the viewer, holding up Medusa's head, harmless in death. The hero's discarded cloak hangs over his left arm, revealing his perfect body.

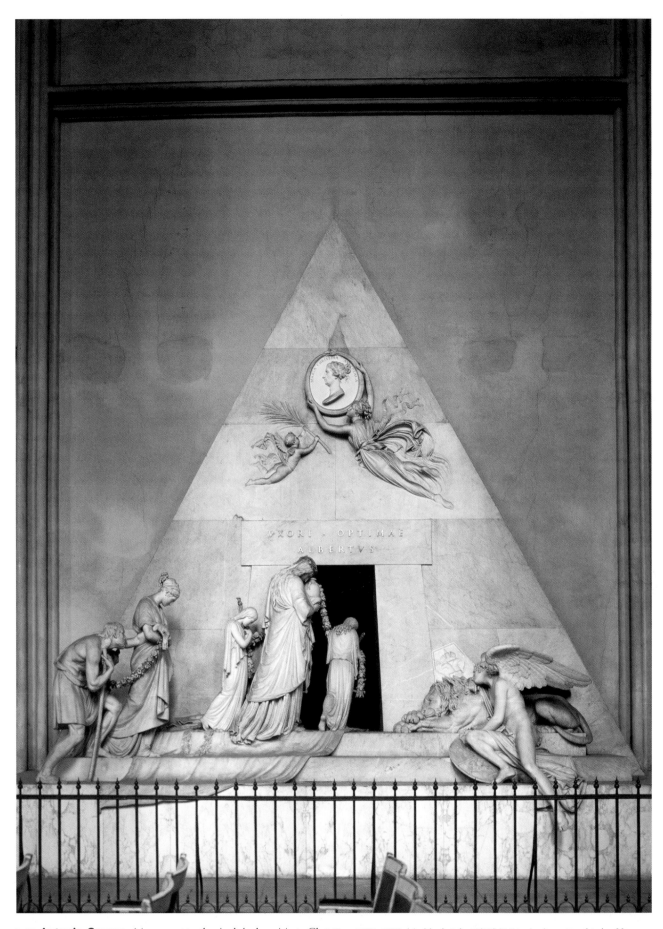

2-22 **Antonio Canova,** Monument to the Archduchess Maria Christina, 1799–1805. Marble, height 18′10″ (5.74 m). Augustinerkirche, Vienna.

procession slowly enters the pyramid. On the far left stand a beautiful young woman and an old man, the pair seeming to represent the course of life from the bloom of youth to the decline of old age. On the right, the winged spirit of death leans on a lion, the symbol of authority, to watch the proceedings. In the middle, a tall woman with an urn, flanked by two young girls, approaches the pyramid's door. The awesome void of death is perhaps best expressed by the little girl carrying a garland, who is disappearing into the dark cavity of the tomb.

Compared with traditional tomb monuments, Canova's is remarkable for the absence of any Christian symbols of death and redemption. Neither does it make an attempt at glorifying the deceased. Instead, the tomb is a quiet, timeless meditation on death. Canova meets the challenge of reconciling the ideal and the specific by making the portrait of Maria Christina not the center of the work but rather the pretext and inspiration for such a meditation.

Canova's *Portrait of Paolina Borghese* (FIG. 2-23) also reveals the artist's uncanny ability to marry the ideal with the real and specific. The artist portrayed Paolina (1780–1825),

wife of the Italian prince Camillo Borghese and sister of Napoleon, as Venus Victorious. Reclining on an antique bed, she holds an apple, the prize of that famous beauty contest of Classical antiquity, in which Venus triumphed over Juno and Minerva. The guise of Venus, which evidently called for a high degree of nudity, was dictated by Paolina herself, a woman who was famous for her beauty and infamous for flouting social and moral conventions.

The practice of portraying a person as a mythological figure went back to the Renaissance and continued throughout the seventeenth and eighteenth centuries. In this way, the artist could illustrate a particular virtue of the sitter by representing him or her in the guise of the mythological figure that exemplified that virtue (e.g. the wisdom of Minerva, the courage of Hercules, etc.). Such portraits for the most part fall into two groups. Some represent their sitters realistically, recording all their physical particularities. To the modern viewer they often seem a little comical in their Classical aspirations. Others, however, are so idealized that the sitter's individuality and actual features are lost. What is fascinating about the *Portrait of Paolina*

2-23 **Antonio Canova,** *Paolina Borghese as Venus Victorious*, 1804–8. Marble, 6'7" (2 m). Galleria Borghese, Rome.

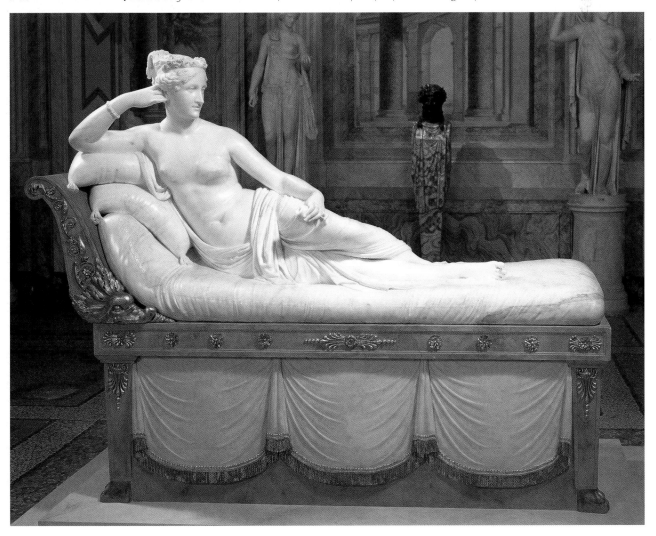

Borghese is that Canova has managed to create a figure who is at once individualized, but at the same time has the timeless beauty and dignity of a goddess. He has done so by streamlining the body so as to create a beautiful flowing contour, without losing the smooth softness of the flesh. Thus Paolina is at once desirable and distant, erotic and cold, mortal and goddess.

Flaxman

Two years older than Canova, John Flaxman never achieved the younger sculptor's stardom. If he became internationally known, it was not so much for his sculptures as for his drawings. Flaxman studied at the Royal Academy in London, but failed to win the coveted gold medal that would have enabled him to study in Rome. Instead, he was employed in the ceramic factory of Josiah Wedgwood (see page 64) to supply designs for the low-relief decorations that have remained the hallmark of Wedgwood pottery (see page 65) to this day. Although Flaxman resented the task, it gave him the opportunity to study Classical vase paintings. These not only inspired his decorations but also taught him to think of form in terms of contour.

At the age of 32 Flaxman had finally earned enough money to travel to Rome. While there, he received a commission for a set of drawings to illustrate Homer's *Iliad* and *Odyssey*. Reproduced be means of engraving and published in album form in 1793, these drawings created a sensation in their time. Looking at Flaxman's illustration of the *Judgment of Paris* (FIG. 2-24) it is easy to see why. First of all, Flaxman has eliminated all shading and reduced his drawings to line only. Secondly, his contours are streamlined and minimally detailed, giving the drawings a powerful simplicity and sobriety. Contemporaries saw Flaxman's illustrations as an attempt to retrace the steps of art to its very beginnings, when there was only contour (see pages 32–3). Their "primitiveness" made a good match to Homer's

epic poems, which were thought to represent the origin of literature. As one fellow artist remarked, Flaxman's drawings looked "as if they had been made in the age, when Homer wrote."

Distributed, copied, and pirated all over Europe, Flaxman's illustrations brought him instant fame. When he returned to England in 1794, he was selected for several important public projects, including one for a statue of *Admiral Lord Nelson* (FIG. 2-25) in St Paul's Cathedral, London. This monument was one of a group commissioned by the British Parliament in 1796 to honor naval and military heroes killed in battles against the French. Produced over some eleven years, the Nelson memorial is a full-length portrait of the admiral standing on a cylindrical pedestal decorated with a relief of ancient river gods. On the left, the allegorical figure of Britannia points out the statue to two young boys; on the right the British lion growls at the viewer. Unlike Canova, who masterfully combined real and mythical figures into single works, Flaxman was less than successful in reconciling the real with the ideal. His Britannia, modelled after images of the goddess Minerva, is a strange companion to the two young boys carrying their school bags. The oversized lion with its excessive detail looks out of place next to the simplified low relief on the pedestal.

Flaxman is at his best in less ambitious works, such as the modest funeral monuments he designed for members of the British middle class. For these he favored the Classical stele form, a vertical slab tapering towards the top, decorated in relief. His marble stele for *John and Susannah Phillimore* (FIG. 2-26), once in a small London church, was destroyed, but the original plaster sketch model shows two mourning women embracing each other across a grave stone in the form of a broken column. Often referred to as "Two Sisters in Affliction," the relief expresses profound grief in an utterly simple and unaffected way. Their faces hidden, the two women lack specificity, reminding us that grief over death is common to all humanity.

2-24 **John Flaxman,** *Judgment of Paris.* Illustration of Homer's *The Iliad,* 1793. Engraving by Tommaso Piroli after Flaxman's drawing. 6' 3" x 4'1" (16 x 10.5 cm). Private Collection.

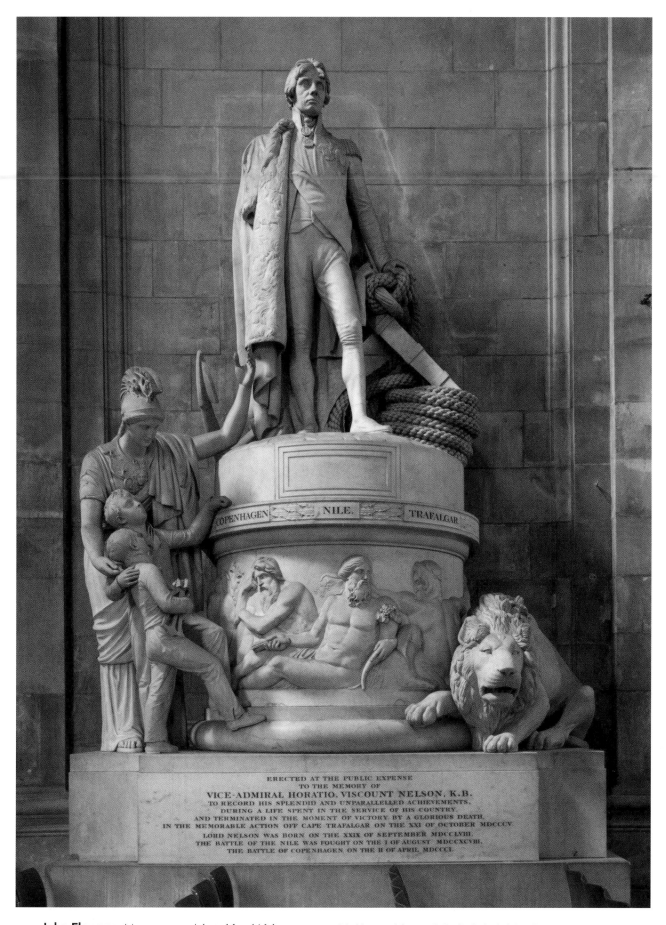

2-25 **John Flaxman,** Monument to Admiral Lord Nelson, 1807–18. Marble, over life-size. St Paul's Cathedral, London.

2-26 **John Flaxman,** *Two Sisters in Affliction.* Plaster sketch model of Monument to John and Susannah Phillimore, 1804. 13'6" x 7'6" (4.13 x 2.34 m). University College, London.

The Industrial Revolution and the Popularization of Neoclassicism

The popularity of Neoclassicism during the last quarter of the eighteenth century was spurred on by the advent of the Industrial Revolution. New manufacturing processes made it possible to produce great quantities of goods at a lower cost than ever before. The resulting supply of inexpensive products led to the growth of a consumer economy, cultivated by industrialists who developed new marketing techniques and advertising strategies. Many of the new goods recall Classical art and artefacts in form or decoration, or both. The simple lines and forms of Classical art lent themselves to mass production, and the fact that Neoclassicism was fashionable in the realm of "high art" may have encouraged industrialists to feature it in their products.

On the forefront of this development was Josiah Wedgwood (1730–1795). The son of a modest potter, he used a series of technical innovations as well as his sharp business skills to build a ceramic empire. Wedgwood realized early on that by lowering the cost of production, he could increase the number of goods to sell. Thus he sought various ways to produce inexpensive, attractive wares that could be sold to a newly affluent middle class and even to well-to-do artisans and farmers. In addition to consumer wares, he also produced small quantities of expensive luxury products to sell to the wealthier classes. Displayed in Wedgwood's elegant London showroom, these were good showpieces, demonstrating the full artistic and technical capabilities of the factory.

Wedgwood took a close interest in the manufacture and the design of his pottery. An enlightened marketer, he realized that good taste would win him customers. The objects produced in his factory show simple clean contours and their forms and decorations are frequently inspired by Classical art. The bulk of Wedgwood's houseware was creamware, an off-white pottery with a hard, lustrous glaze. For the most part, creamware was not decorated by hand but by means of transfer or printed designs, which facilitated mass production. Wedgwood's luxury wares were "for show" rather than for use. Hand-decorated, they included vases and platters as well as wall plaques, medallions, jewelry, and the like. His most enduring invention was jasperware, a fine unglazed stoneware that was tinted in light colors (preferably blue) and decorated with low relief designs.

Wedgwood hired trained artists such as Flaxman to design the decorations for his ceramics. These designs were made into transfers or prints for creamware, or turned into little handmade reliefs by skilled artisans for jasperware. The division of labor between designer and manufacturer was a direct result of new forms of industrial production. The old days, when objects were designed and made by a single craftsperson, were over. Henceforth, manufacture became an increasingly fragmented process, in which each stage of production was left to a different person or machine.

Wedgwood's designers were told to model their work after Classical art; many of their designs were in fact adapted from vases in the collection of William Hamilton (see page 44), which was sold to the British Museum in 1772. Illustrated books showing reproductions of Classical sculptures and reliefs were another important source. A jasperware plaque representing the Greek hero Hercules, probably designed by Flaxman (FIG. 2-27), shows how Classical art was adapted to consumer goods. The plaque, in low relief, recalls a famous statue of Hercules formerly in the Farnese Palace in Rome (FIG. 2-28). The figure was copied not from the original, however, but from a plate in Bernard de Montfaucon's *L'Antiquité expliquée* (Antiquity Explained), an illustrated work in five two-part volumes that was widely used by Wedgwood designers (FIG. 2-29).

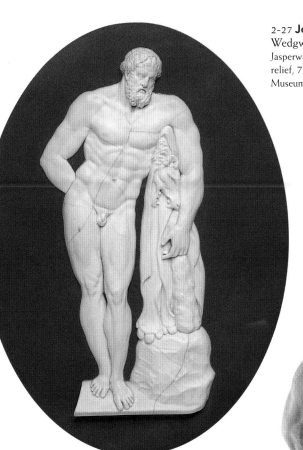

2-27 **John Flaxman** (designer for Wedgwood), *Farnese Hercules*, 1775–80. Jasperware plaque, blue ground and white relief, 7 x 5" (19 x 14 cm). Wedgwood Museum, Staffordshire, England.

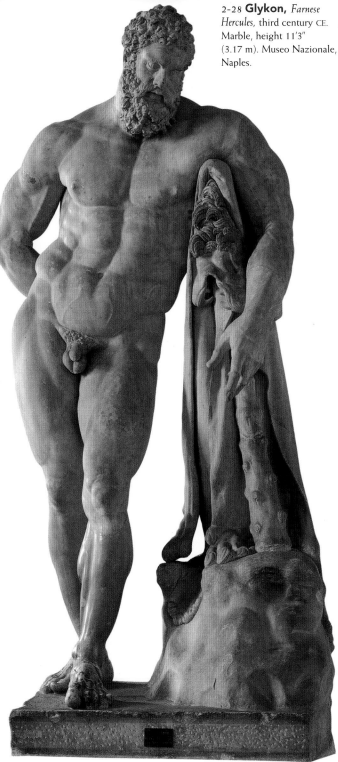

2-28 **Glykon,** *Farnese Hercules*, third century CE. Marble, height 11'3" (3.17 m). Museo Nazionale, Naples.

2-29 *Hercules.* Illustration in Bernard de Montfaucon, *L'Antiquité expliquée et représentée en figures* (vol. 1, pt. 2, p. 124, pl. 62, fig. 11), 1719. Engraving. Private Collection, London.

The newly discovered ancient Roman towns of Pompeii and Herculaneum at once became an important stop on the so-called Grand Tour, the formative trip undertaken by self-respecting, wealthy young men from northern Europe, especially Britain, to further their Classical education. Although its origins went back to the seventeenth century, the Grand Tour reached a climax after the discovery of Pompeii, during the decades from approximately 1760 to the end of eighteenth century, when the Napoleonic wars made travel to Italy all but impossible for non-Frenchmen. It is at this time that Italy, and especially Rome, became truly cosmopolitan, since thousands of travelers from all over northern Europe spent months, sometimes years here, in rented lodgings or hotels. Special industries developed to meet the demands of grand tourism, most importantly, the trafficking of souvenirs. Wealthy travelers bought "antiquities"—sculptures, Greek vases, Roman coins, oil lamps, and the like. Less affluent ones would buy the equivalents of today's postcards—engravings and etchings of views (so-called *vedute*) of Venice or Rome or engraved reproductions of ancient sculptures and reliefs.

A whole new category of portraiture, the "Grand Tour portrait," was developed by the Roman artist Pompeo Batoni (1708–1787). Batoni turned out hundreds of portraits of wealthy travelers—mostly British lords and dukes, rendered against the grandiose backdrop of one or more famous Roman monuments. His striking portrait of Lord Thomas Dundas (FIG. 2.2-1) shows the young traveler in an imaginary architectural setting that contains some of the most famous Classical sculptures of all times: the *Apollo Belvedere*, the *Laocoön*, *Antinous*, and the so-called *Cleopatra*. These eminent signifiers of Classical civilization lent an air of culture, refinement, and respectability to this son of a wealthy Scottish merchant.

2.2-1 **Pompeo Batoni,**
Lord Thomas Dundas, 1764.
Oil on canvas, 9'10" x 6'5"
(2.98 x 1.96 m). Collection of
the Marquess of Zetland,
Aske Hall, Yorkshire.

The Neoclassical Home

Although Wedgwood was perhaps the most successful popularizer of the Neoclassical style, he was by no means the only one. In the late 1700s numerous manufacturers of housewares and home furnishings began substituting Neoclassical designs for Rococo ones. England played a leading role in this development, since it was the first nation in Europe to industrialize and to develop a consumer class. With these new products, a middle-class Englishman could emulate the Neoclassical look that was in vogue among the wealthy.

The truly rich, of course, could afford the services of personal designers such as the Adam brothers. John (1721–1792), Robert (1728–1792), and James (1732–1794) Adam were the sons of a successful Scottish architect, whose financial means allowed at least two of the three to take the Grand Tour. Robert, the second son, visited Italy between 1754 and 1757. There he diligently studied Italy's famous Classical monuments, while skilfully cultivating wealthy British travelers who looked like potential clients. On returning to Britain he immediately became a leading architect and was especially sought after for interior architecture and remodeling. So busy was his practice that he formed a partnership with his two brothers, to carry out commissions all over the country.

The Etruscan Dressing Room in Osterley Park House near London (FIG. 2-30), remodeled by Adam between

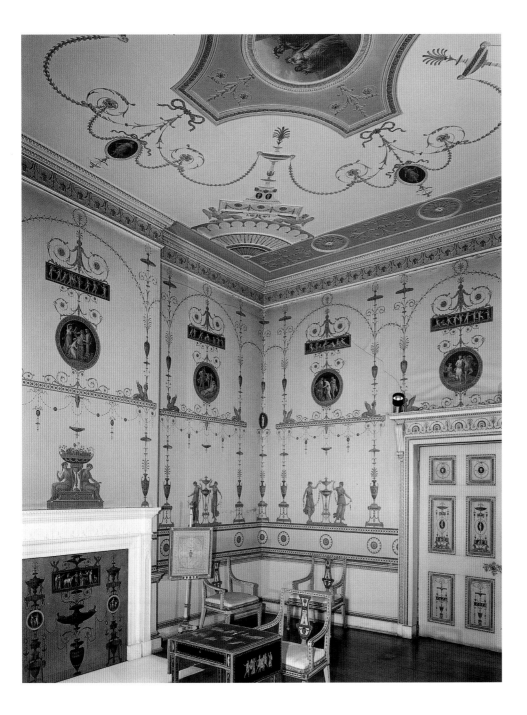

2-30 **Robert Adam,** Etruscan Dressing Room, c.1765–6. Osterley Park House, Middlesex.

1765 and 1780, shows the complex adaptation of Classical sources that was typical of the so-called Adam style. The room has little to do with Etruscan art per se; instead, it draws inspirations from Classical Greek vases, Greek and Roman architecture, Pompeian wall paintings, and Renaissance decorative arts. In spite of the variety of influences, however, the dominant impression is one of order and geometry. Most decorations are painted or molded in low-relief stucco so that the walls and ceilings look flat. No mirrors here open up the interior space, so that the overall effect is decorative but reserved.

Although England led in reinventing the domestic interior in the latter half of the eighteenth century, architects and designers in other countries too were moving away from the Rococo toward a simpler style of decoration. In France this movement is generally associated with the reign of Louis XVI, although in fact it began well before he ascended the throne in 1774. The name "Louis XVI" is given to a style that is exemplified by the rooms of his wife, Marie Antoinette, in the royal palace at Versailles. It is instructive to compare the queen's Cabinet Doré (FIG. 2-31), redecorated in 1783 by Richard Mique (1728–1794) and the brothers Jean-Simon and Jean-Hugues Rousseau, with the Rococo interior designed by Boffrand in the Hôtel de Soubise (see FIGS. 1-4 and 1-5). In the latter, there are undulating walls and a curved ceiling; in the former there is a square box. There are curves and asymmetry, here rectilinearity and exact symmetry. There an abundance of mirrors that create an "expandable" space; here the four walls clearly define the room. Clearly, in less than two generations a revolution in taste had taken place.

Neoclassicism was, of course, more than a mere change in taste. The movement exemplified the final, culminating phase of the Enlightenment. It spoke at once of a new scholarly interest in the past, and of a high-minded desire to change the present. The artistic break with the Rococo that the Neoclassical movement brought was also a break with what many perceived as a decadent culture that had produced it. Neoclassicism represented a return to order, simplicity, harmony, and beauty. Thus it could become the preferred style of the new American Republic as well as Revolutionary France.

2-31 Richard Mique and the brothers Jean-Simon and Jean-Hugues Rousseau, *Marie Antoinette's Cabinet Doré,* Palace of Versailles, redecorated 1783. Versailles, France.

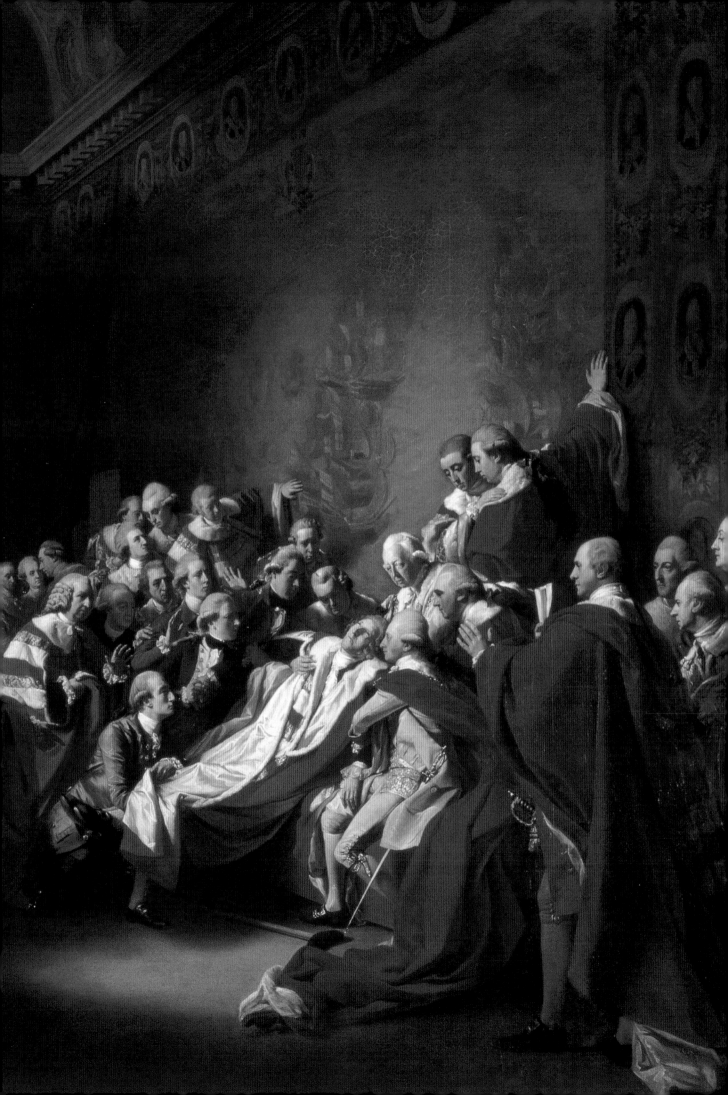

British Art during the Late-Georgian Period

Rome was the cradle of Neoclassicism; Germany provided the movement's theoreticians; and France, in the person of David, produced its greatest painter; but Britain was undoubtedly the economic engine that powered this change in direction. The countless British gentlemen who visited Italy on their grand tours injected a healthy stream of guineas into the Roman art economy. Many of the wealthier ones were avid collectors of original antiquities as well as copies and casts. They bought paintings and prints of Rome, and had their portraits painted against a backdrop of Roman ruins or surrounded by famous antiquities (see *The Grand Tour*, page 66).

Georgian Britain (see *Georgian Britain*, page 72) was among the wealthiest nations in eighteenth-century Europe. The country prospered in spite (or perhaps because) of the Seven Years' War and the American War of Independence, aided toward the end of the century by the Industrial Revolution. Yet, while British landowners and merchants spent lavish sums in Italy, there was little public support for British art. Individuals might commission works privately—mostly painted portraits and sculpted busts, or an occasional funeral monument. But, officially, the British Parliament gave scant support to history paintings and public monuments on a larger scale. This set Britain apart from France, where the government (first through the Office of Buildings, Gardens, Arts, Academies, and Royal Manufactories of the King and, after the French Revolution, through various republican government agencies) was an important patron of the arts. The lack of government support was not compensated for by church art commissions. Following the massive destruction of religious art under Henry VIII (ruled 1509–47) and then the Puritans, the Anglican Church did not pursue the tradition of church art. (By contrast, the Roman Catholic Church had an aggressive program of artistic commissions during the same period.) As a consequence, monumental art patronage in Britain was restricted to the monarch, a handful of aristocrats, and some individual members of the clergy.

The scarcity of official patronage caused British artists to find other avenues to make art, and particularly history painting, profitable. These strategies, outlined below, explain in part why British art of the eighteenth century was different from French art and from European art in general. Other reasons for this difference—and as we shall see they are not unrelated—are the British preoccupation with the "sublime" and the fascination with the cultural heritage of the Middle Ages.

The Sublime

While the quest for ideal beauty was an important driving force in art during the latter part of the eighteenth century, there was also, especially in Britain, a fascination with the sublime. This term, which today refers loosely to something wonderful, in the eighteenth century had a

While France in the eighteenth century was ruled by kings named Louis, Britain was the land of the Georges (George I, 1714–1727; George II, 1727–1760; George III, 1760–1820; George IV, 1820–1830). Unlike the French monarchs, who had absolute authority, the British kings, since 1688, had shared their power with Parliament, following a complex formula that was imbedded in Britich law. For much of the eighteenth century the most powerful man in Britain was the prime minister. Horace Walpole (in office 1721–42) and William Pitt the Younger (in office 1783–1801 and 1804–6)

each played a crucial role in determining Britain's internal and foreign policies. In the forty years that separated their ministries, Pitt's father, though never officially prime minister, served as "virtual" Prime Minister from 1756 to 1761 and again from 1766 to 1768.

The relation between British kings and prime ministers is aptly visualized in a caricature of 1792 (FIG. 3,-1-1) in which Pitt the Younger rides on the shoulders of George III, as they go to battle against seditious writings.

3.1-1 Richard Newton, *A Bugaboo!!!* 1792. Caricature published by the printseller William Holland. British Museum, London.

quite specific meaning that could be traced back to antiquity. Ever since Roman times, philosophers and artists had realized that visual—and, indeed, all sensual— experience cannot be neatly divided into "beautiful" and "ugly." Certain aesthetic experiences deeply affect the viewer without necessarily being beautiful. For these, a Roman philosopher of the 1st century CE known as Longinus (his true identity is unknown) coined the word "sublime." This term was revived in the eighteenth century when it was cogently defined and elaborated by the British politician and philosopher Edmund Burke (1729–1797).

In his *A Philosophical Enquiry into the Origin of Our Ideas of the Sublime and Beautiful*, published in 1757, Burke observed that the most powerful human emotions are evoked not by the experience of beauty, but rather by the sensation of pain or fear, or both. These emotions are, in reality, unpleasant. But when experienced from a "safe distance," pain and fear can be thrilling (as when one watches a raging fire), or, as Burke called it, sublime. Sublime experiences, he wrote, produce a "delightful horror,"

distinct from the emotion inspired by beauty, which he defined as "love, or some passion similar to it."

Burke described sublime experiences at length, touching upon encounters with darkness, power, emptiness, vastness, difficulty, magnificence, and suddenness. He also cited specific examples of the sublime from nature, literature, and art. To Burke, starry nights, thundering waterfalls, raging storms, and roaring animals were all sublime. But so was John Milton's description of Satan in *Paradise Lost* (1667), and the ancient monument of Stonehenge, "those huge rude masses of stone, set on end, and piled each on other."

Although Burke's *Philosophical Enquiry* contains no advice for the artists of his time, his treatise had a considerable impact on the contemporary art world. It encouraged a new role for art, a role that was neither to entertain pleasantly (like Rococo art) nor to moralize, educate, and edify (like much of Neoclassical art). Art, instead, should release a flood of emotions in the viewer. Unlike the theoreticians of the beautiful (Winckelmann, Mengs, Reynolds), who

said that the seeds of beauty were planted in Classical art, Burke did not restrict evidence of the sublime to any single period in history. He maintained that the sublime could be found in nature as well as in the art and literature of various periods.

The Lure of the Middle Ages

The preoccupation with the sublime may be loosely related to a renewed interest in the Middle Ages, which occurred alongside the Classical revival in Britain from about 1750 onwards. In the eighteenth century the Middle Ages were perceived as a dark, mysterious era of primeval forests and haunted castles. While Classical art seemed to reflect beauty and order, the Middle Ages suggested sublimity and confusion. This is not to say that everything medieval was sublime or that the sublime was exclusively confined to the Middle Ages. On the contrary, sublimity could be found in the crumbling ruins of Classical buildings and in the history and legends of Greece and Rome. By the same token, much that was medieval was quaint or grotesque and had nothing at all to do with the sublime.

The interest in the Middle Ages was closely related to the desire of northern Europeans in the late eighteenth century to affirm their cultural roots. Unlike Classical culture, which originated on Mediterranean shores, medieval culture was seen as a typically northern European phenomenon, a mixture of the traditions of the original inhabitants, the Celts, with those of the Germanic tribes who had invaded their territory at the beginning of the Christian era. The appearance, in the 1760s, of two long epic poems titled *Fingal* and *Temora* caused great excitement in Britain and the rest of northern Europe. These poems, apparently discovered and published in modern translation by the Scottish poet James Macpherson (1736–1796), were said to have been written in the third century CE by the ancient Gaelic bard, Ossian. They were hailed as the northern counterpart to Homer's *Iliad* and *Odyssey*. For just as Homer's works were seen as the fountainhead of Classical civilization (see page 62), so Ossian's poems were celebrated as the source of medieval culture, and, by extension, of northern European culture as a whole. It matters little that, in the nineteenth century, scholars discovered that Macpherson's discovery had been a hoax and that he had written most of the two poems himself. By that time, their important role in the revival of interest in Britain's origins had already been played out.

Horace Walpole, William Beckford, and the Taste for the "Gothick" in Architecture

One of the foremost exponents of all things medieval was Horace Walpole (1717–1797), the youngest son of Britain's well-known first Prime Minister, Sir Robert Walpole. In 1747 he bought a country house at Twickenham, near London, and transformed it into a medieval fantasy called Strawberry Hill (FIG. 3-1). To the exterior he added turrets, battlements, and variously shaped medieval-style windows,

3-1 Strawberry Hill. Remodeled for Horace Walpole by Richard Bentley, John Chute, Robert Adam, James Essex, Thomas Pitt, and others, 1753–76. Twickenham, Middlesex.

3-2 **Thomas Pitt and John Chute,** Gallery over the Cloisters: Strawberry Hill, 1759–62. Twickenham, Middlesex.

deliberately striving for an irregular and asymmetrical effect. The interior was remodeled with stucco ceilings and wall paneling inspired by the late Gothic Perpendicular style (FIG. 3-2). Although Walpole employed several architects to help design and remodel his home, the ideas were mostly his own. He was adamant that the details of both exterior and interior decorations should be copied after existing medieval monuments.

At first glance, the interiors of Strawberry Hill seem far removed from the Classically inspired rooms designed by the Adam brothers (see FIG. 2-30). Both, however, were informed by their owners' desire to "live in the past" and to create a space that invited those inside it to meditate on history and the passing of time. Just as in the Etruscan Dressing Room in Osterley Park House various details were copied from Classical originals, so Gothic tombs and altar screens inspired the interiors of Strawberry Hill. Moreover, both interiors contained original period pieces (Classical pieces, acquired through excavations in Italy, and medieval pieces, removed from medieval British buildings) which lent them an air of authenticity.

Strawberry Hill became widely known in the eighteenth century because Walpole published a lengthy description of the house in 1774 and again, in expanded form, in 1784. Through these and other writings, Walpole hoped to promote a "Gothick" fashion in architecture, that is, a building style eclectically inspired by medieval art. Although Gothick architecture could be sublime (see page 73), Walpole's emphasis was rather on the fanciful and what soon would be called the "picturesque" (see page 176).

While his writings about Strawberry Hill were primarily aimed at the British gentry, Walpole stimulated a popular fascination with the medieval period through his creation of the so-called Gothick novel, part mystery and part horror story set in the Middle Ages. It is noteworthy that, applied to literature, the term "Gothick" not merely referred to a form of medievalism but also to the fantastic, the ghastly, and the grotesque. Walpole's *Castle of Otranto*, published in 1765, initiated and exemplified the Gothick literary genre. The novel is dark, stormy, and supernatural in flavor—a head-on assault to the rationalism of the Enlightenment. Although unsuccessful when first published, *The Castle of Otranto* eventually became a popular success and was endlessly imitated, both by hack writers and better-known authors such as Ann Radcliffe (1764–1823). It set the precedent for Mary Wollstonecraft

3-3 **Charles Wild,** *Fonthill Abbey,* c.1799. Watercolor on paper, 11½ x 9¼" (29.2 x 23.4 cm). Victoria and Albert Museum, London.

Shelley's *Frankenstein* (1818) and the fantastic tales of Edgar Allen Poe (1840s), all of which led ultimately to the modern horror story.

Walpole's most extravagant follower among the next generation of British gentlemen was William Beckford (1760–1844). Orphaned at the age of 9, Beckford inherited a fabulous fortune, which enabled him to realize his every whim. His most outrageous project was the refurbishment of his father's estate, Fonthill Splendens, in Wiltshire, southern England. After building a 6 mile (9.65 km) long wall around the property, Beckford converted a garden building into a monastery and erected a central medieval tower that eventually would measure more than 250 ft (76.2 m). Meanwhile, he demolished the old country house and moved into the monastery, renaming the property Fonthill Abbey (FIG. 3-3). As a home, Fonthill Abbey (1796–1807) was a total failure since it was practically speaking uninhabitable. As a realization of a Gothick fantasy, however, it was without equal. Its tower and monastery were awe-inspiring in size, epitomizing the sublime as it had been defined by Burke. Fonthill Abbey came to a fittingly dramatic end when its tower collapsed in 1825, two years after Beckford had sold the property. The ruined tower quickly became a tourist attraction, reminding visitors of the transience of power and wealth.

The Sublime and the Gothick in Painting: Benjamin West

The quest for the beautiful and the fascination with the sublime, and, analogously, the taste for the Classical and the Gothick, were by no means mutually exclusive. Many artists were as much preoccupied with one as with the other. Thus Benjamin West, who painted *Agrippina Landing at Brindisium with the Ashes of Germanicus* (see FIG. 2-11), that early paradigm of Neoclassicism, also produced *The Cave of Despair* (FIG. 3-4), a painting that epitomizes Gothick taste. While *Agrippina* is based on Classical history, the *Cave of Despair* illustrates an episode from the *Faerie Queene,* a lengthy epic poem by the Elizabethan poet Edmund Spenser. The painting depicts a critical moment in the poem when the valiant "Red Cross Knight" enters the Cave of Despair (personified by an old despondent man) to commit suicide. As he is about to thrust a dagger into his throat, the beautiful Una appears and restrains him.

In the *Cave of Despair,* confusion and frenzy have replaced the order and calm of Agrippina. With its medieval subject, dark cave, corpse, skeleton, and ghosts the painting calls to mind the Gothick novels of Walpole and Radcliffe. While *Agrippina* inspires admiration and love, feelings that qualify the painting as "beautiful," the *Cave of*

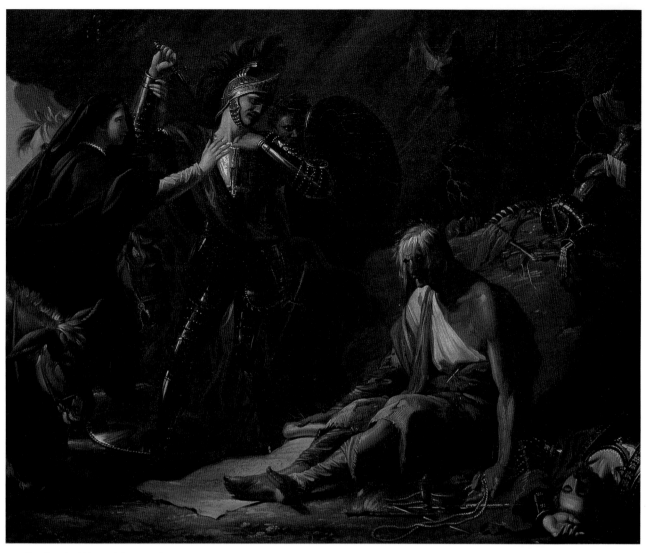

3-4 **Benjamin West,** *The Cave of Despair,* 1776. Oil on canvas, 24 x 30″ (61 x 76 cm). Duxbury Art Complex, Massachusetts.

Despair instills in the viewer a sense of dread and anxiety that compel one to call it "sublime."

It is difficult to understand how *Agrippina* and the *Cave of Despair* could have been painted by the same artist, especially since they were executed only four years apart. Nonetheless, they have some aspects in common. Like *Agrippina*, the *Cave of Despair* teaches a moral lesson, even though it is overwhelmed by its chaotic composition. The painting can be read as an allegory in which the Red Cross Knight represents man's valiant struggle to do what is right, while the old man personifies the despair to which everybody, at times, succumbs. Una, finally, stands for Truth or, alternatively, Religion, both of which can save man from himself and set him back on the proper course.

In addition, both *Agrippina* and the *Cave of Despair* contain numerous eclectic elements borrowed from the art of the past. While Agrippina draws on Roman relief sculpture and Raphael's frescoes in the Vatican Palace, the *Cave of Despair* is reminiscent of the works of Rembrandt

van Rijn (1606–1669) and Salvador Rosa (1615–1673). Clearly, West, like most artists of his generation, followed the advice of Reynolds to study not merely Classical and Renaissance art but all art of the past. For, as Reynolds said in his *Discourses*: "In every school, whether Venetian, French, or Dutch, he [the artist] will find, either ingenious compositions, extraordinary effects, some peculiar expressions, or some mechanical excellence well worthy of his attention, and, in some measure, of his imitation."

West's fascination with the Gothick and the sublime continued to the end of his career. As an artist who was keen on self-promotion and the marketing of his work, he took a great interest in public taste. West must have come to the realization that the Gothick, because of the thrill it provided, had greater public appeal than the Classical; and that the sublime, by arousing strong emotions in the viewer, was ultimately more powerful than the beautiful.

Consequently, during the last ten years of his life, West created a series of colossal paintings that epitomized the

sublime in both size and subject matter. The most impressive of these was *Death on the Pale Horse* (FIG. 3-5), a huge canvas measuring some 12 by 25 feet. Inspired by the Apocalypse or Book of Revelation, the final book of the New Testament, the painting presents an image of St John's gruesome vision of the end of the world: ". . . behold a pale horse; and his name that sat on him was Death. And Hell followed with him. And power was given unto them over the fourth part of the earth, to kill with sword, and with hunger, and with death, and with beasts of the earth."

Death on the Pale Horse was not a commissioned work, intended for some special location. As we have seen, commissions from state or church were rare occurrences in Britain. And West could hardly have anticipated an individual who would buy such a gigantic canvas. How then did he expect to make money from this work, which took many months to complete?

West was counting on a new commercial strategy that he used successfully during the latter part of his life. *Death on the Pale Horse* was exhibited by itself, in a building on the busy London street of Pall Mall, where its huge size, sensational subject, and sublime nature attracted many viewers. Visitors were charged an entrance fee, much as if they were going to see a movie. Thus the income that West earned from the painting did not come from its sale, but exclusively from the box office.

West's initiative was more than a clever entrepreneurial strategy. For one, he put a price on spectatorship, shifting the monetary value of a work of art from the possession of the actual object to its psychological effect on the viewer. For another, he took the power to judge art away from a small elite group of artists and critics, and put it directly into the hands of the general public. Thus he promoted a movement towards the democratization of art that would become increasingly powerful in the nineteenth century.

Boydell's Shakespeare Gallery

The idea of producing paintings for exhibition rather than sale was not West's own, neither was it a new idea in 1817, when *Death on the Pale Horse* was first shown. Some thirty years earlier, in 1789, the English engraver and print-seller John Boydell (1719–1804) had opened a special gallery, also in Pall Mall, where for a fee the public could admire a selection of paintings by different artists on themes of Shakespeare's plays. The idea for the Shakespeare Gallery first came up at a dinner party attended by several artists, who bemoaned the fact that there was no market for history painting in Britain.

Boydell's Shakespeare Gallery was a response to this artistic complaint, but it was also a commercial venture. Boydell planned to make money from both the entrance fees and from the sale of engravings reproducing the paintings in the gallery. He would also market a new illustrated edition of Shakespeare's plays. The choice of themes was carefully calculated to appeal to the ongoing popularity of Shakespeare as well as to the taste for the medieval and

3-5 **Benjamin West,** *Death on the Pale Horse,* 1817. Oil on canvas, 14'7" x 25'1" (4.47 x 7.65 m). Pennsylvania Academy of the Fine Arts, Philadelphia.

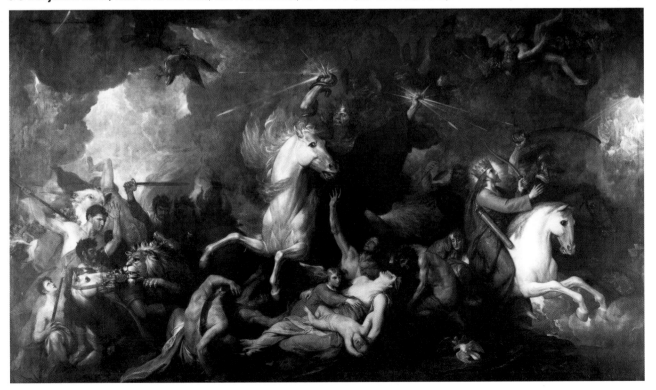

the sublime. Many of Shakespeare's plays are, of course, set in the Middle Ages. What is more, eighteenth-century critics saw in such tragedies as *Macbeth* and *King Lear* exemplary models of the literary sublime.

Among the artists who participated in Boydell's project were several who had shown an earlier interest in the sublime. Benjamin West contributed two paintings, including *King Lear in the Storm*, now in the Museum of Fine Arts in Boston, and *Ophelia before the King and Queen*, in the Cincinnati Museum of Art. The Irish painter James Barry (1741–1806), a close friend of Burke, contributed two paintings as well, including *King Lear Weeping over the Body of Cordelia* (FIG. 3-6), an outstanding example of the sublime in painting. Barry's work shows the final scene of *King Lear* when the old king has discovered that his youngest daughter has been hung. Mad with grief, Lear emerges from a tent carrying the body of Cordelia. His despair is echoed by nature as a thunderstorm breaks loose, causing sudden darkness and a strong wind that sweeps up Lear's long white hair and beard.

In the eighteenth century Shakespeare's play was known to be based on a legend about an ancient pre-Christian British warrior king. Barry has emphasized the primeval

British character of the play by depicting Stonehenge, the prehistoric monument with all its sublime flavor, in the background. Realizing that Stonehenge would have been new at the time of the tale, Barry has painted a "restored" version, probably copied from one of the many archaeological treatises about Stonehenge that had appeared in Britain in the eighteenth century.

Henry Fuseli

The most important contributor to Boydell's Shakespeare Gallery was Henry Fuseli (1741–1825). Born in Zürich, Switzerland, as Johann Heinrich Füssli, he began his career as a Protestant minister. This may explain his lifelong interest in theology, philosophy, and literature, which would inform his art in later times. During a trip to England, Fuseli met Joshua Reynolds, who convinced him to become a painter. After an eight-year trip to Italy, he settled down in London to become one of England's best-known artists at the turn of the eighteenth century.

Fuseli owed his initial reputation to a very unusual painting exhibited at the Royal Academy Exhibition of 1781.

3-6 **James Barry,** *King Lear Weeping over the Body of Cordelia*, 1774. Oil on canvas, 40 x 50″ (1.02 x 1.28 m). Tate Britain, London.

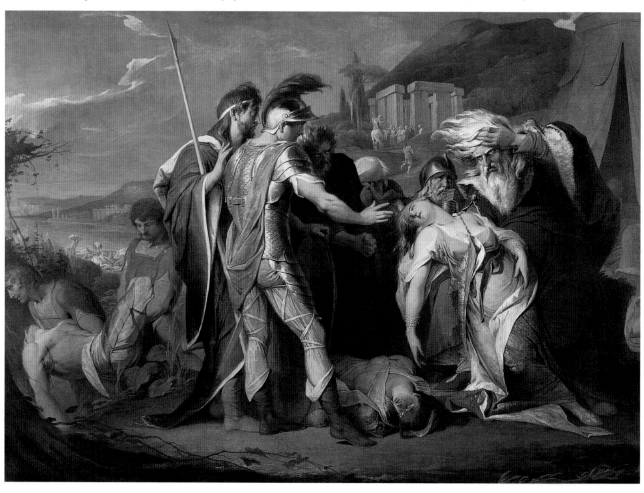

3-7 **Henry Fuseli,** *The Nightmare,* 1781. Oil on canvas, 40 x 50" (1.02 x 1.27 m). Detroit Institute of Arts.

The Nightmare (FIG. 3-7) represents a young girl, dressed in a long white gown, asleep on a bed. Her uncomfortable position appears to be causing a bad dream, represented by a *mara* (a monstrous creature believed to cause nightmares), seated on her lower abdomen. A white horse, perhaps also representative of the nightmare, enters the room through a parted curtain behind the bed. Both *mara* and horse evoke the fear the girl experiences in her sleep, in the absence of a wakeful, rational mind. Fuseli's painting operates halfway between Gothick thrill and sublime terror, as it both repulses and strangely fascinates the viewer. Anticipating by more than a century the ideas of Sigmund Freud (who, incidentally, had a reproduction of *The Nightmare* hanging in his study), Fuseli has by some 120 years, Fuseli has forged an immediate link between dreaming and sexuality. *The Nightmare* hints at the young virgin's repressed desire for, as well as fear of, sexuality. One may see the ugly monster as a dream symbol of male libido and the white horse bursting through the parted curtain as a symbol of the sexual act itself.

The Nightmare brought Fuseli instant renown. This, in addition to the positive reaction to some Shakespeare paintings that he had submitted to the Royal Academy, secured him a commission for eight paintings for Boydell's Shakespeare Gallery. Some, such as *The Witches Appearing to Macbeth and Banquo* (FIG. 3-8), now only known through Boydell's print of the painting, are obvious examples of the sublime. Others, however, show something new and different—an interest in fanciful imagery that, at times, seems to anticipate twentieth-century Surrealism. Like Fuseli's *Nightmare* these paintings seem related to dreams; but instead of representing the dream "from the outside," they seem to draw inspiration from within.

Of these works, executed between 1785 and 1790, the best known is *Titania and Bottom* (FIG. 3-9), which represents a scene from Shakespeare's play *Midsummer Night's Dream*. Jealous Oberon, king of the fairies, has quarreled with his wife Titania. While she is asleep he casts a spell on her to make her fall in love with the first person she sees upon awakening. That person turns out to be Bottom, an

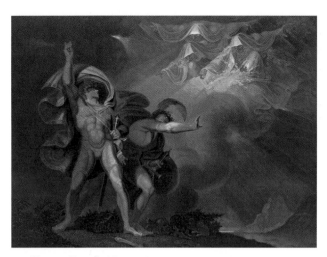

3-8 **Henry Fuseli,** *The Witches Appearing to Macbeth and Banquo.*
Reproduction of the painting by James Caldwall. Stipple engraving on
paper, 17½ x 23⁹/₁₆″ (44.5 x 59.9 cm). Folger Shakespeare Library,
Washington, DC.

amateur actor from a nearby village who is wearing a donkey mask. In the painting, we see the beautiful Titania cuddling Bottom, while her retinue of fairies looks on in amusement. Fuseli has let his imagination run wild in depicting the fairies and their odd-looking attendants. One fairy holds a bearded scholar on a leash; another holds a miniature muscle man on her lap. Fascinating and a little scary, these figures—like Shakespeare's play itself— are evocative of a dream. *Titania and Bottom* occupies an important place in British painting since it gave rise to an exclusively British genre, generally referred to as "fairy painting" (see page 298).

Although Fuseli's contributions to the Shakespeare Gallery earned him a solid reputation as well as membership of the Royal Academy, his financial rewards were minimal. Fuseli was paid 280 guineas for *Titania and Bottom*, while the engraver who made the reproduction of the painting received 350 guineas. The sense that he had been cheated by Boydell led Fuseli to embark on a scheme of his own, the so-called Milton Gallery. By producing

3-9 **Henry Fuseli,** *Titania and Bottom,* 1790. Oil on canvas, 7′ 1″ x 9′ (2.16 x 2.74 m). Tate Britain, London.

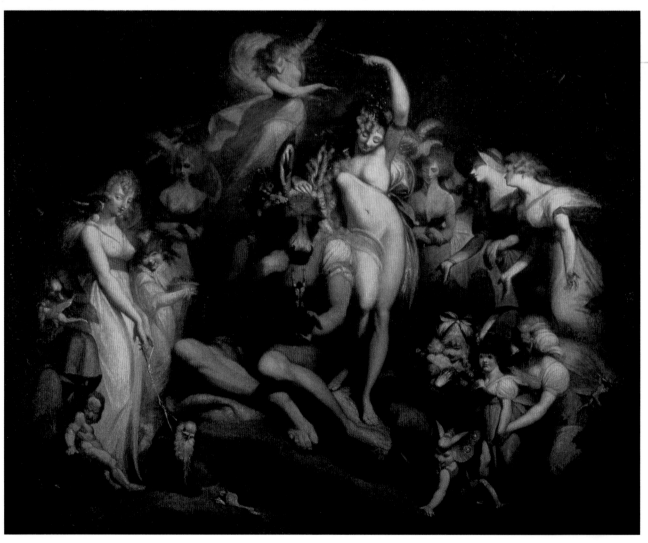

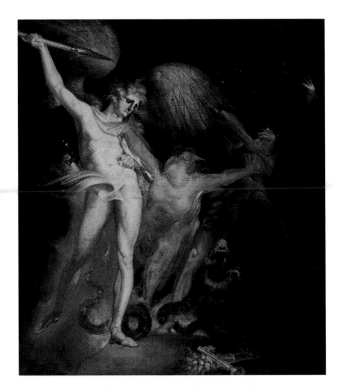

3-10 **Henry Fuseli,** *Satan and Death, Separated by Sin,* 1776. Oil on canvas, 25⅝ x 22″ (65 x 57 cm). Los Angeles County Museum of Art.

3-11 **Henry Fuseli,** *Satan.* Illustration in Kaspar Lavater, *Essays in Physiognomy* (vol. II, opposite p. 285), 1779. Engraving by Thomas Holloway, 5¹³/₁₆ x 4″ (14.7 x 11.5 cm). British Museum, London.

all the paintings himself and controlling the exhibition and the sale of reproductive prints, he hoped to turn a healthy profit.

In 1799 and again in 1800 Fuseli rented a gallery on Pall Mall and showed forty paintings on themes derived from *Paradise Lost,* the masterpiece of the seventeenth-century poet John Milton. The choice of author was no doubt carefully considered. Milton, in the eighteenth century, was as widely read and revered as Shakespeare. Burke himself had singled out Milton's *Paradise Lost,* especially his description of Satan, as the height of the literary sublime.

Satan and Death, Separated by Sin (FIG. 3-10) is a reduced copy by Fuseli of one of his monumental paintings for the Milton Gallery. It is a spectacular composition in which Satan, the Fallen Angel, raises his spear against the ghastly figure of Death but is held back by Sin, a frightening half-woman half-snake figure. Fuseli's notion of Satan as a young male with curly locks and large eyes is one that he conceived some fifteen years earlier as an illustration for a book by his friend Kaspar Lavater, 1741–1801 (see FIG. 3-11). In his *Essays on Physiognomy* this Swiss theologian had introduced a new field of scientific study called physiognomy, which investigated the relationships between facial features and character (see *Physiognomy and Phrenology,* page 238). Fuseli's image of Satan combines several features that Lavater associated with the choleric or angry temperament, such as abundant, curly hair, wide open eyes, and pronounced eyebrows.

Fuseli anticipated that his Milton Gallery would draw huge crowds and, hopefully, attract buyers. But the turnout was disappointing. Although he sold a few paintings, most were returned to his studio and eventually got lost. Even the sale of prints reproducing the paintings was sluggish and did not compensate for the low box office revenues.

William Blake

With few exceptions, British eighteenth-century artists needed the sale of prints of their works as a principal source of income. Generally, they relied on professional engravers and print publishers to reproduce and market their work. Most professional engravers were not fine artists themselves and their names are largely forgotten today. A notable exception was the printmaker and poet William Blake (1757–1827) who, having worked as an engraver in his youth, decided to make prints of his own and use them to illustrate his writing. Blake became obsessed with producing handmade books, a goal that was first realized in two slim volumes of poetry, *Songs of Innocence* (1789) and *Songs of Experience* (1794). Each page in these two volumes features a poem by Blake and an illustration, often connected to the text by a decorative frame. Blake refused to use letterpress and insisted that text and image be printed from the same copper plate. To accomplish

3-12 **William Blake,** *The Lamb.* From *Songs of Innocence,* copy b, 1789. Relief etching with watercolor, 4⁵/₁₆ x 2″ (11.9 x 7.7 cm). Library of Congress, Rare Book and Special Collections Division, Lessing J. Washington, DC. Rosenwald Collection.

this goal, he used an unusual, multi-stage etching technique that allowed him to reproduce his own beautiful handwriting. Text and image were printed in a single color. Other colors were added by hand by Blake or by his wife Catherine. This elaborate method explains why Blake produced so few volumes.

Songs of Innocence and *Songs of Experience* were written in the manner of nursery rhymes. It is not certain whether they were intended for children or for adults. For while the poems, like the simple, almost naïve illustrations that accompany them, may appeal to children, they often contain profound meditations on good and evil, the divine and the demonic. Indeed, the two volumes were conceived in contrast to one another. While the *Songs of Innocence* deal with a world of love and bliss, the *Songs of Experience,* dwell on man's fallen state.

The Lamb in the *Songs of Innocence* (FIG. 3-12) and *The Tyger* (FIG. 3-13) in the *Songs of Experience* seem to carry the themes of the two volumes. Together, they represent what Blake referred to as "the Contrary States of the Human Soul," opposing gentleness, humility, and innocence to

brutality, pride, and experience. This opposition is suggested not only in the poetry but also in the illustrations. While the illustration for *The Lamb* shows gently curving lines and soft pastel colors, that of *The Tyger* is marked by a more austere style of drawing and dark, ominous colors.

The *Songs of Innocence and of Experience* were informed by Blake's admiration for the Swedish scientist and mystic theologian Emanuel Swedenborg (1688–1772). Swedenborg maintained that, while all creation has its origin in divine love, and is consequently perfect, that perfection has been disturbed by man's selfishness. Evil has come into the world because man loved himself more than God.

Most of Blake's subsequent illuminated books show the impact of his Swedenborgian beliefs as well as his increasingly unusual political ideas. A sympathizer of the French Revolution of 1789, Blake joined a radical political circle

3-13 **William Blake,** *The Tyger.* From *Songs of Innocence and Experience,* copy n, 1795. Relief etching with watercolor, 4³/₈ x 2″ (11 x 6.3 cm). Henry E. Huntington Library and Art Gallery, San Marino, California.

3-14 **William Blake,** *The Song of Los*, copy e. Frontispiece of the *Book of Los*, 1795. Color printed from a copper plate, 9 x 6″ (23.4 x 17.3 cm). Henry E. Huntington Library and Art Gallery, San Marino, California.

that also included Henry Fuseli and the writer Mary Wollstonecraft (1759–1797). The fusion of his mystical beliefs and radical political convictions led to the production of his so-called "prophetic" or Lambeth books (after the London suburb where Blake lived) of the mid-1790s. In these books he looked at the history of man's mental and physical enslavement (*Book of Urizen*, *Book of Aphania*, and *Book of Los*), as well as at its future (*America: A Prophecy* and *Europe: A Prophecy*). Both the texts and the illustrations of these books are cryptic and obscure, since Blake insisted that their meaning would become clear only after long and careful study. Nonetheless, the illustrations often have a visceral effect on the viewer, even if the exact meaning is not clear. The title plate of the *Book of Los* (FIG. 3-14) may serve as an example. In it, we see a figure, possibly male, dressed only in a long white skirt, prostrated before an altar covered with a large open book. Above looms a large sun, partly obscured by dark blotches. The sun usually signifies fertility, growth, and enlightenment. Instead, this dark, festering celestial body speaks of a sickened world in which men find counsel in evil books and live in eternal darkness.

3-15 **William Blake,** *Ode to Adversity.* Illustration in *The Poems of Thomas Gray*, c.1797–8. Pen, ink and watercolor on paper, 16 x 12" (41.9 x 32.4 cm). Yale Center for British Art, Paul Mellon Collection, New Haven.

Blake's illuminated books found a small circle of admirers who, to keep him financially afloat, provided him with commissions. Some of these were for engraved book illustrations. Others were for sets of watercolors illustrating time-honored texts such as the Bible, Dante's *Inferno*, and Milton's *Paradise Lost*, or works by modern poets such as Edward Young (1683–1765) and Thomas Gray (1716–1771). Blake occasionally showed these watercolors at the Royal Academy or at the exhibitions of the Associated Painters in Watercolours, one of several watercolor societies that developed in the late eighteenth and early nineteenth centuries (see page 179).

The watercolor illustrating *Ode to Adversity* (FIG. 3-15) is one of a group of 166 watercolors made to illustrate the poems of Thomas Gray. The set was commissioned by Blake's close friend Henry Fuseli as a present to his wife. Centered around the text of Gray's ode, which speaks of

"Gorgon Terrors clad," and "Horror's funeral cry/Despair, and fell Disease, and ghastly poverty," we see a fearsome Gorgon's head, surrounded by viciously snapping snakes and a number of other eerie figures, who are all looking threateningly at the viewer. Here, as in so many of Blake's works, sublimity has been carried to its limits.

Blake never practiced oil painting but during the later part of his career he did develop a unique painting technique that allowed him to produce larger works than his book illustrations and watercolors had been. Mixing pigments with carpenter's glue, he applied these homemade paints to a canvas or thin copper plate that he had first coated with a mixture of glue and plaster. Blake referred to this technique as "tempera," although it is quite different from traditional tempera, in which the pigments are mixed with egg. Blake showed several of these paintings in a private exhibition in his brother's house in 1809.

3-16 **William Blake,** *The Spiritual Form of Pitt Guiding Behemoth,* 1805?. Tempera heightened with gold on canvas, 29 x 25" (74 x 62.7 cm). Tate Britian, London.

Among the works shown was *The Spiritual Form of Pitt Guiding Behemoth* (FIG. 3-16). In this enigmatic work, William Pitt the Younger, the British prime minister from 1783 until his death in 1806, appears as in a vision. Clad in a long gown, his head surrounded by a huge halo, the youthful

Pitt (he was 47 when he died) holds a rein that controls the Old Testament beast Behemoth, here a signifier of the powers of war unleashed by Pitt against the French. In the catalogue that Blake wrote for the exhibition of 1809, he claimed that his painting was inspired by a vision in which

3-17 **James Barry,** *Portrait of William Pitt, 1st Earl of Chatham,* 1778. Etching and aquatint, 17⁷/₈ x 14⁷/₁₆" (45.4 x 36.7 cm). British Museum, London.

he saw ancient paintings and sculptures on the "walls of Temples, Towers, Cities, Palaces . . . erected in the highly cultivated states of Egypt, Moab, Edom, Aram, among the Rivers of Paradise." These paintings, he claims, he endeavored to emulate, applying their grandeur and beauty to "modern Heroes, on small scale."

The Spiritual Form of Pitt Guiding Behemoth exemplifies Blake's admixture of interests in both politics and theology. In Blake's all-encompassing historical vision, myth and reality, past and present all provide examples of the perennial struggle between good and evil, reason and irrationality.

Contemporary Heroes and Historical Context

Blake's *Spiritual Form of Pitt Guiding Behemoth* strikes the modern viewer as depicting contemporary political leaders and events in quite an unusual way. In its day, it was unusual as well, not because it presented Pitt in an imaginary context but because that context itself was exceptional in its display of Old Testament and Apocalyptic imagery.

In the eighteenth century contemporary heroes were commonly represented in Classical garb and context. James Barry's engraved portrait of William Pitt the Elder, 1st Earl of Chatham (FIG. 3-17), the father of William Pitt the

Younger, is a case in point. Commissioned just after his death in 1778, the print shows the earl portrayed as a Roman bust placed on a pedestal. Next to the bust stands the allegorical figure of Britannia, a buxom woman in classical dress. With an arrow, she points at Pitt's accomplishments, which are inscribed on a pyramid. The dome of St Paul's Cathedral is partially visible in the background. Barry's image, so different from Blake's, is a more traditional representation of heroes in the eighteenth century, replete with Classical and allegorical references.

Probably the first British artist to break with this eighteenth-century tradition was Benjamin West. His *Death of General Wolfe* of 1771 (FIG. 3-18) was highly unusual at the time: its hero wears not ancient garb but contemporary dress, and his deeds are not shown by allegorical references but by depiction of the actual events. In so doing, West changed the traditional hero image and simultaneously created a new form of history painting. Unlike earlier history paintings, which depicted events in ancient or medieval history or episodes from literature, the *Death of General Wolfe* celebrates a contemporary event.

British Major-General James Wolfe was a famous hero of the recent Seven Years' War. While commanding the British forces against the French at Quebec in 1759, he was mortally wounded. As he lay dying, a soldier brought

3-18 **Benjamin West,** *Death of General Wolfe,* 1771. Oil on canvas, 4'11" x 7' (1.51 x 2.13 m). National Gallery of Canada, Ottowa.

3-19 **John Singleton Copley,** *Death of the Earl of Chatham,* 1779–81. Oil on canvas, 7'6" x 10'1" (2.28 x 3.07 m). Tate Britain, London (on loan to the National Portrait Gallery, London).

the news of the defeat of the French, causing Wolfe's last words: "Now, God be praised, I will die in Peace."

West's patron, George III (ruled 1760–1820), who altogether brought some sixty paintings from the artist, refused to buy this one. He thought that it was "ridiculous to exhibit heroes in coats, breeches, and cock'd hats." And Joshua Reynolds urged West to use Classical costume instead of the modern uniforms. These criticisms notwithstanding, the painting was a huge popular success when first exhibited at the Royal Academy Exhibition of 1771. Apparently West had understood that the depiction of a contemporary hero in a realistic context would have a powerful public appeal. Comparing himself to a historian, he argued:

> The same truth that guides the pen of the
> historian should govern the pencil of the artist.
> I consider myself as undertaking to tell this great
> event to the eye of the world; but if, instead of
> the facts of the transaction, I represent classical
> fictions, how shall I be understood by posterity?

Of course, the "truth" of West's painting was only relative. Since West had not been present at the scene, he relied on eyewitness accounts. And even these he failed to take very seriously, since he structured his painting to feature Wolfe's heroism and that of fellow leaders. The central scene of Wolfe expiring amidst his officers recalls traditional representations of the lamentation over the dead body of Christ. West obviously wanted the viewer to draw a comparison between Wolfe dying for his country and Christ giving his life for mankind. Of the figures surrounding Wolfe (numbering eleven, just like the apostles present at Christ's death), several portray well-known British officers who fought in Canada. Interestingly, most of them do not seem to have been present at Wolfe's death.

Equally "untrue" to history is the presence in the foreground of a Native American. He appears to serve an allegorical function here, embodying North America, the locale of the battle. His characteristic pose, with legs crossed and head resting on hand, is found in traditional allegories of mourning (as, for example, in the spirit of death in Canova's tomb of Maria Christina; see FIG. 2-22).

West's painting is at once an image of a hero, a group portrait, and a contemporary history painting, complete with a built-in moral lesson about courage and self-sacrifice. It initiated a new genre of history painting that would flourish in France during the Napoleonic period, and would continue into the nineteenth century and beyond.

West's innovation was taken one step further by another American-born artist working in England, John Singleton Copley (1838–1915). His painting titled *Death of the Earl of Chatham* (FIG. 3-19) represents the dramatic collapse in the House of Commons of William Pitt the Elder, whom Barry had portrayed in his engraving of 1778. Unlike West's *Death of General Wolfe*, which was staged for maximum effect

(what West himself referred to as an "Epic Composition"), Copley's painting strikes us as closer to true reportage. The artist made every effort to create individual likenesses of each parliamentarian in the House of Commons at the time of the earl's death. It combines history and portrait painting quite effectively. Inspired perhaps by the success that West had with his *Death of General Wolfe*, Copley decided to organize a private show of the *Death of the Earl of Chatham*, coupled with the sale of a reproductive print. The exhibition was a financial boon for Copley and brought him a great deal of publicity.

Grand-Manner and Bourgeois Portraits

The success of the *Death of the Earl of Chatham* may have been based, in part, on the popularity of portraiture in the eighteenth and early nineteenth centuries. As we have seen in Chapter 1, this genre commanded by far the greatest market in Britain. Nearly all British artists of the time, with the exception of Blake and Fuseli, were active in this field. Although most far preferred history painting to portraiture, the latter was a chief source of income for many talented artists including Joshua Reynolds, George Copley, Thomas Gainsborough, George Romney (1734–1802), Joseph Wright of Derby (1734–1797), and Thomas Lawrence (1769–1830).

As during the first half of the eighteenth century, most portraits were of fashionable Londoners, usually members of the British aristocracy. This class continued to favor portraiture in the "grand manner"—life-size, full-length portraits that duly emphasized their sitters' wealth and status. George Romney's *Portrait of Lady Rodbard* of 1786 (FIG. 3-20) shows some of the changes that had taken place in the twenty-five years or so since Gainsborough painted his *Portrait of Countess Howe* (see FIG. 1-15). Romney's portrait shows a new sentimentality that is distinct from the pragmatic mood of Gainsborough's. Contrary to Lady Howe's purposeful stride, Lady Rodbard is leaning against a pedestal, absentmindedly embracing her pet, as she seems drawn, by the spectator, from a profound reverie.

Next to grand-manner portraiture, there rose in eighteenth-century Britain a very different kind of portrait painting, more in harmony with the aspirations of the British middle class. The new industrialists, who owed their wealth to the Industrial Revolution, were added to the clientele of portrait artists. While some liked to be portrayed just like aristocrats, other demanded a new type of portraiture that stressed not the elegant lifestyle that their wealth had brought, but rather the hard work and entrepreneurial skills that were at its root.

Joseph Wright of Derby's *Portrait of Richard Arkwright* of 1789–90 (FIG. 3-21) serves as an example. It portrays a Lancashire barber turned textile tycoon, whose wealth at the time of his death was estimated at £500,000. On the

table next to Arkwright is a set of cotton-spinning rollers, the crucial part of a new spinning machine that he had invented and that had brought his success. While Wright of Derby still uses some of the conventions of the aristocratic portrait, such as the column and the drapery in the background, his portrait of Arkwright departs from that tradition in that the sitter is indoors, in his office, seemingly interrupted during his work. The portrait lacks the facial make-over, the artificial weight reduction, and posture improvement of grand manner portraits. Instead, it presents an uncontrived, direct likeness of a middle-class entrepreneur who owed his success to diligence and ingenuity.

Both Arkwright and Wright of Derby came from outside London, as did most of the new industrialists. Indeed, textile mills, iron forges, and china works were growing up not in London but in Lancashire, Staffordshire, Derbyshire, and other counties. The two works for which Wright is most famous exemplify the spirit of optimism, curiosity,

3-21 **Joseph Wright of Derby,** *Sir Richard Arkwright*, 1789–90. Oil on canvas, 7'11" x 5' (2.41 x 1.52 m). Private Collection.

3-22 **Joseph Wright of Derby,** *A Philosopher Giving a Lecture on the Orrery, in which a Lamp is Put in Place of the Sun,* c.1764–66. Oil on canvas, 4'9" x 6'7" (1.47 x 2.03 m). Derby Museum and Art Gallery.

and self-improvement that helped such men as Arkwright and Wedgwood to achieve their success. These paintings, *An Experiment on a Bird in the Air Pump* and *A Philosopher Giving a Lecture on the Orrery, in which a Lamp is Put in Place of the Sun* (FIG. 3-22), represent members of a provincial scientific society giving a lecture-experiment. The latter painting depicts a gathering of adults and children around an orrery, an early planetarium. The room is dark except for the light of a candle placed inside the orrery to represent the sun. Behind the orrery, in the center, an elderly man with gray hair gives a lecture on astronomy to three young men, a woman, and three children.

Although each of the figures in the painting represents an individual person, Wright did not exhibit the work as a portrait but rather as a genre painting, or painting from daily life. Such an event would have been familiar to many British viewers of the eighteenth century, when amateur scientific societies were common throughout the land. Wright was a member of such a group, as were many doctors (such as Erasmus Darwin, the grandfather of the evolutionist), inventors (such as James Watt), and early industrialists (such as Josiah Wedgwood).

Wright's painting goes beyond traditional genre painting, not only in its monumental size, but also in the seriousness with which he has treated the theme. The figures in the painting are either closely attending the words of the lecturer or staring meditatively into the orrery, mesmerized by its light. The lecture and the orrery have set them thinking on the vast universe, the wonder of creation, and, perhaps, the meaning of life itself. Wright's *Orrery* and his related painting, better than any other works of the period, convey the spirit of an age when science and technology were seen as the key to the mysteries of the universe, and the means by which humans would progress.

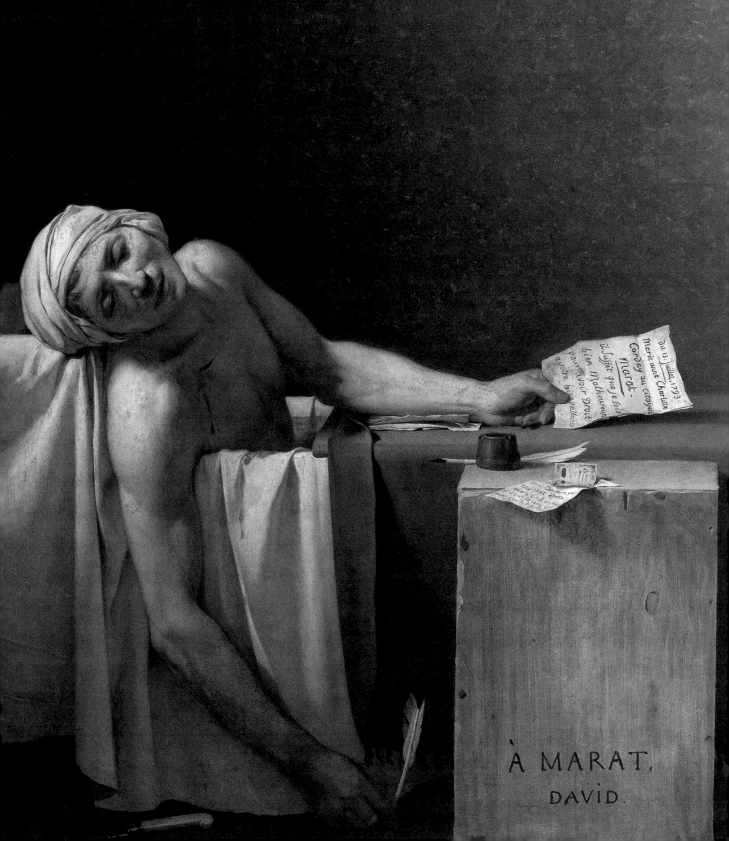

Du 13 Juillet, 1793.
Marie anne Charlotte
Corday au citoyen
Marat.
il suffit que je sois
bien Malheureuse
pour avoir Droit
a votre bienveillance

À MARAT.
DAVID.

Chapter Four

Art and Revolutionary Propaganda in France

While Britain prospered after the American War of Independence, France was plunged into revolution and political chaos. The American revolt against British rule had shown the French how citizens could fight for freedom and equality, and they did not wait long to follow suit.

The French Revolution (see *Major Events of the French Revolution, 1789–95,* page 94) had a complex origin. Periodic food shortages, a political system in which the rapidly growing middle class was entirely excluded from political power, and an intellectual climate dominated by *philosophes* who preached social and political reform combined to make a volatile mixture. The spark that set off the explosion was an attempt by Louis XVI (ruled 1774–92) to raise taxes. The king hoped to legitimate the tax increase by obtaining the backing of a select ad hoc committee of aristocrats, high-ranking clergymen, and wealthy bourgeois. Reluctant to become the target of public criticism, however, the committee advised the king to summon the Estates General, a political body composed of 300 elected representatives of the aristocracy, an equal number of clergymen, and 600 members of the third estate (commoners). This development was unexpected, for although it had been in existence since the fourteenth century, the Estates General had not been summoned since 1614.

The elected representatives of the Estates General met first at Versailles on May 5, 1789. Not surprisingly, they were equally divided between the aristocrats and the clergy, who sided with the king, and members of the third estate, who wanted to reform the tax system and the government in general. Convinced that they could never gain the upper hand within the framework of the Estates General, the third estate formed a new governing entity, the National Assembly. Meeting in an indoor tennis court near the official meeting room, they swore that they would not disperse until they had given France a new constitution. Unable to control them, the king told the clergy and nobility to join the third estate in a "Constituent Assembly" charged with writing a new constitution. Meanwhile, he prepared the army to take action if necessary.

While these events were taking place in Versailles, food shortages had created unrest in Paris and provincial French towns. Hunger, and fear caused by the sight of gathering troops, led to riots. On July 14, 1789, an angry mob stormed the Bastille fortress in Paris and freed the political prisoners that were held inside. The Constituent Assembly saw only one way to pacify the violent crowds. On August 4 it officially abolished the existing absolute regime. Three weeks later (August 27) it issued the *Declaration of the Rights of Man and of the Citizen,* which granted liberty and equality to all Frenchmen. When the king refused to ratify the decisions of the assembly, a large mob marched to the royal palace in Versailles and forcibly took him and his family back to Paris.

Meanwhile, the Constituent Assembly proceeded to write a new constitution based on the principles set forth in the Declaration of the Rights of Man. The initial plan was to create a constitutional monarchy in which the king

May 5, 1789	Estates General convene at Versailles
June 20, 1789	Oath of the Tennis Court
July 14, 1789	Storming of the Bastille (France's national holiday)
August 4, 1789	Constituent Assembly abolishes absolute monarchy
August 27, 1789	Declaration of the Rights of Man and of the Citizen, which became the preamble of the constitution of 1791 and most subsequent French constitutions
October 5–6, 1789	Parisian rabble walks to Versailles and forces the royal family to come to Paris
July 12, 1790	Civil Constitution of the Clergy (reorganization of the Roman Catholic Church in France on a national basis)
September 3, 1791	First Constitution; Constituent Assembly replaced by Legislative Assembly
April 1792	Beginning of the French Revolutionary Wars
August 10, 1792	Attack on the Tuileries Palace in Paris, followed by suspension of the monarchy
September 21, 1792	First assembly of the National Convention; the monarchy is abolished and the First Republic proclaimed
January 21, 1793	Execution of Louis XVI
April 6, 1793	Establishment of Committee of Public Safety
June 22, 1793	Adoption of Second Republican Constitution
July 1793	Robespierre enters Committee of Public Safety
September 1793	Beginning of Robespierre's "Reign of Terror," during which 17,000 people will be executed
October 16, 1793	Execution of Marie Antionette
July 27, 1794	End of Robespierre's reign, followed by his execution the following day
July 28, 1794	Execution of Robespierre
July 1794	Disbanding of the Committee of Public Safety
August 22, 1795	Adoption of Constitution of the Year III, which establishes the Directory

would remain, with his powers severely curtailed. But the king's unwillingness to compromise eventually led to the abolition of the monarchy and the proclamation of the French Repubic. A new governing body, the National Convention, condemned the king to death for treason. Louis XVI went to the guillotine on January 21, 1793; his wife Marie Antoinette followed on October 16.

The Revolution ended the old world order, in which kings had been sacrosanct and people had accepted the place in society given to them by birth (see *Absolutism*, page 19). It ushered in a new era of political equality and social mobility, in which power and wealth had to be earned rather than inherited, and in which the law of the land, rather than the whim of the ruler, governed.

Marie Antoinette, Before and After

Nothing illustrates the drama of the French Revolution better than the juxtaposition of two portraits of Queen Marie Antoinette, executed at an interval of fifteen years. The first portrait (FIG. 4-1), by Marie Antoinette's favored portraitist, Elisabeth Vigée-Lebrun (1755–1842), is a traditional ruler portrait. The queen appears in a low-cut gown, her formidable skirt propped up by panniers, against the obligatory backdrop of column and drapery.

4-1 **Elisabeth Vigée-Lebrun,** *Portrait of Marie-Antoinette,* 1778–79. Oil on canvas, 9' x 6'4" (2.73 x 1.94 m). Kunsthistorisches Museum, Vienna.

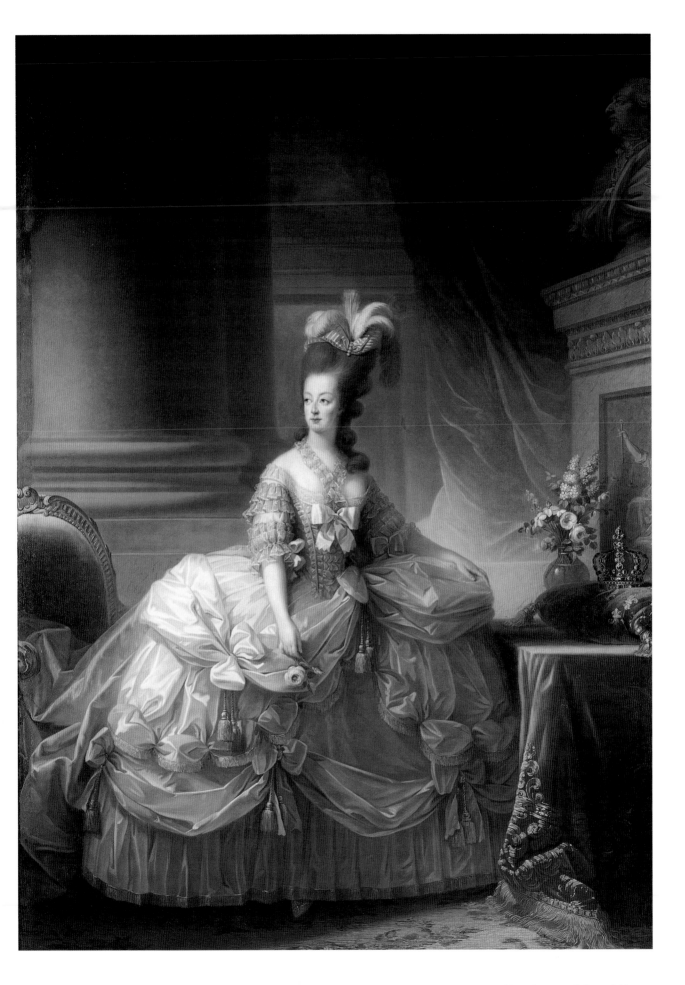

in particular embodied that change. Outsiders watched the events in France in horror and stupefaction. Perhaps Edmund Burke expressed their feelings most succinctly, when he said, in a short speech commemorating Marie Antoinette's death:

> O, what a revolution! And what a heart must I have, to contemplate without emotion that elevation and that fall! Little did I . . . dream that I should have lived to see such disasters fallen upon her, in a nation of gallant men, in a nation of men of honor, and of cavaliers!

David's *Brutus*

Coincidentally, the official opening of the Salon of 1789 came the day before the proclamation of the Declaration of the Rights of Man. Jacques-Louis David, by now a celebrated painter and sought-after teacher in France, had submitted three paintings. The most important of these was the belated product of a commission by Louis XVI's Director of Royal Buildings, the Count D'Angiviller. The painting's subject, *The Lictors Returning to Brutus the Bodies of his Sons for Burial* (FIG. 4-3), was not unlike that of the *Oath of the Horatii* in that it invited the viewer to think about man's conflicting loyalties to family and society.

After having led the movement to oust the last Roman king, Tarquinius, in 509 BCE, the Roman consul Lucius Junius Brutus discovered that there was a plot to reestablish the monarchy. As the plot was unraveled, it appeared that his own two sons had been involved. They were scourged and decapitated on Brutus' orders. The Roman historian Plutarch, who recorded the event in his *Lives*, commented that Brutus' deed was "difficult . . . either to praise or blame sufficiently." How, indeed, should one judge a man who, for the sake of the republic (the *res publica* or "public cause"), kills his own two sons? David addressed this moral question in his painting.

David's *Brutus* represents the interior of Brutus' home as the *lictors* (the ancient equivalent of today's policemen) return the bodies of his two sons. As the first body enters the house on a stretcher, Brutus remains seated on his chair, purposely turning his back to the entrance. He feigns indifference, but his gestures belie his tension. Seated on the edge of the chair, his legs are crossed, his toes curled tightly. In his left hand he grips the letter implicating his sons, while his right arm is raised in an indecisive gesture.

While Brutus tries to be stoic in the face of his sons' deaths, his wife and daughters are devastated at the sight of the bodies. As the mother tries to run toward her sons, one of her daughters faints in her arms. The other shields her eyes, so as not to see the horrendous spectacle. A female servant turns away, not in apparent indifference like Brutus, but to hide her grief and wipe away her tears.

4-2 **Jacques-Louis David,** *Queen Marie Antoinette on the Way to the Scaffold,* 1793. Pen on paper, 6 x 4″ (15 x 10 cm). Musée du Louvre, E. de Rothschild Collection, Paris.

An abundance of flounces, ribbons, ruffles, and tassels enhance the dress, which is completed by a long train. The queen's towering hairpiece, topped with a burst of ostrich feathers, accentuates her regal stature. A marble bust of Louis XVI on a ledge, and the royal crown on the table next to the queen, mark her position as the most powerful woman in Europe.

Compare this image of Marie Antoinette, imperious and remote, with a drawing of her by Jacques-Louis David, made on October 16, 1793 (FIG. 4-2). It shows the former queen, hands tied behind her back, seated on a wooden cart that is taking her to the guillotine. Removed from the protection of the palace, she is exposed to the prying stares of the crowd, as well as to their obscene shouts and angry gestures. Gone are her tall, powdered wig and the elaborate gown that bespoke her unlimited wealth. In her simple, coarse prison dress, with a linen bonnet carelessly flopped on her short greasy hair, Marie Antoinette, only 38 years old at the time, looks like an old hag. Only her bold upright pose still gives a hint of her former glory.

In three years the French monarchy, once one of the most powerful institutions in Europe, had been annihilated. France had changed forever and the fate of Marie Antoinette

4-3 **Jacques-Louis David,** *The Lictors Returning to Brutus the Bodies of his Sons for Burial,* 1789. Oil on canvas, 10'8" x 13'11" (3.25 x 4.25 m). Musée du Louvre, Paris.

Light plays an important role in *Brutus* and the carefully organized *chiaroscuro* adds significantly to its dramatic impact. While Brutus is enveloped in darkness, indicative of his mood of inner strife and gloom, the group of grieving women in the center is strongly lit. Yet the greatest *chiaroscuro* contrast exists between two inanimate objects— the allegorical statue of Rome, set in almost total gloom near the entrance, and the highlighted sewing basket placed near the center of the painting on the table. This is certainly no accident. For these two objects encapsulate the conflict between nation and family, and between duty and love, that are at the heart of this painting.

Although David had begun *Brutus* in 1787, well before the Revolution, the painting, when exhibited two years later, dovetailed with the events that were taking place at the time. Brutus' act of toppling the monarchy and returning the power to the senate could be compared with the abolishment of the old regime and the restoration of power first to the Estates General and later to the Constituent Assembly. Few people in 1789, however, seem to have seen *Brutus* that way. Instead, critics focused on the moral

tenor and the emotional impact of the painting, which several of them characterized as "sublime." They also commented on the painting's masterful execution, praising its powerful *chiaroscuro* effects.

As the events of the Revolution unfolded, however, the story of Brutus came to be seen as the classical example for modern revolutionaries. *Brutus* was viewed as a revolutionary hero and martyr, who had made the ultimate sacrifice to the republican cause. When David exhibited *Brutus* again two years later, at the Salon of 1791, one critic wrote: "Brutus, your virtue has cost you dearly . . . Rome pities you, but Rome will inscribe these words in marble: *To Brutus, who sacrificed his children to his grateful Fatherland."*

Commemorating the Heroes and Martyrs of the Revolution

Although David's *Brutus* became very closely associated with the French Revolution, it is uncertain whether and to what extent David intended it to be a revolutionary

work. When D'Angiviller commissioned the painting from David in 1787, it was agreed that the work would be delivered in time for the Salon of that year and that it would depict the legendary Roman hero Coriolanus. David not only failed to deliver the painting in time, he also changed the subject (though it is not known whether he did so with or without the count's permission). To some art historians, David's cavalier attitude toward the commission was just that; to others it was nothing short of a sign of rebellion against the artistic establishment of his day.

In either case, David was certainly interested in the events of his time. Like most members of the third estate, he was dissatisfied with the old regime. As an artist, he was particularly opposed to the French Royal Academy, which, like the nation itself, was ruled by a select few who guarded their own special interests. It was to reform the Academy that David became involved in politics. In 1790 he joined the radical "Jacobin" group. Between the summers of 1792 and 1794, when the Jacobins were in power, he held several government positions. He was elected deputy to the Assembly, where he voted for the deaths of Louis XVI and Marie Antoinette. In 1793 he served as president of the Jacobin club. In that capacity, he played a major part in abolishing the Academy, which was replaced by the Institut de France in 1795.

In 1791 the Jacobin party commissioned David to paint *The Oath of the Tennis Court* which, had it been completed, would have been the first major painting to memorialize a revolutionary event. The huge canvas was to be hung in the meeting hall of the National Assembly and the funds were to be raised through advance subscriptions to print reproductions of the painting.

Like Copley's *Death of the Earl of Chatham* (see FIG. 3-19), painted a decade earlier, *The Oath* was a contemporary history painting that involved a great many portraits. Six hundred and thirty men had signed the oath, and many more had been present to witness the event. It was, of course, impossible, to paint individual portraits of the nearly one thousand men who had been in the tennis court. Yet it was important that the leaders were portrayed well enough for the public to recognize them.

David worked on the *Oath* for more than a year, preparing a large preliminary drawing and sketching the composition on the canvas. He had already made some progress on the individual portraits when, in the spring of 1792, he decided to abandon the painting. This decision was certainly due to the turbulent political events of the early 1790s. The revolutionaries, though unified at first, had quickly become divided between radicals (Jacobins) and moderates (Girondins). So extreme was their conflict

4-4 **Jacques-Louis David,** Preliminary drawing for *The Oath of the Tennis Court,* 1791. Pen, brown ink, and brown wash, heightened with white, on paper, 26 x 42" (65 cm x 1.05 m). Musée du Louvre (on long-term loan to Musée National du Château de Versailles), Paris.

4-5 **Jacques-Louis David,** *The Oath of the Tennis Court* (fragment of the unfinished painting), 1791–92. Oil on canvas, 11'9" x 21'3" (3.58 x 6.48 m). Musée National du Château de Versailles, Versailles.

that, depending on which party was in control, many of the former heroes of 1789 became enemies of the state. When we learn that the central figure in the *Oath*, a Girondin, was guillotined by the Jacobins in 1793, it is easy to understand that for David to complete the picture would not only have been irrelevant but also dangerous.

David's preliminary drawing for the *Oath* (FIG. 4-4), which was exhibited at the Salon of 1791, suggests how the finished painting might have looked. The scene is set inside the bare wooden walls of an indoor tennis court. In the center, standing on a table, the soon-to-be guillotined Jean-Sylvain Baillie (1736–1793), president of the third estate, reads the oath to the deputies on either side of him. They cheer him on, waving their arms and shouting their approval. In front of Baillie, three liberal clergymen of the day—a monk, a priest, and a Protestant minister—embrace and shake hands. (This detail was a figment of David's imagination, but it helped to symbolize the new political order in which old divisions such as religion and class were obsolete.) A strong wind blows through the open windows, causing one of the curtains to billow like a flag. Bending over the window sills, men, women, and children watch the scene. Pointing down at the deputies, a father impresses upon his sons the importance of the historic event that is taking place under their very eyes.

In the unfinished canvas (see detail in FIG. 4-5), which measures some 11 by 20 feet, portrait heads of several signatories of the oath, painted from life, are placed on meticulously drawn nude bodies. David, no doubt, intended to clothe them in the end, as we know from the preliminary drawing for the painting. But by using nude bodies,

he sought to gain better control of the poses and gestures in his final composition. Although it may seem unusual to us today, David's method conformed to contemporary practice, in which life drawing was strongly emphasized.

David did not receive any other official commission for paintings commemorating revolutionary events. Instead, his artistic skills were put to use in designing new republican fashions and in organizing revolutionary parades, festivals, and funerals of "martyrs of the revolution." In connection with the last, he painted three major works in 1793–94, all representing men who had died for the revolutionary cause. Of the three, the *Death of Marat* (FIG. 4-6) is by far the best known. Painted in 1793, it represents Jean-Paul Marat (1743–1793), a Jacobin journalist who was murdered in his bathtub. Marat, who suffered from a skin disease, used to take medicinal baths while writing. On July 13, 1793 Charlotte Corday (1768–1793), working for the Girondins, entered his house under false pretenses. Once admitted, she drew a hidden knife and stabbed Marat in the heart.

David had known Marat well and had visited him in his house on the day before his murder. He was put in charge of Marat's public funeral, and was inspired to paint a commemorative work as well. His painting, in effect, was based on the memory of his visit when he had observed the "block of wood by his side, on which stood paper and ink, and his hand, emerging from his bathtub, [which] was writing his thoughts about the salvation of the people." In the painting, Marat is represented after the murder. His body is slumped towards one side of the tub; his head, wrapped in a linen towel, is resting on the back.

4-6 **Jacques-Louis David,** *Death of Marat,* 1793. Oil on canvas, 65 x 50" (1.65 x 1.28 m). Musées Royaux des Beaux-Arts de Belgique, Brussels.

In his right hand he still holds the quill, in the left a letter from Charlotte Corday asking him to receive her. On the wooden block, next to the inkstand and quill, we see letters and papers and, inscribed on its front, the words: "A [to] Marat, David."

David represents a national hero in a very unusual way. His painting differs from Flaxman's monument to Nelson (FIG. 2-25) and Barry's posthumous portrait of William Pitt *the Elder* (FIG. 3-17), for example. The allegorical imagery and grandiose architectural settings that were customary for memorial images in the eighteenth century are absent here. Marat looks vulnerable, even pitiful as he slouches, naked, in the tub. David has cleverly kept the image from being absurd, however, by transforming the ridiculous into

the sublime. He uses a vertical canvas, so that Marat's body stands out dramatically against the dark-green backdrop. (David may have been inspired by his own design for Marat's wake, in which the body was laid out in the tall, dark sanctuary of an unused church building; see FIG. 4-7). In addition, he has minimized the grisly details of the murder, such as bruises and blood stains. Instead, Marat's body and face express serenity and dignity. It is not coincidental that the pose of his right arm resembles that of Christ in Michelangelo's *Pietà* in St. Peter's in Rome. We are, in effect, led to compare Marat's death with that of Christ—a martyr's death for the "salvation of the people."

It is instructive to compare David's painting with any one of the numerous prints that were circulated after Marat's

death. In nearly all of them, Marat, the "friend of the people," is contrasted with the heinous murderess Corday. An anonymous print of 1793 (FIG. 4-8) shows Marat in his tub casting a final glace at Liberty, seated by his side. Meanwhile, the fleeing Corday, accompanied by a dragon, is pulled back by her hair by the allegorical figure of Vengeance. Placing David's *Marat* in the context of this and other popular images, we can truly appreciate David's unique conception. By eliminating all action, all allegorical references, and nearly all allusions to Marat's violent death, he has created a true icon of the Revolution.

Less than a year after Marat's death, the Jacobins fell from power and David lost his prominent political position. Imprisoned twice, he was lucky to avoid the guillotine.

Ironically, David, who had once upheld the ideals of the Revolution—liberty, equality, and fraternity—became one of the favorite artists of the man who was to embody imperialism, namely Napoleon Bonaparte.

Creating a Revolutionary Iconography

Under the old regime, power had been the exclusive privilege of the monarch. The traditional image of government was, therefore, the image of the king's body, a perfect illustration of Louis XIV's famous dictum, "The State, it is I" (see page 19). The king's image was enhanced by the use of emblems, symbols representing abstract concepts related

4-9 Cast of the First Official Seal of the First Republic, 1792. Archives Nationales, Collection of seals, Paris.

to power. Emblems such as crowns and scepters are often found in royal portraits (such as the one of Louis XIV in FIG. 1-1), and also occur on coins, stationery, and the like. In addition, kings often had themselves represented in the company of—or, sometimes, in the guise of—allegorical or mythological figures. These embodied virtues, such as charity, justice, strength, or beauty, that rulers wished to attribute to themselves. Together, emblems, allegories, and mythological figures made up the complex iconography (visual language) of monarchic power.

Once the old regime was gone, the new Republic needed a new set of images that would advance the notion of representational rule rather than absolute power. New allegories, representing liberty, equality, and fraternity, had to be created. An entirely new iconography of power emerged in the 1790s, much of it conceived by anonymous artists working in the publishing and minting industries. The allegories and emblems that were born in the wake of the Revolution are found on banners, printed materials, and coins before they appear in paintings and in sculpture.

The allegorical figure of Liberty was an important image in early revolutionary iconography. It drew on classical models. The Romans had already created a personification of freedom in the form of the goddess Libertas. As an allegory Libertas survived through the centuries, and by the eighteenth century she generally took the form of a young woman, dressed in white, with a scepter in one hand and a cap in the other. The scepter symbolized the control a free man has over himself; the cap resembled the so-called Phrygian bonnet, worn in ancient Rome by emancipated slaves to mark their newly-won status as *liber* or free man.

When the king was ousted in 1792, the image of Liberty was chosen for the first official seal of the French Republic (FIG. 4-9). Designed by an anonymous artist, the seal shows a woman dressed in a Classical garment set within the words: "In the Name of the French Republic."

In her right hand, she holds a scepter, surmounted by the Phrygian cap. With her left, she grasps the *fascis* (a bundle of wooden rods and an ax, tied together with a strap). *Fasces* were carried by the Roman lictors as the badge of their power to enforce the law. To the early republicans, clearly, liberty did not mean anarchy but freedom balanced by law and order.

Since the new republican government had resulted from revolutionary ideas of freedom, the image of Liberty was increasingly used to represent the French Republic. The French called their allegorical figure "Marianne," an endearing nickname that rather uncannily echoed the name of the last queen, Marie Antoinette. Strange as it may seem, both Marie Antoinette and Marianne filled the same psychological need to personify government, giving a human face and a name to the abstract system of political rule.

Pierre-Paul Prud'hon

One of the few artists of stature to become involved in the creation of revolutionary imagery was the painter Pierre-Paul Prud'hon (1758–1823). Ten years younger than

4-10 **Pierre-Paul Prud'hon,** *The Spirit of Liberty, and Wisdom*, 1791. Black crayon, graphite and white gouache on antique white paper, 12⅝ x 6¹¹/₁₆" (32 x 17 cm). Fogg Art Museum, Harvard University Art Museums, Cambridge, Massachusetts.

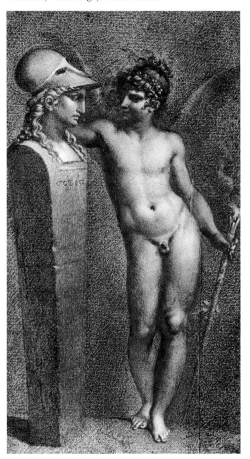

4-11 **Jacques-Louis Copia, after Prud'hon,** *The French Constitution, Equality, Law,* 1798. Engraving, 16 x 19" (40.6 x 50.3 cm). Bibliothèque Nationale, Paris.

4-12 **Pierre Paul Prud'hon,** *The French Constitution, Equality, Law,* 1791. Black and white chalk on blue paper, 11⅝ x 18⅜" (29.6 x 46.8 cm). Private Collection.

David, he was trained in the provinces. Prud'hon moved to Paris just months before the Revolution, and his career was slow to start. Royal patronage had come to a halt. The aristocrats, an important group of art buyers, were emigrating to escape the threat of the impending revolution. Churches were closing as well, and there was not much work for an aspiring young artist like himself. Only portraiture continued to be in demand, since a newly empowered bourgeoisie was eager to have their features memorialized.

In the hope of drawing attention to himself and his work, Prud'hon turned to revolutionary imagery. At the Salon of 1791 he exhibited just one drawing, *The Spirit of Liberty and Wisdom* (FIG. 4-10). In it, freedom is represented not by a woman but by a nude boy, leaning against a term (an ancient boundary post) surmounted by Minerva, goddess of wisdom. In an engraving made after the drawing (in which the young man was, incidentally, given a Phrygian cap) the image is explained in a caption that tells the viewer that freedom results in wise government.

In this early drawing Prud'hon demonstrated his beautiful and highly individual drawing style. Instead of the crisp contours and sparse shading favored by most of his Neoclassical contemporaries (see the drawings by David and Flaxman in FIGS. 2-16 And 2-24), Prud'hon's drawings show soft outlines and subtle *chiaroscuro*. His unique style would not be fully appreciated until the mid-nineteenth century, when *chiaroscuro* rather than contour became admired in drawing and painting.

Starting in 1791, Prud'hon worked closely with the engraver Jacques-Louis Copia (1764–1799), who reproduced his revolutionary drawings so that they could be sold to individuals and institutions. Together, they produced a large engraving, approximately 16 x 20 inches, with an allegorical representation of the constitution (see

FIG. 4-11). Although Prud'hon worked on the three drawings for this print as early as 1791, Copia's final print was delayed until 1798 due to the constant rewritings of the constitution (1791, 1793, and 1795).

In FIG. 4-12 we see Prud'hon's drawing for the print's main image (note that the print reproduces it in reverse). The complex allegory centers around Minerva. She turns her attention to the figure of Law, who holds a scepter with a rooster, symbol of vigilance. On the other side of Minerva, Liberty tramples the yoke and chain of slavery as she shakes hands with Law. At the same time, Liberty turns toward the graceful figure of Nature, a young barebreasted woman with several children in tow. Nature seems to represent the natural social order, in which all men are born free and equal. Various animals complete the allegory. The cat traditionally symbolizes independence, while the biblical image of the lion and the lamb, peacefully walking together, demonstrate that in a free and lawful society everyone is safe. This complex image, like all allegories, is a teaching tool. By trying to figure out its meaning, the viewer is forced to think about the significance of the constitution itself.

Quatremère de Quincy, the Panthéon, and the Absent Republican Monument

Despite a desire to commemorate the new Republic with great works of art, few monumental works were created in the 1790s. This was due in part to the frequent changes of government, which made any sustained official policy of the arts impossible. It was also due to the political unrest and lack of funds that the Revolution left in its path.

4-13 **Jacques-Germain Soufflot,** *Panthéon* (formerly Church of Ste. Geneviève), 1755–92. Paris.

Perhaps the most important monumental endeavor following the Revolution was the transformation of the Parisian church of Ste Geneviève into the so-called Panthéon, a mausoleum for the nation's great men (FIG. 4-13). The church of Ste Geneviève had been built between 1759 and 1790 under Louis XV, according to the designs of the architect Jacques-Germain Soufflot (1713–1780). Even in its time, it was hailed as a masterpiece of Neoclassical architecture, with its centralized plan, its dome based on that of St Peter's in Rome, and its classically inspired exterior and interior details.

The church was scarcely completed when it was decided that it would become a burial place. Antoine Quatremère de Quincy, a sculptor, art critic, and revolutionary, was put in charge of this project. In a series of essays published in 1791 he had promoted the use of art for political propaganda. The Panthéon project offered a perfect opportunity to mobilize the fine arts to revolutionary and republican purposes.

To turn the church into a national mausoleum, Quatremère blocked up the windows, removed all religious sculptural decorations, and replaced them by reliefs on revolutionary themes executed with different artists

under his supervision. Thus the large relief above the main entrance, which originally represented the *Triumph of Faith*, was replaced by one of the *Motherland Bestowing Crowns on Virtue and on Genius*. Ironically, it was destroyed, in turn, after the restoration of the monarchy in 1814.

For the interior, Quatremère designed an enormous sculptural group representing the Republic. Like so many projects of the period, it was never finished, but an etching after Quatremère's design (FIG. 4-14) gives an idea of how it might have appeared. The group centers around the figure of the Republic, a helmeted woman resembling Minerva. In her right hand she holds a rod, in her left an equilateral triangle representing the equality of the three estates. She is flanked by the winged spirit of Liberty, holding a scepter and crowned with a Phrygian bonnet (left), and the winged figure of Equality trampling on a snake, the symbol of tyranny (right).

Quatremère's Panthéon became the focal point for a number of revolutionary pageants related to the burial (or reburial) of great men of the nation inside its crypt. Perhaps the most important of these funeral processions was the transfer of the ashes of the *philosophe* Voltaire from their former resting place to the Panthéon. This ceremony took

4-15 **Jacques-Louis David,** *Transfer of the Ashes of Voltaire to the Panthéon, 11 July 1791*, 1793. Mezzotint, 5¹⁄₈ x 10³⁄₈″ (13 x 26.3 cm). Bibliothèque Nationale, Paris.

place on July 11, 1791, and was one of the many pageants of its kind organized by David. The artist not only designed the chariot that transported the ashes and the casket in which they were contained (see FIG. 4-15), but also orchestrated the procession itself. His drawing for the funeral procession shows that the Classically inspired chariot was drawn by twelve white horses, held in check by footmen dressed in Classical garb. The casket was surmounted by an effigy of Voltaire on his deathbed accompanied by the winged figure of fame. Four empty chandeliers, on the corners of the chariot, symbolized the writer's passing.

Today, nothing but the drawing remains of the elaborate pageant of Voltaire. The same holds true for the numerous other revolutionary pageants and festivals designed by David and fellow revolutionary artists. These were elaborate but ephemeral "happenings," intended for huge popular audiences. In their transience and anti-monumentality, they were the perfect art form for the volatile world of the revolutionary period.

Demolition as Propaganda

While few if any great monuments were produced to celebrate the establishment of the Republic, a great deal of energy and attention was given to the destruction of existing ones. For the most part, this destructive effort was focused on buildings and public sculptures that were hateful to the revolutionaries because they reminded them of the power that the king and, to a lesser extent, the aristocracy and the clergy had wielded in the past. It is safe to say that, for the revolutionaries, destruction had as much if not more symbolic value than creation.

Perhaps the first building to be destroyed during the French Revolution was the medieval Bastille fortress in Paris, a feared and hated prison, in which numerous political prisoners were detained by the monarchy. The artist Hubert Robert (1733–1808) painted a scene of the demolition of the fortress, which was exhibited at the Salon of 1789, a little more than a month after the building had been stormed by a revolutionary mob (FIG. 4-16). Images such as this were powerful signifiers of the need to destroy the old order as a condition for the new. Indeed, erasing the past was so important that the very absence of a royal building or statue could become a positive confirmation of the new order. Several proposals were made for a monument to commemorate the storming of the Bastille; one was a simple sign that said, "Here stood the Bastille;" and another was for an empty space in the place where the Bastille had formerly stood.

The Bastille was was only one of many monuments and buildings that would be annihilated or vandalized by revolutionaries. In addition to public statues of kings, many medieval churches were viciously attacked. These buildings were hateful not only because they represented the overbearing political influence of the church, but also because many of them contained aristocratic tombs. Not surprisingly, the medieval abbey of St Denis, which contained the tombs of nearly all French kings and their relatives, was the hardest hit. In Paris, the cathedral of Notre Dame was a prominent target. At the time, the large-scale statues of Old Testament kings on its façade were thought to be images of the French kings. In 1793

4-16 **Hubert Robert,** *The Bastille during the First Days of its Demolition,* 1789. Oil on canvas, 30⁵/₁₆ x 45" (77 cm x 1.14 m). Musée Carnavalet, Paris.

4-17 *The Thirteenth-Century Room in the Musée des Monuments Français.* Illustration in Jean-Baptiste Réville and Jacques Lavallée, *Vues pittoresques et perspectives des salles du Musée des monuments Français* (Paris, 1816). Bibliothèque Nationale, Paris.

the revolutionary government ordered that they be removed. Most were destroyed or thrown into the Seine river. A few, however, were buried in a garden nearby, perhaps by someone who regretted their destruction. In 1977 they were unearthed during a routine construction excavation.

Not every revolutionary sympathizer was in agreement with this wanton destruction of the past. In 1793 the abbot Henri Grégoire (one of the liberal clerics represented by David in his *Oath of the Tennis Court*) wrote his famous *Rapport... sur le vandalisme révolutionnaire* (Report about Revolutionary Vandalism). In it, he argued that the destruction of monuments was not only shortsighted,

because it deprived the world of so many beautiful works of art, but also counterproductive because these very monuments could serve as pointed reminders of a hated regime.

Two years later, the young artist Alexander Lenoir (1761–1839) created a museum out of confiscated art objects and rescued fragments of buildings and sculptures, many dating from the Middle Ages, that were held in a depot awaiting destruction. By then, the destructive fervor had gone, and in years to come Lenoir's Museum of French Monuments would foster an unprecedented interest in medieval art in France (FIG. 4-17).

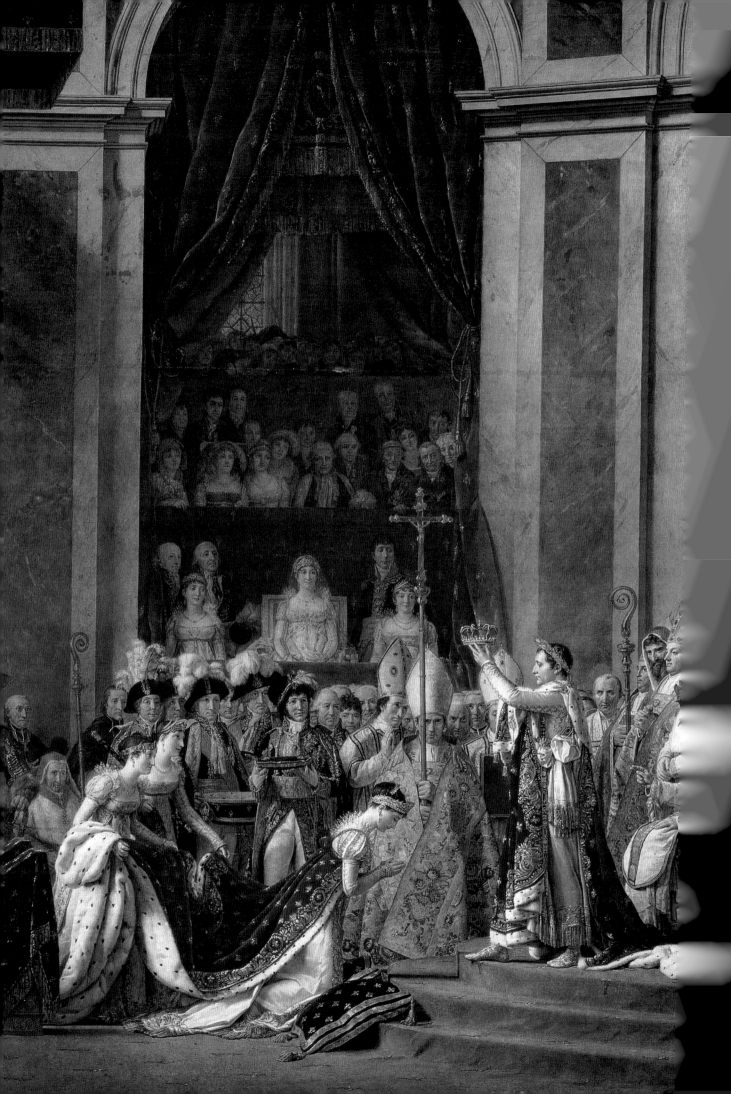

Chapter Five

The Arts under Napoleon

In 1799 Jacques-Louis David organized a paying exhibition to present *The Sabine Women* (FIG. 5-1), a monumental painting on a Classical theme, to the public. The exhibition was held in a meeting room in the Louvre, which the government had placed at the artist's disposal. Measuring nearly 13 by 18 feet, *The Sabine Women* occupied one long wall of the room. Against the opposite wall, David placed a large mirror, in which visitors saw themselves reflected against the backdrop of the painting. Becoming one with the painted figures, even if only for a moment, must have given them a heightened sense of the actuality of the painted scene.

Although the organization of paying exhibitions was common in Britain in the late eighteenth century (see page 77), it was unprecedented in France. The Academy had traditionally prohibited such initiatives, believing that commerce would taint the ideals of the artistic profession. Since this institution had been abolished in 1793, David did not break any existing rules, but he was severely criticized by those who felt that it was wrong to put a price on seeing art.

For David, charging a fee was a necessity. He had painted *The Sabine Women* without a commission or the prospect of a buyer. The painting had taken him nearly five years, on and off, to complete. During this time his own political situation had changed dramatically. In 1794 the ruling Jacobin party, of which he had been a prominent member, had been defeated, and David was thrown in jail.

While he was imprisoned, Maximilien de Robespierre (1758–1794), president of the Jacobin-controlled National Convention, was executed. His virtual dictatorship was replaced by a representative government, led by five executive Directors.

After Robespierre's "reign of terror," an eleven-month period in which 17,000 people had been guillotined, the Directory (1795–99) was a period of healing and reconciliation. David's *The Sabine Women* was intended as a metaphor for this process. The painting represents a scene from the legendary beginnings of Rome, recounted by Plutarch. Romulus, the founder of Rome, organized a large feast, and invited the neighboring clan of the Sabines. At the end of the feast, the Romans, who had a shortage of females, abducted the Sabine women and made them their wives. Three years later the Sabines attacked Rome in revenge. The battle would have been disastrous for both sides, had not the Sabine women intervened. Throwing themselves and their children between the combatants, they called for reconciliation. They showed the men that the children, if nothing else, were a compelling reason to make peace.

David's painting shows the opposing parties against the backdrop of Rome. Dominating the fray are the Roman leader Romulus, on the right, and the Sabine leader Tatius, on the left. The two are preparing to duel, when the beautiful Hersilia, the daughter of Tatius and the wife of Romulus, intervenes, stretching out her arms as if to push them apart.

5-1 **Jacques-Louis David,** *The Sabine Women,* 1799. Oil on canvas, 12'8" x 17'2" (3.85 x 5.22 m) Musée du Louvre, Paris.

A powerful and dynamic figure, Hersilia seems to embody the idea of peace—not as the mere absence of war, but as something worth struggling for. Hersilia is not the only woman to throw herself into the melee. All around her, women and children stand in front of the combatants to block them; some grab the men's legs to prevent them from fighting.

David's *The Sabine Women* has often been compared with the *Oath of the Horatii,* exhibited fifteen years earlier. Both paintings show events from Roman history, involving a war between the Romans and a neighboring clan. While the *Oath of the Horatii* extols such "masculine" virtues as patriotism, courage, and honor, however, *The Sabine Women* seems to celebrate the more "feminine" concerns of family, peace, and collective harmony. Emphasizing women's essential roles of life givers and nurturers, the painting suggests that peace and love, not war, hatred, and destruction guarantee the survival of human civilization. In so doing, it reflects the changed socio-political climate of the Directory, a period when people abandoned the pursuit of the lofty, puritanical ideals of the Revolution for the more humble concerns of safety and happiness.

The Rise of Napoleon

In spite of a promising beginning, the Directory was ultimately unable to deal with the many problems that plagued the Republic. In 1799, the year in which David exhibited *The Sabine Women,* a parliamentary coup ended the government. The uprising was led by one of the Directors, with the military backing of a young general named Napoleon Bonaparte (1769–1821). A new government, called the Consulate, was introduced. It called for a stronger, more effective executive branch comprising three consuls, the first of whom held most of the power. Within days of the coup, Napoleon had emerged as a leader, becoming First Consul in 1800, and again in 1802 when he was granted this position for life by a national referendum. Still not satisfied, Napoleon in 1804 assumed the title of Emperor, an action that ensured that his power would eventually be inherited by his son.

As First Consul and later as Emperor, Napoleon had two main concerns. First, he intended to reform completely the administrative duties of the French state. This involved reorganizing national and regional governments, drawing

up a civil legal system (the so-called Napoleonic code), and revamping all civil services, including police, mail delivery, tax collection, and public education.

Second, Napoleon sought to establish a French hegemony throughout the world. When he came to power, France was still involved in a war, begun by the Revolutionary government, against an anti-French coalition that included several European countries. Through a series of military conquests, and some clever diplomacy, Napoleon ended this war with the Treaty of Amiens in 1802. Peace was not his final goal, however; rather, he saw the treaty as a means of expanding France's power. In the hope of creating markets for French goods abroad, he intended to establish colonies and trading posts around the world. This brought him into renewed conflict with several European powers, which eventually resulted in war and Napoleon's conquest of the greater part of western and central Europe (see *Napoleonic Battles*, below).

At the height of his power, in 1810, Napoleon ruled over all the countries on the western coast of Europe, from the Netherlands in the north to the Iberian peninsula in the south, as well as over Italy, Austria, and most of modern-day Germany and Poland. Napoleon's hegemony came to an end in 1814 when, attacked on all fronts, France capitulated and the emperor was officially deposed. Exiled to the Mediterranean island of Elba, he attempted a comeback in 1815. But he was defeated at Waterloo in Belgium and exiled again after less than four months—a period known as the Hundred Days.

Vivant Denon and the Napoleon Museum

Having risen from complete obscurity to the height of power, Napoleon was the quintessential upstart, who felt the need to bolster his persona and his regime through vast amounts of propaganda. Thus he turned to the arts, not because he felt a particular affinity for them but because he realized their enormous promotional potential. During Napoleon's reign, numerous buildings and monuments emblematic of his power were constructed. Many canvases were painted showing his likeness, or presenting glorified images of his government and military exploits.

While Napoleon took an intense interest in these projects, he delegated most of the details to Dominique Vivant Denon (1747–1825). The emperor had known Denon, an amateur artist and collector, since his early years as a general. In 1799, when Napoleon had led an army to conquer Egypt for France, Denon had joined the expedition as an "artist-reporter," charged with the visual recording of aspects of the campaign.

It was to Denon that Napoleon entrusted the creation of the most spectacular monument to his military might, the Napoleon Museum. Housed in the Louvre, the royal palace in Paris, this museum comprised the former royal collections, confiscated after the Revolution, in addition to hundreds if not thousands of art works pillaged from the countries that Napoleon had conquered. At its height, the museum contained the cream of European art, including such famous Classical sculptures as the *Apollo Belvedere*

Napoleonic Battles

Napoleon's fame as a general was linked to a series of victories, the names of which, to this day, have a ring of success. Their reputation was vastly enhanced by their glorification through architectural monuments, sculptures, and paintings, which lent them lasting renown. Because of the enormous propaganda that surrounded his victories, Napoleon's final defeat at Waterloo became an event of worldwide importance.

Battle of Marengo, June 14, 1800. Victory over the Austrians in northern Italy.

Battle of Ulm, September 25–October 20, 1805. Major strategic triumph over the Austrians in Germany.

Battle of Austerlitz, December 2, 1805. Also called Battle of the Three Emperors, since it involved, besides Napoleon, the emperors of Austria and Russia. Napoleon's greatest victory, because his 68,000 troops defeated almost 90,000 Russians and Austrians.

Battle of Jena, October 14, 1806. Napoleon decimated the Prussian army.

Battle of Eylau, February 7–8, 1807. The battle was fought against the Russians and the Prussians in East Prussia, some twenty miles south of present-day Kaliningrad (Russia) and resulted in a stalemate. Each army lost between 18,000 and 25,000 men.

Battle of Wagram, July 5–6, 1809. Victory over the Austrians, which led to the Treaty of Schönbrunn.

Battle of Borodino, September 7, 1812. Battle against the Russians, in which Napoleon won by a narrow margin. The Russian army was able to recoup, however, and eventually managed to drive the French out of Russia.

Battle of Waterloo, June 18, 1815. Napoleon's final battle, fought in Belgium against the combined forces of the international coalition that had formed against him. Napoleon's defeat ended the Hundred Days of his restoration after his escape from exile on Elba.

5-2 **Anonymous,** *Napoleon Bonaparte Showing the Apollo Belvedere to his Deputies,* c.1899. Etching with aquatint. Bibliothèque Nationale, Départment des estampes et de la photographie, Paris.

5-3 **Jacques Gondouin and Jean-Baptiste Lepère,** *Vendôme Column,* 1806–11. Bronze plaques on masonry core, height 130' (43.5 m). Place Vendôme, Paris.

and the *Laocoön,* and important Renaissance and Baroque works. These included Raphael's *Transfiguration* (Rome, Vatican Pinacoteca), Paolo Veronese's *Marriage of Cana* (still in the Louvre today), Jan and Hubert van Eyck's *Adoration of the Lamb;* the so-called Ghent Altarpiece (Ghent, St. Bavo Church), and Peter Paul Rubens's famous triptychs, *Raising of the Cross* and *Descent from the Cross* (Antwerp Cathedral).

While contemporary visitors were awed by the living art-history lesson taught by the Napoleon Museum, Napoleon himself used it to advertise the prestige and wealth that his military conquests had brought to France. A contemporary print shows Napoleon as First Consul, leading some visitors through the museum (FIG. 5-2). Stopping at the *Apollo Belvedere,* he proudly says: "There it is, gentlemen, two million."

Napoleonic Public Monuments

To commemorate his military exploits, Napoleon initiated several sculptural and architectural monuments in Paris. Perhaps the most important of these was the Vendôme column (FIG. 5-3), a 130-foot-high bronze column decorated with a spiraling sculptural relief. The monument was designed and executed by a team of architects and sculptors, coordinated by Vivant Denon. The immediate occasion for the column was Napoleon's famous victory at Austerlitz where, in 1805, he had defeated the combined armies of Austria and Russia (see *Napoleonic Battles,* page 111). The bronze used to make the monument came from

5-4 Column of Trajan, CE 113. Marble, height 125' (38.1 m). Rome.

confiscated enemy cannons. Originally called the Column of the Great Army, it was erected in one of Paris's most famous squares, the place Vendôme. The location was significant because here, earlier, had stood a monumental equestrian statue of *Louis XVI*, which had been destroyed by revolutionaries in 1792 (see page 106).

The Vendôme column was inspired by the ancient Roman column of Trajan (FIG. 5-4), which commemorated the emperor's victory over the Dacians—a people who lived in eastern Europe. Both columns were decorated with reliefs depicting the two emperors' military exploits and surmounted by their full-length portraits. Like Trajan, Napoleon was attired in Roman military dress.

Because of its assertive claim for imperial power, the Vendôme column became one of the most contested monuments of nineteenth-century Paris, particularly after the defeat of Napoleon in 1815. With every new regime, the column was altered until, during the Commune of 1871 , it was dismantled (see page 361). Reconstructed some years later, however, it can again be seen in Paris today.

The Vendôme column illustrates Napoleon's strong identification with the ancient Roman emperors. Like them, he saw himself both as a civic and a military leader. Moreover, at the height of his power, he ruled over a territory that roughly overlapped with the Roman Empire. Napoleon's preoccupation with Roman imperialism explains his general preference for Roman rather than Greek art. Beside the Vendôme column, two other monuments, initiated during Napoleon's rule, emulate the architecture of imperial Rome. The first was the Arc de Triomphe (FIG. 5-5),

5-5 **Jean-François Chalgrin,**
Arc de Triomphe, 1806–36. Limestone, height 164' (50 m). Place de l'Etoile, Paris.

5-6 **Alexandre-Pierre Vignon,** "La Madeleine" (Church of Mary Magdalene), south front, 1807–45. Place de la Madeleine, Paris.

an enormous stone monument designed after the example of a Roman triumphal arch by the architect Jean-François Chalgrin (1739–1811). Standing at the intersection of five major roads, including the famous Champs Elysées, its placement was carefully calculated for maximum visual effect (for more on this monument, see page 221). The other was a "Temple of Glory," to honor French soldiers (FIG. 5-6). Designed by the architect Alexandre-Pierre Vignon (1763–1828), this building took the form of a Roman temple, complete with the tall platform and colossal, monolithic, Corinthian columns typical of Roman religious architecture. Neither monument had been completed at the time of Napoleon's fall. The arch was finished in 1836 during the July Monarchy (see page 217). The would-be temple was completed according to its original design, and turned into a church, called La Madeleine.

Empire Style

Napoleon's preference for ancient Roman art led to the so-called Empire style, often seen as the final phase of Neoclassicism. This style was indebted to monumental Roman architecture and sculpture, and also used elements derived from Egyptian art. As a young general, in 1798, Napoleon had led an expedition to Egypt which was

intended to wrest control of the Ottoman Empire from the British (see page 124). Although the Egyptian campaign had been a military failure, it led to an upsurge of interest in Egypt, thanks in large part to the publications of artists and scholars who had accompanied Napoleon on his campaign. Vivant Denon, who had joined the expedition as a recording artist, published his popular *Voyages dans la Basse et la Haute Egypte* (Travels in Lower and Upper Egypt) in 1802. A more scientific and comprehensive *Description d'Egypte* (Description of Egypt) in twenty-one volumes was published between 1809 and 1828 by a team of scholars working for Napoleon.

The richly illustrated tomes resulting from the Egyptian expeditions (see FIG. 5-7) fostered an interest in Egyptian art among artists and designers. The influence was felt most strongly in the decorative arts. Napoleon's residences in the palaces of Compiègne, Saint-Cloud, and Malmaison (the last inhabited by Napoleon's first wife, Joséphine) were furnished and decorated in a hybrid style, typical of the Empire period, containing both Classical and Egyptian elements. A washstand (FIG. 5-8) at Malmaison combines a Classical Roman tripod construction and stylized Greek "palmette" motifs (on the pitcher and washbowl) with Egyptian gilded bronze sphinxes. The use of luxurious materials, including mahogany, gilded bronze, and Sèvres porcelain, is also characteristic of the Empire

5-7 *General View of Pyramids and Sphinx, at Sunset.*
Illustration in *Description d'Egypte* (vol. v, "Antiquities,"
pl. 8), 1822. Private Collection, London.

5-8 *Washstand.* Mahogany and gilt bronze, with
Sèvres porcelain pitcher and washbowl, 1802.
Rueil-Malmaison, Château de Malmaison, France.

style. The washstand was kept in Empress Joséphine's bed-room at Malmaison (FIG. 5-9), which exemplifies the Empire style in its solemn richness and the predominance of red and gold tones. Empire interiors such as this one have, as one writer put it, "both the cold splendor of an Egyptian tomb and the sumptuousness of the Byzantine."

The Imperial Image

Throughout his reign Napoleon commissioned a large number of paintings that were strategically planned to glorify his military exploits, and to exalt his qualities of leader, administrator, and protector. It was part of his stated policy that art should treat subjects "of national character," that is, subjects that extolled the French nation, of which he himself was at the helm.

More than any eighteenth-century ruler, Napoleon appears to have understood the potential of the Salon as a vehicle for propaganda; nearly all of the paintings he commissioned were exhibited there. It was a public forum where he could "post" visual messages that reached the crowds of people who visited the exhibition. The Salon was fully covered by newspapers, publicizing the event even to those who did not see the works in person. Once the Salon was over and the commissioned works were returned to the state, they were frequently installed in museums or public buildings for others to enjoy. Inexpensive print reproductions of the most famous works were distributed throughout the French Empire.

Strangely enough, the first heroic image of Napoleon, *Napoleon Crossing the Alps at the Saint-Bernard Pass* (FIG. 5-10), was not commissioned by Napoleon himself but by Charles IV of Spain (ruled 1788–1808), who intended it for his

OPPOSITE
5-9 **Louis-Martin Berthault,**
Empress Joséphine's Bedroom,
c.1810. Rueil-Malmaison, Château de Malmaison, France.

5-10 **Jacques-Louis David,**
Napoleon Crossing the Alps at the Saint-Bernard Pass, 1800–1. Oil on canvas, 8'11" x 7'11" (2.72 x 2.41 m). Musée National du Château de Versailles, Versailles.

gallery of portraits of great military leaders. Proud to be included in that famous gallery, Napoleon immediately ordered several copies for himself. He also demanded that he be painted "sitting calmly on a spirited horse." Napoleon refused to sit for his portrait, for, as he said, "No one inquires whether portraits of great men are likenesses. It is enough if their genius lives on in them." (Fortunately David had made a quick portrait sketch of Napoleon two years earlier when the latter visited his studio.)

Charles IV's commission of *Napoleon Crossing the Alps at the Saint-Bernard Pass* had been triggered by the general's celebrated victory in 1800 on the Marengo plain in northern Italy, where he had crushed the Austrian army (see *Napoleonic Battles*, page 111). Napoleon had led 28,000 men across several Alpine passes, including the treacherous Saint-Bernard pass. Such a feat had been accomplished only twice before in history, once by the Carthagian general Hannibal in 218 BCE and next by the Frankish king, and later emperor, Charlemagne, in CE 773. To remind the viewer of these famous antecedents, Napoleon had David inscribe the names of Hannibal and Charlemagne on the rocks in the foreground, together with his own.

In David's portrait, Napoleon is poised on a rearing horse that he controls, flawlessly, with only one hand. The scene is clearly contrived, since Napoleon is known to have crossed the Alps on a mule. The motif of a ruler on a rearing horse had been introduced by the Venetian painter Titian in the late sixteenth century. It was perfected in the seventeenth century by Peter Paul Rubens (1577–1640), a Flemish painter, and Diego Velázquez (1599–1660), a Spanish artist. In their portraits of the Spanish monarch Philip IV (ruled 1621–65), the king's

5-11 **Etienne-Marie Falconet,** *equestrian statue of Peter the Great,* 1766–82. Bronze on granite base, twice life-size. Decembrists' Square, St Petersburg.

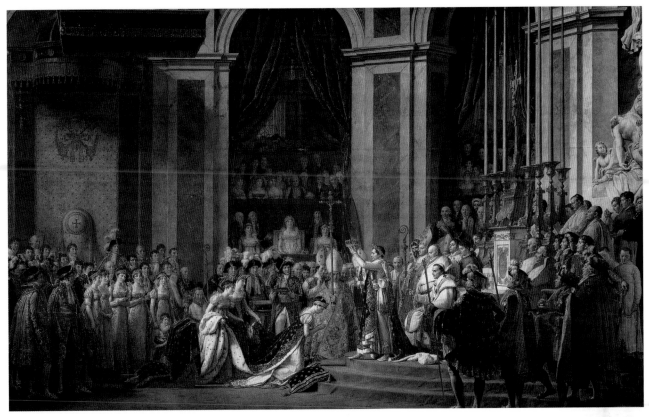

5-12 **Jacques-Louis David,** *Coronation of Napoleon in the Cathedral of Notre Dame,* 1805–7. Oil on canvas, 20'8" x 32'1" (6.29 x 9.79 m). Musée du Louvre, Paris.

easy manipulation of a spirited animal seems to be a metaphor for his skilful control of an unruly nation.

Napoleon undoubtedly had these portraits in mind when he ordered David to paint him "sitting calmly on a spirited horse." He and David may also have recalled the famed "Bronze Horseman," the equestrian statue of Peter the Great (FIG. 5-11), erected in St Petersburg by Falconet (see page 24) in the years 1766–82. In this sculpture, as in David's painting, Czar Peter and his horse scale a mountainous rock, demonstrating courage in the face of adversity. While Peter the Great wears civilian clothes, however, Napoleon is shown as a military leader, urging on his soldiers with his outstretched right arm.

On the strength of this portrait and on account of his reputation as one of the greatest living painters in Europe, David was appointed First Painter to the Emperor immediately after Napoleon assumed the title. His main commission was to commemorate the crowning ceremony with a huge painting (FIG. 5-12). The coronation of Napoleon and Joséphine on December 2, 1804, was carefully planned by Napoleon. No one less than the pope was to put the crown on his head. Thus he intended to create a historic link between his rule and that of Charlemagne, the first emperor of France, who had been crowned by the pope roughly one thousand years earlier. Yet, while Charlemagne had traveled to Rome to be crowned, Napoleon made Pius VII come to Paris. In a final affront to papal

dignity, he did not wait for the pope to crown him, but impatiently took it from him and crowned himself. In David's first sketch for the *Coronation* (FIG. 5-13), this moment is represented, no doubt at Napoleon's request. The emperor was later persuaded that it would be more tactful to commemorate another episode, in which he placed the crown on his wife Joséphine's head.

The *Coronation* took almost three years to paint. Measuring some 20 by 30 feet, it is composed of more than one hundred life-size portraits, many of them full-length. The composition is carefully orchestrated to reflect each person's power and rank. It was thus a reflection of the actual ceremony, which had likewise been planned according to the strictest protocol. The painting does not, however, represent the coronation exactly as it happened. For instance, Napoleon's mother, Maria-Letizia, did not attend the ceremony, since she was angry with Napoleon over his treatment of his younger brother Lucien. Yet in David's painting she sits on a low balcony in the center. Her presence was necessary in the official portrait, because the emperor had everything to gain by emphasizing family unity.

Together with Napoleon, the Empress Joséphine takes center stage in the painting. Kneeling to receive her crown, she wears a gold-embroidered white dress with an enormous red velvet train, studded with golden bees (Napoleon's emblem) and lined with ermine fur. The emperor stands on a platform so that, short as he is, he

5-13 **Jacques-Louis David,** *Perspective Study for the Coronation of Napoleon,* undated. Pencil, pen and ink, 20'7" x 32'
(6.29 x 9.79 m). Musée du Louvre, Département des arts graphiques, Paris.

towers over the archbishop of Paris, on his right, and
Pius VII, who is seated behind him.

Upon its completion, the *Coronation* was exhibited at
the Salon of 1808, where it was widely admired by the
public and by David's fellow artists, who placed a laurel
wreath underneath it. David had his share of critics as well,
many of them former revolutionaries who felt that the artist
had abandoned the revolutionary cause to become a spine-
less courtier. What had happened to David, the radical
painter of *Brutus* and of *Marat?* In truth, he was no differ-
ent from numerous other revolutionaries who had
enthusiastically welcomed Napoleon as the first outstanding
revolutionary leader, and who went along with him even
as he terminated the Republic and assumed a power that
surpassed that of the former kings.

David was not the only painter harnessed to shaping
the emperor's public image. Many of his contemporaries,
including some of his students, became rivals for imperial
commissions. David's student François Gérard (1770–
1837), for instance, was commissioned to paint Napoleon
wearing his imperial robe, to be distributed in painted and
engraved copies throughout the empire (FIG. 5-14). It
re-called earlier portraits from the *ancien régime,* such as
Hyacinthe Rigaud's (1659–1743) official portrait of Louis
XIV (see FIG. 1-1).

Prud'hon, another contemporary, was commissioned to
paint a monumental portrait of Empress Joséphine in 1805
(FIG. 5-15). Since he often took years to finish a painting,
the work was not completed until 1809, the year in which

5-14 **François Gérard,** *Napoleon the Great.* Reproduction of the
artist's official portrait, known in multiple versions. Engraving, Reuil-
Malmaison, Châteaux de Malmaison et Bois-Préau.

Napoleon decided to divorce his wife because she had not borne any children. The portrait was thus not shown at the Salon of 1810, the year in which Napoleon married his second wife, Marie-Louise of Austria. Joséphine is seated on a mossy rock, presumably in the garden surrounding the château at Malmaison. She wears a high-waisted, low-cut dress in the Empire fashion. A red cashmere shawl protects her from the rock's damp coldness, and strikes a bright note in a painting that shows mainly dark and muted colors.

In the nineteenth century Joséphine's pensive expression and her pose, which echoes traditional allegories of

5-15 **Pierre Paul Prud'hon,** *Portrait of Empress Joséphine.* 1805. Oil on canvas, 8' x 5'10" (2.44 x 1.79 m). Musée du Louvre, Paris.

5-16 **Pierre Paul Prud'hon,** *The King of Rome Sleeping,* 1811. Oil on canvas, 18⅛ x 22" (46 x 55.8 cm). Musée du Louvre, Paris.

Melancholy, were attributed to the empress's foreboding of her divorce. While that is not impossible, it is also true that Joséphine lived in a period when periodically to withdraw from society for the purpose of quiet reflection was seen as a virtue. In the years 1776–8, the well-known French philosopher and novelist Jean-Jacques Rousseau (1712–1778) had written a series of essays called *The Reveries of a Solitary Walker.* Rousseau had hailed nature as a temporary escape from human society and as a place conducive to meditation, and he had made escapes into nature fashionable. It is possible that Joséphine wished to have her portrait painted in the park for that reason. Known for her flightiness and her prodigality, she may have wished to project an image of thoughtfulness and natural simplicity.

Prud'hon also received a commission to paint Napoleon's long-desired heir, the imperial prince borne by his second wife Marie-Louise in 1811 (FIG. 5-16). Pronounced the King of Rome at birth, the infant prince is shown sleeping on a patch of grass, surrounded by plants and flowers and illuminated by a radiant light. Although it looks surreal to the modern observer, contemporary observers would have noticed the painting's reference to the ancient myth of the foundation of Rome. According to this story, the goddess Rhea Silvia abandoned her twins Romulus and Remus to the wilderness, not knowing that Romulus would later become the first king of Rome. Many of the details of the portrait have an allegorical meaning. The two gigantic fritillaries, also called "crown imperial," above the prince's knee, signify his descent from two imperial houses, the French and the Austrian. The laurel in the background refers to Napoleon himself. And the radiant glow, no doubt, is the divine light that will illuminate the prince's life and rule.

Of all the portraits of Napoleon and his family, perhaps the most unusual one is the *Portrait of Napoleon on his Imperial Throne* (FIG. 5-17), painted by David's student Jean-Dominique Ingres (1780–1867) and exhibited at the Salon

5-17 Jean-Dominique Ingres, *Portrait of Napoleon on his Imperial Throne*, Salon of 1806. Oil on canvas, 8′9″ x 5′3″ (2.66 x 1.6 m). Musée de l'Armée, Palais des Invalides, Paris.

5-18 Jan and Hubert Van Eyck, *God the Father*, top central panel of the *Adoration of the Lamb*, the "Ghent Altarpiece", 1432. Oil on panel, 6′11″ x 2′6″ (2.1 m x 80 cm). Church of St Bavo, Ghent.

of 1806. This painting had not been commissioned by the emperor himself but by the Legislative Body, which may explain some of its unique qualities. Dressed in a sumptuous robe, the emperor is seated on a gilded throne, the curved back of which forms a halo around his head. In his right hand he holds the golden scepter of Charlemagne; in his left, the ivory hand of justice used by the French Medieval kings. His strictly frontal pose gives the painting an iconic quality that has been compared with that of God the Father in the famed Ghent Altarpiece (FIG. 5-18). That monumental painting, by the fifteenth-century south Netherlandish artists Jan and Hubert van Eyck, was one of the most celebrated "stolen treasures" in the Napoleon Museum. By referring to this well-known work, Ingres—no doubt in an effort to please the emperor—suggested that Napoleon was a godlike figure, omnipotent and endowed with divine wisdom. Ruler and judge, he embodied both legislative and executive powers. No other portrait of the emperor so blatantly exposed the position of absolute, superhuman monarch that Napoleon had assumed in a country that only recently had rid itself of a century-old monarchy.

Antoine-Jean Gros and the Napoleonic Epic

Besides exalting the emperor's image, Napoleonic propaganda was also used to record the emperor's deeds. Napoleon, forever the general, took enormous pride in his military victories. He was mindful, notwithstanding, that his victories were achieved at the cost of many lives. Thus images of war could easily turn into negative propaganda. To avoid this, all war paintings were carefully planned by Napoleon and his artistic advisors, so that Napoleon would appear both as a military genius and as a humane leader, mindful of his soldiers.

Antoine-Jean Gros (1771–1835), a student of David, became Napoleon's favorite artist when it came to recording his military exploits. Gros's *Bonaparte Visiting the Plague House at Jaffa* (FIG. 5-19) was one of the most successful paintings of the Salon of 1804, and launched the artist's career. Upon his failed attempt to conquer Egypt, Napoleon and his generals had moved their armies to neighboring parts of the Ottoman Empire (in present-day Israel and Syria). After a successful assault on Jaffa and the ruthless massacre of its inhabitants (March 1799), a plague broke

5-19 **Antoine-Jean Gros,** *Bonaparte Visiting the Plague House at Jaffa,* Salon of 1804. Oil on canvas, 17′5″ x 23′6″ (5.32 x 7.2 m). Musée du Louvre, Paris.

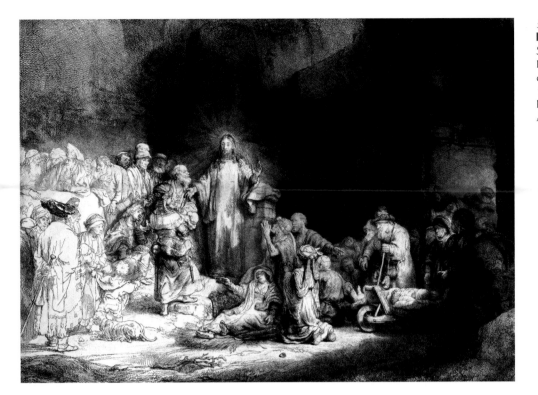

5-20 **Rembrandt van Rijin,** *Christ Healing the Sick* ("Hundred-Guilder Print"), c.1650. Etching, drypoint and burin, 11 x 15⁵/₁₆" (27.8 x 38.8 cm). Rembrandt House, Amsterdam.

out among the French troops. On May 11 Napoleon and some of his staff visited the sick in the hospital. Eyewitness accounts differ as to the purpose of the visit. According to some, Napoleon wanted to assess whether the soldiers should be transported or left to die in Jaffa. Others claim that the general went to the hospital to boost the morale of his troops.

It was important to Napoleon that the visit should be seen in the most positive light, especially because of the negative press he had received for the Jaffa massacre. In *Bonaparte Visiting the Plague House at Jaffa* the general stands inside the courtyard of the hospital building with two of his officers. While the latter are disgusted by the sight and smell of the mortally ill, Napoleon has taken off his glove and reaches out to touch one of the plague-stricken soldiers. Even though little was known about the transmission of contagious diseases at the time, this must nonetheless have been seen as a death-defying gesture. Napoleon appears like a saintly healer whose compassionate touch brings consolation, possibly even a cure to his faithful soldiers. Gros's painting recalls Rembrandt's famous etching of *Christ Healing the Sick* (the so-called "Hundred Guilders" print; FIG. 5-20) of c. 1650, which was much admired at the time.

The success of Gros's painting at the Salon of 1804 was due to the fact that it brought something new to history painting. Not only did the painting depict a contemporary event rather than an episode from ancient history—although that, in itself, was still a novelty in France—but the drama of the work set it apart from the work of David and his followers. Gros played up the exotic

setting, the Islamic courtyard with its imposing arches and stained-glass windows, and the colorful costumes of the Arabic hospital staff. He also emphasized the stark contrast between the dapper uniforms of Napoleon and his officers and the pale, sickly bodies of the patients. Most of these sufferers are concentrated at the bottom of the painting, forming, as it were, a threshold of pathos that the eye needs to cross before scanning the rest of the painting. In the lower left, a hooded figure sits hunched up in a pose of despair derived from Michelangelo's *Last Judgment* in the Sistine Chapel in Rome. In the lower right, a young cadet cradles the body of a dead comrade. Between them, the naked body of a weeping man draws a diagonal line that leads our eye up towards Napoleon, and to the revolutionary flag that signals the glorious cause.

Gros continued to create powerful propaganda with his monumental *Battle of Eylau* (FIG. 5-21), shown at the Salon of 1808. This painting commemorated a battle that took place in Russia on February 8–9, 1807, between the forces of Russia and Prussia and those of France (see *Napoleonic Battles*, page 111). Napoleon desperately needed some positive publicity for this battle, which had ended in a deadlock and cost as many as 50,000 lives. Again, he and his advisors decided to emphasize his humanity in the wake of the bloodbath caused by his military ambitions. Gros was asked not to paint the battle itself but its aftermath when Napoleon, now emperor, visited the battlefield to console his soldiers and to instruct those who had the strength to attend to the wounds of their Russian victims. Once again, Napoleon is represented as a saintly figure, who spreads sympathy across the battlefield to warm and revive

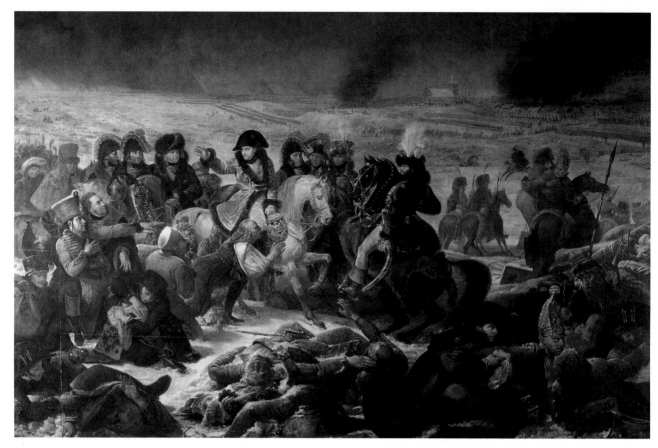

5-21 **Antoine-Jean Gros,** *Battle of Eylau,* Salon of 1808. Oil on canvas, 17′1″ x 25′ 9″ (5.21 x 7.84 m). Musée du Louvre, Paris.

his soldiers. Gros has successfully captured the bleakness of a north Russian winter, with darkly dressed figures set against a drab backdrop of mist, mud, and snow. Only a few red hats enliven this otherwise gloomy picture.

Gros received many more commissions for large-scale pictures of battle scenes, and established an excellent reputation as a painter of Napoleonic propaganda. But he was not alone. The Salons of the first decade of the nineteenth century were dominated by large-scale works commissioned by the imperial government and depicting episodes of Napoleon's campaigns. Smaller commissioned works were also aimed at showing off Napoleon as national leader and skilful administrator, and to demonstrate his qualities as a family man.

The School of David and the "Crisis" of the Male Nude

The imperial art machine was admittedly huge, yet not all art exhibited at the Salon during Napoleon's reign was commissioned by the government. The Empire Salons, like those of the late eighteenth century, featured a variety of works, from Classical scenes and biblical subjects to portraits, landscapes, and genre scenes.

If there is anything that truly marked the Salons of the Empire period, it is that they were flooded by the works

of the students of David. Although it is impossible to say exactly how many aspiring artists trained in David's studio, their number were certainly in the hundreds. David taught for thirty-five years, from 1781 to 1816, so that his students belonged to several generations. The first generation entered his atelier in the early 1780s. This group included the three "G's," Gérard, Gros, and Anne-Louis Girodet Trioson (see below). All three of them eventually became David's rivals, competing with him for imperial commissions.

A second generation entered David's studio in the 1790s. In this group, several began to rebel against the artist's strict Neoclassical training. The most vocal group of dissenters called themselves the "Primitives" or the Barbus (because they sported *barbes* or beards). Instead of studying Classical Greek and Roman art and the art of the High Renaissance masters, they sought inspiration in the "primitive" art of the pre-Classical, medieval, and early Renaissance periods. Ingres, at one time, was drawn to this group and his *Portrait of Napoleon* (see FIG. 5-17), in its medievalizing style, is an example of the artistic tendencies of the Primitives.

The third generation of David's students, who studied with the master from 1800 to 1815, was composed largely of foreign students. Many of them came from the countries that Napoleon had conquered—the Netherlands,

Belgium, Germany, Spain—which were for some years officially part of the French Empire. These foreign students encouraged the spread of David's brand of Neoclassicism across Europe. Their art would dominate European academies far into the nineteenth century.

While some of David's students followed their teacher's Neoclassical precepts religiously, others explored new directions. During the Empire, young artists had access to a wide variety of artistic traditions, thanks to the treasures brought together by Napoleon in the Louvre. In addition, a powerful alternative to David's rigid Neoclassicism was provided by Prud'hon (see page 102) who, throughout his career, maintained an independent artistic stance. These combined influences led many of David's students astray from the classical principles that the teacher expounded in his studio.

Some of the works of Anne-Louis Girodet-Trioson (1767–1824) show how Neoclassicism could be transformed in the hands of David's students. The artist's *Sleep of Endymion* of 1791 (FIG. 5-22) is a dark, mysterious painting that is a far cry from the clearly ordered paintings of David of the 1780s. It depicts a beautiful youth

from Greek myth, who was put to eternal sleep by the moon goddess so that she could love him for forever. The pale, languorous body of Endymion strikes a pose of ecstatic abandonment as his body is caressed by the rays of the moon. A prepubescent Eros (spirit of love) parts the branches that admit the light into the thicket where Endymion rests.

The sensuous, erotic character of this painting differs greatly from the virtuous, edifying nature of David's works. Its dynamic composition, guided by two crossing diagonal lines, is also unlike the more static construction of David's paintings in which horizontals and verticals dominate. Finally and most strikingly, the soft, effeminate body of Endymion is distinct from the heroic male bodies featured in the work of David.

The *Sleep of Endymion* was shown to much acclaim at the Salon of 1793, but Girodet had painted the work two years earlier in Rome, where he first may have become interested in the alternative representation of the male body seen in his work. Androgynous (combining male and female characteristics) bodies such as Endymion's were not unknown in Classical art. Already Winckelmann, in his *History of Ancient Art*, had concluded that there was a duality in the

5-22 **Anne-Louis Girodet-Trioson,** *Sleep of Endymion,* 1791 (Salon of 1793). Oil on canvas, 6'6" x 8'6" (1.97 x 2.6 m). Musée du Louvre, Paris.

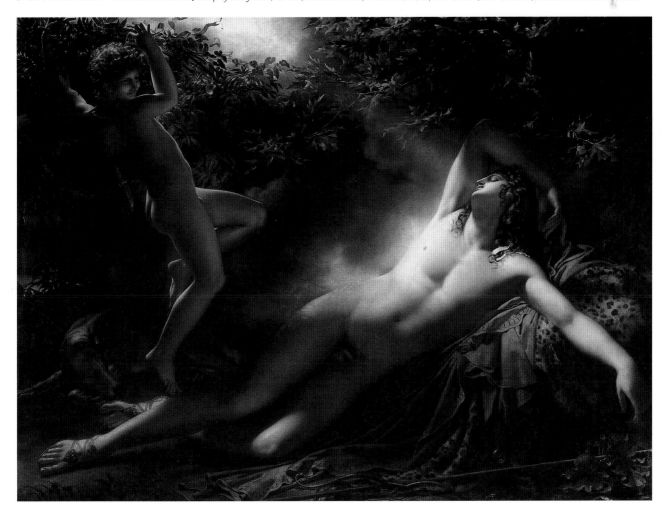

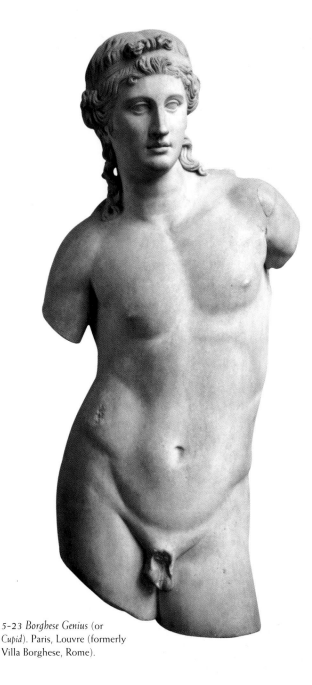

5-23 *Borghese Genius* (or *Cupid*). Paris, Louvre (formerly Villa Borghese, Rome).

hand, it has been interpreted as an act of rebellion against David's relentless emphasis on the heroic nude. (When Girodet described *Endymion* to his guardian Benoît-François Trioson, he wrote that the painting arose from a desire "to get away from [David's] genre as much as I possibly can.") On the other, the new emphasis on sensuality rather than austerity, on gracefulness rather than heroism, has been seen as a reflection of a larger psycho-cultural change following the revolutionary years.

The generation that matured in the 1790s, in the wake of the thousands of guillotine executions that had been performed in the name of the Revolution, looked at life in a way that was different from their fathers and teachers. The virtues of the older generation—moral principle, stoic poise, rationality—had lost their appeal. The new generation was too aware of the suffering that these ideas had caused. They no longer understood Socrates' stoic indifference in the face of his execution; they no longer admired Brutus' condemnation of his own sons to death. Instead, they preferred sensitivity over self-possession. They sympathized with the victim rather than the perpetrator, however heroic, however lofty his goals.

5-24 **Jean Broc,** *Death of Hyacinth,* 1801. Oil on canvas, 70 x 49" (1.78 x 1.26 m). Musée des Beaux-Arts, Poitiers.

Greek ideal of physical beauty; that, in fact, there were two ideal modes, loosely linked to the fifth and fourth centuries BCE, respectively. The first mode was masculine, heroic, and austere; the second was feminine, graceful, and sensuous. While the two modes were most clearly seen in sculptures of male and female bodies, respectively, it was possible to encounter the masculine ideal in female figures (for example, the goddess Athena) and the feminine ideal in masculine figures. Feminine traits were particularly pronounced in the ephebes or adolescent youths who became lovers of the gods: Adonis, Endymion, Hyacinth, or Narcissus (see FIG. 5-23).

The increased preoccupation of David's students, from the early 1790s onwards, with the graceful, androgynous nude has been attributed to various factors. On the one

5-25 **Jean-Auguste-Dominique Ingres,** *Torso of a Man,* Salon of 1801. Oil on canvas, 39³/₈ x 31¹/₂" (100 x 80 cm). École Nationale des Beaux-Arts, Paris.

It is remarkable that many of the androgynous nudes in the works of David's students are suffering. This is obvious in the *Death of Hyacinth* (FIG. 5-24), an unusual painting by David's student Jean Broc (1771–1850) who, in his youth, had belonged to the Barbus. It depicts the beautiful Hyacinth, the playmate of the Greek god Apollo, who accidentally killed the youth as they were throwing disks. In the painting, a youthful Apollo with soft curly locks embraces the lifeless body of Hyacinth. The androgynous bodies of the two figures are curved and soft, having nothing in common with the taut muscular bodies of, for example, the Horatii brothers in David's painting. Their embrace speaks of pathos and sensuality. The painting has a dreamlike quality that is quite different from the clarity and eloquence of David's work.

The masculine eroticism that marks Broc's *Death of Hyacinth* and Girodet's *Endymion* has been linked to David's studio, where an all-male student body spent their days drawing and painting after male nudes under the supervision of a male teacher (FIG. 5-25). This is not to say that David's students were homosexuals; they may or may not have been. But it is fair to assume that the exclusively "homosocial" (i.e. same-gender) environment in which David's students worked, and often lived, caused them to conceive of their art within a masculine frame of reference. Girodet's *Endymion* and Broc's *Hyacinth* are not far removed from the academic studies that David's students made in his studio (see FIG. 5-26). In both, the nudes are "on display" for the viewer to examine, just as the male model in the studio was on display for David's students.

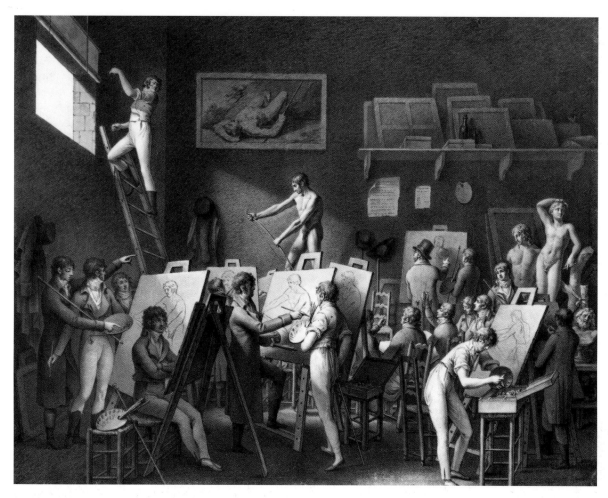

5-26 **Jean-Henri Cless,** *The Studio of David*, c.1810. Black chalk, 17 x 23" (45 x 59 cm). Musée Carnavalet, Paris.

The Female Nude

While the male nude was privileged in the art of the Empire, the female nude, which would dominate nineteenth-century Salons, was not neglected. Although female models were not allowed in the Academy, artists had access to female models in their private studios. One of the most notorious examples of a female nude at the Empire Salons was Girodet's *New Danaë* (FIG. 5-27), exhibited at the Salon of 1799. It shows a young beautiful woman loved by Zeus. As in *Endymion*, the divine love takes the form of a burst of light, which materializes into golden coins that Danaë catches in her blue shawl. Girodet's contemporaries immediately realized that the artist had based his Danaë on a contemporary theatrical star, Mademoiselle Lange. The artist had a grudge against the actress who, one year earlier, had demanded that Girodet remove her portrait from the Salon because she said that it compromised her reputation for beauty. Girodet found revenge in

5-27 **Anne-Louis Girodet,** *The New Danaë*, Salon of 1799. Oil on canvas, 25 x 21" (65 x 54 cm). Minneapolis Institute of Arts.

representing her as Danaë, greedily catching Zeus' amorous gift of gold before it can reach her body. He also surrounded her with symbolic animals and objects—too complex to go into here—that characterize Lange as a promiscuous courtesan.

The Transformation of Neoclassicism: New Subjects and Sensibilities

Girodet and Broc abandoned the scenes of Roman history that David favored for episodes from Greek mythology. They and other students of David often went even further, finding inspiration in medieval and Renaissance history or in contemporary literature. Girodet's *Entombment of Atala* (FIG. 5-28), for example, depicts a scene from François-René de Chateaubriand's *Atala*, first published in 1801 and a sensational best-seller of the period. Set in French Louisiana, this short novel tells the story of a Christian girl of mixed European and Native American descent, whose mother made a sacred vow that her daughter would remain a virgin. When Atala falls in love with Chactas, a Natchez Indian, the conflict between love and religion leads her to poison herself. In Girodet's painting, Chactas and an old Capuchin monk are about to place her virgin body in the grave. The painting is marked by contrasts: between old age and youth, femininity and masculinity, Christianity and paganism. The importance of religion in this painting is especially significant. During the revolutionary period, organized religion had been outlawed and religious themes were frowned upon. Girodet's painting reflects the beginning of a return to Christianity that was fueled by Chateaubriand's book, *The Genius of Christianity* of 1802, and made official by Napoleon through the so-called Concordat with the pope, which proclaimed Roman Catholicism the "preferred" religion in France.

Gérard's *Ossian Summoning the Spirits* (FIG. 5-29) depicts a medieval subject. It was one of two paintings on Ossianic themes commissioned for Empress Joséphine's residence at Malmaison (the other was by Girodet). In Gérard's work, Ossian—here represented as a blind old bard playing an Irish harp—summons up the spirits of the dead. Far removed

5-28 **Anne-Louis Girodet,** *The Entombment of Atala,* 1808. Oil on canvas, 5'5" x 6'11" (1.67 x 2.1 cm). Musée du Louvre, Paris.

from the severe classicism of David, the painting has a haunting sublimity, not unlike the works of contemporary British artists.

Historic Genre Painting and the So-called Troubadour Style

Scenes from medieval and Renaissance history were the favorite subject of a group of artists in David's studio who called themselves the "aristocrats." They were interested in the personalities and private lives of well-known historical figures. In some cases, their works were inspired by popular anecdotes from the lives of famous characters of the past. At other times, these artists attempted to reconstruct the daily life of historic figures or past periods. It is usual to refer to these works as historical genre painting.

To paint their new, intimate subjects, the "aristocrats" had little use for the grand style of David. Instead, they were fascinated by seventeenth-century Dutch genre paintings, which were exceptionally well represented in the Napoleonic Museum. They particularly admired Gerard Dou (1613–1675), a student of Rembrandt, for his use of subtle color combinations and his fine, miniaturist execution. Dou's *Woman Sick with Dropsy* (FIG. 5-30), in the Louvre, was their favorite.

In imitation of Dou's work, the "aristocrats" developed a polished, highly detailed style of historic genre paintings

5-29 **François Gérard,** *Ossian Summoning the Spirits,* 1802. Oil on canvas, 6'3" x 6' (1.92 x 1.84 m). Malmaison, Musée National du Château de Malmaison.

5-30 **Gerard Dou,** *Woman Sick with Dropsy,* 1663. Oil on panel, 34 x 27″ (86 x 68 cm). Musée du Louvre, Paris.

5-31 **Fleury-François Richard,** *King Francis I and his Sister Margaret, Queen of Navarre,* Salon of 1804. Oil on canvas, 30 x 25⁵/₈" (76.8 x 65 cm). Napoleon Museum, Schloss Arenenberg, Mannenbach-Salenstein, Switzerland.

5-32 **Jacques-Louis David,** *Portrait of Madame Récamier,* 1800. Oil on canvas, 5'8" x 7'8" (1.73 x 2.43 m). Musée du Louvre, Paris.

that is referred to as the "troubadour style." The painting of *Francis I and His Sister* (FIG. 5-31), shown at the Salon of 1804, by Fleury-François Richard (1777–1852) is a typical example of this style. This historic genre scene depicts an intimate moment between King Francis I and his beloved sister Marguerite. Like Dou's *Woman Sick with Dropsy,* it shows a domestic interior lit by a single window on the left. The figures are conversing, their faces illuminated by the light that comes through the window. Although the subject of the painting is fictional, the period details have been carefully researched and are rendered faithfully.

The Lesser Genres: Portraiture and Landscape

During the Consulate and the Empire, the Salons were visually dominated by large-scale history paintings. In terms of numbers, however, small-scale genre paintings (such as the historic genre paintings in the troubadour style), portraits, and landscape paintings prevailed. It is true that these genres were rated lower than history painting in the hierarchy of genres of the Academy. But

as the middle class began to grow and thrive, in the wake of the Revolution, there was a new demand for such works which, because of their modest size, were perfectly suited to domestic interiors.

Of all the lesser genres, portraiture was most in demand. The new bourgeoisie liked to furnish their homes with portraits of themselves and their families. Nearly all artists of the period practiced portraiture, for the demand was inexhaustible. David and the artists of his school generally received the more important portrait commissions.

David's *Portrait of Madame Récamier* (FIG. 5-32) portrays a well-connected Parisienne. Her salon (reception room) attracted many well-known political figures, intellectuals, and artists of the day. David's portrait, however, does not focus on his sitter's social status, but on her natural beauty. Barefoot and simply clad, she reclines, in Roman fashion, on an Empire settee. The limited color scheme of the painting was perhaps not originally intended. David was exasperated with this portrait, and left it unfinished. To our modern eyes, however, the austerity and the simple color scheme lend this painting a refreshing purity that is quite distinct from other portraits of the period.

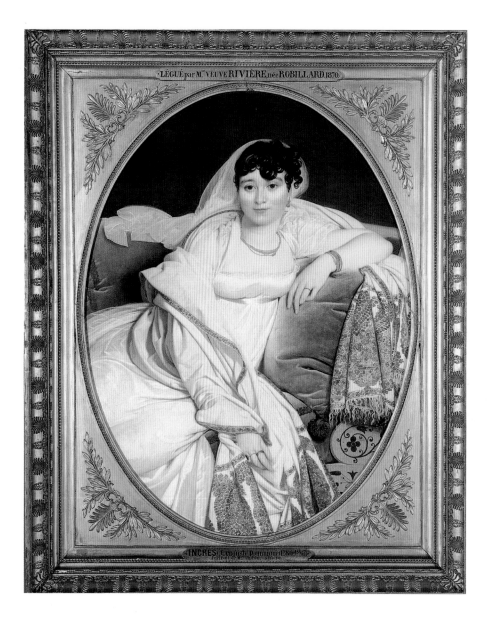

LÉGUÉ par M.ᵉ VEUVE RIVIÈRE née ROBILLARD 1870.

INGRES (Augustd Dominique) 1804

5-33 **Jean-Dominique Ingres,** *Portrait of Madame Rivière,* 1805. Oil on canvas, 45⅝ x 35⅝" (1.16 m x 90 cm). Musée du Louvre, Paris.

Compare David's *Madame Récamier* with the *Portrait of Madame Rivière* (FIG. 5-33) by Jean-Dominique Ingres, for example, and its unique qualities are obvious. This is not to say that Ingres's portrait is not a masterpiece in its own right. Of all of David's students, Ingres became best known for his portraiture. His popularity as a portraitist was directly related to his ability to enhance his sitters' appearance while simultaneously creating the illusion of an incredible realism.

His *Portrait of Madame Rivière* shows a young, raven-haired woman reclining on the icy-blue velvet cushions of a settee. Like Madame Récamier, she is simply dressed. But a huge, cashmere shawl draped around her shoulders and another thin, transparent veil streaming out of her dark curls add a layer of complexity to her appearance. The multiple folds in her shawl and veil form intricate patterns of intersecting lines and dramatic contrasts of light and shade that contrast wonderfully with the smooth, streamlined surfaces of the face and body. The highly finished portrait creates the illusion of an almost photographic realism, which is belied, however, by the curious anatomical distortions (the elongated right arm, the absence of finger joints). One realizes that the painting is a clever deception, all in the name of sensual beauty and grace. Ingres's painting may be compared with the works of such early Renaissance Italian artists as Botticelli (c.1445–1510) and Fra Filippo Lippi (c.1406–1469), artists who likewise sacrificed anatomical correctness to graceful contours.

Of the numerous landscapes that were seen at the Salons of the Consulate and the Empire, relatively few have survived. This may be attributed to the lack of respect that people had for landscape painting, which made its conservation a low priority. Within the broad field of landscape painting, the historical landscape was ranked above all other categories (see *Landscape Painting—Subjects and Modalities,* page 183). Historical landscapes typically depict mountainous scenery dotted with Classical buildings, showing small figures in Classical dress often acting out a

5-34 **Pierre Henri de Valenciennes,** *Landscape of Ancient Greece,* 1786 (Salon of 1787). Oil on canvas, 39 x 60″ (100.3 x 152.4 cm). Detroit Institute of Arts.

historical scene. Although they had their origins in the seventeenth century, in the works of Nicholas Poussin and Claude Lorrain, historical landscapes had largely disappeared in the early eighteenth century. Their revival, at the end of the eighteenth century, was due to Pierre-Henri de Valenciennes (1750–1819), who gave an important impetus to the rise of landscape painting in the nineteenth century.

His early *Landscape of Ancient Greece* (FIG. 5-34) is typical of the classical landscapes that were shown in the Salons from the late 1780s to the 1820s by Valenciennes and his followers. It depicts a mountainous landscape, punctuated by Classical buildings, sculptures, and tiny figures engaged in various activities. Like most historical landscapes, it is loosely inspired by the scenery around Rome, where Valenciennes, like Poussin and Lorrain before him, had spent many years studying. It is clearly an imaginary construct, however, carefully composed to lead the viewer's eye from figures in the foreground, along the river, towards the distant background.

Perhaps the most attractive aspect of Valencienne's painting is the artist's beautiful rendering of light—a warm Mediterranean glow that softly accents the salient points in the landscape. This sensitive rendering of light and atmosphere was informed by Valenciennes's practice of making oil studies outdoors. This was a novelty in the eighteenth century, when painters generally based their landscapes, which invariably were painted indoors, on pencil drawings and color notations. Sketching outdoors in oils helped Valenciennes to recall the true effects of light and atmosphere with a greater degree of accuracy when he was painting his finished landscapes in the studio.

Valenciennes not only re-introduced the classical landscape; he also helped to raise the importance of landscape painting. A teacher at the Ecole des Beaux-Arts in Paris since 1812, he encouraged a considerable number of young art students to paint landscapes. He lobbied for a special Rome Prize for landscape painters (1816). Finally, in his well-known treatise, *Elemens de perspective* (*Elements of Perspective*), he discussed the theory and practice of landscape painting in detail, which raised the status and prestige of the genre and influenced French artists until the end of the century.

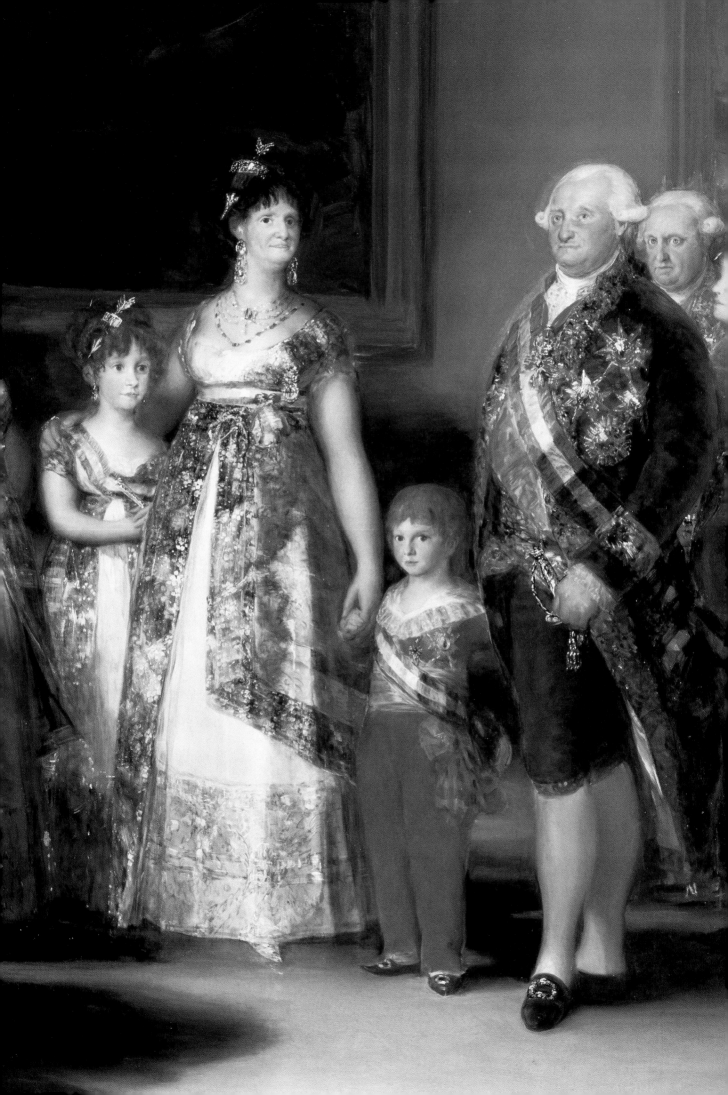

Chapter Six

Francisco Goya and Spanish Art at the Turn of the Eighteenth Century

Spain, a prominent world power during the sixteenth and early seventeenth centuries, had lost much of its prestige by the beginning of the eighteenth. Although it retained a vast colonial empire in the Americas, much of the wealth it generated was squandered in futile wars in Europe.

In 1700 the last Spanish king of the princely Habsburg family died. Epileptic and deformed (his subjects called him "The Bewitched"), Carlos II left no heir, although several parties jockeyed to replace him. The deceased king had Habsburg cousins in Austria as well as French relatives belonging to the royal Bourbon family. Eventually, the Bourbon supporters prevailed and a grandson of Louis XIV, Philippe d'Anjou, ascended the throne as Felipe V (ruled 1700–46).

During much of Felipe's forty-six-year reign and that of his successor, Fernando VI (ruled 1746–59), Spain continued to fight European wars, mostly in order to maintain the Bourbons on the throne. Meanwhile, the country itself steadily decayed. Cities were dangerous; the infrastructure was poor; agriculture was backward; and public education was practically non-existent. There was no significant middle class, only a huge underclass of peasants and paupers and a small but extremely influential elite of clergy and aristocrats. The efforts of Fernando to bring about agricultural progress did little to change this rather dismal situation. His contribution was primarily to the artistic life of Spain as in 1752 he founded the Academy of San Fernando for the fine arts.

Court Patronage under Carlos III: Tiepolo and Mengs

The advent of Carlos III (ruled 1759–88) brought many positive changes. An enlightened monarch, Carlos curbed the power of the church and the aristocracy and promoted education, economic development, science, and the arts. With the help of his secretary of state, José Floridablanca (1728–1808), he built schools, established lending institutions for farmers, and initiated numerous building projects.

To decorate the newly built royal palace in Madrid, Carlos III invited the renowned painters Giovanni Baptista Tiepolo and Anton Raphael Mengs to Spain (see pages 27 and 48). Tiepolo, assisted by two of his sons, produced a series of exuberant Rococo ceiling frescos, such as the *Apotheosis of the Spanish Monarchy* (FIG. 6-1) in the dome of the antechamber or *saleta* to the throne room. Painted between 1764 and 1766, this fresco offers an illusionist view into the higher spheres, where a female figure representing the Spanish monarchy sits on an enormous piece of drapery floating on the clouds. Mercury flies through the sky, delivering her crown. Along the lower edge of the dome, additional gods and heroes—Venus, Mars, Hercules—emphasize the notion of a divinely sanctioned rule.

It is difficult to imagine a greater contrast than the one between Tiepolo's *Apotheosis of the Spanish Monarchy* and the frescoes executed for the royal palace by Mengs. The latter's *Apotheosis of Hercules* (FIG. 6-2), in the Antecámara de Gasparini, lacks the illusionist qualities of Tiepolo's Rococo

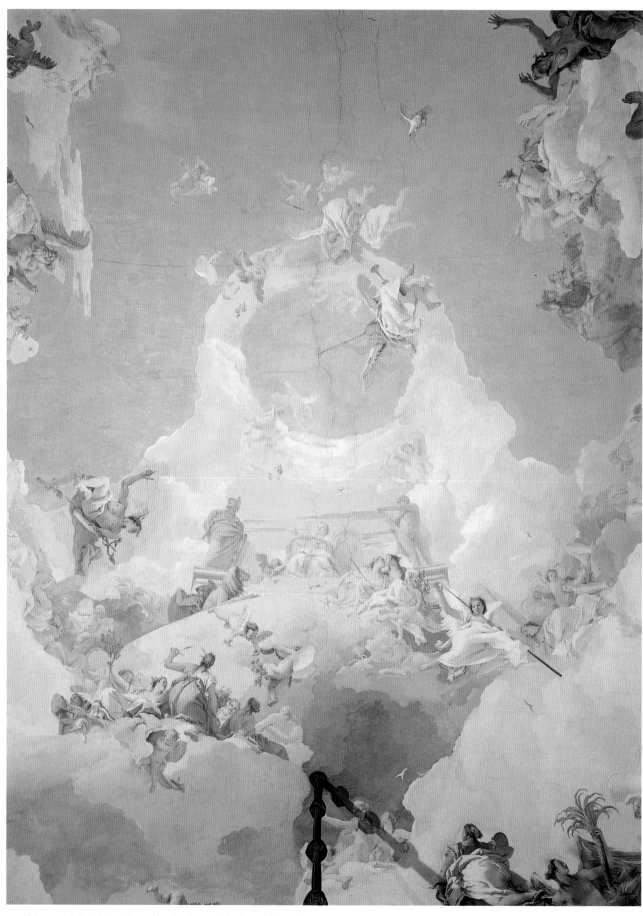

6-1 **Giovanni Battista Tiepolo,** *Apotheosis of the Spanish Monarchy,* 1764–6. Ceiling fresco. 5′ 9″ x 3′5″ (15 x 9 m). Royal Palace, Saleta de la Reina, Madrid.

140 *Francisco Goya and Spanish Art at the Turn of the Eighteenth Century*

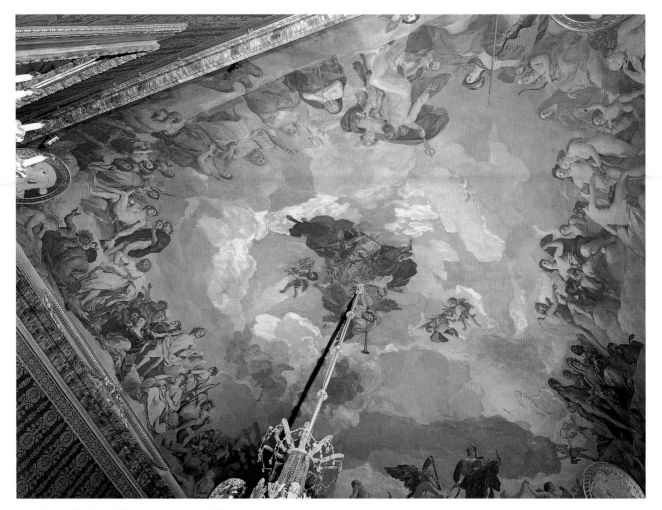

6-2 **Anton Raphael Mengs,** *Apotheosis of Hercules*, 1762–9 and 1775. Ceiling fresco, 31'2" x 33'10" (c. 9.5 x 10.3 m). Royal Palace, Antecámera de Gasparini, Madrid.

fresco. Instead of creating a dramatic build-up towards the center of the ceiling, Mengs has concentrated his efforts on the edges, where he has arranged his figures in the manner of a Classical frieze. Thus his fresco continues the Neoclassical model that Mengs had first introduced in his *Parnassus* in the Villa Albani (see FIG. 2-8).

Mengs also painted a series of portraits of the royal family. His portrait of Carlos III (FIG. 6-3), of 1761, follows the Baroque ruler portrait tradition, perfected by the French painter Rigaud (see FIG. 1-1). Dressed in ceremonial armor, the king is posed before the ubiquitous column, which signifies the solidity of his rule. The curtain, another stock element of Baroque portraits, lends it a formal appearance. Though Mengs has not ignored the king's less attractive features—his oversized nose and small beady eyes—he has minimized them to bring out something of the intelligence and spiritedness that Carlos brought to the Spanish throne. Pleased with Mengs's work, both as decorator and portraitist, Carlos III appointed him First Court Painter and asked him for help in reforming the Spanish art academy, the Royal Academy of Fine Arts of San Fernando. In this influential role, Mengs had an

6-3 **Anton Raphael Mengs,** *Portrait of Carlos III*, 1761. Oil on canvas, 60¹¹/₁₆ x 43⁵/₁₆" (1.54 x 1.1 m). Museo del Prado, Madrid.

6-4 **Francisco Goya,** *The Parasol*, 1777. Oil on canvas, 41 x 59⅞" (1.04 x 1.52 m). Museo del Prado, Madrid.

opportunity to reform art education in accordance with the Classical precepts that he had formulated during his association with Winckelmann in Rome.

The Making of Francisco Goya

While in Madrid Tiepolo and Mengs were pitting Rococo against Neoclassicism, a 13-year-old boy named Francisco Goya y Lucientes (1746–1828) was apprenticed by his father to a local painter in Fuendetodos, northeast of Madrid. Like most provincial art students, Goya spent several tedious years copying engravings and drawing after plaster casts. At the age of 17, feeling that his training was complete, he left for Madrid.

With his provincial training, Goya had a hard time making a living in Madrid until he found a mentor in Francisco Bayeu (1734–1795). This painter, his future father-in-law, was twelve years older than Goya and well-respected in Madrid. The connection became particularly important when Bayeu, together with Mengs, was asked to reform the Royal Tapestry Manufactory of Santa Barbara in Madrid. Founded by Felipe V to compete directly with the famous Gobelin Manufactory in Paris, it had thus far not been very successful. Bayeu and Mengs intended to breathe new life

into the tapestry factory by attracting innovative young artists to paint the initial designs or cartoons. They also sought to introduce new themes. While previously most tapestries had depicted religious and mythological scenes, they encouraged genre subjects, that is subjects taken from the events of daily life.

Goya was among those asked to work on these new designs. Between 1774 and 1792 he produced a steady stream of cartoons, which provided him with a regular income. *The Parasol* (FIG. 6-4), a cartoon for a tapestry that would hang in the princes' dining room in El Pardo, the royal hunting palace outside Madrid, is an early example. A pretty young woman sits on a hillock, with a little dog in her lap. Behind her stands her sweetheart, who shields her with a parasol. Stylistically, Goya's cartoon is rooted in the Rococo; at first glance, it recalls the decorative paintings of his French contemporary, Jean-Honoré Fragonard. When Goya's *Parasol* and Fragonard's *Secret Meeting* (see FIG. 1-8), are closely compared, however, Goya's cartoon appears more broadly painted and less cluttered with detail. More importantly, while Fragonard's young men and women seem artificially pretty, Goya's figures seem earthier, more real. The artist's contemporaries would immediately have recognized the pair as a *maja* and *majo*, members of an urban subculture in eighteenth-century Spain. *Majas* and *majos*

6-5 **Francisco Goya,** *Wounded Mason,* 1786–7. Oil on canvas, 8'10" x 3'7" (2.68 x 1.1 m). Museo del Prado, Madrid.

Goya's interests in realism and popular culture are even more obvious in a set of six cartoons for tapestries representing the rural activities of the four seasons and two scenes of low-class life. One of these, the *Wounded Mason* (FIG. 6-5), shows two men carrying an injured laborer away from a construction site. It is an unusual image for its time, in that it focuses attention on the dismal living conditions of Spain's working class. Painted in dark muted colors, it seems hardly suitable for a decorative tapestry. Nonetheless, this tapestry and the others, equally devoted to peasant and low-class life, were hung in the princes' dining room in El Pardo, which suggests that they fitted within Carlos III's enlightened philosophy of government.

While producing cartoons for the Royal Tapestry Manufactory, Goya regularly accepted commissions for religious paintings. He also worked hard to develop a portrait clientele among the aristocracy. His first breakthrough came in 1783 with the *Portrait of the Count of Floridablanca* (FIG. 6-6). The secretary of state is shown in his office, standing in front of his desk. Although he looks straight at the viewer, he seems to gesture towards Goya, who has come to deliver his portrait. Perhaps he is comparing Goya's painted likeness with his own image in an invisible mirror, hung just about where the viewer is standing. That would explain his frontal pose as well as his expression of curious scrutiny. Goya's portrait differs radically from the more traditional *Portrait of Carlos III* by Mengs because it places the sitter in a genre context. Rather than posing for the artist, the count seems to be going about his usual affairs. His tasks, on this day, include the approval of his portrait as well as the discussion of some floor plans with an architect (the figure in the background has been identified as Francesco Sabbatini, Carlos III's favorite architect). While the portrait still retains some Baroque conventions, such as the drapery in the background (to which the portrait of Carlos III is rather incongruously attached), it clearly presents a new style of portraiture, less formal and more intimately engaged in the subject's life.

Goya's *Portrait of the Count of Floridablanca* contains several references to *Las Meninas* (The Ladies in Waiting; FIG. 6-7), the portrait of Infanta (Princess) Margarita Marià and her retinue by Diego Velázquez (1599–1660). Among them is its genre-like character, the presence of the artist in the portrait, and the play with mirrors (in *Las Meninas*, a mirror reflects the Infanta's parents, the king and queen). Goya's "quotations" from Velázquez's work were probably intentional; the Spanish seventeenth-century court painter was his role model, and he intended to follow in his footsteps.

Goya as Court Painter

The *Portrait of the Count of Floridablanca* was an important step towards Goya's goal of becoming a court painter. The count introduced him to the king's brother, who then

were young women and men who worked as servants or small-time entrepreneurs to make a more or less honest living. Admired by the lower classes because of their gallant behavior and exotic dress, they were fascinating characters for the aristocracy as well.

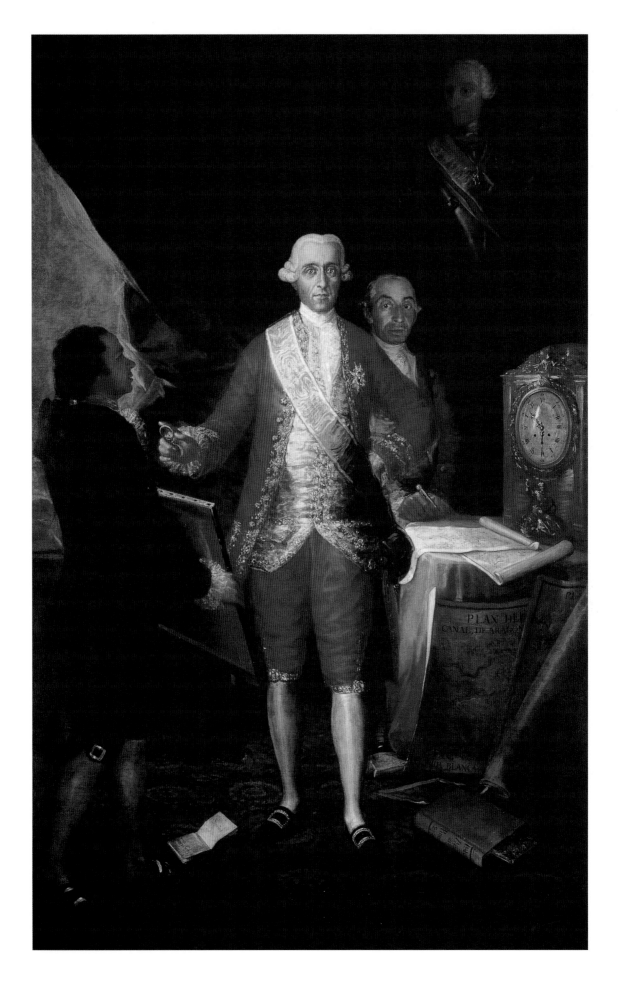

6-6 **Francisco Goya,** *Portrait
of the Count of Floridablanca,* 1783.
Oil on canvas, 8'7" x 5'5" (2.62 x
1.66 m). Banco de España, Madrid.

6-7 **Diego Velázquez,** *Las Meninas,* 1656. Oil on canvas,
approximately 10'5" x 9'1" (3.18 x 2.76 m). Museo del Prado, Madrid.

6-8 **Francisco Goya,** *Family of Carlos IV,* 1800–1. Oil on canvas, 9'2" x 11' (2.8 x 3.36 m). Museo del Prado, Madrid.

presented him to the king. In 1786 he was appointed *Pintor del Rey* (Painter to the King), the same position that Velázquez had held in 1623. Three years later he was promoted to Court Painter, and finally, in 1799, he became First Court Painter.

By that time Carlos III had died and had been succeeded by his son, Carlos IV (ruled 1788–1808). The latter was a kindly man but an ineffective ruler, whose power was usurped by his wife (who slept with the Prime Minister) and, in due course, by his son. Of this conniving clan, Goya painted his most ambitious and intriguing portrait, the *Family of Carlos IV* (FIG. 6-8). It is a life-size, full-length portrait of the royal family, informally grouped around its three major members: Carlos IV on the right, Queen María Luisa in the center, and Crown Prince Fernando on the left. The women are bedecked with jewelry, and the men are covered with ribbons and insignia. Behind the group on the left, barely visible in the half-dark of the room, stands a soberly dressed Goya, facing a huge easel.

It has often been noted that Goya's position behind the royal family defies common sense unless we imagine a scenario in which the royals are standing in front of a large mirror and Goya is painting their reflection. To think of Goya's painting as a "copy" of a mirror image has the advantage that it offers an explanation for its uncompromising realism. This is especially noticeable in the portraits of the king and queen—he with his beady eyes and inflated pink face, and she with her hooked nose, buckteeth, and double chin. Although they look rather buffoonish to us today, the royals apparently liked the painting. The queen was pleased, and the king authorized generous payment to the artist for his materials. Like Floridablanca, they must have looked for a mirror image of themselves in the portrait, and Goya provided it quite faithfully.

The presence of the artist in the *Family of Carlos IV* once again recalls *Las Meninas.* A comparison of the two royal portraits suggests, however, that Goya's attitude has become

more ambivalent since he painted Floridablanca. Now a master in his own right, Goya at once tried to emulate and reject Velázquez's example. Thus while the inclusion of his self-portrait recalls Velázquez, the *Family of Carlos IV* lacks both the genre character and the spatial depth of *Las Meninas*. Goya's figures are compressed in a shallow space, much like Carlos III in his portrait by Mengs. But Goya's lacks the formality and idealism of Mengs' Neoclassical portraits. Instead, he has brought a new informality and realism to court painting that anticipates nineteenth-century portraiture and even photography (see FIG. 14-1).

Goya's court status helped to make him a fashionable portraitist in aristocratic circles. Over the years, he painted numerous dukes, counts, marquises, and their families. The *Portrait of the Duchess of Alba* (FIG. 6-9), widow of one of Goya's lifelong patrons, stands out for its originality. The duchess is set against a loosely sketched landscape background. With one finger, she points to an inscription in the sand which reads, *"Solo Goya"* (only Goya), hinting at her brief infatuation with the artist following her husband's death. She wears traditional Spanish dress: a black ankle-length skirt, girded at the waist with a red sash, and a black lace *mantilla* over a gold bodice. The loose, almost bravura technique that Goya uses sets his work apart from that of his Neoclassical contemporaries in Spain and elsewhere in Europe. A detail of the painting, shown in FIG. 6-10, shows how masterfully he depicts the black lace with a few virtuoso strokes. It is a style of painting that had evolved from the artist's early occupation as a tapestry designer, which had required broad strokes and rapid execution. At the same time, Goya's brushwork is reminiscent of Velázquez in its bold application of paint.

6-9 **Francisco Goya,** *Portrait of the Duchess of Alba,* 1797. Oil on canvas, 6'10" x 4'10" (2.1 x 1.49 m). Hispanic Society of America, New York.

6-10 **Francisco Goya,** *Duchess of Alba,* detail of FIG. 6-9.

Next to engraving (see *Reproducing Works of Art*; page 32), etching was the most commonly used technique to print images in the seventeenth and eighteenth centuries. While engraving was largely practiced by professional printmakers, often for the purpose of making reproductive prints, etching was a fine-art medium that attracted such well-known artists as Rembrandt in the seventeenth century, and Tiepolo, Piranesi, and Goya in the eighteenth.

Etchings are printed from metal (usually copper) plates in which designs are "bitten" by strong chemical acids. To produce an etching, the artist covers a copper plate with a thin layer of etching ground, a soft mixture of resin, wax, and tar. In this layer, he draws with an etching needle, scratching the ground away so that the copper is exposed. The plate is then placed in a bath of acid, which etches away the copper

in the lines that the artist has drawn. The etched lines will get deeper and wider the longer they are left in the acid. After the etching process is complete, the ground is removed and the plate is inked with a roller. The surface of the plate is subsequently wiped clean so that the ink stays only in the lines. A sheet of paper is placed over the plate and the two are run through a press so that the ink in the lines is pressed on to the paper.

In the course of the seventeenth and eighteenth centuries, the etching technique became ever more sophisticated. The invention of the *aquatint* process allowed artists to add tone and even color to the lines of their etchings. Goya, in particular, mastered the aquatint technique, which allowed him to create dramatic *chiaroscuro* effects in his prints.

Goya's Prints

In 1799 Goya published an album of eighty etchings, entitled *Los Caprichos* (The Fancies). This was a new medium for the artist, who had thus far done mostly altarpieces, tapestry cartoons, and portraits (see *Etching*, above). With the *Caprichos*, Goya not only turned to a new medium, printmaking, but he also set himself up as an independent artist, who produced and marketed his own work.

Goya put a notice in the *Diario de Madrid*, the city's main paper, to advertise the *Caprichos*. He described his prints as "A Collection of Prints of Capricious Subjects, Invented and Etched by Don Francisco Goya," and noted that they were for sale in a local "perfume and liquor" shop for 320 *reales*. He further elaborated:

> Since the artist is convinced that the censure of
> human errors and vices (though they may seem
> the province of Eloquence and Poetry) may also
> be the object of Painting, he has chosen as
> subjects adequate for his work, from the multitude
> of follies and blunders common in every civil
> society, as well as from the vulgar prejudices and
> lies authorized by custom, ignorance or interest,
> those that he has thought most suitable matter for
> ridicule . . .

By advertising his prints as such, Goya placed them into a broader eighteenth-century context of pictorial satire. This tradition originated in England with the prints of William Hogarth (see page 33). It continued to flourish in that country during the latter part of the century, thanks to artists such as James Gillray (1757–1815) and Thomas Rowlandson (1756–1827). British satirical prints were certainly known in Spain because they were widely

exported throughout Europe. While British printmakers tended towards political satire (see *Georgian Britain*, page 72), Goya focused on social satire. As a court painter, he

6-11 **Francisco Goya,** *Si Quebró el Cántaro (But He Broke the Pitcher), Los Caprichos,* no. 25, 1797–8. Etching and aquatint, 8³/₁₆ x 6" (20.7 x 15.2 cm). Hispanic Society of America, 1799 edition, New York.

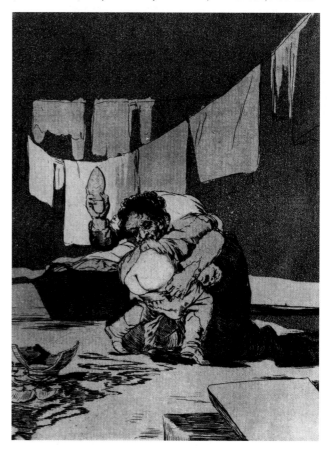

was not likely to attack the royal regime, even though some of his cartoons targeted the clergy and the landed aristocracy, which gained renewed power under Carlos IV. In his *Caprichos*, Goya expressed enlightened opinions at a time when the Enlightenment was rapidly losing ground.

The *Caprichos* fall into two groups. In the first forty or so prints, societal ills are depicted in a straightforward way. *Capricho* no. 25, for example, shows an enraged mother beating her child (FIG. 6-11). *Si quebró el Cantaro!* (But He Broke the Pitcher!) reads the caption, suggesting the mother's justification for abuse. The message here is clear: people accuse others of wrongdoing, without seeing the wrongs they do themselves.

A second group of the *Caprichos* presents fantastic imagery, rooted in an old literary convention of describing the evils of the world as a nightmare. Goya has depicted strange creatures of the night (bats, owls, witches, goblins, giants, etc.), and he used them to make satirical comments. In *Capricho* no. 68, *Linda Maestra!* (A Fine Teacher!), FIG. 6-12, an old witch teaches a young one how to ride a broom. The print exposes people's eagerness to follow bad examples, even though the results of doing so (becoming an ugly, haggard old witch) are evidently negative.

Also in the second group is an etching that was, at one point, probably intended as the album's frontispiece—*Capricho* no. 43, *El Sueño de la razón produce monstruos* (The Dream of Reason Produces Monsters; FIG. 6-13). It shows an artist, perhaps Goya himself, asleep at his drawing table and assaulted (presumably in a dream) by owls and bats. The print seems to comment on human existence in general, and on the work of the artist in particular. First of all, the print suggests that the evils of the world come about when reason sleeps. When man is not rationally in control, then instinct, emotion, and superstition can overtake him. The more specific, artistic meaning of the print is elucidated by Goya himself in his caption, which reads: "Imagination abandoned by reason produces impossible monsters; united with her, she is the mother of the arts and the source of their wonders." This summarizes Goya's view of artistic creation as a process in which imagination is held in check by reason.

6-12 **Francisco Goya,** *Linda Maestra! (A Fine Teacher!), Los Caprichos,* no. 68, 1797–8. Etching and aquatint, 8⅜ x 6" (21.3 x 15 cm). Hispanic Society of America, 1799 edition, New York.

6-13 **Francisco Goya,** *El Sueño de la Razón Produce Monstruos (The Dream of Reason Produces Monsters), Los Caprichos,* no. 43, 1797–8. Etching and aquatint, 8 x 6" (21.6 x 15.2 cm). Hispanic Society of America, 1799 edition, New York.

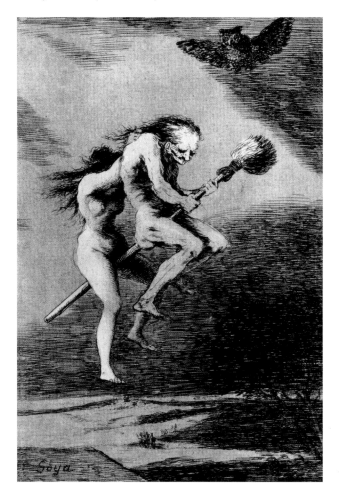

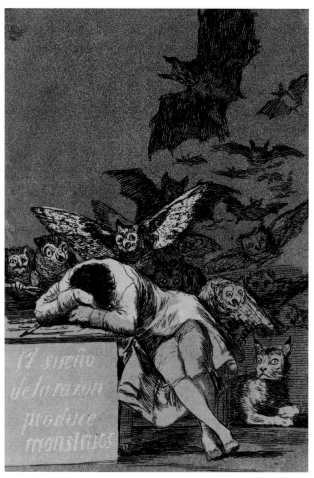

6-14 **Francisco Goya,** *Grande hazaña! Con muertos! (Great Heroism! Against Dead Men!), Los Desastres de la Guerra* (The Disasters of War), no. 39, c.1810–15. Etching and aquatint, 6³/₁₆ x 8³/₁₆ (15.7 x 20.8 cm). British Museum, London.

Although the *Caprichos* brought little financial success, Goya produced three more albums in the years to come. Of these, *Los Desastres de la Guerra* (The Disasters of War), 1810–15, is perhaps the most poignant, because the prints in this album show what happens when mankind abandons reason, and hatred and revenge take control of human behavior. The series was prompted by political events that dramatically changed the Spain that Goya had known in his youth. In 1807 Napoleon turned his attention to conquering Spain. Using force, threats, and political manipulation, he persuaded the royal family to step down, and put his brother Joseph on the throne. Riots broke out in Madrid on May 2, 1808 (Spain's national holiday), and a bloody war of independence ensued that would last for six years. In this guerrilla war, small groups of resisters (so-called *juntas*) attacked French army units with whatever weapons they could lay their hands on—pitchforks, axes, knifes, etc. The *Desastres* depicts scenes from this war, some of which Goya may have witnessed on a trip he made from Madrid to Saragossa. Although Goya supported the *juntas*, his prints seem impartial since he shows the French and the Spanish alike committing extreme atrocities. *Grande Hazaña! Con Muertos!* (Great Heroism! Against Dead Men!; FIG. 6-14), exemplifies his near-obsession with the brutality of war. Three castrated, mutilated corpses and some body parts are tied to a tree. It is impossible to make out whether they are French or Spanish. The emphasis is on the horror of war—a time when human decency disappears and bestiality reigns.

The Execution of the Rebels

Although Goya completed eighty-two plates, between about 1810 and 1815, the *Desastres* series was not published until 1863, some thirty-five years after the artist's death. Perhaps Goya felt that it was impossible to sell the series, either because the prints were too explicit or because they did not glorify the Spanish rebels sufficiently.

Goya was sensitive to the use of art as propaganda, and acted accordingly. In two large canvases, painted in 1814, he represented two significant events at the beginning of the war. One was the riot in Madrid on May 2, 1808; the

6-15 **Francisco Goya,** *Execution of the Rebels on the Third of May, 1808,* 1814. Oil on canvas, 8'8" x 11'4" (2.66 x 3.45 m). Museo del Prado, Madrid.

other was the bloody execution of the rebels by French soldiers the next day. Goya proposed these two paintings, and perhaps two more, to the government and eventually was given a stipend to carry them out. In the *Execution of the Rebels on the Third of May,* 1808 (FIG. 6-15) we see a group of captured rebels, led under cover of night to an execution ground where a French firing squad shoots them one by one. The powerful contrast between the soldiers and the rebels brings the dramatic scene to life. The soldiers, seen from the back, resemble automatons with their identical uniforms and poses. The rebels, lit by the lamp, show their humanity, mortality, and courage in the face of death. The man about to be executed shows a dramatic range of emotions. Dressed in a white shirt and light pants, kneeling before his captors, he raises up his arms in a gesture both desperate and defiant. Some art historians have compared his pose with that of the crucified Christ, explaining it as Goya's way of portraying the struggle between Spanish Catholicism and French atheism.

The *Execution of the Rebels* is unprecedented in the history of painting, since it represents neither a glorious victory nor

6-16 *Execution of Five Franciscan Monks at the Hand of a French Firing Squad,* 1813. Illustration of *Memorias Históricas de la Muerte [. . .] de los RR. PP. [. . .] fusilados por los Francéses el dia 18 de Enero 1812* (Valencia, 1813). Engraving by Miguel Gamborino, probably after a drawing by Andrés Cruá. Biblioteca Nacional, Madrid.

a heroic battle. Instead it portrays human slaughter in all its sordidness. Yet, while this raw subject had never before been treated in high art, it did appear in eighteenth-century

6-17 **Francisco Goya,** *Saturn Devouring One of his Children,* 1820–1823. Mural transferred to canvas, 57⅛ x 32⅝" (1.45 m x 83 cm). Museo del Prado, Madrid.

popular prints such as the anonymous print from 1813, showing the slaughter of five Franciscan friars by French soldiers (FIG. 6-16). These prints were not commissioned by kings or generals as nationalist propaganda. Instead, they were sold to common folk, perhaps to induce their patriotism. Goya, too, must have envisioned his paintings as public works, to be hung in a place where they would be accessible to everyone.

Casa del Sordo

The restoration of Fernando VII to the throne in 1814 did not bring a renewal of portrait commissions from the aristocracy. Apart from a few church commissions, Goya had to produce for an uncertain market. Between 1814 and his death in 1828, he did two more print albums, one devoted to the bullfight (*Tauromaquia*), the other (*Los Proverbios* or *The*

Proverbs) a satirical series analogous to *Los Caprichos*. He also produced a number of genre paintings, some of which recalled his early tapestry designs. Perhaps most unique among his late works are a series of murals made for his country house just outside Madrid. Nicknamed the House of the Deaf Man or Quinta del Sordo (Goya had become deaf after an illness in 1792), the house contained fourteen large paintings, done directly on the plaster, in the main rooms on the first and second floors. These paintings depict scenes from religion, myth, and daily life, seeming to recreate the *Caprichos* on a larger scale. Like the latter, they illustrate a journey from reality into a dream world, in which evil comes alive. *Saturn Devouring One of his Children* (FIG. 6-17), a particularly grotesque example, illustrates the myth of the Roman god Saturn, who is told that one of his children will dethrone him. To prevent this, he decides to eat them one by one.

In Goya's image, Saturn emerges from the dark, his face distorted with hatred and fear. His mouth opens wide to take another bite from a human, whose mutilated form recalls the bodies in the *Desastres*. Goya was between 74 and 76 years of age when he did these paintings, and his view shows an old man's sense of bitterness and defeat. He had seen the world change from a place ruled by reason and optimism to one controlled by fear,

madness, and destruction. Saturn devouring his own children represents Goya's conclusion that mankind is ultimately self-destructive, for to kill one's offspring is to destroy the future.

Spanish Art after Goya

Goya so dominates our modern-day notion of Spanish art at the turn of the eighteenth century that we often forget that he was one of many artists working in Spain at the time. His work was admired by his contemporaries for its inventiveness, bravura technique, and mastery of color. At the same time, he was criticized for a lack of patience and discipline and for his disregard of the rules of art.

Goya had few followers in Spain, in part because the Academy, reformed by Mengs, promoted a Classical curriculum. Most of the young painters used a style that was related to that of David. In fact, many of them studied with David who, at the turn of the eighteenth century, headed a huge teaching studio that attracted aspiring artists from all over Europe. José de Madrazo (1781–1859) is an excellent example of one of Goya's counterparts. His early *Death of Viriato* (FIG. 6-18) differs radically from Goya's *Execution of the Rebels* in style and iconography. Rather than

6-18 **José de Madrazo y Agudo,** *The Death of Viriato,* Oil on canvas, 10′1″ x 15′2″ (3.07 x 4.62 m). Museo del Prado, Madrid.

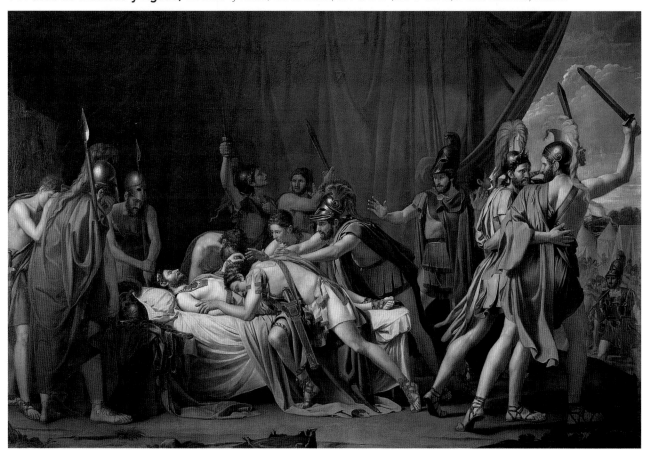

representing a contemporary war scene, it refers to it indirectly by representing a scene of Spanish resistance to Roman occupation in the second century BCE. Viriato, the hero of that war, led a guerrilla troop against the Romans. His death, at the hand of two of his soldiers who had been bribed by the enemy, signified the end of Spanish resistance. It also exposed the evil and cowardice of his Roman enemies. Madrazo's *Death of Viriato* exemplifies Neoclassical painting in its Classical, heroic theme as well as in its frieze-like composition. It recalls to mind some of David's famous deathbed scenes (*Andromache, Death of Socrates;* see FIGS. 2-17, 2-19), although it lacks their sobriety and simplicity.

Goya's successor as First Court Painter, Vincente Lopez (1772–1850), studied not with David, but at the Academy of Madrid, where, thanks to Mengs, he was likewise trained along Neoclassical lines. Lopez was one of the most important portrait painters in Spain in the first half of the nineteenth century. In addition to numerous portraits of the royal family (his *Portrait of Fernando VII* is in the Hispanic Society in New York), he painted a portrait of Goya at 80, two years before the artist's death (see FIG. 6-19). Done in the detailed, meticulous Neoclassical fashion, the portrait contrasts interestingly with Goya's own *Self-Portrait* (FIG. 6-20) painted eleven years earlier. The latter, painted in the sketchy manner of Goya's later years, shows the artist the way he saw himself—a rugged individualist, worn by the trials and tribulations of life. Lopez's portrait, more official and public in nature, shows a different Goya: feisty and crusty, but self-confident in the knowledge of his already historic position in the history of Spanish art.

6-19 **Vicente Lopez,** *Portrait of Francisco Goya,* 1826. Oil on canvas, 36½ x 29½" (93 x 75 cm). Museo del Prado, Madrid.

6-20 **Francisco Goya,** *Self-Portrait,* 1815?. Oil on canvas, 18 x 13¾" (46 x 35 cm). Museo del Prado, Madrid.

The Beginnings of Romanticism in the German-speaking World

While Britain, France, and Spain were political powers to be reckoned with in the eighteenth century, Germany as a political entity did not exist. The country was divided into hundreds of principalities and so-called free cities that were part of the Holy Roman Empire. This loose federation was nominally presided over by the Austrian emperors, who belonged to the powerful Habsburg dynasty.

With the exception of the kingdom of Prussia, ruled by the Hohenzollern family (the Habsburgs' only rivals), most German principalities were small. That did not prevent their rulers from competing for prestige with the kings of France and Spain or even the emperor himself. Every gingerbread prince wanted a royal-size castle and a court life to match. This left little if any resources for social programs or military defense. Moreover, the jealousy and competitiveness among the German princes prevented them from creating a union that could rival France or Britain to any degree.

This lack of unity allowed Napoleon to conquer much of the German-speaking world. Only the Austrian emperor and the king of Prussia would consider resisting Napoleon, and even they had to rely on coalitions with other nations, such as Britain and Russia, to defend themselves. Paradoxically, it was Napoleon's conquest of the German principalities that advanced German unity. At the famous Congress of Vienna, organized after Napoleon's fall in 1814, Germany's 300-odd states were reorganized in the new "German Confederation", comprised of thirty-five sovereign states and four free cities (see the map on p.158). This first step toward German unification culminated in the formal consecration of the German Empire at the crowning of Emperor Wilhelm I of Germany in the Gallery of Mirrors at Versailles in January 1871 (see FIG. 1-3).

The Romantic Movement

Although politically divided and economically weak, the German-speaking world of the turn of the eighteenth century was by no means a cultural backwater. The Germans excelled in music, philosophy, and literature. Wolfgang Amadeus Mozart (1756–1827) Joseph Haydn (1732–1809), and Ludwig van Beethoven (1770–1827) hailed from Germanic countries, as did Immanuel Kant (1724–1804), Georg Wilhelm Friedrich Hegel (1770–1831), Johann Wolfgang von Goethe (1749–1832), and Johann Friedrich Christoph von Schiller (1759–1805).

Towards the end of the eighteenth century, a new intellectual orientation was born in of this highly cultured milieu. Known as Romanticism, it was not merely a literary or artistic movement, but a state of mind, a new attitude to the world that differed radically from Enlightenment rationalism. In short, Romanticism privileged emotion, faith, and spirituality over intellect and reason. Romantics preferred spontaneity to calculation; individuality to conformity; and the freedom of nature over the constraints of culture.

At the Congress of Vienna in 1814 and 1815, Germany was reorganized into thirty-five states and four free cities. The map below shows the fifteen most important of the thirty-five states and the four free cities. Some of the larger states, such as Bavaria and Prussia, were ruled by kings; the smaller ones were ruled by dukes or counts.

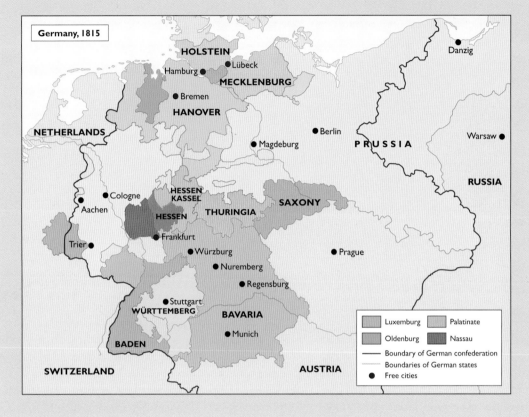

7.17-1 Map of the German Confederation.

As early as the 1770s the young Goethe and Schiller published several works that laid the foundation for Romanticism. In this body of literature, often referred to as "Storm and Stress" (*Sturm und Drang*), they exalted youthful passion and yearning. By far the most famous example of this new sensibility is Goethe's short novel *Die Leiden des jungen Werthers* (The Sorrows of Young Werther; 1774), written when the author was just 25 years old. This tragic tale of a young man who commits suicide because of unrequited love created an international sensation in its time. Written largely in the first person, it provided a direct insight into the psyche of an individual who, casting reason aside, let himself be swept away by his emotions.

Goethe was also one of the first German writers to celebrate the Middle Ages and to adopt a medieval ideal instead of the Classical paradigm that had been promoted by older Germans such as Winckelmann and Mengs. (We have seen, in chapter 3, that there was a similar trend in Britain.) To Goethe, the Gothic cathedrals of the high Middle Ages were the Northern European answer to Mediterranean Classicism. The lofty cathedral vaults, to him, recalled the tall, stately forests of Northern Europe. In his essay, *Von deutscher Baukunst* (*On German Architecture*), published in 1773, he compared the Christian spirituality of the Gothic cathedral to the pagan physicality of the Classical temple. Unlike Classical buildings, which were carefully planned and measured, Gothic architecture, to Goethe, was instinctive, natural, "felt."

The association forged by Goethe between emotion, spirituality, and nature on the one hand and the Middle Ages, Christianity, and German-ness on the other, became one of the central tenets of German Romanticism. In fact, the term "Romanticism" was derived from medieval "romances," popular ballads about adventurous knights that celebrated such primal emotions as love, hatred, and fear. Unlike elite medieval poetry, which was written in Latin following strict rules of rhyme and meter, these popular ballads were written in "Romance," the vernacular of the common people.

According to Friedrich von Schlegel (1772–1829), the poet–philosopher who first attempted to define the term "Romantic" in 1798, the spontaneity and the populist

character of the medieval romance were crucial features of Romanticism. As he wrote:

> Romantic poetry is a progressive, universal poetry … It will, and should… make poetry living and social, and life and society poetic… It embraces everything, if only it is poetic—from the greatest system of art… down to the sigh, the kiss, which the musing child breathes forth in artless song.

Early Nazarenes: Friedrich Overbeck and Franz Pforr

In the fine arts, Romanticism first manifested itself in the works of the so-called Nazarenes. This group of artists rejected Neoclassicism, aiming instead for an art of medieval or Christian inspiration, or both. The movement originated at the Academy of Vienna in 1809, when a group of six art students, including Franz Pforr (1788–1812), a native of Frankfurt, and Friedrich Overbeck (1789–1869), from the north German city of Lübeck, formed the Brotherhood of St Luke (*Lukasbund*), named after the patron saint of medieval and Renaissance artisans. Like the rebellious "Primitives" in David's studio (see page 126), they rejected Classical and High Renaissance examples promoted by the Academy, seeking new inspiration in the art of the fourteenth and fifteenth centuries. In the works of Italian artists such as Fra Angelico (c.1387–1455) and Perugino (c.1445/50–1523) they found an artlessness and sincerity that, they felt, was lacking in the more studied art of the High Renaissance. Among Northern artists, they especially admired the expressive, poignant works of Albrecht Dürer (1471–1528), Lucas Cranach (1472–1553), and others. Pforr spoke of the "noble simplicity and definite character" of sixteenth-century German art. By punning on Winckelmann's famous phrase about the "noble simplicity and quiet grandeur" of ancient art, he intended to compare and contrast the older Neoclassical precedent with the artistic creed of his own generation. Both Classicists and Romantics praised "simplicity," but the former associated it with ideal beauty, the latter with emotional sincerity.

The preoccupation of young German artists with their Germanic ancestry had a political motive as well. Since Napoleon was invading Germany, winning battle after battle, the Nazarenes, like all Germans, felt frustrated and humiliated. They were nostalgic for a medieval past when Germans had played a leading role in Europe. Rejecting the cosmopolitanism of earlier generations of German artists (Mengs, Tischbein) who, living in Rome, had mingled with artists and patrons from all over the world, they wanted to remain closely linked within their German artistic confraternity.

In light of all this, it seems paradoxical that, in 1810, the members of the Brotherhood of St Luke decided to move from Vienna to Rome. Political necessity, not artistic motivation, prompted this decision. After the battle of Wagram of 1809 (see *Napoleonic Battles*, page 111) Vienna was occupied by the French, making life in the city difficult for young artists. Italy became a place of asylum for the Nazarenes. Soon after their arrival in Rome, the members of the Brotherhood received permission to use a vacant monastery. There, living like monks, they worked in their cells during the day and had communal meals and other group activities at night. They also let their hair grow long and wore loose robes to look like biblical figures—hence their nickname Nazarenes or "men from Nazareth."

This monastic lifestyle may have been inspired, in part, by a small book that had something of a cult following at the time—the *Herzensergiessungen eines kunstliebenden klosterbruders* (Outpourings from the Heart of an Art-Loving Monk; 1797). Written in the first person as if by a monk, this peculiar book was, in fact, the work of a young lawyer, Wilhelm Heinrich Wackenroder (1773–1798), who wrote about a triangular relationship between art, nature, and religion. Unlike Classicists such as Mengs, he did not see art as an attempt to overcome human imperfections by emulating abstract ideals. To him, both art and nature were direct manifestations of the Creator, and both were worthy of great reverence. The role of the artist, according to Wackenroder, was to infuse his work with "universality, tolerance, and human love."

Two paintings by Overbeck and Pforr, painted soon after their arrival in Rome, show influences from both Wackenroder and early Romantic authors such as Goethe and Schiller. Friedrich Overbeck's *Portrait of Franz Pforr* (FIG. 7-1) shows the young Pforr, in quasi-medieval dress, seated near the archway of a medieval loggia. Behind him sits a young woman, presumably his wife, who is knitting and reading. A medieval German city with a tall Gothic church is seen in the background through a second arch.

Overbeck's *Portrait of Franz Pforr* does not reflect reality, for Pforr lived in Rome when Overbeck painted his portrait and was not married. Instead, it represents him, as Overbeck wrote to a friend, "in a surrounding in which he would perhaps feel happiest." In his portrait of Pforr, Overbeck represented the Nazarene ideal of the modern German artist. The artist's modest pose and chaste surroundings express the Nazarenes' conviction that, as Pforr put it, "the way to become a truly great painter is identical with the path of virtue." The painting contains numerous references to Christianity, including the Gothic cathedral, the lily (symbolizing the Virgin Mary), the grapevine (symbolizing the Eucharist), and Pforr's own emblem, the skull and cross. Finally, it pays homage to Northern European art, containing obvious allusions to South Netherlandish and Dutch painting, and resembling self-portraits by Dürer in spirit. Dürer's *Self-Portrait with Thistle* (FIG. 7-2), for instance, seems to possess a similar earnestness and intensity.

Overbeck's *Portrait of Franz Pforr* exemplifies the Romantic notion that art is not imitation but transformation. The artist reshapes the subject according to his personal vision, creating an image that brings out the subject's inner nature. The artist has used intuition and imagination to access the inner spirit. Neoclassical artists had sought to improve on reality by infusing it with eternal ideals of beauty; by contrast, Romantics altered reality by trying to reveal the essence and spiritual core of their subjects.

Pforr was 22 years old when he sat for Overbeck's portrait. He had only two more years to live. In 1811, already ill, he painted a friendship picture for Overbeck, completing it only a few months before his death. Such pictures were painted by artists for one another to express their mutual friendship and admiration. Pforr's *Shulamit and Mary* (FIG. 7-3) shows two biblical figures, yet it is not a religious work. Its main purpose was to express Pforr's view of Overbeck's artistic ideals and their relation to his own. *Shulamit and Mary* takes the form of a late-medieval diptych (i.e. a painting done on two separate but connected

panels). Shulamit from the Old Testament is shown on the left, Mary from the New Testament on the right. Mary is seated in a Renaissance interior not unlike the ones seen in some of Dürer's prints. With her prayerbook, her sewing basket, and her cat, she exemplifies German virtue, piousness, and domesticity. Shulamit, the Beloved from Solomon's Song of Songs, is rendered in the guise of a *Madonna* by Perugino or Pinturicchio (c.1452–1513). Cradling a child in her arms, she sits on a grassy bank in a sunny garden overlooking an Italian town. In the middle distance, Overbeck, long-haired and in Nazarene dress, enters Shulamit's peaceful domain. His hands are folded to indicate his reverence for this ideal of virtue and beauty.

Pforr's painting exemplifies the eclecticism of the Nazarene painters, who were inspired now by Italian, then by German, Renaissance painting. In this friendship picture, he opposes his own preference for Northern European painting to Overbeck's love of early Renaissance art in Italy. The painting also suggests the importance of both nature and religion as sources of inspiration. Implicit in

7-3 **Franz Pforr,** *Shulamit and Mary,* 1811. Oil on canvas, 13⁹/₁₆ x 12⁵/₈" (34.5 x 32 cm). Georg Schäfer Collection, Schweinfurt, Germany.

the elaborate landscape background of the Shulamit panel, this idea is made explicit in the decorative paintings in the arches above, in which flowers and birds are juxtaposed with an image of the Cross. Furthermore, by the inclusion of St John, author of the mystical Apocalypse or Revelation (the last book of the New Testament), in the triangular spandrel between the two panels, Pforr has emphasized the importance of inner vision for art.

Later Nazarenes: Peter Cornelius and Julius Schnorr von Carolsfeld

The presence of the Brotherhood of St Luke in Rome split apart the community of expatriate German artists into Classicists, on one side, and "Medievalists" or Romantics, on the other. Before long, the Brotherhood began to attract several German artists who were motivated less by the

new Romantic ideals espoused by Overbeck and Pforr, than by their dislike of the Classicists. Among them were a number of devoutly Roman Catholic artists who were averse to Classical art for the simple reason that it was pagan. After the death of Pforr in 1812 and the conversion to Catholicism of Overbeck in 1813, the Catholic element became increasingly important within the Nazarene group. Henceforth, its main preoccupation became the revival of religious painting, a genre that had lost much of its importance during the eighteenth century.

It was a newcomer, Peter Cornelius (1783–1867), admitted into the Brotherhood in 1812, who became the leader of this revival. Cornelius's dream was to restore religious painting to its former glory during the High Renaissance period. To do so, he felt, it was necessary to return to mural painting, since it allowed artists to give to religious painting the size and scope it deserved.

In 1816 Cornelius secured a first major religious commission for the Nazarenes—the creation of a series of murals in the house of the Prussian consul Salomon Bartholdy in Rome (later transferred to the Alte Nationalgalerie in Berlin). Five artists were involved in the project, most importantly Cornelius and Overbeck. The theme of the murals was the story of Joseph, as told in the biblical Book of Genesis. Cornelius insisted that they be painted in the traditional fresco technique, which involves painting on the freshly plastered wall while it is still wet. His own fresco, which represents *The Reconciliation of Joseph and his Brothers* (FIG. 7-4), demonstrates the new direction that Nazarene painting took after Pforr's death. This monumental painting no longer harks back to late medieval and early Renaissance art, but takes its cues from the art of the High Renaissance, particularly from Raphael's frescoes in the Vatican palace. With its Classical setting and costumes, its tour-de-force perspective, and its sculptural, richly draped figures, it is a far cry from Pforr's *Shulamit and Mary* painted only seven years earlier.

It was Cornelius, together with the slightly younger Julius Schnorr von Carolsfeld (1794–1872), who was responsible for popularizing the revised Nazarene style in

7-4 **Peter Cornelius,** *The Reconciliation of Joseph and his Brothers,* 1817. Fresco, 7'9" x 8'6" (2.36 x 2.90 m). Alte Nationalgalerie, Berlin.

7-5 **Peter Cornelius,** *The Last Judgment,* 1836–9. Fresco, c. 59'1" x 35'2" (19 x 11 m). Ludwigskirche, Munich.

Germany. Both artists were employed by Ludwig I of Bavaria (reigned 1825–48), perhaps the greatest art patron in Germany in the first half of the nineteenth century. Ludwig commissioned them to paint frescoes for the numerous building projects—churches, libraries, museums, etc.— that he initiated in the Bavarian capital of Munich. Cornelius's frescoes for the Glyptothek (museum of Classical sculpture) and the Alte Pinakothek (museum of paintings by the old masters) were destroyed during World War II, but those in the Ludwigskirche have been preserved. His enormous fresco of the Last Judgment (FIG. 7-5) contains obvious references to Michelangelo's fresco of the same subject in the Sistine Chapel, although it also includes borrowings from Raphael and other sixteenth- and seventeenth-century masters. Cornelius's goal was, indeed, to build on the entire tradition of painting, yet, at the same time, to create something new and of the nineteenth century. To this end, he focused less on creating an imagined illusion of the scene than on bringing out its theological importance by symbolic means. He refrained from using the dramatic poses, bold gestures, and vivid colors that make the work of a Michelangelo or Raphael visually interesting. Instead, he preferred commonplace poses and gestures whose significance was easy to grasp and he chose his colors more for their symbolic value than for their aesthetic appeal. It is difficult for us today to understand the enormous esteem in which Cornelius was held in the nineteenth century. If we fail to see the originality of his art, it may be because it had such a wide following that it became part of what we may call popular religious culture. Much of what we see to this day, in church windows and murals, devotional images, and religious book illustrations bears his stamp and that of his Nazarene colleagues.

While Cornelius was covering the walls of the new churches and museums of Munich, Schnorr von Carolsfeld was engaged to decorate the royal palace or "Residenz". For the royal rooms on the ground floor, Ludwig had originally envisioned a series of murals on themes from Homer's *Iliad* and *Odyssey*, but he later opted for paintings illustrating their German equivalent, the so-called *Nibelungenlied* (Song of the Nibelungs). This long epic poem was among the first major works of literature in the German language. Written about 1200 by an unknown author, it was probably a compilation of old legends that went back to the time of the Germanic invasions in the first centuries CE. The poem is centered on the love affairs, quarrels, and intrigues of several Germanic princes, who all end up dead in the process. The revived interest in the *Nibelungenlied* was symptomatic of the Romantic nationalism that swept across Europe in the wake of the Napoleonic invasions (see page 111). Indeed, the *Nibelungenlied* became a nucleus around which a culture of German nationalism was constructed. The poem formed the basis of a famous opera cycle, the so-called *Nibelungen Ring* composed by Richard Wagner (1813–1883) in the third quarter of the nineteenth century. And it remained a mainstay of German nationalism even into the twentieth century, since Hitler appropriated it for the Nationalist Socialist German Workers' Party cause.

In Schnorr's *Death of Siegfried* (FIG. 7-6) the prince of the Nibelungen, Siegfried, is about to be killed by Hagen, the henchman of his brother-in-law Gunther, king of the Burgundians. The scene takes places in a dark Germanic forest. Unaware that Hagen has sneaked up behind him, Siegfried is drinking from a cow horn filled with water from a nearby spring. The cowardice of his opponent is made the more obvious since Hagen is not alone but accompanied by three knights, who approach silently and cautiously to help him kill Siegfried, if necessary.

Like Cornelius, Schnorr abandoned the sober early Nazarene style of painting based on fifteenth-century Italian frescoes and German Renaissance painting. With its pronounced sense of depth, its complex background, and highly detailed figures, this work is an eclectic combination of elements derived from sixteenth- and

7-6 **Julius Schnorr von Carolsfeld,** *Death of Siegfried* from the *Nibelungen Cycle*, 1827–67. Fresco, Residenz, Munich.

seventeenth- century Italian as well as Northern European painting. Like the religious frescoes of Cornelius, Schnorr's historic narrative murals were extremely influential: they became models for generations of town hall muralists as well as fairy book illustrators.

German Painting in Context

Nazarene painting, the most influential German art movement of the turn of the eighteenth century, at first glance is vastly different from the works of Philipp Otto Runge (1777–1810) and Caspar David Friedrich (1774–1840), two artists who are seen today as the greatest German painters of the period. To understand this difference—and the heterogeneous character of early nineteenth-century

German art in general—we must remember the country's fragmented political condition. The thirty-nine states and free cities that constituted "Germany" were quite unlike one another politically, socially, and culturally. In addition, there were important religious differences, because the north of Germany was predominantly Protestant and the south was Roman Catholic.

Unlike most European countries—Britain, France, Spain—where art was centered in the capitals, Germany had no single art center but several. In some of these, such as Munich, there was a large apparatus of official stage patronage, offering employment to dozens if not hundreds of artists. In others, art patronage was primarily an activity of private citizens who bought paintings for their homes. Artistic training, too, was not centralized in Germany as it was in France or Britain, where to attend the academies

of Paris or London was the dream of every aspiring artist. Germany had a number of respected academies—in Berlin, Dresden, Düsseldorf, Leipzig, and Munich—each of which had a distinct history and curriculum. In addition, numerous artists studied outside Germany, especially at the academies of Vienna, Copenhagen, and Paris.

If there was a common denominator in German art of the early nineteenth century, it was the importance of religion, in the broadest sense of the word. This set German art, especially painting, apart from art elsewhere in Europe, most notably in France. The spiritual content of German painting, no doubt, was closely related to the burgeoning Romantic movement in German literature. Nearly all German artists of the turn of the eighteenth century seem to have been familiar with the writings of the *Sturm und Drang* (Storm and Stress) group and of such early Romantic writers as Schlegel and Wackenroder, and few remain untouched by their ideas.

Philipp Otto Runge

The painter Philipp Otto Runge is a case in point. Born in Wolgast, a small town on the Baltic Sea, he was trained at the Academy of Copenhagen. Having moved to Dresden in 1801, he became acquainted with several early Romantic writers, including Friedrich Schlegel and Ludwig Tieck (1773–1853), a close friend of Wackenroder. Tieck introduced Runge to the writings of Friedrich Böhme, a sixteenth-century Protestant mystic. Runge's devout Lutheran upbringing made him particularly receptive to Böhme's thought, which was a fusion of Lutheran theology and Renaissance nature mysticism. Böhme's belief that "nature is a counter-stroke of divine knowledge, through which the eternal (single) will… makes itself visible, perceptive, working and willing," made a great impression on Runge. It seems to have shaped his belief that the highest expression of the divine in art is achieved not in paintings or sculptures of religious subjects but in the painting of nature. As early as 1802 he wrote:

> We are standing at the brink of all religions that grew out of Catholicism, the abstractions are dispersing, everything is lighter and airier than before; everything tends towards landscape, seeks something definite in the indefiniteness and does not know how to begin it. Is there not then in this art—call it landscape if you like—a highest point to be achieved?

Runge was one of the first artists in the nineteenth century to see landscape as the art form of the future, the only one in which the moderns could surpass the ancients, for the simple reason that the latter had not practiced it. Yet, at the same time, he did not quite know "how to begin it."

Accordingly, Runge painted few if any "pure" landscapes, though landscape and natural forms, particularly flowers, do play a crucial role in many of his figure paintings.

The *Rest on the Flight to Egypt* (FIG. 7-7) is an early example of a work in which Runge attempted to express the essence of Christianity by means of landscape. The painting represents a traditional religious theme, the Holy Family resting on their flight to Egypt. In Runge's painting, they have just woken up after having camped out in the open. Joseph is making a fire; Mary rubs her hands together to warm them. In the center of the painting, the Christ child, all naked, reaches out his arms to the warming light of dawn. By establishing a direct connection between the infancy of Christ and the beginning of a new day, Runge helps the viewer to read dawn symbolically as the beginning of a new era, the world of the New Testament.

Behind the Christ child rises a flowering tulip tree, which calls to mind the beautiful tree of knowledge in Paradise. In this tree, however, there is no snake, but two little angels. One blows a trumpet; the other holds a lily, traditional symbol of the Madonna and therefore purity and the absence of sin. A vast panoramic landscape stretches out behind the Holy Family. Filled with ancient structures—pyramids, temples—it suggests the long course of history before the coming of Christ. The colors of the sky—blue, yellow and reddish-pink—may be significant as well. Just as Böhme, influenced by alchemical theory, considered chemical elements to be endowed with religious meaning, so Runge felt that colors could be invested with symbolic significance. While Böhme had proclaimed that salt, mercury, and sulphur reflect the Trinity, Runge allied the primary colors—blue, red, and yellow—with the Father, the Son, and the Holy Ghost, respectively.

Runge's *Rest on the Flight to Egypt* clearly introduces something new—the endowment of natural phenomena and forms with spiritual meaning. This trend is seen more clearly in *Morning* (FIG. 7-8), a preliminary sketch for the first of a series of four large paintings representing the times of day (morning, noon, evening, night). This series preoccupied Runge for most of his brief career since he intended it to be his legacy to the world. The artist envisioned the four paintings as the main element in a monumental *Gesamtkunstwerk*, a work of art combining several different art forms. He intended the paintings to be seen in an architectural setting, inside a Gothic space, especially constructed for the purpose, to the accompaniment of music and poetry readings.

At the time of Runge's death, at the age of 33, the artist had made numerous preliminary drawings and sketches for the series but he had not completed a single painting. An early set of conceptual drawings, made in 1803 (FIG. 7-9), indicates just how different and original his ideas for the series were. The four times of day are represented by symmetrical, stylized plants, surmounted by women and *putti*. Once again, Runge appears to have

been influenced by Böhme, in whose writings flowers serve as symbols of states of awareness.

In the oil sketch for *Morning*, made five years after the drawings, the original concept has changed dramatically. While Runge has retained the large lily flower as a central element, it is here carried by a nude female figure whom Runge calls now Aurora then Venus (goddesses of

7-7 Philipp Otto Runge, *Rest on the Flight into Egypt,* 1805–6. Oil on canvas, 38 x 51" (96.5 cm x 1.3 m). Kunsthalle, Hamburg.

7-8 Philipp Otto Runge, *Morning* (oil sketch), 1808. Oil on canvas, 41 x 32" (1.06 m). Kunsthalle, Hamburg.

7-9 **Philipp Otto Runge,** *The Times of Day* (conceptual drawings), 1803. From the top (left to right). *Morning.* Pen, 28⅜ x 19″ (72.1 x 48.2 cm). *Midday.* Pen, 28 x 19″ (71.7 x 48 cm). *Evening.* Pen, 28⅜ x 19″ (72.1 x 48.2 cm). *Night.* Pen, 28¹/₁₆ x 19″ (71.5 x 48 cm). Kunsthalle, Hamburg.

7-10 **Raphael,** *Sistine Madonna,* 1512–13. Oil on canvas, 8'7" x 6'4" (2.65 x 1.96 m). Gemäldegalerie, Dresden.

dawn and love, respectively). Arising from a layer of pink and blue clouds, she is at the center of an orb of golden light—the rising sun—the periphery of which is defined by little winged *putti*. Down below, in a verdant green meadow lies a little baby, surrounded by flowers. Two additional *putti* kneel in adoration on either side of it. As in the *Rest on the Flight to Egypt*, in *Morning* Runge has established a series of connections—between dawn, light, purity (the lily), spring, birth, Christ, love—that seem to suggest that every thing and every concept in the universe is somehow related and fits within a divine scheme.

The religious message of the painting is further enhanced by the elaborate frame. At the bottom, the sun rises behind an earth blackened by sin. From it emerge two *putti*, who reach out to two other beings who are imprisoned in the darkness of the earth by the roots of an amaryllis bulb. These appear to be angels or divine spirits who are coming to the rescue of earthly sinners. On the two sides of the frame, blond putti arise from the amaryllis flowers. They may represent the souls, redeemed from sin by the Passion of Christ (symbolized by the intense red color of the flowers). The white lilies that rise behind their heads

may represent their new-found purity. Two winged *putti* kneel inside the opened blossoms and bend their heads in adoration of God, represented by a blue heaven filled with little angel heads. The frame thus reinforces the general tenet of the series of paintings, namely the cyclical nature of life, from birth through life to death and resurrection— a cycle that resembles the times of the day.

Unusual as *Morning* may appear to us today, its visionary imagery was not entirely unprecedented. Runge, in fact, appears to have derived his vision of love, life, and purity from Raphael's *Sistine Madonna* (FIG. 7-10) in the Dresden Museum. His painting may be seen as a personal "reworking" of the traditional Roman Catholic theme of the Assumption (the entrance of the Virgin into heaven), which anticipated the blessed state promised to the rest of mankind.

To support himself while he was producing his ambitious *Gesamtkunstwerk*, Runge painted portraits. Perhaps the most interesting of these is the *Portrait of the Huelsenbeck Children* (FIG. 7-11). The three children of his brother's business partner are portrayed in front of their home, just outside Hamburg. The two older ones, a girl and a boy, pull a wooden cart that holds their chubby baby sister or brother (male babies in the nineteenth century often wore skirts). Masculine and feminine roles are already clearly defined as the girl looks and reaches towards the baby with a protective gesture, while the boy aggressively brandishes his whip. As in Runge's religious and symbolical paintings, landscape plays an important role in this portrait. The lush meadow in the background, the large sunflowers that frame the left side of the painting, and the verdant tree that frames it on the right, all reaffirm the

7-11 **Philipp Otto Runge,** *Portrait of the Huelsenbeck Children,* 1805–6. Oil on canvas, 4'3" x 4'6" (1.31 x 1.41 m). Kunsthalle, Hamburg.

health and well-being of the children, whose chubby bodies and red cheeks seem to burst with life. The little village in the background speaks of a simple, uncomplicated lifestyle that characterizes the wholesome upbringing of the children. All this brings us back to Runge's statement that "everything tends towards landscape." Clearly, to Runge the landscape backgrounds in his figure paintings were more than just "backgrounds." Both in his religious–symbolic paintings and in his portraits, the landscape settings are as pregnant with significance as his figures. To Runge, however, landscape could never be the chief or even the sole carrier of meaning. For that, we have to turn to the work of Caspar David Friedrich.

Caspar David Friedrich

Today, Runge and Friedrich are considered Germany's leading Romantic painters. Neither artist, however, enjoyed a wide reputation in his own day. In Runge's case, this was due in part to his early death and the paucity of his work. Yet it is also true that his art was highly idiosyncratic. Runge's mystical visions, such as *Morning*, were different from anything else that was produced in Germany at the time. Indeed, even outside Germany, there were few artists other than, perhaps, Blake, whose work matched Runge's visionary scope.

While lacking the mystic overtones of Runge's work, Friedrich's works were also highly original and outside the artistic mainstream. Not only did he practice landscape painting, a "lower" genre that was less valued than history painting, but Friedrich also brought to landscape painting a personal vision that was outside the range of the conventional Classical landscape then in vogue.

Friedrich's upbringing and background were remarkably similar to Runge's. Like Runge, he came from Pomerania, a region in northeastern Germany bordering the Baltic Sea, which since 1648, had been a part of Sweden. He, too, studied first with a local drawing teacher, then went to the academy in Copenhagen. Like Runge, again, he went from Copenhagen to Dresden which, at the time, was an important center of art and culture in eastern Germany. Yet, while Runge eventually settled in Hamburg, Friedrich remained in Dresden, though he made frequent visits to his home town of Greifswald.

Both Friedrich and Runge grew up in a Protestant milieu and were much influenced by the writings of Gotthard Ludwig Kosegarten (1758–1818), a pastor–poet from Runge's home town of Wolgast. In his sermons and poetry, Kosegarten preached that the personal experience of nature,

7-12 **Caspar David Friedrich,** *Monk by the Sea*, 1809–10. Oil on canvas, 8'8" x 7'6" (1.1 x 1.72 m). Nationalgalerie, Berlin.

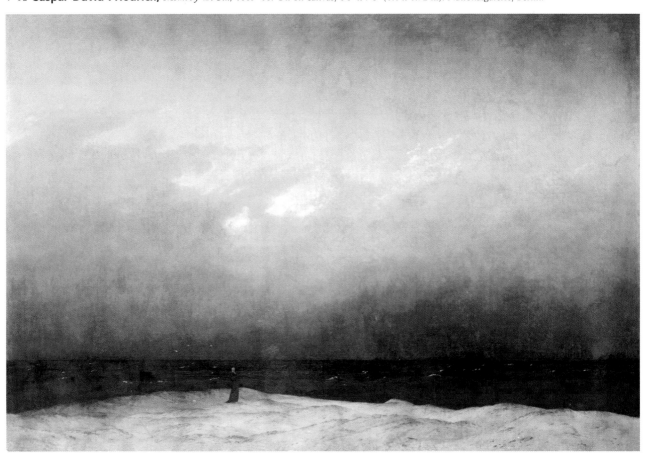

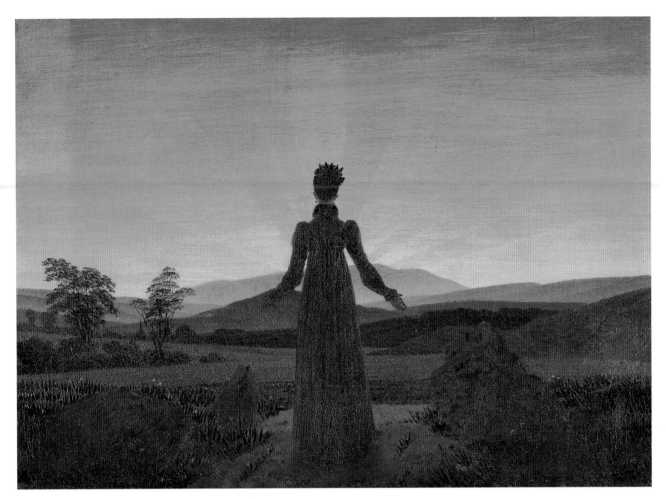

7-13 **Caspar David Friedrich,** *Woman in Front of the Setting Sun,* c.1818–20. Oil on canvas, 8¹¹/₁₆ x 11¹³/₁₆" (22 x 30 cm). Folkwang Museum, Essen.

God's creation, led to a greater understanding of the divine. Kosegarten's theology fell short of Pantheism, the doctrine that God dwells in, and is identical with, nature. To Kosegarten, God was not in but above nature. But just as his wisdom was revealed in the Bible, so he manifested himself in the "Book of Nature."

Kosegarten's view of nature as a manifestation of the divine was neither new nor unique at the turn of the eighteenth century. Indeed, it was an idea that permeated much early Romantic writing. What made Kosegarten's writing particularly meaningful to Friedrich was that the nature imagery he used in his sermons and poetry was directly inspired by the Baltic coast and the offshore island of Rügen, the scenery that Friedrich had learned to love in his youth.

Friedrich's early *Monk by the Sea* (FIG. 7-12) reflects the near-religious awe of nature that marks Kosegarten's writings. Striking in its stark simplicity, this painting represents a coastal scene—beach, sea, sky—populated only by the minute figure of a Capuchin. As we put ourselves into the shoes of the monk, we cannot help feeling overwhelmed by the vast expanse of ocean, the barren headland, the empty horizon, and the enormousness of the sky. Friedrich's

painting evokes Kosegarten's line about "the trumpets of the sea and the many-voiced pipe organ of the storm." Both painter and poet seem to suggest that the contemplation of nature is analogous to a religious experience.

In *Monk by the Sea* Friedrich first introduced, what the Germans call, a *Rückenfigur*—a figure, male or female, seen from the back. Invariably engaged in the contemplation of nature, the *Rückenfigur* became an important motif in many of Friedrich's later landscapes. Its function was to draw the spectator into the painting by inviting her to identify with the figure. Paradoxically, however, the *Rückenfigur* also has the potential to keep us (the viewer) outside of the painting as we are always standing behind him and thus are one step removed from his visual experience.

One of the most striking uses of the *Rückenfigur* in Friedrich's art is seen in *Woman in Front of the Setting Sun* of around 1818 (FIG. 7-13). Standing on a path leading through a meadow, a young woman watches the sun setting behind the mountains in the distance. Her slender figure is darkly silhouetted against a pink, yellow, and orange sky. Once again we are reminded of the sermons of Kosegarten, who described the sun as "the visualized image of the hidden Father/Who dwells in the light that blinds all those who

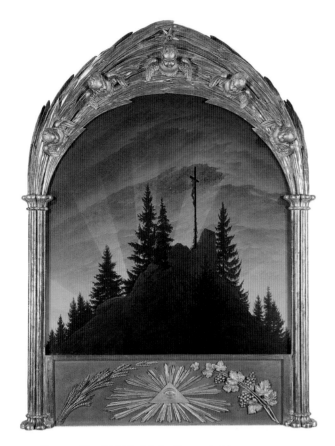

7-14 **Caspar David Friedrich,** *Cross in the Mountains* or
Tetschen Altar, 1807–8. Oil on canvas, 45⁵/₁₆ x 43″ (1.15 x 1.11 m).
Gemäldegalerie, Staatliche Kunstsammlungen, Dresden.

natural and manmade elements shown in the painting
made up a complex allegory of Christian faith.

Friedrich's painting is set in an elaborate gilded frame,
which he designed himself but was carved by a sculptor
of his acquaintance. The frame's traditional religious sym-
bols reaffirm the meaning of the painting. Its rectangular
base shows God's all-seeing eye set in a triangle (the Trin-
ity), surrounded by rays of light. Flanking it, a sheaf of
wheat and a branch of a grapevine are signifiers of the
bread and wine of the Eucharist. The top of the frame,
which is pointed like a Gothic arch, is composed of palm
leaves, interspersed with little cherub heads.

Friedrich appears to have begun *Cross in the Mountains* as
a tribute to Gustavus Adolphus IV of Sweden (reigned
1796–1809), then the king of the artist's native Pomera-
nia. In the end, however, it was acquired by the Count and
Countess von Thun of Bohemia, who told Friedrich they
wanted to place it on the altar of their palace chapel in
Tetschen (Czech Republic). Before shipping the work to
Tetschen—where it would end up in the countess's bed-
room—Friedrich invited the public to come and view it
in his studio. (This was not an unusual practice as we have
seen already in the case of David.) So that visitors would
appreciate the painting's intended effect as an altarpiece,
he placed it on a table, covered with a black cloth. He also
veiled the studio windows, "to imitate as well as possible
the twilight of the lamplit chapel." Public reaction to the
painting was mixed. The conservative critic Friedrich von
Ramdohr fiercely criticized the painting in a lengthy review
in the *Zeitung für die Elegante Welt* (Journal for the Elegant
World). Ramdohr criticized Friedrich for elevating a land-
scape to the status of religious painting, thus ignoring the
hallowed hierarchy of genres. He also contested the fact
that landscape painting could function as an allegory, since
allegories, by definition, were personifications, that is,
human figures whose attributes lent them specific meaning.

Friedrich defended himself in a letter to an acquain-
tance, parts of which were published in the *Journal des Luxus
und der Moden* (Journal of Luxury and Fashion). He asserted
the artist's right to break with tradition and leave the beaten
path for, he wrote, "the roads that lead to art are infinitely
varied." Friedrich denied that there was a single absolute
ideal of beauty and perfection for all artists and which was
achieved by copying standard models and following set
rules. Art, to him, was "at the center of the world, at the
center of the highest spiritual effort." To arrive at that
center each artist had to go his or her own way. Friedrich's
statement was of great importance for the development
of modern art because it made the claim for the necessity
of originality.

The debate between Ramdohr and Friedrich clearly
demonstrates a contemporary awareness that art and
culture were experiencing a revolution. Romanticism had
displaced Rationalism, Classicism, and the concept of an
absolute ideal of beauty on which it was founded. Both

approach." In that context, the woman's body language
and arm gestures may be read as an expression of amaze-
ment, awe, even prayer. The arm gestures may also have
a more specific meaning, however, because it appears that
the woman is pointing to two rocks, traditional symbols
of Christian faith. Seen in combination with the setting
sun, they may serve as a demonstration that faith triumphs
over death. For just as sure as the sun will rise again the
next morning, so the Christian of true faith will be reborn
to eternal life.

The power of Christian faith in the face of death is also
the theme of Friedrich's most unusual work, *Cross in the
Mountains* (FIG. 7-14). This arch-shaped painting shows a
cragged cliff, dotted with pine trees. Near the top of the
rock stands a tall wooden crucifix, its gilded bronze Christ
illuminated by the last rays of the evening sun. Friedrich
himself, in a brief commentary on the picture, explained
the significance of its individual elements. While the rock
represented the solidity of Christian faith, the evergreen
trees and the ivy climbing up the cross were symbolic of
the undying hope of mankind. The setting sun signified
Jesus' departure from the world, but the golden Christ
figure on the Cross indicated that, from heaven, his
light still shone on the earth. Together, it appears, the

Ramdohr and Friedrich explicitly referred to this change. Ramdohr wrote disparagingly of "that mysticism that is now slinking in everywhere and that wafts towards us… like a narcotic vapor." While Friedrich retorted half mockingly, half seriously:

It must sadden a man like Kammerherr von Ramdohr, when he sees the abomination of his time, the specter of approaching barbarism, black as the night, entering defiantly, scornfully trampling all rules, all chains, and all bonds with which the spirit was tied down and restrained from leaving the paved road. Doesn't the artistic spirit of our time cling with a foolish, lamentable faith to an imagined, spiritual being, that knows no boundaries? Doesn't he follow with childlike, even childish enthusiasm every sacred stirring of his heart? Doesn't he embrace in blind surrender every pious presentiment, as if it were absolutely the purest, clearest source of art?

While *Monk by the Sea*, *Woman in Front of the Setting Sun*, and *Cross in the Mountains* all contain some elements that make specific references to Christianity (the monk, the rocks, the cross), many of Friedrich's work are spiritual only in the most general way. His *Moonrise over the Sea* (FIG. 7-15), part of a commission for two paintings representing morning and evening, depicts two women and a man seated on a rocky shore watching the moon rise from behind the evening clouds. Two sailboats are coming into the harbor and their crews begin to lower the sails. The end of their journey no doubt causes the spectators (both inside and outside the painting) to think of death—a thought that is also evoked by the evening sky. While here, again, it is possible to interpret the rocks as symbols of faith and the rising moon as a symbol of resurrection, the painting owes its impact on the viewer primarily to its mood of nostalgia and reverie. It is easy to identify with the three figures in the picture since most of us have similarly experienced the tinge of melancholy combined with awe that a beautiful sunset inspires.

While, in his own time, his art had little impact beyond his immediate circle of artists and intellectuals in Dresden, Friedrich is seen today as the most important Romantic painter in Germany. His work seems to sum up all the main characteristics of Romanticism—subjectivity, individualism, spirituality, and love of nature. The continuing relevance of these tendencies, even in the twenty-first century, goes a long way to explain the enduring appeal of Friedrich's art.

7-15 Caspar David Friedrich, *Moonrise over the Sea*, 1822. Oil on canvas, 21¹¹/₁₆ x 28" (55 x 71 cm). Nationalgalerie, Berlin.

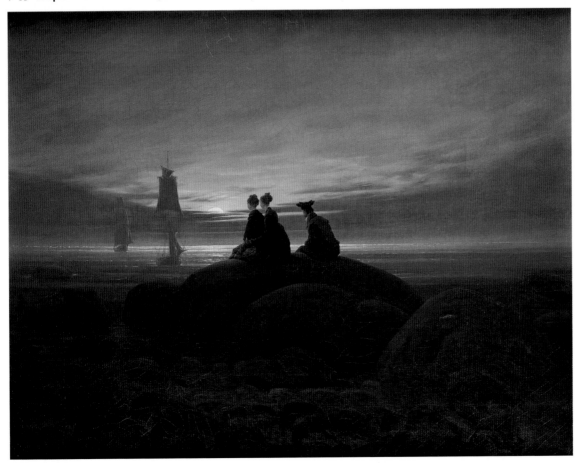

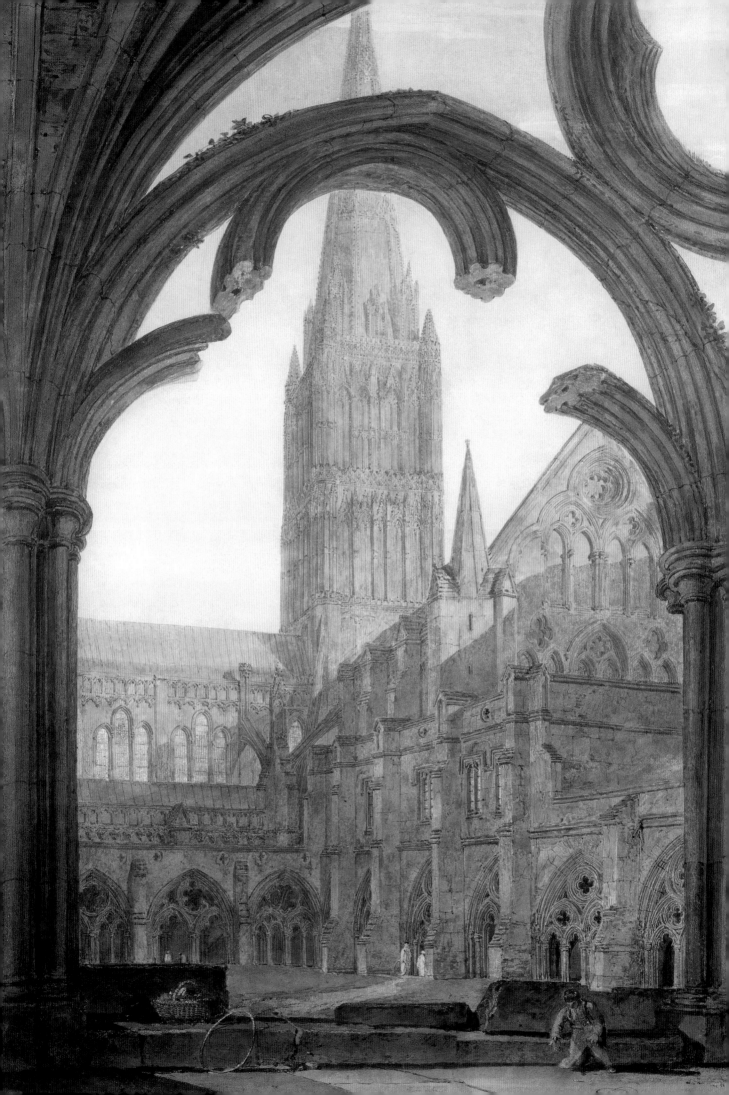

Chapter Eight

The Importance of Landscape—British Painting in the Early Nineteenth Century

Runge's pronouncement, in 1802, that "everything tends towards landscape" (see page 165), seems almost prophetic in retrospect. In the following decades, landscape painting would grow and flourish until, by the middle of the nineteenth century, it was one of the most popular painting genres in Europe. Landscape even became an accepted discipline in most academies, although it never quite gained the prestige of history painting.

The rise in importance of landscape painting was not confined to Germany, but occurred in most western European countries, as well as North America. Yet, perhaps, nowhere was that rise more dramatic than in early nineteenth-century Britain. This is not to say that all British painters suddenly turned to landscape, or even that landscape painting came to dominate the Royal Academy exhibitions. But to posterity the landscape painters of the late Georgian era (see *Georgian Britain*, page 72) came to define this period at the expense of artists working in all other genres.

A growing awareness of nature, beginning around 1770, fueled the renewed interest in landscape painting. Although often seen as an integral part of the Romantic *zeitgeist* or spirit of the age, the new enthusiasm for nature had diverse origins and attributes. In France (see page 122), the writer-philosopher Jean-Jacques Rousseau had advocated a "return to nature," to escape the artificiality of civilization. In Germany (see page 158) *Sturm and Drang* (Storm and Stress) writers such as Goethe and Schiller had drawn parallels

between human emotions and nature's "moods" (a phenomenon that would later be called the pathetic fallacy). Two decades later, German Romantic writers and artists such as Wackenroder, Kosegarten, Friedrich, and Runge saw nature as manifesting the divine. In Britain, meanwhile, the naturalist movement was related to the development of regional tourism, with a distinct nationalist dimension.

Nature Enthusiasm in Great Britain

The French Revolution of 1789 and the subsequent Napoleonic wars made an end to the Grand Tour (see *The Grand Tour*, page 66). Traveling to the Continent became difficult and dangerous. British tourists, who had previously flocked to Italy, were redirected to the south coast of England, the Lake District in the northwest, and to Scotland. Except for the occasional Gothic building or ruin, these destinations had limited cultural riches, but their natural beauty was astounding.

This beauty seemed the more precious since large tracts of the British countryside were claimed by industry: coal mines, textile mills, lime kilns, forges, and the like. While most people recognized the utility of such establishments and some even admitted to their occasional sublimity, they nonetheless regretted the loss of the old pastoral England. William Blake lamented the presence of the "dark Satanic mills... in England's green and pleasant Land." The poet

8-1 **John Laporte,** *A Pithead Near an Estuary,* 1809. Watercolor, 12³/₈ x 17¹/₈" (31.4 x 43.5 cm). Ironbridge Gorge Museum, Shropshire, Elton Collection.

Anna Seward (1748–1808), shocked by the ugly mines at Coalbrookdale in the English Midlands, felt that the region's "grassy lanes" and "woodwild glens" had been "violated."

Artists' renderings of industrial regions evoke a bleak, flowerless countryside, its skies filled with dark and dirty smoke. A watercolor by John Laporte (1761–1839) shows several buildings guarding the entrance to a mine shaft (FIG. 8-1). Eerily silhouetted against a sulfureous sky, they dominate a barren landscape.

As British tourists began to explore the as yet unspoiled reaches of their own country, their attention shifted from culture to nature. Their travel goals, too, changed. Previously, a young gentleman would tour Europe to gain some worldliness and perhaps make valuable contacts with fellow Britons. Now, travel became a more intimate, even solitary activity, important not for networking but for reflecting on life. Travel gradually became associated with self-discovery. The poet William Wordsworth (1770–1850) praised nature's power to inspire, move, and teach people about themselves. In one of his best-known poems, he asserted that a walk in the fields on a beautiful spring day was worth more than "fifty years of reason."

The Picturesque

Eighteenth-century Grand Tour travel guides had focused on the history of cities and monuments. But the new crop of nature-seeking British tourists wanted guides that described natural scenery. To write such guides, a richer descriptive language was needed. As traditional aesthetic categories, the "beautiful" and "sublime" no longer sufficed; the term "picturesque" was introduced.

Picturesque, meaning "like a picture," was not a new word in the English language. In the seventeenth and eighteenth centuries it had been applied to any scene that was suitable for a painting. It was also used in connection with a new style of garden design that had been introduced in England in the 1720s. This new "English" garden differed dramatically from the traditional "French" garden that was fashionable throughout Europe. While the latter was laid out according to a geometric plan (see the plan of the gardens of Versailles in FIG. 8-2), the modern "landskip" garden in England took its irregular layout from nature itself. Instead of straight paths, geometric flower beds, fountains, and shorn hedges, the "English" garden had winding paths,

8-2 Plan of Versailles (gardens, palace, and town) Pierre Le Pautre, 1660s. Engraving, Bibliothèque Nationale, Département des estampes et de la photographie, Paris.

irregularly shaped ponds, and large trees, left to grow freely (see the plan for the gardens of Heveningham Hall, Suffolk, in FIG. 8-3). Landscape architects of the time designed gardens to have multiple "picturesque" views for visitors to enjoy. When the well-known garden planner Lancelot (nicknamed "Capability") Brown (1716–1783) offered his services to the Earl of Scarborough at

Heveningham, he promised that he would design his garden "with Poet's feeling and with Painters' Eye."

The schoolmaster, amateur printmaker, and writer William Gilpin (1724–1804) was one of the first to apply the term "picturesque" to landscape scenery. In several travelogues, illustrated with his own prints, Gilpin suggested that Britain had areas of countryside that resembled the

8-3 **Lancelot ("Capability") Brown,** Plan for the gardens of Heveningham Hall, Suffolk, 1762. Country Life, London.

8-4 *Furness Abbey.* Illustration in William Gilpin, *Observations, Relative Chiefly to Picturesque Beauty, Made in the Year 1772, on Several Parts of England* (London, 1892). Dumbarton Oaks Research Library, Washington, DC.

canvases of such seventeenth-century landscape artists as Claude Lorrain, Jacob van Ruisdael (1628/9–1682), and Salvator Rosa (1615–1673). Gilpin's books helped his readers to appreciate picturesque scenery by pointing out the painterly aspects of landscape, such as composition, light and dark contrasts, form, texture, etc. The picturesque, for Gilpin, fell somewhere between the beautiful and the sublime. It lacked the ideal perfection of the former and the awesomeness of the latter, but it held a special charm for the viewer.

Furness Abbey (FIG. 8-4), an illustration in one of Gilpin's travel books, exemplifies the picturesque. This picture of a moonlit Gothic ruin in the middle of the woods is marked by its dramatic contrasts of light and dark, and its emphasis on bizarre forms and irregular surfaces. Ruins were favorite picturesque motifs because they gave, as Gilpin wrote, "consequence to the scene." A ruin's rough edges and battle scars were testament to the ravages of time and history.

The Popularity of Watercolor: Amateurs and Professionals

In his poem "The Brothers" Wordsworth wrote facetiously about "These Tourists [who]… Upon the forehead of a jutting crag/Sit perch'd with book and pencil on their knee,/And look and scribble, scribble on and look…" Sketching was a favorite pastime of the numerous travelers in the rural regions of England. Gilpin had encouraged this practice, both by his own example and through his *Three Essays: On Picturesque Beauty, on Picturesque Travel, and on Sketching Landscape* (1792).

Sketching was done in pencil (compare Wordsworth's tourists) or watercolor, which became a popular sketching medium in Britain towards the latter part of the eighteenth century (see *Watercolor*, below). Requiring no more than a sketchbook, brushes, and a box of color cakes, watercolor was perfectly suited to working outdoors. Moreover, this transparent, water-based medium lent itself well to the depiction of nature and natural phenomena—water, clouds, and fleeting atmospheric effects.

Sketching was an amateur as well as a professional practice. Amateur artists made watercolors of favorite places as private souvenirs. Professionals made drawings, watercolors or, on occasion, oil paintings of well-known sites to sell to tourists. To meet the high demand for such topographic landscapes, their work was frequently reproduced in prints (engravings, lithographs), which were sold individually or bound in albums.

Amateurs and professionals alike joined "sketching clubs" and "watercolor societies," which played an important artistic as well as social role. Because of its reputation as both an amateur and a commercial medium, watercolor was given short shrift at the Royal Academy exhibitions. Watercolors were often "skied," which meant that they were hung so high that nobody could see them. The newly established watercolor societies and sketching clubs took to organizing their own shows, some of which became eminently fashionable. This was especially true for the exhibitions of the Society of Painters in Water-Colours (later: Royal Watercolour Society), founded in 1804, which rivaled the Royal Academy shows in popularity and prestige.

Watercolor

Watercolor or *aquarelle*, as the French call it, is a paint medium in which the pigment is mixed with a water-soluble glue. It is produced in liquid form (in tubes) or in dried cakes, to which the artist adds water to obtain a color of the desired strength. In true watercolor, the paint is applied to a sheet of paper in the form of "washes," thin transparent layers of color. Non-transparent watercolors are referred to as "gouaches." To obtain complete coverage, extra "body" is given to the colors by the addition of an opaque white.

While the use of water-based colors on paper has its roots in medieval manuscript illumination, watercolor painting as we know it today did not come into its own until the seventeenth century. Initially, artists ground their own pigments and mixed them with Arabic gum or other glues, or both. In 1780 the Reeves family firm in London began to produce watercolor cakes in portable boxes. This made watercolor the perfect outdoor sketching medium. It also contributed to the use of watercolors by amateurs.

8-5 **Thomas Girtin,** *Guisborough Priory,* 1801. Watercolor, 26 x 19″ (66 x 48.3 cm). National Gallery of Scotland, Edinburgh

Thomas Girtin and the Pictorial Possibilities of Watercolor

One of the leading watercolorists at the turn of the eighteenth century was Thomas Girtin (1775–1802), who died young. His work is discussed here in some detail to demonstrate the variety of subject matter, aesthetic modality, and artistic purpose of British watercolorists (see *Landscape Painting—Subjects and Modalities*, page 183). Briefly a fellow student with Turner (see page 184), Girtin began his career as a topographic artist, drawing popular tourist sites to illustrate books and travel guides. Between 1796 and 1801 he went on a number of sketching tours of different parts of England and Scotland. During one of these, he made the watercolor *Guisborough Priory* (FIG. 8-5), showing a Gothic ruin against a landscape background. Although this is a topographic landscape, it is also fashionably picturesque. Not only does it depict the type of scenery that was favored by Gilpin (see page 177), but it is also marked by a dramatic composition, strong light and dark contrasts, and irregular surface textures.

Bamburgh Castle, Northumberland (FIG. 8-6) is a watercolor in a very different mode: sublime rather than picturesque. By dwarfing the human figures that inhabit the castle, Girtin has emphasized its colossal size; and by placing the dark mass of the architecture against a threatening sky, he has created a sense of foreboding and apprehension.

Village along a River Estuary in Devon (FIG. 8-7) has neither the picturesque qualities of *Guisborough Priory* nor the sublimity of *Bamburgh Castle*. Nor is it, strictly speaking, a topographic landscape, since it does not represent a specific site. Instead, it shows a flat, coastal landscape, with a village located between the two arms of an estuary. Numerous sailboats are moored by the village, and a new boat is being built on a wharf on the left side. The artist has carefully rendered light and atmospheric effects in an effort to create an image that evokes reality in a convincing manner. The term "naturalism" is generally used to describe this aspect of Girtin's work. It ushered in a new trend in early nineteenth-century British landscape painting that would culminate in the work of John Constable (see page 189).

Girtin and the Vogue for the Painted Panorama

It would be wrong to think of British watercolorists as artists working exclusively on a small scale. Several of them became involved in large-scale commercial projects that exceeded in size the enormous history paintings that contemporary figure painters such as West and Fuseli put on public view.

Girtin's *Eidometropolis* of 1802 was the artist's response to a popular vogue, since the late eighteenth century, for painted panoramas—huge, circular topographic paintings that showed 360-degree panoramic views of famous sites. Panorama paintings were skilfully mounted and carefully lit so that viewers, standing in the center, would receive a strong illusion of reality. Like the Shakespeare and Milton galleries of Boydell and Fuseli, panoramas were a form of popular entertainment, in which spectators paid "per view." Although generally painted in tempera or oils, panorama paintings required the skills of topographic watercolorists, who made the preliminary on-the-spot drawings on which the final painting was based.

Girtin's *Eidometropolis* was a 360-degree view of London that was mounted in a rented locale in Spring Gardens. In a newspaper advertisement, the artist claimed that his panorama showed, "to the greatest advantage the Thames, Somerset House, the Temple Gardens, all the churches, bridges, principal buildings, etc., with the surrounding country to the remotest distance, interspersed with a variety of objects of the great Metropolis." Although, like most panorama paintings, *Eidometropolis* is now lost, some of Girtin's preliminary drawings have been preserved (see FIG. 8-2-1). These show

how the artist prepared careful perspective studies, perhaps with the help of some mechanical device, so as to create the illusion that the entire panorama was seen from a single identifiable viewpoint. While such elaborate perspective constructions were a prerequisite for the verisimilitude of panorama paintings, the illusion of reality that Girtin attained in his *Eidometropolis* was apparently due to other factors as well. Contemporary reviewers especially praised the artist's skill in suggesting effects of light and atmosphere.

8.2-1 **Thomas Girtin,** *View of London*, presumably a sketch for the *Eidometropolis*, 1801–2. Pen and watercolor on paper, British Museum, London.

8-6 **Thomas Girtin,** *Bamburgh Castle, Northumberland,* c.1797–9. Watercolor, gouache, and pencil on paper, 21½ x 17¾" (54.9 x 45.1 cm). Tate Britain, London.

8-7 **Thomas Girtin,** *Village along a River Estuary in Devon,* 1797–8. Watercolor over pencil on oatmeal-color paper, 11⁹/₁₆ x 20⁵/₁₆″ (29.3 x 51.6 cm). National Gallery of Art, Washington, DC.

Landscape Painting—Subjects and Modalities

The term "landscape painting" covers a wide variety of images, whose only common denominator is that they depict outdoor scenery. Landscape paintings may feature mountains, woods, fields, seas, rivers, or cities. They may include human figures and animals or they may be devoid of them. They may be set in the present or they may be reconstructions of the past drawn from imagination.

A landscape painting may present an apparently truthful rendering of reality; or it may be the product of the artist's imagination. Its aim may be to delight, to awe, to charm, to move, or to inform the viewer. In addition, landscape paintings may be categorized by subject matter or by their "aesthetic modality," that is, the particular effect on the viewer that the artist has aimed at.

Certain subjects lend themselves well to certain modalities. Thus historic landscapes are often in the ideal mode. Mountainous landscapes and seascapes (particularly stormy seas) may be sublime. Pastoral or bucolic landscapes are generally naturalistic and townscapes topographic.

There are also geographic links. Ideal landscapes often show Italian scenery, while sublime landscapes are set in the Swiss Alps. The picturesque is associated with England, while the Low Countries, especially the Netherlands, offer the best scenery to naturalist artists.

SUBJECT CATEGORIES

Historic landscape A landscape scene, set in the past, furnished with figures that are part of a mythological, biblical, historical, or literary narrative.

Mountainous landscape

Seascape View of the sea, with or without boats (if boats dominate, we speak of marine painting)

Panoramic landscape Vast view of a landscape seen from an elevated point

Wooded landscape
Pastoral or Bucolic landscape Landscape that represents pastures and fields, usually including rustic cottages, peasants working on the land, perhaps with grazing cattle.

Townscape Painting that contains information on the visual appearance of a town.

AESTHETIC MODALITIES

Beautiful or Ideal
Sublime
Picturesque
Naturalistic
Topographic

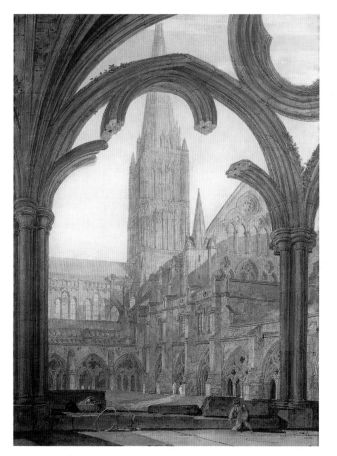

8-8 **J. M. W. Turner,** *Salisbury Cathedral Seen from the Cloister,*
c.1802. Watercolor, 26¹³/₁₆ x 19" (68 x 49.6 cm). Victoria and Albert
Museum, London.

8-9 **J. M. W. Turner,** *Dido Building Carthage* or *Rise of the
Carthaginian Empire,* 1815. Oil on canvas, 5'1" x 7'7" (1.56 x 2.32 m).
National Gallery, London.

Joseph Mallord William Turner

Nearly all British landscape painters began their careers
as watercolorists and James Mallord William Turner
(1775–1851), the best-known nineteenth-century English
landscapist, was no exception. Yet, while he remained
drawn to watercolor all his life, Turner also turned to oils.
For he was determined to make a career within the Royal
Academy, where watercolor was a "lesser art" and oil paint-
ing alone was deemed worthy of serious attention. Turner
not merely studied at the Academy, but also became an
academician in 1802 and later served as Professor of
Perspective (the usual teaching subject of landscape painters)
from 1807 until 1837.

Turner's determination to make a career within the Royal
Academy was directly related to his ambition of raising
the status of landscape to equal that of history painting.
To further this effort, he pursued a two-pronged strategy.
First, he tried to emulate renowned landscapists of the
seventeenth and eighteenth centuries—"old masters" such
as Claude Lorrain and Jacob van Ruisdael, who were well
represented in British collections. Second, he imbued his
paintings with narrative and allegorical meaning, treating
landscape as if it were history painting.

In the course of his career Turner experimented with
several aesthetic modes, ranging from the topographic
and the picturesque to the beautiful and the sublime.
His early watercolor, *Salisbury Cathedral Seen from the
Cloister* (FIG. 8-8), combines the meticulous accuracy of
topographic drawing with a dramatic composition that
brings out the scene's picturesque qualities. While Turner
keenly understood the marketability of the picturesque,

he preferred the ideal and sublime. As a young artist, he especially admired the ideal beauty of the landscapes of Claude Lorrain. In his *Dido Building Carthage* otherwise known as *Rise of the Carthaginian Empire* (FIG. 8-9) Turner tried to emulate Lorrain's famous views of seaports (see FIG. 8-10). Like Lorrain, he composed his painting around a central body of water, flanked by unequal groupings of buildings and bathed in a warm, golden light.

Dido Building Carthage exemplifies Turner's dual method of raising the status of landscape to equal that of history painting. Paraphrasing the work of an old master, it is also filled with historic references and visual metaphors. The painting is an imagined rendering of the ancient city of Carthage on the North African coast. In his *Aeneid* the Roman poet Virgil had related how Queen Dido of Tyre (seen on the left bank of the river) fled her country after the murder of her husband, and founded Carthage. Turner's audience, well versed in the Classics, would have appreciated his historic and symbolic references. The magnificent sunrise and the dynamic activity on the left bank convey a sense of hope and expectation at the rise of the new city. The dark and desolate right bank with its magnificent tomb, presumably of Dido's husband, is a reminder of past tragedies. It may hint, as well, at the ominous future of Carthage, which was to be annihilated by the Romans in the notorious Punic Wars.

While in Dido Building Carthage Turner embraced the Classical ideal, he was ultimately more drawn to the sublime. Beginning around 1800, he sought to express the sublimity of nature by emphasizing its immense powers. *The Shipwreck* of 1805 (FIG. 8-11), represents a storm at sea. In the right foreground, a large sailboat is about to

8-10 **Claude Lorrain,** *The Port of Ostia with the Embarkation of St Paula.* Oil on canvas, 6'11" x 4'9" (2.11 x 1.45 m). Museo del Prado, Madrid.

8-11 **J. M. W. Turner,** *The Shipwreck*, 1805. Oil on canvas, 67½ x 95" (1.76 x 2.46 m). Tate Britain, London.

8-12 **Willem van de Velde,** *Ships in a Stormy Sea*, 1671–2. Oil on canvas, 4'2" x 6'4" (1.32 x 1.92 m). Toledo Museum of Art, Toledo, Ohio.

8-13 **J. M. W. Turner,** *Snow Storm—Hannibal Crossing the Alps*, 1812. Oil on canvas, 4'9" x 7'9" (1.46 x 2.38 m). Tate Britain, Clore Gallery for the Turner Collection, London.

capsize as its crew abandons ship. In the middle and far distance other boats are desperately trying to stay afloat as they are tossed to and fro by the turbulent sea. *The Shipwreck* speaks of man's insignificance in the face of nature. It is a meditation on the frailty of human life and the vanity of human endeavor. Like most of Turner's early seascapes, *Shipwreck* was indebted to seventeenth-century Dutch marine painting, notably the works by Willem van de Velde (1633–1707), which were widely admired in England. Van de Velde's *Ships on a Stormy Sea* (FIG. 8-12), owned by one of Turner's patrons, may serve as an example of the kind of paintings the artist attempted to emulate.

Imbuing his landscapes with meaning was for Turner a lifelong preoccupation. The various means he used to make meaning, as well as the heterogenous meanings he attempted to convey, make his work incredibly varied and diverse. While his early works, such as *Dutch Boats in a Gale* and *Dido Building Carthage*, tend to teach general life lessons, his later works often convey specific political or social messages. *Snow Storm—Hannibal Crossing the Alps* (FIG. 8-13), for example, is a historical landscape that depicts the army of Hannibal, general of Carthage during the Punic Wars,

caught in a snowstorm as he is crossing the Alps to invade Italy. The painting was inspired both by Turner's trip to Switzerland in 1802 and by a recent political event, namely Napoleon's invasion of Italy in 1800 (see page 118). When Turner sent the painting to the Royal Academy exhibition, he included a poem of his own for the catalogue. In it, he condemned Hannibal for wasting so many lives in his futile attempt to conquer Rome. The poem and Turner's painting indirectly commented on Napoleon, the "new Hannibal", whose efforts to conquer Europe were widely condemned in England.

While *Snow Storm—Hannibal Crossing the Alps* comments on contemporary events by means of a reference to the Classical past, *Slavers Throwing Overboard the Dead and Dying* (FIG. 8-14) depicts an event in recent British history. The painting, exhibited at the Royal Academy in 1840, shows depraved British slave traders drowning sick slaves in order to claim damages from insurers (they could not do so if the slaves died on board). Although the painting was based on an event that had occurred in the early 1780s, it had not lost its relevance in the 1840s. The slave trade had been officially abolished in Britain in 1807, but slavery

8-14 **J. M. W. Turner,** *Slavers Throwing Overboard the Dead and Dying,* 1840. Oil on canvas, 35⅞ x 54¼" (91 cm x 1.38 m). Museum of Fine Arts, Boston.

8-15 **J. M. W. Turner,** *Rain, Steam and Speed—The Great Western Railway,* 1844. Oil on canvas, 35⁷/₈ x 49" (91 cm x 1.22 m). National Gallery, London.

was, of course, still practiced. Moreover, the painting could be interpreted as a comment on all man's inhumanity against man for the sake of material profit.

Turner's painting is difficult to read at first. It is a chaos of brushstrokes in different colors—red, yellow, various shades of white, and black. Only gradually does one discover a three-master, silhouetted against the sunset. Then, among the dark smudges that mark the high waves, one sees groping manacled hands and bodies torn apart by monstrous fish. The full meaning of the painting now becomes clear. Colors and brushwork acquire a new significance, because red hints at blood, black at disaster, and the chaotic application of the paint at the cataclysmic nature of the event.

Hannibal Crossing the Alps and *Slavers* display a much looser painting style than *Shipwreck*. Both paintings mark a progressive trend towards pictorial freedom that would culminate in Turner's works of the 1840s. During his final years Turner became increasingly interested in reducing landscape to its basic elements of water, light, and atmosphere. His works became abstract to the point where they sometimes

resemble twentieth-century non-objective painting. *Rain, Steam and Speed—The Great Western Railway* (FIG. 8-15) exemplifies this trend. As its title indicates, the painting is foremost about capturing effects of atmosphere and movement; its subject, a train, is secondary. Turner has used an extraordinary technique in this painting. In some places, thinned oil paint is used in the manner of a watercolor wash; in others the paint is plastered on the canvas to form a heavy *impasto*. The variegated surface creates an active viewing experience, in which the viewer shifts back and forth between experiencing the painting as a representation of reality and seeing it as a canvas covered with paint. Turner's masterful use of paint to express almost tangible atmospheric effects was greatly admired in his time. The critic William Makepeace Thackeray (1811–1863), in *Fraser's Magazine*, wrote:

> As for Mr. Turner, he has out-prodigied all former prodigies. He has made a picture with real rain, behind which there is real sunshine, and you expect a rainbow. Meanwhile there comes a train

8-16 **John Crooke Bourne,** *Maidenhead Bridge,* London, 1846. Lithograph, 11 x 17" (29 x 43 cm). Private Collection, London.

down upon you, really moving at the rate of fifty miles an hour... All these wonders are performed with means not less wonderful than the effects are. The rain, in the astounding picture called "Rain—Steam—Speed", is composed of dabs of dirty putty *slapped* on the canvas with a trowel; the sunshine scintillates out of very thick, smeary lumps of chrome yellow...

Turner relished being seen as a sort of magician who created miracles out of paint. During the later part of his career, he would work on his paintings as they were already hanging on the walls of the Royal Academy. The opening day of the exhibition was varnishing day, when most artists came in to put a final coat of varnish on their paintings. Turner, however, used that day to finish off paintings begun in the studio, eager for the public to see his virtuoso painting method.

In his *Rain, Steam and Speed—The Great Western Railway* of 1844 the artist showed that even a prosaic steam train could, under certain circumstances, produce the kind of delightful terror that Burke had defined as sublime. In this painting, exhibited at the Royal Academy in 1844, Turner depicted a Great Western Railway Company train crossing Maidenhead bridge, which had recently been constructed under the direction of Isambard Kingdom Brunel (1806–1859). A contemporary topographic print (FIG. 8-16) by J. C. Bourne (1814–1896) gives us a more technical view of this marvel of engineering, showing the broad span of its arches, unprecedented at the time. Turner's painting is not mechanically explicit, but it too celebrates modern technology. To him, as the title indicates, the marvel of technology is speed. While it is impossible to *represent* speed in the static medium of painting, Turner suggests speed by rendering the bridge and the train in radical perspective. The side barriers of the bridge rush toward the horizon, and the train seems to hurl itself forward through the mist and steam. In front of the train, Turner adds a hare, who is running for its life. While it provides some comic relief, it also reinforces the impression of speed since in Europe, at that time, hares were traditionally considered the fastest animals.

John Constable

John Constable (1776–1837), the other great English landscape painter of the nineteenth century, differed greatly from Turner. Although the two artists were only one year apart in age, their works have little in common. Turner covered an extensive range of landscape subjects and traveled widely both in Britain and Continental Europe. Constable stayed close to home, painting the countryside in his native East Anglia, a region northeast of London bordered by the North Sea. Turner wanted to emulate the great masters and create landscapes of historical significance. Constable's first aim was to render landscape naturalistically—even though, as we shall see, his works were not necessarily "true" to reality. These differences notwithstanding, the two artists had one common interest. Both were determined to elevate the stature of landscape painting within the Academy and, ultimately, to raise its position within the hierarchy of genres.

Constable was a late-blooming artist. The son of a wealthy miller and flour merchant, he began painting as an amateur and was already in his early twenties when he finally decided on a professional career. Admitted to the Royal Academy in 1799, he did not exhibit a single painting before 1802, when Turner had already been accepted as a full-fledged academician. It was not until 1820 that his work received serious critical attention.

Constable took a "naturalistic" approach towards landscape painting, meant that, rather than striving for ideal beauty, or for sublime or picturesque effects, he aimed at painting "believable" pictures that reminded viewers of familiar sights. His goal was to develop a "natural painture," which would faithfully represent the British countryside. To this end, he focused on pastoral landscapes, a category that had been largely neglected by seekers of the sublime and picturesque.

Constable's *The Hay Wain* (FIG. 8-17) exemplifies the artist's notion of "natural painture." It is one of a series of "six-footers," painted in Suffolk between 1819 and 1825. With the help of these large-scale works, Constable hoped to make his reputation as a landscape painter and to raise the respect for his pastoral scenes. The *The Hay Wain*, like all "six-footers," features the Stour, a partly canalised river that bordered the Constable family lands. The painting is centered on two farmers riding an empty hay cart across a ford in the river. On the left, a rustic cottage stands out against a dark green clump of trees. On the right, a grassy meadow enclosed by trees is punctuated by hay makers and cows. The painting evokes the halcyon days of summer, when everything moves at a leisurely pace. It is a bucolic scene that makes city dwellers long for the peace and quiet of country life.

When Constable exhibited this work in London in 1821, however, the British countryside was far from peaceful. Due both to the Industrial Revolution and the Napoleonic wars, rural life in Britain had changed considerably. Heavy taxation and a fall in agricultural prices had led to rural unrest. Farm laborers, unable to meet the needs of their families, were rioting everywhere, destroying property, and lighting random fires. In the light of this, it would appear that *The Hay Wain* was not, in fact, a truthful representation of the British countryside at all but rather a nostalgic reconstruction of an idyllic past. Indeed, Constable's pastoral landscapes seem to have been aimed at recovering his own youth and that of many of the middle-class and middle-aged visitors to the Royal Academy exhibitions.

8-17 **John Constable,** *The Hay Wain*, 1821. Oil on canvas, 4'3" x 6'1" (1.3 x 1.85 m). National Gallery, London.

8-18 **John Constable,** *Study of Cirrus Clouds,* c.1822. Oil on canvas, 4 x 7″ (11.4 x 17.8 cm). Victoria and Albert Museum, London.

To achieve the illusion of reality that his pictures convey, Constable had developed his own method. Like all landscapists, he composed his paintings inside the studio, using sketches made outdoors. But while most other artists sketched in pencil or watercolors, Constable was in the habit of sketching outdoors in oils. The practice was not entirely unprecedented. The French artist Pierre Henri de Valenciennes had begun to sketch in oils during a stay in Italy in the early 1780s and had encouraged the practice among his students. In Britain, however, Constable seems to have been the first to embrace the oil sketch. It was, to be sure, a complicated process, since paint in tubes was not yet available and the artist had to store small amounts of paint in pig bladders to transport it. To Constable, however, this was worth the effort, because it made it easier to record accurately the effects observed in nature and to translate them faithfully into the finished painting.

The beneficial effects of Constable's method may be seen in the sky in *The Hay Wain,* which effectively suggests the approach of a thunderstorm through its masterful depiction of a gradually darkening sky. For many years, Constable sketched the sky and clouds at different times of the day and under varied weather circumstances. His cloud studies are marvels of meteorological observation. Painted outside, on small panels, each study is carefully annotated with the time, date, and weather conditions. In the study reproduced in FIG. 8-18 Constable has even indicated that it represents a "cirrus" cloud. In his finished paintings, Constable tried to preserve the freshness of these outdoor studies. For the *The Hay Wain,* he may have referred to two oil studies, one for the clear sky on the right, and another for the threatening sky on the left.

During his lengthy career, Constable painted hundreds of oil sketches, which clearly fall into two groups. Some, like the cloud studies, were aimed at the direct observation of nature. Others were conceptual sketches, in which the artist worked out a satisfactory composition for his paintings. For his "six-footer" *Flatford Mill, Suffolk* (FIG. 8-19), exhibited at the Royal Academy in 1812, Constable made four outdoor sketches, focusing on different elements in the landscape—the lock, the mill, the trees, and the wooden pilings in the foreground (FIG. 8-20). In a fifth sketch, done in the studio, he worked out the composition (FIG. 8-21) of his painting. All sketches are loosely painted in an almost impressionistic manner and they are striking for their freshness and immediacy. Yet Constable's contemporaries never saw these works; they were intended for the artist's own use and were never shown.

While today Constable's finished paintings may seem a little tedious in comparison with his freely rendered preliminary sketches, in their own time they were often

8-19 **John Constable,**
Flatford Mill, 1812. Oil on
canvas, 26 x 36″ (66 x 92.7 cm).
Private Collection.

8-20 **John Constable,**
Flatford Mill from the Lock
(outdoor sketch), *c.*1811. Oil
on canvas, 10 x 12″ (25.4 x
30.5 cm). Henry E. Huntington
Library and Art Gallery, San
Marino, California.

8-21 **John Constable,** *Flatford Mill from the Lock* (conceptual sketch), *c.*1811. Oil on canvas, 9 x 11" (24.8 x 29.8 cm). Victoria and Albert Museum, London.

criticized for their "spotty pencilling." This was a reference to Constable's practice of painting with small dabs of pure color (often using a palette knife rather than a brush) instead of applying the paint smoothly and evenly. Only a few critics realized that this technique allowed Constable to render light effects more effectively. In time, Constable's technique would be quite influential. When his *The Hay Wain* was exhibited in Paris at the Salon of 1824, the French painter Eugène Delacroix (1798–1863) was so impressed with it that he repainted his own painting (shown at the same exhibition). Delacroix's art, in turn, became a model for the paintings of the Impressionists and, even more, for the "pointillist" paintings of Georges Seurat and his followers.

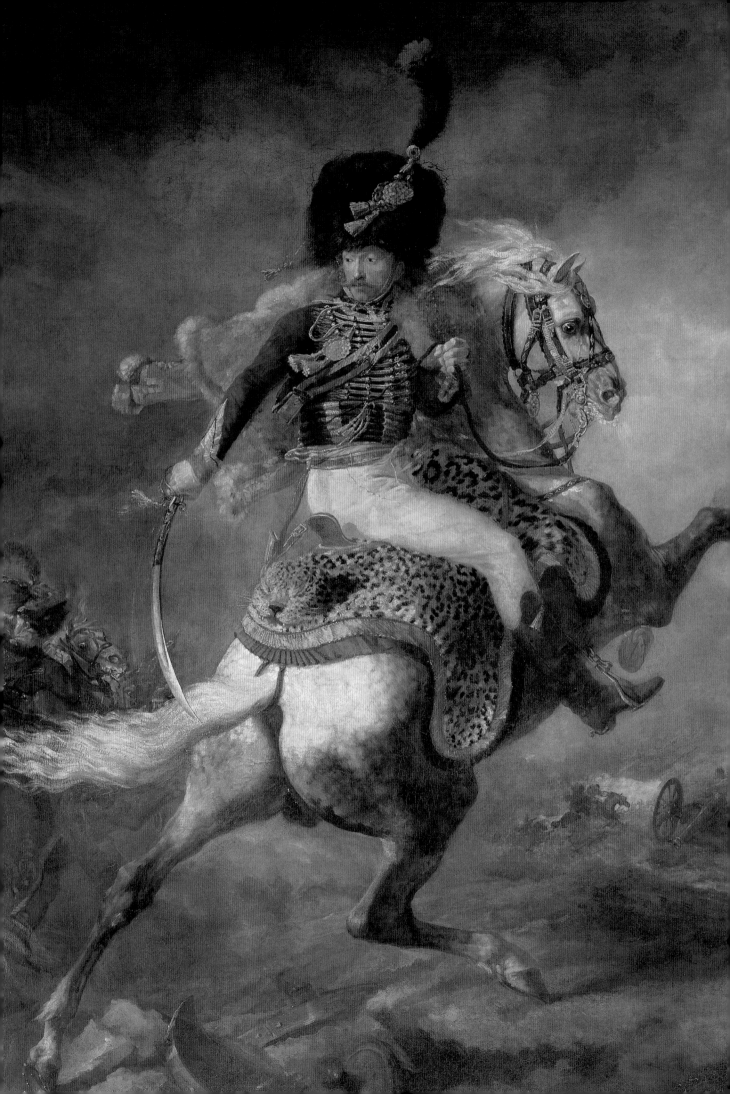

Chapter Nine

The Restoration Period and the Rejection of Classicism in France

Napoleon's Russian campaign of 1812 marked the beginning of the end of his regime. In a matter of months, his Grand Army was reduced from some 453,000 soldiers to 10,000. The emperor's prestige plummeted, and the nations he had conquered began to revolt. Even inside France, there was growing resistance to his rule. In the so-called Battle of Leipzig of 1813, the Grand Army was wiped out by an allied force of several hostile nations. By 1814 this force had invaded France. The French had had enough; Napoleon was deposed and exiled to the island of Elba. Although he attempted a come-back in 1815, it lasted only one hundred days and ended with another exile, to the remote island of St Helena, in the South Atlantic Ocean.

Meanwhile, Louis XVIII, the younger brother of Louis XVI, had been calling himself King of France since 1795, even as he wandered around Europe as an exile. In 1814 he hastened back to France to fill the power vacuum left by Napoleon's defeat and departure. He ruled until his death in 1824 and was succeeded by his younger brother, Charles X (rules 1824–30). Both governed as constitutional monarchs, sharing the power with a bi-cameral (i.e. two-chambered) parliament. In the course of their successive regimes, called the Restoration period, the government became increasingly conservative, even reactionary. Liberal opposition grew steadily. When Charles dissolved the Chamber of Deputies, intending to rule by decree, Paris rose against him. A three-day long revolution (July 27–29) forced his abdication.

Government Patronage and the Rejection of Classicism

In the field of art, the Restoration government's first order of business was to restore important monuments of the monarchy. Former royal buildings, such as the palace at Versailles and the medieval abbey of St Denis (traditional burial ground of the French kings), were reclaimed by the Bourbons and repaired. Royal statues that had been destroyed during the Revolution (see page 106) were made anew. Among them was the huge equestrian statue of King Henry IV on the Pont Neuf or "New Bridge" in Paris (FIG. 9-1). Designed by the sculptor François Lemot (1772–1833), it was a re-creation (based on prints and drawings) of a late Renaissance statue that had been erected in 1614 and destroyed in 1792. The figure of Napoleon, which only a few years earlier had crowned the Vendôme column (see page 112, FIG. 5-3), was melted down to provide the bronze for this sculpture. Thus the memory of Napoleon was not merely erased but forcibly and symbolically replaced by Bourbon propaganda.

Among Louis XVIII's major new monumental initiatives was the Chapelle Expiatoire or Expiatory Chapel (FIG. 9-2). It was to be the symbolic site of expiation or atonement for the French people's sin of having guillotined their king and queen. The chapel was built on the grounds of a small cemetery where Louis XVI and Marie Antoinette had been buried after their execution in 1793. (Their bodies had since been exhumed for official reburial in the royal

9-1 **François Lemot,** Equestrian statue of Henry IV, 1818. Bronze, approximate height 42' (12.8 m). Pont Neuf, Paris.

abbey of St Denis.) It was designed by Fontaine, who had made a smooth political transition from his former post as First Imperial Architect to his new one as Royal Architect.

A centralized, domed structure with an attached cloister, the Expiatory Chapel combines various styles, including Greco-Roman, Etruscan, Renaissance, and medieval, and may be seen as an early example of eclectic historicism. Indeed, the chapel shows the first signs of a trend, typical of the Restoration period, to move away from Classicism (associated with Revolutionary and Napoleonic times) towards a mixture of styles from a pre-Revolutionary past, such as medieval, Renaissance, and Baroque.

Two sculptures inside the chapel also reflect this trend. One is titled *Apotheosis of Louis XVI*, the other *Marie-Antoinette Seeking Solace with Religion* (FIG. 9-3). The latter was the work of Jean-Pierre Cortot (1787–1843), one of the most successful sculptors of the period. The statue takes its cue from a line in the queen's last letter, to Louis XVI's sister Elisabeth, which is quoted on its pedestal: "I die in the apostolic Roman Catholic religion." Marie Antoinette is kneeling, anxiously reaching out toward the allegorical female image of Religion. Compared to David's drawing of Marie Antionette on her way to the guillotine (see FIG. 4-2), the queen looks young and pretty, wearing a summer dress sprinkled with *fleur-de-lys* (stylized lily flowers that were the emblem of the royal Bourbon dynasty). She still wears the ermine stole, symbol of royalty, but her lost crown lies by her side.

Compared to Marie Antoinette, whose writhing pose speaks of her anxiety, Religion, dressed in a long Classical garment, stands calm, tall, and erect. By juxtaposing human anxiety and the stabilizing force of religion, Cortot has heightened the sculpture's emotional effect.

9-2 **Pierre-François-Léonard Fontaine,** Chapelle Expiatoire (Expiatory Chapel), 1816–21. Place Louis XVI, Paris.

9-3 **Jean-Pierre Cortot,** *Marie-Antoinette Seeking Solace with Religion,* c.1825. Marble, slightly over life-size. Chapelle Expiatoire, Paris.

The Academy

An ordinance issued in 1816 by Louis XVIII restored the pre-Revolutionary Royal Academy of Painting and Sculpture (see page 33). The Academy had been abolished in 1793, when its functions had been taken over by the so-called Arts Commune, presided over by David. Two years later, the arts had become part of a "National Institute" of arts and sciences. The fine arts (classified as painting, sculpture, architecture, and music) constituted the fourth class of the Institute.

Louis XVIII's ordinance of 1816 not only restored the Royal Academy, it also restructured it. The new Académie des Beaux-Arts (Academy of Fine Arts) had forty two members, including fourteen painters, six sculptors, eight architects, four engravers, and eight musicians. Although David, who for so many years had dominated the arts in France, was not a member (he had gone into political exile in Brussels), the Academy was dominated by his students, including Gros, who had taken over his teaching atelier, Gérard, and Ingres.

The Academy controlled the fine arts in France in several ways. In 1819 art teaching became centered in the newly founded École des Beaux-Arts (School of Fine Arts), a merger of the schools of architecture, painting and

9-4 **Paulin Guérin,** *Portrait of Louis XVIII,* Salon of 1819. Oil on canvas, 8'10" x 6'8" (2.69 x 2.03 m). Musée National du Château de Versailles, Versailles.

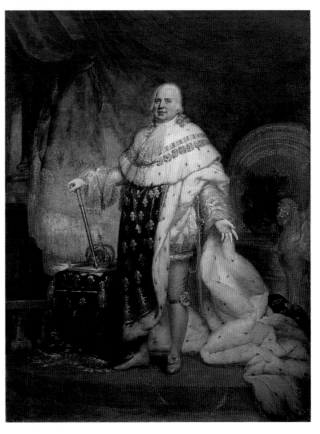

The contrast also reflects the two different realities of the figures—one real and specific; the other allegorical and timeless.

The figure of Religion is Neoclassical, stylistically speaking, while Marie Antoinette harks back to the Baroque style of the preceding two centuries. Style *par excellence* of the age of absolutism, the Baroque was favored for portraying royalty. The official portraits of the restored Bourbon monarchs similarly revived the Baroque style. The *Portrait of Louis XVIII* (FIG. 9-4) by Paulin Guérin (1783–1855), shown at the Salon of 1819, is a deliberate restatement of Rigaud's *Portrait of Louis XIV* (see FIG. 1-1). By having himself portrayed in the pose, robes, and setting of that famous king's earlier portrait, Louis XVIII intended to emphasize both the historic legitimacy of his rule and the renewed glory that it would bring to France. Ironically, to the visitors to the Salon of 1819, the painting may well have appeared as a pathetic attempt to recapture a glorious past that was forever gone. Guérin's gouty, overweight Louis XVIII, with his vacuous gesture and insipid smile, fails to inspire the same sense of awe as Rigaud's Louis XIV. Weighed down by his interminable ermine-lined cape, he seems burdened rather than bolstered by the past.

sculpture. Even though the school had its own administration, the Academy selected its faculty, controlled the entrance exam, and organized student contests, including the important Rome Prize competition (see page 33). The Academy also controlled the French Academy in Rome. It appointed the director of the Rome program and judged the *envois*, works that the students holding the Rome prize were required to send back home. Finally, the Academy was heavily involved in the organization of the Salons. Academicians often served on, or influenced the formation of, Salon juries, thus affecting the resulting exhibitions in a decisive way.

One unavoidable change that occurred in the Academy in the nineteenth century was the "graying" of its membership. While in the eighteenth century the members were mostly youthful (David, for example, became a full member of the Academy at the age of 35), nineteenth-century Academicians tended to be past middle age. This was because Academicians served for life, and they themselves elected new members. Thus it was, quite literally, an "old boys" club (no women were ever full members!), comfortable in its traditions and suspicious of change. The graying of the Academy made it difficult for young, innovative artists to be admitted to the Salon. No wonder that, between 1816 and the Revolution of 1848 (when the jury system was temporarily abandoned), there was growing dissatisfaction among young artists with the official management of the fine arts in France.

The Salons of the Restoration Period

During the Restoration, Salons continued to be held every two years, though on occasion a year was missed (see *Paris Salons*, right). Housed in the Louvre, as before, the early Restoration salons resembled those of the Napoleonic period, except that paintings glorifying Napoleon were substituted by paintings extolling the virtues of the Bourbons. Moreover, religious paintings, already on the rise during Napoleon's rule, increased in numbers.

As during Napoleon's reign, the monumental canvases or *grandes machines* ("big contraptions") that dominated the Salon were largely the result of government commissions. Most were painted by well-established older artists, many of whom were members of the Academy. Yet, in the course of the Restoration period, young artists increasingly began to submit large canvases independently since they realized that smaller works failed to attract the attention of newspaper critics and the general public. A painting by François-Joseph Heim (1787–1865), *Charles X Distributing Prizes after the Salon of 1824* (FIG. 9-5), illustrates this point. The Louvre's tall walls are plastered with paintings; the *grandes machines* dominate the middle range. Smaller works, hung above, below, or between them, are completely overpowered by them.

The early Restoration Salons continued to be dominated by followers of David, who carried on in the master's Classical tradition. Starting in 1819, however, several young artists began to show new and different works at the Salon. Initially, their impact was only slight but, by 1824, discerning visitors were clearly aware of a change in the Salon. New names, such as those of Horace Vernet and Eugène Delacroix, were suddenly on everyone's lips and the term "Romantic," selectively known in France for more than a decade, became a household word overnight.

Paris Salons

From the French Revolution through the Restoration Period

Year	Number of Entries	Opening Date
1789	350	August 25
1791	794	September 8
1793	1043	August 10
1795	735	October 2
1796	641	October 6
1798	536	July 19
1799	488	August 18
1800	541	September 2
1801	490	September 2
1802	569	September 2
1804	701	September 22
1805	705	September 15
1808	802	October 14
1810	1123	November 5
1812	1298	November 1
1814	1369	November 1
1817	1097	April 24
1819	1702	August 25
1822	1802	April 24
1824	2180	August 25
1827–28	1834	November 4

From: Patricia Mainardi, *The End of the Salon: Art and the State in the Early Third Republic*. Cambridge/New York: Cambridge University Press, 1993

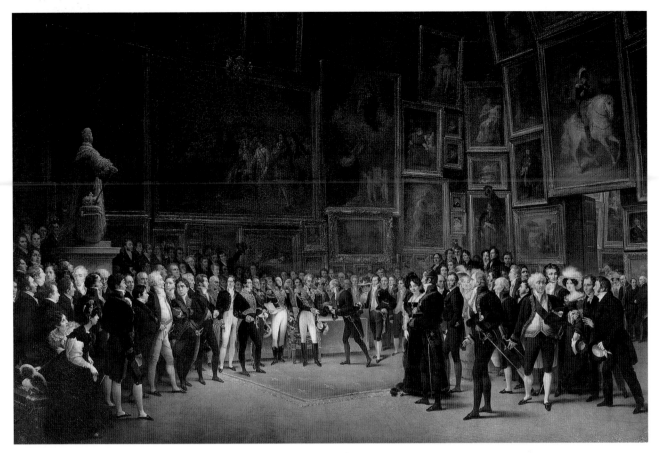

9-5 **François-Joseph Heim,** *Charles X Distributing Prizes after the Salon of 1824, 1825.* Oil on canvas, 5'8" x 8'5" (1.73 x 2.56 m). Musée du Louvre, Paris.

Madame de Staël and the Introduction of Romantic Ideas into France

In 1810, just when Napoleon's power was at its zenith, a book had appeared in France that bore the innocuous title *Germany.* Its author was Germaine de Staël (1766–1817), a 54-year-old woman who had made a reputation for herself with several popular novels. Although banned by Napoleon, who had no use for Germany or for de Staël, *Germany* became an international best-seller. The book was widely read in France as well, thanks to a brisk market in pirate copies.

The product of a five-month trip to Germany, *Germany* was meant to acquaint de Staël's readers with German culture and ideas, most notably with the new Romantic movement (see page 157), which she officially launched in France and on the broader European scene. Intrigued by Goethe's and Schlegel's ideas that Europe was divided into a Romantic, Germanic, Christian north and a Classic, Mediterranean, pagan south, Madame de Staël questioned France's cultural place. Sandwiched between Germany and the Mediterranean, the country was in a peculiar position. Its upper class, following de Staël, had always favored Classicism, but it had never become popular with the middle and lower classes because it was not native to France. The country had a scant Classical past, but a rich medieval history. Therefore, de Staël proclaimed, Classicism had gone as far as it could in France, but Romanticism still had a way to go:

> Romantic literature is the only one that is still susceptible to being perfected because, as it has its roots in our own soil, it is the only one that can grow and revive itself. It expresses our religion, it recalls our history; its origin is old, but not ancient.

The focus on France's medieval past and the return to Christianity that de Staël advocated fell in line with the agenda of the Restoration regime. Both Louis XVIII and Charles X had traced their roots back to the Middle Ages, to prove their hallowed royal pedigrees. Both kings saw the Roman Catholic Church as a crucial buttress to the principle of divine right. Charles X, in particular, bolstered the Church by encouraging the foundation of new missionary orders and religious lay societies.

Stendhal

If her medievalism and sympathy for religion appealed to the politically conservative element in France, Madame de Staël's emphasis on the populist character of Romanticism and its emotional focus excited several young artists, writers, and intellectuals. Her enthusiastic effusions about the "soulfulness" of modern German poetry were echoed in the writings of Henri Beyle (1783–1842), a French writer who used the German pen name Stendhal.

As an art critic during the Restoration period, Stendhal became an advocate for a new and modern art that was "to have a soul" and was to express "some human emotion or spiritual impulse in a vivid manner intelligible to the general public." In his lengthy review of the Salon of 1824, he announced the end of the school of David, which he found incapable of producing an art that touched the common heartstring. "The school of David can only paint bodies; it is decidedly inept at painting souls."

Stendhal referred to the new art he was calling for as "Romantic," but to him that term did not mean a return to a Christian, medieval past. Instead, he felt that Romanticism needed to be engaged with the present if it was, indeed, to be a true alternative to Classicism. "Romanticism," he wrote, "in all the arts is what represents the men of today and not the men of those remote, heroic times, which probably never existed anyway." Modern

painters, he felt, should renounce the naked body, which had no place in modern life, and they should paint pictures that would appeal to the greatest number of people.

De Staël and Stendhal laid out two paths for French Romantic artists. One was to return to the medieval and post-medieval past of northern Europe, the other to become enthusiastically engaged in modern times. In the course of the Restoration period, yet a third path emerged, that of exoticism. Exoticism, the interest in a cultural domain beyond the confines of Western culture, perhaps best reflected the Romantic longing for raw emotion, unfettered by reason or rules of beauty and morality.

Horace Vernet

To Stendhal, the most outstanding representative of the "new art" was Horace Vernet (1789–1863). A painter's son, Vernet had intended to follow in his father's footsteps, painting hunting and war scenes. But his ambition to paint heroic Napoleonic battle paintings was cut short when the Restoration regime took over. In 1822 two of his paintings, one representing a revolutionary battle, the other a scene of the defense of Paris against the allied troops in 1814, were refused by the Salon jury for fear of political repercussions. Vernet promptly exhibited both paintings in his studio, where they drew such crowds that the jurors

9-6 **Horace Vernet,** *Battle of Montmirail,* 1822 (Salon of 1824). Oil on canvas, 5'10" x 19'7" (1.78 x 2.9 m), National Gallery, London.

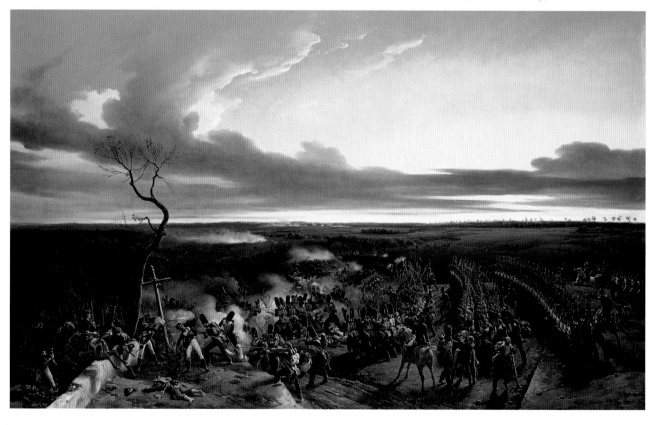

realized that they had made these works quite the rage by rejecting them. At the following Salon of 1824, Vernet was allowed to exhibit all of the nearly forty works he submitted. Even his Napoleonic battle scenes were accepted, as long as Napoleon himself did not feature in them.

One of these, titled the *Battle of Montmirail* (FIG. 9-6), to Stendhal epitomized Romantic painting, not only because it dealt with a contemporary theme but also because of the "amount of pleasure" it gave to the spectator. While that comment at first may seem strange, it points to a major paradigm shift that had taken place in the early decades of the nineteenth century. No longer was art expected to educate and edify the viewer by means of moralizing subjects and noble, idealized forms. Instead, it was to affect the spectator at a visceral level through subjects that evoked strong emotions, and through striking colors and forms that appealed powerfully to the senses.

The *Battle of Montmirail* depicts war in all its chaos and savagery. Unlike Napoleonic battle paintings such as Gros's *Battle of Eylau* (FIG. 5-21), it does not glorify a single hero. Instead, it shows masses of soldiers fighting, struggling, and dying. Vernet's journalistic approach lends to his work a sense of immediacy and truth that is distinct from Gros's carefully constructed propaganda image.

Théodore Géricault

If we were asked today which artist best answered Stendhal's call for a new, Romantic art, our choice would probably not be Vernet but his good friend Théodore Géricault (1791–1824). Vernet approached modern scenes like a journalist, representing them in all their minute details, Géricault's engagement with the present was more

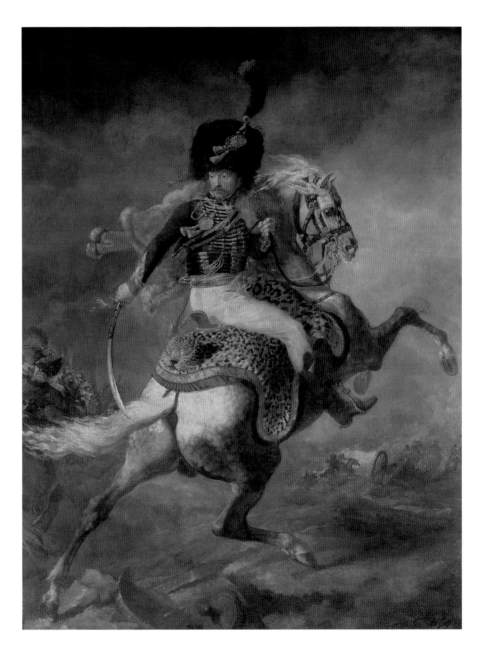

9-7 **Théodore Géricault,** *Charging Chasseur,* 1812. Oil on canvas, 11′5″ x 8′9″ (3.49 x 2.66 m). Musée du Louvre, Paris.

9-8 **Peter Paul Rubens,** *Hippopotamus and Crocodile Hunt,* c.1615–16. Oil on canvas, 8'2" x 12'7" (2.48 x 3.21 m). Alte Pinakothek, Munich.

philosophical, exploring profoundly the tragedies of modern life. Stendhal's choice was, nonetheless, understandable. While Vernet exhibited nearly forty paintings at the Salon of 1824, Géricault's work was notably absent. The artist had died several months before the Salon opened, at the age of 32. In his tragically short life, he had exhibited only three works—at the Salons of 1812, 1814, and 1819—hardly enough to make a broad impact in Paris.

Géricault's childhood coincided with the rise of Napoleon, his adolescence with the great battles of the Empire—Marengo, Austerlitz, Jena. As a student in the famed atelier of Pierre-Narcisse Guérin (1774–1833), he may have aspired to paint war scenes, following the example of Gros, his artistic role model. His love of horses, both in real life and as artistic subjects, would have made him especially suited to that task. As it was, Géricault reached artistic maturity just as the Empire crumbled. His first two military paintings were also his last. Both were exhibited at the Salon of 1814, which opened only months after Paris fell to the allied troops. One, a painting that he had already exhibited once before, in 1812, represented a cavalry officer of the regiment of the *chasseurs* (FIG. 9-7), the other, fresh off the easel, a wounded *cuirassier* (FIG. 9-9). The contrast between the two paintings, one bursting with energy, the other sunken in defeat, cannot have been lost on the visitors to the Salon. Géricault's paintings painfully illustrated the changed fate of France in the course of a few years.

The *Charging Chasseur* (FIG. 9-7) represents a cavalry officer on a rearing horse, ready to attack. David's *Napoleon Crossing the Alps at the Saint Bernard Pass* (see FIG. 5-10) had presented an earlier example of this motif. Yet, unlike David's painting, in which the rider is seen in profile, Géricault, in a dramatic tour de force, has represented the horse diagonally from the rear. (It is as if the horse is jumping away from an invisible attacker, while the rider turns around to strike him with his sword.) Géricault has created a powerful sense of space quite different from the more relief-like effect in David's painting. Even Gros had not attempted such dramatic foreshortening effects, which were beyond the limits of the Classical aesthetic. One has to go back to seventeenth-century Baroque paintings, such as Rubens's *Hippopotamus and Crocodile Hunt* (FIG. 9-8), to find a similar interest in spatial dynamics. Géricault's brushwork recalls Rubens as well, showing a freedom that is quite distinct from the smooth paint surfaces that characterize the works of David and his followers.

Wounded Cuirassier (FIG. 9-9) may have been conceived as a pendant (matching painting in a pair) to *Charging Chasseur*, even though it is larger. It represents a member of Napoleon's feared "steel hammer" cavalry, staggering down a slope. Using his saber as a crutch, and grabbing on to his frightened horse, he looks back over his shoulder to make sure he is not followed. From a technical point of view, *Wounded Cuirassier* is less daring than *Charging Chasseur*. From the point of view of content, however, the painting is novel in that it monumentalizes the "anti-hero." Géricault's *cuirassier* is a loser, limping stealthily from the battlefield. Such a scene would have been unthinkable in war paintings done for Napoleon, which were required to present war in a glorious light. Yet, *Wounded Cuirassier* is not

9-9 **Théodore Géricault,** *Wounded Cuirassier Leaving the Field of Battle,* Salon of 1814. Oil on canvas, 11'7" x 9'8" (3.53 x 2.94 m). Musée du Louvre, Paris.

9-10 **Théodore Géricault,** *The Raft of the Medusa*, 1819. Oil on canvas, 1'1" x 23'6" (4.9 x 7.16 m). Musée du Louvre, Paris.

a propaganda painting: it is a painting "from one French-man to another." The soldier's abandonment of the battlefield in an attempt to save his life expresses a commonly shared feeling of lassitude with war. The painting may be seen as a metaphor of France's recent capitulation to allied troops and its unwillingness to have more blood shed for France.

Géricault's next and last submission to the Salon, *The Raft of the Medusa* (FIG. 9-10), is his best-known work, for good reason. A five-year interval separates *The Raft* from Géricault's two military paintings. In the intervening years, the artist had traveled to Italy where he had improved his skills in drawing the human figure and creating monumental, multi-figure compositions. At the same time, he had remained interested in representing contemporary life. In the drawings and paintings he did in Italy, scenes of daily life in Rome alternated with timeless episodes of Classical mythology, reflecting some ambivalence towards the contemporary and the Classical. Signs of this ambivalence still linger in the *The Raft of the Medusa*. Even though it depicts a contemporary event, it is centred around a male nude, the central component of Classical art.

The *Raft of the Medusa* was inspired by an incident during the summer of 1816, when the *Medusa*, a French frigate transporting colonists and soldiers to Senegal, ran aground near the west coast of Africa. When it became necessary

to abandon ship, it appeared that the lifeboats had room for only about half of the 400 people on board. To accommodate the others, the ship's carpenter assembled a raft using some of the wood from the ship. The colonists and the low-rank soldiers were herded onto the raft, which was so overloaded that it was half submerged under the water. Although the men in the lifeboats had promised to tow the raft ashore, they soon cut the cables, preferring to save themselves. The rudderless raft was left at the mercy of the waves.

Within a week, all but fifteen passengers had died. The survivors were eventually rescued by a search boat. On their return to Paris in the fall, one survivor wrote an account of the events, which leaked to the press. A huge scandal ensued, because it became obvious that the *Medusa* disaster was caused by the incompetence of a captain who owed his appointment not to his nautical skills but to nepotism in the highest ranks of government. The newly restored Bourbons were facing growing opposition. For their critics, the raft of the *Medusa* became a symbol of France, a country adrift for lack of a competent leader.

Géricault's decision to base a painting on the *Medusa* affair was unusual at the time. Although printed images of the raft had been produced by minor artists, a current event such as this had never been the subject of a monumental

9.2-1 **Théodore Géricault,** *Mutiny on the Raft,* 1818. Pen drawing. Stedelijk Museum, Amsterdam.

9.2-2 **Théodore Géricault,** *Study of Arm and Two Feet,* 1818–19. Oil on canvas, 20 x 25³/₁₆″ (52 x 64 cm). Musée Fabre, Montpellier.

The Raft of the Medusa was Géricault's first (and, as it turned out, his only) major figure composition and it involved extensive preparations. The artist made numerous preliminary sketches in which he searched for the episode in the real-life drama that offered the greatest possibility for a meaningful work. They show that he hesitated between scenes of fighting or mutiny on the raft (FIG. 9.2-1), of cannibalism, and of final rescue. His choice of the episode of the sighting of the rescue ship was no doubt based on his desire to maximize the emotional breadth and drama of the painting.

In addition to compositional studies, Géricault made numerous drawings for individual figures on the raft, using some of the survivors and friends, as well as professionals, as models. He also, at this time, made several oil sketches of severed heads and limbs. It has long been assumed that Géricault painted these grim studies in a morgue in an effort to bring more verisimilitude to his representation of dead and dying people on the raft. But no direct correspondence between the sketches and *The Raft* can be found. Moreover, the heads and limbs all seem carefully posed, in the way that a still-life painter would pose his objects. In a study of two severed heads, a female and a male head are juxtaposed on white sheets almost in the way one would see a married couple lying in bed; and in *Study of Arm and Two Feet* (FIG. 9.2-2) an arm tenderly embraces one of the feet as if in a homo-erotic encounter. These macabre "still lifes" seem to defy the traditional subject categories since they confuse the boundaries between still life and narrative figure painting.

painting. Of course, under Napoleon, contemporary events had been painted in heroic dimensions. But those paintings commemorated episodes that glorified the rule who had made them happen. The *Medusa* affair was neither an important historic event, nor a propaganda opportunity. On the contrary, it was an isolated episode involving the commonest of people—farmers, soldiers, and sailors.

Géricault's treatment was original as well. Faced with the task of turning journalism into art, Géricault steered a careful course between realism and idealism. He went to great lengths to learn all the details of the event only to ignore them selectively as he transformed the scene into one that transcends the timely and specific (for more on the genesis of the painting, see *The Making of The Raft of the Medusa*, page 205). *The Raft of the Medusa* represents the fifteen survivors at the moment when they see the ship that is coming to their rescue. Set obliquely to the picture plane, the raft fills the width of the canvas, creating a sense of close-up. Of the men on the raft, some react with enthusiasm, raising themselves up to wave their shirts to attract the ship. Others are too weak or dejected to move. The figures on the raft are caught in a diagonal upward sweep, beginning, in the lower left, with the tragic figure of the father mourning his dead son, and culminating, in the upper right, with the African who has raised himself on a wine barrel to alert the crew of the distant ship. The diagonal marks not only a physical and emotional crescendo, but also an existential journey from death to life and a moral revival from despair to hope.

When we compare Géricault's *Raft of the Medusa* with one of the popular images of the event (FIG. 9-11), we notice immediately that the artist has drastically reduced the size of the raft (Géricault's raft could never have accommodated 150 people) in order to achieve the dramatic diagonal massing of the figures. We also notice that Géricault has shown several survivors in complete nudity. In so doing he has given them a timeless quality not unlike the historical, mythological, and allegorical figures in Neoclassical works. However, much as we are tempted to see them as allegories—of life, of death, or suffering—we are prevented from doing so by the intrusion of realistic details: the white cotton socks of the dead young man, for example, or his father's sailor pants.

The Raft of the Medusa was exhibited at the Salon of 1819, where it had a mixed reception. Most critics did not know what to make of a work so unlike traditional Salon paintings. Moreover, many were loathe to praise it because they realized that the painting had a subversive political message. Reluctant to roll up and store a work in which he had invested so much time, money, and energy, Géricault decided to take it to England. Here he hoped to follow the example of West (*Death of General Wolfe;* see FIG. 3-18) and Copley (*Death of the Earl of Chatham;* see FIG. 3-19) by showing his painting to the public for a fee. In London he found a professional exhibition organizer who agreed to show the painting in exchange for two-thirds of the box office proceeds. For six-and-a-half months, the painting was shown in the "Egyptian Hall" in Piccadilly where its sensational subject drew large crowds. It was then shipped to Dublin in Ireland and exhibited for another six weeks.

All this time, Géricault stayed in London, where he became fascinated by the daily life in the city. In addition to painting the famous Derby horse race at Epsom, he produced an album of prints on London themes, for which he felt there might be a market both in Britain and in France. Choosing the new print medium of lithography (see *Lithography*, opposite), he made twelve prints which

9-11 **Anonymous,** *Raft of the Medusa*, 1818. Lithograph, Bibliothèque Nationale, Département des estampes et de la photographie, Paris.

9-12 **Théodore Géricault,** *Pity the Sorrows of a Poor Old Man,* 1821. Lithograph, 12⁷/₁₆ x 14³/₄" (31.5 x 37.5 cm). British Museum, London.

Lithography

In 1799 a German inventor by the name of Aloys Senefelder (1771–1834) patented a new printing process. Soon to be called lithography (from the Greek word for stone), it was based on the phenomenon that grease repels water.

Lithography is a complex process. Basically, to make a lithograph, an artist draws with a greasy ink or crayon on the smoothly polished surface of a porous stone. The stone is then sponged with water. The porous surface absorbs the water except where the lines are drawn. The artist next applies a greasy printer's ink to the stone with a roller. The ink will adhere to the drawn lines but not to the wet surface of the stone. A piece of paper is placed on the stone and carefully rubbed down. The image drawn on the stone will be printed accurately in reverse on the paper. By re-inking the stone, the printing can be repeated numerous times, allowing the artist to "pull" multiple prints from the stone.

Although originally applied to the printing of sheet music, lithography soon became the domain of fine artists. The process was refined to enable artists to draw on paper and transfer their drawings to the stone; to make better impressions with the help of a newly developed lithographic press; and to print in more than one color. By the end of the nineteenth century, it would be possible to print large poster-size lithographs in a wide range of colors.

he published in 1821 as *Various Subjects Drawn from Life and on Stone. Pity the Sorrows of a Poor Old Man* (FIG. 9-12) is one of these. It shows an old beggar seated outside a bakery shop, trying to still his hunger with the smells of fresh-baked bread. These works differ greatly from Géricault's large-scale Salon paintings. Meant for a middle-class public they depict genre subjects, which had always appealed to that class. Yet, just as the *The Raft of the Medusa* brings something new to history painting, these lithographs bring something to genre painting. Compared with the works of Hogarth or Chardin in the eighteenth century, they neither tell a story nor sentimentalize their subjects. Instead, they depict their subjects with an uncompromising realism that foreshadows the Realist movement of the mid-nineteenth century. These prints show Stendhal's "men of today" in the ordinary circumstances of daily life. Moreover, by focusing on the miserable lives of the urban poor, Géricault has elicited, in Stendhal's words, "some human emotion or spiritual impulse in a vivid manner intelligible to the general public."

The realism of Géricault's lithographs is also seen in several late works, done between December 1821 and the artist's death in 1824. Most important among them are five portraits of insane people, the only ones remaining of an original series of ten. The series was owned at one time by Dr Georget, a physician specializing in psychiatry, and

9-13 **Théodore Géricault,** *Man Suffering from Delusions of Military Rank,* 1822–3. Oil on canvas, 32 x 26″ (82.5 x 66 cm). Collection Oskar Reinhart "Am Römerholz," Winterthur, Switzerland.

may have been commissioned by him for scientific purposes. Psychiatry was a new field in the early nineteenth century when, for the first time, madness was seen as a mental illness and the insane as human beings that should be treated with compassion. Based on the ideas of Caspar Lavater (see page 81), many psychiatrists believed that there was a direct correlation between mental illness and physiognomy, so that the study of the patient's facial structure played an important role in the diagnosis and classification of mental diseases.

Géricault's portraits of insane people may be related to this theory. According to Georget's annotations, the men and women shown in the portraits suffered from different types of delusions. *Man Suffering from Delusions of Military Rank* (FIG. 9-13) is perhaps the most striking of the five.

An old man, with sunken cheeks and gray stubble, wears a hat with a red tassel, vaguely resembling a Napoleonic military hat. A blanket is draped over one shoulder, and around his neck he wears a large pierced coin as if it were a medal of honor. Besides the strange outfit, his facial expression also hints at the sitter's delusional state. The shifty eyes, avoiding the viewer, and the fiercely pursed lips show the impossibility of communicating with this person, whose mind seems to have wandered off into an unknown realm. The contrast between the illuminated left half of the face and the deeply-shaded right half seems to suggest that, although we can study the appearance of those who suffer this mental illness, our understanding is limited as we can never truly penetrate the dark recesses of their minds. Theirs is a mysterious world apart from our own.

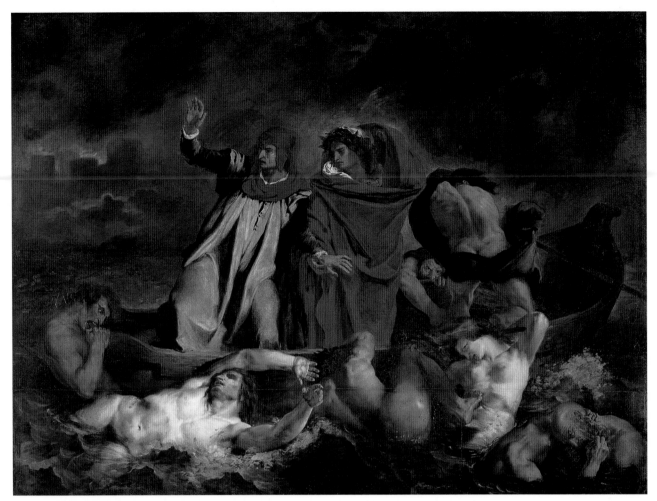

9-14 **Eugène Delacroix,** *Dante and Virgil*, 1822. Oil on canvas, 6'2" x 7'11" (1.88 x 2.41 m). Musée du Louvre, Paris.

Eugène Delacroix

While Vernet and Géricault were engaged with reality and the present, Eugène Delacroix (1798–1863) preferred the past, the fictional, and the exotic. The artist made his debut at the Salon of 1822 with *Dante and Virgil* (FIG. 9-14). Inspired by the *The Divine Comedy*, an epic poem by Dante Alighieri (1265–1321), it shows the author and his guide, the Roman poet Virgil, traveling through hell and purgatory. In this scene, the two poets are ferried across a lake in which damned souls are punished by eternal drowning. The spectacle of the souls (represented, as custom dictates, by naked human figures) desperately clinging to the boat and vainly struggling to climb on board arouses a mixture of horror and disdain in the three figures inside the vessel. While the boatman rows furiously across the lake, both Dante and Virgil have risen and silently watch the gruesome spectacle.

Although Delacroix was doubtless inspired by Géricault's *Raft of the Medusa* in his use of nude male bodies as vehicles of pathos and suffering, he departed from that work in a decisive manner. By choosing a historic, literary subject, he asserted that the present offered few subjects of interest to him. Delacroix felt that nineteenth-century France was bland and ugly. He complained about the "wretchedness of the modern costume," and the lack of poetry in modern life. To him, art, like poetry, "live[d] on fiction," by which he meant that they must have an element of fantasy. The present, which stood right before the artist's eyes, did not offer enough space for imagination.

In contrast to David and his followers, Delacroix felt that Classical literature and Classical art failed "to awaken that part of the imagination which the moderns [i.e. post-Classical artists] excite in so many ways." He sought his subjects in the Middle Ages, the Renaissance, and beyond, preferring to approach these periods through the eyes of the poet. He turned to historic writers such as Dante, Cervantes, Milton, and Shakespeare, as well as modern authors of historic drama and fiction such as Goethe, Byron (see page 212), and Sir Walter Scott (1771–1832).

While *Dante and Virgil* was generally praised, Delacroix's next major work, *Scenes from the Massacre at Chios* (FIG. 9-15), became one of the most contested paintings of the 1824 Salon. It was criticized both for its formal qualities and for its emphasis on agony and suffering. One of Delacroix's

9-15 **Eugène Delacroix,** *Scenes from the Massacres at Chios*, 1824. Oil on canvas, 13'8" x 11'7" (4.17 x 3.54 m). Musée du Louvre, Paris.

rare paintings on a contemporary theme, *Scenes from the Massacres at Chios* showed an episode in the war, waged by the Greeks in 1821, to gain independence from the Ottoman Empire. In the second year of this war, the Ottomans raided the island of Chios, burned most of its villages, and massacred or sold into slavery the island's Christian people. Like many artists and intellectuals in western Europe, Delacroix had a passionate interest in the Greek War of Independence, which resonated with early nineteenth-century ideals of freedom and nationalism.

9-16 **Eugène Delacroix,** *Study for Scenes from the Massacres at Chios*, 1824. Watercolor and pencil on paper, 13³/₈ x 11¹³/₁₆" (34 x 30 cm). Musée du Louvre, Département des arts graphiques, Paris.

His painting shows a group of Greek prisoners huddled under the watchful eye of a Turkish soldier. An Ottoman officer, mounted on a white stallion, abducts a half-naked woman, while another tries to hold him back. The prisoners form a random group of young and old, naked and clothed. They cling to one another in despair, since they suspect that they are about to be separated forever.

Like Gros's *Plague House of Jaffa* (see FIG. 5-19) and Géricault's *The Raft of the Medusa* (both of which the young Delacroix is known to have admired), *Scenes from the Massacres at Chios* shows a group of victims, but there is an important difference. While Gros's victims are redeemed by the heroism of their commander and while Géricault's painting, despite its horror, still carries a message of hope, Delacroix's painting is unapologetically pessimistic. This shocking depiction of horror deterred many critics. Even to Stendhal, otherwise open to innovation, the painting erred "on the side of excess."

Other critics objected, equally strongly, to the painting's form. *Scenes from the Massacres at Chios* seemed to lack unity and focus, with figures randomly placed, without any organizing principle to their grouping. Conservative critics also objected to the painting's brushwork and color, although some of the more open-minded ones, in fact, saw in them Delacroix's most important innovation. Stendhal, for example, who "with the best will in the world," could not admire "M. Delacroix and his *Massacres at Chios*" acknowledged

that Delacroix had "a feeling for color," which, as he said, "in this century of draughtsmen is saying a lot."

When looking at the painting today, it is hard to take Stendhal's remark seriously because *Scenes from the Massacres at Chios* seems so dark and muddy. This may not always have been the case, however. The painting, like many of the period, has deteriorated over time due to inadequate materials. Since the late eighteenth century, artists no longer made their own paints but bought commercially fabricated colors. By the early nineteenth century, the standards for commercial paints had sunk so low that many paintings of the period were unfit to stand the test of time. Today they look much darker than intended, and the paint surface is frequently cracked.

To imagine what *Massacres at Chios* may originally have looked like, or at least, what coloristic effects Delacroix had in mind, it is useful to look at a preliminary watercolor study (FIG. 9-16). Here we see not only rich colors and striking color contrasts (for example, the use of the three primary colors, yellow, red, and blue, in the dress of the mounted Turk), but we also notice that Delacroix was in the habit of "sketching" with colors. In other words, he did not first draw the figures in pencil and then fill in the tints, but conceived the entire image in terms of color patches.

The finished painting, too, was sketched in large flat color masses, which were subsequently enlivened with small touches of paint to suggest light and shade and surface particularities. A detail of the painting showing the old woman's arm (FIG. 9-17) demonstrates Delacroix's technique. While the arm itself is painted in a beige flesh tone, the shadow cast on it is loosely painted in red, with an

9-17 **Eugène Delacroix,** *Scenes from the Massacres at Chios.* Detail of FIG. 9-15.

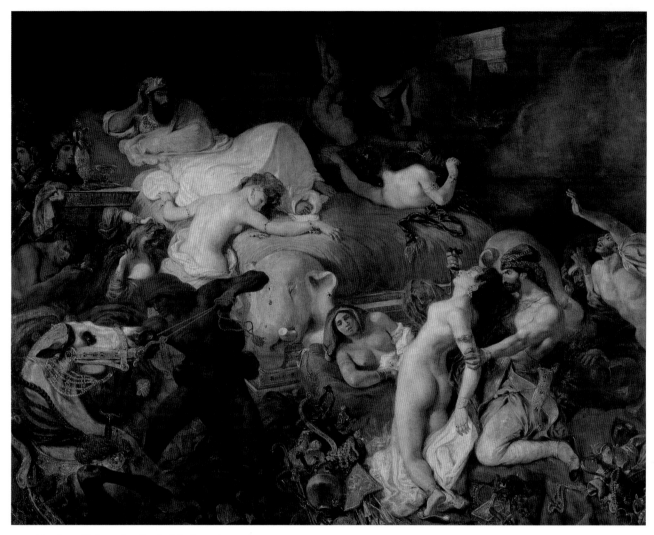

9-18 **Eugène Delacroix,** *Death of Sardanapalus,* 1827–8. Oil on canvas, 13' x 16'3" (3.95 x 4.95 m). Musée du Louvre, Paris.

occasional touch of its complementary, green. This is quite different from the way a cast shadow was painted by, for example, Ingres. A look at the sitter's arm in the *Portrait of Madame La Rivière* (see FIG. 5-33), for example, shows that Ingres, and the Classicists in general, showed light and shade by mixing white or black with the basic flesh color of the arm.

Innovative as Delacroix's brushwork and use of color may seem, it was not without precedent. Already in the sixteenth and seventeenth centuries, artists such as Paolo Veronese in Italy and Rubens in Flanders had used similar coloristic effects. In his own time, Delacroix's free brushwork was attributed to his knowledge of the work of Constable, whose *The Haywain* (see FIG. 8-17) was exhibited at the Salon of 1824. A close friend of Delacroix reported that the artist was so impressed by Constable's painting, that just before the opening of the Salon he requested permission to take down his picture and to repaint it.

Delacroix's chaotic composition, his loose brushwork and his unorthodox use of color seem to suit the painting's exotic subject. *Scenes from the Massacres at Chios* depicts a contemporary scene in a far-away country, peopled with Turks and Greeks, who differed in every respect (race, religion, dress) from the French visitors to the Salon. Exoticism (see page 200) represents the absence of Western civilization's rationality and morality and may well be seen as the quintessential Romantic mode. It is, perhaps, no accident that *Massacres at Chios* was the first painting by Delacroix that was labeled "Romantic" by his contemporaries.

Exoticism found full expression in Delacroix's next major painting, *Death of Sardanapalus* (FIG. 9-18), which was exhibited at the Salon of 1827–8. Inspired by the writings of the British Romantic poet George Byron (1788–1824), whose work found popular success in England and abroad, this painting is not merely exotic but savage—a delirious mass of bodies, painted in hot, feverish colors. Byron's poetic drama, *Sardanapalus* (1821), tells the story of an ancient Assyrian king whose decadent lifestyle and unwillingness to govern invite rebellion. To spite the rebels, who are about to overtake his palace, the king orders its total destruction. According to Delacroix's own "storyboard" for the picture (as published in the Salon catalogue):

The rebels besiege him in his palace ... Reclined on a superb bed, above an immense funeral pyre, Sardanapalus orders his eunuchs and palace officers to slaughter his wives, his pages, even his favorite horses and dogs; none of these objects which had served his pleasure was to survive him ... Aischeh, a Bactrian woman, did not wish to suffer a slave to kill her, and hung herself from the columns supporting the vault ... Baleah [on the right], cupbearer of Sardanapalus, at last set fire to the funeral pyre and threw himself upon it.

Delacroix's painting is composed along a sweeping diagonal line from upper left to lower right. At the top, a white-clad Sardanapalus reclines on an enormous red bed, decorated with golden elephant heads. Morosely, he watches as servants bring in his treasures—golden vessels, jewelry, clothing, horses and women, to be destroyed or killed before his eyes. If paintings could make a sound, this one would be filled with screams, shouts, horses neighing, and the clanging of metal pots; if they gave off scent, it would reek of sweat, blood, and fire.

To the contemporary viewer, the *Death of Sardanapalus* exemplifies Romanticism in its emotional drama and exotic ardour, as well as its dynamic composition, free brushwork, and explosive colors. The painting seems an emphatic response to the call of De Staël and Stendhal for an emotionally charged and sensual art. Yet, in the 1820s, its Romanticism was not so obvious. *Sardanapalus* was not Romantic by Stendhal's definition since he had called for an art depicting modern man. Nor did Delacroix himself refer to it as Romantic. To him, that term had a populist connotation that went contrary to the profundity of the ideas that underlied his work. (Indeed, throughout his career, Delacroix preferred to be called a Classicist.) What then did Romanticism mean in the 1820s? As one critic wrote, in 1824, the term Romanticism was most commonly used to describe artists who had departed, as he said, "from the beaten path." Romanticism thus was associated with originality (see page 172). And it was seen as a departure from the Classical tradition that was perpetuated and promoted by the Academy.

Ingres and the Transformation of Classicism

The Classical tradition itself, however, did not remain unchanged. During the Restoration period, its transformation, which had already begun during the Empire (see page 116), went apace with the progress of Romanticism. And it is seen even in the work of an artist who was considered in his time to be the embodiment of academic painting. David's student Jean-Auguste-Dominique Ingres (1780–1867).

The Salon of 1824 not only saw the triumph of the young Romantics, notably of Vernet and Delacroix, it also marked the first official recognition of Ingres. After exhibiting *Napoleon on his Imperial Throne* (see FIG. 5-17) at the Salon of 1806, the artist had left for Italy as a recipient of the Rome Prize. During his four-year residency in Rome, he had dutifully sent back the obligatory *envois* to Paris. He had also made important connections in Rome, which, due to Napoleon's occupation of Italy, was crowded with Frenchmen. In 1811 he received a commission for two paintings to decorate Napoleon's residence in Rome, the Palazzo Quirinale. He had also received commissions for two paintings of female nudes from Napoleon's sister Caroline Murat, queen of Naples. And he had built quite a portrait clientele among French expatriates in Rome.

In Paris, however, Ingres was little known. The artist had been reluctant to send works to the Salon since his *Napoleon on his Imperial Throne* and his portraits of the Rivière family, (exhibited before his departure for Rome in 1806) had been criticized as Gothic and perverse. He exhibited three small paintings at the Salon of 1814, but they attracted little notice. In 1819 he submitted three further paintings, which met with a mixture of indifference and hostility. Most of this hostility was directed at the *Grand Odalisque* (FIG. 9-19), one of the two nudes that Ingres had painted for Caroline Murat in 1814. A picture of a nude, reclining harem woman (the French word *odalisque* comes from the Turkish *odalik*), it was a work of shocking originality. The *Odalisque* was unprecedented in late eighteenth- and early nineteenth-century painting in that it represented a nude outside a narrative context. Unlike Girodet's *Danaë* (see FIG. 5-27), which could be readily inserted into the mythological narrative of one of Zeus' famous escapades, the *Odalisque* was nothing more or less than a naked woman on display. To be sure, "display nudes," such as the so-called *Venus of Urbino* (see FIG. 12-40) by Titian, had been produced before. But those paintings had been executed for private patrons. Ingres's *Odalisque*, by contrast was exhibited in the Salon, where her nakedness was accessible to the public at large.

The shocking implications of Ingres's choice of subject matter (only prostitutes showed off their naked bodies) were mitigated by the artist's insistence, through the title and the woman's paraphernalia, that his nude was not a French woman but an "oriental" harem woman. For the visitors to the Salon, therefore, she was not "one of us," but "the other," a woman belonging to an exotic world where Western rules of decorum did not apply.

Yet it was not only the content but also the form of Ingres's painting that unsettled many visitors to the Salon. For while it retained some aspects of Davidian Classicism, most notably the emphasis on contour, it also marked a departure from that style. No one could fail to notice that the luscious curvature of the back was achieved by an unnatural elongation of the spine (critics complained

9-19 **Jean-Auguste-Dominique Ingres,** *Grand Odalisque,* 1814. Oil on canvas, 35⁷/₈ x 63″ (91 cm x 1.62 m). Musée du Louvre, Paris.

9-20 **Jean-Auguste-Dominique Ingres,** *The Vow of Louis XIII,*
Salon of 1824. Oil on canvas, 13'9″ x 8'8″ (4.21 x 2.65 m). Montauban
Cathedral.

that at least three vertebrae had been added). The smooth, sensuous contour of the body, moreover, had been achieved by eliminating all bodily joints. Ingres had taken the Classicist idea of line as an artistic means to purify reality beyond the traditional boundaries. To the Classicists, purification of reality had not meant the complete *departure* from reality. To Ingres, however, his was a justifiable attempt to bring out the essence of the subject: if the essence of the harem woman was her sensuality, then line and contour could and should be used to express that. Or, as Ingres himself is recorded to have told his students: "Drawing does not simply consist of reproducing the contours, drawing does not simply consist of line: drawing is, above all, expression, interior form, concept, modeling."

As in Ingres's earlier *Portrait of Madame Rivière* (see FIG. 5-33), the daring distortion of contour is counteracted by the near-photographic verisimilitude of details and surface textures. From the pearls in the Odalisque's hair to the peacock's feather fan in her hand, from the smooth texture of her flesh to the rich shimmering of the background curtain, all details appear so real that one can nearly overlook the picture's "incorrections."

The criticism that was leveled at the *Odalisque* once more prevented Ingres from showing at the next few salons. It was not until 1824 that he found the courage to submit his work again, this time showing seven paintings. Most

9-21 **Raphael,** *The Madonna of Foligno,* 1511–12. Oil on canvas transferred from panel, 10'6" x 6'4" (3.2 x 1.94 m). Vatican Museum, Rome.

important among them was a large-scale painting destined for the cathedral in his home town of Montauban (FIG. 9-20). Commissioned by the Ministry of the Interior, it represented an event in 1634, when Louis XIII placed France under the protection of the Virgin of the Assumption. It was a difficult subject to represent, since it required the combination of a historical figure (Louis XIII) with a supernatural event—the entrance of the Virgin into heaven after her death. Ingres chose to represent the scene as a vision, in which Louis XIII beholds the Virgin and Child seated on a cloud. That this is, indeed, a revelation is shown by the two angels on the side who part the curtains to "reveal" the Virgin to the king.

Compared to the *Grand Odalisque*, this is, at first glance, a conservative painting that may be seen as a homage to—or an attempt to improve on—Ingres's favorite artist, the Renaissance painter Raphael. His Virgin and Child is an amalgam of Raphael's two most popular Madonnas, the *Sistine Madonna* in the Painting Gallery in Dresden (see FIG. 7-10) and the so-called *Madonna of Foligno* in the Vatican (FIG. 9-21). But Ingres has given the Virgin his own personal stamp. Her face has been smoothed and stream-lined, lending it a remote sensuality. Indeed, as Stendhal remarked in his review of the Salon: "The Madonna is beautiful enough, but it is a physical kind of beauty, incompatible with the idea of divinity. This is a psychological, not a technical defect."

To conservative critics, however, Ingres's painting embodied a Classical tradition of perfect beauty that was the more precious since it seemed under attack from the side of such "heretics" as Vernet and Delacroix. Little wonder, then, that Ingres emerged triumphantly from the Salon. Within a few months after its closure, he was elected a member of the Academy and awarded a Legion of Honor cross. Ingres's success in Paris had finally come. His newly opened studio attracted more than a hundred students.

Classicism and Romanticism

The Restoration period is commonly seen as a period that marks the beginning of a split in art between Classicism and Romanticism, where by the first represents the status quo in art—the official style promoted by the Academy and taught in the Ecole des Beaux-Arts—and the second the *avant-garde*. Classicism and Romanticism, in this view, represent two contrary trends—one conservative and orthodox, the other progressive and modern.

While there is truth in this model, it has, like all historic models, its weakness. Ingres, the great protagonist of Classicism, is conservative only to a point. As a youth he rebelled against David and his mature works are quite removed from the art of David and his followers, both in subject matter and technique. By the same token, Delacroix, who we see as the great protagonist of Romanticism, saw himself as a Classicist, an artist working in the great traditions of the history of art.

The Popularization of Art and Visual Culture in France during the July Monarchy (1830–1848)

Delacroix's *Liberty Leading the People* (FIG. 10-1), one of the highlights of the Salon of 1831, commemorates the three-day revolution in July 1830 that led to the overthrow of the Restoration government. A national icon in France, the painting shows the allegorical figure of Liberty carrying a musket in her left hand and the "tricolor" (the red, white, and blue revolutionary flag) in her right. She leads a motley group of revolutionaries, composed of factory workers, artisans, peasants, and students, through the streets of Paris. Climbing over the remainders of a barricade (a barrier built by the revolutionaries to halt government troops), they encounter the bodies of a member of the Royal Guard and a worker-rebel—two opponents who have both become victims of the Revolution.

Liberty Leading the People occupies a singular position in Delacroix's *oeuvre* (the total body of the artist's work) not only because it depicts a contemporary event, but also, and more remarkably, because it combines images of real people with an allegorical figure. Delacroix has successfully blended reality with allegory by depicting Liberty as a flesh-and-blood woman, with red cheeks, powerful arms, and large breasts. While some of his contemporaries were shocked by the figure, calling her a fishwife or a whore, others praised the artist for having invented a "new allegorical language."

The vigor and enthusiasm of Delacroix's painting captures the excitement of "the three glorious days" that marked the overthrow of the Bourbons and the beginning

of a new political era. Charles X was replaced by Louis Philippe, from the ducal Orléans family, who would rule for the next eighteen years. His reign, the "July Monarchy," was an important phase in French history since it witnessed the rise and expansion of the middle class and the beginning of socialism, a political ideology that, in its initial stages, centered on the poverty brought about by the industrial revolution and the capitalist system it entailed.

Louis Philippe became "King of the French" in the summer of 1830. The title signaled that he governed not by divine right but by popular acclaim, his powers circumscribed by a constitution. Building on the support of a newly rich middle class, Louis Philippe steered a middle road between the Bourbon supporters (the so-called Legitimists) and the liberal Republicans, all the while trying to be on good terms with the Bonapartists. It was a compromise policy referred to at the time as *juste milieu* or "happy medium." Louis Philippe's eventual downfall was caused by his government's failure to attend to the needs of the lower classes, most notably the growing urban proletariat. It was this group that, aided by middle-class intellectuals, would bring about the notorious Revolution of 1848.

The July Monarchy was a crucial period for French culture and art. It started with the dialectic between Classicism and Romanticism (see next page) and witnessed the eventual synthesis between the two. It saw the resurgence of landscape painting and a vogue for historic and Orientalist genre scenes. Most importantly, it was witness

10-1 **Eugène Delacroix,** *The 28th of July: Liberty Leading the People,* 1830 (Salon of 1831). Oil on canvas, 8'6" x 10'8" (2.6 x 3.25 m). Musée du Louvre, Paris.

to the rapid popularization of "high art" (painting and sculpture) and a simultaneous explosion of printed images in books, newspapers, and magazines. This led, perhaps for the first time in European history, to a popular visual culture that was shared by a considerable segment of the French population.

Classicism, Romanticism, and *Juste-Milieu*

Towards the end of the July Monarchy, the French critic Charles Baudelaire (1821–1867) jokingly suggested that the artists of the July Monarchy comprised three groups, which he labeled "linearists, colorists, and doubters." To Baudelaire, the art of the period was marked by the tension between Classicism ("linearists"), promoted by Ingres and the French Academy, and Romanticism ("colorists"), embodied in the works of Delacroix. In the space between these two movements operated the "doubters," those who were hesitant to go to extremes and preferred to take a

10-2 **Bertall (Albert d'Arnoux),** *"Music, painting, sculpture."* Illustration in George Sand, P. J. Stahl, and others, *Le Diable à Paris* (vol. 2), 1846. Providence, Rhode Island, Brown University, John Hay Library.

safe middle course. Their artistic eclecticism, that is their selective appropriation of what appeared best in both styles, seemed to parallel the *juste milieu* policy of the July Monarchy government. Both have been related to the philosophy of Victor Cousin (1792–1867), an influential thinker and teacher, whose ideal of "systematic eclecticism" held that, if all philosophies contain some good ideas, a perfect philosophical system may be built from a combination of those elements.

Baudelaire's view of the contemporary art scene reflected popular opinion. A cartoon of 1846 (FIG. 10-2) shows the artists and musicians of the period gathered around Delacroix and Ingres. Delacroix, on the left, holds up a huge pig bladder filled with color, labeled "color law." Behind him, a giant paintbrush carries a placard reading: "Line is a myth." Next to Delacroix stands Ingres, the linearist, with a placard saying: "There is only grey, nothing but grey, and Mr. Ingres is its prophet." With his hand he points to a long sinuous line on the ground, along which is written: "line of Raphael … augmented by Mr Ingres." While Delacroix and Ingres each have a small camp of supporters, most artists have wandered off, forming two large clusters that represent the artistic *juste milieu*. Only a few artists are detached from any of the groups. Among them is Horace Vernet (see page 200) who, seated in a movable chair that hangs from a pulley, is busy painting a gigantic battle scene. This artist's journalistic approach to art, apparently, made him difficult to categorize and he was put in a class of his own.

Louis Philippe and the Museum of the History of France

Like Napoleon and the Bourbon kings before him, Louis-Philippe was keenly aware of the propagandist power of art. Yet while his predecessors had used art for self-promotion or to glorify their dynasty (see pages 195 to 198), Louis Philippe saw it as a means to unite his divided country and, in so doing, to strengthen his own legitimacy.

In the knowledge that all French citizens were bound by a common history, Louis Philippe conceived the Museum of the History of France, for the public teaching of history. Located inside the former royal palace of Versailles, the museum was dedicated to "all the glories of France," suggesting that each period in French history— royalist, revolutionary, and imperial—had had its own glorious moments.

Unlike modern history museums, the Museum of the History of France was not a repository of objects from the past. Instead, it was a gallery of paintings of historic events, beginning with the reign of the historic founder of France, the Merovingian king Clovis I (ruled 481–511), and ending with the regime of Louis Philippe himself. At its height, the museum comprised several hundreds of monumental paintings. Nearly all had been commissioned by the king from leading contemporary artists. In addition, the museum contained numerous full-length sculptures and portrait busts of major figures in French history.

The most important room in the museum was the Gallery of Battles, still intact today (FIG. 10-3). It featured

10-3 Modern view of the Gallery of Battles at the Palace of Versailles, opened 1837. Versailles, France.

10-4 **Ary Scheffer,** *Battle of Tolbiac, Won by King Clovis over the Alamanni,* Oil on canvas, 13'7" x 15'3" (4.15 x 4.65 m). Musée National du Château de Versailles, Versailles.

thirty-three battle scenes, ranging in time from the medieval Battle of Tolbiac in CE 496 to Napoleon's victory at Wagram in 1809. Other rooms were dedicated to the Crusades, the revolutionary wars of 1792, the Napoleonic era, the Revolution of 1830, and the French colonization of Africa. These rooms drew an emphatic connection between France's past and its present.

The *Battle of Tolbiac* (FIG. 10-4) by Ary Scheffer (1795–1858) is characteristic of the *juste-milieu* art of the time. Its author was Dutch but he had studied with the Neoclassical painter Pierre-Narcisse Guérin (1774–1833), and had then become an admirer of Delacroix. With its medieval subject matter and dynamic composition, the *Battle of Tolbiac* has a Romantic side. Yet its linearity and subdued colors are more closely related to the Classical tradition that Scheffer had absorbed in Guérin's studio.

Horace Vernet's anecdotal, detail-oriented mode of representation lent itself well to the "story-telling" that was the history museum's chief purpose. Not surprisingly, Vernet was asked to paint four monumental battle scenes, as well as several smaller works for other rooms. Among the latter was *The Duc d'Orléans on his Way to the Hôtel de Ville, July 31, 1830* (FIG. 10-5), which represents an episode during the days immediately following the Revolution. The painting shows the future king, preceded by a revolutionary brandishing the tricolor, riding towards the town hall to accept the kingship. From atop his horse, he greets the crowd that has come out to welcome him. It is interesting to compare this painting with the Napoleonic history scenes of David and Gros. While their primary purpose had been to glorify a ruler, Vernet's was to record an important historical event. This does not mean that the painting

10-5 **Horace Vernet,** *The Duc d'Orléans on his Way to the Hôtel-de-Ville,* *31 July 1830,* Salon of 1833. Oil on canvas, 7'8" x 8'6" (2.28 x 2.58 m). Musèe Nationale du Château de Versailles, Versailles.

is ideologically neutral; but the message is more subtle, the propaganda less blatant. Unlike Napoleon, Louis Philippe wanted to be seen as a "citizen-king," a leader among equals. That explains why his likeness is shown in the background while the central element in the painting is the tricolor, emblem of the Revolution and of the French people.

Monumentalizing Napoleon

Besides founding the Museum of the History of France, Louis Philippe completed a number of monuments that had been begun by Napoleon. While his preoccupation with Napoleon may seem surprising, it is not hard to understand its centrality to his middle-of-the-road political strategy. After Napoleon's death in 1821, a flood of biographies, historic novels, poems, and illustrated books had turned the emperor into a legendary figure, even something of a secular saint. The Napoleon cult had strengthened

the Bonapartist movement. By joining in the veneration for Napoleon, Louis Philippe hoped to harness the support of this important opposition group to his own regime.

The completion of Napoleon's Arc de Triomphe (see page 113 and FIG. 5-5), which had been left unfinished in 1815, was one of the leading sculptural projects of the July Monarchy. Between 1832 and 1835 the government commissioned several huge sculptures to decorate the arch's monumental pillars. *The Departure of the Volunteers of 1792* (FIG. 10-6) by François Rude (1784–1855) evokes the nationalistic spirit of the men who volunteered to defend their country against the Austro-Prussian invaders immediately after the French Revolution. Following the example of Neoclassical monuments, the sculpture does not represent the scene as it might have happened. Instead, it shows the allegorical figure of Liberty–France rousing six ancient warriors to battle. Their abundant hair growth and rugged features characterize them not as Greeks or Romans but as Gauls, the ancient inhabitants of France.

10-6 **François Rude,** *The Departure of the Volunteers of 1792* ("*La Marseillaise*"), 1833–6. Limestone, c. 42' (12.8 m). Arc de Triomphe, Paris.

10-7 **Louis Visconti,** *Tomb of Napoleon,* 1840–61. Paris, Les Invalides. Lithograph by P. Benoist, 1864. Bibliothèque Nationale, Paris.

10-8 **James Pradier,** *Victory Figure: The Italian Campaign,* completed by the artist's assistants in 1853. Tomb of Napoleon. Marble. Paris, Les Invalides.

What sets this work apart from earlier monumental sculpture is the energy and enthusiasm that pervade all the figures. The female figure of France is particularly striking for the animated pose of her body and her dramatic facial expression. This work is a far cry from the belated Classicism that continued to be the norm throughout most of the nineteenth century (see, for example, FIG. 10-8). Indeed, Rude's work was one of the rare examples of true Romanticism in monumental sculpture of the first half of the nineteenth century.

Louis Philippe also called for the construction of a monumental tomb to house Napoleon's ashes, which he had shipped back from St Helena to France. The specifications of the project were debated at length—where was the tomb to be located and what form would it take? Eventually it was decided to place the ashes in the church of the Hôtel des Invalides, the seventeenth-century veterans' hospital in Paris. The architect Louis Visconti (1791–1853) designed a round funeral chamber underneath the church's dome (FIG. 10-7) to house a colossal porphyry sarcophagus. The circular wall of the chamber was decorated with sculptural allegories of victory, each one corresponding to a specific Napoleonic success

(FIG. 10-8), and with reliefs that illustrated Napoleon's contributions to French society. Napoleon's tomb exemplifies the conservatism of nineteenth-century monumental art, which would remain mired in Neoclassicism, the style promoted by the Academy. Only a handful of sculptors—Rude, Carpeaux, Dalou, and Rodin—would dare to explore new artistic possibilities.

The Revival of Religious Mural Painting

During the July Monarchy the church reemerged as a major art patron. The Revolution of 1830 had brought about a definitive separation of church and state. Roman Catholicism was henceforth declared the religion "of the majority of Frenchmen." A powerful religious revival among middle-class citizens led to the building or restoration of many churches and to new commissions for religious paintings and sculptures. Among these was a large number of mural paintings, that is, paintings that were painted directly on a wall, dome, or ceiling.

Christ's Entry into Jerusalem (FIG. 10-9), a mural in the refurbished medieval church of St Germain-des-Prés in Paris, is typical of a new, abstract style of mural painting that developed in France during the July Monarchy. It was to survive for several decades until it was assimilated and ultimately transformed by late nineteenth-century modernist artists. *Christ's Entry* was painted by Hippolyte Flandrin (1809–1864), a student of Ingres who had studied in Rome in the early 1830s. There, like the Nazarenes before him, Flandrin had become interested in early Christian and Byzantine art which, to the Romantics, expressed the pure and uncorrupted faith of primitive Christianity.

Flandrin's fresco represents the biblical episode of Christ's triumphant entry into the city of Jerusalem. A cheering crowd has carpeted the road with cloaks to welcome him as he rides on a foal. Unlike earlier representations of the scene, Flandrin's painting is not turbulent and action-packed; instead, the figures seem frozen in time. Their hieratic poses as well as the golden backdrop against which they are set recall early Byzantine mosaics, although the figures themselves are inspired by Italian Renaissance painting. Their friezelike arrangement in a shallow space is part of a new mural aesthetic that was gaining ground at the time. Unlike easel paintings, which were expected to be illusionistic (i.e. resembling three-dimensional reality), wall paintings, according to this aesthetic, should be decorative, that is, flat and stylized.

10-9 **Hippolyte Flandrin,** *Christ's Entry into Jerusalem,* 1842–4. Fresco. Church of St Germain-des-Prés, Paris.

10-10 **Eugène Delacroix,** *Pietà*, 1844. Oil and wax medium on wall, 11'7" x 15'7" (3.55 x 4.75 m). Church of St Denis-du-Saint-Sacrament, Paris.

Decorative muralists were expected not to negate the wall surface but rather to work with it.

Flandrin's was not the only approach to religious mural painting during the July Monarchy. An entirely different mode is seen in Delacroix's *Pietà* (FIG. 10-10), a mural in the Parisian church of St Denis-du-Saint-Sacrement that is exactly contemporary with Flandrin's *Entry into Jerusalem*. In this dramatic work, the Virgin and followers of Christ hold up his body as if they want to show it to the faithful in the church. Delacroix's emphatic use of perspective creates the illusion of a spatial recession, quite contrary to the shallow space of Flandrin's mural. The emphatic gestures of Christ's companions express their profound grief, in which the viewer is invited to share.

It is common to explain the differences between Flandrin and Delacroix by calling the first Classic and the second Romantic. These terms, as we have seen, must be used with a certain reservation. It is important to keep in mind that Delacroix called himself a Classicist, and that he referred to Flandrin's murals as "Gothic smears." This clearly demonstrates that cultural categories, such as Classic and Romantic are extremely problematic and offer only an imperfect way to understanding history.

The Salon during the July Monarchy

The paintings in the Museum of the History of France in Versailles, the sculptures on the Arc de Triomphe, and the church murals in Paris were all accessible to anybody who had the means to travel to these places and the time to visit them. The same was true for the Parisian Salon. During the July Monarchy it became a much-anticipated public event. Previously held every two years, in 1833 it was decided to make it annual. At the same time, the number of submissions increased dramatically. While during the Restoration period the Salon had peaked at 2,180 works, in the first years of the July Monarchy that number climbed to 3,318 before it went back down to a median of 2,200. Both the number of works exhibited and the number of visitors increased. While no adequate statistics are known, contemporary images and descriptions of the Salon suggest that it was a crowded affair. A painting by the little-known artist François-August Biard (1798/9–1882), *Four O'Clock at the Salon* (FIG. 10-11), gives us an idea of the throngs that flocked to the Salons to see and be seen.

Every self-respecting paper and journal (including art journals, ladies' journals, and family journals) featured a

10-11 **François-Auguste Biard,** *Four O'Clock at the Salon*, Salon of 1847. Oil on canvas, 22⁵/₈ x 26⁹/₁₆" (57.5 x 67.5 cm). Musée du Louvre, Paris.

lengthy Salon review each year, often extending over many issues. Papers competed for intelligent reviewers, such as Théophile Gautier (1811–1872), who wrote for *La Presse;* Gustave Planche (1808–1857), a contributor to the periodical *Revue des deux mondes;* and Théophile Thoré (1807–1869), who was attached to *Le Constitutionnel*. Art criticism became an important literary genre and it was not unusual for critics to re-publish their reviews in book form after they had appeared in the papers. Many influential critics of the July Monarchy were important authors in their own right. Gautier was known for his poetry and novels and Charles Baudelaire, who made his debut as a critic in 1846, was one of the greatest poets of the nineteenth century.

While *grandes machines* (see page 198) continued to dominate the Salons of the 1830s and 1840s, the numbers of small and mid-size works were on the rise. As the middle class prospered, its members became interested in buying art for the home. Artists began sending smaller works to the Salon in the hope of finding buyers. Thus the Salon increasingly became a marketplace, a function that was the more important since commercial art galleries were still a rarity in Paris at the time. Although Salon catalogues did not list the prices of the works that were exhibited at the Salon, they did provide artists' addresses. Interested buyers could thus visit the artist in his studio and buy from him (or, on occasion, from her) directly. A number of subjects enjoyed a particular popularity at the Salon. These included historic genre paintings, Orientalist scenes, portraits, and landscapes.

Historic Genre and Orientalist Painting

During the July Monarchy there was renewed interest in historic genre paintings. Such paintings had enjoyed a vogue among an elite group of collectors (including Empress Eugénie) during the Napoleonic period, when they were labeled "troubadour" (see page 226). But their true

10-12 **Paul Delaroche,** *The Children of Edward: Edward V, King of England, and Richard, Duke of York in the Tower of London,* 1830. Oil on canvas, 5'11" x 7'1" (1.81 x 2.15 m). Musée du Louvre, Paris.

popularity had to wait for the July Monarchy and the fad for historic novels—Victor Hugo's *Notre Dame de Paris* (*Hunchback of Notre Dame;* 1831, for example, or the numerous novels of Walter Scott—which likewise approached history as fiction.

The Children of Edward: Edward V, King of England, and Richard, Duke of York, in the Tower of London (FIG. 10-12) by Paul Delaroche (1797–1856), exhibited at the Salon of 1831, set the tone for the new historic genre. It represents the 12-year-old king of England, Edward V, and his younger brother Richard, Duke of York, locked up in the Tower of London by their jealous uncle, the future Richard III. Little Richard sits on the bed, while Edward half-kneels on a prayer bench, clasping a religious book. Both princes seem scared because, apparently, they hear a noise at the door. Edward moves closer to his brother while Richard folds his hands in prayer, fighting back tears. The

painting owes its poignancy to the fact that the spectator, presumably familiar with Shakespeare's *Richard III,* already knows that both children are about to be murdered. The *Children of Edward* enjoyed great success in its time for its sentimental theme, psychological drama, detailed execution, and rich coloring, all characteristics that marked *juste-milieu* art.

Delaroche was instrumental in creating a large market for historic genre paintings, of which nearly all figure painters of the period took advantage. Both Ingres and Delacroix supplemented their income from official commissions by selling such paintings to private collectors. Delacroix also helped to launch another popular genre, Orientalist painting. The interest in the "Orient"—roughly the Islamic world of North Africa and the Near East—originated in the Romantic enchantment with the exotic, discussed in Chapter 9. Napoleon's Egyptian's campaign,

10-13 **Eugène Delacroix,** *Women of Algiers in their Harem,* 1834. Oil on canvas, 5'11" x 7'6" (1.8 x 2.29 m). Musée du Louvre, Paris.

as we have seen, served as a catalyst for this phenomenon. The French colonization of North Africa, pursued by Louis Philippe from the early 1830s, added further fuel to the fascination with the Orient, but it also changed it. As travel to North Africa, Egypt, and the Near East became ever easier, Orientalism—the representation of the Orient in Western art and literature—became increasingly rooted in reality rather than fantasy.

Delacroix's important role in the popularisation of Orientalist subject matter is directly related to the fact that he was one of the first French artists to travel to North Africa. In 1832–33 he was asked to accompany the Duc de Mornay on a diplomatic mission to Morocco. The duke had been asked to negotiate a treaty with that country's sultan, to ensure the safety of its neighbor Algeria, colonized by France in 1830. Today it may seem strange to have an artist join a diplomatic missions but it was common practice in the days before photography (see page 111), when artists were needed to record the voyage. In Morocco, Delacroix executed hundreds of watercolors feverishly documenting the country's

landscape, architecture, people, and local customs. To an artist who loved color. Morocco must have seemed a paradise. Brightly lit by an ever-present sun, which accentuated the colors of exotic buildings, costumes, and vegetation, it was a far cry, indeed, from gray Paris.

Upon his return to France, Delacroix painted numerous Oriental scenes. One of these, *Women of Algiers in their Harem* (FIG. 10-13), was exhibited at the Salon of 1834. Three *odalisques* or harem women are seated within the secluded interior of a North African house smoking, a water pipe. A black servant woman, on the right, seems about to leave the room. The sparsely furnished tile-clad room is dimly lit by an invisible window, causing dramatic *chiaroscuro* effects throughout. Compared with Delacroix's earlier works, such as *Liberty Leading the People* of 1831 (see FIG. 10-1), *Women of Algiers* shows a new richness of color. The two women in the center, alone, display a rainbow of colors ranging from red and yellow to violet, blue, green, off-white, salmon, and pink.

Orientalism could encompass not only such quiet, feminine subjects as female harems and baths, all charged with

10-14 **Eugène Delacroix,** *Arab Cavalry Practicing a Charge*, 1832. Oil on canvas, 23⅝ x 28⅞" (60 x 73.2 cm). Musée Fabre, Montpelier.

latent sexuality, but also such eminently masculine subjects as hunts and skirmishes. *Arab Cavalry Practicing a Charge* (FIG. 10-14) is an early example in Delacroix's oeuvre of a subject that was immensely popular throughout the July Monarchy and beyond. With its fiery Arab horses mounted by exotic riders, this painting seems to overflow with energy and aggression. Together, *Women of Algiers* and *Arab Cavalry Practicing a Charge* show a Western view of the Orient as a place where passions were heightened.

Portraiture

Portrait painting continued to be lucrative for artists. The middle class saw portraiture as an art form that could bolster their status and prestige. Ingres, recently returned from Italy, set the tone for much of the portraiture that was done during the July Monarchy. His *Portrait of Louis-Francois Bertin* (FIG. 10-15), a prominent newspaper man, exemplifies the prosperity and self-confidence of the French middle class

in this period. Compared with his earlier works, this portrait shows a new degree of realism and psychological insight.

An interest in the character of the sitter and an emphasis on his or her emotional state at the time of portrayal mark Romantic portraiture. These characteristics are seen most explicitly in the portraits of contemporary writers, artists, and musicians. The *Portrait of Franz Liszt* (FIG. 10-16), by Ingres's student Henri Lehmann (1814–1882), for example, shows the well-known Hungarian pianist and composer, dramatically posed. Standing upright, his arms folded across his chest, he turns towards the viewer as if startled by their presence. The *chiaroscuro* of the face and the unkempt long hair suggest that the artist has been wrenched from a moment of intense inspiration by an intruding spectator.

Portraits of musicians, artists, and writers were popular among the Salon public. This had much to do with the "Romantic cult of personality"—or, to use more contemporary terminology, the fascination with stardom. A similar impulse that today leads us to buy *People*

10-15 **Jean-Auguste-Dominique Ingres,** *Portrait of Louis-François Bertin,* 1832. Oil on canvas, 45 x 37⅜″ (1.16 x 95 cm). Musée du Louvre, Paris.

10-16 **Henri Lehmann,** *Portrait of Franz Liszt,* 1840. Oil on canvas. Musée Carnavalet, Paris.

10-17 **Pierre-Jean David,** called David d'Angers, *Honoré de Balzac,* 1843. Bronze medallion, diameter 7″ (18.4 cm). Musée du Louvre, Paris.

10-18 **Achille Devéria,** *Portrait of Victor Hugo,* Lithograph, 14¹/₈ x 11⁵/₈″ (35.9 x 29.5 cm). Rutgers University, Jane Voorhees Zimmerli Art Museum, New Brunswick.

Magazine led the public of the July Monarchy to acquire images of nineteenth-century celebrities. Many artists of the period saw a marketing opportunity here. The sculptor Pierre-Jean David d'Angers (1788–1856) produced plaster models for more than seven hundred portrait medallions of well-known people of his time. These were cast in bronze and sold to collectors. His medallion of the novelist Honoré de Balzac (FIG. 10-17) is typical of these small-scale relief portraits, which show the profile of the sitter next to his signature. Achille Devéria (1800–1857) made something of a specialty of the portrait lithograph. His numerous lithographs of celebrities, such as the *Portrait of Victor Hugo* (FIG. 10-18), were widely known and distributed during the July Monarchy.

Landscape Painting: Corot and the Historic Landscape Tradition

Of all the genres, landscape painting was best represented at the Salon, constituting some 25 to 30 percent of all exhibited paintings. The genre was in strong demand. People sought landscape paintings to decorate their homes. They were sold not only through the Salon but also in curio shops and home furnishing stores.

Three principal trends of landscape painting stood out during the July Monarchy. One was the historic landscape

tradition that was upheld by the Academy (see page 175). While this was represented for the most part by conservative artists, it also attracted some innovative, highly original artists. Among them was Jean-Baptists-Camille Corot (1796–1875), whose *Hagar in the Wilderness* (FIG. 10-19), submitted to the Salon of 1835, established his reputation as the greatest landscape painter of his time. The painting represents an episode from the biblical book of Genesis (16:1 to 21:21). Abraham's wife, Sarah, is unable to conceive and encourages Abraham to sleep with her faithful servant Hagar. When Hagar gets pregnant, Sarah becomes jealous and even though she eventually bears a child herself, she sees to it that Hagar and her son Ishmael are banished to the wilderness of Beersheba. In Corot's painting, we see Hagar kneeling in despair beside the body of her child. All around her the wilderness stretches out as far as the eye can see. Corot's contemporaries admired the painting because they felt it surpassed ordinary historical landscapes in two respects. For one, Corot had established a perfect harmony between Hagar's desperate state and the desolate landscape. Or, as one critic wrote: "M. Corot's landscape contains something that grips your heart even before

you become aware of the subject matter." For another, the landscape was based on personal observation, and had a sense of freshness and immediacy that was quite convincing.

Indeed, the earlier part of Corot's career had been largely devoted to the direct study of nature. In the late 1820s he had spent two-and-a-half years in Italy where, like Valenciennes before him, he had sketched outdoors, in oils, "from the motif." This taught him to represent light and atmospheric effects with great mastery. *Bridge at Narni* (FIG. 10-20) is an early oil study, executed on paper, that conveys a convincing impression of a vast panoramic landscape. With only a limited palette, Corot has suggested the atmosphere of an early morning, when the rising sun emits a soft light and causes people and objects to cast long, trembling shadows. Small dabs of color suggest the sandy surface of a towpath and the shrubbery by the roadside.

In Corot's time these sketches were never publicly shown and remained, for the most part, in his studio. The artist did, however, produce a category of paintings that were less formed than *Hagar in the Wilderness*. These were mid-size paintings, mostly of French scenes, which he sold to

10-19 **Jean-Baptiste-Camille Corot,** *Hagar in the Wilderness,* 1835. Oil on canvas, 5'11" x 8'1" (1.8 x 2.47 m). Metropolitan Museum of Art, New York.

10-20 **Jean-Baptiste-Camille Corot,** *Bridge at Narni,* 1826. Oil on paper mounted on canvas, 13³/₈ x 18⁷/₈" (34 x 48 cm). Musée du Louvre, Paris.

collectors. Corot would exhibit works such as this at the Salon, to bring them to the attention of potential buyers, or he might show them in smaller art exhibitions in Paris or the provinces. (Many artists, including Delacroix, followed this practice of alternately submitting *grandes machines* and mid-size paintings to the Salon. Many, as well, increasingly sought out exhibitions in the provinces, organized by local art societies, to market their works.)

Fishing with Nets, Evening (FIG. 10-21) may serve as an example of such mid-size works. This painting was probably identical with a work exhibited at the Salon of 1847 as *Landscape.* It was bought, some years later, by the well-known provincial collector Alfred Bruyas (1821–1877), who also bought many of Courbet's works. *Fishing with Net, Evening* exemplifies a mode in Corot's work that was to prove extremely popular with collectors in years to come. The painting depicts a simple landscape scene, with water, trees, and a few figures. The use of fresh greens and a light, feathery touch for the rendering of foliage suggests springtime. The painting has a quiet, poetic quality that has an easy appeal. Works such as this became exceedingly popular during the following decades when Corot turned out hundreds of similar uncomplicated, lovely landscapes.

Landscape: The Picturesque Tradition

After the historical landscape tradition, a second major trend in July Monarchy landscape painting was the picturesque. It owed much to practices that had been brought to France by several British watercolorists, who traveled to France during the Restoration period. As in Britain, the French interest in picturesque landscapes was closely related to a new vogue for travel, which began in the wake of the fall of Napoleon and became ever more widespread. While picturesque landscapes, in watercolors and oils, were exhibited at the Salon, the demand for such scenery was met primarily by printmakers. These produced etchings and lithographs for picture albums and travel books that were immensely popular during the July Monarchy period. The most famous among them was a series of travel books published under the supervision of Baron Isidore Taylor (1789–1879). This amateur artist, art administrator, and art entrepreneur set up a serial publication called *Voyages Pittoresques et Romantiques dans l'ancienne France* (Picturesque and Romantic Voyages in Ancient France), 1820–78, in which each volume was to describe a region of France. The success of Taylor's publication, twenty-four volumes in all, was due to the involvement of Charles Nodier

10-21 **Jean-Baptiste-Camille Corot,** *Fishing with Net, Evening,* Oil on canvas. Musée Fabre, Montpellier.

10-22 **Eugène Isabey,** *Château de Pont-Gibaud, Auvergne,* 1830. Plate 72 from vol. 4 of *Voyages pittoresques et romantiques dans l'ancienne France* (1833). Lithograph. Ann Arbor, University of Michigan Museum of Art.

(1780–1844), a well-known Romantic writer who wrote the copy, and to the latter's ability to attract excellent artists to the project. Nearly all major landscape artists of the period contributed to Taylor's publication, producing drawings that skilful lithographers would turn into prints. *Château de Pont Gibaud*, after a drawing by Eugène Isabey (1803–1886; FIG. 10-22), exemplifies the illustrations in the *Voyages pittoresques et romantiques* (Picturesque and Romantic Voyages). This image of a medieval castle, towering over a rustic vilage, perpetuates the picturesque tradition of eighteenth-century Britain (see page 176). It is seen in the strong contrast between light and dark, caused by the peculiar light fall before a thunderstorm; and in the irregular, worn surfaces of the castle and the old, tired houses of the village.

Landscape Painting: The Barbizon School and Naturalism

The third and most important trend in July Monarchy landscape painting was what may be called the "natural-ist" trend. Influenced by the work of the English painter Constable, this trend focused on the faithful depiction of the French countryside. Naturalist landscapists were not interested in the medieval castles and ruins shown in Baron Taylor's *Voyages pittoresques et romantiques*. They preferred to depict the woods and fields of France, occasionally enlivened by a small cottage, some cows, a shepherd, or a farmer. Théodore Rousseau (1812–1867) was the chief proponent of this trend. Born in Paris, he sought the motifs for his landscapes close to home, especially in the extensive forest of Fontainebleau just outside Paris. Enamored with the woods and clearings of that forest, Rousseau spent long periods in the small village of Barbizon where, eventually, he settled permanently. Due, in part, to his presence there, Barbizon became a center of landscape painting, attract-ing many other artists, some of whom came to live there

as well. The term "Barbizon school" is commonly applied to these painters, and is often extended to all French land-scape painters who embraced a naturalist landscape style during the July Monarchy. It is noteworthy that the term Barbizon school was not coined until the late nineteenth century. In their own time, these artists were referred to as the School of 1830.

Although Rousseau was the leading painter of the Barbizon school, his works were rarely seen at the July Monarchy Salons. Between 1836 and 1841 his submis-sions were consistently refused. This so disturbed the artist that from 1842 he stopped sending works to the exhibition altogether and resumed only after the Revo-lution of 1848. Despite his absence from the Salon, however, Rousseau managed to build an almost legendary reputation. This reputation was due to several art critics who discussed his works in their Salon reviews even though they were not actually on exhibit. Rousseau's staunchest supporter was the critic Théophile Thoré, who began his review of the Salon of 1844 with a "Letter to Rousseau," in which he called the artist a "poet... look-ing at the great outdoors, at the fair weather and the rain, and at thousand things imperceptible to the common eye." To Thoré, Rousseau was able to see "mystic beau-ties" in commonplace landscapes—beauties that he was able to "lovingly reproduce" and this make visible to "ordi-nary" viewers.

Rousseau's *Heath* (FIG. 10-23), painted in the early 1840s, exemplifies Barbizon school painting in its focus on a quiet corner of France devoid of ruins or other picturesque struc-tures. The elements of nature themselves—sky, trees, terrain, water—are given importance as pictorial subjects. Rousseau, indeed, was a painter of nature rather than a landscape painter. He was less interested in capturing effects of light and atmosphere than in representing nature and natural processes such as birth, growth, and decay. He concen-trated on the tangible aspects of nature, such as the dense

10-23 **Théodore Rousseau,** *Heath*, 1842–3. Oil on canvas, 16³/₈ x 24¹³/₁₆" (41.5 x 63 cm). Musée Saint-Denis, Reims.

foliage of trees, rugged moorland, and the mirror-smooth surface of water. He spent much time drawing and sketching outdoors, to acquire an intimate knowledge of nature. His preoccupation with detail and his tendency to work on his paintings for months, even years, grew from his profound respect for creation. It is not surprising that Rousseau was an early conservationist who was involved in an effort to prevent developers from destroying the forest of Fontainebleau.

Rousseau's preoccupation with nature's enduring cycle of life and death found masterful expression in *The Forest in Winter at Sunset* (FIG. 10-24), a work that has been called his "artistic testament". Rousseau worked on it, at intervals, for over twenty years, from 1845 until his death. It presents a powerful vision of the vitality of nature, even in the dead of winter. The dense entanglement of gnarled tree trunks and branches, seen against the red of the evening sky, is a testament to Rousseau's

10-24 **Théodore Rousseau,** *The Forest in Winter at Sunset*, 1845–67. Oil on canvas, 5'4" x 8'6" (1.63 x 2.6 m). Metropolitan Museum of Art, New York.

10-25 **Jules Dupré**, *Crossing the Bridge*, 1838. Oil on canvas, 19¹¹/₁₆ x 25⁵/₈″ (50 x 65 cm). Wallace Collection, London.

profound belief in the indestructibility of nature and its enduring potential for regeneration.

No other Barbizon school artist ever achieved the raw intensity of Rousseau's work. Perhaps for that very reason, their works were more popular with collectors. Both Jules Dupré (1811–1889) and Narcisse Diaz (1808–1876) produced paintings that had a lyrical, pastoral quality that was often absent from Rousseau's works, and hence were more inviting to look at. Dupré's *Crossing the Bridge* (FIG. 10-25), exhibited at the Salon of 1838, for example, has a pleasant rustic quality that greatly appealed to city dwellers. Indeed, as Paris and other urban centers expanded at a frightening speed, a growing nostalgia for the countryside ensured a market for his paintings.

The Explosion of the Press and the Rise of Popular Culture

During the July Revolution press censorship was eliminated: newspaper editors were allowed to publish almost anything they saw fit, except libel. This unprecedented freedom of the press helped to foster a dramatic expansion of print media, especially newspapers and magazines. While newspapers had existed in France since the seventeenth century, their real importance dates from the time of the French Revolution when, for the first time, their propaganda value was realized. Until about 1830 they were read primarily by the well-to-do, not only because they were expensive, but also because the lower classes were largely illiterate. By the early 1830s, however, a dramatic rise in literacy rates coincided with considerable improvements in paper making and printing, which made newspapers easier and cheaper to produce. The introduction of newspaper advertising, which shifted part of a paper's cost from subscribers to advertisers, was another cause of the veritable media explosion during the 1830s and 1840s.

The expansion of the media led to the rise of a popular culture, that is, a culture that embraced several classes at once. By 1840 a paper such as *La Presse* had a readership that ranged from aristocrats and wealthy professionals to shopkeepers and working-class artisans. It is important to realize that this popular culture was not yet a mass culture, for it was by no means universal. Most peasants and the

vast underclass of the urban poor did not share in it because they did not have access to the media that promoted it.

Thanks to the vast increase, in the early 1830s, of papers and magazines that carried illustrations, the new popular culture had a strong visual component. Two newly invented printmaking techniques, wood engraving (see *Wood Engraving*, below) and lithography (see *Lithography*, page 207), enabled the mass reproduction of images. The advantage of images as a way to boost the sales of papers was quickly realized by several keen publishers. One such entrepreneur was Charles Philipon (1802–1862), who published humorous journals featuring political caricatures and social satire. His first two journals, *La Caricature*, founded in 1830, and *Le Charivari*, founded in 1832, enjoyed considerable success at first. Both journals ran into trouble, however, in 1835 when Louis Philippe, tired of the unrelenting criticism of his government in the opposition press, restricted the press through the so-called September laws. *La Caricature* was forced out of business and *Le Charivari* was strongly censored.

Honoré Daumier

Although himself a caricaturist of some merit, Charles Philipon's real strength was as a talent scout. To his various journals he attracted gifted draftsmen, including Honoré Daumier (1808–1879), a cutting political caricaturist. Together, Philipon and Daumier developed the most famous satirical emblem of the July Monarchy, *La Poire* or "The Pear." It began as a caricature of Louis Philippe, whose heavy-jowled face had the outline of a pear (FIG. 10-26). But the image owed its special potency to the slang meaning of the French word *poire*, which is "fathead." In a caricature by Daumier, *Masks of 1831* (FIG. 10-27), a phantom *poire* appears among a group of masks—caricatures of Louis Philippe's ministers. The message is multi-layered. Not only are we to understand that Louis Philippe is nothing but a figurehead, faceless and voiceless, out-ruled by his ministers, but by drawing the countenances of the ministers as masks (which hide their true selves), Daumier has also emphasized the hypocrisy and deceitfulness of the men who ruled in the name of the king.

Masks of 1831 is typical of Daumier's early work, which is composed almost exclusively of portrait caricatures. To advertise the issue of Philipon's *La Caricature* in which they were published, Daumier produced a series of caricature busts out of clay that were displayed in the shop window of Philipon's publishing house. Clay was an ideal medium for Daumier to develop exaggerated likenesses. Its easy malleability enabled him to tweak the faces of his "models" to experiment with their characterization. Daumier's bust of the Count de Kératry (FIG. 10-28), with its reduced cranium and enormous buck-teeth, gives the count an almost apelike appearance, suggesting that he has some

10-26 **Charles Philipon,** *Les Poires* (The Pears). Illustration in *Le Charivari*, January 17, 1831. Wood engraving. Bibliothèque Nationale, Département des estampes et de la photographie, Paris.

Wood Engraving

The most common printing technique of the nineteenth century, wood engraving was used to illustrate books, newspapers, and magazines. Unlike the related woodcut, which had been in use in the West since the late fourteenth century, wood engraving was not known until the eighteenth. The Englishman Thomas Bewick (1753–1828) has often been credited with its invention, but he did little more than improve on and popularize a technique that had already been in sporadic use.

The main difference between woodcut and wood engraving lies in the materials used. While the first is printed from a block of soft wood, cut along the grain, the second derives its special effects from the use of a hard boxwood, cut across the grain, that is, carved with an engraver's burin (a chisel with a lozenge-shaped cutting edge). Wood engravings allow for fine detail. Especially well suited to translate the effect of pen drawings, they can also be used to convey the effects of *chiaroscuro*.

10-27 **Honoré Daumier,** *Masks of 1831*. Illustration in *La Caricature*, no. 71, March 8, 1832. Lithograph, 8³/₈ x 11" (21.2 x 29 cm). Bibliothèque Nationale, Département des estampes et de la photographie, Paris.

Physiognomy and Phrenology

The caricaturists of the first half of the nineteenth century were intimately familiar with the pseudo-sciences of physiognomy and phrenology, developed by the Swiss Protestant minister Kaspar Lavater (see page 81) and the Austrian physician Franz-Joseph Gall (1758–1828) respectively. Each one had established a set of systematic relationships between the appearance of human heads on the one hand, and character and intelligence on the other. In analyzing the shape of the human head, they attached great importance to facial angles, proportions, and measurements. The angle of the nose, the height of the forehead in relation to the total height of the head, and the circumference of the skull were all important indicators of characteristic human traits.

Both systems relied loosely on the resemblance of certain human faces to specific animals, the characteristics of which were frequently assigned to the humans who looked like them. Caricaturists such as Daumier and especially Grandville (see pages 238 and 242) often exaggerated the traits of their sitters to make them look like monkeys, dogs, or birds (see FIG. 10-28).

Such resemblances acquired a whole new meaning after the publication *On the Origin of Species* by Charles Darwin in 1850. All of a sudden, they raised the specter of degeneration—the possibility that the human race would not progress to a higher state but instead regress to a less advanced stage in the evolutionary process. Degeneration was especially feared at the end of the nineteenth and the beginning of the twentieth centuries (see page 411) and led to the concept of eugenics—the deliberate attempt to improve the human race.

10-28 **Honoré Daumier,** *Count de Kératry.* Unbaked clay, painted, height 5" (12.9 cm). Musée d'Orsay, Paris.

of the characteristics of that animal. This was a common tactic in Daumier's portrait caricatures, which often owe much of their powerful impact to visual association (see *Physiognomy and Phrenology*, opposite).

While Daumier drew caricature portraits for *La Caricature*, he also made political cartoons for Philipon's papers. Most of these were so virulent that Philipon (and, on occasion, Daumier himself) was continually summoned in court for libel. A cartoon titled *Gargantua* (FIG. 10-29) led to their imprisonment and to a ban on the publication in which it appeared. It shows a pear-headed Louis Philippe in the guise of the giant Gargantua, a character invented by the medieval French writer François Rabelais (c.1494–1553). Gargantua is seated on a nineteenth-century john (a chair with a hole in the seat), devouring baskets full of gold that are brought up to his mouth by an army of carriers. Thanks to an excellent digestion, Gargantua immediately expels a mound of paper documents, which, inscriptions tell us, are letters of nomination and appointment to special government positions and court honors.

With cruel sarcasm, Daumier criticized a government that levied taxes not to improve the lives of the common people (represented in *Gargantua* by the group of men and

10-29 **Honoré Daumier,** *Gargantua.* Illustration, 1831. Lithograph, 8 x 12" (21.4 x 30.5 cm). Bibliothèque Nationale, Département des estampes et de la photographie, Paris.

10-30 **Honoré Daumier,** *Rue Transnonain, April 15, 1834.* Illustration in *L'Association Mensuelle,* July 1834. Lithograph, 17 x 11" (44.5 x 29 cm). Private Collection, London.

women on the right) but to fatten up that government by giving special honors to tax collectors and other reprehensible types. In Daumier's scatological caricature, the body of the king is a metaphor for the government. "The State, it is I," Louis XIV had boasted in the seventeenth century. Here Daumier gives a negative meaning to that royal proclamation by representing the king as a grossly overweight creature, engaged in the basest bodily function.

Not all Daumier's political lithographs are in a satirical vein. One of his best-known images, *Rue Transnonain, April 15, 1834* (FIG. 10-30), is a dramatic re-creation of an actual event. Because it was not libellous, the government was unable to bar its publication, even though it contained an implicit critique of its actions. In the spring of 1834 there was great unrest in Paris, fueled by secret republican and socialist societies that opposed the July Monarchy regime. The government sent in troops to end the riots that had broken out in the poorer sections of Paris. On April 15 a rioter hiding in a tenement house on Transnonain Street shot a popular army officer. To avenge him, his soldiers went through each house on the street and killed everyone. Twenty innocent men, women, and children were slaughtered in a night that became known as the Transnonain Massacre.

Daumier's print shows the bedroom in one of the worker's apartments, its floor covered with corpses. A man wearing a nightshirt and nightcap lies beside the bed from which he has been dragged. His dead body crushes that of his baby, which lies in a puddle of blood. Like *Gargantua, Rue Transnonain* is a politically subversive image, although it operates in a very different way. Comedy and satire have been replaced by stark, explicit imagery to make a dramatic point. Daumier's lithograph may be compared with twentieth-century photojournalistic images, such as Ronald Haeberle's *My Lai Massacre Scene* (FIG. 10-31), which shows the bodies of women and children lying on a road in South Vietnam. Just as the American government dreaded such images for their potential to arouse anti-war protests, so the July Monarchy government feared Daumier's lithograph. Unable to bar Philipon from publishing it, they purchased as many of the newspapers in which it appeared as possible, and destroyed them.

The realization of the dangerous power of images led Louis Philippe's government, in September 1835, to introduce strict censorship laws that made the publication of politically subversive imagery very difficult. Henceforth, Philipon and his illustrators were forced to concentrate on social rather than political satire. The new imagery focused on specific urban locales, such as the streets of

10-31 **Ronald Haeberle,** *My Lai Massacre Scene*, 1968. Gelatin silver print. Timepix, New York.

Paris, the theatre, the Salons, or special groups, such as doctors, lawyers, bourgeois, or bluestockings. *Good-Bye My Dear, I Am Going to My Editors* (FIG. 10-32) belongs to the last category. It shows a woman who leaves the house to take a literary manuscript to an editor, while her husband stays at home to watch the baby. Caricatures such as this made fun of the ambitions of contemporary women— such as Madame de Staël, George Sand (1804–1876), and Louise Colet (1810–1876)—to become poets or novelists. Their humoristic effect depended on their visual presentation of an "upside-down world," in which gender roles were switched. In Daumier's caricature the man sits at home, gently feeding the baby, while the woman goes out in search of fame and fortune.

10-32 **Honoré Daumier,** *Good-bye My Dear, I Am Going to My Editors*. From the series of *Les Bas Bleus* (The Bluestockings). Illustration in *Le Charivari*, February 8, 1844. Lithograph, 11 x 7" (27.8 x 17.9 cm). Bibliothèque Nationale, Département des estampes et de la photographie, Paris.

Gavarni and Grandville

In the realm of social satire Daumier had to compete with many other draftsmen, including Paul Gavarni (1804–1866) and J. J. Grandville (1803–1847), who were also employed by Philipon. Unlike Daumier, both these artists not only contributed to humorous journals, they made drawings for fashion magazines and family journals and, on occasion, they did book illustrations as well. Both Gavarni and Grandville also produced special albums reproducing their drawings, for direct sale to admirers of their work.

Gavarni began as an illustrator of *La Mode*, a well-known fashion magazine. He earned his reputation, however, with his drawings of *lorettes*, young working-class girls of loose morals who were the favored companions of students and artists. (Musette and Mimi, in Puccini's famous opera

10-33 **Paul Gavarni,** What are you reading?—*The Virtue of Women*—Are you sick? Illustration in *Le Charivari*, January 29, 1843. Lithograph, British Library, London.

10-34 **J. J. Grandville** (pseudonym of Jean-Ignace-Isidore Gérard), *Venus at the Opera.* Illustration in *Un Autre Monde* (*Another World*), Paris, 1844. Wood engraving, 5¼ x 4″ (2 x 1.6 cm). Private Collection, Paris.

La Bohème of 1896, are outstanding examples of the *lorette*.) The lithograph reproduced in FIG. 10-33 appeared in *Le Charivari* in 1843 and was part of a series of seventy-nine prints that appeared in that journal between 1841 and 1843. It shows two *lorettes* in a room, one reading on the bed, the other putting a comb in her hair. The caption records the following conversation: "What are you reading?"—"*The Virtue of Women*,"—"Are you sick?"

Grandville, who began as a political caricaturist and social satirist, eventually became best known for his fantastic drawings. The most interesting of these are contained in his album *Un Autre Monde* (Another World) in 1844, not long before his death. *Venus at the Opera* (FIG. 10-34) is one drawing from the album. It mocks the ambiance of the nineteenth-century theatre, in which spectators were more interested in each other than in the drama that was performed on stage. We see a crowd of male spectators craning their necks to see a beautiful woman on the balcony. She feigns to ignore their gazes even though her whole purpose for being in the theatre is to be on display. The special interest of Grandville's caricature lies, of course, in the metamorphosis of the men's heads into eyes (visually to express the notion that they are "all eyes") and of the woman into a bust placed on a podium (illustrating the expression of placing a person "on a pedestal"). This transformation of reality gives to Grandville's prints a surreal quality that seems to anticipate the works of such artists as Salvador Dali and René Magritte in the twentieth century.

Louis Daguerre and the Beginnings of Photography in France

In addition to the printing techniques of lithography and wood engraving, a new process of chemical printing was developed in the 1830s by Louis Daguerre (1787–1851). One of the most inventive men of his time, Daguerre was a stage designer, a painter, a printmaker, an amateur scientist, and an entrepreneur. Before he became involved with photography, he had obtained international fame as the inventor of the "diorama," a form of artistic entertainment analogous to the panorama (see *Girtin and the Vogue for the Painted Panorama*, page 181) that owed its illusionary effects to the manipulation of light.

10-35 **Louis-Jacques-Mandé Daguerre.** *The Artist's Studio*, 1837. Daguerreotype, 6 x 8" (16.5 x 21.7 cm). Société français de photographie, Paris.

PHOTOGRAPHIE
Nouveau procédé employé pour obtenir des poses gracieuses.

10-36 **Honoré Daumier,** *Photography. A New Procedure, Used To Ensure Graceful Poses.* From the series *Croquis parisiens* (Parisian Sketches). Illustration in *Le Charivari*, 1856. Lithograph. Los Angeles, University of California, Armand Hammer Museum of Art.

10-37 **E. Thiesson,** *Louis-Jacques-Mandé Daguerre*, 1844. Daguerreotype. Musée Carnavalet, Paris.

Together with Nicéphore Niepce, Daguerre developed the first of numerous photographic processes that were to be used in the nineteenth century. His "daguerreotype" differed from other processes in that it was printed not on paper but on thin silver plates. One of the earliest examples, dating from 1837, is a still-life arrangement in the artist's studio (FIG. 10-35). Still life was a common subject in early photography. Exposure times were so long, initially 15–30 minutes, that it was impossible to photography anything that moved. Already by 1842, however, the process had been improved to allow for much shorter exposure times of 10–50 seconds. By the mid-1840s the daguerreotype could be used for portrait photography, as long as the models sat very still. To help them meet this challenge, photographers used a special apparatus that clamped and effectively immobilized the sitter's head (see FIG. 10-36). This explains the stiff formality of many early portrait photographs (see, for example, FIG. 10-37), which, paradoxically, often seem less lively than painted portraits of the same period.

Portraiture was probably the most common early use of photography. The camera offered members of the middle

10-38 **Jean-Baptiste-Louis Gros,** *View of the Seine and the Louvre,* 1847. Daguerreotype. George Eastman House, Rochester, New York.

class an opportunity to record likenesses of themselves and their loved ones without having to lay out the cash to have a portrait painted. Yet photography was also commonly used to document places, as we see in the *View of the Seine and the Louvre* (FIG. 10-38) of 1847 by Jean-Baptiste-Louis Gros (1793–1870). Such photographs were the predecessors of the picture postcard of modern times.

Daguerre's process was only one of many that were developed in various parts of Europe in the second and third quarters of the nineteenth century. Among these the calotype, invented in England by William Henry Fox Talbot (1800–1877), was the first process that allowed printing on paper rather than a metallic surface (see page 321).

Chapter Eleven

The Revolution of 1848 and the Emergence of Realism in France

A cartoon was published in *Le Charivari* of March 4, 1848, that, to many Parisians, must have recalled the events of 1789 (FIG. 11-1). It showed the king's chair in the Tuileries Palace occupied not by Louis Philippe but by a street urchin exclaiming: "Wow! . . . How softly you sink down in it!"

The cartoon appeared in the wake of the notorious Revolution of 1848. During the last week of February, there was an uprising in Paris that in the next few months would escalate into a wave of revolutions across Europe. Before the end of the year, the German states, Italy, Austria, Hungary, and Bohemia (the present-day Czech Republic) experienced complete political upheaval.

The revolutionary sweep was caused by a severe food shortage that had begun as early as 1846 and soon affected the entire European economy. In France recession and massive unemployment fanned political discontent. Throughout the 1840s the middle and lower classes had clamoured for increased participation in government. Political agitators now demanded universal male suffrage, as well as freedom of speech and assembly.

After two days of street fighting, Louis Philippe abdicated and fled to England. The Second republic was proclaimed, and a provisional government, led by the poet Alphonse de Lamartine (1790–1869), attempted to restore order. This was no easy task, especially because of the grave unemployment problem. The effort to create "national workshops" to provide temporary work collapsed when jobless workers from all over France poured into the

11-1 **Honoré Daumier,** *The Urchin of Paris in the Tuileries Palace* ("Wow! . . . How softly you sink down in it!"). Illustration in *Le Charivari,* March 4, 1848. Lithograph, 10 x 9" (25.5 x 22.7 cm). British Library, London.

capital to take advantage of this opportunity. The government had neither the infrastructure nor the money to cope with the crowds, and was forced to close the workshops in June. The unemployed took to the streets, and were joined by students, artisans, and employed workers. The government sent in troops, and the bloody "June Days" ensued, leaving 1,500 rebels dead. Another 12,000 were arrested, and some were exiled to France's new colony, Algeria. A military dictatorship replaced the republican government until elections could be scheduled.

In December 1848 Louis Napoleon, a nephew of the former emperor, was elected president. He had been biding his time to enter politics and the Revolution of 1848 provided a long-awaited opportunity. Although his presidency was supported by the French, the constitution of the Second Republic restricted it to a non-renewable four-year term, which meant that elections had to be held again in 1852. To prevent this, Louis Napoleon staged a military coup in December of that year, effectively terminating the Second Republic and establishing a military dictatorship. Less than a year later, like his uncle, he proclaimed himself emperor. As Napoleon III he would reign until the Prussians invaded France in 1870.

The Salons of the Second Republic

The Revolution of 1848 had a dramatic impact on that year's Salon. The Provisional Government sympathized with young artists who, for years, had complained about extreme conservatism and nepotism in the Academy's jury selection process. The government decided to suppress the jury entirely that year, allowing all artists to exhibit. A record 5,180 works were shown, more than twice the number that had appeared in previous exhibitions. Many of the works were mediocre, making it obvious that doing away with the jury was not the answer to the Salon's problems. In 1849 a new democratic organization of the Salon was established, whereby the jury was elected by artists instead of an elite group of academicians. This jury reduced the number of works to 2,586, its former average. The following year the number rose again, because the Salon of 1850 was combined with that of 1851. Held, for the first time, in the Palais Royal (rather than the Louvre), it included almost 4,000 works.

While the open Salon of 1848 was an opportunity for many young artists to make their debut, few of them were able to make a mark. The Salon was too crowded, and preoccupation with the Revolution sapped people's interest in art. Thus the Salons of 1849 and 1850–1 were a better opportunity to show new and innovative works that would never have been admitted by the conservative juries of the July Monarchy.

Of the works exhibited at these Salons, several demonstrated the profound impact of the events of 1848. While some artists had been swept up in republican enthusiasm, others mourned the revolution and its atrocities. Jean-Louis Ernest Meissonier (1815–1891), a conservative artist who had shown some small historic genre paintings in the Salons of the July Monarchy, was in the latter group. *Memory of Civil War* (FIG. 11-2), exhibited at the Salon of 1850–51, was his first contemporary picture, a small, carefully painted canvas representing the June Days. Although it was painted after the fact, with the help of models, it was based on a scene that Meissonier had witnessed personally. During the June Days he had stormed the rebel barricades as an artillery captain in the National Guard. Meissonier later remembered this time, writing: "When the barricade in the rue de la Mortellerie was taken,... I saw the defenders shot down, hurled out of windows, the ground strewn with corpses, the earth red with the blood it had not yet drunk."

Meissonier's painting shows a back street in Paris, its cobblestones dug up for the construction of a barricade. But the government troops have toppled the barricade, and the rebels, shot dead, are piled up amidst the rubble. This is a far cry from Delacroix's splendid barricade scene in *Liberty Leading the People* (see FIG. 10-1). While that painting suggests that a glorious revolution is worth the sacrifice of a few victims, Meissonier's painting stresses the civil tragedy of a revolution in which Frenchmen are killing each other. The painting reflects the different characters of the two revolutions—the "three glorious days" of July 1830, which were relatively quick and bloodless, versus the bloody June Days of 1848. The sober realism of his work, quite different from the Romantic élan of Delacroix's paintings, was more in tune with the newly-emerging movement in the arts known as "Realism."

The Origins of Realism

In 1846 the poet and journalist Charles Baudelaire (see page 218) wrote a book-length review of the Salon. While hailing what he perceived as the positive qualities of Romanticism, "intimacy, spirituality, color, aspiration towards the infinite," he criticized Romantic and Classical artists alike for always depicting the past and neglecting the present. Baudelaire did not deny that some artists (such as Gros, Géricault, and Delacroix) had treated contemporary scenes, but he down played their contribution because they had painted "public" and "official" subjects.

In the final chapter of his Salon review, entitled "On the Heroism of Modern Life", Baudelaire challenged artists to paint the ordinary aspects of modern life and to find in them some grand and epic quality. For, as he wrote, "There *are* such things as modern beauty and modern heroism!" He demanded that artists renounce allegory and nudity, as well as any kind of historic costume (togas, medieval armor, etc.). He wanted to see modern man, in the dark suit and overcoat of the times.

11-2 **Jean-Louis Ernest Meissonier,** *Memory of Civil War* or *Barricade in the Rue de la Mortellerie, June 1848,* 1848. Oil on canvas, 11 x 8″ (29 x 22 cm). Musée du Louvre, Paris.

As for the garb, the outer husk, of the modern hero,... [does it not have] its own beauty, its native charm? Is it not the necessary garb of our suffering age, which wears the symbol of perpetual mourning upon its thin black shoulder?

It is true that the bourgeois subjects that Baudelaire was referring to had already been represented in the prints of Gavarni, Grandville, and Daumier (see chapter 10). In fact, Baudelaire greatly admired the work of these artists and, in a later essay, called Daumier one of the most important figures in modern art. Baudelaire was also well aware that a small number of July Monarchy painters had produced modest genre pictures of everyday people for a middle-class market. Yet in his review of the Salon of 1846 he called for something more. He was asking for large-scale, serious works that would have the same artistic merit as the history paintings that were shown at the July Monarchy Salons.

Gustave Courbet's A Burial at Ornans

At least one painting at the Salon of 1850–51, seemed to respond to Baudelaire's call. It was painted by Gustave Courbet (1819–1877), who had befriended the poet-critic in the late 1840s. Entitled *A Burial at Ornans* (FIG. 11-3), it was a monumental representation (approximately 10 x 22 feet) of a middle-class burial in the French provinces.

The painting shows a funeral procession making its way from the small town of Ornans (the artist's home town) to the cemetery. On the left, four pall bearers wait as the priest reads from the Bible. Surrounding the priest are various church functionaries: a cross bearer, choir boys, sacristans, and beadles, dressed in red. A gravedigger kneels beside the grave. To the right of the grave are the relatives of the deceased. The men have taken off their hats, while the women wipe away their tears with large white linen handkerchiefs. A dog stands quietly among them.

Unlike earlier paintings, such as David's *Death of Socrates* and Delacroix's *Death of Sardanapalus* (see FIGS. 2-19 and 9-18), Courbet's *Burial* neither ennobles nor dramatizes death. It represents death for what it is—a recurrent event in people's lives. Yet, even though the painting emphasizes the prosaic nature of death, the artist does not trivialize it. Instead he seems to express the impossibility of truly fathoming death's mystery.

One of Courbet's close friends compared the long procession in the *Burial* with medieval representations of the "Dance of Death" (FIG. 11-4), in which Death leads a procession of kings, bishops, rich, and poor to the grave. In medieval thinking, death was the great equalizer, since it dealt the same fate to king and pauper. Courbet's *Burial*, with its uniformly dressed figures, suggests that in the modern age—thanks to the revolutions of 1789 and 1848—equality may be achieved even during one's lifetime.

Courbet's *Burial* caused a scandal at the Salon of 1850–1. Its line-up of provincial bourgeois in black suits was said to be dull and boring. Courbet was also criticized for glorifying a trivial subject. Underlying all this criticism was a good deal of fear, stemming from recent political changes. Courbet's painting was a reminder to Parisian visitors that, under the new republican regime, ordinary, provincial bourgeois had to be reckoned with. The Revolution of 1848 had brought universal male suffrage; voting rights were no longer restricted to the rich, as was the case

11-3 **Gustave Courbet,** *A Burial at Ornans*, 1849–50. Oil on canvas, 10'4" x 21'11" (3.15 x 6.68 m). Musée d'Orsay, Paris.

11-4 Totentanz (Dance of Death), detail of wall painting in the porch of St Mary's Church, Berlin, c.1484. Approximately 6 x 66' (1.83 x 20.12 m).

during the July Monarchy. Every male resident of France could now vote. The men in Courbet's *Burial* represented the large mass of new voters in the provinces that could completely change the political picture of France.

Today, *Burial at Ornans* may be seen in the Musée d'Orsay in Paris. There, it hangs near another colossal painting, done three years earlier, by Thomas Couture. His *Romans of the Decadence* (FIG. 11-5) was the toast of the Salon of 1847, the last Salon of the July Monarchy. Couture's painting shows a scene from Roman imperial times. Through the majestic columns of a palatial courtyard, the sun rises on a drunken crowds of revelers. After a night

11-5 **Thomas Couture,** *Romans of the Decadence,* 1847. Oil on canvas, 15'5" x 25'14" (4.72 x 7.72 m). Musée d'Orsay, Paris.

CONVOI FUNÈBRE DE NAPOLÉON.

11-6 *Convoi Funèbre de Napoléon* (Napoleon's Funeral Procession), 1821, (Epinal, published by Pellerin, 1835). Woodcut, 16 x 23⅝″ (41.2 x 60.1 cm). Epinal, published by Pellerin. Bibliothèque Nationale, Paris.

of cavorting, most seem exhausted or sick. One of the few still-energetic revelers has climbed up on a pedestal to offer a drink mockingly to a statue of a Roman republican hero.

The painting's critical acclaim was due to its successful reconciliation of Classicism and Romanticism (see page 111), as well as its pertinent visual message. Many critics saw *Romans of the Decadence* as a thinly disguised image of the excesses of the *nouveau riche* middle class of the July Monarchy. Just as the Roman Empire fell due to the decadence of its ruling class (a commonly-held belief of the time), so France was suffering because of the excesses of its rich and powerful bourgeoisie.

Courbet's *Burial* was the post-revolutionary answer to Couture's work. His painting alludes to the new republican ideal of equal representation that had replaced the oligarchic and self-serving regime of the July Monarchy symbolized in Couture's *Romans*. What is more, through the *Burial* Courbet asserted the importance of representing the ideas of his time in contemporary rather than historical terms. "To go backward is… to waste effort," he would write several years later. "I deny the possibility of historical art applied to the past. Historical art is by nature contemporary. Every age must have its artists, who give expression to it and reproduce it for the future."

Courbet also responded to the dramatic poses and the stylish composition of Couture (which combines Classicist

symmetry with sweeping diagonals full of Romantic dynamism) by opting instead for a stiff line-up of motionless figures. At least one critic commented that the painting reminded him of an enlarged daguerreotype (see page 244) and, indeed, the painting has much of the rigidity of contemporary group photographs (see FIG. 14-1). Others felt that his painting resembled contemporary folk art, such as the woodblock prints produced in the French town of Epinal (FIG. 11-6). Courbet's defenders, however, praised his "egalitarian" composition, in which each figure had equal importance, and felt it suited Courbet's new "democratic art." They also hailed the awkward, folksy character of his painting, arguing that Courbet's "naïf" approach was a perfect antidote to the bombast of Couture and Company.

Courbet, Millet, and an Art of Social Consciousness

A Burial at Ornans was only one of nine canvases that Courbet had submitted to the Salon of 1850–51. Another that drew much attention was *The Stonebreakers* (FIG. 11-7), a work allegedly destroyed during World War II but known today through photographs. It is a painting of two men, one old, the other young, working in the bend of a road bordering on a wheat field. Their thankless job is to crush large field

stones into gravel to be used for paving the roads. Courbet has emphasized the poverty of the two men by dressing them in tattered rags and showing their meagre lunch, to be eaten by the roadside. Their age differential suggests that those who are born poor will remain poor. Or, as Courbet himself put it, in reference to this painting: "Alas, in that class, that is how one begins and that is how one ends up."

Courbet's painting is a comment on the grinding poverty that had become endemic during the July Monarchy. Louis Philippe's policy of improving the economy by encouraging the industrialist middle class to "get rich" had led to a rapidly widening gap between rich and poor. The pathetic condition of the lower classes had become a closely-debated issue in the later years of the July Monarchy and continued to be so during the Second Republic and the Second Empire. In 1846 Courbet's friend Pierre-Joseph Proudhon (1809–1865) wrote a book called *La Philosophie de la Misère* (The Philosophy of Poverty) which established him as a leading spokesman of "socialism." Not yet a specific movement, socialism at that time comprised people of various philosophical and religious persuasions who were concerned about poverty. Among them was the future president and emperor, Louis Napoleon, who in 1844 wrote a pamphlet entitled *Extinction du Paupérisme* (Extinction of Pauperism), which later helped him win the presidency. Among them, too, was the German Karl Marx (1818–1883), who in the mid-1840s lived in France. Marx would eventually abandon socialism and become the spokesman for the new "Communist League," for which, in 1848, he wrote the Communist Manifesto.

Considering the lively debate on poverty, it is hardly surprising that Courbet was not the only young artist to become interested in the lives of the poor. At the same Salon of 1850–51, Jean-François Millet (1814–1875) exhibited *The Sower* (FIG. 11-8), a painting of a peasant casting seed from a cloth bag that hangs from his shoulder. Millet, son of a prosperous farmer, had previously painted portraits and nudes. In 1848 he had moved to Barbizon, where he became a neighbor of Théodore Rousseau (see page 234). Living in the countryside, he became interested in peasant subjects. Like Courbet's stonebreakers, his sower is "anonymous," his face darkly shaded and turned away from the viewer. Both paintings suggest that, much like machines, these men are valued only for the work they perform, not for their human individuality.

But there is also a difference between the two paintings. Whereas Courbet's *The Stonebreakers* merely invokes sympathy for the poor, Millet's *The Sower* inspires respect. His figure has power and dignity, and his expansive gesture spreads life to the earth itself. This is even clearer in an earlier version of the painting, now in the Museum of Fine Arts in Boston, which Millet, for some reason, did not send to the Salon.

11-7 **Gustave Courbet,** *The Stonebreakers*, 1849–50. Oil on canvas, 6'2" x 9'9" (1.9 x 3 m). Destroyed, formerly in Gemäldegalerie, Dresden.

11-8 **Jean-François Millet,** *The Sower,* 1850. Oil on canvas, 39 x 31" (1 m x 80.6 cm) after restoration. Yamanashi Museum of Art, Japan.

Courbet's *Stonebreakers* and Millet's *Sower* invited the Salon public to consider France's largely invisible underclass. Not surprisingly, critical reactions were mixed, depending largely on the political biases of individual critics or of the papers for which they wrote. Conservative critics berated the works for being "socialist." Progressive critics praised the artists for their sense of social responsibility. Neither Courbet nor Millet found much of a market for these works, which were too radical for the state and too "dark and ugly" for private collectors.

Daumier and the Urban Working Class

While Courbet and Miller focused on country life, a few artists were interested in the urban working class. Among them was Honoré Daumier who, in the course of the 1840s, began to complement his work as an illustrator by trying his hand at painting. While he treated religious and mythological, as well as allegorical themes, Daumier is best known today for his paintings depicting aspects of the lives of the Parisian working class. For the most part,

11-9 **Honoré Daumier,** *The Heavy Burden*, c.1850–3. Oil on canvas, 21⁷/₈ x 17¹⁵/₁₆″ (55.5 x 45.5 cm). National Gallery, Prague, Czech Republic.

these works remained unseen during the artist's lifetime because Daumier rarely exhibited his painting. It was not until 1878, one year before the artist's death, that a retrospective exhibition of his paintings was held in the commercial gallery of Paul Durand-Ruel.

Among Daumier's favorite subjects were laundry women, who, for a small fee, washed people's linens in the Seine river. Laundry had become something of a cottage industry in the 1840s, particularly among unwed mothers who were unable to get jobs as domestic servants. To facil-itate their work, special washing barges were moored in the river. Daumier lived on the banks of the Seine and saw the laundry women on a daily basis. Summer and winter, they dragged their loads of laundry to the river, often with their children in tow. After washing for hours, they lugged the wet laundry home to dry it in their small dank rooms, which must have been unbearable to live in. Their work was not only hard but low-paid and thankless; no wonder that many of these women turned to drink for solace.

11-10 **Honoré Daumier,** *The Fugitives, c.*1849–50. Oil on panel, 6 x 12″ (16 x 31 cm). Private Collection, on permanent loan to National Gallery, London.

The Heavy Burden (FIG. 11-9), painted during the early 1850s, is one of several variations on this theme, which preoccupied Daumier for nearly twenty years. A young laundry woman, carrying a basket filled with wet clothes, walks home along the Seine quay, struggling against the wind. Her bent pose is echoed by the little girl by her side, who clutches her skirt. Much like Courbet's *Stonebreakers*, Daumier's *Heavy Burden* suggests that poverty is inescapable—once one is born into it, one's life is determined by it.

The painting is highly simplified: facial features and details of clothing are only summarily indicated. The palette is limited, almost monochrome, much like the early works of Courbet and Millet. As in his caricatures, Daumier has exaggerated bodily forms and gestures in his painting. But here, distortions of reality do not serve a humorist purpose, but express the essence of this woman's tortured life.

The Fugitives (FIG. 11-10) represents refugees, another subject that preoccupied Daumer around the same time.

11-11 **Honoré Daumier,** *The Fugitives, c.*1862–78. Relief in patinated plaster (third state), 11 x 26 x 3⅛″ (28 x 66 x 8.5 cm). Musée d'Orsay, Paris.

Mass movements of people were a common sight in these revolutionary years. After the bloody June Days, 4,000 revolutionaries and their families were ordered to "leave town." Elsewhere in Europe, similar "emigrations" occurred. In Germany and central Europe, hunger drove large groups of people to wander around in search of food. In Ireland about 1.5 million Irish emigrated to America to escape the great potato famine of 1845–8; at the same time, some 40,000 people moved across North America during the California Gold Rush of 1848. Mass movements of people were so ubiquitous at the time that one French journalist spoke of a "paroxysm of emigration."

In *Fugitives* a group of refugees trudges aimlessly through a desolate landscape. Dark storm clouds gather overhead and a strong wind hampers their movements. A sense of doom pervades the painting. In the string of dark, shapeless figures stretching diagonally across the picture plane, Daumier has captured the hopelessness of these estranged, modern nomads.

Daumier's sculptural reliefs on the theme of fugitives (see, for example, FIG. 11-11) differ dramatically from his paintings. Instead of loose strings of shapeless figures, they show men, women, and children densely packed in a rectangular frame. The figures are nude rather than clothed, which gives them a Classical character. Their significance goes beyond an engagement with the contemporary homeless problem. Rather, they may be seen as an allegory of human life—that aimless march from birth to death that is often referred to as the "human condition."

Realism

Today, the artistic engagement with the ordinary, contemporary life that began in the 1840s is known as "Realism." This term had been used in France since the 1830s by artists and critics who felt, like Baudelaire, that a renewal in literature and art was possible only if artists abandoned their love affair with the past and focused on the present.

When Courbet entered the art scene with his *Burial at Ornans* and his *The Stonebreakers*, critics referred to these works as "realist," a term at once complimentary and pejorative. While advocates saw in it a democratic style of art, an art by the common man for the common man, detractors criticized it for a lack of poetry and imagination. By the mid-1850s Courbet had "officially" adopted the term Realism as the name for the movement in art that he had inaugurated and of which he proclaimed himself the leader. At the Paris International Exhibition of 1855 he opened his own "Realist Pavilion," to promote Realism internationally (see page 307).

Chapter Twelve

Progress, Modernity, and Modernism—French Visual Culture during the Second Empire, 1852–70

After the proclamation of the Second Empire in 1852, the economy of France expanded and the country prospered. Louis Napoleon, who now assumed the title Napoleon III (FIG. 12-1), was an able administrator who, like his contemporaries, believed that science, technology, and industry were the engines of progress.

The term "progress," during the second half of the nineteenth century, implied advances in civilization leading to a better quality of life. The seeds of this concept can be found in the writings of the French philosopher Auguste Comte (1798–1857), who held that all pursuit of knowledge must be aimed at moral progress, or at increasing human integrity and happiness. Rejecting religion and metaphysics, Comte agreed with the British Empiricists that true knowledge must be based on the positive data of experience. Comte's "Positivist" philosophy, moreover, overlapped with the views of the British Utilitarianists, men such as Jeremy Bentham (1748–1832) and John Stuart Mill (1806–1873). The former's call for the "greatest happiness for the greatest number" and the latter's advocacy of the widest possible expression of individual liberty became the cornerstone of liberal political thought in mid-nineteenth-century Europe.

Eager to advance progress and prosperity in France, Napoleon III promoted public works and encouraged the establishment of lending institutions to finance both public and private projects. He supported a massive program of railroad construction, which provided thousands of new jobs and also helped the rural industries to expand their markets. Unlike Louis Philippe, who had encouraged the middle class to get rich with little regard for the workers, Napoleon III did not ignore the underclass. By controlling the price of bread and creating a variety of social programs, he remained true to his earlier concern with poverty (see page 253). Nonetheless, workers' lives during the Second Empire remained miserable, since the emperor was both unwilling and unable to enforce his progressive ideas in the realm of private enterprise.

Napoleon III continued Louis Philippe's colonial policies, and expanded French power in West Africa and Indochina (present-day Cambodia and Vietnam). He also tried to gain a foothold in the New World by setting up a puppet regime in Mexico that was backed by French troops. On the European front, he was much more aggressive than Louis Philippe, and engaged in wars against Russia (the so-called Crimean War) and Austria. His belligerence eventually caused his demise. Defeated in the Franco-Prussian War of 1870, he was ousted from the throne and forced to leave France for Britain.

Napoleon III and the "Haussmannization" of Paris

By far the most ambitious of Napoleon III's public projects was the complete overhaul of Paris, starting in 1853. The emperor aspired to turn the largely medieval city, with

12-1 **Hippolyte-Jean Flandrin,** *Portrait of Napoleon III,* c.1860–1. Oil on canvas, 6'11" x 4'10" (2.12 x 1.47 m). Musée National du Château de Versailles, Versailles.

Emile Zola and Second-Empire France

Life in Second-Empire France is evocatively described in the novels of the French writer Emile Zola (1840–1902; see FIG. 12-37). Between 1870 and 1893 he wrote a series of twenty novels that give a detailed account of the fortunes and misfortunes of the Rougon-Macquarts, a fictitious family living during the Second Empire. Some members of the family become rich, others end up in the gutter. Together the Rougon-Macquart novels, many of which have been translated into English, provide a complete picture of high- and low-class life in Paris and the provinces and of many of the institutions that characterized the period. Thus *Au*

bonheur des dames (The Ladies' Paradise) is centered around the department store, a revolutionary type of retailing that was first introduced during the Second Empire. *La Ventre de Paris* (The Belly of Paris) deals with the colossal Parisian wholesale food market; *Germinal* (1885) with life in the coal mines; and *La Terre* (The Earth), with peasant life. Nana (1880) describes the world of a Parisian *cocotte* (see page 282); while *L'Assommoir* (1877) gives an account of the lives of laundry women (see page 256). In *L'Oeuvre* (The Masterpiece), finally, Zola dealt with the lives of artists, a clear indication of the importance of the art world in Second-Empire France.

12-2 Elevation of apartment building at 39 Rue Neuve-des-Mathurins, 1860. Architectural drawing. Bibliothèque des Arts Décoratifs, Paris.

its narrow, crooked streets, into a modern metropolis with tree-lined avenues, parks, and public buildings. The architect and supervisor of this vast project was Baron Georges Haussmann (1809–1891), who masterminded the new plan for the city and oversaw the design of most of its buildings. As well as churches and public buildings, these included elegant five- or six-story apartment houses for wealthy bourgeois, in the center of town (FIG. 12-2), and more modest tenements for workers, on the periphery. Most of the former were designed in a classically inspired style that was heavily indebted to the grandiose architecture of the Louis XIV period (see page 20). The term Beaux-Arts is often used to describe this style of building, which was taught at the École des Beaux-Arts in Paris (see page 197) well into the twentieth century.

Haussmann's many innovations included a new sewer system, train stations in the heart of the city, and wide thoroughfares to accommodate the growing number of horse-drawn carriages. He also planned the installation of gas street lamps to illuminate the center of the city at night. This encouraged a nightlife of outdoor cafés and street theatres that had been practically non-existent before this time.

The "Haussmannization" of Paris made the city *the* place to be in Europe during the last third of the nineteenth century. While many praised the project, some criticized it on social or aesthetic grounds, or both. The German journalist-philosopher Karl Marx, who had lived in Paris in the years 1843–45 (see page 253), referred to the "vandalism of Haussmann," and accused him of "razing Paris for the Paris of the sightseer." This point had some validity. The rebuilt city attracted wealthy foreign tourists and benefited the lucky few who could afford the expensive apartments in the center. But it drove poorer Parisians to the tenement houses on the outskirts of the city or, worse, to the shanty towns beyond.

Many Parisians also regretted the loss of the old picturesque streets with their medieval and Renaissance dwellings, and bemoaned the uniformity of the new apartment buildings (see *Viollet-le-Duc and France's Gothic Heritage*, page 262). By 1868 the municipal government of Paris had begun to realize that Haussmann's urbanization plan was erasing a large part of the city's past. It ordered the photographer Charles Marville (1816–1879) to take pictures of the old streets before they were destroyed. Marville's photographs, such as the one seen in FIG. 12-3, exemplify an important new role for photography. While initially it had been used primarily for portraiture, from

12-3 **Charles Marville,** *Intersection in Old Paris,* one of 425 views of old Paris, c.1865–9. Bibliothèque Historique de la Ville de Paris, Paris.

12.2-1 Cathedral of Notre Dame, west façade, thirteenth century. Nineteenth-century view, showing the gallery of kings with the figures made under the supervision of Viollet-le-Duc.

While Haussmann was busy destroying the medieval fabric of Paris, Eugène Viollet-le-Duc (1814–1879) was engaged in the restoration of the city's most famous medieval monuments, the Gothic cathedral of Notre Dame (Our Lady) and the so-called Sainte Chapelle, or Holy Chapel, built by the canonized king Louis IX in the thirteenth century. Both of these projects were begun under the July Monarchy, when the interest in France's Gothic past peaked (witness the success of Victor Hugo's *Hunchback of Notre Dame* of 1837), after its early beginnings during the Napoleonic and Restoration periods. The sustained interest in their completion indicates that, even while Paris was being filled with buildings in the popular Beaux-Arts style, Gothic still retained its attraction as France's national style par excellence.

Viollet's restoration of the façade of Notre Dame (FIG. 12.2-1) is representative of nineteenth-century methods. These were aimed not at preserving what was left but at re-establishing the building in its original state. Notre Dame had suffered great damage during the Revolution of 1789, when many of its statues (especially the row of Old Testament kings) were taken down and, in many instances, smashed to pieces (see page 107). Under Viollet-le-Duc's direction, they were newly made and reintegrated in what was left of the original Gothic façade. Such "inventive" restoration is no longer practiced today. It first came under attack at the end of the nineteenth century, when the emphasis began to shift from restoration to protection and conservation.

the middle of the nineteenth century it was also used to document cities and other environments. Marville's photographs go beyond mere documentation, however. Their careful compositions and dramatic lighting make for startling, sometimes even haunting images. They remind us that, like many photographers, Marville had a background as an artist. During the 1830s and 1840s he had worked as an illustrator, drawing pictures for novels and travel books.

The Opéra and Mid-Nineteenth-Century Sculpture

The Avenue de l'Opéra (FIG. 12-4) is one of the "high end" streets of Haussmann's Paris. This broad thoroughfare still looks much the way it did in the nineteenth century, even though the road bed was widened in the 1950s. The street is lined with luxury six-story shops and office buildings that are separated from the road by sidewalks or *trottoirs*. Large enough to accommodate outdoor terraces and cafés, these encourage street life and make Paris a haven for pedestrians.

12-4 *Avenue de l'Opéra.* Paris, France.

The Avenue de l'Opéra leads to the spectacular Opéra (FIG. 12-5), begun in 1861 by Charles Garnier (1825–1898). Although not completed until after the fall of Napoleon III, this splendid building epitomizes the culture of the Second Empire. It was a time of optimism and wealth, a

century. While many praised the project, some criticized it on social or aesthetic grounds, or both. The German journalist-philosopher Karl Marx, who had lived in Paris in the years 1843–45 (see page 253), referred to the "vandalism of Haussmann," and accused him of "razing Paris for the Paris of the sightseer." This point had some validity. The rebuilt city attracted wealthy foreign tourists and benefited the lucky few who could afford the expensive apartments in the center. But it drove poorer Parisians to the tenement houses on the outskirts of the city or, worse, to the shanty towns beyond.

Many Parisians also regretted the loss of the old picturesque streets with their medieval and Renaissance dwellings, and bemoaned the uniformity of the new apartment buildings (see *Viollet-le-Duc and France's Gothic Heritage*, page 262). By 1868 the municipal government of Paris had begun to realize that Haussmann's urbanization plan was erasing a large part of the city's past. It ordered the photographer Charles Marville (1816–1879) to take pictures of the old streets before they were destroyed. Marville's photographs, such as the one seen in FIG. 12-3, exemplify an important new role for photography. While initially it had been used primarily for portraiture, from

12-2 Elevation of apartment building at 39 Rue Neuve-des-Mathurins, 1860. Architectural drawing. Bibliothèque des Arts Décoratifs, Paris.

12-3 **Charles Marville,** *Intersection in Old Paris*, one of 425 views of old Paris, c.1865–9. Bibliothèque Historique de la Ville de Paris, Paris.

its narrow, crooked streets, into a modern metropolis with tree-lined avenues, parks, and public buildings. The architect and supervisor of this vast project was Baron Georges Haussmann (1809–1891), who masterminded the new plan for the city and oversaw the design of most of its buildings. As well as churches and public buildings, these included elegant five- or six-story apartment houses for wealthy bourgeois, in the center of town (FIG. 12-2), and more modest tenements for workers, on the periphery. Most of the former were designed in a classically inspired style that was heavily indebted to the grandiose architecture of the Louis XIV period (see page 20). The term Beaux-Arts is often used to describe this style of building, which was taught at the École des Beaux-Arts in Paris (see page 197) well into the twentieth century.

Haussmann's many innovations included a new sewer system, train stations in the heart of the city, and wide thoroughfares to accommodate the growing number of horse-drawn carriages. He also planned the installation of gas street lamps to illuminate the center of the city at night. This encouraged a nightlife of outdoor cafés and street theatres that had been practically non-existent before this time.

The "Haussmannization" of Paris made the city *the* place to be in Europe during the last third of the nineteenth

12.2-1 Cathedral of Notre Dame, west façade, thirteenth century. Nineteenth-century view, showing the gallery of kings with the figures made under the supervision of Viollet-le-Duc.

While Haussmann was busy destroying the medieval fabric of Paris, Eugène Viollet-le-Duc (1814–1879) was engaged in the restoration of the city's most famous medieval monuments, the Gothic cathedral of Notre Dame (Our Lady) and the so-called Sainte Chapelle, or Holy Chapel, built by the canonized king Louis IX in the thirteenth century. Both of these projects were begun under the July Monarchy, when the interest in France's Gothic past peaked (witness the success of Victor Hugo's *Hunchback of Notre Dame* of 1837), after its early beginnings during the Napoleonic and Restoration periods. The sustained interest in their completion indicates that, even while Paris was being filled with buildings in the popular Beaux-Arts style, Gothic still retained its attraction as France's national style par excellence.

Viollet's restoration of the façade of Notre Dame (FIG. 12.2-1) is representative of nineteenth-century methods. These were aimed not at preserving what was left but at re-establishing the building in its original state. Notre Dame had suffered great damage during the Revolution of 1789, when many of its statues (especially the row of Old Testament kings) were taken down and, in many instances, smashed to pieces (see page 107). Under Viollet-le-Duc's direction, they were newly made and reintegrated in what was left of the original Gothic façade. Such "inventive" restoration is no longer practiced today. It first came under attack at the end of the nineteenth century, when the emphasis began to shift from restoration to protection and conservation.

the middle of the nineteenth century it was also used to document cities and other environments. Marville's photographs go beyond mere documentation, however. Their careful compositions and dramatic lighting make for startling, sometimes even haunting images. They remind us that, like many photographers, Marville had a background as an artist. During the 1830s and 1840s he had worked as an illustrator, drawing pictures for novels and travel books.

The Opéra and Mid-Nineteenth-Century Sculpture

The Avenue de l'Opéra (FIG. 12-4) is one of the "high end" streets of Haussmann's Paris. This broad thoroughfare still looks much the way it did in the nineteenth century, even though the road bed was widened in the 1950s. The street is lined with luxury six-story shops and office buildings that are separated from the road by sidewalks or *trottoirs*. Large enough to accommodate outdoor terraces and cafés, these encourage street life and make Paris a haven for pedestrians.

12-4 *Avenue de l'Opéra.* Paris, France.

The Avenue de l'Opéra leads to the spectacular Opéra (FIG. 12-5), begun in 1861 by Charles Garnier (1825–1898). Although not completed until after the fall of Napoleon III, this splendid building epitomizes the culture of the Second Empire. It was a time of optimism and wealth, a

12-5 **Charles Garnier,** *Opéra*, 1860–75. Place de l'Opéra, Paris.

"gilded age" when prosperous members of the bourgeoisie had both the means and the time to enjoy opera, theatre, concerts, and restaurants. The Opéra accommodated lavishly staged grand operas by such popular composers as Richard Wagner (1813–1883), Giuseppe Verdi (1813–1901), and Georges Bizet (1838–1875).

Built in an eclectic style recalling the seventeenth-century Baroque, the exterior abounds with architectural details and sculptural decorations. It is difficult to appreciate the building in a photograph. Since its most striking feature is the way it "unfolds" as the visitor approaches it. From successive points on the Avenue de l'Opéra, the viewer encounters a series of different and striking views. Upon finally entering the building, an enormous, brightly lit hall and an opulent staircase (FIG. 12-6) complete the experience.

Several important artists of the mid-nineteenth century contributed to the decoration of the Opéra. Among them was Jean-Baptiste Carpeaux (1827–1875), author of *The Dance* (FIG. 12-7), one of four monumental allegorical sculptures on the first story of the façade. These stone sculptural groups represent the main artistic elements that enter into the making of an opera—composition, instrumental music, lyric drama, and dance. But while the first three sculptures are unimaginative in their repetition of Neoclassical

models (see FIG. 12-8), Carpeaux's *Dance* is both dynamic and exciting. Although the artist has followed the prescribed composition of a central allegorical personification surrounded by several secondary figures, he has rejected the standard use of a draped female. Instead, his allegory of dance is a young male nude, raising both arms and waving a tambourine. This graceful youth both animates and is worshipped by an entourage of nude and scantily dressed women. *The Dance* is hardly representative of the stylized, operatic ballets that were performed inside the building. Instead, the uninhibited joy and vitality of the figures remind us of pagan bacchanalia, orgiastic festivals in honor of the wine god Bacchus, in which participants are supposed to have danced in drunken frenzy.

The Dance caused a small scandal in its time, because many people were offended by the grouping of several nude females around a nude male figure, whose genitals are hidden but nonetheless suggested by a floating end of drapery. To make the sculpture even more scandalous, the women are not the remote, ideal beauties found in Classical art. Instead, they are all too real, with their plump bodies and drunken smiles. As one critic wrote:

Ah, if only those lost dancers were Greek women with their splendidly bodily attitudes and forms.

The Opéra and Mid-Nineteenth Century Sculpture **263**

12-6 **J. L. Charles Garnier,** *the Grand Staircase in the Opéra,* 1860–75. Engraving from Charles Garnier, *Le Nouvel Opéra de Paris,* 1880, Vol. 2, plate 8.

But no, no, look at those hard faces, which provoke the passerby with their furious grins. Look at those tired, sagging legs, those flaccid and deformed torsos, and, admit it, we are in the midst of the nineteenth century, in the midst of a diseased and undressed Paris, in the midst of realism.

In his *Dance* Carpeaux defied the unwritten law that had governed public sculpture since the mid-eighteenth century—a law that dictated that public art, especially sculpture, should edify and instruct. Carpeaux's sculpture, by contrast, threatened public morality. A contemporary caricature shows a bourgeois couple running away from the depraved statue. The wife admonishes her husband: "Don't look at them, that excites them even more!"

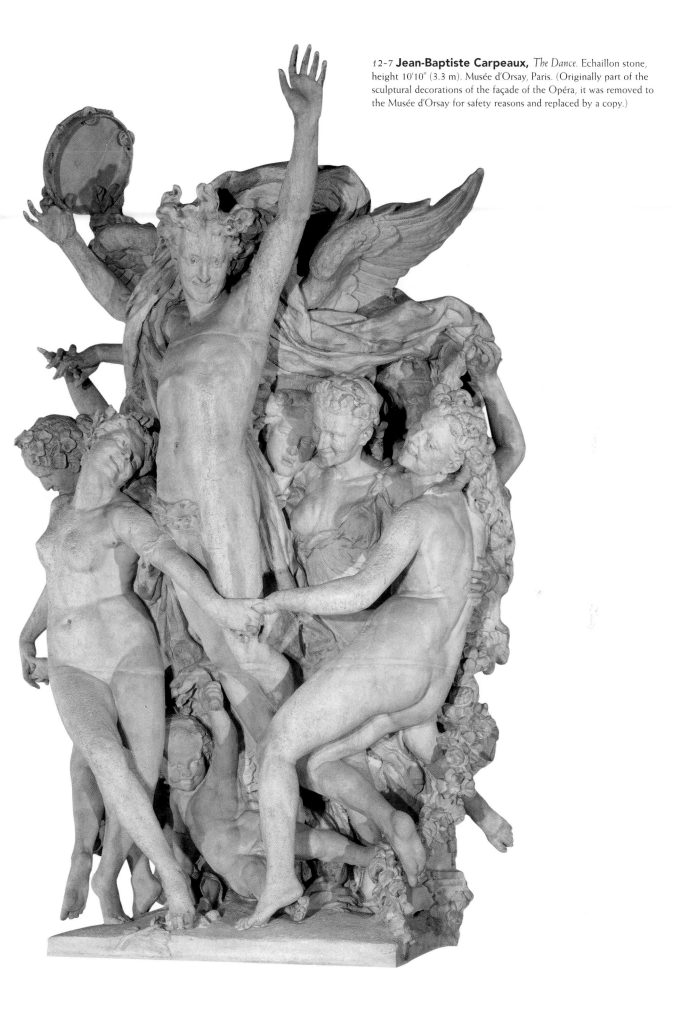

12-8 **Eugène Guillaume,** *Instrumental Music, 1865–9. Echaillon stone, height 10'10"* (3.3 m). Opéra, Paris. (Part of the sculptural decorations of the façade of the Opéra.)

Among the sculptures that decorate the interior of the Opéra is a bronze by the Swiss artist Adèle d'Affry, Duchess of Castiglione Colonna (1836–1879). Better known as "Marcello," she was among the first female sculptors to make a name for herself in France. Her *Pythian Sibyl* (FIG. 12-9), representing the ancient Greek prophetess at Apollo's sanctuary, was installed in the Opéra in 1875. In Marcello's sculpture the sibyl is seated on a tripod, her body convulsed as her mind receives the divine message. The subject seems appropriate since, in the nineteenth century, religious

rapture was often compared with artistic inspiration. It is said that Marcello made casts of her own shoulders and left hand to aid her in the modeling of this figure. Nonetheless, compared with the plump, drunken women in Carpeaux's *Dance,* the *Pythian Sybil* strikes us as an idealized figure that lacks the realism that so offended Carpeaux's opponents. In that sense, Marcello's figure is more typical of mid-nineteenth-century academic sculpture, which rarely ventured far beyond the Classicist formulas that had been established early in the nineteenth century.

12-9 **Marcello** (pseudonym of Adèle d'Affry, Duchess of Castiglione Colonna), *Pythian Sibyl*, 1867–70. Bronze, height 9'6" (2.9 m). Opéra, Paris.

Salons and Other Exhibitions during the Second Empire

The art world of the Second Empire was marked by significant government involvement. When he became president in 1848, Louis Napoleon appointed as the Director-General of Museums Count Alfred de Nieuwerkerke (1811–1892). Nieuwerkerke was responsible for acquiring modern paintings and sculptures at the Salon. These became the property of the state and the best among them were displayed in the Luxembourg Museum, the Parisian museum of contemporary art since 1818. Works would stay there until the artist's death, at which time they would be sent on to the Louvre or to a museum in the provinces, depending on their perceived quality.

In 1863 Nieuwerkerke was promoted to Superintendent of Fine Arts. This guaranteed him unprecedented authority in the art world. As Superintendent he instituted various reforms in the Salons as well as the Ecole des Beaux-Arts. While these measures curtailed the much-maligned power of the Academy, they replaced it by increased state control which, to most artists, was equally objectionable.

Throughout the Second Empire, innovative artists continued to experience difficulty in gaining admission to the Salon. By 1863 their discontent had become so acute that the imperial government decided to open a parallel Salon. This was the notorious Salon des Refusés (Salon of the refused), an exhibition of all the works that had been rejected by the jury of the official Salon of that year. Although it contained much mediocre and even bad art, the Salon des Refusés also featured a number of shockingly original works by artists such as Edouard Manet (see page 283), who pioneered new artistic content and forms. The exhibition thus played an important role in confronting the public, for the first time, with the newest trends in contemporary art.

Until the middle of the nineteenth century, the Salon was the only venue where French artists could show their works, unless, like David and Géricault, they organized private exhibitions (see pages 53 and 206). Beginning in the 1850s, however, the rise of commercial art galleries offered new exhibition opportunities. Although art dealers had been active in France since at least the eighteenth century, they had generally sold works by old masters. By the beginning of the Second Empire, however, a number of dealers had become interested in the sale of contemporary art. At first they ran their businesses like shops, where people could come and browse. Then, following the example of British dealers, they held exhibitions of the works of artists they represented in "galleries," showrooms for art that were accessible to anyone who chose to walk in from the street (see FIG. 16-20).

Such was the story of the famous Durand-Ruel Gallery, which began as an art supply store during the Restoration period and became and remained one of the most famous galleries in Paris until its closure in 1974. During the Second Empire, it represented most of the artists of the Barbizon school. Its real fame and fortune, however, was tied to the Impressionists, whom the gallery represented during the final quarter of the nineteenth century (see page 399).

Popular Trends at the Second-Empire Salons

Visitors to the Salons of the Second Empire were confronted with a bewildering variety of works, differing in size, subject, and style. The trend towards smaller paintings, begun in the July Monarchy (see page 217), continued. Historic genre scenes, Orientalist scenes, and female nudes (in the form of Venus, nymph, *odalisque*, etc) became increasingly popular. The Salon of 1863 was so glutted with female

12-10 **Ernest Meissonier,** *The Painting Connoisseurs,* 1860. Oil on panel, 14 x 11″ (35.5 x 28.5 cm). Musée d'Orsay, Paris.

nudes that the critic Théophile Gautier dubbed it the "Salon of the Venuses" and Daumier drew a cartoon with the caption, "Venuses and more Venuses."

Landscape paintings, widely collected during the Second Empire, continued to be an important staple of the Salon. Indeed, so popular was landscape that many figure painters, including Courbet, turned to it as the ultimately marketable genre. Animal painting and hunting scenes were popular subcategories of landscape. Realist peasant painting developed into a major category, one that was encouraged by the Second Empire government, particularly if farm life was cast in a palatable, idyllic form. In addition, scenes from contemporary urban life began to be shown by a few younger artists. Finally, portraiture, always popular, continued to be a presence at the Salon, despite the growing competition it received from photography. Sculpture also remained a staple though, increasingly, it became secondary to painting. Lack of patronage forced sculptures to produce small sculptures for the home.

History through a Magnifying Glass: Meissonier and Gérôme

Meissonier's *The Painting Connoisseurs* (FIG. 12-10) is representative of a new trend in historic genre painting. The modest-size picture shows an eighteenth-century artist at work in his studio, surrounded by three admiring connoisseurs. Although

Meissonier continued the historic genre traditions of Empire troubadour painters and July Monarchy artists such as Paul Delaroche, his work surpasses theirs in its high degree of "authenticity." The artist has done his utmost to achieve historic accuracy: even the smallest detail of clothing and furniture has been carefully researched. Moreover, there is a verisimilitude in the rendering of faces, hands, and the postures of figures that seems to bring the historical figures to life. Meissonier's works are highly detailed and meticulously finished. This lends them a miniaturist quality that was both admired and scorned in the artist's own time. The poet Baudelaire, disturbed by Meissonier's popularity among the general public, criticized the artist for having introduced a "taste for littleness."

Following the example of Horace Vernet, Meissonier painted a number of scenes commemorating the battles of Napoleon III and the military exploits of his uncle, Napoleon I. *The Emperor at Solferino* (FIG. 12-11) shows Napoleon III surveying the battlefield at Solferino, Italy, where the French helped the Piedmontese in their fight for independence from Austria. Like *Painting Connoisseurs*, it reflects Meissonier's obsession with historical verisimilitude. In contrast to the Romantic battle painters before him, he does not show the emperor heroically entering into the fray. Emperors' lives, he knew, were much too valuable to be risked on the battlefield. In his work we see the real situation of the battlefield, rendered in minute detail of landscape and military paraphernalia.

12-11 **Ernest Meissonier,** *The Emperor at Solferino,* 1863. Oil on panel, 17⅛ x 30″ (43.5 x 76 cm). Musée Nationale du Château, Compiègne.

12-12 **Jean-Léon Gérôme,** *The Cock Fight,* 1847. Oil on canvas, 4'8" x 6'9" (1.43 x 2.04 m). Musée du Louvre, Paris.

12-13 **Jean-Léon Gérôme,** *Pygmalion and Galatea,* c.1890. Oil on canvas, 35 x 27" (88.9 x 68.6 cm). Metropolitan Museum of Art, New York.

While Meissonier focused primarily on recent and contemporary history (the eighteenth and nineteenth centuries), Jean-Léon Gérôme (1824–1904) preferred Classical antiquity. Gérôme made his reputation with the *Cock Fight* (FIG. 12-12), exhibited at the Salon of 1847. It represents a young Greek boy, naked, spurring on two roosters. A young girl looks on, with a mixture of aversion and fascination. This painting is a far cry from David's vision of antiquity, with its heroes and philosophers and its moral didacticism. Gérôme's painting is to be enjoyed for the window it provides on daily life in ancient times and for its eroticism. Enormously popular at the Salon of 1847, Gérôme's *Cock Fight* ushered in the *Néo-Grec* style—a trend in painting and interior design aimed at recreating daily life in Classical antiquity.

Gérôme, who remained active as an artist until shortly before his death in 1904, produced *Néo-Grec* works throughout his long career. Perhaps his best-known work in this vein is *Pygmalion and Galatea* (FIG. 12-13), dating from about

1890. Although it represents a scene from Greek mythology (Pygmalion's love of his sculpture of "ideal womanhood" makes the statue come alive), it has all the qualities of a genre painting. Like Meissonier's *Painting Connoisseurs*, it offers a glimpse into the studio of a historic artist, rendered in carefully researched detail.

Second-Empire Orientalism: Gérôme, Fromentin, Du Camp, Cordier

Although Gérôme first made his name as a *Néo-Grec*, his reputation, ultimately, rests on his paintings of life in North Africa and the Near East. During the Second Empire he embraced Orientalism, a trend that had started during the July Monarchy (see page 226) and continued to flourish throughout the nineteenth century.

Gérôme traveled to Turkey in 1853, and made several trips to the Near East and North Africa in later years. From the 1850s onward, he produced a steady flow of pictures depicting life in the various countries he visited. *Prayer in the Mosque* (FIG. 12-14) was based on drawings made during a trip to Egypt in 1868. The seventh-century mosque of 'Amr in old Cairo is the setting for his painting. Like the artist's historic genre scenes, it is painted in meticulous detail. Architecture, furnishings, clothing, and people are

12-14 **Jean-Léon Gérôme,** *Prayer in the Mosque,* c.1872. Oil on canvas, 35 x 29" (88.9 x 74.9 cm). Metropolitan Museum of Art, New York.

12-15 **Eugène Fromentin,** *Arab Falconer,* 1863. Oil on canvas, 42 x 28″ (1.08 m x 73 cm). Chrysler Museum of Art, Norfolk, Virginia.

rendered with photographic accuracy. Gérôme is known to have relied on photographs for many of his paintings and, at the end of his life, acknowledged the importance of photography in bringing about a new artistic vision. Yet the verisimilitude of his pictures is not due to photography alone. It also reflects contemporary travelogues and the reports of missionaries and colonial administrators, whose careful descriptions of the land and people of North Africa and the Near East anticipated those of late nineteenth-century ethnographers.

Gérôme's Orientalist scenes were enormously popular and the artist had many followers, eager to capitalize on his success. Yet his highly colored and detailed style, ultimately derived from the harem scenes of Ingres, was not the only mode of Orientalist painting. Other artists of the period developed a different approach, more akin to the Orientalist works of Gros and Delacroix. The paintings of Eugène Fromentin (1820–1876), for example, differ

considerably from Gérôme's. For one, Fromentin, who made three trips to North Africa in the late 1840s and early 1850s, concentrated on outdoor, rural scenes. For another, his paintings show none of the sharp-focus realism found in Gérôme's work. Instead, they are loosely painted, recalling the African battle and hunting scenes of Delacroix (see FIG. 10-14). Fromentin's *Arab Falconer* (FIG. 12-15) of 1863 is a case in point. The artist has aimed at capturing the action and movement of the agile horseman, the excited horse, and the diving falcons, rather than at painstakingly recording every detail.

The Orient attracted photographers as well as painters. Maxime Du Camp (1822–1894), who traveled to Egypt between 1849 and 1851, was an early pioneer of photography in the Near East. Financed by the French Ministry of Public Education, he had instructions to record ancient Egyptian monuments and inscriptions. He also photographed several non-archaeological views, however. On

12-16 **Maxime Du Camp,** *View of Cairo: The Citadel and the Mohammed Ali Mosque.* Salt print, 6⅛ x 8″ (15.5 x 20.5 cm). Agfa Foto Historama, Cologne.

his return to France, Du Camp published his photographs in the form of a pictorial travel album, a first in nineteenth-century France.

View of Cairo: The Citadel and the Mohammed Ali Mosque (FIG. 12-16) is one of Du Camp's views of a contemporary urban scene in Egypt. The artist seems to have set up his camera so as to include a maximum of picturesque details. Two slender minarets rise amidst a jumble of dilapidated structures, which are punctuated by an elegant Islamic arch and occasional pieces of latticework. Du Camp's photograph bridges the gap between the contrived picturesque illustrations in the *Voyages pittoresques* (see FIG. 10-22) and modern travel photography. Although his camera has recorded the site faithfully, the artist has chosen his view-point carefully so as to create a visually interesting effect.

While Du Camp focused on monuments and urban views, the sculptor Charles Cordier (1827–1905) traveled to the Orient to photograph indigenous people. Employed by the ethnographic department of the Museum of Natural History of Paris from 1851, Cordier made trips to Algeria (1856), Greece (1858–9), and Egypt (1865) to document different racial and ethnic "types" (the whereabouts of Cordier's photographs are unknown but a related example of ethnographic photography is shown in FIG. 12-17). His purpose, as he wrote to the ministry sponsoring his trip, was to "reproduce… the various types that are at the point of merging into one and the same people." In so doing, he was one of the first practitioners of "ethnographic photography," a genre whose growth in importance went hand in hand with the rise of European imperialism (see page 433).

12-17 **H. Béchard,** *Egyptian Peasant Girl,* c. 1880. Albumen print, 10½″ x 8¼″ (27 x 21 cm).

Although large-scale history painting, long the pride of the Academy, gradually lost its pre-eminence, the nude remained the ultimate academic test. Ingres, who had anchored the female nude into the academic program, also created its most famous prototypes—the *Grande Odalisque* (see FIG. 9-19), exemplar of the reclining so-called "display nude," and the *Venus Anadyomene* (FIG. 12-19), the standard for the standing frontal nude. Both types originated in Renaissance painting—the reclining nude in works by Venetian Renaissance painters such as Giorgione and Titian (see FIG. 12-32), the standing nude in Botticelli's famous *Birth of Venus*.

First conceived in 1808, but repainted in 1848 and exhibited at the Salon of that year, Ingres's *Venus Anadyomene* was hailed by the critic Théophile Gautier as

12-18 **Charles Cordier,** *Negro of the Sudan in Algerian Costume,* c.1856–7. Silvered bronze and Algerian jasper on porphyry, height 38" (97 cm) without base. Minneapolis Institute of Arts, Minnesota.

Cordier's photographs were intended as documentation for his grandiose project of creating an ethnographic sculpture gallery in the museum, with life-size busts of different racial and ethnic types. *Negro of the Sudan in Algerian Costume* (FIG. 12-18) is one of the works that formed part of that gallery. It carefully records the physiognomy of a young Sudanese man and the rich Algerian costume in which he is dressed. To add to the verisimilitude of the work, the artist has used a combination of bronze and striated jaspar, creating a striking polychrome (multicolored) effect. While the combination of stones of different colors, with or without bronze, had been popular in Roman times as well as in the sixteenth and seventeenth centuries, it had fallen into discredit during the Neoclassical period. Cordier gave a major impetus to the revival of polychrome sculpture, which would become especially popular at the end of the nineteenth century.

12-19 **Jean-Auguste-Dominique Ingres,** *Venus Anadyomene,* 1808, 1848. Oil on canvas, 64¹/₈ x 36" (1.63 m x 92 cm). Musée Condé, Chantilly.

a work that could give modern viewers an idea of the beauty of the lost masterpieces of Greek painting. This work, representing the newborn Venus rising from the sea (*anadyomene* in Greek), exemplifies the nineteenth-century aestheticized nude—streamlined, smoothly polished, and devoid of unsightly sexual markers such as public hair and genitalia. Like a modern Barbie doll, Ingres's Venus has been de-sexed to make her suitable for public display. De-sexed, however, does not mean de-eroticized; her soft curves and smooth skin lend the painting a sensuality that is in marked tension with her forbidden body.

Birth of Venus (FIG. 12-20), by the celebrated academic painter Alexandre Cabanel (1823–1889), was one of the most popular derivatives from Ingres's prototypes. Exhibited at the Salon of 1863, the painting was immediately acquired by Napoleon III for his private collection; Cabanel made numerous replicas for eager collectors. In accordance with Classical mythology, Cabanel's painting shows Venus washed ashore by the waves of the sea. Her "birth" is suggested by a gesture of awakening: Venus opens her eyes just a little to peek out at the viewer from behind her folded arm. In the sky above her float several cupids, little messengers of love. Like the nudes of Ingres, Cabanel's *Venus* sends a contradictory message. The goddess's idealized form gives her an unattainable aura, which is belied by the seductive forward thrust of her chest and the coy expression of her face.

The implicit hypocrisy of Cabanel's *Venus* and the numerous other representations of nude Greek godesses that crowded the walls of the Salons of the 1860s was a perfect match for the shallow pretense of virtue made by the period's wealthy French bourgeoisie. Napoleon III himself set the example for the countless men whose marriages were nothing but a façade for numerous extramarital affairs.

Landscape and Animal Painting: Courbet and Bonheur

In terms of subject matter, landscape was the undisputed favorite of mid-nineteenth-century art collectors. For the typical art buyer of the period, the harried businessman or overworked industrialist, landscapes were a pleasant reminder of the beauty, calm, and wholesomeness of the countryside. There was an insatiable market for woodland scenes, pastoral paintings, and seascapes. Hunting scenes, too, were popular, particularly among sportsmen.

The Barbizon school flourished during the Second Empire, and its artists, who had previously struggled, were now highly successful. The village of Barbizon became a magnet for young artists who flocked to the forest of Fontainebleau to paint. Many other regions of France attracted artists as well. Gustave Courbet, who turned to landscape during the late 1850s, specialized in scenes from his native Jura region, as well as seascapes painted in Normandy. His *Entrance to the Puits Noir Valley* (FIG. 12-21), exhibited at the Salon of 1865, was bought by Count de Nieuwerkerke for Napoleon III's private collection. The

12-20 **Alexandre Cabanel,** *Birth of Venus,* 1863. Oil on canvas, 4'4" x 7'6" (1.32 x 2.29 m). Musée d'Orsay, Paris.

12-21 **Gustave Courbet,** *Entrance to the Puits Noir Valley,* 1865. Oil on canvas, 37 x 53³/₁₆" (94 cm x 1.35 m). Musée du Louvre, Paris.

work became so popular that Courbet made dozens of variations and replicas for other collectors.

Courbet's style of landscape painting was quite different from the elaborate, overworked method of Rousseau. He used rapid brushstrokes and made extensive use of the palette knife—a knife with a broad, flexible blade without a cutting edge, designed to scrape the palette clean. The palette knife enabled the artist to apply the paint in irregular dabs to create the thick, encrusted paint surfaces, called *impasto.* This technique was eminently suitable for rendering the surfaces of the dramatic rock formations of the Jura.

Courbet used the same technique in a series of seascapes, done in Normandy in the late 1860s (though some bear the date 1870). Many of these were unique for their close-up view of waves (see FIG. 12-22). In the past, the sea had been painted only from a safe distance. Courbet, an avid swimmer, represented it as if he were about to dive in. Thickly painted with heavily impastoed foamy crests, his waves are almost palpable, causing one caricaturist to lampoon a Courbet seascape as a slice of pie with heavy whipped cream.

Courbet also painted a number of hunting scenes and animal paintings; but in this area he was surpassed by the most famous female painter of the nineteenth century,

12-22 **Gustave Courbet,** *The Wave,* 1870. Oil on canvas, 44¹/₈ x 56" (1.12 x 1.44 m). Nationalgalerie, Berlin.

12-23 **Rosa Bonheur,** *Plowing in the Nivernais Region,* 1849. Oil on canvas, 5'9" x 8'8" (1.75 x 2.64 m). Musée National du Château de Fontainebleau, Fontainebleau.

Rosa Bonheur (1822–1899). Trained by her father, Bonheur made her reputation at the Salon of 1850–1851 with *Ploughing in the Nivernais Region* (FIG. 12-23). Like Courbet and Millet, whose *Stonebreakers* and *Sower* were shown at the same Salon, Bonheur focused on a rural theme, but her painting is more idyllic. Whereas Courbet and Millet emphasized the hardships and drudgery of peasant life, Bonheur lent it a rustic grandeur. Focusing on the oxen that strain to pull the heavy plough, she created a bucolic scene that has a timeless and enduring quality. *Ploughing in*

the *Nivernais Region* is said to have been inspired by *La Mare au diable* (*The Haunted Pool*; 1846), a popular novel about country life by the famous French female writer Aurore Dudevant (1804–1876). Dudevant, who used the masculine pen name George Sand, was certainly a role model for the younger Bonheur as a professional female artist. Through tireless self-promotion, she had managed to make her career in the masculine literary world.

Bonheur became especially famous after the exhibition of the *The Horse Fair* (FIG. 12-24) at the Salon of 1853. The

12-24 **Rosa Bonheur,** *The Horse Fair,* 1853. Oil on canvas, 8' x 16'7" (2.45 x 5.05 m). Metropolitan Museum of Art, New York.

painting represents the biweekly horse market in Paris where draft and work horses were bought and sold. The long, oblong canvas is filled with a throng of horses, some held by the reins, others ridden by handlers, who seem to have a difficult time to keep the jittery animals under control. Bonheur's painting is a tour de force of horse painting, since it represents the animals life-size, in different poses and seen from a variety of angles. To accomplish this feat, Bonheur made numerous trips to the horse market. Women were rarely seen at that eminently masculine event, and Bonheur is known to have dressed in pants (after obtaining permission from the moral police) to avoid undue attention as well as to prevent her skirt and crinolines from getting soiled.

The Horse Fair, that enormous painting with its masculine subject, was intended to prove that women could do more than paint watercolors and flowers on porcelain—the usual genres of female artists exhibiting at the Salons of the period. What is more, *The Horse Fair* was painted with a force and bravura that suited the subject matter but which contrasted sharply with the genteel brushwork that marked most women's art of the period. Indeed, Bonheur

was determined to make her reputation on masculine terms—to show that women, like men, could lay a claim to artistic "genius."

The Horse Fair became a sensation in its time, both on its own merits and because it was the work of a woman. The painting went on tour in Britain and North America and was widely available in reproduction. In 1887 it was bought by Cornelius Vanderbilt, who donated it to the newly founded Metropolitan Museum of Art in New York, where it can still be seen today.

Second-Empire Peasant Painting: Millet and Jules Breton

The success of Rosa Bonheur's *Plowing in the Nivernais Region* at the Salon of 1850–51 suggested that there was a market for paintings of peasant life, provided that artists underplayed its wretchedness and emphasized its idyllic qualities or, at least, its dignity. Such affirmative views of peasant life, showing what one art historian has called "the bourgeois myth of rural society," became quite popular

12-25 **Jean-François Millet,** *The Gleaners,* 1857. Oil on canvas, 33 x 44" (83.8 cm x 1.12 m). Musée du Louvre, Paris.

12-26 **Jean-François Millet,** *Grafting a Tree*, 1855. Oil on canvas, 32 x 39⅜" (81 cm x 1 m). Private Collection, United States.

during the Second Empire and were actively promoted by the government. Although the founder of nineteenth-century peasant painting, Millet, continued to draw attention to the miserable fate of contemporary peasants, even he, gradually, preferred a more idealizing approach.

Millet's *The Gleaners* (FIG. 12-25), exhibited at the Salon of 1857, represents three women who are collecting stray ears of wheat left in the field after the harvest. In the nineteenth century gleaning was a privilege that was extended by wealthy farmers to the families of indigent farm laborers. Because there were so many of them and so little wheat to collect, gleaning was carefully supervised, as is borne out by the figure of the mounted constable in the background. In Millet's painting, the three gleaners, in their fusty, patched clothes, represent the poorest of the poor. By representing them bending down to the ground, the artist alludes to the lowly, even debased position of peasants in nineteenth-century society. Yet, at the same time, the women's carefully orchestrated poses and

gestures and the way their ponderous forms dominate the land lend them a sense of dignity and epic grandeur. By focusing on the activity of gleaning, moreover, Millet made an allusion to the biblical heroine Ruth, who gleaned on the field of Boaz. Thus his painting assumed a moralizing, even religious importance.

While in *The Gleaners* Millet ennobled the very wretchedness of peasant life, in *Grafting a Tree* (FIG. 12-26) he showed its idyllic qualities. This painting depicts a country family in front of their tidy, well-kept cottage. The farmer grafts a tree, while his young wife, carrying their small infant, looks on. Contented peasant pictures such as this one were popular among collectors, but that was not the only reason for their presence in Millet's *oeuvre*. *Grafting a Tree* was representative of a form of peasant life that actually existed in mid-nineteenth-century France. The peasant in Millet's painting is an independent farmer, master of his own small tract of land, which he cultivates himself with the help of a family. Millet's own father was

such a farmer, so the painter knew this kind of peasant life firsthand. Yet he also realized that it was disappearing fast, since farming was turning into an industry in which huge tracts of land, owned by capitalist farmers, were cultivated by low-paid day laborers (as in *The Gleaners*).

As small farming waned, the nostalgia for an idyllic rural past increased. This explains the enormous success of Millet's *Angelus* (FIG. 12-27), begun in 1857 and completed in 1859. The painting shows a farmer and his wife interrupted as they labor to pull potatoes in their little plot. At sundown, they hear the toll of the "Angelus" bell in the village church. The farmer takes off his cap, his wife bows her head, and they recite the biblical text of the angel Gabriel's greeting: "*Angelus Domini nuntiavit Mariae …*" (The angel of the Lord announced to Mary). To our modern eyes, the painting, showing the praying peasants set against the sunset, may seem overly sentimental. In the late nineteenth and early twentieth centuries, however, it was widely admired and became something of a cultural icon. In 1889 it was bought by an American consortium for the unprecedented sum of more than 500,000 francs. Sent on tour in the United States, it was billed as the most famous painting in the world.

While Millet's reputation was long and hard in the making, a slightly younger painter, Jules Breton (1827–1906), became the most widely recognized master of the peasant genre during the Second Empire. His paintings were repeatedly bought by the government, which preferred his positive, even epic vision of peasant life to Millet's challenging one. It is instructive to compare Breton's *Recall of the Gleaners* (FIG. 12-28) of 1859 with Millet's *The Gleaners* exhibited two years earlier. In Breton's large painting a crowd of women is leaving the field, upon being recalled by the field-guard on the left. In the center stands a tall young woman. Carrying a large bundle of grain on her head, she resembles traditional allegories of the harvest.

12-27 **Jean-François Millet,** *Angelus,* 1859. Oil on canvas, 21⅞ x 26" (55.5 x 66 cm). Musée d'Orsay, Paris.

12-28 **Jules Breton,** *Recall of the Gleaners,* 1859. Oil on canvas, 36 x 70¹/₈" (91.5 cm x 1.78 m). Musée d'Orsay, Paris.

On either side of her are other women, young and old, carrying heavy bundles and sacks of grain. Breton does not show the backbreaking labor of gleaning. Instead, his women look content as they carry away their rich bounty. Although the festive mood of the picture belies all that we know about nineteenth-century peasant life, contemporary critics praised Breton's painting for its realism. To them, the careful characterization of the women—every one lovingly painted from a model—as well as Breton's faithful rendering of their regional clothing and his apt characterization of the northern French landscape setting, rang more true than Millet's probings of the essence of peasant life.

Baudelaire and "The Painter of Modern Life"

In his review of the Salon of 1846 (see page 248) Baudelaire had called for an art that would glorify life in the big city:

> The spectacle of elegant life and of the thousands of floating existences that circulate in the underground of a big city—criminals and kept women: the *Gazette des Tribunaux* and the *Moniteur* [two government papers that reported on crime in the city] prove to us that we only have to open our eyes to know our heroism.

Few artists of his generation answered his call. Yet Baudelaire did, eventually, find his painter of modern urban life in Constantin Guys (1802–1892), a somewhat forgotten artist, who worked primarily in pencil and watercolor. To this artist, he devoted a lengthy article in the well-known newspaper *Le Figaro* entitled "The Painter of Modern Life" (1863). Born in Flanders, Guys had started his career as an illustrator for two English magazines, the *Illustrated London News* and for *Punch.* During the first twenty years of his career, he had traveled around the world to record important historic events, such as the battles of the Crimean War. Living in Paris from the late 1850s onward, he spent the remainder of his life drawing street scenes, focusing on the comings and goings of the rich.

According to Baudelaire, Guys spent afternoons and evenings sauntering (the French use the verb *flâner*) on Haussmann's new boulevards, mingling with the elegant crowds. At night he sketched, from memory, the figures and scenes that had caught his eye. *Two Women Wearing Blue Feathers* (FIG. 12-29) is such a sketch. Like most of Guys's works it is done in pencil and thinly washed watercolor, a medium that was eminently suited to depict momentary scenes of urban street life. Guys's watercolor almost certainly represents two ladies of the night. Their extravagantly wide skirts, impudently lifted, and the blue feathers in their hair give them away. Guys was the chief recorder of what Baudelaire had mockingly called the "elegant life," and he showed it in all its phony splendor and underlying sadness. If he did not "heroicize" modern life in one or more large-scale oil paintings, he certainly created a monument to it in the sheer quantity of his drawings.

Guys's women, dressed and groomed in the latest styles, fascinated Baudelaire. He felt that they embodied

12-29 **Constantin Guys,** *Two Women Wearing Blue Feathers.* Watercolor, 8'5" x 6'7" (21.4 x 17.1 cm). Musée Carnavalet, Paris.

"modernity," a newly-coined term describing the state of transience and continual change that, the poet felt, characterized his times. It is not coincidental that the terms "modern" and "modernity" had their roots in the French word *mode* (fashion), for it was in women's fashions that the phenomenon of change was most clearly visible (see *Women's Fashions and Women's Journals*, below). Moreover, as Baudelaire keenly observed, the more women's fashions changed, the less they were useful as indicators of class. Indeed, in his essay on *Le Peintre de la Vie Moderne* (The Painter of Modern Life), Baudelaire referred to the difficulty of distinguishing ladies from tramps. This was especially true for the Second Empire, when it was fashionable for men of wealth to "set up" mistresses in elegant apartments and give them handsome allowances. These kept women or *cocottes* defied traditional class boundaries. Coming from all walks of life, they formed the so-called *demimonde*, a shifting and unstable world that, to Baudelaire, was the breeding ground of modernity.

Courbet, Manet, and the Beginnings of Modernism

Although Baudelaire took little notice, there were a few artists during the Second Empire who did paint modern urban life on a larger scale. One was Courbet who, in at

Women's Fashions and Women's Journals

The manufacturing of men and women's clothing was one of the biggest industries of the nineteenth century. Thanks to the mechanization of spinning, weaving, dyeing, and even sewing, clothes could be produced much more cheaply and easily than a century before. As a result, they became a commodity rather than a necessity.

Clothing manufacturers found that they could increase sales by continuously changing fashion trends, especially women's, so as to encourage them to renew their wardrobes on a regular basis. Publishers relied on manufacturers' need to advertise and women's desire to be informed by launching "ladies" journals, which were among the most lucrative publications of the nineteenth century. In them, as in *Vogue* and *Glamor* today, women could find pictures and descriptions of the latest dresses to wear in town, at home, or on the beach; as well as of the underwear to go with them—whalebone corsets to squeeze the waist, horsehair or iron-enforced crinolines to widen the skirts.

A fashion plate from *Le Moniteur de la mode* (The Fashion Monitor; FIG. 12.3-1) exemplifies nineteenth-century fashion illustrations, which generally show two women in dresses for different occasions. Both the ball outfit and the visiting clothes in this illustration show the enormous skirts that were fashionable during the Second Empire. Reaching their largest proportions in the late 1850s, they were lampooned by contemporary caricaturists such as Daumier, who showed the many difficult situations that crinolines would get women into.

12.3-1 *Ball outfit and visiting clothes.* Illustration in *Le Moniteur de la mode*, 1853. Bibliothèque Nationale, Paris.

12-30 **Gustave Courbet,** *Young Ladies on the Banks of the Seine (Summer),* 1856. Oil on canvas, 5'8" x 6'6" (1.74 x 2 m). Musée du Petit Palais, Paris.

least one painting, monumentalized the *demimonde* that Guys had represented only in miniature. Courbet's *Young Ladies on the Banks of the Seine, Summer* (FIG. 12-30) of 1856–7 shows two fashionable young women on the grassy banks of the Seine, just outside Paris. Apparently they have come to this spot in the company of one or more men, because a black top hat lies in their rowboat. The woman in the background has picked some flowers and gazes across the water. Her cohort, meanwhile, has made herself truly comfortable by taking off her dress, to use it as a pillow. She reclines on the grass in her underwear, only summarily covered by a cashmere shawl. Contemporary Salon visitors must have understood the irony of Courbet's title, since these, of course, were not "young ladies" but *cocottes*, whose easy availability was manifest both in their partial undress and their reclining position (one of the many French nick-names for call girls was "horizontals").

If Courbet's *Young Ladies* shocked many a Salon visitor in 1857, it is evident why *Déjeuner sur l'herbe (Luncheon on the Grass;* FIG. 12-31) by Edouard Manet (1832–1883) was refused outright by the Salon jury in 1863. Manet's paint-ing, shown at the Salon des Refusés, also represents two *cocottes*, but they have undressed down to the skin. While Courbet only hinted at the presence of male lovers, Manet has placed two fully dressed men in close proximity to one of the women.

Manet was 31 years old when he submitted *Déjeuner sur l'herbe* (or *Le Bain* [The Bath]), as it was originally called) to the Salon of 1863. A student of Thomas Couture, he had already won a medal two years earlier for his *Spanish Singer* (FIG. 12-32). But while that painting represented an acceptable aspect of Parisian public life, *Déjeuner sur l'herbe* ventured into more private corners. Moreover, while the *Spanish Singer* was painted in a traditional style inspired

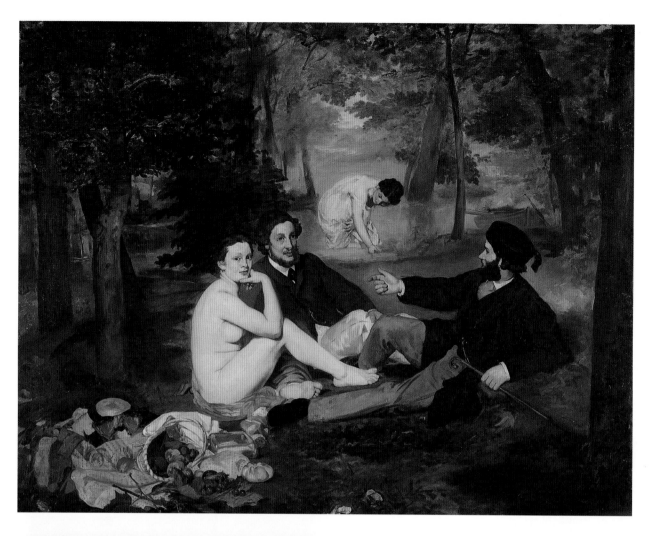

12-31 **Edouard Manet,** *Déjeuner sur l'herbe* or *Luncheon on the Grass*, 1863. Oil on canvas, 6'9" x 8'10" (2.06 x 2.69 m). Musée du Louvre, Paris.

12-32 **Edouard Manet,** *Spanish Singer*, 1860. Oil on canvas, 58 x 45" (1.47 x 1.14 m). Metropolitan Museum of Art, New York.

by seventeenth-century Spanish painting, *Déjeuner sur l'herbe* represents an entirely new way of seeing and representing reality.

Déjeuner sur l'herbe shows two young Parisians dressed in the formal attire of university students. They are seated in the wood, outside Paris, together with a naked woman. (The word "naked" is appropriate here, for this woman is not a nude—i.e. an ideal human being in its natural state. Rather, she is a specific individual who has purposely taken off her clothes, which lie in a heap in the foreground of the painting.) A second woman, lightly draped in a diaphanous chemise, bathes in a shallow pool in the distance.

As one or two critics reporting on the Salon des Refusés noticed, the subject of the painting and even the general arrangement of the figures are related to a work by the

sixteenth-century Venetian painter Titian, *Pastoral Concert* (FIG. 12-33). That painting, formerly attributed to Giorgione, likewise shows two unclothed women in the company of two men dressed in contemporary costume. The general arrangement of the figures—three seated, one standing apart—is also similar. Titian's painting was well known in nineteenth-century Paris since it was one of the most widely admired Renaissance paintings in the Louvre.

Manet's paraphrase of the famous Venetian painting was, no doubt, deliberate. His painting may be seen as an attempt to demonstrate that an undressed body can be read in different ways, depending on its visual context. It can be seen aesthetically, as a pure and beautiful form, and erotically, as an object of sexual desire. Manet chose to create a context that made an erotic reading unavoidable. Yet, in so doing, he also raised questions about Titian's hallowed masterpiece.

Among the many questions raised by *Déjeuner sur l'herbe* is one that affects the way we read this work today. Does the distance in time and the masterpiece status of paintings, such as Titian's *Pastoral Concert* and Manet's *Déjeuner*,

dull the erotic effect of the nude? Nineteenth-century viewers were able to ignore the erotic aspects of Titian's painting because it was supposed to represent people from the past, not the present. Similarly, today, we are only mildly shocked to see nineteenth-century men in the company of naked women, as in Manet's painting. But if we translate Manet's painting into modern terms, remove the dignity of the museum setting, and put it on a popular album cover (FIG. 12-34), the effect changes dramatically. Indeed, unless the viewer realizes that the image on the cover is a pun on Manet's painting, he or she may find it rather shocking.

In Manet's "remake" of Titian's painting, he not only modernized the costume but also introduced a new way of representing reality. In typically Renaissance fashion, Titian had emphasized the three-dimensionality of the nudes in his painting with pronounced *chiaroscuro*. The strong contrast between lights and shades and the gentle transitions between them no doubt reflect what Titian saw as he observed the nude model lit by the directed light that came through his atelier window. Had he painted out

12-33 **Titian** (formerly attributed to Giorgione), *Pastoral Concert*, c.1508. Oil on canvas, 43³/₈ x 54³/₈" (1.1 x 1.38 m). Musée du Louvre, Paris.

in the open, however, light and dark contrasts would have been much less visible. One look at the nude figure on the BowWowWow cover (FIG. 12-34) shows that, in broad daylight, *chiaroscuro* is limited to narrow areas of shading. Manet was keenly aware of this visual phenomenon and, although he painted his *Déjeuner sur l'herbe* inside the studio, he tried to retain the effect of outdoor light in his painting. He did this by minimizing *chiaroscuro*: shading is reduced to little more than a narrow black line on the underside of the woman's thigh.

In his memoirs, Manet's close friend Antonin Proust recalled an incident when he and Manet were lying on the banks of the Seine, outside Paris, watching some women bathing in the river. Proust quotes Manet as having said: "When we were in [Couture's] studio, I copied Giorgione's women, the women with musicians. It's black that painting. The ground has come through. I want to redo it … with a transparent atmosphere with people like those you see over there." Although the authenticity of this statement has been doubted, it brings up some important points. First, Manet appears to have objected to Titian's painting—and to old master paintings in general—because it was too dark. It did not convey the sunny outdoors; the pearly white skins of the nudes, which should glow in the sunlight, are obscured by too much shading. Secondly, Manet pointed out that Titian used a dark ground, or undercoating, for his painting, which inevitably increased its dimness. In *Déjeuner sur l'herbe* Manet effectively abandoned the dark ground to paint directly on the white canvas. The artist predicted that his painting would be attacked for the newness of its formal qualities, and, indeed, several older critics faulted the painting for its

foreground modeling. Younger critics, however, praised Manet's fresh and innovative approach.

Manet took his innovations one step further in a painting that he submitted to the Salon of 1865, the famous *Olympia* (FIG. 12-35). In the wake of the famous "Salon of the Venuses" of 1863 (see page 269) he may have felt the urge to take on the art establishment once again by treating the traditional subject of the reclining nude. *Olympia* represents a young woman, undressed, her body "displayed" on a cashmere shawl casually thrown upon a bed. Behind her, a black servant approaches with a bunch of flowers. But the woman turns away from her to look, somewhat defiantly, at the spectator.

Like *Déjeuner sur l'herbe*, *Olympia* contains an obvious reference to an old master painting—Titian's *Venus of Urbino* in Florence (FIG. 12-36). But the black choker around the woman's neck, as well as her fashionable slipper makes it clear that she is not a mythical being but a mercenary love goddess of the nineteenth century. Once again, Manet has subverted a much admired traditional image by substituting a courtesan for a goddess. The name Olympia, though it has a Classical ring to it, was not used by women in ancient times. It did not become popular until the nineteenth century, when it was a common "professional" name for prostitutes.

As in *Déjeuner sur l'herbe*, Manet has reduced shading to little more than a dark contour. By choosing to focus again on the nude—the darling subject of every academic painter—Manet clearly set himself up as an innovator, even a rebel. In *Olympia* he literally thrashed all the basic rules that were taught in the Academy: rules pertaining to subject matter, which dictated decorum; rules pertaining to form, which

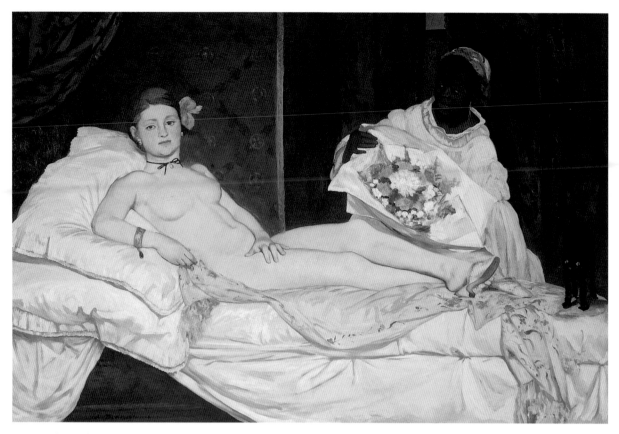

12-35 **Edouard Manet,** *Olympia,* 1865. Oil on canvas, 4'3" x 6'2" (1.3 x 1.9 m). Musée du Louvre, Paris.

12-36 **Titian,** *Venus of Urbino,* 1538. Oil on canvas, 47 x 65" (1.19 x 1.65 m). Galleria degli Uffizi, Florence.

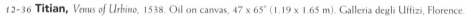

12-37 **Edouard Manet,** *Portrait of Emile Zola,* 1868. Oil on canvas, 57 x 45" (1.46 x 1.14 m). Musée d'Orsay, Paris.

emphasized modeling with light and shade; and rules of beauty, which emphasized the ideal perfection of Classical Greek art. For breaching tradition and advocating something that was radically new, Manet has been called the father of "modernism"—an important trend in late nineteenth and early twentieth-century art that entails the continuous rejection of the past and the unremitting search for new forms of expression.

While Manet was widely attacked by his contemporaries, he also had a number of defenders. Among them was the writer Emile Zola (see page 260), who, in a series of essays devoted to Manet, defended him for his "originality," a term that became closely linked to "modernism."

> A young painter has obeyed, in a very straightforward manner, his own personal inclinations concerning vision and understanding [of reality]; he has begun to paint in a way which is contrary to the sacred rules taught in schools.

Thus, he has produced original works, strong and bitter in flavor, which have offended the eyes of people accustomed to other points of view... I ask them not only to criticize Edouard Manet fairly, but also *all* original artists, who will make their appearance. I extend my plea further—my aim is not only to have one man accepted, but to have all art accepted.

As a gesture of appreciation, Manet painted Zola's portrait in 1868 (FIG. 12-37). In it, the young writer is seated in his study at a desk littered with books and papers. Zola's pamphlet on Manet is clearly visible behind the writer's quill, framing the artist's name. In the background we see a Japanese screen, suggesting that the writer is caught up in the new craze for Japanese art. We also see a Japanese print, set in a large frame, together with a photograph of Manet's *Olympia* and an engraved reproduction of a painting by the seventeenth-century Spanish painter Velázquez.

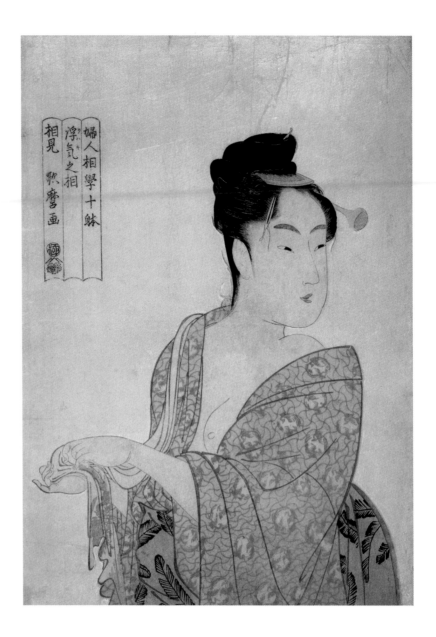

12-38 **Kitagawa Utamaro,** *The Fickle Type* from the "Ten Facial Types of Women," c.1792–3. Woodblock print, 14³/₈ x 9⁵/₈" (36.4 x 24.5 cm). British Museum, London.

The juxtaposition of Manet's *Olympia* and a Japanese print was, no doubt, intentional. In his essay on Manet, Zola had urged viewers to compare Manet's "simplified style of painting" with Japanese woodblock prints, which, he felt, "resemble[d] Manet's work in their strange elegance and magnificent bold patches of color." Japanese prints had been coming into western Europe since 1854 (see pages 348 and 358), and soon become the rage among young artists for offering a rendition of reality that ran counter to the traditional Western representational model. Japanese prints lacked most of the formal devices used in the West to suggest three-dimensionality and depth, particularly linear perspective and *chiaroscuro*. Asian artists were less obsessed than Western artists with approximating reality. They had different aesthetic priorities, preferring to capture the essence of their subjects rather than fooling the beholder into thinking that he or she was looking at the "real thing." A print by Kitagawa Utamaro (1753–1806; FIG. 12-38), showing a Japanese geisha girl after her bath, is typical of the kind of Japanese prints were now reaching the West. Its simple, flowing contours, lack of shading, and pure colors impressed contemporary viewers, including Manet.

We will never know whether Japanese prints caused Manet drastically to reduce *chiaroscuro* in his works; or whether, vice versa, his "*chiaroscuro* fatigue" caused him to become interested in Japanese prints. What is noteworthy is that, beginning with Manet, the history of "modernism" in art goes hand in hand with a growing awareness of and interest in non-Western art. (This was facilitated by the imperialism of the later nineteenth and early twentieth centuries.) Exposure to non-Western art forms showed artists that it was possible to create art unbound by traditional rules. Indeed, non-Western art as well as art outside of the "high art" tradition (folk art, children's art, etc.) provided a fresh alternative to the aesthetic precepts, rooted in Classical art, that were promoted by the academies from the seventeenth through the nineteenth centuries.

Portrait Painting and Photography

Manet's *Portrait of Zola* demonstrates that portrait painting survived in Second-Empire France, despite the increasing competition of photography. Since portrait photography took over the documentary as well as the publicity roles of portraiture (see page 244) portrait painters needed to change to survive. Unlike photographs, paintings left considerable room for subjectivity. Painters could import into the portrait indications of the sitter's character or contribution to society. They could also convey something about their own personal relationship to the sitter. Manet's *Portrait of Zola*, as we have seen, is filled with references to Manet himself, making it a true "friendship" portrait.

Meanwhile, portrait photography itself was evolving from a technique of convenience to a true art form.

Perhaps the greatest portrait photographer of the period was Félix Tournachon (1820–1910), who used the pseudonym Nadar. Nadar began his career as a portrait caricaturist, and had a sharp sensitivity to the facial characteristics of his sitters. He brought out the physical and psychological essence of his sitters through posing, lighting, and various darkroom manipulations.

Nadar's *Portrait of Manet* (FIG. 12-39) brings out both the artist's intensity and his anti-authoritarian attitude. By photographing the artist close-up, Nadar has put him "in your face," emphasizing his rebellious nature. By lighting Manet's face from above, so that the eyebrows shade the eyes, he has intensified the artist's penetrating gaze.

Nadar made a specialty of photographing the political and artistic celebrities of his time. There was a great demand for celebrity photographs during the nineteenth century,

12-39 **Nadar** (pseudonym of Félix Tournachon), *Portrait of Edouard Manet,* c.1865. Caisse Nationale des Monuments Historiques, Archives photographiques.

and competition in the "star market" became increasingly stiff. This led the photographer André-Adolphe-Eugène Disdéri (1819–1889) to develop a new, convenient, and inexpensive portrait format that he referred to as *cartes-de-visite*. The *cartes-de-visite* was a full-length portrait photograph pasted on a mount the size of a calling card. First produced in the late 1850s, *cartes-de-visite* became fashionable in the 1860s, when they were collected by adults much the way that children today collect baseball cards. People had special *cartes-de-visite* albums, with photographs of celebrities as well as of relatives and friends.

Disdéri's *cartes-de-visite* of Empress Eugénie, the wife of Napoleon III, is a typical celebrity portrait. Because they were small and full-length, *cartes-de-visite* could not offer the psychological insight of Nadar's *Portrait of Manet*. Instead, pose, dress, and setting played an important role in the

characterization of the figure. In Disdéri's photograph of Eugénie (FIG. 12-40), the empress is shown in a private moment, perusing an album. Dressed, according to the latest fashion, in the stiff crinoline that made sitting quite difficult for women, she is both pretty and modest, according to the ideals of French nineteenth-century womanhood.

Disdéri's *cartes-de-visite* are one symptom of the ever-growing popularity of images, a phenomenon that began during the July Monarchy and escalated throughout the remainder of the nineteenth century. Photography contributed immensely to this phenomenon, because it flooded the world with portraits and images of different sites (compare the photographs of Marville and Du Camp on pages 261 and 273). It also helped to familiarize the public with art, since photographs of artworks, like the one of *Olympia* in Manet's *Portrait of Zola*, became increasingly available.

12-40 **André Adolphe-Eugènie Disdéri,** *Portrait of Empress Eugénie,* c.1858. *Carte-de-visite* photograph. Bibliothèque Nationale, Département des estampes et de la photographie, Paris.

Art in the German-Speaking World From the Congress of Vienna to the Birth of the German Empire 1815–71

The Congress of Vienna of 1814–15 sealed the fate of the Holy Roman Empire, which *de facto* had ceased to exist in 1806. In its place came the German Federation, an amalgam of thirty-nine states ranging from the powerful state of Prussia and the Habsburg Empire (comprising present-day Austria and Hungary), to a number of small principalities and free cities (see *German States and Free Cities*, page 158). The German Federation was a loose political association that lacked a central power structure. The member states were ruled, for the most part, by their own absolute governments. There was, however, a federal parliament or Diet that met periodically to consider common legislation.

In the decades following the Congress of Vienna, widespread reform movements surfaced, aimed both at increasing democracy and unifying the German states. These movements erupted in full force in 1848. Popular demonstrations in Prussia forced the Prussian king Frederick William IV to allow the creation of a national Prussian assembly. Liberal leaders in other German states took advantage of the Prussian rebels' victory by pushing their own agendas of constitutional reform and unification. In May 1848 the Diet convened in Frankfurt with the dual mission of framing a federal constitution and drafting a plan for German unification. Ten months later, the crown of the new German nation (which excluded the Habsburg Empire) was offered to the Prussian king. But Frederick William refused to lead the new nation under the conditions spelled out by the Diet, and so the unification attempt failed.

Germany might never have been united, were it not for the brilliant political machinations of Otto von Bismarck (1815–1898; see FIG. 13-1), a Prussian squire or *Junker*, who had entered politics in 1847. As Minister-President and foreign minister of the Prussian cabinet, he led Prussia into a seven-week-long war against the Habsburg Empire (1866), weakening it to the point where it no longer presented a threat to German unity. Putting further pressure on the Empire, he arranged for it to be divided into a dual monarchy, composed of Austria and Hungary, united under a single ruler, Francis Joseph, who was both emperor of Austria and king of Hungary.

When France, in turn, threatened to become a hindrance to German unification, Bismarck provoked it into the Franco-Prussian War of 1870, in which the French suffered a humiliating defeat. The path was now clear for unification, and the German Empire was proclaimed in January 1871. It marked a glorious period for Germany that would continue until World War I (1914–18).

Biedermeier Culture

The three decades from the Congress of Vienna to the Revolution of 1848 are the period of Biedermeier culture. The term is derived from the name of a fictitious poet, Gottlieb Biedermeier, whose poems appeared in a well-known satirical newspaper in Munich in the mid-1850s.

13-1 **Franz Seraph von Lenbach,** *Portrait of Otto von Bismarck,* 1879. Oil on canvas, 47³/₄ x 38" (121 x 96.5 cm). Deutsches Historisches Museum, Berlin.

Written by two contributors to the journal, the verses of "Biedermeier" parodied a category of poetry that was popular among middle-class readers from the early 1820s through the 1840s. Written by schoolmasters and ministers, its simple verses celebrated bourgeois values such as simplicity, frugality, hard work, and piety.

The pseudonym Biedermeier had been carefully chosen. The German adjective *bieder* means plain, solid, and unpretentious. The noun *Meier* refers to an administrator of an estate, that is a man who earned his money not with his hands (like a peasant) but with his brains. The term Biedermeier, then, referred to the culture of the middle class or bourgeoisie, a class that blossomed in Germany during the first half of the nineteenth century.

Biedermeier culture took German Romantic ideas (see page 158) and toned them down to suit middle-class mentalities. Where the Romantics had celebrated profound, extreme emotions, Biedermeier culture embraced sentimentality. Where the Romantics had worshipped nature with near-religious fervor, the bourgeois Biedermeiers enjoyed nature in a more relaxed and down-to-earth fashion. One can imagine them enjoying a healthy hike in the wood or a pleasant boat ride on a lake, but not, like Goethe's sensitive young hero Werther (see page 158), having their "heart[s] undermined" by the consuming power that lies hidden in the Allness of nature."

Unlike Romanticism, which put a premium on individualism, Biedermeier culture emphasized community. Political debates, parlor games, poetry readings, and musical soirées were popular social activities that took place in the comfort of the bourgeois parlor. Music played an important role during this period. Every household owned a piano, which was often the focal point of social gatherings. Guests would be invited to enjoy the music of such well-known contemporary composers as Ludwig van Beethoven (1770–1827), Franz Schubert (1797–1828), Felix Mendelssohn (1809–1847), Robert Schumann (1810–1856), and Franz Liszt (1811–1886), which was performed by professionals and amateurs alike.

Biedermeier culture cast a wide net, reaching well beyond the borders of present-day Germany. Its social values and mores touched Denmark in the north, Switzerland, Austria and Hungary in the south, and Poland in the east.

Biedermeier Conversation Pieces

A watercolor by the Hamburg artist Carl Julius Milde (1803–1875), portraying *Pastor Rautenberg and his Family* (FIG. 13-2), shows a Biedermeier family at home, gathered around a table for their afternoon tea. Wife and daughters, as well as a family servant, standing to the side, are looking intently at the pastor, a dignified figure in his long dark robe. He is reading a letter, which appears to contain eagerly awaited news—perhaps from a son who is serving in the army.

13-2 **Carl Julius Milde,** *Pastor Rautenberg and his Family,* 1833. Watercolor, 17⁵/₈ x 17" (44.7 x 45.1 cm). Kunsthalle, Hamburg.

13-3 **Jozef Danhauser,** *Liszt at the Grand Piano,* 1840. Oil on panel, 46⅞ x 65″ (1.19 x 1.67 m). Nationalgalerie, Berlin.

The room is simply but comfortably furnished, with neatly parted curtains, flowering plants, silver and porcelain tea wares, a starched tablecloth, and a plaited rug. The pastor's chair and the wooden water warmer are representative pieces of Biedermeier furniture, the simple but elegant curved lines of which recall the French Empire style. The papered walls are densely hung with portraits, drawings, and print reproductions of famous paintings. Art was an integral part of the Biedermeier home, which was decorated with small-size paintings of domestic scenes (like the Rautenberg portrait itself), urban scenes, landscapes, and portraits.

Pastor Rautenberg and his Family may be seen as both a genre painting and a group portrait. This type of painting is called a conversation piece, a term that refers to a painting of a group of people engaged in some form of social activity. Such pictures were especially popular in the Biedermeier period, because they were eminent reflections of its sociable culture. *Liszt at the Grand Piano* (FIG. 13-3) by the Viennese artist Jozef Danhauser (1805–1845) is another

example of a Biedermeier conversation piece. Here the well-known Hungarian composer and pianist Franz Liszt is shown performing for a group of Parisian friends in a domestic setting. On the window sill, in the background and yet still compelling, sits the bust of Liszt's hero, Beethoven. It is instructive to compare this image of Liszt with his portrait by the French Romantic painter Henri Lehmann (see page 230). While Lehmann's portrait shows Liszt as a Romantic artist-genius par excellence, Danhauser brings the Romantic genius into a domestic setting, where hero-worship turns into sentimental adulation.

Danhauser's painting typifies the Biedermeier style not only in content but also in form. Pictures of this period tend to be small and painted in a detailed, colorful style reminiscent of the works of such seventeenth-century Dutch painters as Frans van Mieris, Jan Steen, and Gerard Terborch. Danhauser's painting may be compared with a conversation piece attributed to Steen, which likewise represents a house concert (FIG. 13-4). Seventeenth-century Dutch paintings were easily

13-4 **Jan Steen,** *The Van Goyen Family and the Painter,* c.1659–60. Oil on canvas, 33 x 39″ (84.5 cm x 1.01 m). Nelson-Atkins Museum of Art, Kansas City.

accessible to artists and collectors during this period. Even the most insignificant of German princes had his own art gallery, in which paintings by the Dutch masters were generally predominant. But the similarities between Biedermeier and seventeenth-century Dutch painting were not merely due to the ubiquity of Dutch art; they also reflected common social and political values. In Germany as well as in France, the bourgeois culture of the seventeenth-century Dutch Republic was a model for the liberal bourgeoisie of the mid-nineteenth century.

Urban Scenes and Landscapes

Biedermeier paintings not only depicted the parlor life of the bourgeoisie but also its outdoor activities, both in the city and the countryside. *Granite Bowl in the Pleasure Gardens of Berlin* (FIG. 13-5) by Johann Erdmann Hummel (1769–1852)

depicts the gardens in front of the Royal Palace in Berlin (now destroyed). The enormous bowl in the center of the picture was one of a series of civic improvements carried out in the city center in the 1830s. Hummel chose to paint it before it was lowered into position, when it was still an object of curiosity and wonder for Berliners. Walking up to admire the bowl, spectators were delighted to see their forms reflected and distorted in the shiny surface of the highly polished granite. Hummel's painting is the perfect image of an orderly bourgeois society, in which the dual authority of state and church guarantees its citizens peace and prosperity.

View from the Embankment of Lake Sortedam (FIG. 13-6) by the Danish painter Christen Købke (1810–1848) shows two women, standing on a landing plank, looking out over a lake just outside Copenhagen. While the painting recalls the work of Caspar David Friedrich, particularly in the use of the *Rückenfigur* (see page 171), it has a more mundane

13-5 **Johann Erdmann Hummel,** *Granite Bowl in the Pleasure Gardens of Berlin,* c.1831. Oil on canvas, 26 x 35" (66 x 89 cm). Nationalgalerie, Berlin.

13-6 **Christen Købke,** *View from the Embankment of Lake Sortedam,* 1838. Oil on canvas, 20⁷/₈ x 28¹/₈" (53 x 71.5 cm). Statens Museum for Kunst, Copenhagen.

13-7 **Karl Blechen,** *View of Roofs and Gardens*, c.1835. Oil on paper on board, 7⁷/₈ x 10″ (20 x 26 cm). Nationalgalerie, Berlin.

character. Unlike Friedrich's figures, awed by the wonders of nature, Købke's women are gazing at a rowboat full of tourists, who are out on a pleasure trip on he lake. Beyond them, the opposite embankment of the lake is lined with the visible signs of civilization—houses, windmills, and even a smokestack from a modern factory. Clearly, this is not the vast, untamed nature of the Romantics, but nature domesticated and civilized.

The effect of man on nature is also an important theme in the work of the Berlin painter Karl Blechen (1798–1840), perhaps the greatest German landscape painter of the first half of the nineteenth century. His *View of Roofs and Gardens* (FIG. 13-7) of about 1835 differs dramatically from the work of Romantic landscape painters such as Friedrich, in that it focuses on scenery that is ordinary and apparently random. Blechen's painting shows a view through a window of houses, backyards, and sheds. Yet the artist has transformed this mundane scenery into an image of great visual interest. By placing the sloped roof of a nearby house in the foreground, he has turned it into a *repoussoir*, a striking element that leads the viewer's glance, across fences,

gardens, and trees, to the distant horizon. The contrast between the straight, smooth surfaces of the manmade structures and the irregular forms and textures of nature adds interest to this painting, as does the skilful rendering of light on a rainy, overcast day.

Biedermeier Portraiture

As in July Monarchy France, portraits were in high demand during the Biedermeier period. Both group portraits in interiors (such as Milde's *Pastor Rautenberg and his Family* discussed earlier) and individual portraits were in demand. Among the latter, the *Portrait of Frau von Stierle-Holzmeister* (FIG. 13-8) of about 1819 by the Viennese painter Ferdinand Georg Waldmüller (1793–1865) may be seen as a representative example. The embodiment of the German bourgeoisie, Frau (i.e. Mrs.) von Stierle-Holzmeister is seen here in all her glory. Her round face is framed by a bonnet of Bruges lace, from which a few curls escape coquettishly. Her well-fed body is stuffed into a striped silk dress,

13-8 **Ferdinand Georg Waldmüller,**
Portrait of Frau von Stierle-Holzmeister, c.1819.
Oil on canvas, 21 x 16¹/₈" (54 x 41 cm).
Nationalgalerie, Berlin.

13-9 **Elizabeth Jerichau-Baumann,** *Double Portrait of the Grimm Brothers,* 1855. Oil on canvas, 24 x 21" (63 x 54 cm). Nationalgalerie, Berlin.

whose tightness is accentuated by a vertical flounce, a knotted cord, and a heavy golden waist watch. Waldmüller has depicted his sitter with the care and precision that we encountered in contemporary portraits by Ingres (see page 228). While Ingres tended to flatter his sitters, however, ironing out their wrinkles and streamlining their bodies, Waldmüller has rendered every hair, every wrinkle, and every wart with relentless accuracy.

The *Double Portrait of the Grimm Brothers* (FIG. 13-9) by the female painter Elizabeth Jerichau-Baumann (1818–1881) represents another aspect of German portraiture of the early part of the nineteenth century. It reminds us that the Biedermeier middle class included not only wealthy industrialists and professionals, but also the German intelligentsia. The portrait represents the two brothers, Jacob and Wilhelm Grimm, who became world-famous for their compilation of German folk tales, published between 1812 and 1820. The two intellectuals are portrayed in a simple bust-length portrait, one brother in profile, the other in a three-quarter view, with a book and a quill reminding us of their occupation.

German Fairie Painting

The Grimm brothers' interest in fairy tales had its origins in the German Romantic fascination with folk culture (see page 158). Their edition of German stories helped to popularize folk literature among the middle class. Taking advantage of this trend, the Viennese illustrator and painter Moritz von Schwind (1804–1871) specialized in painting episodes and characters from popular tales and legends. Some of these were conceived as narrative cycles, in which a group of paintings told a story. Others depict individual fairy characters, such as Rübezahl (Number Nip; FIG. 13-10), which shows a popular German mountain gnome roaming through the woods in search of a wife.

Von Schwind's fairy scenes have a strong element of realism. His Rübezahl, trudging through an eerie forest of gnarled and ominous trees, is a middle-aged man, dressed in a short tunic and hooded poncho that allow a view of his bare legs and sagging socks. It is known that Rübezahl's

13-10 **Moritz von Schwind,** *Rübezahl*, 1851. Oil on canvas, 25½ x 15⅛" (64 x 38 cm). Schackgalerie, Munich.

features were modeled after a painter in Munich, and they appear convincingly realistic in spite of the huge, protruding beard. Von Schwind's representation of Rübezahl as a real man, albeit eccentric in dress and behaviour, makes it possible for the viewer to believe in his existence, even if in some faraway fairy world. This clever blend of fantasy and realism was much admired in the nineteenth century. Widely imitated in fairy book illustrations, its popularity continues up to the present day.

German Academies

Unlike France and England, which had undisputed art capitals (Paris and London), the German-speaking world had several roughly equivalent art centers. These included Berlin, Dresden, Düsseldorf, Munich, and Vienna, each of which had its own art academy. The academies of Berlin and Dresden, which were founded in 1697 and reorganized in 1786 and 1765 respectively, were the oldest. The Academy of Vienna dated back to 1772, while those of Munich and Düsseldorf were started in the early nineteenth century (1808, 1819).

The German academies played a major role in the nineteenth century and several of them had far more than local importance. Düsseldorf and Munich, especially, attracted many foreign students, and became major competitors of Paris and London as the century progressed. American artists, in particular, favored the German academies. Richard Caton Woodville (1825–1855) and Eastman Johnson (1824–1906), for example, studied in Düsseldorf, while Frank Duveneck (1848–1919), John Twachtman (1853–1902), and William Merrit Chase (1849–1916) studied in Munich.

As in France and England, the academies in Germany organized periodic exhibitions. Most of them were local affairs, attracting few artists from abroad. Indeed, German artists who were keen on making an international reputation preferred to show their works at the Paris Salons, or, even better, at the art exhibits organized for the International Expositions (see page 341).

Like their counterparts in Paris and London, German academies held fast to Classical idealism and to the hierarchy of the genres. They placed a premium on history painting and disparaged lower genres, such as portrait and landscape painting. This led to a similar disparity between professional and market demands, forcing German artists to produce large-scale history paintings to establish themselves professionally, and small-scale genre scenes, portraits, or landscapes to put bread on the table.

Academic History Painting

History painting was most vigorously advanced at the Munich Academy, where Peter Cornelius, director from

1824 to 1840, promoted the mature Nazarene style that he had formulated in Rome (see page 161). This style, strongly indebted to Italian Renaissance art, remained the standard of German academic history painting until the mid-1850s. At that time, the 30-year-old Karl Theodor Piloty (1826–1888) joined the faculty of the Munich Academy and introduced a new, more realist approach to the painting of historical scenes. Piloty's appointment, in 1856, was based on the sensational success of his *Seni by the Corpse of Wallenstein* (FIG. 13-11), shown at the Academy exhibition of the previous year. Inspired by an episode in the Thirty Years' War (1618–48), this huge canvas shows the scene of the murder of Friedrich Wallenstein, the treacherous general of the Holy Roman Emperor's armies. Wallenstein's personal astrologer, Seni, who had foreseen his violent death in the stairs, is standing over his patron's body. His contemplative pose suggests that

he is meditating on the fate of the general, who had deceived the emperor and betrayed his trust.

Unlike the idealized Nazarene paintings of the time, *Seni by the Corpse of Wallenstein* is a historically accurate and meticulously detailed reconstruction of a historic event. The painting recalls the works of contemporary French history painters, such as Delaroche's *Princes in the Tower* (see FIG. 10-12). The use of heightened colors and the virtuoso rendering of light and texture especially distinguish Piloty's painting from those of Cornelius and his school, with their muted colors, smooth textures, and homogenous lighting (see FIGS. 7-4 and 7-5). No wonder that Piloty's lively style of history painting became an important alternative to the Nazarene style. What is more, its popularity was to spread beyond the German-speaking world, extending into to eastern Europe and Russia as well (see chapter 445).

13-11 **Karl Theodor Piloty,** *Seni by the Corpse of Wallenstein,* 1855. Oil on canvas, 10′5″ x 12′2″ (3.18 x 3.7 m). Neue Pinakothek, Munich.

Adolph Menzel

Although Piloty's mode of history painting became vastly popular in Germany, there were other approaches to history as well. One such option may be seen in the early work of Adolph Menzel (1815–1905), who, in a series of mid-size historic genre paintings, celebrated the world of the eighteenth-century Prussian king Frederick II (1712–1786), better known as "Frederick the Great."

The son of a lithographic printer, Menzel had begun his career as a book illustrator. He first became known for his nearly four hundred illustrations for Franz Kugler's *Geschichte Friedrichs des Grossen* (History of Frederick the Great), published in Leipzig in 1840. Menzel's drawings for these illustrations, which were handed over to professional wood engravers for reproduction (see *Wood Engraving,* page 237), are lost but several preparatory drawings have been preserved. Most of these depict places where Frederick the Great had lived, which Menzel visited and sketched in order to give greater accuracy to his illustrations.

13-13 **Adolph Menzel,** *The King at his Desk.* Illustration in Franz Kugler, *Geschichte Friedrichs des Grossen*, 1840. Wood engraving, 43 x 33" (1.09 m x 85 cm). Kupferstichkabinett, Berlin.

13-12 **Adolph Menzel,** *Frederick the Great's Study in the Palace of Potsdam*, 1840. Pencil, 8¹/₈ x 5" (20.8 x 12.7 cm). Kupferstichkabinett, Berlin.

His drawing titled *Frederick the Great's Study in the Palace of Potsdam* (FIG. 13-12) was made in preparation for the illustration representing the king at his desk (FIG. 13-13). It shows the interior of the New or City Palace in Potsdam, one of Frederick the Great's residences (destroyed in 1945). To render the Rococo style of the palace suggestively, Menzel used a free and loose style of drawing that was quite different from the tight, Classical contour drawing that was practiced in the academies during the Biedermeier period. Although his technique was well suited to the artist's Rococo subject matter, it was criticized in academic circles. Johann Gottfried Schadow (1764–1850), the director of the Berlin Academy, *Geschichte Friedrichs des Grossen*, for example, referred to Menzel's illustrations as nothing but "scrawls."

The success of Menzel's illustrations for the *Geschichte Friedrichs des Grossen* led him to do a series of related paintings for the expositions of the Berlin Academy. Of these, *The Flute Concert of Frederick the Great at Sansoucci* (FIG. 13-14) became most popular. Like many of the German princes, Frederick the Great was an enthusiastic amateur flute player. He played several nights a week, accompanied by his court chamber orchestra. In Menzel's painting, the king stands in one of the reception rooms at Sansoucci, his garden palace at Potsdam. On his right, we see his court harpsichordist, Carl Philipp Emanuel Bach (1714–1788), the son of Johann Sebastian Bach, who directs the royal chamber

orchestra. On his left, a select audience composed of family members, friends, and courtiers listens politely to the music. One of the special attractions of this painting is its candlelight illumination. Two large glass chandeliers cast a soft light across the spectators and the king. The musicians remain in semidarkness, except for the glow of the individual candles attached to their music stands.

Menzel's painting presents a view of history that was different to both the Renaissance-style history paintings of the Nazarenes and the new realist style of history painting of Piloty. Like Meissonier in France, who was his exact contemporary, Menzel was primarily attracted to historic genre scenes. But he had no use for the miniaturist approach of Meissonier. As in his drawings, he deliberately modeled his style after Rococo painting (see Fragonard's painting in FIG. 1-8) in order to capture the ambiance of the eighteenth century. Only in its unapologetically realistic portrayal of the figures (see especially the group on the left of the canvas) does the painting betray its nineteenth-century roots.

While Menzel habitually submitted historic genre paintings to the Academy exhibitions of the 1840s and 1850s, he was by nature more interested in portraying contemporary life, and it is in his paintings of the private and

Tableaux Vivants

The staged character of Menzel's *Flute Concert of Frederick the Great* made it an appropriate model for *tableaux vivants* or "living pictures." The social practice of the *tableau vivant*, in which a group of people would dress up and strike poses in order to create the effect of a painting, was popular in the nineteenth century. *Tableaux vivants* could be imaginary pictures, in which the subject and composition were conceived by the performers, or they could be modeled after well-known paintings by old or modern masters.

The staging of *tableaux vivants* was both a parlor activity and one that was practiced in art academies, where students would often go to great lengths to "recreate" famous masterpieces of the past. For Menzel's 70th birthday, the students of the Berlin Academy staged the *Flute Concert*, even arranging for the "actors" to perform a piece by Carl Philipp Emanuel Bach.

13-14 **Adolph Menzel,** *The Flute Concert of Frederick the Great at Sansoucci,* 1852. Oil on canvas, 4'8" x 6'8" (1.42 x 2.05 m). Nationalgalerie, Berlin.

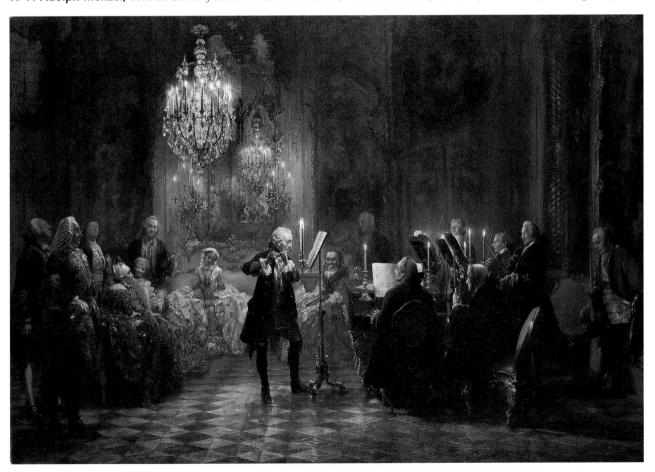

13-15 **Adolph Menzel,** *Balcony Room,* 1845. Oil on board, 22⅞ x 18″ (58 x 47 cm). Nationalgalerie, Berlin.

public spheres of Berlin, as well as the landscape scenery around the city, that his originality as an artist is most clearly visible. *Balcony Room* (FIG. 13-15), one of his best-known paintings, differs radically from *The Flute Concert,* not only because it depicts a contemporary interior, but also because it is about vision rather than narration. The painting shows one side of a sparsely furnished bedroom, its French windows opened wide, with a breeze swaying the long lace curtains. Two Biedermeier chairs stand, back-to-back, beside a mirror that reflects the other half of the room. The painting hints strongly at a human presence, and even encourages us to imagine some scenario that may have led to that strange configuration of furniture; but that search proves futile, forcing us to concentrate on the visual aspects of the painting.

Thus we begin to marvel at the early morning light and gentle breeze that Menzel has so successfully captured in this painting. We also become intrigued by the different degrees of precision with which the forms are rendered. While the mirror and the chair are highly detailed, the wall in the background is loosely sketched. The varying

degrees of "focus" in Menzel's painting may be related to contemporary photography. Using the primitive cameras of the period, focusing on one object inevitably meant that others would be fuzzy. It may also be related to the growing interest in visual perception, advanced by the German scholar Hermann von Helmholtz (1821–1894), and the ensuing realization that the human eye does not see everything in its visual field with equal precision.

Menzel's interest in the ordinary also manifests itself in his numerous early landscapes. He painted a number of "rear window" scenes, similar to Blechen's *View of Roofs and Gardens,* as well as landscapes showing the impact of modern industry, a theme that Blechen had also treated. His *Berlin–Potsdam Railway* (FIG. 13-16) of 1847 is one of a group of contemporary paintings that indicate an interest in the railways, which so dramatically affected both the landscape and human mobility during the nineteenth century. With its panoramic perspective and bravura brushwork Menzel's painting recalls Turner's *Rain, Steam, and Speed* (see FIG. 8-15), done only three years earlier. Both artists used loose brushwork and blurred edges to create the illusion

13-16 **Adolph Menzel,** *The Berlin–Potsdam Railway,* 1847. Oil on canvas, 16 x 20″ (42 x 52 cm). Nationalgalerie, Berlin.

13-17 **Adolph Menzel,** *The Théâtre du Gymnase,* 1856. Oil on canvas, 18⅛ x 24⅜″ (46 x 62 cm). Nationalgalerie, Berlin.

of speed, depicting the fleeting scene that a traveler in a fast-moving train might see. Unlike Turner's painting, however, which was widely acclaimed at the Royal Academy exhibition of 1844, Menzel's *Berlin–Potsdam Railway* was never exhibited. Menzel probably considered the work a mere sketch, not suitable for public exhibition.

It was not until the later 1850s that Menzel began to exhibit landscape paintings and scenes of contemporary life. His changed exhibition policy may be due to a visit to the International Exhibition of 1855, held in Paris (see page 349). There he must have seen the work of Gustave Courbet, who for several years had loudly proclaimed that artists should paint the reality of their own time rather than an imagined historic past. The *Théâtre du Gymnase* (FIG. 13-17), exhibited in Berlin in 1861, was a direct result of Menzel's trip. Anticipating the works of the French Impressionists and Post-Impressionists (see FIGS. 16-34 and 17-5), the painting depicts a view of a Parisian stage. Like *Balcony Room*, *Théâtre du Gymnase* presents evidence of Menzel's interest in perception. Its elevated oblique viewpoint and the tripartite division of the painting into stage, orchestra pit, and audience suggest the view that a spectator would have from a balcony seat. The painting's dramatic contrasts between light and dark further enhance the sense of reality of the theatrical experience.

Despite its steady movement toward realism, nineteenth-century painting rarely treated industrial scenes, although they were commonly illustrated in newspapers and magazines. Artists tended to focus on peasants rather than factory workers; neither Courbet nor Millet painted industrial scenes. Menzel generally avoided such scenes as well, with one noteworthy exception. His *Iron Rolling Mill* or *Modern Cyclops I* (FIG. 13-18) was one of the most striking industrial paintings to emerge from the nineteenth century. This monumental work, measuring some five by eight and a half feet, was exhibited in Berlin in 1876 and again at the Paris International Exhibition of 1878.

Menzel's *Iron Rolling Mill* represents the interior of a rolling mill for train rails in the artist's native region of Silesia (now in Poland). The painting centers around one of the mills, attended by several workers whose faces are dramatically lit by the glow of the red-hot molten iron. On the periphery of this scene, we see workers at rest—drinking, eating their lunch, or washing the sweat from their faces and backs. In the distance, additional mills are visible.

Menzel's painting contains few hints of the sympathy toward workers that mark the early works of Courbet and Millet. *Iron Rolling Mill* was painted at a time when Bismarck's government aided industrial capitalists so that

13-18 **Adolph Menzel,** *Iron Rolling Mill*, or *Modern Cyclops I*, 1872–5. Oil on canvas, 5'2" x 8'4" (1.58 x 2.54 m). Nationalgalerie, Berlin.

13-19 **Wilhelm Leibl,** *Village Politicians,* 1876–7. Oil on canvas, 29³/₄ x 38¹/₈" (56.6 x 96.8 cm). Museum Oskar Reinhart am Stadtgarten, Winterthur, Switzerland.

the country could compete on the international market, a move generally applauded by the middle class. Although the first volume of Karl Marx's *Das Kapital,* with its grim description of the lives of British workers, was published in Berlin in 1867 and, again, in 1873, few Germans appear to have taken more than an intellectual interest in it. Menzel seems to have been interested in the factory as a new kind of heroic subject rather than one through which he could register his social concerns. His lengthy description of the painting, composed for its exhibition in 1879, reveals his interest in the industrial process and the worker's role in it, rather than his sympathy with the working class.

Realism and Idealism: Diverging Trends in the Early 1870s

Although Menzel, even in his own time, was recognized as one of the greatest artists of nineteenth-century Germany, his influence was limited. Indeed, his work had less of an impact on German art of the third quarter of the

nineteenth century than the work of French artists, most notably Courbet. The latter's influence on young German artists in the late 1860s and early 1870s led to the formation of several regional realist movements, especially in the cities of Frankfurt and Munich.

Courbet's importance for German art has often been linked to the artist's stay in Munich in 1869. The recipient of a Bavarian Cross at the Great International Art Exhibition of 1869, he became acquainted with several German artists including the young Wilhelm Leibl (1844–1900), whose works Courbet singled out as the best in the show. As a result, Leibl received an invitation to travel to Paris, where he studied contemporary French painting.

In its close-up representation of country life *Village Politicians* (FIG. 13-19), painted in 1876–7, is reminiscent of Courbet's early works, such as *A Burial at Ornans* and *The Stonebreakers* (see FIGS. 11-3 and 11-7). Five villagers of various ages are huddled together in a room, focusing intently on a newspaper held by one of them. Presumably, the paper contains a list of those who are eligible to vote.

13-20 **Hans Holbein,** *Portrait of Desiderius Erasmus,* 1523. Oil on panel, 16½ x 12½" (42 x 32 cm). Musée du Louvre, Paris.

Leibl's characters show suspense and tension in their facial expressions and gestures, as they await this crucial information. Leibl goes beyond Courbet in his scrupulous attention to physiognomy, pose, and gesture, all for the purpose of achieving greater psychological truth. His sharp-focus realism may be credited to his drawn to photography as well as his study of sixteenth-century German portraits by such artists as Albrecht Dürer (1471–1528) and especially Hans Holbein (1497/8–1543), with whom Leibl's mature work has often been compared. Holbein's works, such as his famous *Portrait of Desiderius Erasmus* (FIG. 13-20), may have inspired Leibl's crisp contours, his emphasis on faces and hands, and, above all, the keen characterization of his figures.

Just when Leibl achieved his first artistic successes in the early 1870s, a number of German artists rejected both the sentimental realism of Biedermeier artists and the new forms of realism of Menzel and Leibl. This reaction was prompted by a distaste, among young artists and intellectuals, for bourgeois materialism and the increasing commercialization of the art world. Realism, these artists felt, was both a symptom and a consequence of these phenomena. Like the Nazarenes before them, they were drawn to the idealism of Classical sculpture and Italian Renaissance painting; many of them spent prolonged periods of time in Italy. Unlike the Nazarenes, however, these anti-realists did not form a coherent movement, and worked in very different styles.

Hans von Marées (1837–1887) is perhaps the best-known painter in this category of late nineteenth-century German artists. Although he started out as a realist, Von Marées became interested in Renaissance art in the 1860s when he went to Italy to copy Italian paintings for a German collector. Several years later, in 1873, he was commissioned to paint five large frescos depicting scenes of life in the Bay of Naples for the German zoological observatory in that city. *Orange Grove of Sorrento* (FIG. 13-21) is one of these. It shows an orange grove with a nude male, seen from the back, reaching up to pick an orange from the tree. Lying on the ground next to him is a nude boy playing with an orange. Another child, dressed and seated, looks on; behind the two children, an old man digs at the soil. The painting has been interpreted as an allegory of human life, representing its different stages: the playfulness of youth, the fruitful labor of adulthood, and the preparation for death and eternity of old age. It conveys a feeling of peacefulness and earnestness, evoking a utopian world in which all men are equal and conflict is unknown. Indeed, the work may be seen as a re-interpretation of the Classical Golden Age or the biblical notion of Paradise.

The careers of Leibl and Von Marees suggest that there were two main paths for German painters of the last thirty years of the nineteenth century, the glory period of the German Empire. One was the path of realism, which would lead German artists on to the road of the international Naturalist movement of the late-nineteenth century (see page 441). The other was that path of idealism that became the precursor to the Symbolist movement (see page 470).

13-21 **Hans von Marées,**
Orange Grove of Sorrento, 1873.
Fresco, 15'5" x 7'10" (4.7 x 2.4 m).
German Marine Zoological Station,
south wall, Naples.

Chapter Fourteen

Art in Victorian Britain (1837–1901)

From 1837 to 1901 Britain was governed by Queen Victoria. British culture during this sixty-four-year period is so closely identified with her reign that the term "Victorian" is commonly used to describe it. A sweeping adjective, "Victorian" refers at once to the prevailing moral values and social customs, and to the art, architecture, and literature of the time.

Victoria ascended the throne at the tender age of 18. Her uncles George IV (reigned 1811–30) and William IV (reigned 1830–37), the previous monarchs, had both died without an heir, and so Victoria, daughter of the fourth son of George III (see Georgian Britain, page 72), became their legitimate successor. She had been groomed for her role since she was 10 years old. When first told that she was to ascend the throne, she is reported to have said: "I will be good."

And good she was. During her sixty-four years as queen, she restored some much-needed dignity to the crown. Although the monarchy lost much of its political power in the course of her reign, Victoria lent it sufficient popularity to ensure its survival until the present day. So beloved was the queen that, when she died, the American expatriate novelist Henry James (1843–1916) wrote that all England was feeling "quite motherless."

James's perception of Victoria as mother of the nation was closely linked to the queen's domestic life. Her marriage to her first cousin Albert in 1840 produced no less than nine children. Photographs of the queen, surrounded by her brood, were widely circulated (FIG. 14-1). These advanced Victoria's image as queen and mother and promoted the family values that were paramount during her reign.

The informal image of the queen that photographs such as the one reproduced in FIG. 14-1 present were, to a degree, inherent to the medium. Indeed, similarly casual group portraits exist of the French and Austrian imperial families. But unlike Napoleon III or Franz Joseph, Victoria deliberately promoted this kind of image. Rather than emphasizing her superior status as queen, she liked to cast herself as just another British citizen who espoused the same ideals and values as the rest of the nation. There is nothing in Fenton's photograph that suggest the royal status of the family group it represents. The demeanor as well as the dress of the queen, the prince, and the royal children are indistinguishable from other members of the well-to-do British middle class.

Likewise, in Edwin Landseer's *Windsor Castle in Modern Times* (FIG. 14-2), we see the young Victoria, dressed like a middle-class woman of the period, greeting her husband who has just returned from the hunt. Meanwhile little Vicky, their first child, has her pet bird inspect one of the dead partridges. Although no one would mistake the picture for a scene from an ordinary British household, it nonetheless reflects many virtues held high by the Victorian middle class: domestic harmony, spousal fidelity, masculine "character," and feminine devotion and modesty.

14-1 **Roger Fenton,** *Queen Victoria, the Prince and Eight Royal Children in Buckingham Palace Garden, 22 May 1854.* Windsor Castle, Berkshire, Royal Archives.

14-2 **Edwin Landseer,** *Windsor Castle in Modern Times,* 1841–5. Oil on canvas, 44⅝ x 56⅞" (1.13 x 44 m). London, St James's Palace, Royal Collection.

Social and Economic Conditions during the Victorian Age

The Victorian age was a period of important social changes, brought about by economic pressures caused by the Industrial Revolution. In the eighteenth century the social structure of Britain had resembled a pyramid with a broad base of powerless peasants, a center section of middle-class people, and a small upper section of powerful landed aristocrats. By the time that Victoria ascended the throne, that structure had markedly changed. A huge mass of industrial laborers had now joined the peasants at the bottom. A wealthy upper class of industrialists competed for importance with the aristocracy. The differences in political and economic power between the elite upper class and the vast lower class had become enormous. The first group lived in comfort, even luxury, while the other existed on the brink of starvation. As in France (see page 253) during the 1830s and 1840s, a small but vocal group of journalists, politicians, and intellectuals called for change. Some changes were indeed made. In 1842 legislation forbade the employment of women and children under the age of 10 in the mines. In 1846 the unpopular Corn Law of 1815, which called for taxation on all imported grains (causing high prices for bread and cereals), was repealed. The measure did little for Irish peasants, whose failed potato crops in 1845 and 1846, combined with the reluctance of the British government to bail them out, caused half a million people to die and another million to emigrate to the United States.

The belated response to socio-economic problems was symptomatic of Victoria's reign. In spite of the continued efforts of writers such as Thomas Carlyle (1795–1881), Charles Dickens (1812–1870), Charles Kingsley (1819–1875), and the German immigrant Friedrich Engels (1820–1895) to expose various social injustices, reform was painfully slow. As late as 1872 the French illustrator Gustave Doré (1832–1883) graphically delineated the differences between rich and poor in his drawings for *London: A Pilgrimage*, written by the British journalist Blanchard Jerrold. Comparing his drawing of a garden party at Holland House with one of a London slum (FIGS. 14-3 and 14-4), one gains some awareness of the wide gap that existed between rich and poor.

14-3 **Gustave Doré,** *Holland House, A Garden Party.* Illustration in Blanchard Jerrold, *London: A Pilgrimage,* 1872. Wood engraving, 7⅞ x 9″ (20 x 24 cm). Private Collection, London.

14-4 **Gustave Doré,** *Orange Court, Drury Lane.* Illustration in Blanchard Jerrold, *London: A Pilgrimage,* 1872. Wood engraving, 2 x 7″ (7 x 18 cm). Private Collection, London.

Around the time that Doré's drawings were published, the urgent sense that change was needed finally led to a burst of legislation. The Factory Act of 1878 restricted the working week to fifty-six (!) hours. Other acts improved housing, public hygiene, and education.

The Victorian Art Scene

The Victorian middle class not only controlled the political and economic scene, it also informed British culture, because its members were the chief cultural producers and consumers. Middle-class readers advanced the popularity of the novel, as they devoured the historic novels of Walter Scott (1771–1832), as well as fictional tales set in modern times by such writers as the Brontë sisters—Charlotte (1816–1855), Emily (1818–1848), and Anne (1820–1849)—Charles Dickens, and George Eliot (1819–1880).

In the fine arts, too, the middle class set the tone. When Victoria ascended the throne in 1837, the Royal Academy moved from Somerset House to a new building in Trafalgar Square, which it shared with the National Gallery. There, more paintings and people could be accommodated in the annual Summer Exhibitions. Like the Parisian Salons, these exhibitions were a fashionable venue, drawing crowds of visitors anxious to see and be seen (FIG. 14-5).

The Summer Exhibitions were important for artists to gain exposure, but, like the Parisian Salons, they hardly helped them to sell their works. While serious collectors might make the effort to visit the studio of an artist whose work they had admired at an exhibition, for casual buyers this was impractical. Hence, from the 1830s onwards—even earlier than in France—art dealers became important as middlemen between artists and the public. To encourage art buying, they mounted exhibitions in galleries, where people could come in, look, and buy on the spot. As the Victorian age progressed, dealers, especially important ones such as Thomas Agnew (1794–1871) and Ernest Gambart (1814–1902), became increasingly influential since they controlled not only the prices of the pictures but also, to an extent, the subject matter and styles of the artists they represented.

The middle-class art buyers who, after 1820, began to replace the gentleman collectors of the eighteenth and early nineteenth centuries generally lacked the broad view of the history of art that the latter had acquired during the Grand Tour. Instead of large-scale history paintings and grand-manner portraits, they preferred small genre paintings, narrative scenes, landscapes, animal paintings, and portraits. They liked watercolors, drawings, and prints. Most middle-class art buyers bought just enough art to decorate the walls in their home, although there were a few true collectors. John Sheepshank (1787–1862), a wool manufacturer from Leeds, built up a substantial collection

14-5 **George Bernard O'Neill,** *Public Opinion,* 1863. Oil on canvas, 21 x 31" (53.4 x 78.7 cm). Leeds City Art Galleries.

of contemporary paintings and drawings, which he donated to the Victoria and Albert Museum in 1857. Robert Vernon (1774–1849), a horse trader, bequeathed his collection of contemporary art to the National Gallery (now at the Tate Britain) in 1849.

Painting during the Early Victorian Period: Anecdotal Scenes

In view of the changing market demands of the 1830s and 1840s, British artists increasingly moved away from history painting, never very popular in Britain even before the Victorian era. Instead, they devoted themselves to the kind of sentimental–Romantic scenes from modern life, history, or literature that were popular in Biedermeier Germany and July Monarchy France. *The Poor Teacher* (FIG. 14-6) by Richard Redgrave (1804–1888), which was exhibited at the Royal Academy in 1843, may serve as an example. So popular was this painting that Redgrave made four or five replicas for different collectors, including the one shown in FIG. 14-6. The painting shows a poor teacher in a schoolroom, eating a simple meal at her desk. Her black dress suggests that she is in mourning. In her hand she holds a letter, probably from home, which seems to

have caused her nostalgia. "She sees no kind domestic visage here," reads the explanatory line in the exhibition catalogue. Indeed, by placing the young woman in a dark, cavernous space, Redgrave emphasized her sense of loneliness and abandonment.

The success of Redgrave's painting derived, in large part, from its ability to suggest a story or anecdote to the mind of the observer. The Victorian taste for narrative or anecdotal painting was closely related to the popularity of the novel, perhaps the most accessible form of literature. Redgrave's *The Poor Teacher* invites a direct comparison with Charlotte Brontë's *Jane Eyre*, a novel published only two years later, in 1847. It, too, centered on a young female teacher who, alone in the world, longs for love and sympathy. Both works, moreover, deal with the theme of poverty: not the brutal poverty of factory laborers, which would have repelled the British middle-class public, but a genteel poverty that they could sympathize with.

The anecdotal character of Redgrave's work was shared by many popular genre scenes painted during the early Victorian era. Such works, often depicting literary or historical subjects, owed their popularity to two painters who were already well established by the time that Victoria became queen, David Wilkie (1785–1841)

14-6 **Richard Redgrave,** *The Poor Teacher,* 1845. Oil on canvas, 25 x 30" (64 x 77.5 cm). Shipley Art Gallery, Gateshead, Tyne and Wear.

14-7 **David Wilkie,** *Christopher Columbus in the Convent of La Rabida Explaining his Intended Voyage,* 1834. Oil on canvas, 58 x 74" (1.49 x 1.89 m). North Carolina Museum of Art, Raleigh.

14-8 **Sir Joseph Noël Paton,** *The Reconciliation of Oberon and Titania,* 1847. Oil on canvas, 30 x 48″ (76.2 cm x 1.22 m). National Gallery of Scotland, Edinburgh.

and the American-born Robert Leslie (1794–1859). Wilkie's *Christopher Columbus in the Convent of La Rabida Explaining his Intended Journey* (FIG. 14-7) exemplifies the kind of works that these artists and their followers produced in the 1830s and 1840s. Inspired by the biography of Columbus by Washington Irving (1783–1859), Wilkie's painting shows Columbus and his son inside the monastery of La Rabida, where they have stopped for food and water. Chatting with the prior, Columbus tells him his idea about the possibility of a westward route to the Indies. Enthused by Columbus's convincing explanation, the prior would later recommend him to the priest-confessor of Queen Isabella, who enabled Columbus to set out on his quest.

Loosely painted in a manner that recalls the seventeenth-century Spanish artist Velázquez, Wilkie's painting differs stylistically from Redgrave's tightly painted *The Poor Teacher.* Eclecticism reigned supreme during the Victorian period, as it did in mid-nineteenth-century France and Germany. Artists studied a variety of historic sources, ranging from Italian High Renaissance painting to British, Dutch, Flemish, and Spanish painting of the seventeenth and eighteenth centuries. Newly opened museums, notably the National Gallery in London (founded in 1824), made old master paintings increasingly accessible to everyone.

Fairy Painting: Paton and Dadd

A special subcategory of pictures based on historic and literary themes are the so-called fairy paintings. Fairy paintings are a uniquely British genre, although they have some common ground with the paintings of fairy tales that were produced in Germany by Moritz von Schwind (see page 300). British fairy paintings originated in late eighteenth- and early nineteenth-century Shakespearian scenes, notably those inspired by paintings of *A Midsummer Night's Dream* and *The Tempest.* Fuseli's *Titania and Bottom* (see FIG. 3-9) may be seen as an early prototype of the genre. The popularity of fairy paintings may also be related to the Victorian interest in the preternatural, the psychic, and the occult.

The Scottish artist Joseph Noël Paton (1821–1901) painted a number of fairy paintings, including *The Reconciliation of Oberon and Titania* (FIG. 14-8), based on *A Midsummer Night's Dream.* The painting shows Oberon, king of the fairies, and his wife Titania sleeping in the woods after their earlier quarrel. Between them, their fairy personifications rule over a forest teeming with fairies, male and female, good and evil, that are splashing in puddles, frolicking on the ground, and fluttering among the trees. Like most British fairy paintings, Paton's are elaborate exercises of the imagination, and were admired in their time for their inventiveness.

While Paton was perhaps the best-known fairy painter in his own time, today that distinction goes to Richard Dadd (1817–1887). From the early 1840s onwards, Dadd presented fairy paintings based on Shakespeare's plays to the Royal Academy. These days, however, he is especially known for the works he did later on in life, when he was a patient in "Bedlam," the Royal Hospital of Bethlehem in London. Dadd was admitted there in 1844, after having murdered his father in a first major bout of schizophrenia. The *Fairy Feller's Master Stroke* (FIG. 14-9), painted in Bedlam over a period of eleven years (1855–64), epitomizes fairy painting in its highly inventive imagery and startling manipulation of size. The use of diminutive figures set among giant flowers, grasses, seeds, and hazelnuts is reminiscent of both traditional and modern fairy tales. *Alice's Adventures in Wonderland*, written around the same time by Lewis Carroll (1832–1898), in particular, comes to mind. At the same time, the *horror vacui* (fear of emptiness) and obsession with detail that mark Dadd's painting are characteristic of the imagery produced by schizophrenic patients. The meaning of Dadd's imagery is difficult to grasp. The painting appears to be centered on the "feller," who stands in the foreground and raises his axe, as if to crack one of the gigantic hazelnuts that are lying around. Do we see,

14-9 **Richard Dadd,** *Fairy Feller's Master Stroke*, 1855–64. Oil on canvas, 21 x 15" (54 x 38.7 cm). Tate Britain, London.

in the feller, something of Dadd's murderous tendencies, here condensed in a diminutive figure in eighteenth-century costume—a transformed *alter ego*?

Dadd's paintings and watercolors are among the first works by an insane artist to have been preserved. Although hardly known during the artist's lifetime, they apparently were judged to be sufficiently interesting, both for artistic and medical reasons, to be preserved. It was not until the middle of the twentieth century, however, that a new interest in "outsider art" led to a re-evaluation of Dadd's work. In 1974 a major retrospective exhibition at the Tate Gallery in London confirmed his position as an important nineteenth-century British artist.

Early Victorian Landscape and Animal Painting: Martin and Landseer

Landscape painting, which had gained so much importance during the early decades of the nineteenth century, remained popular during the early Victorian period. Although Constable died the very year in which Victoria became queen (1837), Turner continued to exhibit at the Royal Academy throughout the 1830s and 1840s. Interest in his work, in fact, peaked after 1843, as a result of the publication of the first volume of *Modern Painters* by the young

critic John Ruskin (1819–1900). Ruskin hailed Turner as one of the greatest landscape painters ever, praising especially the "truth" of his paintings.

Turner's huge reputation inhibited many younger landscapists of the period, but not John Martin (1789–1854), a born showman, whose sensational landscapes became very popular in Victorian times. His *Great Day of his Wrath* (FIG. 14-10) is a terrifying image of God's punishment of the world, as predicted in the biblical Book of Revelation or Apocalypse (6:17): "For the great day of His Wrath is come; and who shall be able to stand." With its thunder and lightning, burning fires, and tumbling boulders, it may be seen as a belated example of the sublime in art (see page 71). The abundance and exaggeration of its "special effects," however, are more closely related to popular entertainment than to Burke's lofty notion of the sublime. Martin's painting appears to have been inspired by contemporary panoramas (see *Girtin and the Vogue for the Painted Panorama*, page 181), dioramas (see page 243), and magic lantern shows. To the mid-nineteenth-century viewer, these offered dramatic visual effects, often combined with artificially produced sounds, that anticipated modern movies.

Martin's paintings, for the most part, were enormous and not suited for sale to a middle-class public. Like Benjamin West and Fuseli before him, he relied on the success of his paintings at exhibitions by marketing

14-10 **John Martin,** *Great Day of Wrath*, 1852. Oil on canvas, 6'3" x 9'10" (1.9 x 3 m). Tate Britain, London.

14-11 **Edwin Landseer,**
Alexander and Diogenes, 1848. Oil
on canvas, 44¹/₈ x 56¹/₈" (1.12 x
1.43 m). Tate Britain, London.

14-12 **Edwin Landseer,**
Hunted Stag, 1833. Oil on panel,
27 x 35" (69.9 x 90.2 cm). Tate
Britain, London.

black-and-white print reproductions. The *Great Day of his Wrath* was reproduced by the printmaker Charles Mottran in a striking mezzotint (a special type of engraving; see *Reproducing Works of Art*, page 32), which found its way into numerous homes throughout the nineteenth century.

Of all nineteenth-century genres, animal painting is, perhaps, the one that has fallen most into discredit today. In its time, however, it was enormously popular, not only in Britain but all over Europe and North America. The British painter Edwin Landseer (1802–1873) was especially known for this genre, surpassing even the French artist Rosa Bonheur (see page 277) as a champion of animal painting. Landseer was so renowned that at the international art exhibition held in Paris in 1855 (see page 349), he was the only British artist to receive a medal of honor.

Landseer's work falls into two categories. The first, featuring house pets, may be called anecdotal; the second, featuring animals in the wild, may be called heroic animal painting. *Alexander and Diogenes* (FIG. 14-11) is an example of the first category. The painting's title is a reference to a Classical tale in which the Greek king Alexander the Great visits the philosopher Diogenes, who, indifferent to earthly possessions, lives in a barrel. In Landseer's painting, dogs personify humans. Thus an aggressive-looking bulldog becomes Alexander the Great, while a phlegmatic mutt represents Diogenes. Writing around the turn of the nineteenth century, the German art historian Richard Muther commented that Landseer "Darwinized" dogs, by which he meant that Landseer hinted at the process of evolution by lending human character to his dogs.

Landseer's "heroic" animal paintings often feature deer and stags in their natural surroundings, frequently in dramatic situations where they are battling, fleeing, etc. The *Hunted Stag* (FIG. 14-12), shown at the Royal Academy exhibition of 1833 and later acquired by Robert Vernon, shows a scene that is much more "natural" than *Alexander and Diogenes*. Both the terrified stag and yelping dogs are moved by instinct rather than by human considerations. Yet the instincts that Landseer's animals act on are ones that humans relate to, such as fear and aggression. Landseer's painting thus acquires a moral significance, helping the viewer to realize the evil of such impulses as revenge and wrath.

Early Victorian Portraiture and the New Photographic Medium

Grand-manner portraiture, so brilliantly practiced by British painters at the turn of the nineteenth century, ended with the death of its last representative, Thomas Lawrence (1769–1830). Because the middle class replaced the aristocracy as major art patrons, there was no longer a market for portraits that would fit only in palatial town and country houses. During the Victorian period, the demand was for portraits that were modest in both size and demeanor.

As a result, painters were loathe to specialize in portraiture, which no longer offered the possibility of important commissions and received increasing competition from photography.

As in France, photography in Britain began in the 1830s. Independently from Niépce and Daguerre, the British scientist William Henry Fox Talbot (1800–1877) experimented with the effects of light on certain chemicals. About 1840 he developed a practical photographic process to produce what he called "calotypes." The advantages of Talbot's calotype over the French daguerreotype (see page 243) were, first, that it could be printed on paper rather than silver foil; and, secondly, that it was possible to make multiple copies. Its disadvantage was a lack of sharpness and clarity.

By the mid-1840s Talbot had vastly improved his process. At that time it was used, for profit, by David Octavius Hill (1802–1870) and Robert Adamson (1821–1848), a team of portrait photographers in Edinburgh. Their photograph of Thomas Duncan and his brother (FIG. 14-13) differs from daguerreotype portraits in France, which generally show figures in a stiff frontal pose (see page 244). Hill's and Adamson's photograph is marked by a seemingly spontaneous informality that belies the fact that it must have required a minutes-long pose. This informality was deliberate, aimed at distracting the viewer from the photograph's lack of facial detail by focusing on characteristic gestures and movements. Indeed, the faces in the photograph are only roughly blocked out in areas of light and shade, making them look like old, darkened paintings. As Hill wrote in 1848:

14-13 **David Octavius Hill and Robert Adamson,** *Portrait of Thomas Duncan and his Brother,* 1845 or earlier. Modern print from calotype negative. George Eastman House, Rochester, New York.

14-14 **Julia Margaret Cameron,** *Portrait of Sir John Herschel,* 1867. Albumen print, 13¼ x 10⅜ (33.8 x 26.7 cm). Museum of Modern Art, New York.

The rough surface, and unequal texture throughout of the paper is the main cause of the Calotype failing in details, before the process of Daguerreotypy—and this is the very life of it. They look like the imperfect work of a man—and not the much diminished perfect work of God.

Photography was carried one step further by the next generation of British photographers, including most importantly Julia Margaret Cameron (1815–1879). Cameron was one of many amateur photographers in the mid-nineteenth century, a category that included Queen Victoria herself. Most amateurs were happy to shoot an occasional picture, but a few, like Cameron, strove for professional recognition, developing and printing their own photographs and submitting them to photographic exhibitions. Cameron was especially known for her portraits of British writers, artists, and intellectuals. Using the difficult but highly sensitive collodion process, she was able to achieve dramatic *chiaroscuro* effects akin to those found in portraits by Rembrandt and Velázquez. Her portrait of the well-known astronomer John Herschel (FIG. 14-14) exemplifies an approach to portrait photography aimed consciously at imitating painted portraits, rather than at presenting a mirror image of the sitter.

Government Patronage and the Houses of Parliament

Three years before Victoria ascended the throne, an enormous fire in London had destroyed much of Westminster Palace, including the Houses of Parliament. A competition was held to find the best architect to rebuilt this important government complex. It was won, in 1836, by Charles Barry (1795–1860), together with his assistant A. W. N. Pugin (1812–1852). Barry was an established architect in the eclectic historicist style that was favored during the period. Young Pugin, however, was a fervent admirer of the Gothic style, which he advanced in all his designs. A recent convert to Roman Catholicism, he found in Gothic architecture a spiritual quality and a sense of

14-15 **Charles Barry and A. W. N. Pugin,** Houses of Parliament, rebuilding begun 1840. London.

moral integrity that, he felt, were lacking in pagan Greek and Roman architecture and the Renaissance and Baroque styles derived from it.

The new Houses of Parliament (FIG. 14-15) were constructed around the only remaining part of the old palace, Westminster Hall. They were built to imitate the late Gothic style of the early Tudor period (end of the fifteenth century). While Barry was responsible for the plan and the layout of the building, Pugin designed most of its interior. The Peers' Lobby (FIG. 14-16), exemplifies his design style in its creative reinterpretation of the Gothic style, its elaborate decoration, and the skilled workmanship of every element in the room. Pugin sought out the best wood- and stone carvers, metal smiths, and tile makers to give his interiors the beautifully crafted look that he admired so much in medieval art.

In 1841 a royal commission, chaired by Prince Albert, was set up to discuss the interior decoration of Westminster Palace. The commission felt that a large number of monumental paintings and sculptures (along the lines of Louis Philippe's Museum of the History of France in Versailles or Ludwig of Bavaria's Residenz in Munich; see pages 219 and 163) would not only benefit the building but also raise the general level of art in Britain. Indeed,

14-16 **Charles Barry and A. W. N. Pugin,** The Peers' Lobby, looking towards the House of Lords, 1848. Houses of Parliament, London.

14-17 **William Dyce,** *Mercy: Sir Gawaine Swearing To Be Merciful and Never Be Against Ladies,* 1854. Fresco, 11'2" x 5'10" (3.42 x 1.78 m). Houses of Parliament, Royal Robing Room, London.

there was a genuine concern in government circles at the time that British art was degenerating into nothing more than middle-class entertainment, and that "grand" and "meaningful" art was rapidly dying out.

Thus in 1842 a competition was organized for artists to submit sample designs and fresco specimens. The decision to use the fresco technique (a medium rarely used in Britain) for the murals inside the parliament building was clearly related to the effort of elevating British art. The fresco technique had been used by all great Renaissance artists, including Michelangelo and Raphael. Many British people, moreover, were aware of its recent revival by the Nazarenes and its successful use in German public buildings.

Following the competition, twelve or so artists were hired. To make the Houses of Parliament a truly national monument, they were asked to paint frescos on subjects from British history and literature. The project moved slowly, however, and eventually was scaled back. Nonetheless, several murals, in a variety of styles, were completed. Some continued the grand style of history painting of Copley and West, itself inspired by High Renaissance art. Others, by contrast, reflected Nazarene painting and were inspired by early Renaissance frescos.

Perhaps the most coherent fresco cycle in the parliament building is the one in the Royal Robing Room. Here William Dyce (1806–1864) painted five episodes from Thomas Malory's *Le Morte d'Arthur*, the first prose account of the life of the legendary Celtic king Arthur, published in 1485. The Arthurian legend became exceedingly popular during the early Victorian period, replacing the epic poems attributed to Ossian (see page 73) as the national "classic" of Britain.

Dyce's success in planning and executing his fresco cycle may be related to the fact that, as a student, he had made two lengthy visits to Rome. There he had become acquainted with the ideas and works of the Nazarenes, which led to his interest and fascination with early Renaissance art. Back in England, he remained aware of the Nazarenes' activities. During a short trip to Munich

in 1837, he was introduced to Julius Schnorr von Carolsfeld, who at that time was working on his Nibelungen frescos in the Residenz (see page 164). The sight of these frescos, celebrating Germany's foundational literary work, may well have inspired Dyce's choice of the Arthurian legend, which occupied a similar position in British culture.

To link the frescos in the Royal Robing Room and lend them contemporary relevance, Dyce selected stories from the Arthurian legend that exemplified values prized in early Victorian Britain, specifically piety, hospitality, mercy, courtesy, and generosity. *Mercy*, subtitled *Sir Gawain Swearing To Be Merciful and Never To Be Against Ladies* (FIG. 14-17), illustrates Sir Gawain's trial for having accidentally killed a woman at the wedding feast of King Arthur and Queen Guinevere. A jury of court ladies, appointed by Guinevere, sentences him to a life of mercifulness, courtesy, and devotion to ladies. In Dyce's fresco, Gawain is taking an oath that he will abide by the ladies' verdict. Behind him, Guinevere administers the oath while the ladies of the court stand by as witnesses. Of all the frescos in the cycle, this one comes closest to fifteenth-century Italian painting. In format, the painting resembles early Renaissance *sacra conversazione* (sacred conversation) altarpieces, in which the enthroned Virgin and Child are flanked by groups of saints (see FIG. 14-18). By inviting a comparison between Queen Guinevere and the Virgin Mary,

14-18 **Domenico Veneziano,**
Virgin and Child with Saints, c.1445.
Oil on panel, 6'10' x 7' (2.08 x 2.13 m).
Galleria degli Uffizi, Florence.

Dyce lent to the Celtic queen an almost divine importance. At the same time, the representation, within the Royal Robing Room, of Guinevere as enthroned queen, served as a reminder of Queen Victoria's regal ancestry.

The Pre-Raphaelite Brotherhood

Dyce formed an important link between the Nazarenes and a group of young artists who, in 1848, formed the Pre-Raphaelite Brotherhood, or PRB. Modeled after the Nazarene brotherhood, the PRB was an association of youthful and idealistic artists and poets, who scorned middle-class taste for eclecticism, sentimentality, and cheap sensationalism. They blamed the Royal Academy for bending to these mediocre tastes, and for allowing the standards of painting to erode.

The leading figure of the brotherhood was the young Dante Gabriel Rossetti (1828–1882), an aspiring painter and poet of Italian descent, whose magnetic personality drew the group together. He was joined by two students at the Royal Academy, John Everett Millais (1829–1896) and William Holman Hunt (1827–1910); Rossetti's brother William (who became an art critic and the historian of the PRB) and James Collinson, the boyfriend of Rossetti's sister Christina (1830–1894), also joined the group. As a woman, Christina was not allowed into the brotherhood, although she was an important poet and did contribute verses to its magazine, *The Germ*.

PRB members were enthusiastic about Ruskin's *Modern Painters*. By 1848 two volumes had appeared. In the first volume, Ruskin had scorned the Academy public, who were easily impressed by "tricks of the brush" or a "grimace of expression" and blind to an art of "noble conception and perfect truth." The purpose of his book, in fact, was to teach the public to become more discerning viewers.

In order to produce truthful art works, the Pre-Raphaelites felt that it was necessary to study nature. As for creating works of noble conception, artists needed "to sympathize with what is direct and serious and heartfelt in previous art, to the exclusion of what is conventional and self-parading and learned by rote." Like the Nazarenes, the PRB found directness and seriousness not in High Renaissance art but in the works of the masters of the early Renaissance. Their name, Pre-Raphaelites, is a direct reference to their preference for the works of Botticelli, Ghirlandaio, and Perugino over those of the High Renaissance artists Raphael and Michelangelo.

In addition to looking for inspiration in early Renaissance art, the Pre-Raphaelites abandoned the sentimental genre subjects so popular during the 1830s and 1840s to devote themselves to serious literary themes. The Bible, Shakespeare's plays, and the Arthurian legend were important sources of inspiration. If they did paint genre subjects,

14-19 **John Everett Millais,** *Christ in the Carpenter's Shop*, 1849–50. Oil on canvas, 34 x 55" (86.4 cm x 1.4 m). Tate Britain, London.

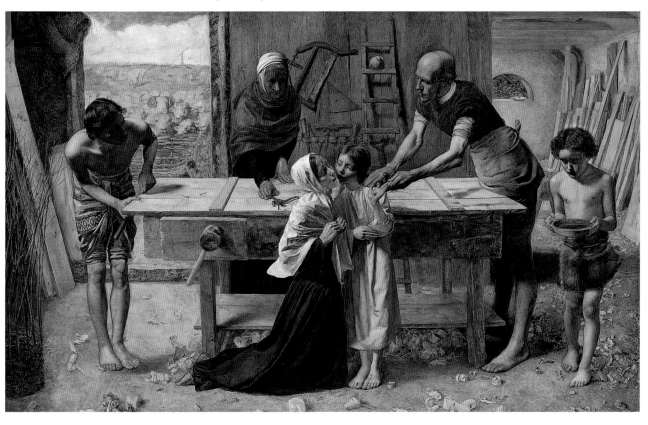

they had a profoundly moralizing, even didactic quality that is absent in early Victorian art. The Pre-Raphaelites treated these serious themes, often rich in symbolic meaning, in a very detailed, realistic manner, developing a mode of painting that has been referred to as Symbolic Realism.

During the early years of their association, the Pre-Raphaelites were particularly attracted to religious subject matter. Not that all of them were especially pious; but religious subjects, they felt, had an inherent spirituality that elevated them above the materialism of the Victorian age. Depending on the context, even the most prosaic forms could become rich in symbolic meanings that would be easily understood by all Christians.

Millais's *Christ in the Carpenter's Shop* (FIG. 14-19), shown at the Royal Academy exhibition of 1850, exemplifies the Symbolic Realism of the Pre-Raphaelites. The painting, inspired by the Bible, overflows with symbolic forms and actions. Playing in Joseph's carpenter shop, the young Christ has pierced his hand with a nail, an incident that foreshadows his crucifixion. As Joseph inspects his wound, Mary kneels down by his side and kisses him. Her sorrowful expression suggests her premonition of his suffering on the cross. On the right, the young John the Baptist brings over a bowl of water, an obvious allusion to his subsequent role to baptize Christ. Further symbols include the white dove on the ladder (the Holy Spirit), the carpenter's triangle above Christ's head (the Trinity), and the sheep in the background (Christ's flock).

Millais has rendered the biblical figures as simple folk, whom one might encounter in any shop. His execution is meticulous, and even the most insignificant details—Joseph's dirty fingernails, the wood shavings on the floor—are rendered with the greatest care. Today, we are used to realistic recreations (on film, television programs, etc.) of the life of Christ. But to Millais's contemporaries the painting was nothing short of blasphemous, since biblical figures and scenes were expected to be idealized in order to underscore their spiritual greatness. Critics almost invariably hated *Christ in the Carpenter's Shop*, and expressed their scorn quite stridently. Charles Dickens called the Christ child "a hideous, wry-necked, blubbering, red-haired boy in a nightgown" and found the Virgin "so horrible in her ugliness that (supposing it were possible for any human creature to exist for a moment with that dislocated throat) she would stand out from the rest of the company as a monster in the vilest cabaret in France or in the lowest gin shop in England." Such was the scandal created by Millais's painting that Queen Victoria demanded that the painting be brought to her in person so that she could judge it for herself.

Also in 1850 Dante Gabriel Rossetti exhibited a religious painting at the exhibition of the National Institution, an alternative to the Royal Academy. His *Ecce Ancilla Domini* (FIG. 14-20), too, drew a great deal of criticism, though not for its blasphemous realism but rather for its excess of

didacticism. Rossetti saw art, first of all, as a vehicle for representing ideas. *Ecce Ancilla Domini* ("Behold the handmaid of the Lord") represents the Annunciation as told in Luke 1:30. The painting shows the young, timid Virgin seated on a bed. She is approached by the angel Gabriel, who seems to reassure her: "Fear not, Mary: for thou has found favour with God." The angel holds a white lily, symbol of purity, but Rossetti has expanded its symbolism by painting nearly the entire canvas in shades of white. The few bright colors that do appear in the picture seem to carry symbolic meanings as well. Blue is traditionally associated with the Virgin, while red suggests the blood of Christ.

Unlike Millais, Rossetti was not particularly interested in an abundance of carefully executed details. On the contrary, his painting has a minimum of formal elements. While this deliberate simplicity may be attributed to Rossetti's

14-20 **Dante Gabriel Rossetti,** *Ecce Ancilla Domini,* 1849–50. Oil on canvas mounted on panel, 28⅞ x 16" (72.6 x 41.9 cm). Tate Britain, London.

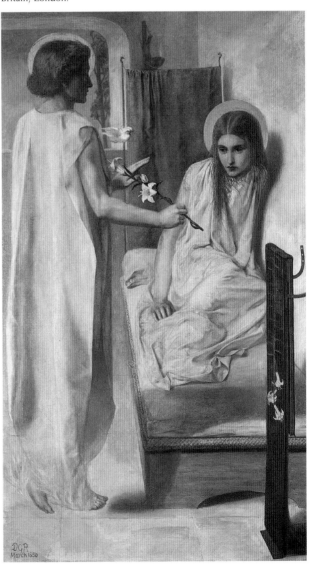

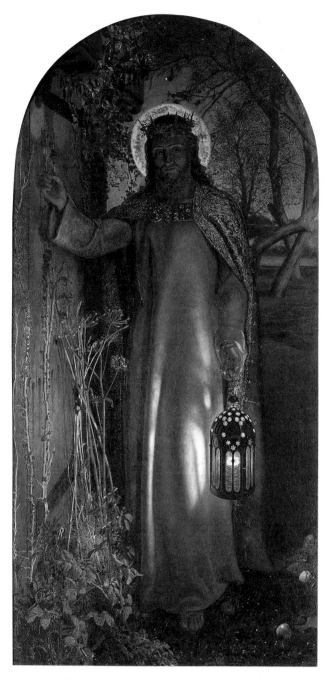

14-21 **William Holman Hunt,** *Light of the World*, 1851–3, retouched 1858, 1886. Oil on canvas over panel, arched top, 49³/₈ x 23" (1.25 m x 59.8 cm). Warden and Fellows of Keble College, Oxford.

on a door at night time. He is dressed like a priest in a long green chasuble, a richly embroidered cape around his shoulders, and with a crown of thorns on his head. The large lantern that he carries and his halo are the two main sources of light in the picture. Like Millais's *Christ in the Carpenter's Shop*, the painting abounds in details, all of which carry specific symbolic meanings. In a pamphlet that he wrote about the painting in 1865, Hunt explained the weeds in the foreground as "idle affection," the neglected orchard in the background as the "uncared-for riches of God's garden;" the lantern as the "conservator of truth;" and the rust that covers it as the "corrosion of the living faculties."

Hunt's painting, unlike those by Millais and Rossetti, does not illustrate a story told in the Bible. Instead, it visualizes a symbolic idea of Christ as man's friend and comforter. The painting is inspired simultaneously by several biblical texts, including John 8:12, "I am the Light of the World," and Revelation 3:20, "Behold, I stand at the door and knock: if any man hear my voice, and open the door, I will come in to him and will sup with him, and he with me."

The phenomenal success of Hunt's *Light of the World*, which was reproduced in numerous engravings and photographs, was due, no doubt, to its successful combination of realism and idealism. Viewers were in awe of Hunt's masterful and highly detailed style. At the same time, they admired the idealized representation of Christ. Millais clearly expressed this admiration when he praised Hunt for having painted "far the most beautiful head I have ever seen of Christ, ... *most lovely.*"

The Pre-Raphaelites and Secular Subject Matter

Well before Hunt exhibited his highly successful *Light of the World* in 1854, Millais realized that the uncompromising realism of his *Christ in the Carpenter's Shop* would fail to bring him public success. In his *Death of Ophelia* (FIG. 14-22), exhibited in 1852, he followed a different strategy whereby, like Hunt, he combined idealism and realism by creating a picture that was both aesthetically pleasing and rendered in meticulous and truthful detail. The painting also marks Millais's abandonment of religious subject matter for themes inspired by literature, history, and contemporary life.

Based on Shakespeare's *Hamlet* (act IV, scene vii), the *Death of Ophelia* represents the suicide of Hamlet's rejected lover, driven to madness after Hamlet had murdered her father. Millais has followed Shakespeare's text closely, particularly in the depiction of Ophelia who, in the poet's words, was "mermaid-like," as the water bore her up repeatedly, at "which time she chanted snatches of old tunes." Like *Christ in the Carpenter's Shop*, the *Death of Ophelia* was painted with great attention to detail, but the attractive natural setting of willows and daisies, and the fashionable beauty of Ophelia made the painting an exhibition success.

acquaintance with the work of Dyce, it is probably more directly related to his admiration for the French painter Hippolyte Flandrin (see page 223), whose murals had greatly impressed him during a trip to Paris in 1849.

Rossetti's *Ecce Ancilla Domini* forms an interesting contrast to William Holman Hunt's *Light of the World* (FIG. 14-21), exhibited at the Royal Academy exhibition of 1854. Although both are narrow, vertical paintings on religious themes, Hunt's painting is richly complex and executed in much detail. It shows a young, bearded Christ knocking

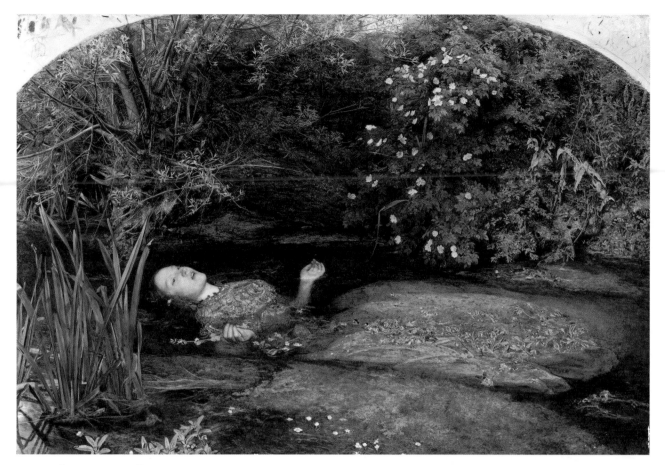

14-22 **John Everett Millais,** *Death of Ophelia*, 1852. Oil on canvas, top corners rounded, 30 x 44" (76.2 cm x 1.12 m). Tate Britain, London.

14-23 **William Holman Hunt,** *The Awakening Conscience*, 1853–4. Oil on canvas, arched top, 30 x 22" (76.2 x 55.9 cm). Tate Britain, London.

Like Millais, Rossetti turned away from religious subjects after 1852, although he occasionally returned to them later on. This left Hunt, a profoundly pious man, as the only Pre-Raphaelite to paint religious subjects consistently. Yet after 1852 even he, on occasion, turned to scenes from literature and modern life. In 1854, together with his *Light of the World*, he exhibited *The Awakening Conscience* (FIG. 14-23), a work that was meant as its modern foil. The painting depicts the sudden remorse of a young prostitute, who has been entertaining a wealthy young man. Rising from his lap, she looks out of the window. Thus confronted by the light and the beauty of nature, she suddenly sees the evil of her situation.

The scene is set in a rich Victorian interior, with rugs, polished furniture, and various knickknacks. Hunt painted all the furnishings, as well as the clothing, with meticulous care, since to him they represented the material world that distracts human attention from spiritual matters. In case the moralizing aspect of the painting was not obvious enough, he had biblical verses inscribed on the frame and printed in the catalogue. Nonetheless, many critics

ignored the painting's moralizing meaning and focused instead on its scandalous and sensational subject matter.

Despite their lofty idealism, the Pre-Raphaelites, on the whole, showed little interest in improving society. Instead, their preoccupation with biblical and literary themes may be seen as an escape from the brutal realities of contemporary life. A few exceptions confirm the rule. Millais's *Blind Girl* of 1856 (FIG. 14-24) touches on the problem of homelessness. A blind girl and her child companion are seated on the side of the road, listening, so it seems, to the rumble of a distant thunderstorm. Both are dressed in rags, suggesting that these are vagrants who travel from village to village, scraping together a few shillings by playing on the concertina and holding up a cup. Millais used middle-class girls as models for this painting, which explains the carefully combed hair and clean faces of his two beggars. Thus this painting is a far cry from Courbet's *The Stonebreakers* or Millet's *The Gleaners* (see FIG. 11-7, FIG. 12-25) with their unkempt hair and dark, nearly invisible faces.

14-24 **John Everett Millais,** *Blind Girl*, 1856. Oil on canvas, 32 x 24" (82.6 x 62.2 cm). Birmingham Museum and Art Gallery.

14-25 **Ford Madox Brown,** *Work*, 1852; reworked between 1856 and 1863. Oil on canvas, arched top, 4'6" x 6'6" (1.37 x 1.97 m). City of Manchester Art Galleries.

14-26 **William Frith,** *At the Seaside (Ramsgate Sands),* 1854. Oil on canvas, 30 x 60" (76.2 cm x 1.54 m). St James's Palace, Royal Collection, London.

More realistic representations of workers are found in a handful of paintings by artists who worked on the periphery of the PRB. One of these was Ford Madox Brown (1821–1893), Rossetti's painting teacher from 1848. Brown painted several works on religious and moralizing themes that resemble those of Millais and Hunt. Yet he also painted a large painting called *Work* (FIG. 14-25) that was intended to draw attention to the fate of the working class and the contrast between rich and poor. The painting shows a fenced-in excavation site in London, where several workmen are digging or carrying bricks and cement. To the left of the site, a flower girl, barefoot and dressed in rags, is followed by two middle-class ladies carrying parasols. Behind them is a pastry cook carrying a box of pastries on his head—a "symbol of superfluity," according to Brown. A group of vagrant orphans, in the foreground, is balanced by two well-dressed riders in the background. On the right side of the painting two middle-class men observe the workers. One is the writer Thomas Carlyle, who in his *Past and Present* (1843) had exposed some of the inequities in society. The other is F. D. Maurice (1805–1872), a teacher at the Working Men's College, known for his advanced sociological concepts. These men, both highly concerned with Britain's social situation, represent the eyes through which this painting is to be seen.

Work was not entirely Brown's conception. The painting was commissioned by T. E. Plint (1823–1861), the first serious collector of Pre-Raphaelite painting. Plint strongly sympathized with the Christian Socialists, a group formed around 1848 that included Maurice as well as the novelist Charles Kingsley (see page 313). Plint took a great interest in the picture and several times asked Brown to change it, so as to make it conform more to Christian Socialist ideas.

Genre Painting in the Mid-Victorian Period, c.1855–70

While the Pre-Raphaelites tried to give painting a religious or moralizing significance, genre painting remained popular even after the middle of the nineteenth century. Its focus, however, gradually shifted from the anecdotal towards the descriptive. A new fashion rose for paintings that depicted middle-class life in a detailed, documentary fashion. William Frith (1819–1909), from the mid-1850s onwards, painted a series of pictures that documented the public life of the middle class at the seashore, the races, or the railroad station. *At the Seaside (Ramsgate Sands)* (FIG. 14–26) was the first in the series. Exhibited at the Royal Academy Summer Exhibition in 1854, it was bought by Queen Victoria herself, which underscored its enormous success. Frith was an exact contemporary of Gustave Courbet, and both shared an interest in depicting contemporary reality. Yet their approach was entirely different. Frith had none of Courbet's political zeal. Instead, he aimed at entertaining the viewer, using a miniaturist style of painting that shows up every detail of clothing and every nuance of facial expression. There is no end to the amusement that his paintings have to offer because the viewer has ever more to discover.

Although descriptive genre paintings were the "new thing" during the mid-Victorian period, anecdotal genre paintings such as Redgrave's *The Poor Teacher* remained popular for much of the nineteenth century. *Nameless and Friendless*

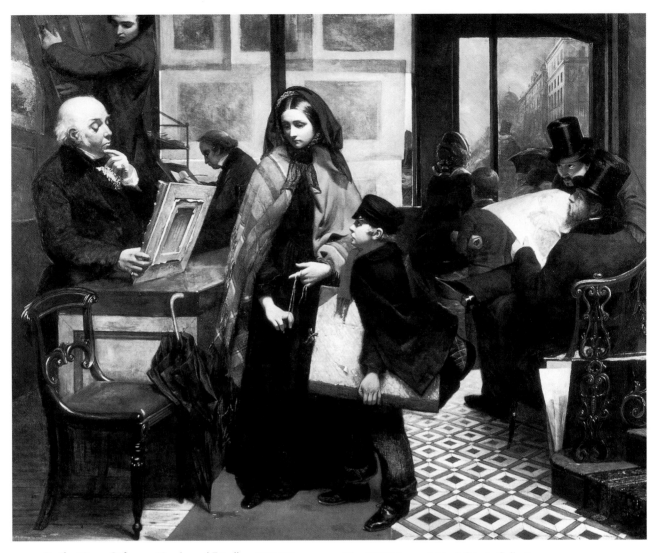

14-27 **Emily Mary Osborn,** *Nameless and Friendless,* 1857. Oil on canvas, 32 x 41" (82.5 cm x 1.04 m). Private Collection.

(FIG. 14-27) by Emily Mary Osborn (1834–1913) is an interesting example dating from the 1850s. It was painted by one of the numerous female painters who were active in Britain in the mid-Victorian period. Women were not allowed to exhibit at the Academy and often had a difficult time breaking into the art world, since they were outside the "old boys' network." Although Osborn herself was quite successful, she must have been aware of the plight of other female artists. In *Nameless and Friendless* she shows a young woman artist offering a painting for sale to an art dealer. While she and her young son wait anxiously, the dealer casts a deprecating glance at the picture. No doubt, he is feigning dislike so that he can offer the lowest possible price for the picture, even though, judging by the keen interest of his assistant, it is quite good.

Narrative genre imagery remained so successful in the mid-Victorian era that it was taken up by photographers. The best-known practitioner was Henry Peach Robinson (1830–1901), who was famous for his "art photographs," one of which he published every year beginning in 1858.

The first one, *Fading Away* (FIG. 14-28), shows a young girl on her deathbed, surrounded by members of her family. Deathbed scenes of young people and children were common scenes in sentimental novels of the day. Sadly, they were rooted in the reality of the nineteenth century, when diseases such as "consumption" (tuberculosis), cholera, and diphtheria struck many young people.

Robinson carefully staged his pictures and hired models to pose for the figures. At the time it was impossible to shoot the entire scene in sharp focus, so he shot it in several sections and then combined the negatives to create a "combination print." In so doing he could achieve dramatic contrasts between light and dark as well as a sharp focus.

Photographs such as Robinson's were shown at the special exhibitions organized by any one of the numerous photographic societies that had sprung up all over Britain. To market them better, they were mounted on cardboard, matted, and framed. The title of the photograph would often be printed in engraved or embossed letters on the

14-28 **Henry Peach Robinson,** *Fading Away,* 1858. Photograph. London, Royal Photographic Society.

mat and sometimes a text was added to enhance the meaning. The mat of *Fading Away,* for example, was inscribed with a strophe from a poem by the British Romantic poet Percy Bysshe Shelley (1792–1822): "Must then, that peerless form/Which love and admiration cannot view/Without a beating heart; those azure veins,/Which steal like streams along a field of snow,/That lovely outline, which is fair/As breathing marble, perish?"

From Pre-Raphaelitism to the Aesthetic Movement

By the mid-1850s the Pre-Raphaelite Brotherhood had begun to lose coherence. Millais married in 1855, and became increasingly aware that he needed to pander to middle-class tastes in order to provide for his family. He became enormously successful painting sentimental genre scenes, often centered on pretty children. Elected president of the Royal Academy in 1863, he was, perhaps, the best-known British painter of his time. Hunt, the most religious Pre-Raphaelite, made several trips to the Holy Land in order to bring greater authenticity to his biblical pictures.

Rossetti, who had painted little since the negative reception of his *Ecce Ancilla Domini,* moved into new circles. In 1857 he befriended Algernon Charles Swinburne

(1837–1909), a controversial poet. Swinburne's poetry was criticized both for its form and for the "feverish carnality" of its content. Intimately familiar with French literature, Swinburne admired both Baudelaire (see pages 218 and 248) and the slightly older Théophile Gautier (see page 225). The latter was the outstanding proponent of the theory of *l'art pour l'art* or "art for art's sake," which held that the role of art was neither to moralize and instruct, nor to amuse and entertain the viewer. First and foremost, the purpose of art was art itself. Art needed to appeal to the senses, it was to be "aesthetic," from the Greek word *aisthetikos,* meaning "of sense perception."

Gautier's ideas appealed to Swinburne, who propagated them among his friends. By the late 1860s there was enough of a groundswell for the theory of art for art's sake that one can speak of an "Aesthetic Movement," even though there was no organized group per se. The Aesthetic Movement was guided by a complex set of ideas, most clearly formulated by the nineteenth-century art historian Walter Horatio Pater (1839–1894). In his essay of 1877, "The School of Giorgione," Pater advanced two important ideas. First, that art is superior to nature. (This, of course, was not a new idea but one that harked back to the Neoclassical period.) Second, that content is not as important as form. In other words, it is not the subject that counts, but the aesthetic beauty that the artist brings to

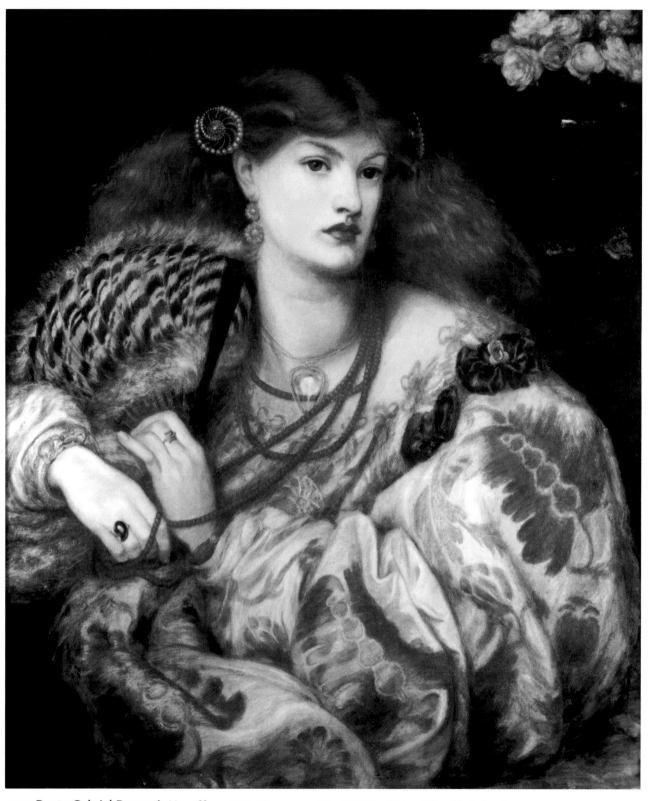

14-29 **Dante Gabriel Rossetti,** *Monna Vanna*, 1866. Oil on canvas, 35 x 34" (88.9 x 86.4 cm). Tate Britain, London.

the work. To Pater, the most perfect art form was music, which was devoid of content and thus purely an art of form. He felt that "all art constantly aspires to the condition of music" for, "In music ... is to be found the true type or measure of perfected art."

Like the Pre-Raphaelite movement of the late 1840s, the Aesthetic Movement was directed against reigning bourgeois tastes. By depreciating content, the Aesthetes belittled the narrative and the descriptive genre paintings that were beloved by middle-class collectors. The well-known writer Oscar Wilde (1854–1900), one of the most vocal critics of bourgeois culture, wrote disparagingly about the "anecdotage of painting." To him, "pictures of this kind ... do not stir the imagination, but set definite bounds to it."

Inspired by the Aesthetic Movement, Rossetti resumed work and painted a series of beautiful, sumptuously dressed young women. His *Monna Vanna* (FIG. 14-29) of 1866 may serve as an example. The painting is iconic rather than narrative, meaning that unlike such genre paintings as Redgrave's *Poor Teacher*, it does not suggest a story but presents an icon or image for purely visual contemplation. *Monna Vanna* is not a portrait of an actual woman; it is rather an idealized vision of a woman. The subject, "woman," is just a vehicle for a beautiful picture. Was the choice of the subject, then, arbitrary and insignificant?

Ever since the eighteenth century, the experience of beauty had been compared with sexual arousal. In his *Philosophical Enquiry into the Origin of our Ideas of the Sublime and Beautiful*, Burke had equated the "inward sense of melting and languor" that characterizes sexual arousal with the softening of "the solids of the whole [human] system" that is caused by the contemplation of the beautiful. No wonder then that in a male-dominated society such as Victorian Britain the idea of beauty was well carried in the guise of a woman.

Other Aesthetes, including Rossetti's one-time student Edward Coley Burne-Jones (1833–1898), Frederic Leighton (1830–1896), and the American-born James Abbott McNeill Whistler (1834–1903), likewise focused on women as the principal theme of their work. Burne-Jones's *Golden Stairs* (FIG. 14-30), painted between 1876 and 1880, depicts not one but eighteen women, dressed in long gowns and descending a curved staircase. They all hold musical instruments, some dating back to the Middle Ages. The painting does not spell out or illustrate a story, but leaves it up to the viewer to imagine what is going on. *Golden Stairs* is striking for its formal qualities: its subtle color scheme, composed almost entirely of shades of blue and yellow; its semicircular composition; and the contrast between the geometric lines of the architecture and the irregular contours of the female bodies. Finally, the musical theme invites the viewer to compare the painting's formal qualities, such as its gentle color "tones" and "harmonies" of shape, with those of music.

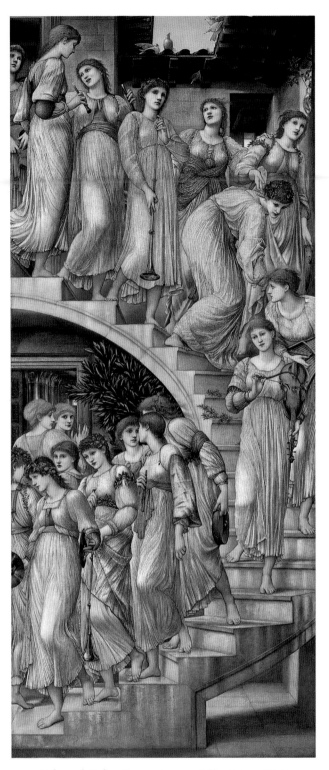

14-30 **Edward Coley Burne-Jones,** *Golden Stairs*, 1876–80. Oil on canvas, 9'1" x 3'10" (2.69 x 1.17 m). Tate Britain, London.

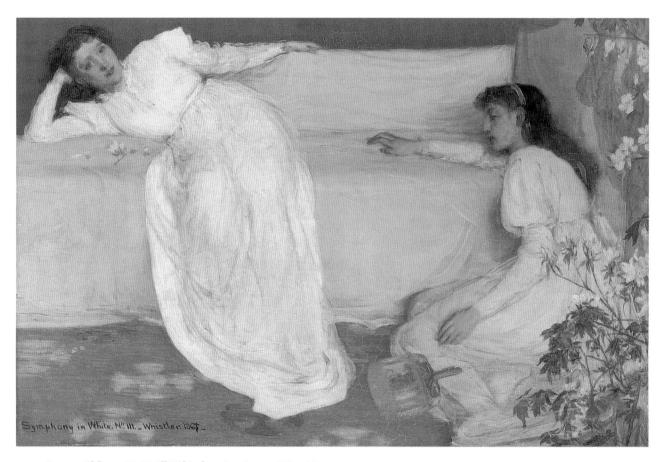

14-31 **James Abbott McNeill Whistler,** *Symphony in White, No.* 3, 1867. Oil on canvas, 20 x 30¹/₈" (51.1 x 76.8 cm). University of Birmingham, Barber Institute of Arts.

Aestheticism was carried furthest by the American-born painter James Whistler, who came closer than any other nineteenth-century British artist to abandoning subject matter in order to fully embrace form. Born in the United States, Whistler grew up in New England and Russia, and studied art in France. After befriending Courbet, he painted a number of Realist works, then moved to England where he entered the orbit of the Pre-Raphaelites.

Whistler was particularly interested in the analogy between painting and music, going so far as to give his paintings musical titles, such as "Symphony," "Sonata," and "Nocturne." Carrying Pater's ideas to an extreme, Whistler came very close to twentieth-century non-objective painting. His *Symphony in White, No.* 3 (FIG. 14-31), exhibited at the Royal Academy exhibition of 1867, shows two girls dressed in white and a white couch. The color scheme is limited to various hues of white, enlivened only by the reddish tones of the girls' hair and the green plant in the foreground. As in Burne-Jones's painting, an interesting and deliberate contrast is created between the straight lines of the room décor and the "arabesque" contours of the girls' bodies.

Symphony in White, No. 3 was the first work that Whistler exhibited under a musical title. One critic remarked that

the painting was "not precisely a symphony in white," because one could see other colors in the painting as well. Never short of a reply, Whistler responded by asking the critic whether he believed "that a symphony in F contains no other note, but shall be a continued repetition of F, F, F? . . . Fool!"

Whistler was the only Aesthete to devote serious attention to landscape paintings. In these, he came closest to complete abstraction. Most of his landscape paintings are called "Nocturnes," and depict night-time views of London. The term "nocturne" was used for piano compositions of a meditative character, made famous by the Romantic composer Frédéric Chopin (1810–1849).

Nocturne in Black and Gold: The Falling Rocket (FIG. 14-32) is perhaps the best known (and, in its time, the most notorious) of Whistler's landscapes. At first glance, the painting looks like a twentieth-century non-objective work. Only a closer look reveals figures on a river bank, trees, city lights, and fireworks against a dark-blue sky. The painting represents Cremorne Gardens in London, where fireworks were staged on a regular basis. Yet Whistler's *Nocturne* is not a realistic landscape, but rather an evocation of the magical mood created by the glowing sparks raining down against the dark evening sky. Like Whistler's

figure paintings, this landscape is done in a limited color scheme that combines blues, ranging from ultramarine to black, with yellows, ranging from crème-white to orange. The dark-blue and black background is thinly painted while the light of the fireworks and the sparks in the sky are suggested by bright dabs of paint.

When the painting was first exhibited in 1877 at the opening exhibition of the prestigious new Grosvenor Gallery in Bond Street in London, the aging Ruskin took offense at its lack of detail and the seemingly casual handling of the paint. In a review of the exhibition he wrote that he "never expected to hear a coxcomb ask 200 guineas for flinging a pot of paint in the public's face." Whistler reacted by suing Ruskin for libel. The infamous Whistler–Ruskin trial that followed became an important test case for the validity of the theory of art for art's sake. Under cross-examination by the attorney-general Sir John Holker, Whistler asserted that a work of art is nothing but an artistic arrangement; and that although his work may not have required extensive time and craftsmanship, it was the conception and aesthetic purpose of the work that gave it validity and economic value. Such arguments would become central tenets of modernism (see *The Whistler–Ruskin Trial*, right).

The Royal Academy

Comparing the art worlds of late nineteenth-century France and Britain, the most important differences are found in the roles of and attitudes towards their national academies. In France, since the July Monarchy, there had been increasing tension between the Academy, which wanted to maintain the grand tradition of Classicist history painting, and the majority of French artists, who strove to create an art more in tune with their time. The Academy wanted a Salon that showed only the loftiest art that its members and their students could produce, while most artists wanted an exhibition where they could get the exposure necessary to sell their art. A similar tension did not develop in Victorian Britain. While the French Salons moved slowly but surely towards their eventual dissolution, the Royal Academy exhibitions continued to flourish. Indeed, just when the French Salon experienced its first major crisis in the early 1870s (see page 370), the Royal Academy exhibitions moved from the National Gallery to Burlington House in Piccadilly to have a building all their own. Of course, the Royal Academy exhibitions did have their critics. Many artists complained that members of the Academy dominated the exhibitions, because they had the exclusive right of hanging eight pictures in the exhibition each year. Yet the public generally admired academic painting, and flocked to see the works of Millais (who became an academician in 1863), Lawrence Alma-Tadema (1836–1912), and Frederic Leighton.

As in France, British academic painting had changed, in the middle of the nineteenth century, from the sober Neoclassicism of the early nineteenth century to a meticulous historicism. Alma-Tadema's *A Reading from Homer* (FIG. 14-33) may be compared with the *Neo-Grec* works by Gérôme (see page 271) in its precise rendering of details as well as the realism of its figures, which gives to the scene a powerful sense of actuality. Like many of Alma-Tadema's works, this one has a narrow horizontal format. This causes it to resemble a Classical frieze, such as the Parthenon frieze in the British Museum, which the artist greatly admired.

Fatidica (FIG. 14-34), by Frederic Leighton (1830–1896), president of the Royal Academy from 1878 until his death twenty years later, demonstrates the relative proximity, in Britain, of academic and avant-garde trends. The painting depicts a Roman goddess, worshipped for her ability to foretell the future. In Leighton's painting she is seated on a throne, set within a grey stone niche. Like Whistler's *Symphony in White*, *Fatidica* is painted with a palette limited to white and grey hues. The painting derives its impact not so much from its subject, but from the subtle play of

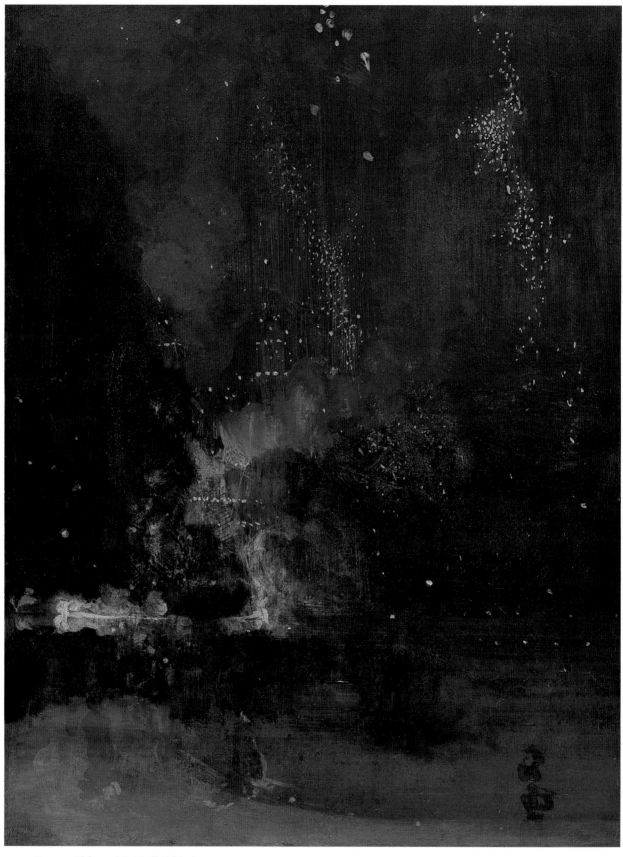

14-32 **James Abbott McNeill Whistler,** *Nocturne in Black and Gold: The Falling Rocket,* 1875. Oil on wood, 23 x 18⅜" (60.3 x 46.6 cm). Detroit Institute of Arts.

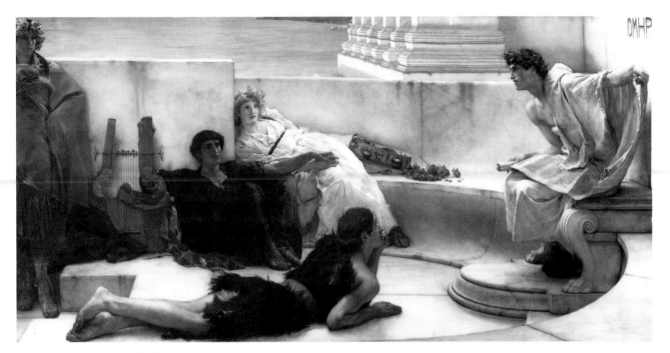

14-33 **Lawrence Alma Tadema,** *A Reading from Homer,* 1885. Oil on canvas, 3' x 6' (81.4 cm x 1.84 m). George W. Elkins Collection, Philadelphia Museum of Art.

light and shade and the complex pattern caused by the folds of her garment. Leighton's painting does differ from Whistler's, of course, in the way it emphasizes subject matter and in the tight precision of its painting style. But these differences are far less pronounced than are those between progressive and academic trends in France at the end of the nineteenth century (see Chapters 19 and 20).

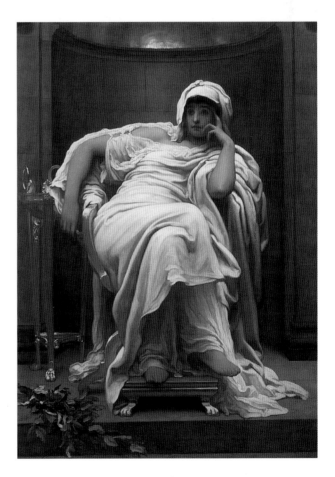

14-34 **Frederic Leighton,** *Fatidica,* c.1893–4. Oil on canvas, 5' x 3'64" (1.53 x 1.11 m). Port Sunlight, Lady Lever Art Gallery (Board of Trustees of the National Museums and Galleries on Merseyside).

BAINS

National Pride and International Rivalry— The Great International Expositions

The great international expositions of the second half of the nineteenth century perhaps best capture the *zeitgeist* or cultural essence of that particular period. The predecessors of the world fairs of the twentieth century, they showed off the latest miracles of industry and technology, in a spirit of optimism and belief in progress. By exhibiting industrial and agricultural products and the machines and tools used to produce them, they offered a representative overview of contemporary material culture.

By encouraging rivalry among nations, the international expositions fanned Romantic nationalism, which, for better or worse, became a guiding political principle in the second half of the nineteenth century. At the same time, however, the exhibitions promoted a broad, international view of the world. From the very beginning, an attempt was made to include contributions from non-Western nations, such as Japan and the Ottoman Empire. Moreover, as western European industrial powers stepped up their colonization efforts, the mainimperialist nations (Britain, France, Germany, Belgium, and the Netherlands) supplemented their national displays with colonial pavilions. There, they showed not merely the agricultural and industrial products of their colonies but they also presented visitors with ethnographic exhibits that were meant to familiarize them with native cultures in the colonial territories (see page 429). Such exhibits would include tools, clothing, jewelry, furnishings, and ritual objects, and eventually even the natives themselves.

Origins of the International Exhibitions

Although the first international exhibition was organized in Britain in the early 1850s, its origins went back to late eighteenth-century France. When the French economy slumped after the Revolution of 1789, it looked to Britain as a model for recovery. Seeing that rapid industrialization could foster economic growth, the French government established several new schools and universities to train engineers, technicians, and artisans. At the same time, it decided to organize regular exhibitions of the "mechanical arts," featuring the latest industrial products and technological wonders. (The idea for such exhibitions may have come from the Salons, which had been initiated some one hundred years earlier in a similar effort to improve and promote the "fine arts" in France; see page 33.)

The first "Public Exposition of the Products of French Industry" took place in Paris in September 1798. It was followed by ten further exhibitions between 1801 and 1849, each larger and more important than the one before. The exhibitions were strictly national affairs. Although they attracted some foreigners, they were primarily intended for the French public. As time went on, however, their example caught on, and many other countries began to organize similar shows. A notable exception to this trend was Britain. The British, it seems, were so confident of their lead in the Industrial Revolution that they felt no need to promote themselves.

15-1 **Joseph Paxton,** *Crystal Palace*, 1851. London. (Re-erected in Sydenham, Kent, in 1852 and destroyed in 1936.)

The Great Exhibition of the Works of Industry of All Nations

It is surprising, therefore, that the British took the initiative for the first international industrial exposition, held in London in 1851. The driving force behind the "Great Exhibition of the Works of Industry of All Nations" was Henry Cole (1808–1882), a British civil servant with a passion for good design, particularly in the area of mass-produced goods. Cole co-founded the *Journal of Design and Manufactures*, which was to foster "the germs of a [design] style which England of the nineteenth century may call its own." He had visited the French exhibitions, and proposed to the British government that they hold a similar function in England to encourage and promote design.

The idea greatly appealed to Queen Victoria's consort, Prince Albert, who shared Cole's interest in product design. The prince suggested, however, that the exhibition be international rather than national, so that the products of different nations could be juxtaposed and compared. Albert was keenly aware that Britain would be the major star of an international exhibition of industrial products, and he believed that this might act to help the country to expand its international markets.

It is no coincidence that the organization of the Great Exhibition coincided with a concerted British effort towards the establishment of free trade, which Adam Smith had advocated as early as 1776 in his *The Wealth of Nations*. In the course of the 1850s several major trade restrictions between Britain and France were lifted, and in 1860 the two nations concluded the Anglo-French trade agreement, eliminating most remaining trade barriers.

The Crystal Palace: A Revolution in Architecture

To the organizers of the exhibition, it was crucially important that the architecture of the exhibition hall give expression to Britain's technical superiority by surpassing in size and ingenuity any structure that had been built before. When an architectural competition did not yield a satisfactory design, the commission for the exhibition building (FIG. 15-1) was given to Joseph Paxton (1801–1865), a gardener by trade. Paxton, who had much experience constructing hothouses, proposed plate glass as the principal building material. Glass, used at the time for skylights in museums and shopping arcades, admitted light, an essential requirement for a building in which viewing was the main activity. Moreover, it was inexpensive and relatively lightweight, and it could be mass-produced and easily transported by boat or train.

Paxton fulfilled the criteria for an exhibition building that was both gigantic and easy to construct. He used three types of modular units: glass panes set in wooden frames, iron girders on which the panes rested, and cast-iron supporting pillars (see interior view in FIG. 15-2) to construct the building. Prefabricated in different locations, these units were transported to the site by train and assembled on the spot. The entire building, which measured 1,847 feet (563 meters) by 407 feet (124 meters) was put together in a little more than six months.

Both the airiness of the construction and the exposure of all structural elements were unprecedented in a period when elaborately decorated historic revivalist or eclectic buildings were the norm. And although Paxton's contemporaries marveled at the shiny glass structure, nicknaming it the Crystal Palace, most thought of the building not as architecture with a big "A" but merely as a fancy temporary structure. Some astute observers, however, realized

15-2 Crystal Palace, interior, view of the barrel-vaulted "transept", 1851. Etching. Victoria and Albert Museum, London.

Machines at the International Exhibitions

The Crystal Palace exhibition featured a wide variety of manufacturing machines. These were of special interest to industrialists, who were able to compare their own equipment with that used by others. Yet they also fascinated the general public who, perhaps for the first time, got an idea of the multitude and complexity of the machinery that produced the consumer goods they had come to expect to find in department and specialty stores.

Because the textile industry was most advanced from the point of view of mechanization, many of the mechanized manufacturing tools at the exhibition were related to textile production. The device for winding silk threads (FIG. 15.1-1) may serve as an example. It was designed to transfer silk thread from the loosely coiled lengths that came from the mechanical spinning wheels on to bobbins. A machine such as this replaced the arduous task of hand winding, but it still needed workers to mend the threads as they broke in the course of the winding process. This task, as we are told in

the special issue of the *Art Journal* devoted to the exhibition (see page 345), required "the unwearied attention of children." Indeed, we learn that, at the time of the exhibition, there were about 8,000 children under 13 years of age employed in British silk factories.

Machines would be increasingly prominent at later exhibitions. Beginning with the Paris exposition of 1855, special exhibition halls were exclusively devoted to showing large-scale engines and machinery (see page 351).

15.1-1 Machine for winding silk thread. Invented by Mr Frost of Macclesfield. Illustration in *The Crystal Palace Exhibition Illustrated Catalogue*, London, 1851. Reprinted by Dover Publications Inc., New York, 1970.

that this structure perfectly expressed the spirit of a new industrial age, and that it might well influence future architects. The German journalist Lothar Bucher (1817–1892), who would later become one of Bismarck's closest aides, claimed: "the Crystal Palace is a revolution in architecture from which a new style will date." Even he could not have predicted, however, how important Paxton's example would be for Modernist architecture of the twentieth century.

The Crystal Palace Exhibition and the Design Crisis in Britain

Inside the Crystal Palace, the public could admire a variety of consumer products, from kitchen wares to small-size decorative sculptures, intended for the bourgeois home. The exhibition also featured a variety of specialized machines, mostly modest in size, for the textile industry (see *Machines at the International Exhibition*, page 343). Each nation had a section for its products. That for the United States (FIG. 15–3), for example, showed pianos, gas lamps, Hiram Power's famous *Greek Slave*, and an Indian tepee, complete with a life-size wooden Indian and his squaw.

From the numerous publications that accompanied the exhibition, many of them lavishly illustrated with wood engravings, we can form a fairly complete idea of what the public could see there. The combination clock and inkstand (FIG. 15–4), is typical of the kind of ornate domestic pieces that visitors came to admire. It reflects the ambition of the wealthy mid-nineteenth-century bourgeoisie to imitate the life styles of the aristocracy of the eighteenth century.

Unlike eighteenth-century objects, however, which were made fully by hand, this clock is a hybrid product of machine manufacturing and human craftsmanship. The clock itself is a manufactured piece of machinery, while the elaborate case and stand were carved by W. G. Rogers, well-known in Britain for this kind of decorative work. Rogers's carving comprises ornamental forms from various decorative styles of the past: a Renaissance cartouche at the bottom; Rococo swirls and flowers in the middle and at the top; and a realistically carved little dog that seems to come straight out of a seventeenth-century Dutch painting. Such an odd combination of historic styles is typical of the eclecticism that had been fashionable in architecture and the decorative arts since the 1830s (see page 322).

15-3 Crystal Palace, The United States' Department. Illustration in *The Crystal Palace Exhibition Illustrated Catalogue* (London, 1851). Wood engraving.

15-4 **W. G. Rogers,** *Carved Wooden Clock and Ink Stand.* Illustration in *The Crystal Palace Exhibition Illustrated Catalogue,* (London, 1851). Wood engraving. Reprinted by Dover Publications Inc., New York, 1970.

Since this piece was accepted by the exhibition jury, it and many others like it (see also FIG. 15–7) apparently represented good design, even though today we may feel that they are derivative and too ornate. It is noteworthy that some contemporary critics denounced the products at the exhibition as well, complaining that they failed to demonstrate an "educated" taste. The art critic Ralph Nicholson Wornum, in a special issue of the *Art Journal* devoted to the exhibition, complained that there was "nothing new in the Exhibition in ornamental design; not a scheme, not a detail that has not been treated over and over again in ages that are gone." The exhibition, he felt, revealed the creative poverty of eclecticism; he hoped that, in the future, designers and manufacturers would shy away from it and strive, instead, for the "cultivation of pure and rational individualities of design." Even the exhibition's main planner, Henry Cole, was disappointed with the "universal likeness" of all the objects. He urged artists to abandon the worn-out European styles of the past and turn elsewhere for inspiration.

New Attitudes toward Design: Owen Jones and John Ruskin

By highlighting the existing standards for the design of consumer products, the Crystal Palace exhibition caused a major reorientation in the thinking about design and ornamentation. One of the principal figures in this design "revolution" was the architect Owen Jones (1809–1874). As the person responsible for the interior decoration of the Crystal Palace and the arrangement of its displays, Jones had closely studied the exhibits. He concluded that, rather than slavishly imitating and randomly combining the ornaments of the past, designers should, instead, analyze the logical principles behind them. Only then could they begin to develop a suitable decorative style for the nineteenth century.

With the help of his friend Cole, Jones developed thirty-seven "axioms" of design, which appeared in his *Grammar of Ornament,* published in London in 1856. The book was innovative not only in its approach to design, but also because Jones selected his decorative art examples (all beautifully illustrated in color lithographs) from an unusually wide range of historic styles. Going far beyond the popular revival styles of the Renaissance, the Baroque, and

15-5 **Owen Jones,** Plate lxvii from *The Grammar of Ornament*, 1856. Color lithograph, 11″ x 8″ (28 x 20 cm). Private Collection, London.

the Rococo, he found inspiration in medieval manuscripts (FIG. 15–5) as well as Islamic and Far Eastern art.

Another important figure in the movement to re-orient British design was John Ruskin (see page 326). This critic and amateur artist belonged to a group of theorists and designers, including Pugin (see page 322), who criticized the eclectic borrowing of historical ornament in contemporary design and complained that mass production degraded these forms and rendered them lifeless. Feeling that design and manufacturing were controlled by the materialist interests of industrialists, they lamented the loss of a spiritual element in the production process. They advocated that architects and designers should study the Gothic period, not merely to imitate its architectural and decorative forms, but to recapture the lofty spirit in which they were created.

In his *Stones of Venice*, a three-volume work published between 1851 and 1853, Ruskin hailed Gothic architecture and decorative arts, writing that their forms were inspired by the faith and morality of their creators. Beginning with the Renaissance period, he said, these values had gradually waned until the Industrial Revolution had annihilated them completely. If architecture and design were to regain beauty and integrity, artists had to regain the spirituality of the medieval period. Only then, Ruskin felt, could they create buildings and objects that would truly touch contemporary society.

The International Exhibition in London, 1862

Although the organizers of the Crystal Palace exhibition had conceived of it as the first of a series of quinquennial exhibitions, it took almost eleven years before the British organized a second exhibition, in 1862. Cole, again, was the prime mover, but this time he did not have the backing of Prince Albert, who had died in 1861.

Consumer goods were once more the principal focus of the exhibition. The organizers hoped to display the advances made in British design and manufacturing during the intervening years. Some of the most original products were found in the "Medieval Court," which featured the works of designers and manufacturers who, following the ideas of Ruskin and Pugin, had turned to medieval art for inspiration. A cabinet designed by Philip Webb (1831–1915) (FIG. 15–6) displays a formal simplicity that looks startlingly innovative when compared with some of the extravagant pieces of furniture that had appeared at the exhibition of 1851 (FIG. 15-7). Webb's cabinet is a rectangular box supported by four high posts that are connected at the bottom by a shelf. Lacking any kind of carved ornamentation, the decoration of the cabinet is limited to painting. Much of it is simple and abstract: bands of color or small geometric motifs. Only the two doors show a figurative scene based on a drawing by the well-known artist Burne-Jones (see page 335).

15-6 **Philip Webb,** Backgammon cabinet, with figures painted after a drawing by Edward Burne-Jones, 1861. Painted pine, oil paint on leather, brass and copper, height 6'1" (1.85m). Metropolitan Museum of Art, New York.

15-7 **Mr Stevens of Taunton,** *Carved Wooden Cabinet.* Illustration in *The Crystal Palace Exhibition Illustrated Catalogue* (London, 1851). Wood engraving, Reprinted by Dover Publications Inc., New York, 1970.

Webb's cabinet was exhibited under the auspices of a new British design firm, founded in 1861, called Morris, Marshall, Faulkner and Co. The driving force behind the firm was the young William Morris (1834–1896), who was soon to become one of the most influential designers in Britain. An admirer of Ruskin, Morris shared his interest in medieval art and architecture. He admired the Middle Ages as a period when art was made by the people for the people, an ideal that he intended to revive in his time. To counter the negative effects of manufacturing, he became a staunch advocate of handmade products. Through his writing and lectures, he inspired the Arts and Crafts Movement, an international movement that rejected machine production, promoting instead the practice of pre-industrial craft techniques.

Morris himself was primarily active as a wallpaper and textile designer and, later in life, as a graphic artist. His *Daisy* wallpaper (FIG. 15-8), designed in 1862 though not exhibited at the International Exhibition of that year, is

an early example of his output. Its flower motif, a favorite in his work, is simple and stylized, and appears to have been inspired by traditional folk art. Like all of Morris's wallpapers, this one was hand-printed, thus very expensive. Unfortunately, Morris's emphasis on manual rather than machine production was in conflict with his ideal of producing an art for "the people," since handcrafted products were inevitably more expensive than mass-produced ones.

The Japanese Court at the Exhibition of 1862

With the exception of the Turkish–Egyptian department and a small exhibit of Chinese objects belonging to a London trader, the Crystal Palace exhibition had featured only products from Europe and North America. By contrast, the exhibition of 1862 included contributions from India, China, and Japan. The Japanese section, by far the most notable, was introduced to the public by the Japanese ambassador and his retinue, whose colorful kimonos struck an exotic note at the opening ceremonies.

Japan, which had been isolated from the rest of the world for centuries, had been forced to sign a trading agreement with the United States in 1854. The treaty was the direct result of military pressure: in 1853 Commodore Matthew C. Perry had sent a fleet of warships into Tokyo Bay, forcing the Japanese to open their ports to United

15-8 **William Morris,** *Daisy* wallpaper, 1862. Handprinted for the firm of Morris & Co. by Jeffrey & Co. Victoria and Albert Museum, London.

15-9 Japanese objects at the International Exhibition of 1862 in London. Illustration in J. B. Waring, *Masterpieces of Industrial Art and Sculpture at the International Exhibition, 1862,* 1863. Chromolithograph. Cambridge, Massachusetts, Harvard University, Fine Arts Library.

15-10 **E. W. Godwin,** Drop-leaf table with shelf, c.1872. Mahogany with lacquered brass braces, Ellen Terry Memorial Museum, Smallhythe, Kent.

States ships to obtain supplies. The American maneuver brought an end to the reign of the feudal war lords or shoguns, and marked the beginning of the modernization of Japan under the regime of the Meiji emperors.

Almost as soon as the so-called Perry convention was signed, Japanese goods were shipped to Western markets. These created an immediate fascination with Japanese culture, which was further fanned by Japan's contribution to the exhibition of 1862. Most of the articles in the Japanese Court were utilitarian (FIG. 15-9). Their beautiful craftsmanship and simplicity attracted several designers, who saw Japanese decorative traditions as an alternative to the Gothic style. In a review of the exhibition, the architect William Burges (1827–1881) drew a direct parallel between the two styles, writing: "To any student of our reviving arts of the thirteenth century [i.e. the Gothic period] an hour or even two days spent in the Japanese Department will by no means be lost time, for these hitherto unknown barbarians appear not only to know all that the Middle Ages knew but in some respects are beyond them and us as well."

Together with Gothic architecture, Japanese decorative arts inspired those mid-nineteenth-century British designers who wanted to abandon historic eclecticism in order to develop a new, authentically nineteenth-century style. A table designed by E. W. Godwin (1833–1886; see FIG. 15-10) exemplifies some of the lessons that Western architects learned from the Far East. Devoid of all carved or painted ornament, it owes its visual attractiveness purely to the perfect craftsmanship and the design of its structural elements. One of the most striking features of the table is its asymmetry, a characteristic element of Far Eastern art and design.

Godwin's table seems strikingly innovative, even revolutionary when compared to the average consumer furniture produced during the Victorian period. Not surprisingly, it would take a long time before the general public was ready to give up the frills of eclecticism to embrace the new, sparse simplicity that the most innovative designers of the period proposed.

The Universal Exposition of 1855 in Paris

Although the British "invented" the international exposition, the French most fully realized its potential, both as an instrument of national propaganda and as a showcase of innovation and progress. Between 1855 and 1900 five

major "universal exhibitions" took place in Paris, each more lavish and comprehensive than the one before (see *Major Nineteenth-Century International Exhibitions*, left).

Napoleon III was the driving force behind the first exhibition, held in the spring of 1855. Aware of the success of the Crystal Palace exhibition, which had drawn huge crowds and earned £170,000 for Britain, the emperor saw the initiative as a means of consolidating his imperial power (planning for the exhibition started less than a year after his coronation) and enhancing the prestige of France.

Unlike the Crystal Palace exhibition, which was housed in a single hall, the Paris exposition of 1855 comprised a number of different buildings on the right bank of the Seine. Most important among these was the Palais de l'Industrie or Industry Palace, which was designed with the aim of surpassing the Crystal Palace in size, beauty, and technology. Glass, once again, figured importantly in the construction of this building, but it was used more daringly. In the central hall of the building a series of enormous iron arches supported a vaulted glass ceiling, enabling a much wider span than had been possible in the Crystal Palace (compare FIG. 15-11 and FIG. 15-2).

15-11 The interior of the Palais de l'Industrie at the Universal Exposition of Paris, 1855. Wood engraving. Bibliothèque Nationale, Département des estampes et de la photographie, Paris.

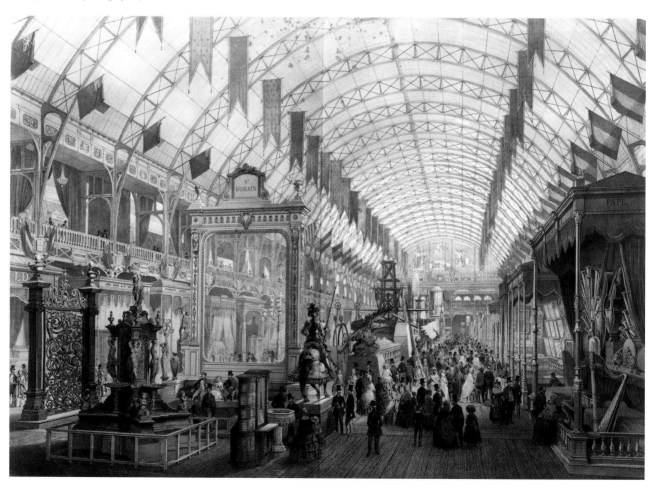

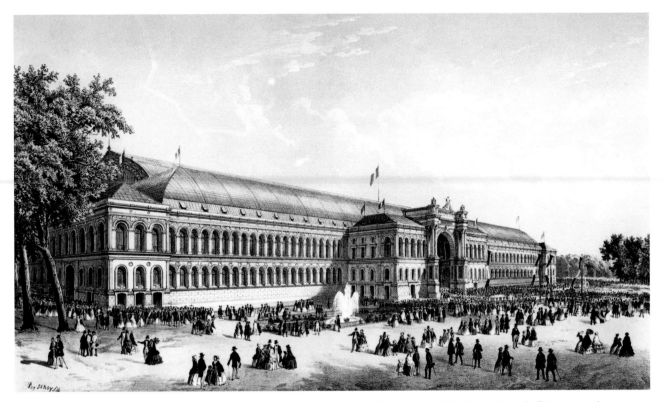

15-12 The exterior of the Palais de l'Industrie at the Universal Exposition of Paris, 1855. Engraving. Bibliothèque Nationale, Département des estampes et de la photographie, Paris.

The main difference between the Palais de l'Industrie and the Crystal Palace, however, was its exterior appearance (FIG. 15-12). While the Crystal Palace clearly displayed its glass, wood, and steel construction on the outside, the Palais de l'Industrie in Paris was "clothed" in a traditional stone structure, complete with arched windows and a huge arched entrance, all in accordance with contemporary Beaux-Arts norms. From our twenty-first-century viewpoint, therefore, it seems less progressive than the Crystal Palace, in spite of the technological advances that mark its interior.

In addition to the Palais de l'Industrie, which was devoted to industrial products, the exhibition of 1855 featured a separate Hall of Machines (FIG. 15-13). Located along the bank of the Seine, it was much narrower than the Palais de l'Industrie but measured almost one mile in length. Lined up on one side of this long gallery was a series of enormous machines, which so fascinated visitors that, henceforth, machine galleries would be a standard feature of international expositions.

15-13 The Hall of Machines at the Universal Exposition of Paris, 1855. Wood engraving. Bibliothèque Nationale, Département des estampes et de la photographie, Paris.

The International Art Exposition

In an effort to emulate the British, Napoleon III and his advisors decided to add an international art exposition to their show. This would make the French exposition different from and more comprehensive than the Crystal Palace show. More importantly, art was a field in which the French could excel, something that they were unable to do in the industrial domain. Although the art exhibition was first scheduled to take place in the Louvre, in the end a special Fine Arts Palace or Palais des Beaux-Arts was constructed in the exhibition grounds. To encourage French participation in the show, the Salon of 1855 was cancelled.

The International Exposition of 1855 offered a first opportunity, for art critics and the general public alike, to see a large-scale exhibition of art from across Europe. Twenty-eight nations in all were represented. Britain, Germany, and Belgium made the strongest showing. Russia was notably absent since, at the time, it was at war with the French in the Crimean peninsula.

Of the foreign artists whose works were shown at the exhibition, several were already known in France. Since the beginning of the nineteenth century there had been some interchange of influences in the art world. Foreign artists had exhibited works at the Paris Salons, and French artists had occasionally sent their works to exhibitions abroad, in Brussels, London, Munich, or Amsterdam. While in these earlier instances, however, artists had participated as individuals, in the International Exposition of 1855 they represented their countries. Each national exhibit was carefully selected by a committee composed of artists and government officials, so that it was truly representative of "national culture."

The French Show

The exhibit of French art eclipsed all others in the International Exposition of art. It had been carefully orchestrated. The Imperial Commission in charge of the International Exposition had actively courted the artists whose works, they felt, would make a good show. A small number of artists, including, most importantly, Delacroix, Ingres, and Vernet, were honored with comprehensive retrospective exhibitions of their work.

While these and a few other featured artists were allowed to exhibit groups of paintings, all others were invited to submit works to a jury, which would select individual pieces for the exhibition. Composed of artists and *amateurs* (informed art lovers), the jury was dominated by older men who, for the most part, had little interest in promoting new and different forms of art. Hence, the exhibition was backward rather than forward looking—summing up the artistic accomplishments of the July Monarchy rather than promoting the young artists who had emerged since the Revolution of 1848. If their works were visible at the exposition at all, as were those of the Realist painter Gustave Courbet, it was due not to the exhibition jury but to individual initiatives.

Courbet's Private Pavilion

Gustave Courbet was nearing his mid-thirties as the Universal Exposition took shape, and he quickly realized an opportunity for instant international recognition. He eagerly submitted no less than fourteen paintings to the jury of the International Exposition. Courbet must have known that this was an immodest number, since only the featured artists at the exhibition were expected to show that many paintings. Included among his submissions, moreover, was his recently completed *The Painter's Atelier: A Real Allegory of Seven Years of my Artistic Life* (FIG. 15-14), an enormous, self-indulgent work that summed up his artistic ideas and career to date.

Not surprisingly, this painting and two others were refused by the jury, so Courbet decided to organize an exhibition of his own. With amazing entrepreneurial skill, he arranged to rent a terrain on the exhibition grounds, opposite the Palais des Beaux-Arts. There he constructed a temporary pavilion for a retrospective exhibition of his work that featured no less than forty paintings, including his monumental *Atelier*.

Courbet was not the first artist to organize a private exhibition of his work. Several artists before him had shown off one or more works in their studios or in a rented space (see pages 55, 81, and 215—David, Fuseli, Géricault). Courbet's initiative was novel and important, however, both for its scope and for the competitive context in which it occurred. His private exhibition was a powerful assertion of the artist's right and ability to show his work to the world, without the approval of a jury to legitimize it. This liberated the artist as well as the public; for once, people could judge an artist's work directly, unmediated by a panel of art "experts."

Courbet's *Atelier*, the centrepiece of his private exhibition, expressed how he saw his role as an artist in the modern world. Courbet is shown painting in his studio, surrounded by people. On the right side of the artist is a gathering of the friends, collectors, and critics who supported him over the years; on the left, a motley group of popular types—veterans, street performers, hunters, peasants, beggars, and the like—art waiting to take their place in his painting. It is, as he wrote to a friend, "the world that comes to me to be painted."

By subtitling his large canvas *A Real Allegory of Seven Years of my Artistic Life*, Courbet hinted at a parallel between Napoleon III and himself. Just as the International Exposition of 1855 was the culmination of seven years of Louis Napoleon's reign over France (he had come to power

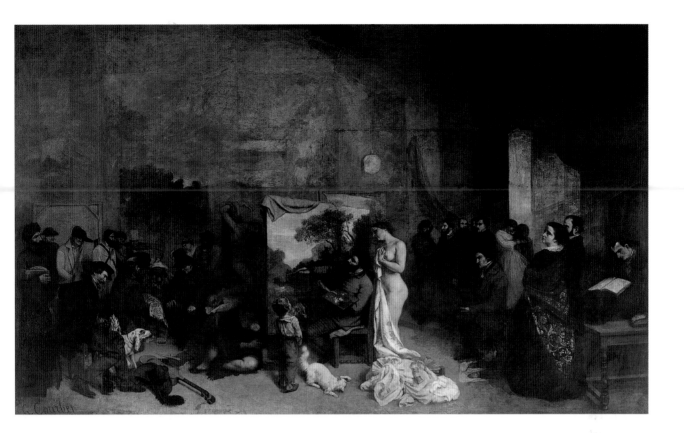

15-14 **Gustave Courbet,** *The Painter's Atelier: A Real Allegory of Seven Years of my Artistic Life,* 1854–5. Oil on canvas, 11'9" x 19'7" (3.59 x 5.98 m). Musée d'Orsay, Paris.

15-15 **Henri Valentin,** *The Opening Ceremony of the Universal Exposition, 15 May 1855.* Wood engraving. Bibliothèque Nationale, Département des estampes et de la photographie, Paris.

in 1848, see page 248), so Courbet's exhibition crowned seven years of artistic prominence. And while Napoleon, through his exhibition, hoped to place himself at the center of the political world (FIG. 15-15), Courbet wished to put himself at the center of the artistic world.

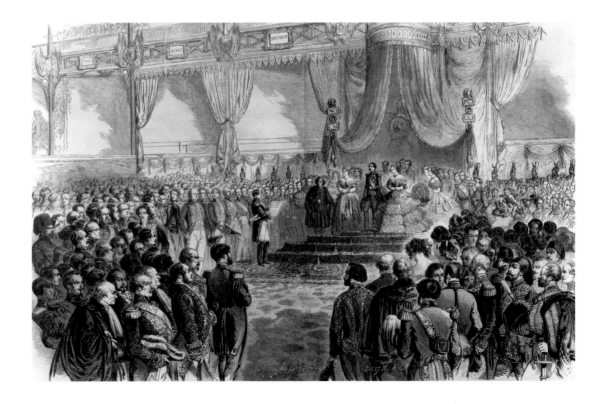

15-16 **Hendrik Leys,** *Thirty-day Mass of Berthal de Haze,* 1854. Oil on canvas, 35 x 52″ (90 cm x 1.33 m). Musées Royaux des Beaux-Arts de Belgique, Brussels.

Foreign Artists at the International Exposition of 1855

The art exhibits at the Palais des Beaux-Arts, like those in the Palais de l'Industrie, were organized by country. This encouraged critics and visitors to compare them and to reflect on the "character" of each nation. The search for "national character" in the art and culture of different countries was a favorite intellectual pastime in the nineteenth century, when nationalism was a powerful sentiment and the definition of a nation's character became a matter of serious concern. Indeed, national juries selecting the exhibits saw it as their task to bring together those paintings that best represented their nation. Such selections typically included paintings inspired by national history, genre paintings depicting scenes from daily life in the nation (preferably in the countryside, where regional customs and costumes were still preserved), and landscape paintings depicting nationally specific scenery (Norwegian fjords, Swiss mountains, Dutch polders, Scottish highlands, etc.).

The *Thirty-day Mass of Berthal de Haze* (FIG. 15-16) by the Belgian painter Hendrik Leys (1815–1869) is typical of the history paintings that could be found in nearly all national exhibits. It depicts the mass that was said on the thirtieth day after the death of Berthal de Haze, a sixteenth-century Belgian hero from Antwerp, Leys's home

city. Leys's painting shows the meticulous attention to detail that we have encountered in the works of Delaroche and Meissonier in France and Piloty in Germany. It also shows the influence of traditional Flemish painting, recalling the works of such sixteenth-century artists as Jan Gossaert (c.1478–1532), also called Mabuse, whose portraits (FIG. 15-17) seem to have served as prototypes for Leys's figures. Because his work was characteristic of Flemish painting, and treated a subject from Flemish history, Leys was admired as an eminent representative of his nation. At the exhibition of 1855 he was awarded one of the only ten grand medals of honor, making him the *premier* painter of Belgium.

Perhaps even more popular than national history scenes were scenes of daily life. Rural scenes, depicting regional "folk" life, drew much attention and admiration. The *Service in the Chapel of Lövmokk in Lapland* (FIG. 15-18) of 1855, a monumental work by the Swedish painter Johan Fredrik Höckert (1826–1866), was especially well received. It depicted a gathering of Laplanders, in traditional costumes, attending a service in a small wooden chapel. Napoleon III bought the canvas and donated it to one of France's provincial museums. (It was returned to Sweden in 1952, suggesting that, today, such paintings are primarily of local interest.)

15-17 **Jan Gossaert** *(Mabuse),* *Two Portraits of Donors,* sixteenth century. Oil on panel. Each panel measures 27 x 9″ (70 x 23.5 cm). Musées Royaux des Beaux-Arts de Belgique, Brussels.

15-18 **Johan Fredrik Höckert,** *Service in the Chapel of Lövmokk in Lapland,* 1855, Norrköping, Sweden, Kontstmuseet.

Landscapes depicting national scenery could also be found throughout the exhibition. In the Swiss pavilion, many visitors were drawn to the work of Alexandre Calame (1810–1864), whose *Lake of the Four Cantons* (FIG. 15-19) would be awarded a first-class medal. Paintings such as Calame's appealed to the public's growing interest in travel, facilitated by the expansion of the railroads and the development of a tourist industry that included travel agencies, hotels, and printed travel guides.

Of course, not all paintings in the International Exposition fell into the three categories outlined above. Portraits, bourgeois genre scenes, animal paintings, and still lifes could be found in all the national exhibits. Although they varied stylistically, the differences among them had more to do with the individual temperaments of artists than with their "national character." Indeed, from a stylistic point of view, European painting at the exhibition presented a relatively homogenous picture, due in large part to the enormous influence of the academies, which offered a similar training throughout the continent.

This artistic homogeneity was even more obvious in the area of sculpture. Restricted to figures, whether human or animal, sculptors had less flexibility in terms of subject matter than painters. In most national exhibits one encountered similar female nudes, either standing or reclining, now called Venus, then "Greek Slave." Even the sculptures of national heroes looked very similar, since kings or generals on horses and scholars in their gowns differed only in the details of their clothing and physiognomies.

The Paris Universal Exposition of 1867

In 1867, still during the regime of Napoleon III, a second exhibition opened its doors in France. (It followed the International Exhibition in London of 1862, just as that of 1855 had followed the Crystal Palace exhibition.) The site chosen for the exhibition was the so-called Champ de Mars, or Mars Field, located on the left bank of the Seine. The main exhibition building was planned to be round, symbolizing the globe, but in the end site restrictions forced the architect to design it as an ellipse, measuring 1,608 feet (490 m) long by 1,266 feet (386 m) wide (see FIG. 15-20). The ellipse contained seven concentric galleries, the outermost of which was the machine gallery. The next five galleries, moving inward, held clothing, furniture, raw materials, the history of work, and the fine arts. The innermost gallery contained a garden with palms and statues. According to the official catalogue of the exhibition, circling through the galleries was "literally to go around the world. All peoples are here, enemies live in peace side by side."

15-19 **Alexandre Calame,** *Lake of the Four Cantons,* 1855. Oil on canvas, 5'7" x 8' (1.7 x 2.44 m). Riggisberg, Abegg-Stiftung, Switzerland.

15-20 **Jean-Baptiste Krantz and Frédéric Le Play,** *Exhibition Building and Pavilions,* Universal Exhibition, 1867. Champs de Mars, Paris. Hand-colored engraving. Private Collection.

The Fine Arts Exhibition of 1867

The fine arts exhibition of 1867 was less comprehensive than the one of 1855. First of all, the conservative jury for the French exhibit had selected only 550 paintings, less than one-third of the number that had been exhibited in 1855. Most of these were works by themselves or their artist friends, so that the exhibition was far from an adequate reflection of what was happening in the art world at the time. French artists were so disgusted that they insisted that there be a Salon concurrently with the fine arts exhibition at the International Exhibition. Moreover, as in 1855, Courbet, and now also Manet, set up their own private exhibition pavilions on the exhibition grounds.

Further weakening the art exhibition of 1867 was the fact that several countries, including Belgium, the Netherlands, Switzerland, Bavaria, and Japan, decided to present their own art exhibitions in national pavilions scattered around the Champ de Mars. Their absence from the art exhibition was partly compensated for by the presence of Russia, which had not been represented at the earlier exhibition. Indeed, for the first time in 1867, the French public could see a substantial body of work by contemporary Russian painters and sculptors.

Among the works that were admitted as "most Russian" were the rural genre paintings of Vasily Perov (1834–1882), an artist in his early thirties, who was born in Siberia and trained in Moscow. In 1863–4 he had lived in Paris and had become acquainted with the works of Realist painters such as Courbet, Millet, and Breton. On returning to Moscow, Perov painted a number of scenes of peasant life. In contrast to his earlier, satirical works, these paintings show a sympathetic, even sentimental view of the poor. No less than five of Perov's paintings were shown at the exhibition of 1867, including *Troika: Apprentices Fetching Water* (FIG. 15-21), a painting that one year earlier had caused Perov to be elected to the Russian Academy of Arts. *Troika* represents three children, unpaid apprentices to a master craftsman, who are pulling a sled carrying a huge water barrel. The scene is set in the dead of winter. Snow covers the street and the buildings, and the water leaking over the edge of the barrel has frozen into a thick coat of ice. Struggling against the ice-cold wind, the pale-faced children, dressed in rags, involuntarily elicit the viewer's sympathy. To the public of the 1867 exhibition, Perov's painting confirmed a stereotyped view of Russia as a cold, harsh country where life, especially among the lower classes, was an endless string of hardships.

15-21 **Vasily Perov,** *Troika: Apprentices Fetching Water,* 1866. Oil on canvas, 4'1" x 5'6" (1.23 x 1.67 m). State Tretyakov Gallery, Moscow.

The Japanese Pavilion

The organizers of the Paris exhibition of 1867, like those of the London exhibition five years earlier, had secured the participation of Japan. This country, once again, showed off its handmade furniture and decorative objects for the home. But perhaps the most admired items in the Japanese section were several paintings and woodblock prints after sketches by the recently deceased Japanese artist Katsushika Hokusai (1760–1849). Numerous pages of Hokusai's *Denshin Kaishu Hokusai Manga,* a multi-volume work reproducing the artist's random sketches, were shown. Among these was a page showing several sketches of wrestlers (FIG. 15-22). Western viewers were especially struck by Hokusai's ability to reduce the subject to its bare essence. Confining himself largely to contour, Hokusai, like all Asian artists, did not use *chiaroscuro.* In his prints and drawings, he managed to suggest depth and three-dimensionality, without the distribution of light and shade that Western artists so relied on.

The absence of *chiaroscuro* was seen as a unique quality of Japanese art in the 1860s and 1870s. Already in 1863, the British critic John Leighton, in a lecture on Japanese art (inspired by the exhibit of the previous year), had pointed out that the Japanese "never produce a picture, because the principal element of pictorial art is wanting: light and shade—a cloak with us [Western artists] that covers a multitude of sins—they know not of." To Leighton, however, this did not mean that the Japanese were not great artists. On the contrary, "Art of the highest kind may, and often does exist without *chiaroscuro;* for instance, the divine compositions of Flaxman owe none of their world wide fame to shade or color …"

The Importance of the International Exhibitions of the 1850s and 1860s

The international exhibitions of the 1850s and 1860s, notably the ones held in London and Paris, were catalysts for many changes in the arts that would come to fruition in the last thirty years of the nineteenth century. In architecture, the exhibitions led to advances in building technology, such as the use of prefabricated modules, which

15-22 *The Hokusai Sketches (Denshin Kaishu Hokusai Manga)*, vol. 3 of Etehon, 1815 [1816]. British Museum, London.

made the construction of large buildings cheaper and easier. In addition, some exhibition buildings pioneered an entirely new architectural aesthetic, in which the structural elements were not clothed within traditional historic forms but left exposed to become themselves the "beauty" of the building.

By focusing attention on the visual aspects of manufactured goods, the exhibitions caused a new, critical attitude towards product design, albeit only among a select group of critics, architects, and designers. These men (for there were very few women among them) rejected the eclecticism so in vogue in the middle of the nineteenth century, and called for a new rationality, honesty, and purity in design. What is more, by featuring manufactured products from different parts of the world, the expositions encouraged creative exchange. Exposure to new products and styles inspired artists to think about design in new and different ways.

In the fine arts, as in design, access to non-Western art had a liberating influence. Certain axioms that had been considered unshakable in the West, such as perspective and *chiaroscuro*, were apparently unimportant if not entirely irrelevant in other artistic traditions. For some of the artists who visited the expositions, it seemed that the pillars of academic teaching had come tumbling down.

Another important lesson taught at the expositions was that artists could take their fate into their own hands. Courbet's successful challenge of the art establishment in 1855 showed that juried, government-sponsored exhibitions were not the only way to gain public exposure. By organizing and financing his own show, Courbet set an example for Manet, in 1867, and, subsequently, for a group of younger artists, nicknamed the "Impressionists," who would organize their first private group show in 1874.

Chapter Sixteen

French Art after the Commune—Conservative and Modernist Trends

In 1870 the Prussian chancellor Otto von Bismarck (see page 293) deliberately provoked a political crisis to induce France to declare war on his country. France had been the biggest obstacle to Bismarck's dream of German unification, for the French were justifiably worried that a united Germany would undermine their dominance in continental Europe. Weakening France's resistance was of vital importance if Bismarck's unification plan was to succeed.

The French government readily took the bait and declared war on July 14, 1870, even though its troops were entirely unprepared. Only six weeks later, the French army was decisively beaten at Sedan, a town close to the German border. Napoleon III was captured, the Second Empire collapsed, and the Third Republic was proclaimed.

Meanwhile, German troops marched on to Paris expecting to celebrate their victory in the French capital. Instead, they found the Parisians unwilling to surrender. Forced to lay siege to the city, the Germans cut off all food and fuel supplies, but Paris did not capitulate. While its citizens suffered and died, however, the rest of France elected a new, conservative "Government of National Defense," which was installed in Versailles. Despite the heroic resistance of Paris, this government decided to conclude a peace with Germany, thus forcing the city to capitulate.

Feeling betrayed, the Parisians refused to recognize the new government and established the Paris Commune, an independent city state. Not surprisingly, it was short-lived. On May 21, 1871 government troops entered the city.

During the "Bloody Week" that followed 25,000 insurrectionists were killed, and the Commune was eliminated.

The Commune and Early Photo-Journalism in Europe

Like the American Civil War, which had been photographed by Matthew Brady ten years earlier, the French civil war of 1871 and its aftermath were thoroughly documented by photographers, both amateur and professional. An anonymous photograph (FIG. 16-1), shot in May 1871, shows a group of Communards posing behind a fallen statue of Napoleon in Roman imperial garb. The colossal figure had once stood atop the Vendôme column (see page 112). Led by the painter Gustave Courbet, the Communards had toppled this hated symbol of imperial power in an attempt to erase the memory of both Napoleon and his nephew. Although the photograph follows the traditional format of the group portrait (see FIG. 14-1), it is particularly effective for emphasizing the contrast between the stiffly posed, erect Communards, dressed in dark suits and uniforms, and the prostrate statue of the emperor, looking pathetic in his short little tunic. The image thus gives visual form to the Communards' dream of eradicating imperialism and establishing a modern, democratic republic instead.

In sharp contrast to this proud image of rebellion is Disdéri's photograph of "boxed" Communards (FIG. 16-2),

16-1 **Anonymous,** *The Fallen Vendôme Column.* 1871. Photography. Bibliothèque Nationale, Département des estampes et de la photographie, Paris.

16-2 **André-Adolphe-Eugène Disdéri,** *Cadavers of the Insurgents,* 1871. Photograph. Bibliothèque Nationale, Département des estampes et de la photographie, Paris.

lined up for burial after a mass execution ordered by the Versailles government. It is a stark exposé of a government that methodically killed its own people. Disdéri built on a tradition of documenting the horrors of war and political brutality that went back to Francisco Goya (see FIG. 6-14) and Honoré Daumier (see FIG. 10-30). At the same time, his photograph anticipates modern photo-journalism.

Auguste-Bruno Braquehais (1823–1875) photographed Paris in the wake of the war. It was a city in ruins, since many of its major buildings and thoroughfares had been destroyed. Braquehais's photograph of the burnt-out town hall of Paris (FIG. 16-3) shows a charred, abandoned building that stands silent, even ghostlike in the aftermath of the war. Images such as this were not primarily intended

16-3 **Auguste-Bruno Braquehais,** *Hôtel de Ville,* May 1871. Photograph. Bibliothèque Nationale, Département des estampes et de la photographie, Paris.

for reproduction in newspapers or magazines, because the halftone process for reproducing photographs had not yet been invented. Instead, they were sold in shops, individually or in albums. However, only some of them found their way into illustrated magazines, reproduced as wood engravings.

Republican Monuments

The Commune had torn the urban and social fabric of Paris to shreds. The city was in ruins; its people, recent opponents in a civil war, were shocked and demoralized. Returning to Paris from Versailles, the French government was insecure, composed as it was of members of opposing factions—most importantly royalists and republicans. For a time it looked as if the monarchy would be restored. The Third Republic miraculously survived, however, although the republicans had to steer a conservative line to maintain their power.

The new government slogan was "moral order." To stabilize society, the government arrested some 40,000 people who had been involved in or were sympathetic to the Commune. Of these, more than 10,000 were either executed, deported to France's penal colonies, or incarcerated. Next, the government set about restoring the city by reconstructing the buildings and monuments that had fallen. The re-erection of the Vendôme column in particular, became symbolic of moral order itself.

By the end of the 1870s Paris had been largely rebuilt and the Third Republic had established a firm foothold. A new republican constitution had come into effect in 1875 and, in the elections of January 1879, the republicans at last achieved a majority in the Senate. It was time now for the commemoration of the tragic events of 1870–1 and for the artistic endorsement of the new republic.

In 1879 two major competitions were organized by the city council of Paris. The first was for a two-figure sculpture to honor its citizens for their courage in defending the city against the Prussians; the other was for a multi-figure monument celebrating the triumph of the Republic. Some one hundred sculptors competed for the commission of the first monument, which was to represent an allegory of Defense. Among them was a young, little-known sculptor by the name of Auguste Rodin (1840–1917). He submitted a plaster cast (see *The Techniques of Sculpture*, page 481) showing a winged figure with a Phrygian bonnet—a mixed allegory of Liberty, France, and Victory—urging a nude wounded soldier not to give up the struggle (FIG. 16-4). Rodin's model represented a continuation of the Romantic sculptural tradition of Rude and Carpeaux (see pages 221 and 263). His winged allegorical figure may be seen as a deliberate reference to Rude's *Departure of the Volunteers* on the Arc de Triomphe, almost as

16-4 **Auguste Rodin,** *La Défense* (The Call to Arms), 1879–80. Plaster, 46" (1.12 m) in height. Musée Rodin, Paris.

if he intended to align his sculpture with the tradition of earlier patriotic monuments. At the same time, Rodin departed from Rude's example by emphasizing the three-dimensional character of his work and by dramatizing the contrast between the active figure of Liberty–France–Victory and the passive figure of the soldier.

In its tension between enthusiasm and exhaustion, the will to live and the desire to die, and, ultimately, between mind and matter, Rodin's sculpture seems very effective to us today. Yet it was not chosen by the jury, perhaps because Rodin's conception was too generic and timeless. Instead,

16-5 **Louis-Ernest Barrias,** *La Défense de Paris*, 1879–80. Rond-point de Courbevoie, Paris.

16-6 **Jules Dalou,** *Triumph of the Republic*, inaugurated 1889 (model dated 1879–89). Bronze, over life-size. Place de la Nation, Paris.

it selected a sculpture by Louis-Ernest Barrias (1841–1905), in which the allegorical figure of Paris, dressed in the costume of a contemporary French civil guard, towers over a young soldier who is loading his rifle (FIG. 16-5). The specificity and the realism of this work made it more suitable for its commemorative purpose.

The second competition, for a multi-figure monument to the Republic, drew seventy-eight submissions. The selection committee gave few votes to the model by the sculptor Jules Dalou (1838–1902), an ex-Communard who had lived in London since 1871. Yet Dalou was successful, because he had the enthusiastic support of several republicans who were influential in government circles. In 1879 he was commissioned to create a huge monument titled the *Triumph of the Republic* (FIG. 16-6), to be placed in the center of the place de la Nation or "Nation Square" in Paris.

Completed over a period of ten years, Dalou's monument centers on a larger-than-life allegory of the Republic,

complete with Phrygian cap and fasces (see page 102). She stands on a globe, which rests on a chariot pulled by two lions. Symbolizing the strength of the people, the lions are led by the genius of Liberty, a young boy with a torch in his raised right hand. Additional allegorical figures—Labor, Justice, and Abundance (or Peace)—surround the chariot on the other three sides.

Like Rodin's *Defense, Triumph of the Republic* is representative of the direction that French sculpture had taken since the Romantic period, when sculptors such as Rude and later Carpeaux, had abandoned the static forms of the neo-classical period for more dynamic, active figures. Dalou's work is more akin to seventeenth-century Baroque art than to Classical or even Renaissance sculpture. His dramatic piling up of forms may be compared with several paintings by the seventeenth-century Flemish painter Peter Paul Rubens (see, for example, FIG. 16-7), whom Dalou greatly admired.

16-7 **Peter Paul Rubens,** *Assumption of the Virgin*, 1611–15. Oil on panel, 40 x 26″ (1.02 x 66 cm). Royal Collection, Buckingham Palace, London.

16-8 **Frédéric-Auguste Bartholdi,** *Statue of Liberty* (or Liberty Enlightening the World), 1875–84. Copper sheeting over iron armature, height 151′ 6″ (46.18 m). New York Harbor.

While Dalou was working on his *Triumph of the Republic*, an even larger sculpture, likewise on a republican theme, was under construction in Paris. It was *Liberty Enlightening the World*, better known as the *Statue of Liberty* (FIG. 16-8), a colossal figure intended to commemorate a century of friendship between France and the United States. The idea to erect this monument, a gift from the French to the United States, had first come up during the Second Empire among a group of republicans led by Edouard Laboulayue. The fundraising campaign to pay for the work did not, however, start until after the Commune.

The commission for the *Statue of Liberty* went to Frédéric-Auguste Bartholdi (1834–1904), a sculptor with some experience in creating colossal monuments. For its location, Bartholdi chose Bedloe's Island (now Liberty Island) in New York harbor, where, he felt, the statue would be most visible. Having received the necessary permissions, he designed a sculpture that was specifically suited to the site. Because it would most often be seen from afar—from the decks of passenger ships or the shores of New York and New Jersey—he conceived of a figure with a simple

form and a dramatic silhouette. Instead of the Baroque intricacies of Dalou's *Triumph of the Republic*, he opted for a Classical allegorical figure with three clearly defined attributes—a helmet with sunray spikes, a torch, and a tablet.

These, of course, were not the traditional attributes of Liberty (see page 102) and their choice was significant. The replacement of the Phrygian bonnet by a spiked helmet was a considered response to the American dislike of the bonnet, which carried associations with both slavery and French revolutionary radicalism. Bartholdi may have derived the idea of the helmet from descriptions of the so-called Colossus of Rhodes, a lost mammoth sculpture of the sun-god Helios, which had stood astride the harbor of Rhodes in ancient Greece. The sense of "enlightenment" that the sun-spiked helmet suggested was reinforced by the torch. Both attributes referred to America's status as a shining beacon of freedom to the entire world. (Bartholdi positioned the statue to face Europe, because it was to the Old World, in particular, that America set an example.) Finally, the tablet nestled in the crook of Liberty's left arm is the law, which protects people's freedoms but also prevents freedom from turning into anarchy. It is inscribed with the date of the Declaration of Independence (1776), written in Roman numerals.

More than 150 feet tall, the *Statue of Liberty* could not be cast in bronze but required a new, industrial method of production. The colossal lady was constructed from beaten copper sheets that were riveted together and attached with iron braces to a central skeleton (FIG. 16-9). The architect Viollet-le-Duc (see page 262) and, after his death, the engineer Gustave Eiffel (see page 429) served as Bartholdi's technical consultants on the project, which was executed in Paris and then dismantled for shipping. Meanwhile, Americans had raised funds for a gigantic pedestal, which was designed by the well-known American architect Richard Morris Hunt (1827–1895). In 1886, 110 years after the Declaration of Independence, the *Statue of Liberty* was raised onto the pedestal and officially dedicated.

Mural Painting during the Third Republic

In addition to commissioning sculptural monuments, the national government and city councils throughout France also embarked on an active, even frantic program of mural commissions. To the ideologues of the Third Republic, mural painting was the public art form par excellence. Accessible to everyone free of charge, it was an "art for the people," suitable for the expression and propaganda of republican ideals. Thousands of murals were commissioned for all sorts of public buildings—town halls, court houses, museums, and the like.

One of the most ambitious mural programs centered on the Panthéon in Paris. As we have seen above (page 104), this building was conceived as a church under Louis XV but was turned into a mausoleum of the "great men of France" in 1791, at the height of the French Revolution. In the course of the nineteenth century the building alternated between being a church under Napoleon, a mausoleum under Louis Philippe, and a church once again under

16-9 Stage of construction of the Statue of Liberty. Photograph. Bartholdi Museum, Colmar.

Napoleon III. The government of the Third Republic was at a loss what to do with the building. Returning it to its status as a mausoleum for the "great men of France" smacked too much of the radical republicanism of the Jacobins. But leaving it as a church was a reminder of the building's royalist and imperialist past.

The vast program of mural commissions for the Panthéon, initiated in 1873, constituted an attempt to reach a compromise. The Panthéon was to remain a church, dedicated as before to the fifth-century French saint Geneviève, the patron saint of Paris. But by celebrating her life through a series of murals, it was also to commemorate the nation's history. In the words of Philippe de Chennevières, Minister of Fine Arts between 1873 and 1878, "The decoration of the Panthéon … should form a vast poem of painting and sculpture dedicated to the glory of Geneviève who

will remain the most ideal representative of our race's early history." To enhance the patriotic message of the Panthéon, Chennevières envisioned additional murals depicting scenes from the lives of other French Christian heroes, rulers, and saints, such as Joan of Art, Charlemagne, and St Louis. (The mural program of the Panthéon continued even after it was decided, upon the death of Victor Hugo in 1885, to turn the building once more into a national mausoleum, which it has remained to this day.)

Some of the most celebrated artists of the time were asked to contribute to the mural cycle in the Panthéon. In the end, however, it was a relatively unknown artist, Pierre Puvis de Chavannes (1824–1898), who painted two out of four of the murals dedicated to the life of St Geneviève. One of these, seen on one's right upon entering the Pantheon, is shown in FIG. 16-10. It includes three scenes

16-10 **Pierre Puvis de Chavannes,** *Legendary Saints of France and the Pastoral Life of St Geneviève,* installed in 1877. Oil on canvas. Panthéon, Paris.

16-11 **Piero della Francesca,** *Meeting between Solomon and the Queen of Sheba,* 1452–66. Fresco, 11' x 24'6" (3.36 x 7.47 m). San Francesco, Arezzo.

16-12 **Pierre Puvis de Chavannes,** *The Childhood of St Geneviève,* right panel of *The Pastoral Life of St Geneviève,* installed in 1877. Oil on canvas. 15'1" x 9'1" (4.6 x 2.78 m). Panthéon, Paris.

of Geneviève's childhood, including, in the center, the episode when Bishop Germain, traveling through the French countryside, is drawn to the seven-year-old girl who seems marked for sainthood. At first glance, Puvis's murals recall those by Hippolyte Flandrin in the church of Saint Germain (see FIG. 10-9). Particularly in the center mural, we notice a similar friezelike arrangement of figures and a related tendency to underplay perspective and preserve the impression of the flat surface of the wall. (That tendency is even more visible in the rectangular mural above the Geneviève scenes, which shows a procession of saints.) Puvis's mural is different from Flandrin's, however, in several respects. For one, it has an element of realism that is almost entirely absent from the hieratic idealism of Flandrin. This realism is particularly visible in the right panel, which depicts Geneviève's childhood in the French countryside. We see a woman milking a cow, men plowing the land, a little girl watching her younger siblings, and an old man limping around on his crutch. Clearly, this is not realism *à la* Courbet or Millet, since the figures are dressed in timeless garments and their bodies and faces are idealized. But the very presence of such down-to-earth details as chickens and chicks scurrying around among the figures would have been unthinkable in Flandrin's frescos.

In addition, Puvis's murals show a deliberate tendency towards simplification that may be compared with the works of the early Nazarenes (see page 159) and the Pre-Raphaelites (see page 326). Although Puvis seems to have had little interest in these artists' works, he was, like them, fascinated by fourteenth- and fifteenth-century Italian frescoes, especially those by Giotto (*c.*1267–1337) and Piero della Francesca (d. 1492). Puvis's mural may be compared with Piero's fresco titled *Meeting between Solomon and the Queen of Sheba* (FIG. 16-11) for the streamlining of the figures and

their quiet dignity and aloofness. His colors, however, call to mind the frescoes of Giotto, whose muted palette, he felt, lent itself best to architectural decoration. (Interestingly, Puvis himself did not practice the fresco technique. Instead, he painted his murals on canvas, which was subsequently attached to the wall surface.)

It is instructive to compare Puvis's murals with those by other artists working in the Panthéon, such as *St Geneviève on her Deathbed* (FIG. 16-13) by Jean-Paul Laurens (1838–1921). With its emphasis on spatial illusion and its realistic mode of representation, this mural has been conceived as a traditional easel painting. Instead of the simplification that makes Puvis's murals so easy to read, Laurens's complex multi-figure composition with its bright colors and abundant details seems disjointed, even muddled. Before he embarked on his mural, Laurens complained that the space

16-13 **Jean-Paul Laurens,**
St Geneviève on her Deathbed,
installed in 1882. Oil on canvas.
Panthéon, Paris.

available for his painting was too narrow to pack in all the figures he wanted to include. Unlike Puvis, he was unwilling to reduce their number in order to arrive at a satisfactory mural aesthetic (see also page 223). Instead he piled the figures on top of one another to create a mural that is difficult to comprehend at a glance.

The Third Republic and the Demise of the State-Sponsored Salon

The Third Republic marked a crisis in the state-sponsored Salon that would lead to its demise in 1880. This crisis had to do with the nagging question of the role of the Salon, which came to a head in the early 1870s. Was the Salon, as originally envisioned, an exhibition where the nation showed off the very best its artists had to offer? Or was it, as it had become during the July Monarchy and the Second Empire, a vast marketplace where the public could find works of art to decorate the home? The implications of this question were important. For the answer determined what would be shown at the Salon—large paintings depicting lofty scenes from history and literature, or mid- and small-size landscapes, genre paintings, portraits, and still lifes. Related to the question of the role of the Salon was the issue of the jury. Was it to be selected by academicians only, or by a democratic vote of all artists?

The conservative ministers or "directors" of Fine Arts, who were in charge of the Salons during the 1870s, felt that it was crucial for the prestige of the Third Republic that the Salon return to being a showplace of artistic excellence. As Charles Blanc, Director of Fine Arts between 1870 and 1873, said, "the state exhibits [art] works and not products, it sponsors a Salon and not a bazaar." Although Blanc and his successor Philippe de Chennevières (Director, 1873–8) both wished to remake the Salon into an exclusive place for serious art of the highest quality, in practice they were not successful. While Blanc managed to keep the number of admissions to the Salons of 1872 and 1873 down to a little more than 2,000, under de Chennevières the numbers climbed up again, reaching an all-time high of 7,289 admissions in 1880. Seeing that the state could not gain effective control of the Salon, the government cut the exhibition loose and handed its organization over to artists. Henceforth, the Salons were run by the Society of French Artists. The state, meanwhile, sponsored an exclusive triennial exhibition of the loftiest examples of French art.

The Society ran nine Salons between 1881 and 1889 but, before long, it was challenged by artists who found its leadership to be just as conservative and oppressive as the government's had been. A number of these objectors founded the Society of Independent Artists, which organized its first Salon in 1884. The Society of French Artists itself split into two rival associations in 1890, each of which

organized its own Salon. In addition, in 1883 and 1886 the state sponsored two triennial exhibitions, to be followed by the Paris World Fair exhibition in 1889. With so many large art shows, Paris continued to be the art capital of Europe. But it had lost the artistic core that the official Salon had provided since the late eighteenth century.

Academic and Realist Art at the Salons of 1873–90

During the last ten years of its existence, the official Salon still played a major role in the artistic world of France. The numbers of exhibited works set all-time records and the public came in hordes. The Salon of 1874 drew 400,000 visitors in six weeks. On the first Sunday opening (when entrance was free of charge) 30,000 visitors attended. Even after it was taken over by the Society of French Artists, the Salon continued to attract both numerous submissions from artists and large crowds of visitors. Indeed, it was not until the Society split in 1890 that the importance of the Salons began to decline.

Throughout the 1870s and 1880s most artists, conservative or avant-garde, continued to look to the Salon as a vehicle for gaining both exposure and recognition. As late as 1881 the Impressionist painter Auguste Renoir (1841–1919) wrote to his dealer, Durand-Ruel: "In Paris there are barely fifteen collectors capable of liking a painter without the backing of the Salon. And there are another eighty thousand who won't buy so much as a postcard unless the painter exhibits there."

Among the most celebrated artists who regularly exhibited at the Salons of the 1870s and 1880s was William Bouguereau (1825–1905). His *Young Girl Defending Herself against Eros* (FIG. 16-14), shown at the Salon of 1880, exemplifies the polished, seductive prettiness of much of academic painting in the last decades of the nineteenth century. The painting's subject is rather absurd, at least to modern eyes. A young girl seated on a block of stone is warding off Cupid, who must be read as an allegory of masculine libido. Her struggle does not show much conviction, however, because she pushes away Cupid playfully, coyly showing off her naked body to its best effect. The mild eroticism of the scene is matched by the sensuous contours of the two bodies, the subtle *chiaroscuro*, and the muted colors. Nothing here is dramatic or tense; everything is soft, pretty, and relaxed. No wonder that Bouguereau's paintings had a tremendous appeal in North America, where the busy tycoons of the Gilded Age snapped up his works to decorate their newly built homes.

16-14 **William Bouguereau,** *Young Girl Defending Herself against Eros,* 1880. Oil on canvas, 5'3" x 3'9" (1.6 x 1.14 m). University of North Carolina, on loan to the North Carolina Museum of Art, Wilmington.

16-15 **Jules Breton,** *Song of the Lark*, 1884. Oil on canvas, 43 x 33" (1.1 m x 85.7 cm). Art Institute of Chicago.

While Bouguereau represents popular academic art of the Third Republic, Jules Breton (1827–1906) represents popular Realism. To the extent that his paintings became more sentimental, in the course of the 1870s and 1880s, they became more popular with the general public. *Song of the Lark* (FIG. 16-15) of 1884 shows a young peasant girl, sickle in hand, on her way to work in the early morning. As the sun rises dramatically behind her, she looks up to listen to the song of a skylark. The painting's positive image of an ingenuous peasant girl awakening to the beauty of the world could not fail to appeal to a bourgeois public that liked to think of the lower classes as content with the little pleasures life had to offer. Like Bouguereau's works, Breton's were extremely popular in the United States. *Song of the Lark* was bought by an American collector and ended up in the Art Institute of Chicago where, for decades, it was the museum's most popular picture. It even inspired a novel, Willa Cather's *Song of the Lark* (1915), which deals with a girl from the prairie who becomes an artist.

Naturalism at the Salons of 1870–90

In addition to Breton, a number of other peasant painters emerged at the Salons of the 1870s and 1880s. Best-known among them was Jules Bastien-Lepage (1848–1884), a prime representative of a new direction in painting referred to by contemporary critics as Naturalism. While the exact definition of Naturalism has been and continues to be

16-16 **Jules Bastien-Lepage,** *The Haymakers*, 1878. Oil on canvas, 61 x 70⅞" (1.55 x 1.8 m). Musée d'Orsay, Paris.

much debated, it was basically a revised form of Realism, without the political or sentimental overtones of the works of Courbet, Millet, or Breton. In addition, Naturalism was devoid of all overt references to past art. Instead, it was based on the direct observation of carefully staged scenes that imitated real-life situations. Naturalism differed from contemporary Impressionism, which also placed a premium on direct observation (see page 379) in its preference for detail and careful finish. Many Naturalist painters, including Bastien-Lepage (who had studied with Alexandre Cabanel), followed a technical procedure that was similar to academic painting. Naturalists, moreover, were primarily attracted to the depiction of peasant life, while the Impressionists, as we shall see, focused on the leisure life of the bourgeoisie.

The Haymakers (FIG. 16-16), exhibited at the Salon of 1878, exemplifies Bastien-Lepage's Naturalist mode of painting. It shows a young peasant couple resting in a field after their midday soup. The man is fast asleep, his straw hat pulled over his eyes, but the woman is sitting up, dazed from her nap, staring vacantly into the distance. Bastien-Lepage's painting differs from Courbet's *The Stonebreakers* (see FIG. 11-7), Millet's *The Gleaners* (see FIG. 12-25), or even Breton's *Song of the Lark* in its light, fresh tonality. Like the Impressionists, the Naturalists put a premium on *plein-air* or open-air painting, preparing their sketches and sometimes even their finished paintings entirely out of doors. Their light, true-to-life colors, combined with a meticulous finish, give their paintings an almost photographic effect.

16-17 **Jules Bastien-Lepage,** *Joan of Arc Listening to the Voices,* 1879. Oil on canvas, 8'4" x 9'1" (2.54 x 2.79 m). Metropolitan Museum of Art, New York.

Recent research has shown that many Naturalists used photographs as aids in painting their pictures, although some vehemently denied it and destroyed all evidence. (Bastien-Lepage may have been among them, for no preparatory photographs for his works are known.) Other painters, however, were quite candid about their use of photography and carefully kept their negatives, just as they kept their preliminary drawings. In assessing the relative importance of photography for the Naturalists, it is important to remember that color photography had not yet been invented. Thus photographs were important primarily as reference tools for composition and drawing. For color, artists still had to rely on the study of real life.

The photographic quality of Bastien-Lepage's work is even more pronounced in his famous *Joan of Arc Listening to the Voices* (FIG. 16-17), which must be called a naturalistic

work even though it depicts a historic subject. The painting received a mixed reception at the Salon of 1880 precisely because it occupied such an ambiguous position midway between history painting and the depiction of real life. The subject of Joan of Arc, popular throughout the nineteenth century, had gained renewed poignancy after the Franco-Prussian war, because the Germans had annexed the Lorraine region of north-eastern France where Joan of Arc was born. Bastien-Lepage, himself a native of Lorriane, chose to depict Joan of Arc not in the usual way— as a heroine clad in full armor leading the French troops to victory—but as a young Lorraine peasant girl receiving her divine calling. Joan is standing behind her parents' little cottage in the hamlet of Domrémy, seemingly enraptured by the sound of saintly voices speaking to her. The viewer is awed by the verisimilitude of the picture,

both in the representation of Joan herself and in the rendering of the peasant garden. Yet as the eye turns from Joan to the spinning wheel, which she has knocked over in this moment of ecstasy, one becomes aware of the ethereal forms of saints Michael (in armor), Margaret, and Catherine. Contemporary critics blamed Bastien-Lepage for the way in which he combined elements of reality and fantasy in his picture. They failed to realize that he wished to emphasize the reality of Joan's vision in order to explain her extraordinary accomplishments in the months to come. His ingenuous blending of realism and fantasy is matched by his combination of areas that are extremely finished with others that are loosely brushed, almost resembling Impressionist works.

Although Bastien-Lepage's artistic output was limited, because of his early death at the age of 36, his influence was far-reaching and long-lasting. He may be seen as the father of an international Naturalist movement that, in some countries, lasted well into the twentieth century (see page 435).

Manet at the Salons of the 1870s and 1880s

Surrounded by the canvases of Bouguereau, Breton, and Bastien-Lepage, the works of Manet continued to strike a dissonant note, even though, by the 1870s, the artist had abandoned the shocking subject matter of the *Déjeuner sur l'herbe* and *Olympia*. *Railroad* (*Gare St-Lazare*; FIG. 16-18), the only one of three pictures by him admitted to the Salon of 1874, shows a scene from contemporary urban life. At the Gare St-Lazare (St-Lazare Station) a young woman and a little girl are waiting near a black iron fence that spans the width of the canvas. The woman, wearing a simple dark-blue dress and a black hat, sits on the masonry base that anchors the fence. Aware of our presence, she looks up from her reading, marking with her finger the place in the book where she has left off. Meanwhile, the little girl in her pretty white frock is fascinated by the urban life beyond the fence. She turns her back as if oblivious to our presence. We, the viewers, are cast in the role

16-18 **Edouard Manet,** *Railroad (Gare St-Lazare),* 1873. Oil on canvas, 36 x 45⅛" (93.3 cm x 1.15 m). National Gallery of Art, Washington, DC.

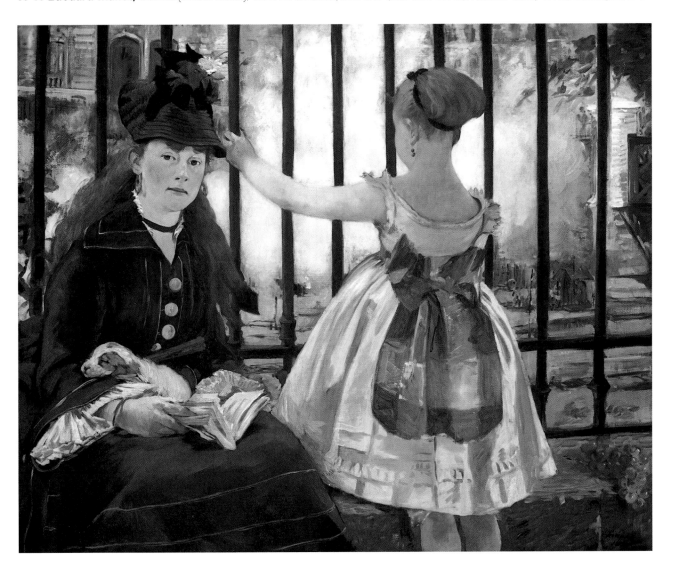

of passers-by. The scene suggests one of those fleeting moments in modern life when our eyes momentarily meet those of a stranger in the crowd and when, for just a second, we consciously isolate and register a visual sensation within the continuous bombardment of visual stimuli that hit our eye. The impression of the picture as a fleeting moment is further enhanced by the sketchy, loose brushwork. Some parts of the painting, like the girl's hand, seem hardly finished. The lack of definition is even more pronounced in the background of the painting, where a huge cloud of steam, apparently coming from a train, blurs the view.

Contemporary critics were at a loss how to deal with this picture. Although it was not blatantly offensive, as was Manet's earlier *Déjeuner* and *Olympia* (see FIG. 12-31, FIG. 12-35), it was nevertheless startling because it was so entirely devoid of beauty, sentiment, and narrative. That caused the subject to be, as one critic put it, "unintelligible." "Properly speaking," he wrote, "there was no subject at all; no interest attaches to the two figures because of what they are doing." Humor was one way of coping with this work, and it was the subject of numerous jokes and caricatures. In a cartoon by the well-known caricaturist Cham

(pseudonym of Count Amédée-Charles-Henry de Noé), the young woman has become a drunken witch and the puppy on her lap a baby seal, while the extended arm of the little girl has been stretched to ridiculous proportions. The caption reads: "Manet. The Lady with the Seal. These unfortunate creatures, seeing themselves painted this way, wanted to flee. But he [Manet], foreseeing this, has introduced a fence, which makes it possible for them to retreat."

Only a few critics defended Manet, such as the one who wrote: "I should understand how one might disapprove of the style of the work and even that one could grow indignant. But what is the problem? What has the painter wanted to do? To give us a truthful impression of a familiar scene." That defense sounds so simple as to be almost worthless. Today we are used to the idea that even the most trivial scene or object from daily life can be the subject of art or even art itself. But the nineteenth-century imperative that art should teach a moral lesson or evoke a powerful sentiment dictated that it should have a meaningful subject. To concede that a painter need only evoke a glimpse of modern life to create a work of art was quite a revolutionary statement.

16-19 **Edouard Manet,** *A Bar at the Folies Bergère,* 1881–2. Oil on canvas, 37¹³/₁₆ x 51" (96 cm x 1.3 m). Courtauld Institute Galleries, London.

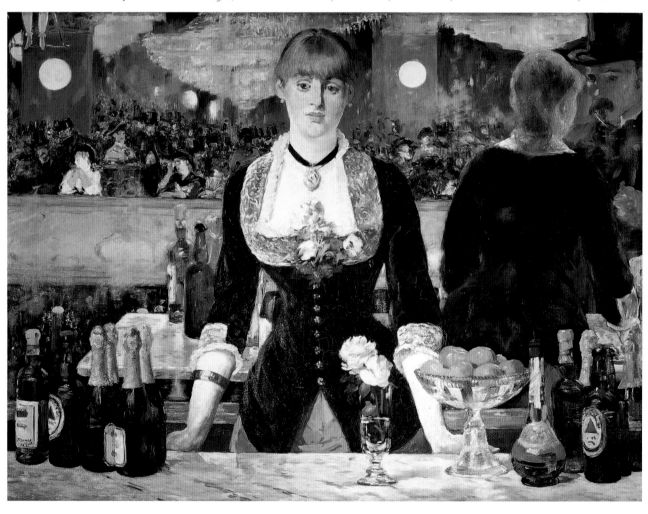

If the meaning of the *Railroad (Gare St-Lazare)* was unclear to many, so was that of Manet's last major painting, *A Bar at the Folies Bergère* (FIG. 16-19), submitted to the Salon of 1882. The painting is centered on a young barmaid, who glances at the viewer from behind a marble counter covered with bottles and glassware. Behind her is a huge wall mirror in which we see the reflection of the Folies Bergère, one of the most famous variety nightclubs of late nineteenth- and twentieth-century Paris. Also in the mirror, though apparently at an incorrect angle, we see the barmaid's back and a man with a droopy mustache, who appears here as a stand-in for us, the viewers. We do not know whether he is ordering a drink or propositioning her. The barmaid's face is aloof and emotionless, showing only boredom and indifference to the customer—one of countless men who, night after night, ask for drinks or the price of her after-hour services. Like the *Railroad (Gare St-Lazare)*, *Bar at the Folies Bergères* suggests that the essence of modernity is the fleeting encounter, the superficial contact that leaves no lasting impression.

Salon Alternatives

In addition to the growing number of Salons, art galleries played an important role in bringing art to the attention of the public. Dealers such as Paul Durand-Ruel (see page 266) and Georges Petit (1856–1920) organized exhibitions in their elegant galleries. Although these could not compete in numbers with any of the Salons, they offered a much more pleasant viewing experience (see FIG. 16-20).

Especially equipped for art exhibitions, with expensive textile wall hangings and gas spotlights (for evening viewing), dealer exhibitions surpassed the Salons in the tasteful presentation of art works and in the coherence of their arrangements. Moreover, unlike the Salons, which were open four to six weeks a year, galleries were open year-round.

If all these exhibitions were not enough, during the 1870s and 1880s there were artists' initiatives that aimed at organizing private and group shows in borrowed or rented spaces. Courbet and Manet had given the example for such initiatives with their private exhibitions of the 1850s and 1860s. But neither artist had continued his efforts, because both still looked upon the Salon as a major site of exposure and marketing potential. By contrast, during the 1870s and 1880s there was at least one effort to bypass official government shows and maintain autonomy from dealers by creating an independent market for new and innovative art. This initiative was taken by a group of artists, many of them admirers of Courbet and Manet, who had been trying in vain to break through the conservatism of Salon juries since the mid-1860s. Exasperated by the severity of the juries of the Salons of 1872 and 1873, these artists incorporated as the so-called Private Company of Artists, Painters, Sculptors, Engravers, Etc. in December 1873. Between 1874 and 1886 this cooperative organized eight group shows known today as the Impressionist exhibitions. In so doing they cast themselves in the role of an artistic avant-garde, determined to go their own way and willing to face all forms of criticism.

16-20 **E. Bichon,** *Exhibition of Watercolors in the Durand-Ruel Gallery,* 1879. Wood engraving. Durand-Ruel Archives, Paris.

16-21 **Claude Monet,** *Impression, Sunrise,* 1872. Oil on canvas, 18⅞ x 24" (48 x 63 cm). Musée Marmottan, Paris.

Origin and Definition of the Term "Impressionism"

The first exhibition organized by the Private Company of Artists took place in the recently vacated studio of the photographer Nadar (see page 290). It featured more than 150 works by 33 artists, and was well attended. Some 30,500 visitors came during the four weeks of the show, which was announced and reviewed in several papers.

One of the reviews, by a certain Louis Leroy, was entitled "The Exhibition of the Impressionists." Leroy had taken his cue from a landscape painting by Claude Monet (1840–1926) entitled *Impression, Sunrise* (FIG. 16-21). This painting and its title became the target of all the resentment that Leroy felt towards the exhibition. His nickname, "Impressionists," was meant to mock the artists whose work, he felt, was "an attack on proper artistic custom, on the cult of form, and the respect for the masters."

Today the term "Impressionist" is applied to only a fraction of the fifty or sixty artists who participated in the eight exhibitions of the Private Company of Artists. Among them were, most importantly, Frédéric Bazille (1841–1870), Gustave Caillebotte (1848–1894), Mary Cassatt (1844–1926),

Edgar Degas (1834–1917), Claude Monet, Berthe Morisot (1841–1895), Camille Pissarro (1830–1903), Auguste Renoir, and Alfred Sisley (1839–1899). At the time of the first Impressionist exhibition in 1874, most of these artists were in their mid-thirties. They had submitted works to the Salon since the mid-1860s, with little success. Their works had either not been accepted or had remained unnoticed.

The indifference of both juries and critics to the works of these young artists had to do with their subject matter as well as their mode of painting. For the most part, their paintings depicted landscapes and genre scenes, subjects less valued than history or portrait painting. Their genre painting, moreover, did not fit traditional categories of historic or peasant genre. Instead, they depicted the life of the contemporary bourgeoisie, focusing in particular on leisure situations. These young artists deliberately defied academic principles in the execution of their paintings. Admirers of Manet, they followed his example of underplaying or even negating *chiaroscuro*. Some also flouted traditional rules of composition, while others neglected to "finish" their paintings, deliberately leaving them in a sketchlike state.

Indeed, many of these young artists strove for a mode of painting that, like the academic oil sketch, would faithfully and immediately reproduce the artist's perception. Unlike the Naturalists, who wanted to "freeze" reality like a photograph, the Impressionists wanted somehow to suggest the constantly changing aspect of reality. More than any artists before them, with the possible exception of Delacroix, they were interested in the nature of seeing. They were fascinated by exploring how people look at the world and what they really see. Some landscape painters, such as Monet, Pissarro, Morisot, and Sisley, were obsessed with the fact that the visual world is in constant flux. Others, like Degas and Cassatt, realized that the neatly composed, perfectly centered images of reality that one sees in traditional paintings do not correspond to the random ways in which we normally view the world.

Claude Monet and the Impressionist Landscape

Monet's *Impression, Sunrise* exemplifies the novel vision of the Impressionists. It depicts the harbor of Le Havre, the port city in Normandy where he had spent his youth. The sun rises behind the high horizon, a red-hot disk burning through the early morning fog. Two rowboats are silhouetted against the light, scintillating water. In the distance, through the mist, we see a ghostlike forest of smokestacks and tall masts.

It is not hard to understand why this painting infuriated Leroy. It is painted in a sketchy manner, with loose, choppy brushstrokes that, seen up close, boldly assert that they are nothing but dabs of oil paint hastily applied to a canvas. Yet when one steps away from the painting a miraculous thing happens: as the strokes and colors blend in the viewer's eye, one suddenly sees the rippling of the water, the vibrations of the air, and the gentle movement of the smoke from the stacks mixing with the fog. Thus, paradoxically, the same picture that reminds the viewer that a painting is nothing but a mass of brushstrokes on a flat canvas surpasses earlier landscape paintings in its powerful evocation of the shimmering effect of light and atmosphere.

To understand the effect of Monet's work on contemporary viewers like Leroy, one need only compare it with Bouguereau's *Young Girl Defending Herself against Eros* (see FIG. 16.14). In Bougereau's work, as in most Salon paintings, the figures and the landscape background are painted in a way so as to dissimulate, even negate the brushwork. In Monet's work, by contrast, the brushwork attracts our attention. Had Monet exhibited *Impression, Sunrise* as a "sketch," Leroy might have been less critical of it. Within the Academy, it was acceptable, even commendable for an oil sketch to be loosely painted, with broad, free strokes. In the 1860s and 1870s it had become common practice for artists to submit sketches to the Salon, which were considered for exhibition as long as they were listed in the catalog as "sketch." But Monet did not call his work a sketch. In the catalog of the first Impressionist exhibition, the word *etude*, sketch, was not mentioned in any of his entries.

Monet's decision to eliminate the distinction between sketch and finished painting had occurred sometime between 1869 and 1874. In the summer of 1869 he had painted two pictures of a popular bathing place on the River Seine called La Grenouillère, or The Frog Pond (see FIG. 16-22). Anticipating *Impression, Sunrise* in their loose and spontaneous brushwork, they were intended as preliminary

16-22 **Claude Monet,** *La Grenouillère* (The Frog Pond), 1869. Oil on canvas, 29³⁄₈ x 39" (74.6 x 99.7 cm). Metropolitan Museum of Art, New York.

sketches for a large tableau or finished painting that Monet intended to submit to the Salon of 1870. But that painting never materialized, both for personal and artistic reasons. At the outbreak of the Franco-Prussian War in 1870, Monet left for London, to avoid being drafted. There he must have seen the works of Turner, whose bold brushwork may have set him thinking about the artificiality of the boundary between sketch and finished painting and about the possibility of producing exhibition paintings that retained the freshness and freedom of the sketch. Four years later, at the first Impressionist exhibition, he exhibited one of his sketches for the *La Grenouillère* as if it were a finished work.

Of crucial importance to Monet's decision to ignore the boundary between sketch and finished painting was his growing conviction of the absolute necessity to paint landscapes outdoors. The traditional distinction between the landscape sketch and the finished painting had been that the first was painted outdoors, while the second was done in the studio. Monet, who had sketched outdoors since he was an aspiring artist in Normandy, came to the conclusion that it was impossible to paint finished landscapes indoors and retain the effect of the firsthand impression of light and atmosphere. To him, landscapes had to be done outdoors, on the spot, enabling artists to translate their visual sensations into paint immediately. At the same time, he realized that, to achieve that goal, the carefully finished paint surface of academic painting was altogether unsuited.

Other Impressionist Landscape Painters: Pissarro and Sisley

Monet was not the only artist who was interested in *plein-air* painting. In the 1850s outdoor sketching in oils had become a common practice, facilitated by the invention of paint in tubes. Most Barbizon artists sketched outdoors, as did Courbet. Monet's own *plein-air* practice had been encouraged by Eugène Boudin (1828–1898), a local Norman painter who produced fashionable beach scenes for sale to summer tourists. Boudin's works were based on numerous sketches made outdoors (FIG. 16-23), often in the company of Monet. Monet, in turn, appears to have encouraged other artists to leave the studio. In Paris, as a student of the academic painter Charles Gleyre (1806–1874), he had befriended Auguste Renoir, with whom he went sketching frequently. In 1869 Renoir worked with him at La Grenouillère, where he sketched the same scene that we have seen in Monet's work (FIG. 16-24).

In Gleyre's studio Monet had likewise met Frédéric Bazille and Alfred Sisley, who, like the Barbizon school artists, often sketched in the forest of Fontainebleau. Moreover, at the so-called Académie Suisse, a "drop-in" studio where artists could, for a small fee, draw from the nude, he had met Camille Pissarro and Paul Cézanne (1839–1906), who were also attracted to landscape painting outdoors.

All these artists eventually joined Monet in founding the Private Company in December 1873, because they had experienced similar difficulties in getting admitted to the Salon. To Leroy, their works looked so similar that he felt justified in calling them all "Impressionists." Yet in so doing he ignored the fact that the various members of the group were attracted to different types of landscape scenery and approached it in different ways. The works of Pissarro and Sisley may serve as an example.

Pissarro's *White Frost* (FIG. 16-25) shows a rural landscape near Pontoise, a small village outside Paris where the artist lived during the early 1870s. Such rural scenes are rare in the work of Monet, who preferred to center his landscapes on water. Pissarro's different brushwork was, in part, a result of his specific subject matter. Monet's broad, horizontal strokes, so effective for water scenes, were not suited to

16-23 **Eugène Boudin,** *The Beach at Trouville,* 1865. Oil on canvas, 10⅜ x 16" (26.5 x 40.5 cm), Musée d'Orsay, Paris.

16-24 **Pierre-Auguste Renoir,** *La Grenouillère,* 1869. Oil on canvas, 26 x 31⅞″ (66 x 81 cm). Nationalmuseum, Stockholm.

16-25 **Camille Pissarro,** *White Frost,* 1873. Oil on canvas, 25⅝ x 36⅝″ (65 x 93 cm). Musée d'Orsay, Paris.

16-26 **Alfred Sisley,** *Inundation at Loge Island,* 1872. Oil on canvas, 17 x 23⅜" (45 x 60 cm). Ny Carlsberg Glyptotek, Copenhagen.

the painting of frozen fields. Pissarro, instead, used short, fuzzy dabs of paint that seem to meld together. Keenly sensitive to the effects of light and atmosphere, he knew how to translate them into paint. In *White Frost* the long, watery-blue shadows cast by an invisible row of poplar trees beautifully suggest the clear, thin light of a bright winter day.

Like Monet, Alfred Sisley was interested in water. He never painted harbors or the sea, but was fascinated by rivers. Although he moved frequently in the course of his career, he always lived close to the Seine river or its tributaries. *Inundation at Loge Island* (FIG. 16-26), exhibited at the first Impressionist exhibition, depicts a river flooding, a frequent occurrence in the Seine system. A common subject in Sisley's art, river floodings offered the artist an opportunity to paint vast expanses of water, punctured by vertical elements such as houses, trees, and telegraph poles. Perhaps because of his British descent, Sisley seemed more attracted to the subdued, gray light of rainy days than to the sparkling sunlight effects that Monet so often depicted.

Monet's Early Painting Series

Throughout his career, Monet remained primarily focused on landscape painting, constantly experimenting with new kinds of subject matter and new ways of rendering light and atmosphere. At the third Impressionist exhibition of

16-27 **Claude Monet,** *Gare St-Lazare, Paris,* 1877. Oil on canvas, 32 x 39" (82 cm x 1 m). Fogg Art Museum, Harvard University Art Museum, Cambridge, Massachusetts.

16-28 **Claude Monet,** *Manneporte, Etretat,* 1883. Oil on canvas, 25⅝ x 31⅞" (65 x 81 cm). Metropolitan Museum of Art, New York.

1877 he exhibited three paintings of the Gare St-Lazare in Paris (one is seen in FIG. 16-27). The scenery depicted in these paintings is far removed from his earlier harbor, sea, and river canvases. Instead of trees, sky, and water, we see dark locomotives, the glass roof of the station overhead, and the dirty gravel under the railroad tracks. Altogether, Monet made twelve paintings of the station, seen from various viewpoints and at different times of day. The series leads the viewer on a tour of the station and impresses him or her with the endless variety of spectacles it has to offer. With their trains coming and going, their billowing steam clouds evaporating into the air, their passengers hurrying along the platforms, the paintings in the *Gare Saint-Lazare* series exemplify modern life, in all its chaos and instability.

In the course of the 1890s Monet became increasingly interested in creating groups of paintings of the same subject. Between 1883 and 1886, during lengthy summer vacations spent at or near Etretat, on the Atlantic coast, he made dozens of paintings of the steep chalk cliffs. In

do doing, he became fascinated by the effects on the rocks of the changeable light, caused by the movement of the sun and the inconstant weather.

In one of these paintings, a close-up view of the dramatic Manneporte rock (FIG. 16-28), the rock is composed of thin, straight strokes of orange, pink, blue, violet, green, and yellow. Instead of painting it beige-gray—as he "knew" it to be—Monet tried to forget what he was looking at to capture the shifting sensations of color, caused by the reflection and refraction of light by the chalky, irregular rock surface. A few years later, he recommended to a young American artist Lilla Cabot Perry (1848–1933): "When you go out to paint, try to forget what objects you have before you— a tree, a house, a field, or whatever. Merely think, here is a little square of blue, here an oblong of pink, here a streak of yellow, and paint it just as it looks to you, the exact color and shape …" He added that he "wished he had been born blind and then had suddenly regained his sight [so] that he could have begun to paint in this way without knowing what the objects were that he saw before him."

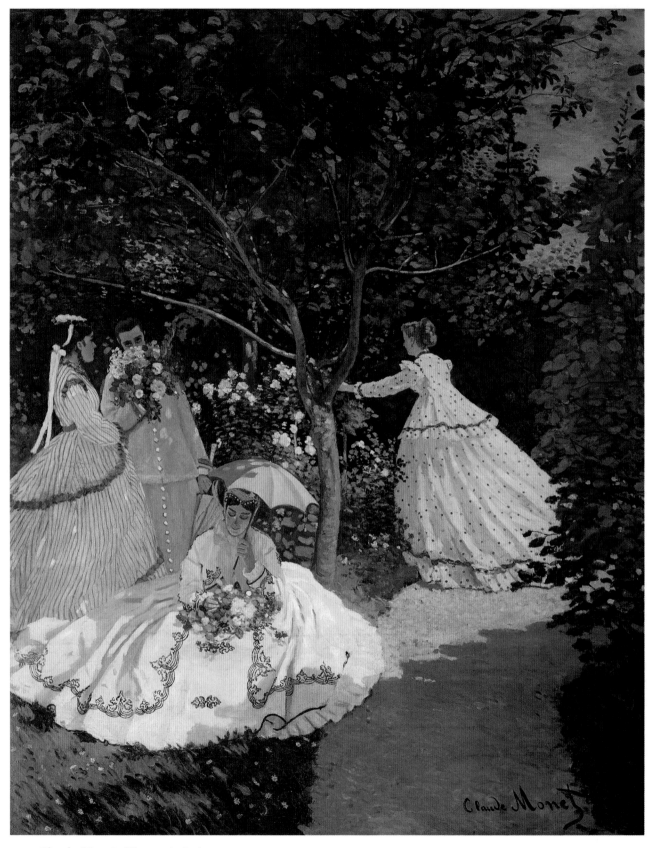

16-29 **Claude Monet,** *Women in the Garden,* 1866–7. Oil on canvas, 8'4" x 6'8" (2.55 x 2.05 m). Musée d'Orsay, Paris.

It has been suggested that a connection may exist between the Impressionist way of seeing and contemporary scientific theories of vision, notably those of the German Hermann von Helmholtz, whose two-volume *Handbook of Physiological Optics* was published in Germany between 1656 and 1867. In the second volume of this book, Helmholtz noted that our brains often adjust what we see in reality to what we know or expect, causing our perception to be inadequate. To improve perceptions, Helmholtz encouraged viewers to focus attention on "individual sensations." If we do so, Helmholtz suggested:

> We have no difficulty in recognizing that the vague blue-gray of the far distance may indeed be a fairly saturated violet and that the green of vegetation blends imperceptibly through blue-green and blue into this violet, etc. This whole difference seems to me to be due to the fact that the colors have ceased to be distinctive signs of objects to us, and are considered merely as being different sensations.

Impressionist Figure Painting

Impressionist painting was not limited to landscape; it also encompassed the human figure. It is possible to distinguish two categories of Impressionist figure paintings. In the first, figures are rendered in an outdoor setting; in the second, they are placed in an urban context. In both categories, the figures are dressed in contemporary, bourgeois clothes and are engaged in some kind of leisure activity. Those in outdoor settings are shown strolling, picnicking, boating, and so on., while the protagonists of urban scenes are sitting in cafés and theatres, or, more rarely, at home. Urban figure paintings may also depict the providers of bourgeois entertainment—such as ballet dancers, cabaret singers, circus artists, barmaids.

Their emphasis on bourgeois leisure life sets the Impressionists apart from both the Realists and the Naturalists, who focused on the working life of peasants and the urban poor. Impressionist pictures appear less politically charged than those of their Realist and Naturalist colleagues, whose works often seem intended to make bourgeois viewers feel guilty about their material comforts.

The subject of bourgeois leisure life was modern, par excellence. Leisure, a by-product of capitalism, was a new phenomenon in the second half of the nineteenth century, when most middle-class people were no longer forced to work throughout the year in order to make a living. Excess capital and new forms of transportation allowed them to spend part of the summer away from home, on vacation. In addition, new technologies of illumination enabled a vast expansion of recreational nightlife, ranging from nightclubs such as the Folies Bergère to operas, theatres, cafés, and cabarets. Bourgeois women, who were not expected to work at all, were the main protagonists of leisure life.

Monet's early *Women in the Garden* (FIG. 16-29) launched Impressionist outdoor figure painting. Begun during the summer of 1866 and completed in the spring of 1867, it was the artist's second attempt at emulating Manet's *Déjeuner sur l'herbe*. The first attempt, an enormous painting three times the size of Manet's *Déjeuner* and intended for the Salon of 1866, was never completed. From a preliminary sketch and two fragments of the unfinished painting that remain we know that it depicted a group of young men and women gathered in the woods for a picnic.

Women in the Garden, submitted to the Salon of 1867 but refused, was more modest, though still monumental (roughly 8 by 6 feet). Using his wife as a model, Monet painted four fashionably-dressed women in an elegant garden, picking flowers to make bouquets. Rather than painting this large canvas in the studio, using outdoor sketches, Monet, in an unprecedented move, painted the entire picture outdoors. In so doing, he hoped to capture with full accuracy the effects of sunlight and atmosphere on the human figure.

It is instructive to compare Monet's painting with Manet's *Déjeuner sur l'herbe*. At the Salon des Refusés of 1863 Monet and his friends had admired this painting both for the audacity of its subject matter and for Manet's attempt to narrow the gap between perception and representation. Yet in his *Women in the Garden* Monet went well beyond Manet. The latter had still painted his work in the studio, which accounts for a certain discrepancy between the figures, which were painted from models posed in the studio, and the landscape setting, which was based on sketches made outdoors. Monet achieved much greater coherence between figures and background by basing the entire picture on direct observation. As in Manet's *Déjeuner*, the figures in *Women in the Garden* look flat, for Monet has almost completely abandoned *chiaroscuro*. Where shading does occur, as in the face of the seated woman in the foreground, it is not grayish or beige, as in traditional paintings, but tinted green. Like Delacroix, who had made this observation several decades earlier (see page 212), Monet noted that shading and cast shadows are tinted by the reflections of surrounding colors, and he painted them that way.

Although Monet's *Women in the Garden* was not exhibited at the Salon, it became well known among his friends and young French painters in general. They were excited by Monet's success in painting the figure outdoors, because many of them had toyed with the idea themselves. Paul Cézanne, for example, wrote to Emile Zola, in 1866:

> But you know all pictures [*tableaux*] painted inside, in the studio, will never be as good as those done outside [*en plein air*]. When out-of-door scenes are represented, the contrast between the figures and the ground is astounding and the landscape is

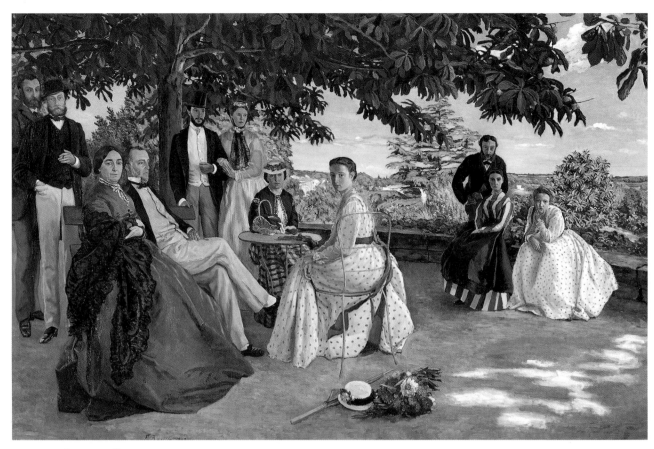

16-30 **Frédéric Bazille,** *The Family Gathering,* 1867. Oil on canvas, 5' x 7'6" (1.52 x 2.3 m). Musée d'Orsay, Paris.

16-31 **Pierre-Auguste Renoir,** *Ball at the Moulin de la Galette,* 1876. Oil on canvas, 51 x 69" (1.3 x 1.75 m). Musée d'Orsay, Paris.

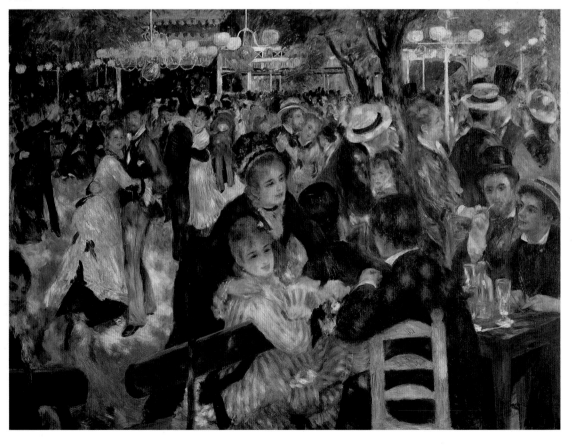

magnificent. I see some superb things and I shall have to make up my mind only to do things out-of-doors.

One of the first works painted after Monet's example was *Family Gathering* (FIG. 16-30) by Frédéric Bazille, a fellow student of Monet in the atelier of Gleyre. Bazille is little known today, for he painted only a handful of works. A soldier in the Franco-Prussian War, he was killed at the age of 29. *Family Gathering* was exhibited at the Salon of 1868, where it was seen by Zola, who wrote in a review: "One can see that the painter loves his time, like Claude Monet, and that he believes one can be an artist while painting a frock-coat."

The painting, comparable in size to Monet's, depicts a gathering of bourgeois on a terrace, dressed in their Sunday best. Its original title, *Portrait of the *** Family*, indicates that this is not a casual gathering but a family portrait (indeed of Bazille's own family), not unlike the numerous family photographs that were made at holiday gatherings (see the photograph of Victoria and Albert and their family; FIG. 14-1). The figures are carefully, even stiffly posed, though clearly with a view to create a sense of informality. They are not lined up in a row, like the British royal family, but are freely distributed across the terrace, some standing, others seated, in a seemingly casual fashion. Like Manet, Bazille was greatly preoccupied with the integration of the figure in the outdoor setting, and he paid much attention to the light. His painting evokes beautifully the soft, dappled light of the tree-shaded terrace. Only in the representation of the figures was Bazille less daring than Monet, because he maintained the careful modeling of bodies and faces that he had learned in Gleyre's studio.

Neither Monet's *Women in the Garden* nor Bazille's *Family Gathering* shows the choppy brushwork that was to characterize Impressionist landscape painting from the late 1860s. The first artist to apply the Impressionist brushstrokes to figure painting was Monet's close friend Renoir. His *Ball at the Moulin de la Galette* (FIG. 16-31) represents a popular café in Montmartre, then still a largely rural area of Paris. The large garden of the café housed an old windmill, where young people came to dance every summer Sunday to the music of a band. To suggest the liveliness of this outdoor ball, Renoir used short brushstrokes of color, freely applied. He aimed at evoking the movement of dappled light across the figures, the shimmering of hair and satin dresses, and the reflection of light in the glassware on the table.

Renoir's painting differs from Monet's and Bazille's not only in its brushwork, but also in its more engaging quality. The aloof figures of *Women in the Garden* and *Family Gathering* seem related to the stiff-posed figures in photographs. Renoir's painting, however, is closer to traditional genre painting in that the figures interact with one another.

In the foreground, a girl and her chaperone talk to a young man, while his friends look on in amusement. Behind them, couples are dancing and kissing. It is easy to relate to the figures in the painting and to imagine oneself to be part of the scene.

Impressionism and the Urban Scene: Edgar Degas

Dancing Class (FIG. 16-32) by Edgar Degas, shown at the second Impressionist exhibition of 1876, differs so dramatically from all the Impressionist paintings we have seen so far that we may wonder if the term "Impressionist" is even appropriate for this work. If an Impressionist is defined as someone who took part in the Impressionist exhibitions, Degas certainly qualified. A founding member of the Private Company, he participated in all eight exhibitions it organized. If Impressionist painting is defined broadly as painting that shows a new vision, based on the artist's close scrutiny of how we perceive reality, then Degas was also an Impressionist. His interest in perception certainly equaled Monet's, though it had a different focus. Degas did not share the interest in light and atmosphere that fascinated Monet, Sisley, and Pissarro. Instead, he was intrigued by questions related to the field and angle of vision, as well as to the perception of moving bodies.

If we confine the term Impressionism to light-filled landscapes and figures in outdoor settings, however, then Degas was definitely not an Impressionist. He was a painter of urban life, who focused most often on indoor scenes.

16-32 **Edgar Degas,** *Dancing Class*, 1876. Oil on canvas, 32⅝ x 29⅞" (82.9 x 75.9 cm). Metropolitan Museum of Art, Collection of Harry Payne Bingham, New York.

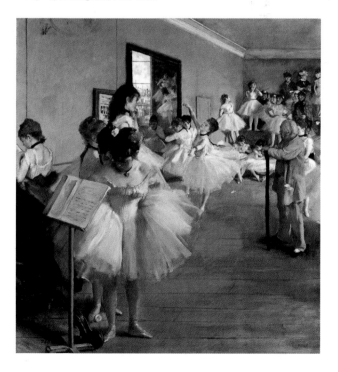

He has been called a Realist and there is a connection between his works and some of Daumier's. He has also been categorized as a Naturalist and the photographic quality of some of his early works does, indeed, relate to the urban scenes of Bastien-Lepage (see FIG. 18-9).

Dancing Class or, as it was originally entitled, *Dance Audition*, shows a room crowded with ballerinas who are waiting their turn to dance for the teacher, an old man in a baggy suit who is beating a rhythm with a long stick. Judging by the body language of the dancers, the audition is a tedious event. We see the ballerinas stretching, scratching, biting their nails, and adjusting their own and one another's tutus. This, of course, is the "backstage" aspect of the ballet, where the glamorous, ethereal creatures that the public admires on stage have been brought down to reality.

Even though it represents a scene of boredom, this painting is visually exciting because of its many compositional innovations. For one, its unusual perspective creates the impression that the viewer is above the scene, standing on a ladder or perhaps on a platform like the one in the rear of the room where chaperones and mothers wait for the dance lesson to be over. For another, the distribution of the figures is highly unusual. While the lower right quarter of the painting is entirely empty, the figures in the lower left corner seem to crowd each other out, to the point where one is almost completely hidden by two others and a fourth has her face cut off. Meanwhile, the main event of the painting, the ballerina dancing for the dance master, has been denied the visual importance that seems her due. She is pushed to the rear and surrounded by ballerinas on all sides. To enhance the visual complexity

of the scene, Degas has introduced a mirror on the left wall, in which more ballerinas and part of a view through a window are reflected.

Degas's compositional innovations are an attempt to come closer to the way we see the world. Rarely, indeed, does a subject present itself to us as in traditionally composed pictures—in the center of our field of vision and surrounded by a neutral space. Instead, our view of the world is composed of a succession of casual glimpses that are randomly framed and lack compositional order and symmetry. As we sit down, stand up, or climb a staircase, our viewpoint changes radically. In many cases we are not viewing reality at eye level, but at an oblique angle, looking down, or up, depending on our position.

Degas's painting represents the dancing audition much in the way that a chaperone might have seen it as she looked up from her book. It is a random glimpse of a fleeting moment that captures the scene much like a photographic snapshot. Degas's paintings have, indeed, been compared to photography. The seemingly haphazard way in which his compositions are framed, frequently cutting off figures, echoes the inadvertent way in which photography slices up reality. Yet the comparison of his paintings with photography should not be carried too far. Even if they

16-34 **Edgar Degas,** *Dancer with Bouquet,* 1876–7. *Essence* and pastel on paper, 25⅝ x 14⅛" (65 x 36 cm). Musée d'Orsay, Paris.

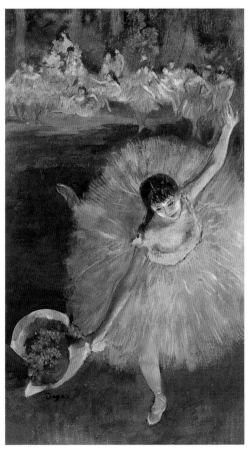

16-33 **Suzuki Hanurobu,** *Beauties Reading a Letter,* c.1765. Woodcut, 8 x 11" (20.3 x 28 cm). Collection of Mitsui Takaharu, Tokyo.

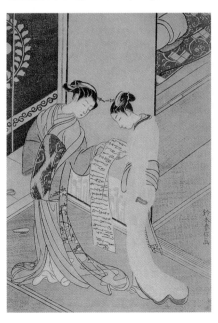

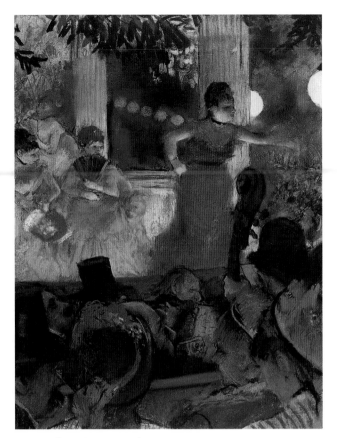

16-35 **Edgar Degas,** *Café-Concert*, 1876–7. Pastel on monotype paper, 14 x 10⅝" (36.8 x 27 cm). Musée des Beaux-Arts, Lyons.

look like photographic snapshots, Degas's paintings anticipate a kind of photography that, due to technical limitations, was not really possible until the end of the nineteenth century. Indeed, most photographs made in Degas's time are more traditionally composed than are his paintings.

Degas's works also call to mind Japanese prints. Almost all avant-garde artists of the period were looking at Japanese prints as an important alternative to Western forms of

16-36 **Edgar Degas,** *In Front of the Stalls*, 1866–8. *Essence* on paper mounted on canvas, 18⅛ x 24" (46 x 61 cm). Musée d'Orsay, Paris.

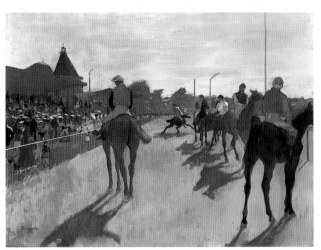

representation. Degas appears to have been especially interested in the Japanese choice of unusual viewpoints. The oblique "bird's-eye" viewpoint was popular in Japanese prints, as we see, for example, in Suzuki Hanurobu's *Beauties Reading a Letter* of about 1765 (FIG. 16-33).

As Degas matured, his viewpoints became increasingly daring and his compositions more striking. *Dancer with Bouquet* (FIG. 16-34), exhibited at the Impressionist exhibition of 1870, shows a ballerina greeting the public, holding the bouquet of an admirer in her upheld hand. Behind her, at the top of the painting, a fuzzy cloud of tutus represents the corps de ballet. The bird's-eye view is here more exaggerated than in *Dancing Class*, suggesting that the viewer sees the ballerina from a high opera box close to the stage. That could also be the explanation for the sliced-off tutu of the ballerina, which suggests that the rest of it is hidden from view behind a stage set or curtain.

Dancer with Bouquet is executed in pastels (see *Pastel*, page 390), Degas's favorite technique after about the mid-1870s. Using pastels in combination with oils, in a complex technique that he had developed himself, Degas achieved a new luminosity of color that was especially suited to his brightly lit stage scenes. (From the middle of the nineteenth century, gas and limelight made it possible to have operatic and stage performances at night, illuminated from overhead and by footlights.) Degas's *Café-Concert* (FIG. 16-35), also exhibited at the Impressionist exhibition of 1879, shows the wonderful effects of bright illumination and deep shadows that Degas managed to achieve with this technique. The work represents one of the numerous outdoor cafés that had become fashionable in Haussmann's Paris. This one provides a variety show of singers accompanied by a small pit orchestra. As opposed to the bird's-eye view in Degas's *Dancer with Bouquet*, we have here what we may call a worm's-eye view. Looking upward rather than downward, our eye is led past some colorful ladies' hats, past the heads of the musicians in the pit, towards the singer dressed in red, whose skirt is partly obscured by the neck of a double base. The stage lighting, which, like our glance, comes from below, leaves the parts of the face and body that are usually highlighted (eyes, cheeks, chest) in a dark shade.

The ballet theatre and the cabaret fascinated Degas because they were modern sites par excellence. And so was the horse race, another important subject in his work. (It may be seen as the counterpart of the ballet, calling for exterior scenes dominated by men, rather than interior scenes dominated by women.) What made these places modern? For one, they were sites where those who were "with it"— who were, as the French say *à la mode*—were found. For another, they were places where watching was an important activity. And watching was an eminently modern activity, judging by the numerous new opportunities for observation that presented themselves in the nineteenth century.

In Front of the Stalls (FIG. 16-36), dating from 1869–70, is a relatively early example of Degas's horse race pictures,

Pastel

Pastels are crayons made of finely ground pigments that are mixed with a non-greasy binder, such as gum. They are generally applied to specially textured papers that easily take up the powdered pigments, which remain on the surface of the paper. Pastels can be used in drawings, using the crayons primarily to make colored lines. But they can also be used in a painterly way by smearing and even blending the pigments with the finger or some rubbing tool. Because pastels contain very little binder, pastel drawings and paintings are very unstable. It is necessary to frame them behind glass or to treat them with a fixative spray.

Pastels were first used in the sixteenth century but they did not become popular until the eighteenth, when they were used for portraiture by such artists as Maurice Quentin de la Tour (see FIG. 1-11), Jean-Baptiste Chardin, and Anton-Raphael Mengs. Considered a Rococo technique par excellence, pastel fell out of favor in the late eighteenth and early nineteenth century but it was revived at the end of the nineteenth century by the Impressionists, most notably Degas and Renoir. It continued to be a favorite medium of Post-Impressionist and Symbolist artists, such as Henri de Toulouse Lautrec, Gustave Moreau, and Odilon Redon.

16-37 **Eadward Muybridge,**
Horses Trotting and Galloping.
Reproduced in *La Nature*, 1878. Wood engravings from photographs. Library of Congress, Washington, DC, Prints and Photographs Division.

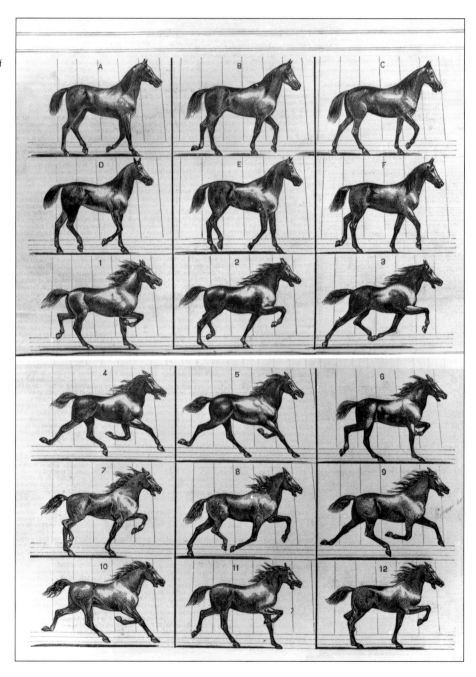

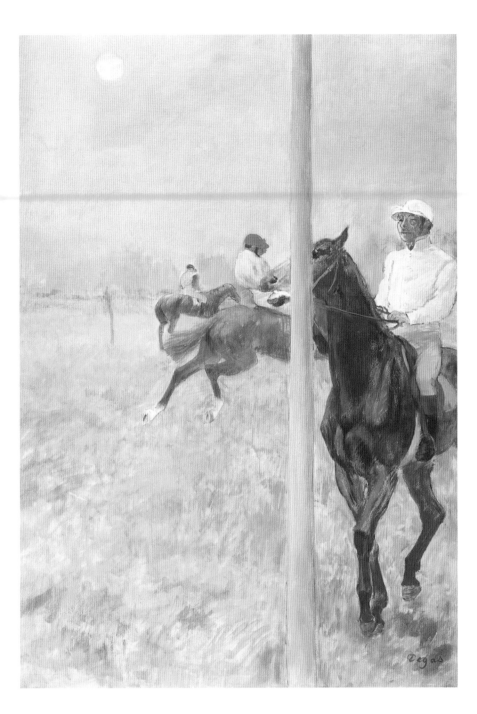

16-38 **Edgar Degas,** *Jockeys before the Start,* c. 1878–80. Oil, *Essence,* and touches of pastel on paper, 42 x 29" (1.07 m x 73.7 cm). Barber Institute of Arts, University of Birmingham.

representing the fashionable track at Longchamp. The jockeys are parading their horses in front of the spectators' stalls before the race. It is a crisp summer day, and a flowering of colorful parasols protects the viewers from the sun. The nervously dribbling horses cast fuzzy shadows on the ground. Factory chimneys in the background emit thin plumes of smoke that blow away in the wind. There is a sense of expectation, even tension in the air that seems to be condensed in the horse in the background that, scared by a sudden movement, is galloping away.

Degas was a master of representing the moving horse, a subject that had always presented a challenge to artists. Horses move fast, and depicting their four legs, in motion, requires great powers of observation. Degas's preoccupation with this challenge as well as his interest in photography led him to the so-called stop-action images of the British photographer Eadweard Muybridge (1830–1904), which were reproduced in 1878 in the French journal *La Nature* (FIG. 16-37). Degas copied several of these photographs, incorporating his new knowledge into several of his later works on equine themes, such as *Jockeys before the Start* (FIG. 16-38), exhibited at the fourth Impressionist exhibition of 1879 as *Race Horses*. In this picture, all Degas's interests seem to have come together. The composition of this painting is startling. First, there is the starting pole, which divides the painting into two vertical panels, slicing the head of the horse in two. Then there is the large amount of empty space in the left foreground,

which would have been unthinkable in earlier paintings. Reviewing the fourth Impressionist exhibition, the critic Arthureaux Rolland expressed what most people must have felt about Degas in general and this painting in particular:

> I won't say much more about this strange artist who, having made up his mind to paint only what he sees and how he sees it—but also, not to see what everyone else sees—invariably finds himself in front of ugly or bizarre things that others refrain from rendering in their works. When he represents a racehorse on the course, an enormous pole is in the foreground plane, cutting the racer in two parts, and allowing us to see only the extremities.

Impressionists and the Urban Scene: Caillebotte

While Degas's vision was certainly unique, there were other artists who were similarly interested in reproducing the randomness of the casual glimpse at reality. One artist whose compositions frequently equal those of Degas in their unexpected viewpoint is Gustave Caillebotte. Younger than most of the Impressionists, he, unlike most of them, was wealthy. Thus, he was a patron of the Impressionist group as well as a member. His important collection of Impressionist works, many of them bought while the paint was still wet, now forms the core of the Impressionist collection of the Musée d'Orsay in Paris, the chief museum of nineteenth-century art in France.

Caillebotte is best known today for his street scenes, which evoke the spectacle that the average *flâneur*, or casual walker, would see as he traversed the modern Paris of Haussmann. *Paris Street, Rainy Weather* (FIG. 16-39), a large painting measuring some 7 x 8 feet, is among the artist's most striking works. It represents one of the numerous star intersections that were part of Haussmann's plan. On the wide sidewalks that flank the cobblestone streets, pedestrians walk and look at the shops and the people. It is a typical Parisian winter day. A drizzling rain falls from the leaden sky, making the city, with its stone buildings and stone streets, look even more gray than usual. The dark

16-39 **Gustave Caillebotte,** *Paris Street, Rainy Weather,* 1877. Oil on canvas, 6'11" x 9' (2.12 x 2.76 m). Art Institute of Chicago.

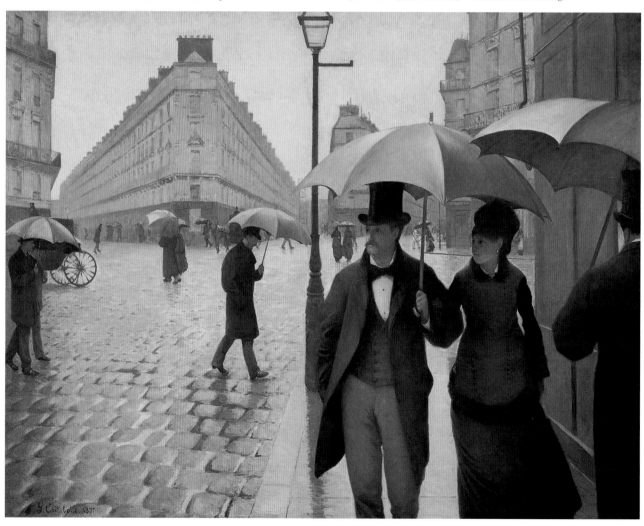

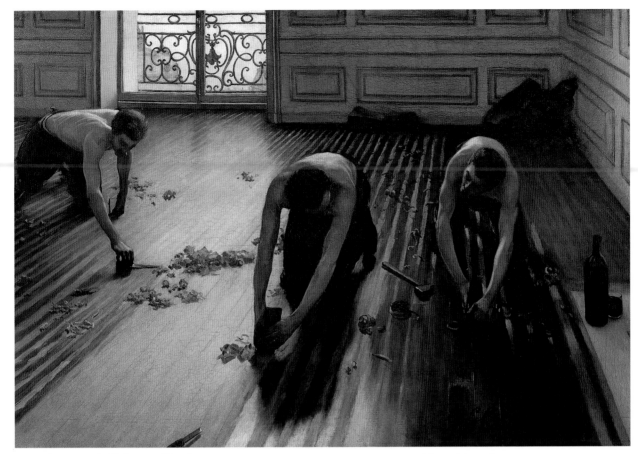

16-40 **Gustave Caillebotte,** *Floor Scrapers,* 1875. Oil on canvas, 39⁵/₈ x 57¹/₈" (1 x 1.45 m). Musée d'Orsay, Paris.

clothes of the men and women do little to enliven this dreary scene. This, Caillebotte seems to say, is modernity as well. It is not all color, light, and movement, it is also dreariness and uniformity. Caillebotte's painting shows the bird's-eye viewpoint, the random framing, and deliberately unbalanced composition that we have encountered in Degas's painting, but his work is executed in a much more traditional manner. Indeed, the sharp focus of his painting matches that of the Naturalists and, like them, Caillebotte may have used photographs in the preparation of his paintings.

Caillebotte came closest to the Naturalists in a group of paintings about work, of which *Floor Scrapers* (FIG. 16-40) of 1875 is among the most striking. The painting, exhibited at the second Impressionist exhibition of 1876, combines the bird's-eye view of Japanese prints with the verisimilitude of Naturalist painting. It reintroduces the subject of the male nude in painting, but in a strikingly updated form. Instead of the heroes of antiquity, here are the heroes of modern life—sinewy and strong—in stooped poses that would appear demeaning if they did not convey a sense of masculine strength and honest labor.

Caillebotte's renewed interest in the male nude, set in a modern context, has been linked to his presumed homosexuality. It must be noted, however, that it was part of a larger trend, not necessarily limited to homosexual artists, that was first introduced by Courbet in a painting of two wrestlers (Budapest, Szépmüvészeti Museum). Courbet's example was followed by, among others, Bazille, who in 1869 had painted a large painting of male bathers, *Summer Scene* (FIG. 16-41), in which a theme traditionally associated with the female nude (see FIG. 17-17) was translated in both masculine and modern terms. In the 1880s and 1890s the male nude, adult and adolescent, became a common theme particularly in the works of Naturalist painters.

While Caillebotte's scenes of work, such as *Floor Scrapers,* relate closely to Naturalist painting, his scenes of leisure link him to Impressionism. An avid rower, he painted a series of paintings of canoeists, such as the one reproduced in FIG. 16-42. This oblique bird's-eye view of a river, with a number of men paddling downstream in their skiffs, differs from his street scenes and scenes of work in the loose, "Impressionist" treatment of the paint and the light coloring, quite different from the subdued, almost monochromatic coloring in his other paintings. These works seem closer to Monet than to Degas, even though neither artist could have painted this picture.

16-41 **Frédéric Bazille,** *Summer Scene,* 1869. Oil on canvas, 63⁷/₁₆ x 63⁷/₁₆" (1.61 x 1.61 m). Fogg Art Museum, Harvard University Art Museums, Cambridge, Massachusetts.

16-42 **Gustave Caillebotte,** *Canoes,* 1877. Oil on canvas, 35 x 45" (88 cm x 1.17 m). National Gallery of Art, Washington, DC.

16-43 **Berthe Morisot,** *The Cradle,* 1872. Oil on canvas, 20 x 16" (51 x 41 cm). Musée d'Orsay, Paris.

Women at the Impressionist Exhibitions

Women were not particularly well represented in the Impressionist exhibitions, but those who did participate equaled their male colleagues in the quality and quantity of the works they presented. This phenomenon paralleled the situation in the Salons, where, in the course of the Third Republic, a small but growing number of professional women artists exhibited both paintings and sculptures.

Before 1870, with some notable exceptions such as Rosa Bonheur (see page 277), women who participated in the Salon had been amateurs. They worked in the "lower" genres (landscape, portrait, still life) and used "lesser" media and techniques, such as porcelain painting, watercolor, and pastel. From the 1870s onward an increasing number of women, ambitious to achieve in the arts on masculine terms, painted in oils or produced large-scale bronze and marble sculptures.

The new professionalism of female artists was aided by the increased availability of professional training. Although women were barred from the École des Beaux-Arts, because life classes for both sexes were considered taboo, a number of private schools emerged to offer training to women artists. Perhaps the best-known among them was the so-called Académie Julian, founded in 1868 by Rodolphe Julian, which accepted both male and female students.

A particularly innovative aspect of Julian's atelier was that women were allowed to draw and paint from nude models, even working alongside male students.

Of the female artists who exhibited at the Impressionist exhibition, Berthe Morisot and the American expatriate painter Mary Cassatt are best known today. Morisot began her career as an amateur. Together with her sister Edma, she was trained by a private drawing teacher. Her connection to the professional art world was facilitated by her close relationship to Manet, whose brother she married in 1874.

It is a credit to Morisot's independent spirit that, against Manet's advice and that of her drawing teacher (who told Morisot's mother that she was wrong to "associate with madmen"), she submitted two paintings to the first Impressionist exhibition, even though her works had been exhibited at the Salons of the late 1860s. She went on to show at almost all the subsequent Impressionist exhibitions.

Morisot's works, like those of Cassatt, focus on the public and private lives of women, partly by choice and partly by necessity. In spite of a certain degree of emancipation, the movements of bourgeois women in the 1870s and 1880s remained restricted, and much of the subject matter painted by their male colleagues would have been outside their normal visual experience. Morisot's *The Cradle* (FIG. 16-43) is by far her best-known work. It shows a young woman (perhaps her sister Edma) seated next to a cradle, contemplating the sleeping baby inside. Although several male artists, including Millet, had treated the theme of mothers and infants, they had generally depicted peasant women rather than bourgeois mothers. The reason for this was, no doubt, that the nursery in nineteenth-century middle-class homes was an exclusively female space that was rarely visited by men. Indeed, it has been argued that to find visual equivalents for Morisot's work, one should turn not to traditional painting but to images in fashion magazines, which show women in nurseries modeling fashionable "indoor" wear (FIG. 16-44).

The novelty of Morisot's subject matter is matched by that of her style. Like her male colleagues, Morisot seems to have felt that new subjects and ways of seeing demanded new and individual painterly approaches. She once wrote in her notebook: "What's needed is new, personal sensations; and where to learn those?" She developed a free, loose touch that became increasingly personal as she matured as an artist.

Unlike Morisot, Mary Cassatt received a formal training, first at the Philadelphia Academy of Art, then in the private ateliers of Gérôme, Couture, and others. She also traveled throughout Europe before settling down in Paris in 1874. Like Morisot, she sought out subject matter that was both modern and feminine, and felt this called for a new approach to painting. At the Salon of 1874 one of her works attracted the attention of Degas, who invited her to participate in the fourth Impressionist exhibition.

Here she exhibited four works on a theme that would long preoccupy her, that of one or two women seated in a theatre box. One of these, *Woman in a Loge* (FIG. 16-45), is a characteristic example, showing a young woman at the opera before the performance, when the lights are still on. Behind her is a mirror-covered wall, in which we see the reflection of part of the curved balcony opposite her, dotted with spectators who are looking around the theatre with their binoculars. The girl seems both excited and slightly uneasy, aware as she is of being on display. Dressed, perhaps for the first time, in a low-cut dress that is pulled down from the shoulder, she seems at once embarrassed about her nakedness and happy with the attention she attracts. Like Degas, Cassatt was interested in suggesting the effect of a casual glimpse. The cut-off arm and the

16-44 *"House dress and little boy's suit."* Illustration in *Le Moniteur de la Mode*, June 1871. Wood engraving, 7⅝ x 6⅝" (19.5 x 17 cm). Bibliothèque Historique de la Ville de Paris, Paris.

16-45 **Mary Cassatt,** *Woman in a Loge,* 1879. Oil on canvas, 31⅝ x 23" (80.3 x 58.4 cm). Philadelphia Museum of Art.

16-46 **Mary Cassatt,** *Little Girl in a Blue Armchair,* 1878. Oil on canvas, 35 x 51⅛" (89.5 cm x 1.3 m). National Gallery of Art, Washington, DC.

unusual illumination, which brightens the side of the face while leaving eyes, nose, and mouth in the shade, resemble some of the effects seen in his work.

While Cassatt was fascinated with certain aspects of women's public life, like Morisot she was also interested in the depiction of women's private lives and in the related subject of the lives of children. Among her most striking paintings is *Little Girl in a Blue Armchair* (FIG. 16-46), also exhibited at the fourth Impressionist exhibition. It shows a little girl alone in a large room filled with several over-stuffed blue armchairs. Her skirt pulled up, legs widespread, she reclines on one of them in a pose that expresses boredom and a rebellion against "good manners." This is a radically new image of childhood that evinces a degree of psychological insight not seen in earlier art. The per-ceptive insight into the child's mind is matched by a new way of representing the pictorial space. While the bird's-eye viewpoint suggests the way that we, adults, see the child, the device of cutting off the room near the bottom of the windows replicates the limited view that the child has of the room.

Impressionism and Modern Vision

Monet's little dabs of color, Degas's randomly framed com-positions, Caillebotte's high, and Cassatt's low viewpoints all signal the Impressionists' interest in finding ways of representing reality that matched the new ways of view-ing that had developed in the modern bourgeois world. In their attempts to find ways to re-present the world as they *saw* it rather than as they *knew* it, the Impressionists contravened traditional rules of perspective, shading, com-position, and pictorial finish. In so doing, they called attention to the painterly aspects of their work, remind-ing the viewer that pictures are nothing but flat surfaces covered with lines and brushstrokes of different colors.

Impressionist paintings thus present a paradox: while offering a heightened illusion of reality, they also call atten-tion to their artifice. Thus Impressionism occupies a pivotal position in nineteenth-century art, representing at once the culmination of a decades-long trend towards an ever more convincing realism and the beginning of a tendency towards abstraction.

French Avant-garde Art in the 1880s

In 1886, after a four-year hiatus, the Impressionists organized their last group show. Disagreements between the founding members of their cooperative were probably the chief reason for the demise of the exhibitions. Yet they had also outlived their usefulness as a Salon alternative, because the new Society of Independent Artists had organized its first non-juried Salon, the Salon des Indépendents, in 1884 (see page 370). In addition, many of the original members of the Impressionist group had made lucrative arrangements with art dealers to show their works in private galleries, and no longer needed to show their works in group exhibitions.

This was the heyday of what Harrison and Cynthia White have called the "dealer–critic system." In their book *Canvases and Careers*, 1965, they define this system as a mode of art marketing in which dealers would buy large numbers of paintings by relatively unknown artists and organize exhibitions of their works. They would cajole, bribe, or otherwise persuade critics to write positive reviews, and would then sell the works at vastly inflated prices. It was pure art speculation, made possible by new developments in banking that allowed dealers to take out substantial loans to finance their purchases. Of all nineteenth-century artists, the Impressionists benefited most from this system, since they were emerging at the time it reached maturity. The two principal French dealers of the late nineteenth century, Paul Durand-Ruel and Georges Petit, made their

fortunes by investing in Impressionist paintings. The artists, in turn, became rich and famous thanks to the dealers.

While the dealer–critic system improved the economic situation of some artists, it also created a ruthless world in which greed ruled and money talked. Many young artists trying to make a career in the 1880s and 1890s felt drained and demoralized by the cut-throat competition. Paul Cézanne retreated to his native region of Provence, where he was supported by his family; Paul Gauguin (1848–1903) escaped to the distant island of Tahiti, and Vincent van Gogh (1853–1890) shot himself tragically at the age of 37 after a year-long stay in a mental hospital in the south of France. While these incidents cannot wholly be blamed on the Parisian art world, it was certainly a contributing factor. None of these artists sold more than a handful of works during their lifetime and when they died their names were virtually unknown.

Georges Seurat and Neo-Impressionism

The Impressionist shows ended on a high note. The exhibition of 1886 featured a near-record number of 246 works, including several major paintings by young, still largely unknown artists. And although neither Monet, Sisley, nor Renoir participated in it, their absence was compensated by substantial submissions of new and original works by Cassatt, Degas, Morisot, and Pissarro.

17-1 **Georges Seurat,** *A Sunday at La Grande Jatte, 1884,* 1884–6. Oil on canvas, 6'7" x 9'10" (2 x 3 m). Art Institute of Chicago.

Perhaps the most discussed painting at the exhibition of 1886 was *A Sunday at La Grande Jatte, 1884* (FIG. 17–1), a monumental landscape with figures by the 26-year-old Georges Seurat (1859–1891). The painting represents a popular Parisian park on the island of La Grande Jatte (The Big Bowl) in the River Seine. Here, on Sundays, Parisians came out to stroll, fish, row, or just relax. While at first glance the subject resembles Impressionist paintings of leisure life, such as Renoir's *Ball at the Moulin de la Galette* (see FIG. 16-31), on closer inspection it differs radically. First of all, measuring more than 6 x 9 feet, it dwarfs most Impressionist paintings, except for a few early works by Bazille and Monet. Secondly, the painting juxtaposes the social classes, an unusual if not unprecedented incident in Impressionist painting. Looking at the lower left corner of Seurat's painting, for example, we see the reclining figure of a worker, dressed in sleeveless top and cap, right next to a seated middle-class couple in their Sunday best. In the center, a prim nanny with a little girl dressed in white is contrasted with the elegant lady and her husband—or paramour—in the right foreground. Similar oppositions of social class are found throughout the painting.

Not only the painting's content, but also its formal qualities show a departure from Impressionist painting. Seurat's seemingly frozen, aloof, and simplified figures are far from

the living, moving men and women encountered in the works of Renoir or Degas. Instead, they bear a resemblance to the statuesque figures in the wall paintings of Puvis de Chavannes (see FIG. 16-10, FIG. 16-12), even though the classic timelessness of the latter is, of course, quite distinct from the modernity of Seurat's characters. According to someone who knew him well, Seurat was impressed by the "pictorial majesty" of Puvis's works. He is also said to have admired the artist's superior "arrangements of figures." And there is, indeed, an interesting parallel between the careful spacing of the figures in Seurat's *A Sunday at La Grande Jatte, 1884* and the figural compositions of many of Puvis's later murals, including the idyllic *Sacred Wood* (FIG. 17-2), which was exhibited at the Salon of 1884 before being installed as a mural in the Museum of Lyon.

The carefully ordered composition of Seurat's picture is matched by a meticulous paint application, commonly referred to as Pointillism. In a process that took nearly two years, Seurat built up the entire painting with small pointed strokes of uniform size and shape (see detail in FIG. 17-3). These minute dabs of color were placed on a base color that approximated the local color, i.e. the color he knew the object depicted to be. The grass, for example, is composed of touches of blue, dark green, light green, and orange, painted over a thin green ground.

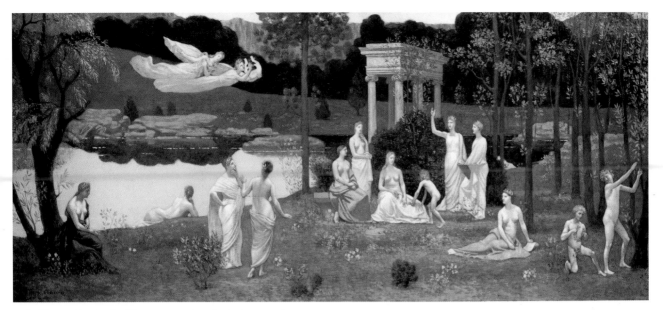

17-2 **Pierre Puvis de Chavannes,** *Sacred Wood,* 1884–9. Oil on canvas, 3' x 7"7" (92.7 cm x 2.31 m). Art Institute of Chicago.

At the exhibition of 1886 Seurat's painting attracted a great deal of critical attention for this unprecedented brushwork. Félix Fénéon (1861–1944), a young critic the artist's age, was especially enthusiastic. Referring to Seurat at a "Neo-Impressionist," he saw him as an heir to the Impressionists for the way he broke up the paint surface. But he argued that Seurat had gone beyond the Impressionists (hence the suffix "Neo-", meaning "new") by turning the Impressionists' random, choppy brushwork into a systematic, even scientific method of paint application. Referring to the textbook on color *Modern Chromatics* by

17-3 **Georges Seurat,** *A Sunday at La Grande Jatte, 1884,* detail of FIG. 17-1.

the British physicist Ogden Root (published in French in 1881), Fénéon proclaimed that Seurat's method was aimed at achieving an "optical mixture." He explained that the little color dots in the artist's paintings sent out light rays of different colors, which fused in the eye. According to Fénéon, this lent to Seurat's painting a greater luminosity than the traditional "pigment mixture," in which the colors were mixed on a palette. Comparing Seurat's painting to a tapestry, Fénéon argued that a tapestry woven of, for example, blue and yellow threads, presents a more luminous, lively green than one woven of green threads alone.

In spite of Fénéon's authority, it is doubtful that Pointillism enhances the luminosity of painted colors. Seurat's works often seem *less* rather than *more* luminous than those of the Impressionists. If not luminosity, what did the artist attempt to achieve with his painstaking technique? When we study Seurat's paintings in detail, we find that in most areas he offsets the dominant color with small touches of its complementary. In the dark-blue jacket of the seated girl with the ponytail, for example, a base color of dark blue is enlivened with touches of light blue and orange—its complementary (see FIG. 17-3).

Eugène Delacroix had done something quite similar fifty years earlier in the shaded area of his paintings (see page 370). It is no coincidence that there was renewed interest in Delacroix's work in the 1870s and 1880s, sparked in part by the writings of the art critic and theorist Charles Blanc (see page 370). In his discussion of Delacroix's use of color, Blanc repeatedly referred to the writings of Michel-Eugène Chevreul (1786–1889), a pigment chemist who, early in the century, had developed a theory about the psychological impact of colors. Chevreul argued that color combinations appear beautiful when they are "in harmony." Such harmony could be achieved

17-4 A section from the frieze depicting the Panathenaic procession, Parthenon, Athens, 442–438 BCE, height 41″ (1.06 m). British Museum, London.

either by juxtaposing similar intensities of analogous colors or by carefully balancing contrasting ones.

Seurat's method, like Delacroix's, appears to be indebted to Chevreul. The achievement of color harmony by means of the use of contrasting colors was important to him both for aesthetic and for symbolic reasons. Aesthetically, it was a way to achieve an effect of timeless and ideal beauty. Seurat, as we have seen, was not interested in capturing a fleeting glimpse of contemporary reality. Instead, he wanted to create paintings that were idealized monuments to modernity. His artistic model was the Classical frieze of the Parthenon, representing the Panathenaic procession (FIG. 17-4). "I want to make the moderns pass by as in that frieze," he once said "capturing their essential qualities by placing them on canvases arranged in color harmonies." Symbolically, his harmonies of contrasting colors reflected the harmonious gathering of Parisians of contrasting social backgrounds.

Seurat's tendency to impart form with meaning—in other words, for his colors, brushstrokes, and lines to be as meaningful as the content of his paintings—was carried even further in later works, especially those he created shortly before his premature death at the age of 31. *Le Chahut* of 1889–90 (FIG. 17-5) depicts a scene not dissimilar in subject and composition to that of Degas's *Café-Concert* (see FIG. 16-35). The painting shows performers on a narrow stage, seen from the angle of a spectator, who is identical with the viewer of the picture. It is you, the viewer, who is seated right behind the base player in the orchestra pit. On your left, you see the conductor, raising his baton; on your right is a fellow spectator who is drooling at the sight of the dancers' underwear. On the stage, illuminated by fancy gas lamps, two male and two female dancers dance the *chahut*, a variety of the cancan, distinct from it in that it involves both male and female dancers.

Marked by what, at the time, was considered an obscene display of legs and petticoats, it was deemed a vulgar form of entertainment, attended by seedy bourgeois and prostitutes hoping to snare a lustful client.

Both the composition and the individual figures in *Le Chahut* seem subject to strict rules of geometry, symmetry, and repetition. Note, for example, the exact repetition of the fold patterns in the dancers' skirts, and the symmetry and sameness of the dancers' legs, even male and female, identical but for the little bow ties on the women's shoes. Note also the emphasis on diagonals and the insistent use of yellow, orange, and rust-brown, offset by touches of blue, throughout the entire painting. In 1886 Seurat had become acquainted with Charles Henry (1859–1926), a university librarian, whose interests combined science and aesthetics. Fascinated, like Chevreul, by the psychological effects of color, Henry had developed a systematic theory of the psychological impact of lines and colors. In simplified terms, this theory held that some lines and colors (such as upward-moving diagonals and warm colors) give pleasure and, in so doing, expand human consciousness; others (such as downward-moving diagonals and cool colors) cause discomfort and a feeling of lethargy and numbness. Henry used the term "dynamogenous" for the first, "inhibitory" for the second.

Formal analysis of *Le Chahut* quickly reveals the importance of Henry's theories for Seurat's late works. The painting's composition is dominated by upward-sweeping diagonals at angles that are most effectively achieve Henry's "dynamogeny." In addition, its palette, in which warm colors (oranges, yellows, brown) dominate, creates an uplifting and energizing effect. Form and subject thus work together to suggest that, in the dreary existence of modern man, spectacles such as the *chahut*, filled with light, music, and erotic stimulation, provide brief

17-5 **Georges Seurat,** *Le Chahut,* 1889–90. Oil on canvas, 66⅝ x 55″ (1.69 x 1.41 m). Kröller-Müller, Otterlo.

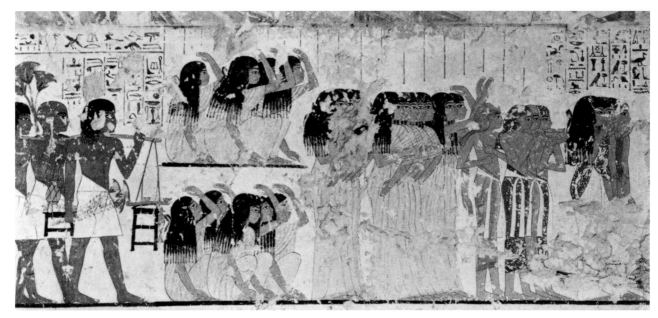

17-6 *Funeral Procession of Ramose*, Hall of Pillars tomb of the Vizier Ramose, c.1350 BCE. Wall painting. Thebes, Egypt.

interludes of pleasure and oblivion. Through his careful stylization, Seurat has turned the performance of the *chahut* into something of a modern ritual, much like the sacred procession in the Panathenaic frieze or the ceremonies depicted in Egyptian art (FIG. 17-6) that he so admired. Such rituals, as contemporary anthropologists realized, likewise served to lift participants and viewers temporarily above the humdrum of everyday life.

17-7 **Georges Seurat,** *Bathing Place at Asnières,* 1883–4 (with additions from 1887). Oil on canvas, 6'7" x 9'10" (2 x 3 m). National Gallery, London.

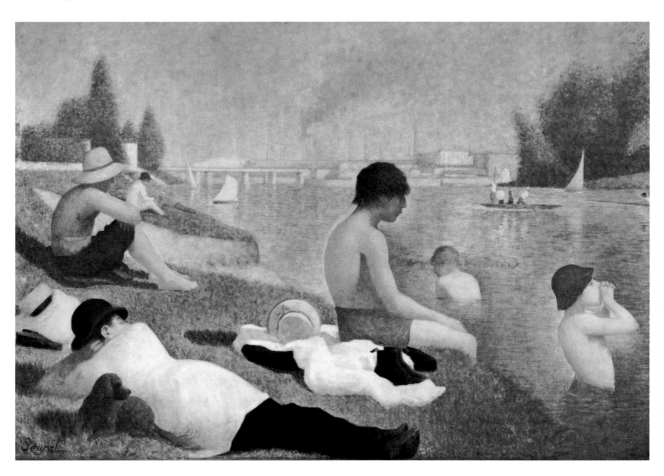

17-8 **Paul Signac,** *Gasholders at Clichy,* 1886. National Gallery of Victoria, Melbourne.

Neo-Impressionism and Utopianism: Signac and Pissarro

Seurat's *A Sunday at La Grande Jatte, 1884* carried the day at the Impressionist exhibition of 1886. But it was not the only work to show the new, methodical approach to painting that Fénéon had labeled Neo-Impressionism but that, more popularly, was known as Pontillism. (Seurat himself preferred the term "Chromo-luminarism" and his follower Signac, "Divisionism"). Seurat's pictorial interests were shared by a number of artists, who had been familiar with his work since he exhibited his first major painting, *Bathing Place at Asnières* (FIG. 17-7), at the first Salon des Indépendents (of which he was one of the founders). Although that painting did not yet show the full development of Seurat's Pointillist method, it did demonstrate his preoccupation with capturing the essential, permanent qualities of contemporary urban life. And it made a big impression on many artists who saw it.

Among the "followers" of Seurat were several who were his age or slightly younger, such as Paul Signac (1863–1935), but also a few who were older, notably Camille Pissarro. Signac exhibited eleven paintings at the Impressionist exhibition of 1886. Some of these were older works, still in an Impressionist vein; others demonstrated his new "Divisionist" method. *Gasholders at Clichy* (FIG. 17-8) was perhaps the most original among them, both for its subject and its formal qualities. The painting depicts a group of huge rusted gas tanks at Clichy, the Parisian suburb where the gas for the city's street lighting was stored. It is a modern industrial landscape, the type of scenery that at the time (and still today) was considered ugly and unsuitable as a pictorial subject. Although modern industry had not been absent from nineteenth-century painting, it had, for the most part, been an incidental element in landscape pictures. In Impressionist paintings, such as Monet's *Impression, Sunrise* and Sisley's *Inundation at Loge Island* (see FIGS. 16-21 and 16-26), for example, steamboats and telegraph poles are mere accents denoting modern times. They do not

distract the viewer's eye from the beauty of the natural landscape; on the contrary, they focus attention on it.

To Signac, however, the gasholders are the main subjects in an outdoor scene in which a few weeds are the only natural elements to be found. The artist has, however, transformed the dreary industrial subject into a festive, colorful scene, dominated by bright blues, oranges, yellows, and greens. Even the dark gasholders are flickering with touches of yellow, rust-red, and blue. Signac's unusual approach to his grim and grimy theme has often been linked to his political convictions. Along with Seurat and many of his contemporaries, he hoped for a better world in which class differences would be eliminated and there would be social justice for all. While to some this hope never went beyond a utopian dream, to Signac it was a spur to political engagement. Like many artists and writers of his day, he was drawn to anarchism, a political doctrine that held that government is not only unnecessary but harmful. Anarchists blamed social injustice not on specific governments, but on governments per se. Only by eliminating the institution itself, they felt, was radical change possible.

In painting the grim suburb of Clichy and its ugly, polluting gasholders in such a way that they looked "solid and dazzling," Signac wished to create a monument to industrial workers. It did not matter to him that the workers themselves were not present, except through the blue smocks and dark blue pants hung out to dry on the picket fence. The gasholders were testimony to their heroic labor.

Yet Signac had to admit that the city fringe was not only the site of the workers' glory but also the site where the consequences of social injustice were most blatantly visible. When, later in his career, he tried to imagine the new harmonious world that he and his friends hoped that anarchy would bring about, it was a natural one, unspoiled by industry, in which people of different class, gender, and age enjoyed their leisure time together. His *In Times of Harmony* (which he originally intended to call *In the Time of Anarchy*; FIG. 17-9) of 1894 lies in the tradition of Seurat's *Sunday at La Grande Jatte* and, ultimately, of Puvis's *Sacred Wood*, with which it shares the timeless dream of a golden age. It is a celebration of a modern utopia, a beautiful, clean, and natural world in which men, women, and children live together in peace and harmony.

17-9 **Paul Signac,** *In Times of Harmony,* 1894. Oil on canvas, 9'10" x 13'1" (3 x 4 m). Montreuil Town Hall.

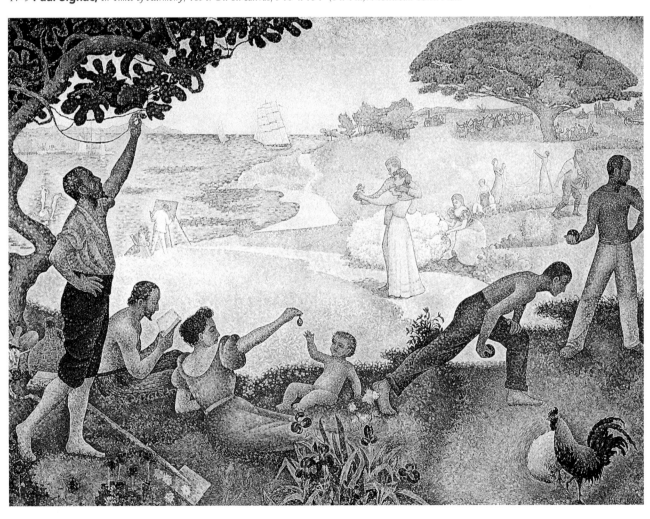

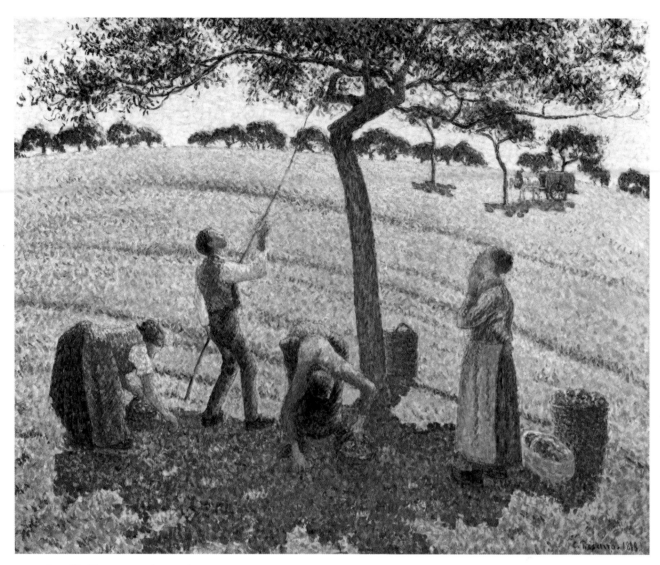

17-10 **Camille Pissarro,** *Picking Apples at Eragny,* 1888. Oil on canvas, 23 x 28″ (59 x 72.4 cm). Dallas Museum of Art.

Although Signac was a follower of Seurat rather than the instigator of Neo-Impressionism, he became its most important propagandist and spokesperson. Signac befriended Camille Pissarro's son, Lucien, who introduced him to his father. The elder Pissarro shared Signac's political views, and had similarly began to use his work to express his dream of social justice. Unlike Signac, however, Pissarro concentrated on rural life, and, starting in the 1870s, increasingly turned from landscape to peasant painting. By the mid-1880s he had begun to combine this subject matter with a new formal approach, influenced by the scientific ideas about color that Seurat and Signac had pioneered.

In Pissarro's idealized view of the countryside, peasants labor in peace and harmony. *Picking Apples at Eragny* (FIG. 17-10) of 1888, one of the later versions of a subject he treated frequently in the 1880s (a larger version of the subject was exhibited at the exhibition of 1886), exemplifies his numerous paintings of harvesting scenes in which each person performs a necessary task. One man shakes

the tree to make the apples fall while two women pick them up and put them in baskets. A third woman, whose baskets are filled, looks on, perhaps giving the man some hints as to which branches to hit. The figures are set against the vast expanse of a field, painted in small touches of bright colors, which give it an almost festive appearance. Labor here is not a chore, but a joyful form of social cooperation.

The "Crisis" in Impressionism

The innovative works that were exhibited by Seurat, Signac, and Pissarro at the last Impressionist exhibition are often seen as symptomatic of what has been called a "crisis" in Impressionism. This expression seems to indicate that, some time during the mid-1880s, serious doubts arose in artists' minds about the validity of Impressionism and its essential goal of capturing reality as it presented itself to the human eye. Few artists or

critics, however, would have used or even understood the term "crisis," because the changes that did take place in art at the time were more of an evolutionary nature. But change there was, not only in the works of these three artists but also, in different ways, in the works of established Impressionists such as Monet, Degas, and Renoir, and those of their younger followers.

Monet and the Later Series Paintings

Monet's artistic approach, in the course of the 1880s, evolved from pictorial objectivity to subjectivity. He had always been interested in painting the world as he saw it rather than as he knew it. Yet from the early 1880s onwards (see, for example, FIG. 16-28), he increasingly called attention to his personal vision of reality, presumably to suggest to the viewer that there was no knowable reality; that the appearance of reality depended both on exterior circumstances, such as light and atmosphere, and on the viewer's perception.

This point was made most emphatically in several series of paintings made in the 1890s, in which he represented the same subject—haystacks, the cathedral of Rouen, a row of poplars by a river—at different times of the day, in different seasons, and in different weather conditions. These series were different from the ones that he had made in the 1870s and 1880s (see page 382), in which he had frequently changed the viewpoint and the angle of vision. While in the earlier series the viewer is taken on a tour of the St-Lazare Station or the Normandy coast, in the later series he or she is asked to sit still and quietly observe the dramatic changes wrought in a simple form by changing light and atmospheric effects.

The *Haystack* series (see FIGS. 17-11 and 17-12) came first. The nearly thirty canvases were painted outside Monet's house in Giverny, a small village not far from Paris, where he had moved in 1883. Monet worked on the series for nearly two years, beginning some time in 1890. In May 1891 his dealer Durand-Ruel showed fifteen of the canvases in his gallery. It was an unprecedented event, not only because solo exhibitions were still uncommon at the time but also because of the simplicity and monotony of the subject. To a public used to the motley variety of the Salons and other contemporary exhibitions, this show must have appeared as an exercise in minimalism. Indeed, arranged as they were in Durand-Ruel's gallery, these paintings no longer functioned as individual pieces that each

17-11 **Claude Monet,** *Haystack,* 1890–1. Oil on canvas, 25⁷⁄₈ x 36" (65.6 x 92 cm). Art Institute of Chicago.

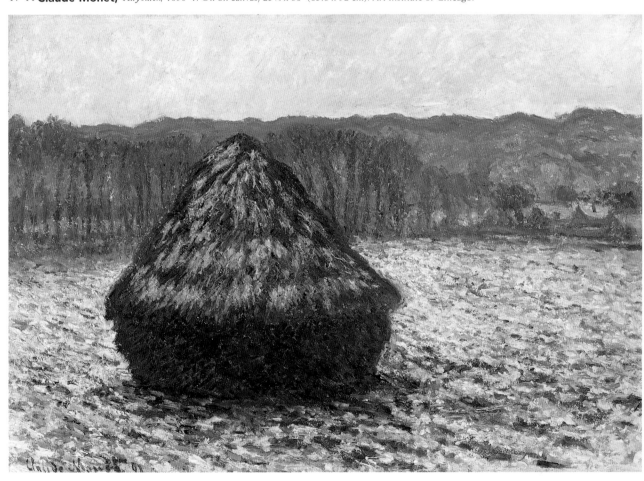

required attention. Instead, they had become a sort of decoration, enhancing the wall surface with their varied colors and textures. This increased importance of form and substance at the expense of content and meaning represented a radical redirection of pictorial art that paved the way to twentieth-century non-objective painting.

In 1890, however, things had not progressed that far. In Monet's painting the haystacks are still clearly recognizable for what they are. Haystacks, common signifiers of rural prosperity, had been frequent motifs in Barbizon painting, and Monet himself had painted them earlier in his career. In 1890 he may have selected them for their simple forms, which made them a suitable medium to depict the effects of sunshine, mist, rain, snow, dawn, and dusk. FIGS. 17-11 and 17-12 demonstrate that the *Haystack* paintings differ dramatically in spite of the identical subject. Each painting depicts a single cone-shaped stack of hay in a field lined by trees, but the palette and brushwork are distinct. In one painting a haystack on a snowy field is painted with thick, heavy strokes in largely cool colors—blues, blue-greens, and whites—offset by reds in the lower part of the stack and the ground. In the other, a haystack painted in orange and violet is set against a barely defined background, composed of dense, short strokes of pink, orange, yellow, and violet. The painting's subtitle, "Sun in the Mist," points to the remarkable effects that occur in nature when light and atmosphere cooperate to transform the ordinary into the poetic. While both

paintings were based on actual observation, the artist went beyond merely noting down his color sensations as he had in earlier works. In these paintings he tried to intensify his sensations, condensing them into an ever smaller number of dominant colors. It also appears that Monet became interested in the aesthetic rather than the documentary aspect of his paintings. His formerly haphazard brushwork has been replaced by a much more orderly treatment of the paint surface, in which different surfaces (ground, sky, mountains, haystack) are marked by different paint textures. It is noteworthy that, from this time onward, Monet increasingly finished his paintings inside the studio, taking more time to reach the desired coloristic and textural effects.

Degas in the 1880s

While Monet's evolution in the 1880s and 1890s is marked by a changing pictorial approach, the work of Degas, during the later part of the 1880s, changed most visibly in its content. Without abandoning the ballet and racetrack scenes that he had treated earlier, Degas became interested in the theme of women grooming themselves in the privacy of their bedrooms. This involved a shift in the presentation of his human subjects from the "theatrical" to the "absorptive." These two terms, coined by the art historian Michael Fried, help to distinguish

17-12 **Claude Monet,** *Haystack, Sun in the Mist,* 1891. Oil on canvas, 25⅝ x 39⅜" (65 cm x 1 m). Minneapolis Institute of Arts.

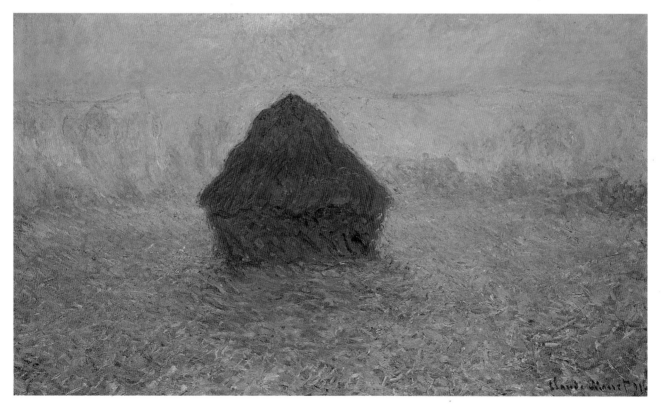

between figure paintings in which the subject seems to be aware of the painter's (and, by extension, the spectator's) presence, and those in which the subject is not. In "theatrical" paintings, figures look and act a certain way because they are conscious that they are being looked at. In "absorptive" paintings, figures are unaware of the observer, absorbed as they are in their private thoughts and actions.

Degas's pictures of ballerinas on stage exemplify theatricality, but his images of naked women are utterly absorptive. Looking at pictures such as *The Tub* (FIG. 17-13), exhibited at the last Impressionist exhibition in 1886, the viewer feels like a voyeur catching a forbidden glimpse through a keyhole. This pastel presents a woman crouching in a small tub and rubbing her neck with a sponge. On the counter next to her is a haphazard array of grooming tools. Nothing could be further from the elaborately posed "display" nudes of Ingres, Cabanel, or even Manet. This is truly the modern nude as Baudelaire had en-visioned it when he wrote that naked women, in modern times, are seen only "in bed, … in the bath, or in the anatomy theatre."

Pastel (see *Pastel*, page 390) was the medium of choice for Degas's *Toilettes*, as his pictures of women bathing were called in his day. As time went on he used pastel in an ever more virtuoso manner, combining it with other media such as charcoal or tempera to reach rich, brilliant effects. Like Monet, and perhaps following the example of the Neo-Impressionists, he became increasingly interested in surface texture. In most of his late pastels the colors are applied in a carefully organized manner, often with a view to simulate the surface textures of the different objects and materials represented.

During this period Degas also turned to sculpture, not for the purpose of sales and exhibitions, but as a private medium, for his own enjoyment. Indeed, only one of his sculptures was ever exhibited, a highly unusual work that became his most famous three-dimensional piece and remains one of the best known and most loved nineteenth-century sculptures today. Shown at the Impressionist exhibition of 1881, Degas's *Little Dancer of Fourteen Years Old* (FIG. 17-14) was a wax statue of a child ballerina. She wore a tutu made of gauze and sported a wig of real hair, tied with a ribbon. The sculpture was exhibited in a glass case, much like the figures found in contemporary wax museums. (Today the sculpture is better known through the approximately twenty-eight bronze casts that were made of it in the twentieth century and that are distributed among museums across the world.)

17-13 **Edgar Degas,** *The Tub*, 1886. Pastel, 23⅝ x 32¹¹/₁₆" (60 x 83 cm). Musée d'Orsay, Paris.

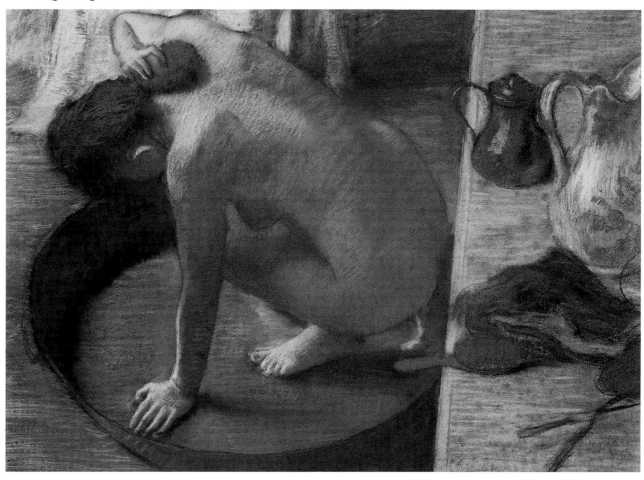

Believing that this class included a higher percentage of criminals and prostitutes than all other classes, scientists concluded that its children, girls like that represented in *Little Dancer*, were destined to a life of crime and depravity.

Even those who praised the work could not help seeing the *Little Dancer* as a human specimen. They applauded it for its "exact science," admiring the way Degas had captured the facial characteristic of the degenerate, such as a low forehead that presumably indicated a return to an evolutionary state closer to the ape. According to the critic Joris Huysmans, the "terrifying reality" of the sculpture and its unusual materials made the work daringly modern. "The fact is that, at a stroke, M. Degas has upset all the traditions of sculpture in the same way that, already some time ago, he had rocked the very foundations of painting." Few critics saw the sculpture as we see it today—an image of a spirited teenager, proud of her lithe body and eager to show off the dance steps she has learned.

The *Little Dancer* aside, sculpture, for Degas, was primarily an experimental medium in which he explored relationships between form and space. Using wax and plasticene, he made hundreds of ballerinas, horses, and bathers, often reusing the materials to make new figures. At his death, some 150 pieces were found in his studio. Many of these were later cast in bronze and found their way into museums and private collections. *Rearing Horse* (FIG. 17-15)

17-14 **Edgar Degas,** *Little Dancer of Fourteen Years Old*, 1881. Bronze, partially colored, cotton skirt, satin ribbon, wooden base, height 39″ (99.1 cm). Metropolitan Museum of Art, New York.

17-15 **Edgar Degas,** *Rearing Horse*, 1888–90. Bronze, height 12½″ (30.8 cm), Metropolitan Museum of Art, New York.

The sculpture raised something of an uproar, not only for the medium used by the artist but also for its "dreadful ugliness." One critic recommended that the work should be relegated to the Musée Dupuytren, a celebrated zoology collection that contained wax models of the heads of murderous criminals. The *Little Dancer* was perceived as a specimen of human degeneration, a much-feared biological trend that entailed a return to a lower condition in the evolutionary process traced by Charles Darwin. Degeneration, believed to manifest itself both in behavior and physical characteristics, was thought to occur in the lowest urban class from which dancers and actresses were normally recruited.

17-16 **Pierre-Auguste Renoir,** *Children's Afternoon at Wargemont,* 1884. Oil on canvas, 50 x 68³/₁₆″ (1.27 x 1.73 m). Nationalgalerie, Berlin.

may serve as an example. Like Degas's paintings of horses (see FIGS. 16-36 and 16-38), it shows the artist's interest in exploring the way that horses move in real life. The work may be based on the artist's actual observation of a horse or on his study of the photographs of Muybridge (see page 390). Clearly, Degas's horse is unlike the carefully-orchestrated rearing or trotting horses we see in eighteenth- and nineteenth-century sculpture (see FIGS. 5-11 and 9-1). Degas shows the complexity of the horse's movement as it simultaneously rears its front legs and turns its head, perhaps in a moment of fright.

Renoir in the 1880s

If any artist consciously experienced an artistic crisis in the 1880s, it was Renoir. Thanks to a business deal with Durand-Ruel in 1881, he was financially independent and, for the first time, able to travel abroad. A trip to Italy, where he was "seized by the fever to see the Raphaels," seems to have confirmed doubts in his mind as to the validity of all that he had accomplished up to that time. Many

years later he told the dealer Ambroise Vollard (c.1867–1939) that, by the early 1880s, he felt that he had "reached the end of Impressionism, and could neither paint nor draw." In despair, Renoir retraced his steps to his academic training in the studio of Charles Gleyre and began to study the works of Ingres, whom he saw as the greatest academic artist of the nineteenth century.

Renoir's works of the mid-1880s look as if they were painted by a different artist from the one who had painted the *Ball at the Moulin de la Galette* (see FIG. 16-31). *Children's Afternoon at Wargemont* (FIG. 17-16), for example, shows a new emphasis on flowing, streamlined contours and a return to a smooth paint surface that are vastly different from the choppy brushwork of the 1870s. Even though we would never mistake the work for a painting by Ingres, in some ways it is more like that artist's paintings (see, for example, FIGS. 5-33 and 10-15) than Renoir's own earlier work.

Renoir's "Ingresque" period culminated in the *Bathers* (FIG. 17-17) of 1887, a large painting that not only recalls Ingres's painting style but also his subject matter. Indeed, *Bathers* would seem to be the consequence of what the literary critic Harold Bloom has called "anxiety of influence."

17-17 **Pierre-Auguste Renoir,** *Bathers,* 1887. Oil on canvas, 46 x 67⅛" (1.18 x 1.71 m). Philadelphia Museum of Art.

Bloom's term refers to the feeling of awe an artist may feel in the presence of the work of an older, much admired artist. Such a feeling can lead to creative impotence, and yet it can also drive the artist to an attempt to emulate the older master. This is precisely what Renoir appears to have aimed at in *Bathers,* which he subtitled *Trial for Decorative Painting.*

Bathers is Renoir's attempt to provide a modern version of Ingres by creating an idealized, "decorative" work without the older artist's anatomical distortions. Renoir felt strongly that art should be anchored in nature, the essence of which was, for him, irregularity and infinite variety. Rejecting what he called "false perfection," he aimed for an idealism that did not subject nature to rules of symmetry and geometric proportions. Thus, while his *Bathers* has the flowing contours and large areas of smooth, soft flesh of Ingres's nudes, it differs in that the figures have spines and joints, dimples and skin folds. In addition, the bathers have varied bodily proportions, complexions, and hairstyles. What Renoir's painting does have in common with Ingres is an effect of timelessness and permanence. Indeed, Renoir's interest in creating such an effect was analogous to Seurat's, even though his method was quite different.

By the late 1880s Renoir had retreated from the linearism and stylization of the *Bathers. Gathering Flowers* (FIG. 17-18) of 1890 represents a return to looser brushwork and to contemporary subject matter. Yet the painting lacks the snapshot quality of earlier paintings such as *Ball at the Moulin de la Galette.* The poses of the two girls seem carefully studied rather than "snatched" from reality. Turned with their back to the viewer, they seem completely engrossed in the making of their wild-flower bouquets. Their contemplative absorption is a far cry from the action and theatricality of Renoir's early paintings.

Paul Cézanne

Like Seurat, Paul Cézanne tried to give his subjects a sense of timelessness and permanence. Perhaps the artist best summarized their analogous efforts when he said that he wanted to "make of Impressionism something solid and enduring, like the art in museums." Cézanne belonged to the Impressionist generation. Born in 1839 in Aix, in the south of France, he came to Paris in 1861. Unenthusiastic about city life, he frequently returned to Aix, and settled there permanently in the mid-1880s. In

17-18 **Pierre-Auguste Renoir,** *Gathering Flowers*, 1890. Oil on canvas, 31⁷⁄₈ x 25¹⁄₂″ (81 x 65 cm). Metropolitan Museum of Art, New York.

the 1870s he participated in two Impressionist exhibitions, urged on by Pissarro, his self-appointed mentor. Feeling sympathy for the shy Cézanne, Pissarro may have hoped that his inclusion in the Impressionist shows would make up for the artist's repeated rejections by the Salon juries of the 1860s. Ironically, the negative criticism that his works received at these shows caused Cézanne to stop exhibiting altogether.

The paintings that Cézanne exhibited at the Impressionist exhibitions of 1874 and 1877 mark his rapid move from an early vaguely Romantic mode during the 1860s and early 1870s, via Impressionism in the mid-1870s, towards his mature painting style first seen in the late 1870s. A belated example of the first mode, *A Modern Olympia* (FIG. 17-19), exhibited as a "sketch" at the exhibition of 1874, shows a curled up nude reclining on a white, shapeless mount. She is "unveiled" by a black woman for the enjoyment of a balding, middle-aged man (perhaps Cézanne himself), seated on a couch in the foreground.

Seen from the back, both he and his dog seem so absorbed by the nude that they are oblivious to the wine and fruit that are displayed on the side table.

As the title suggests, Cézanne's sketch was an attempt to update Manet's *Olympia* (see FIG. 12-35), much as Renoir's *Bathers* had been an attempt to modernize Ingres. But whereas Renoir's effort seemed serious, Cézanne's painting, deliberately childlike, looks like a joke. This may be fitting, since Manet's *Olympia* itself had been a parody of a work by Titian. Like *Olympia*, Cézanne's painting is ambiguous. Is this a bordello, in which a prostitute is dramatically presented to a client? Or are we in a gallery, in which a painting of a nude is shown to a potential buyer? Or—as one contemporary critic thought—are we witness to an erotic dream, induced by alcohol or hashish? Or, finally, is it possible that we are getting a glimpse of the artist's private fantasy life, in which art and erotic dreams are fused together?

Such speculation aside, it appears that in *A Modern Olympia* Cézanne attempted to position himself as a modernist, an

17-19 **Paul Cézanne,** *A Modern Olympia*, 1874. Oil on canvas, 18¹/₈ x 21⁷/₈" (46 x 55.5 cm). Musée d'Orsay, Paris.

17-20 **Paul Cézanne,** *The House of the Hanged Man,* c.1873. Oil on canvas, 21¹¹/₁₆ x 26″ (55 x 66 cm). Musée d'Orsay, Paris.

artist wishing to go beyond previous generations by breaking the traditional rules of art. The deliberate awkwardness of the painting, its strangely proportioned figures, its distorted perspective, and the racy subject matter all outdo Manet's *Olympia* in flouting the nineteenth-century definition of high art.

At the exhibition of 1874 *A Modern Olympia* was accompanied by three landscapes, all showing houses in a country setting. They were done in an Impressionist style that owed much to Pissarro, with whom Cézanne had been working the previous year. *The House of the Hanged Man* (FIG. 17-20) resembles Pissarro's work both in its subject matter and form (see, for example, FIG. 16-25). Like Pissarro, Cézanne applied the paint in short strokes yet, while the former had a light touch, Cézanne applied it in heavy dabs, creating a thick, encrusted surface.

Cézanne did not show at the Impressionist exhibition of 1876, but he returned in 1877 with no less than sixteen works. A number of these show the beginning of his growing desire to "renew" his art and "add a new link" to tradition. As he embarked on the realization of this goal, he increasingly turned to still life. Still life had long been a favorite subject for pictorial experimentation; lowest in the academic ranking of genres, it was most conducive to "messing around." Still lifes did not move, like models, or change, like landscapes. What is more, they could be arranged to suit the artist's pictorial purpose.

Three "still lifes" and two "studies of flowers" were among Cézanne's paintings shown at the exhibition of 1877. It is impossible to identify them with certainty, but one of them may have been the *Plate of Apples* (FIG. 17-21) now in the Art Institute of Chicago. This is a simple painting that shows just the corner of a table with a white ceramic plate filled with red and green apples. Patterned wallpaper, a flowered tablecloth, and a rumpled napkin lend added visual interest to the picture.

At first, the broken brushwork recalls Impressionism, but a closer look reveals that it is not as loose and

seemingly haphazard as the paint application in Monet's *Still Life with Apples and Grapes* (FIG. 17-22). One begins to notice that Cézanne's carefully organized brushstrokes serve an entirely new purpose—not to call to mind the flickering reflections of light in an irregular, shiny surface, but to suggest the three-dimensionality of the apples. Rather than using traditional means of highlighting and shading to express form, Cézanne uses brushwork, in combination with color, to express volume and mass.

In the Renaissance, when the systematic pursuit of perspective began, the representation of rounded forms had been a major challenge. Artists such as Albrecht Dürer had broken down rounded forms into flat geometric surfaces (FIG. 17-23) to understand better how they appeared in

17-23 **Albrecht Dürer,** *Two Heads Divided into Facets and St Peter,* 1519. Drawing, 4 x 7" (11.5 x 19 cm). Sächsische Landesbibliothek, Dresden.

color was mobilized in the effort of conveying three-dimensionality without the use of traditional *chiaroscuro*. Relying on the perceptual phenomenon that warm and saturated colors look closer than cool and unsaturated ones, Cézanne carefully chose colors to maximize the suggestion of the three-dimensionality of the apples and other subjects in his paintings.

Cézanne's interest in the renewal of traditional perspective was not limited to the representation of objects, but extended to the representation of space itself. The *Plate of Apples* conveys a sense of instability; the plate looks lopsided and the table top warped (its excessive tilt causes us to worry that the plate might slide off). Critics of the Impressionist exhibition of 1877 joked that Cézanne's still lifes were "not 'still' enough" and some were so shocked by their distorted representation of reality that they called them "detestable jokes."

Few people realized that Cézanne's experiments in representing space broke, once and for all, with the rules of perspective that had been followed since the Renaissance. Traditional perspective construction was based on the premise of a single viewpoint, that is, an eye that does not change its position. In a woodcut by Dürer illustrating perspective (FIG. 17-24) we see an artist drawing a figure on a two-dimensional plane. The artist looks through a hole

perspective. Cézanne, similarly, applied paint in short parallel strokes (much like the hatchings in Dürer's print) to form small, planar facets that together constitute the surface of the apple. Never before had facture (the way the paint is applied to the canvas) played such an important role in painting. Not only brushwork but also

17-24 **Albrecht Dürer,** *Draftsman Drawing a Portrait.* Illustration in *Underweysung der Messung,* 1525. Woodcut, 5³/₁₆ x 5⁷/₈" (13.1 x 14.9 cm). Harvard University Libraries, Cambridge, Massachusetts.

17-25 **Paul Cézanne,** *The Gulf of Marseilles Seen from l'Estaque,* c.1883–5. Oil on canvas, 28 x 39⅛" (73 cm x 1 m). Metropolitan Museum of Art, New York.

drilled in a flat little plate attached to a stick. This keeps his eye stationary, so that he looks at every part of the subject from the same, stationary viewpoint.

Dürer's artist sees the world, of course, in an idealized fashion. In reality, when one observes something, the eye moves back and forth to scan the subject. Sometimes the head and body move as well to get a more thorough view. In *Plate of Apples* Cézanne tried to convey this eye motion. We appear at once to be looking down upon the table (as if we were standing) and straight at it (as if we were seated). This mixture of viewpoints is bound to create pictorial problems. The dip in the horizontal edge of the table (hidden behind the plate) and the strangely irregular rim of the plate (similarly hidden behind three apples) mark the transitions from one viewpoint to another.

Cézanne's contemporaries found his pictures to be strangely distorted because they were so used to traditional perspective that they did not realize that these works required a new way of looking. Truly to appreciate Cézanne's work, the viewer's eye must wander across the picture in the same way as the artist's eye once scanned reality. By using multiple viewpoints, Cézanne made time

a prerequisite for viewing his paintings. One might say that he added a "fourth dimension" to his work.

Cézanne's new approach to perspective, only faintly visible in his works of the late 1870s, was further developed in the 1880s, not only in still-life paintings but also in landscapes and figure paintings. *The Gulf of Marseilles Seen from l'Estaque* (FIG. 17-25) shows the Mediterranean Sea, seen from the little village where Cézanne went to paint in the early 1880s. More than *Plate of Apples,* it shows the meticulous way in which Cézanne "built up" his paintings: short, diagonal strokes for the roof, curved strokes for the trees, heavy lines for the sea, and fluffy brushstrokes for the sky. Unlike the Impressionists, Cézanne appears to have been unconcerned with capturing the effects of weather or the quality of daylight. Instead, he seems to have wanted to present a generic view, a condensation of all the various sensations that the artist had in front of the landscape. "Art is a harmony parallel to nature," he once wrote to a friend, suggesting that art is not the re-presentation of reality but its re-creation.

While *The Gulf of Marseilles Seen from l'Estaque* demonstrates Cézanne's progress in the "structural brushstroke,"

visual sensations to which he was subjected daily, from the moment he woke up to the time he closed his eyes. "Treat nature by the cylinder, the sphere, the cone," he once wrote to a young artist who had come to him for advice, encouraging him somehow to find order in the chaotic spectacle of nature.

Vincent van Gogh

Among the numerous visitors to the eighth Impressionist exhibition was a 33-year-old Dutch painter by the name of Vincent van Gogh. Newly arrived from the Netherlands, he was staying with his brother Theo, who lived in Montmartre, where many artists had their studios. Theo worked for the art dealer and print publisher Boussod-Valadon and was put in charge of the sale of "new" paintings.

Van Gogh had come to art late and was largely self-taught. Until his arrival in Paris he had practiced a form of peasant painting that was inspired by Millet, but which was rawer and more uncouth than that master's work. *Potato Eaters* (FIG. 17-27) was the most important painting that he had produced to date. He had completed it just before he came to Paris and hoped it would make his reputation, which was as yet non-existent.

As he became acquainted, in Paris, with the art of the Impressionists and Neo-Impressionists, van Gogh quickly realized that, though his work was highly original, it was out of step with modern trends. His *Potato Eaters* was a tonal painting, in which the color was kept within a narrow range of browns and blue-greens. The painting's subject was simple: inside a grimy peasant cottage, five peasants from his native region of Brabant are gathered around their frugal evening meal. The light from the oil lamp above the table moves across their tired, gloomy faces to settle on the platter of potatoes, the humble fruits of their hard labor. With their round, coal-black eyes, their huge noses and protruding jaws, they look like caricatures and they would be laughable were it not for the serious, even solemn mood of the picture. By distorting the faces of his subjects, van Gogh wished to convey that poverty and hard physical labor stunt the human mind. What is more, he wished to express his indignation that society allowed its members to live such stultifying lives. At the same time, however, he tried to express his respect for the integrity of peasant life. "I have tried to emphasize," he wrote to his brother Theo, "that those people, eating their potatoes in the lamplight, have dug the earth with those very hands they put in the dish, and so it speaks of *manual labor*, and how they have honestly earned their food."

Van Gogh's painting may be called expressive, in that the artist consciously tried to convey his emotions to the viewer. In some sense, one may say that all art is expressive because through the very choice of medium and subject matter the artist reveals something about himself. But

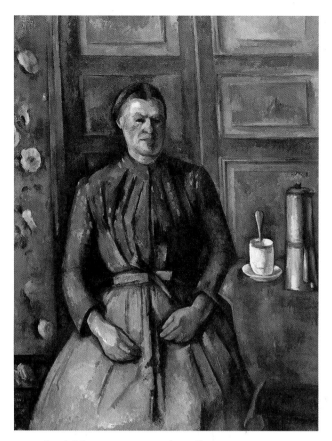

17-26 **Paul Cézanne,** *Woman with a Coffeepot,* c.1890–5. Oil on canvas, 51 x 38" (1.3 m x 97 cm). Musée d'Orsay, Paris.

Woman with a Coffeepot (FIG. 17-26) from about 1890–5 demonstrates the evolution of his use of the multiple view-point. Looking at this painting, we seem to sit "knee to knee" with a middle-aged peasant woman, probably in Cézanne's native region of Provence. Our eyes are at the same height as hers, so that we are looking straight at her face and torso. If we want to see her apron, however, we have to look down upon her lap. If we refuse to take the time and effort to do this, the woman looks strangely suspended in mid-air, neither standing nor sitting but hovering next to the table. The same observation holds true for the table. If we take the time to scan the table slowly, from the cup and saucer at the other end to the empty corner at our own, it all makes sense. It is only when we want to capture the picture in a single glance that the table looks weirdly distorted, like a floppy tablecloth floating in the air.

What does all this have to do with Cézanne's wish to "make of Impressionism something solid and enduring, like the art in museums?" Although Cézanne (like Seurat and like Renoir) admired Impressionism for its emphasis on direct observation, he felt that simply recording scenes was not enough. He once said somewhat disparagingly that Monet was "nothing but an eye," though he added, "but, my God, what an eye!" To Cézanne, an artist had to create something solid and permanent from the flood of

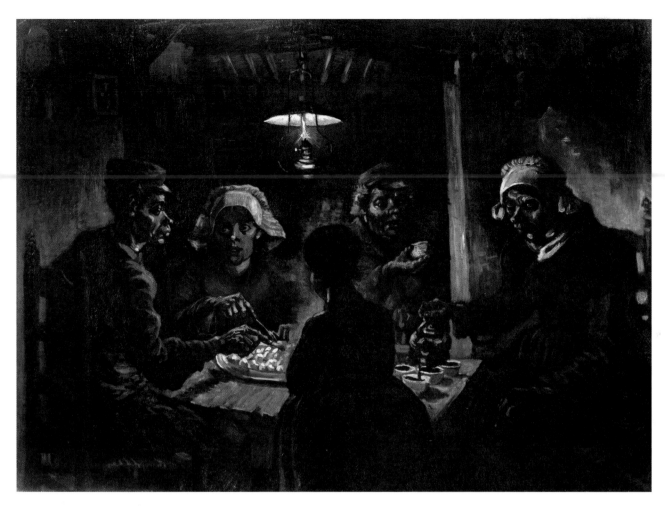

17-27 **Vincent van Gogh,** *Potato Eaters,* 1885. Oil on canvas, 32⁵/₁₆ x 44¹⁵/₁₆" (82 cm x 1.14 m). Rijksmuseum Vincent van Gogh, Amsterdam.

The Letters of van Gogh

Between 1872 and 1890 Vincent van Gogh wrote nearly 700 letters to his brother Theo, who lent him lifelong financial and moral support. Twenty-four years after the death of the two brothers in 1890 and 1891 respectively, Theo's wife Johanna Bonger published these letters in a three-volume edition in the artist's native Netherlands.

Translated into many languages, Vincent's letters are perhaps the most moving and evocative documents that we have about any nineteenth-century artist. Vincent described his day-to-day life and shared his most intimate thoughts about life, death, love, and art. He not only expressed his thoughts about art in general, but he also described in detail the creative trajectories of particular works and the meanings he intended to convey in them.

Beautifully written, the letters of van Gogh are an important work of literature in their own right, one that has

given rise to at least two major movies, *Lust for Life*, 1956 (with Kirk Douglas and Anthony Quinn) and the more recent *Vincent and Theo*, 1990 (Tim Roth and Paul Rhys). Both films would have been unthinkable without the letters, which inspired their main themes as well as much of the storyline.

The publication of the letters of van Gogh was important not just for their own sake but also because it alerted scholars to the enormous wealth of art-historical source material that was contained in artists' letters and other written materials, such as diaries, notebooks, and the like. In the course of the twentieth century, much of this material was collected and published. Today we have access to published diaries, notebooks, and letters of Constable, Friedrich, Runge, Ingres, Delacroix, Courbet, Degas, Cassatt, Pissarro, Gauguin, Cézanne, and Toulouse-Lautrec, to mention only a few.

whereas previously artists had expressed themselves primarily through their choice of subject matter and their careful selection from and manipulation of reality, they had not distorted reality for the purpose of enhancing art's expressive possibilities. Distortion of reality, until this time, had been the prerogative of caricaturists (who were expected to draw a laugh) and of artists specializing in the imaginary and fantastic.

In *Potato Eaters* Vincent's chief vehicles of expression were contour and tone. But his stay in Paris taught him that brushwork and color were equally if not more effective in conveying emotions. In the avant-garde artists' milieu in which he moved, he must have become acquainted with the ideas of Chevreul and Henry concerning the psychological impact of colors, which had so impressed Seurat and Signac. In a number of paintings produced in Paris, van Gogh actually adopted the Pointillist method of the Neo-Impressionists. *Interior of a Restaurant* (FIG. 17-28), painted in the late spring of 1887, is a prime example. The painting could hardly be further removed from *Potato Eaters*.

Color has been substituted for tonality and a light Pointillist brushstroke has replaced heavy smearing. Instead of a pitiful peasant repast, we have the promise of a genteel meal in a cheerful bistro, complete with starched linens, sparkling crystal, and fresh flowers on the table. Unlike the *Potato Eaters*, this painting is full of cheery anticipation, a sense that is conveyed by subject as well as form. Warm colors and an abundance of diagonal, upward-moving composition lines contribute to that feeling of cheerful relaxation that Henry had dubbed "dynamogeny."

The Italian Woman (FIG. 17-29), painted some six months after *Interior of a Restaurant*, represents a further stage in the evolution of van Gogh's style of painting during his two-year stay in Paris. Here we see a woman dressed in a colourful regional costume, her form sharply silhouetted against a garish yellow background. No longer Pointillist, this painting is built up of short, straight strokes that suggest volume and texture. This method calls to mind the paintings of Cézanne but, whereas that artist used exclusively local colors (see page 400), van Gogh

17-28 **Vincent van Gogh,** *Interior of a Restaurant*, 1887. Oil on canvas, 18 x 22" (45.5 x 56.5 cm). Rijksmuseum Kröller-Müller, Otterlo.

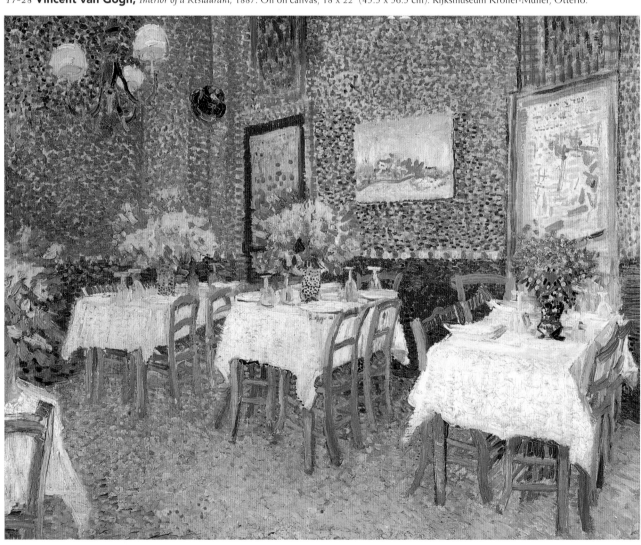

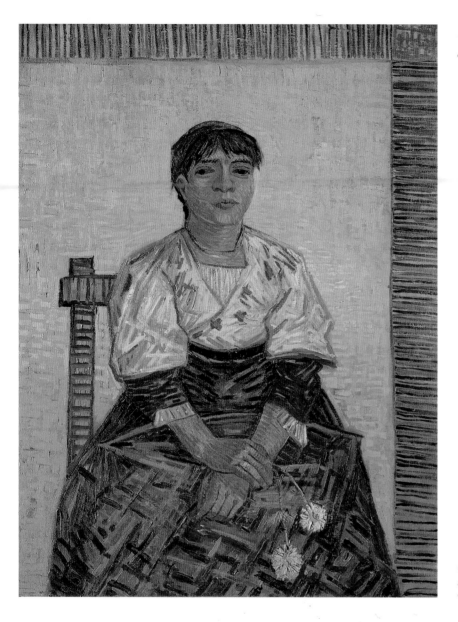

17-29 **Vincent van Gogh,** *The Italian Woman,* 1887. Oil on canvas, 32 x 23⅝" (81 x 60 cm). Musée d'Orsay, Paris.

17-30 **Kitagawa Utamaro,** *The Courtesan,* mid-1790s. Woodblock print, approximately 10 x 15" (25 x 38 cm). Private Collection, London.

juxtaposed contrasting colors. In the face, arms, and hands of the Italian woman, for example, strokes and touches of reddish pink alternate with turquoise (or aquamarine) to suggest effects of light and shade. So convincing is his use of color that it seems that the woman is seated in front of a sunlit window, her face seen against the light.

Contour plays an important part in this painting: many forms are emphatically outlined. This emphasis on contour may be attributed to van Gogh's renewed enthusiasm, in Paris, for Japanese prints (FIG. 17-30). (Around this time he wrote to his brother that the Japanese printmaker Hokusai could bring him to tears by "his line, his drawing.") Like Japanese prints, too, *The Italian Woman* lacks perspective, which gives it a patterned, decorative character.

Van Gogh's move to the south of France in 1888 was motivated as much by his distaste for the Parisian art world as by his desire to find a place that would resemble Japan, which to him seemed a sort of utopia. In the small town

of Arles, in the sun-drenched region of Provence, he hoped to found an artist's colony, where he and friends would live and work together. Although this did not work out and although Arles turned out to be just another small French town, Vincent's stay here, nonetheless, coincided with the most creative period in his short life—two years in which he produced one masterpiece after another.

Arles: View from the Wheat Fields (FIG. 17-31) is a representative work of this period. In the foreground of the painting, on a stretch of field that has already been reaped, sheaves of wheat are leaning against one another; in the middle distance, a farmer is cutting grain with a sickle. Farther back, against a sulfur-yellow sky, we see the silhouette of the town—a mixture of municipal gasworks, medieval

17-31 **Vincent van Gogh,** *Arles: View from the Wheat Fields,* 1888. Oil on canvas, 28 x 21″ (73 x 54 cm). Musée Rodin, Paris.

buildings, and new bourgeois homes, all partly hidden by a train, chugging along the edge of the field. With its juxtaposition of country and city and of old and new, and with the prominence of the reaper, traditional symbol of death, van Gogh's painting calls attention to the passing of time—the changing of seasons, the gradual disappearance of nature at the hand of industry, the human cycle of life and death.

Van Gogh adopted the short choppy brushstrokes of the Impressionists but he adjusted their thickness and length to make them express the affective value of each object. Thus the hay stubble in the foreground is depicted with thin, furious strokes, conveying something about the violence done by the sickle. By contrast, the wheat still standing is painted with thicker, slower strokes, suggesting the heaviness of the overripe ears. In the sky, the heavy clouds of exhaust gas that billow forth from the gasworks are rendered with a heavy, almost suffocating impasto.

Color too plays a crucial role. The overwhelming amount of yellow speaks of the power of the sun as the giver of light and life. It also suggests the brutal, relentless heat that envelops the field. Finally, the painting's composition, in which the wheat field takes up almost the entire picture plane, alludes to the endless task of the reaper.

To van Gogh, brushwork, color, and composition all worked together to lend meaning to his paintings. He saw these formal elements as so crucial to the production of meaning that, increasingly, he felt justified in departing from actually observed reality. In *Night Café* (FIG. 17-32), for example, the colors are exaggerated, even "untrue" (note the green hair of the bartender, for example), and the perspective is strange. The heavy contours around figures are crudely drawn, distorting their proportions. In one of his many letters to his brother Theo (see *The Letters of van Gogh*, page 421), he explained what he had tried to do in this painting: "So I have tried to express, as it were, the powers of darkness in a low public house, by the soft . . . green and malachite, contrasting with yellow-green and harsh blue-greens, and all this in an atmosphere like a devil's furnace of pale sulphur." In another letter he wrote: "It is color not locally true from the point of the delusive realist, but color suggesting some emotion of an ardent temperament." Van Gogh was well aware that his paintings might shock the contemporary public. He admitted that the *Night Café* seemed to him "atrociously ugly and bad." But paintings like that, he wrote to Theo, "are the only ones which appear to have any deep meaning."

17-32 **Vincent van Gogh,** *Night Café*, 1888. Oil on canvas, 27⅝ x 35" (70.2 x 88.9 cm). Yale University Art Gallery, New Haven.

17-33 **Vincent van Gogh,** *Starry Night,* 1889. Oil on canvas, 28 x 36" (73 x 92 cm). Museum of Modern Art, New York.

Van Gogh's expressive exaggerations are perhaps most clearly seen in his last works, painted after a series of seizures that led him to commit himself, in 1889, to an asylum in Saint-Rémy, near Arles. There he painted his famous *Starry Night* (FIG. 17-33), during one of the extended lucid periods between his intermittent attacks. *Starry Night* was a view from Vincent's window, modified to express the artist's feelings about life, death, and infinity. The modest-size canvas shows a small village nestled among hills, underneath a glorious starry sky. What is most striking about the image is that, with the sole exception of the village, everything appears to be in motion. Mountains, like waves, wash up and recede, and cypress trees, like huge flames, lick the sky. The bright stars in the sky rotate rapidly, leaving long, coiled trails. A huge serpentine form, looking like a spiral nebula, unrolls itself. We are confronted in this painting with the stirring, animating force of nature that some call "God," others the "Creator."

Post-Impressionism

Although it is obvious to us today that Seurat, Cézanne, and van Gogh moved away from the Impressionists' core concerns, these artists, with the possible exception of Seurat (see page 405), still thought of themselves as Impressionists. Few contemporary critics argued otherwise, especially since Cézanne and van Gogh were little known artists working outside Paris.

It was not until the early twentieth century that a true interest in Seurat, Cézanne, van Gogh, and contemporaries such as Paul Gauguin (see Chapter 19) and Emile Bernard developed and that their works began to be widely exhibited. At that time, critics felt the need to coin a name for their art, which, they now realized, was distinct from Impressionism. In 1910 the British critic Roger Fry (1866–1934), asked to write an essay for a gallery exhibition of the works of Cézanne, van Gogh, Gauguin, and others, coined the name "Post-Impressionism." Fry defended the name—which means little more than that these artists

came *after* the Impressionists—by arguing that it was impossible to define the disparate works of these artists "by any single term." "In no school," he wrote, "does individual temperament count for more. In fact, it is the boast of those who believe in this school that its methods enable the individuality of the artist to find completer self-expression in his work than is possible in those who have committed themselves to representing objects more literally." To Fry, the only common denominator among the Post-Impressionists was that they "consider[ed] the Impressionists too naturalistic."

The term Post-Impressionism, today, is used in two ways. Some art historians use it broadly to refer to all art created in France in the last fifteen years of the nineteenth century, including the works of Seurat, Cézanne, van Gogh, the late works of the Impressionists and the works of the so-called Symbolists (see Chapter 19). There are those who would even include in the term the works of contemporary artists working outside France. Others, however, reserve the term, more narrowly, for the art of Seurat, Cézanne, and van Gogh—artists who, like the Impressionists, remained faithful to the idea of working from nature. They contrast the Post-Impressionists with the Symbolists, who allowed imagination to enter into their art. In this book, the latter usage is followed, with the proviso that the terms "Post-Impressionism" and "Symbolism" are both fluid and interactive.

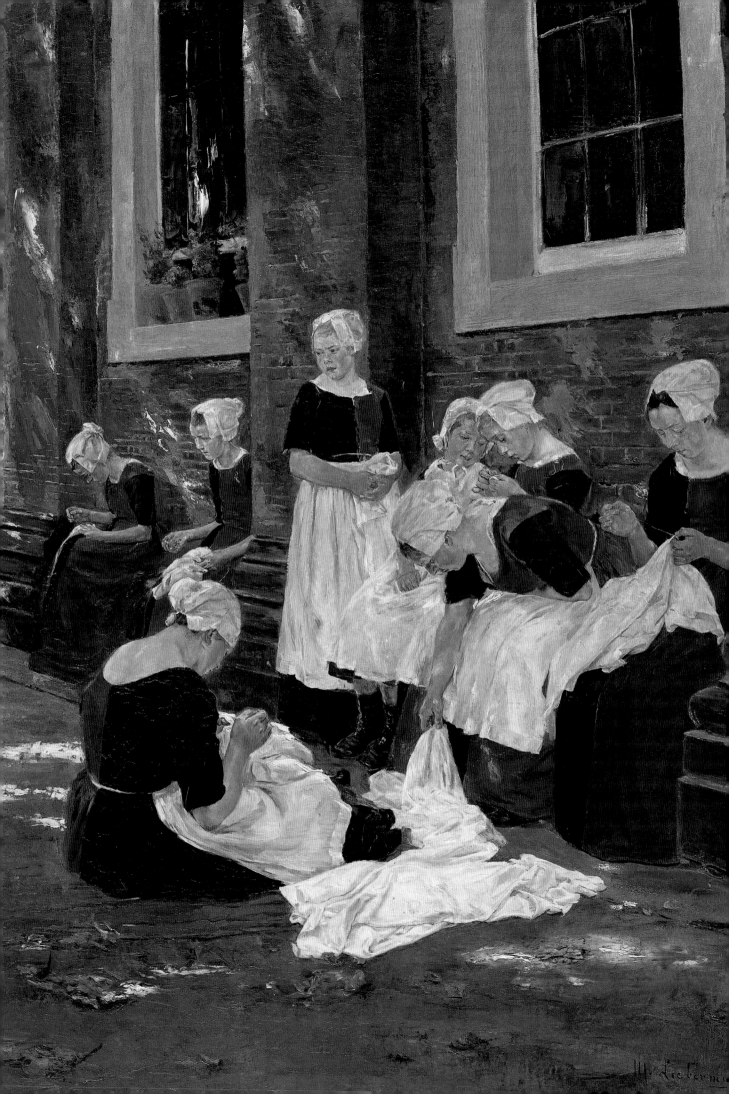

Chapter Eighteen

When the Eiffel Tower was New

In the mid-1880s the government of the Third Republic decided to organize a monumental international exposition in order to celebrate the centennial of the French Revolution. It was to be the largest such event to date, and the French hoped for maximum participation from other nations. Edouard Lockroy, its chief organizer, wanted the exhibition to illustrate that the Revolution had been not only a glorious event in French history but "a European event, welcomed by enthusiastic nations; the point of departure, for the entire world, of a new era." Although the exhibition of 1889 was undoubtedly a huge success, it was not as universal as Lockroy had hoped. A number of nations, including the Ottoman empire, declined to participate in order to show their disapproval of the ideals of the French Revolution.

The Universal Exposition of 1889 was to be situated on the so-called Champ de Mars (literally, the field of Mars, the Roman god of war) in Paris. This large open area on the right bank of the Seine river had been the site of earlier international expositions as well as several important revolutionary celebrations. The exposition was to include the obligatory hall of machines, and various exhibits of industrial products as well as fine arts. Moreover, colonial displays, which had been a regular feature since the Crystal Palace exhibition of 1851 in Britain, were vastly enlarged and enhanced with "live" exhibits.

The Eiffel Tower

The planners of the exhibition wanted a monumental gateway at the entrance that would express the ideas of revolution, renewal, and progress that underlay its conception. A competition was organized and more than one hundred designs were submitted. Significantly, the commission for the gateway went not to a traditionally trained architect, but to an engineer who specialized in bridges and industrial buildings. It was the 55-year-old Gustave Eiffel (1832–1923) who, with the help of a young assistant, designed and built the monumental entrance tower that has become the hallmark of Paris (FIG. 18-1).

The Eiffel Tower was an unprecedented structure that combined features of the Roman triumphal arch and the Gothic spire. It had a dual function as both a monumental entrance and a giant beacon. Measuring 984 feet (300 metres) in height, it was by far the tallest structure of its time. Elevators took visitors up to the top, where they were treated to a panoramic view that surpassed any they had even seen before. No wonder that, during the seven months' exposition alone, nearly two million people visited the tower, a record number for any tourist site to date at that time.

The Eiffel Tower's unprecedented height was made possible by an entirely new mode of wrought-iron construction that combined strong supporting girders with open latticework. To make the building windproof, and also for

18-1 **J. Kuhn,** *The Champ-de-Mars and the Eiffel Tower,* c.1889–90. Photograph, 8 x 10" (20.9 x 27.3 cm). Wesleyan University, Davison Art Center Collection.

18-2 **H. Sicard,** *The Eiffel Tower at Night,* 1889. Chromolithograph, 8⅞ x 6" (22.6 x 15.8 cm). Private Collection.

aesthetic reasons, Eiffel designed it so that the tower rested on four enormous lattice-girder piers, connected by arches. The piers tapered inward to form a tall, slender spire. The rapid and economic construction (it took only 26 months and 250 men on-site to construct the tower) was facilitated by the off-site prefabrication of standard modular parts (compare the Crystal Palace discussed on page 342) that were assembled on the spot. Among its more remarkable features were the glass-cage elevators. Designed by the Otis Elevator Company in New York, they ascended on a curve as they made their way from one of the piers to the viewing platform near the top of the tower.

For the exhibition, the Eiffel Tower was coated with iridescent paint that shimmered in the sunlight. At night, lit by gas and electricity, it emanated a rosy glow. A lithograph of the period (FIG. 18-2)—one of the numerous mass-produced souvenirs of the time—conveys something of the miraculous spell that the tower must have cast over the thousands of visitors from across the world that crowded around it every night.

The Gallery of Machines

Passing through the arched openings of the Eiffel Tower, visitors entered a vast courtyard formed by the main exhibition building in the rear and the fine arts and "liberal arts" wings on either side. Behind these three buildings was the immense Gallery of Machines (FIG. 18-3), a glass and steel behemoth approximately 350 feet wide and nearly one-third of a mile long. It surpassed all previous structures in length and width, including St Pancras station in London, which for more than twenty years had been the largest roofed space in the world. The Gallery of Machines had two floors housing a vast array of exhibits. To gain access to the second floor, visitors stepped on a moving crane that transported them from one end of the hall to the other. Up to 100,000 passengers rode these "rolling bridges" every day, a measure of the extent to which people were mesmerized by machines and the progress they were thought to bring.

By far the most popular exhibit in the Gallery of Machines was the display of the products developed by Thomas Alva Edison, which featured examples of Edison's newly invented phonograph and "fountains of light," made with hundreds of electrical light bulbs.

The History of the Habitation Pavilions

The technological progress exemplified in the Eiffel Tower and the Gallery of Machines was juxtaposed with the "History of Habitation" street, a walkway along the Seine that was lined with forty-four dwellings that told the story of "the slow but inevitable march of humanity" through the ages. A contemporary illustration (FIG. 18-4) reproduces several of these dwellings, which included grottoes, tents, straw huts, cottages, and villas from different parts of the world. Designed by Charles Garnier, architect of the Paris Opéra (see page 262), some of the dwellings, like the Egyptian house, were representative of a bygone past. Others, like the nomadic tent, were still in use in certain parts of the world. Seen against the backdrop of the Eiffel Tower, these domestic structures emphasized the progress that had been made in architecture, most notably in the "civilized" Western world of which Paris was featured as the center.

Colonial Exhibits

Ever since the Crystal Palace show of 1851, the organizers of international expositions had made an effort to

18-3 **Anonymous,** *Gallery of Machines,* 1889. Photograph, 9⅝ x 12" (24.5 x 30.5 cm). Library of Congress, Washington, DC.

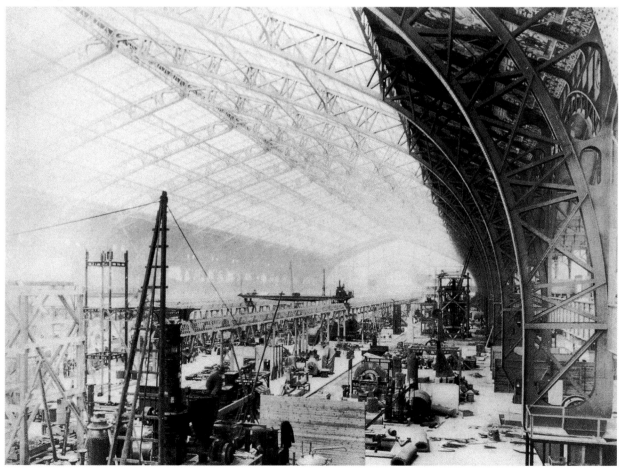

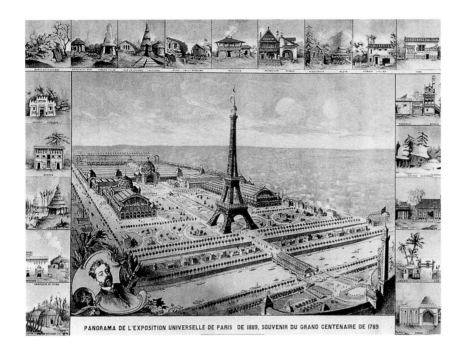

18-4 **Artist unknown,** *Panorama of the 1889 Exposition.* From *Magasin du Printemps,* 1889. Chromolithograph, 22 x 28" (55.9 x 71.2 cm). Private Collection.

combine displays of industrial and artistic progress in Europe and North America with displays featuring the non-Western world. The latter focused on the Far East (Japan, China), South Asia (India, Indonesia), the Orient (a vague term that denoted the Near and Middle East, Egypt, and North Africa), and what was then thought of as the "primitive" world of central Africa and Polynesia.

Non-Western exhibits took on ever greater importance as European nations became increasingly imperialistic (see *Nineteenth-Century Imperialism,* opposite). Countries with important overseas colonies mounted huge exhibits in special "colonial palaces." These were built in fantastic styles that combined Western plans with eclectically borrowed native motifs. The Tunisian Palace at the 1889

18-5 **Henri-Jules Saladin,** *The Tunisian Palace at the 1889 Exposition (destroyed).* Illustration in E. Monod, *L'Exposition Universelle de 1889* (vol. 2), Paris, 1889. Bibliothèque Nationale, Paris.

Colonization, a Western European practice since the sixteenth century, changed and expanded dramatically in the course of the nineteenth century. The vastly increased productivity made possible by the Industrial Revolution caused Europeans to look for new sources of raw materials as well as for new markets. Merchants found that the best places for trade were outside Europe. It soon became clear, however, that for overseas trade to flourish colonies or protectorates were essential because they alone could offer security and stability. Already, in the middle of the nineteenth century, the British (whose experience in colonization went back to the seventeenth century) held colonies in Canada, Australia and New Zealand, India, and various African countries, while the French were in control of North Africa. Increasingly, colonialism turned into imperialism, which involved heightened political control of the colonized countries to the point where they became integral parts of the "mother" country.

The 1880s witnessed the beginning of the so-called new imperialism, a desperate scramble among Western European nations to annex as much as they could of the non-Western world, most notably Africa. Although the race for empire was won unquestionably by the British, which at the time of Queen Victoria's death in 1901 was the greatest colonial power in the world, many nations took part in it, most notably France, Germany, the Netherlands, and Belgium. The consequences of the "new imperialism" would be felt for most of the twentieth century, and continue to affect the world today.

exhibition (FIG. 18-5), for example, had a façade derived from the Great Mosque at Kairouan, a dome and minaret resembling the Islamic center of Sidi Ben-Arus in Tunis, and verandas borrowed from traditional Tunisian domestic architecture.

While the first colonial exhibits, in 1851 and 1855, featured mostly products (both raw materials and goods manufactured in the colonies), later ones were aimed at acquainting Westerners with the cultures of colonized peoples. Inside the colonial pavilions one could admire native tools, costumes, and photographs documenting the lives and the people of the colonies. (Thus the international expositions became the precursors of twentieth-century anthropological museums.)

Another and more direct way of familiarizing visitors with the cultures of colonized people was the live human exhibit, in which native people were displayed much like animals in a zoo. The practice of the so-called native village exhibiting became especially popular in 1889. Native villages were reconstructed habitats, populated by between 50 and 200 native Africans or Asians who were temporarily "imported" for the purpose. For the duration of the exhibition, they would go about their daily lives (in as much as this was possible) so that visitors could get an idea as to how they dressed, talked, prepared their food, etc. The purpose of the exhibits was both educational and imperial. Bringing together the colonizer and the colonized, the exhibits stressed the "primitive" circumstances under which most "native" people lived. Thus they served as a justification for the colonial enterprise, which was thought to bring modernization and progress. The "colonized" were present to impart due respect for the achievements of Western imperialists.

In addition to the "native villages," the exhibition of 1889 included the popular "Cairo Street" (FIG. 18-6).

Designed (and perhaps also financed) by a wealthy Frenchman who had lived in Egypt for many years, it was a reconstruction of a street in old Cairo, containing some architectural fragments from demolished buildings in that city. Unlike the "native villages," which were supposedly educational, Cairo Street was devised for amusement. The

18-6 *Cairo Street*, Exposition of 1889. Wood engraving. Bibliothèque Nationale, Département des estampes et de la photographie, Paris.

18-7 **Pascal-Adolphe-Jean Dagnan-Bouveret,** *Brittany Pardon,* 1886. Oil on canvas, 45¹/₈ x 33³/₈" (1.15 m x 84.8 cm). Metropolitan Museum of Art, New York.

street was populated by musicians, dancers, artisans, camels, and donkeys imported from Egypt. To the horror of Islamic visitors, it included a mosque that served as a coffeehouse, complete with dancing girls and other forms of exotic entertainment.

Despite their frequent lack of authenticity, the non-Western exhibits at the 1889 Universal Exposition contributed greatly to familiarizing the public with the world outside Europe. For artists, in particular, the acquaintance with non-Western architecture, art, and artifacts was of great importance because it stimulated them to rethink traditional Western forms and techniques.

The Fine Arts on Exhibit

The Fine Arts Palace had several distinct exhibitions that showed off a great number of paintings and sculptures. The "Centennial Exhibition" provided an overview of French art between 1789 and 1889. It included works by all famous French artists from David to the present. Another exhibition, the Decennial, emphasized the art produced during the last decade. Each country, moreover, had its own section in the Fine Arts Palace, featuring works that were selected by national committees. And, as if this were not enough, the exhibition coincided with the annual Salon, which opened its doors on May 1 with no less than 5,810 entries.

Visitors to the Fine Arts Palace of the 1889 exhibition or, for that matter, to the contemporary Salon, would have looked in vain for the works of Seurat or Signac, van Gogh or Cézanne, or even the Impressionists. The works of these artists were known only to a small number of critics, collectors, artists, and aficionados of contemporary art. This does not mean that truly interested visitors to Paris in 1889 would not have been able to find them. At the Salon des Indépendents, held in the late summer and early fall, they could have seen works by Seurat, Signac, van Gogh and Toulouse-Lautrec (see page 456). At the Gallery Georges Petit, some 145 works by Monet were on exhibit, together with a number of sculptures by Rodin. And the works by other Impressionist, Post-Impressionist, and Symbolist artists were shown in several more or less prominent galleries, and even in cafés. Yet none of these exhibitions came even close to attracting the numbers of visitors who crowded the Fine Arts Palace every day.

The Triumph of Naturalism

Both the Decennial Exhibition and the Salon of 1889 were dominated by Naturalism, which, by the late 1880s, had become an international style, practiced across Europe and in the Americas. Although Bastien-Lepage, the prophet and apostle of Naturalism, had been dead for almost

five years, several of his works—including the famous *The Haymakers* and *Joan of Arc Listening to the Voices* (see FIGS. 16-16 and 16-17)—were shown at the Decennial Exhibition, a clear indication of his eminent status in his own time. *Joan of Arc* was lent by the American collector Erwin Davies, who, that same year, donated it to the Metropolitan Museum in New York, where it can still be seen today.

It was generally acknowledged in 1889 that Bastien-Lepage's role as torchbearer for the Naturalist movement had been passed to Pascal-Adolphe-Jean Dagnan-Bouveret (1852–1931), whose *Brittany Pardon* (FIG. 18-7) was one of the most widely admired works at the exhibition. The painting, now in the Metropolitan Museum as well, depicts a religious custom practiced in the French province of Brittany. In a "Pardon," villagers moved in procession around the church—some barefoot, others crawling on their knees—in order to show penitence for their sins.

Dagnan-Bouveret brought something new to Naturalism, namely the use of photography. Although, like Bastien-Lepage, he followed the academic painting practice of preparing careful preliminary drawings for each figure, he incorporated the photograph into this routine as yet another step or, sometimes, as a substitute for a drawing. For the woman in the foreground of *Brittany Pardon*, for example, he relied on a photograph of a volunteer model, carefully posed and dressed for the purpose (FIG. 18-8).

18-8 Gustave Courtois's mother models for the foreground figure in *Brittany Pardon*. Photograph. Archives Départementales, Vesoul.

18-9 **Jules Bastien-Lepage,** *The London Bootblack,* 1882. Oil on canvas, 52⅛ x 35″ (1.33 m x 89.5 cm). Musée des Arts Décoratifs, Paris.

Contemporary critics (who may or may not have been familiar with Dagnan-Bouveret's method) praised the photographic exactitude of his paintings, which they admired the more as it was applied to subject matter that recorded rapidly disappearing national and regional traditions. Dagnan-Bouveret, as one critic observed, had answered the call that a beautiful work contain everything from ancient art united with the modern spirit.

Not all French Naturalists focused on traditional rural scenes. Bastien-Lepage himself, in the early 1880s, had painted a number of paintings of urban types, mostly children forced to make a living on the street. His *The London Bootblack* (FIG. 18-9), painted during one of several trips to London, may serve as an example. It shows a young boy, dressed in the red cap and jacket of the London Shoe Black Brigade, leaning against a street corner post. As he resigns

himself to wait for a customer, the city traffic rushes behind him. Hansom cabs stop and go, following the directions of a policeman. Pedestrians crowd the busy sidewalks. Although different in spirit from his rural scenes, Bastien-Lepage's *The London Bootblack* shows the same attention to detail, all for the purpose of lending the painting a feeling of authenticity.

Work (FIG. 18-10) of 1885 by Alfred Roll (1846–1919) likewise depicts an urban scene, though on a more monumental scale. The painting represents a construction site at Suresnes, near Paris, where, in the 1880s, a dam was built in the River Seine. Measuring some 14 by 19 feet, it documents, in great detail, the varied activities of the construction workers. In its mural size and its focus on "work" as a state of life, the painting functions both as an image of a specific event and as a generic representation of urban

18-10 **Alfred Roll,** *Work,* 1885. Oil on canvas, 14'5" x 19'8" (4.39 x 6 m). Musée Municipal, Cognac.

labor. Neither Bastien-Lepage's *Bootblack* nor Roll's *Work* were shown at the exhibition of 1889 but several similar paintings of urban life were included in it.

Nordic Naturalism: Nationalism and Naturism

Among the foreign art exhibits, the greatest surprise was caused by the Nordic countries, which were better represented than ever before, with works from Denmark, Norway, Sweden, and Finland. Many, if not most, of the artists whose works were shown in the Nordic pavilion had studied in Paris. Some had attended the École des Beaux-Arts, others the city's private art schools or "academies," such as those run by Rodolphe Julian, a former wrestler, or Filippo Colarossi, an expatriate Italian sculptor. Frequented especially by foreign art students and by women (who were not allowed to attend the École des Beaux-Arts), the Julian and Colarossi academies were important breeding grounds for international Naturalism.

More than in other European countries, Naturalism in the Nordic countries was closely bound up with nationalism. Nordic Naturalist painters had a special preference for scenes of rural life that typified the "national character." This preoccupation with nationalism coincided with movements aimed at political or cultural independence, including the Norwegian movement towards independence from Swedish rule, and the movement to make Finnish (rather than Swedish) the official language of Finland.

Peasant Burial (FIG. 18-11) by the Norwegian painter Erik Werenskiold (1855–1938), a huge success at the 1889 exhibition, may serve as an example. Werenskiold had studied in Munich before moving to Paris in 1881. A famous illustrator of Norwegian folk tales, he also painted large-scale paintings of Norwegian country life. In *Peasant Burial* a group of male peasants of different ages stand around a freshly dug grave mound, on which a cross has been formed with dirt. On the left, a young schoolmaster, standing in for an absent clergyman, reads from the burial ritual. Behind him stands a single woman, perhaps the wife or daughter of the deceased.

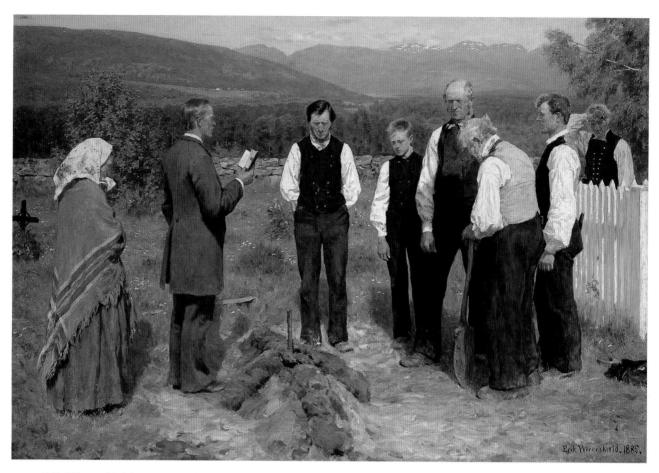

18-11 **Erik Werenskiold,** *Peasant Burial,* 1883–5. Oil on canvas, 40 x 59" (1.02 x 1.5 m). Nasjonalgalleriet, Oslo.

It is instructive to compare this painting with Courbet's *A Burial at Ornans,* (see FIG. 11-3) painted almost thirty years earlier. In the Realist painting, the artist's aim was not in the first instance to provide an accurate representation of a scene from real life. In fact, Courbet is known to have painted the painting in his studio. His foremost aim in the *Burial* was to lend to the modest subject of a country burial the aura of a historical event.

In his Naturalist rendering of a country burial Werenskiold had no interest in making the scene look grander than it was. Instead, he aimed at the faithful representation of a simple scene in the Norwegian countryside. His purpose was anthropological rather than political. It was an attempt to record for future generations the beautiful simplicity of life in the Norwegian countryside, as yet untouched by industry. Indeed, to Werenskiold, as to other Nordic artists who had travelled abroad, their homeland seemed preciously virgin and pure compared with the industrialized nations of Western Europe.

The work of the Finnish painter Albert Edelfelt (1854–1905), winner of a Grand Prize of Honor at the 1889 exhibition, likewise exemplified Nordic nationalism. His *Old Women of Ruokolahti on the Church Hill* (FIG. 18-12) of 1887 represents four women from the small town of

Ruokolahti (south-eastern Finland) chatting after church. If the painting resembles the work of Bastien-Lepage, it is not surprising. Edelfelt was a close friend of the French artist and wrote about him in the Finnish press. Like many Nordic artists, Edelfelt divided his time between Finland, where he found most of his subject matter, and Paris, where he exhibited and marketed his work.

The Swedish painter Anders Zorn (1860–1920) also spent a good deal of time in Paris, where he took an interest not only in Naturalist painting but also in the works of the Impressionists. This may explain why many of his works show a pronounced interest in *plein-air* effects. Although Zorn painted numerous scenes from Swedish country life, in his own time the artist was especially known for a group of paintings, done from the late 1880s onwards, of female nudes in natural surroundings. To paint these works, Zorn actually posed female nude models outside, to capture the play of light on the unclothed human body. In the prudish social climate of the late nineteenth century, this was a daring and unconventional method that few Impressionists had undertaken. To paint his *Déjeuner sur l'herbe* (see FIG. 12-31), for example, Manet had still posed his nude models in the studio, and so had Renoir for his *Bathers* (see FIG. 17-17). But for *Outside* (FIG. 18-13),

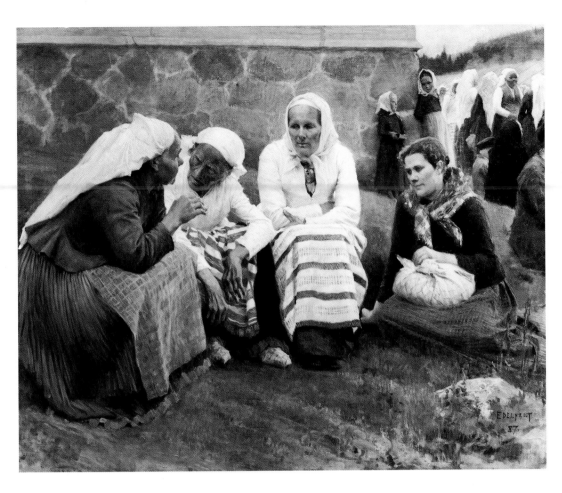

18-12 **Albert Edelfelt,** *Old Women of Ruokolahti on the Church Hill,* 1887. Oil on canvas, 51⅝ x 62" (1.31 x 1.59 m). Ateneum, Helsinki.

18-13 **Anders Zorn,** *Outside,* 1888. Oil on canvas, 4'4" x 6'5" (1.33 x 1.98 m). Konstmuseum, Göteborg.

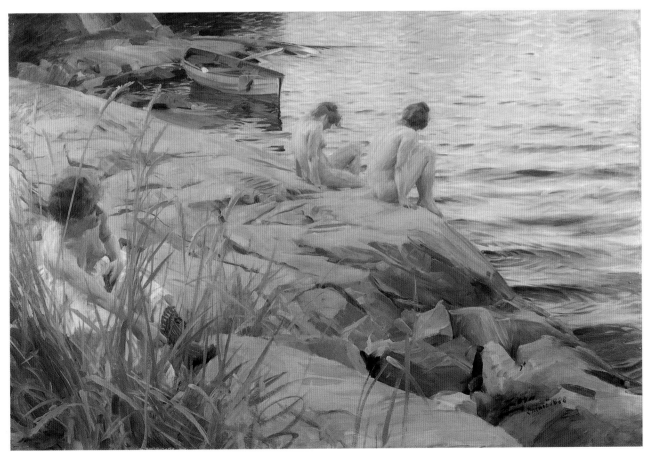

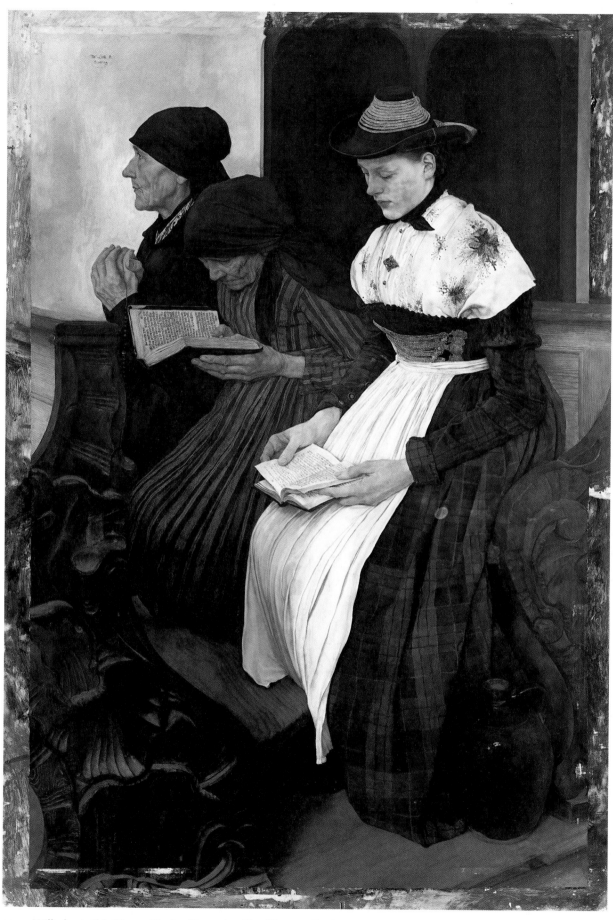

18-14 **Wilhelm Leibl,** *Women of Dachau (Bavaria)* or *Three Women in Church,* 1882. Oil on canvas, 44³/₈ x 30¹/₄" (1.13 m x 76.8 cm). Kunsthalle, Hamburg.

a success of the Salon of 1889, Zorn actually took his models outdoors. There he would sketch and photograph them as they were bathing, walking, or climbing up rocks. The result of this practice was a series of paintings and large watercolors in which the human body appeared truly as a natural form at one with other forms of nature—rocks, trees, water. Bathed in the same sunlight and brushed with the same brush, Zorn's nudes seem to belong in their surroundings, unlike the nude in Manet's painting, who appears quite literally as a "foreign body" in the woods.

Zorn's paintings seemed to advocate a new, liberated attitude towards the female body that has often been identified with Swedish culture. This attitude defied the custom of lacing the body up in corsets and imprisoning it in crinolines; Zorn's nudes coincided with a call for loose clothing, for physical fitness, and for a wholesome life style that began in the last fifteen years of the nineteenth-century and culminated early in the twentieth century. Indeed, Zorn's paintings and photographs of nudes anticipated the beginnings of the "naturist" or "nudist" movement, which was aimed at stripping the sexual connotations from nudity, emphasizing instead its naturalness.

Naturalism in Germany: Max Liebermann and Fritz von Uhde

In Germany, the work of Wilhelm Leibl (see page 307) formed a crucial link between a mid-nineteenth-century German Realism influenced by Gustave Courbet and the international Naturalism that triumphed at the Salon of 1889. Liebl was well represented at the exhibition with works such as *Women of Dachau (Bavaria)*, also called *Three Women in Church* (FIG. 18-14), painted in 1882. Unlike his earlier *Village Politicians* (see FIG. 13-19), a generic image of peasant life, *Women of Dachau*, both through its title and the careful attention to costume, reflects a new interest in pictures celebrating national identity.

While Leibl represented an older generation of German painters at the 1889 exhibition, "new" German Naturalist painting was exemplified by the work of Max Liebermann (1847–1935). Like Zorn, Liebermann was familiar with French painting. He was close friends with several French Naturalist painters, including Bastien-Lepage and Dagnan-Bouveret. He also knew the works of the Impressionists, which he admired for their *plein-air* effects. Many of Liebermann's paintings depict scenes in

18-15 **Max Liebermann,** *Amsterdam Orphan Girls,* 1882. Oil on canvas, 30 x 42″ (78 cm x 1.08 m). Städelsches Institut, Frankfurt-am-Main.

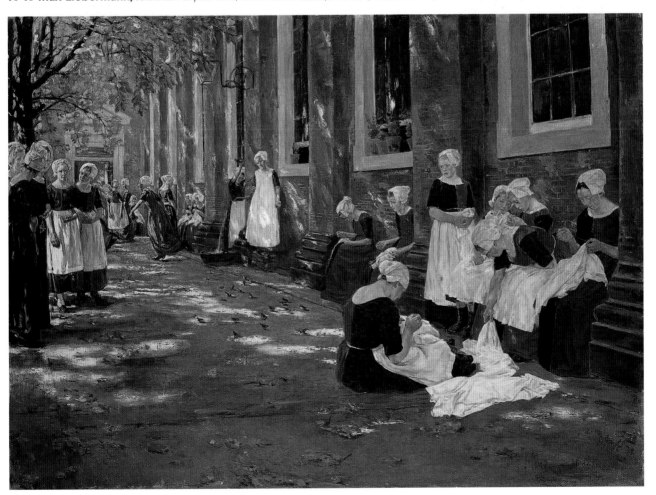

18-16 **Fritz von Uhde,** *Last Supper,* 1886. Oil on canvas, 6'9" x 10'8" (2.06 x 3.24 m). Staatsgalerie, Stuttgart.

18-17 **Léon Frédéric,** *Chalk Sellers,* 1882–3. Oil on canvas, left panel: *Morning,* 1882, 6'6" x 3'9" (2 x 1.15 m); central panel: *Noon,* 1882, 6'6" x 8'9" (2 x 2.68 m); right panel: *Evening,* 1883, 6'6" x 3'9" (2 x 1.15 m). Musées Royaux des Beaux-Arts de Belgique, Brussels.

the Netherlands, where he spent most of his summers. *Amsterdam Orphan Girls* (FIG. 18-15), shown at the 1889 exhibition, shows the courtyard of an orphanage in Amsterdam during recess. While the painting is clearly representative of Naturalism, it also shows an interest in capturing effects of light and atmosphere, confirming Liebermann's close study of Impressionism.

Fritz von Uhde (1848–1911) was another major German Naturalist painter. His early paintings resemble Liebermann's, especially because they also depict Dutch scenes. After the mid-1880s, however, he gave Naturalism a new twist by applying it to religious subject matter. In his *Last Supper* (FIG. 18-16), a prizewinning painting at the 1889 exhibition, he dressed Christ and the apostles as German workmen and placed them in an interior that resembled a nineteenth-century tavern. Gone are the idealized facial features and the long classicizing gowns that were obligatory in the religious paintings of the German Nazarenes. Von Uhde tried to imbue religious painting with new life, by transposing biblical scenes into modern times and into the social milieu to which the apostles had truly belonged.

Naturalism in Belgium

Among the numerous Naturalist painters from Belgium, two deserve special attention. Léon Frédéric (1856–1940) is interesting, especially, because he was among the first painters to lend symbolic overtones to his Naturalist scenes. His *Chalk Sellers* (FIG. 18-17) of 1882–83 strikes the viewer

at once because it is painted on three separate canvases that are attached to one another. This format harks back to medieval and Renaissance triptychs, paintings composed of three hinged panels that were commonly hung behind altars in churches and chapels. Frédéric's choice of this traditional format suggests that *Chalk Sellers* was more than an objective rendition of ordinary life, but a scene with some larger, moral significance. In the center panel of the triptych, subtitled *Noon*, a family of itinerant chalk sellers has just finished blessing their meagre roadside meal of boiled potatoes. Shoeless and dressed in patched-up clothes, they are the image of desperate poverty. In the distance is a gray town, with a church on the left and a smokestack on the right. On the two side panels, called *Morning* and *Evening* respectively, another family of itinerant salesmen sets out on the road (left) and returns (right) to whatever it calls "home"—a shack or a room in a tenement building on the city fringe. Together, the three panels comment on the fate of common people in the new industrial age. Bereft of traditional havens such as church, community, land, and home, they have become homeless wanderers, displaced by the very revolution that was supposed to improve their lives. The triptych format emphasizes the inescapable routine of the life of the poor, in which one miserable day follows another, without interruption or escape.

18-18 **Constantin Meunier,** *Puddler,* c.1884. Bronze with brown patina, height 14″ (36.9 cm), Musées Royaux des Beaux-Arts de Belgique, Brussels.

Frédéric's concern with the social conditions of his time were shared by Constantin Meunier (1831–1905). The latter, like Leibl in Germany, belonged to the generation of the Realists but he did not become well known until the end of the nineteenth century. Meunier's reputation is closely bound up with his representation of mines and miners. It was a subject he discovered in 1878, when chance led him to one of Belgium's mining districts— dismal locales that no one at the time visited for choice. While he started out as a painter, Meunier eventually moved towards sculpture and became one of the greatest Naturalist sculptors of his time. At the exhibition of 1889, he received a grand prize for *Puddler,* a subject that he treated several times during the later part of his career. The version reproduced in FIG. 18-18 shows a laborer in the

mining industry who has to produce wrought iron by stirring hot molten ore. Puddling was a physically demanding job that required strength and endurance due to the intense heat. In Meunier's sculpture, the puddler is resting, exhausted from his labor. Seated on an anvil, he supports his bare torso with his right arm, which is resting heavily on his thigh. It is all that he can do to lift his head to acknowledge the presence of the viewer. Millet's *The Gleaners* and Courbet's *The Stonebreakers* (see FIG. 12-25 and FIG. 11-7) come to mind when we look at this figure, which inspires a similar mixture of empathy and admiration for the laboring classes.

Jozef Israëls and The Hague School in the Netherlands

One of the most widely admired works in the exhibition of 1889 was *Toilers of the Sea*, which won a grand prize for the Dutch artist Jozef Israëls (1824–1911). Israëls's painting is now lost, but another work, *Peasants' Mealtime*, also on view at the exhibition, is shown in FIG. 18-19. Like the sculptures of Meunier and the paintings of Leibl, the work of Israëls is often closer in style and spirit to mid-nineteenth-century Realism than to the Naturalism of Bastien-Lepage or Dagnan-Bouveret. This is no surprise, because Israëls was born in 1824 and was therefore closer in age to the Realists than to the Naturalists.

Peasants' Mealtime repeats a theme that Israëls had treated as early as 1882 and which may have inspired Vincent van Gogh's better-known painting of the *Potato Eaters* of 1885 (see FIG. 17-27). To compare Israëls's painting with van Gogh's is to understand the difference between the kind of painting that was popular in the second half of the 1880s and the new artistic course that van Gogh was embarking on during this time. Van Gogh caricatured his peasants,

18-19 **Jozef Israëls,** *Peasants' Mealtime,* 1889. Oil on canvas, 51 x 59″ (1.3 x 1.5 m). Private Collection.

18-20 **Anton Mauve,** *Fishing Boat on the Beach,* 1882. Oil on canvas, 45 x 67" (1.15 x 1.72 m). Gemeentemuseum, The Hague.

capturing the coarseness brought on by a life of malnourishment and back-breaking labor. Israëls, by contrast, showed a serene image in which a family of peasants, accepting its place in society, quietly enjoys the modest fruits of its labor. To the middle-class public of the 1880s, van Gogh's painting was disturbing for it reminded them that their own comforts rested on the backs of the lower classes—a social group that they both needed and feared. Israëls, by contrast, had "tamed" the peasants by representing them as peaceful and acquiescent to their fate.

Israëls was one of the oldest members of the so-called Hague school, a loose association of figure and landscape painters who worked in and around The Hague, a Dutch town near the North Sea. These painters developed a unique mode of Naturalist landscape painting that owed a debt both to the artists of the Barbizon school and to the seventeenth-century Dutch landscape painters. Like the Barbizons (see page 234), Hague school painters emphasized the importance of *plein-air* painting. Like the Dutch landscapists, their interest went out, in first instance, to the capturing of atmospheric effects. To render subtle contrast between light and shade accurately, they subordinated color to tone, painting their landscapes in different gradations of beige or gray with only touches of other colors. Although the practice of tonal painting earned the Hague

school the unflattering nickname of "Grey School," it was well suited to the depiction of the Dutch landscape with its flat polders and beaches, commonly seen under overcast skies and through rain and fog.

Among the twelve or so artists who were associated with the Hague school was Anton Mauve (1838–1888), a second cousin of van Gogh and for a while his teacher. Mauve's *Fishing Boat on the Beach* shows several teams of horses pulling a heavy wooden fishing boat away from the sea and up towards the dunes (FIG. 18-20). The painting exemplifies the tonal style of the Hague school. Beige, brown, and bluish gray are the predominating colors in this painting, which resembles nineteenth-century photographs in the sensitive rendering of light and dark tonalities.

Russian Painting

Critics of the art exhibitions of 1889 were generally disappointed by the showing of Russian art, which, they felt, compared poorly with the exhibits of other countries. The problem, apparently, was not that there was no great Russian art in 1889, but that too little of it had been sent to Paris. The Russian exhibit was dominated

18-21 **Ilya Repin,** *Barge Haulers on the Volga,* 1870–3. Oil on canvas, 4′4″ x 9′3″ (1.31 x 2.81 m). Russian Museum, St Petersburg.

by older, conservative artists, while young, promising painters were represented only with minor works.

In Russia, as in Western Europe, an anti-academic movement had developed around the middle of the century. In 1863 thirteen Russian artists had seceded from the Academy and formed a society called the Wanderers (*Peredvizhniki*). The name was a reference to their practice of foregoing academic exhibitions in order to organize travelling exhibitions in the Russian countryside for the benefit of society at large. Like Realism in France and the Pre-Raphaelite movement in Britain, the Russian rebel movement was both anti-academic and anti-Romantic. The Wanderers believed that art should represent real life and comment on it. They rejected the "art for art's sake" philosophy of the older generation and insisted that art be an important source of social reform. They had use neither for the large-scale history paintings that were produced by the leaders of the St Petersburg Academy, nor for the sentimental scenes of Russian life produced by older painters such as Vasili Perov (see FIG. 15-21).

One of the leading painters to exhibit his work regularly in the Wanderers' exhibitions was Ilya Repin (1844–1930). Before joining the group, Repin had made his debut at the Academy with a strikingly non-academic work, *Barge Haulers on the Volga* (FIG. 18-21), a large canvas that shows a team of ten men towing a heavy barge on the still waters of the River Volga. Although painted ten years after serfdom had been abolished in Russia, the painting shows that that edict had done little to alleviate the fate of the underclass in Russia. Indeed, the bargemen, yoked to the barge with leather straps and ropes, are doing the work that was more often done by animals.

Repin's work differs from that of the French Realists, most notably Courbet and Millet, in that the Russian artist has taken great pains to paint individual portraits of the barge haulers, a motley group of different ages and ethnic groups. While the French Realists had "de-individualized" their subjects to show how hard and demeaning labor takes away people's humanity, Repin instead shows the psychological effects it has on the haulers. Some look resigned to their fate, others seem rebellious, indifferent, or simply too exhausted to have any emotions at all. Like Millet, however, Repin presents his *Barge Haulers* both as an image of suffering and as an example of the dignity and strength of the lower classes.

Barge Haulers on the Volga was seen at the 1873 exhibition of the St Petersburg Academy by the Russian writer Fyodor Dostoevsky (1821–1881), who was greatly impressed by it. Sharing, like many Russian intellectuals, Repin's feeling of personal responsibility for the fate of the poor, Dostoevsky wrote in his *Writer's Diary,* a monthly publication: "You can't help but think that you are indebted, truly indebted to the People . . . You will be dreaming of this whole group of barge-haulers afterward; you will still recall them fifteen years later!"

Like many Russian artists during the 1880s, Repin turned away from Realist subject matter toward themes from Russian history. This trend was closely related to the growth of Russian nationalism, in which Russians became intensely interested in their history and folklore. *Ivan the Terrible and his Son Ivan on November 15, 1581* (FIG. 18-22) is one of the most famous and dramatic of Repin's history paintings. It depicts Ivan, Russia's first czar, who murdered his son and heir in a fit of rage. The event was important historically,

18-22 **Ilya Repin,** *Ivan the Terrible and his Son Ivan on November 15, 1581,* 1885. Oil on canvas, 6'4" x 8'4" (2 x 2.54 m). State Tretyakov Gallery, Moscow.

because it led to the "Time of Troubles," a period of crisis that ended only with the establishment of the Romanov dynasty, which still ruled Russia in the nineteenth century. But Repin's painting was connected to contemporary events. In 1881 the Russian czar Alexander II had been murdered by a revolutionary terrorist, an event that led to a period of bloody government reprisals. Touched by the "unbearable tragism of history," Repin painted *Ivan the Terrible and his Son Ivan* as a way to show the senselessness of killing one's kin, one's fellow countryman. Repin's painting stands out not merely by its convincing rendering of setting and costumes, but also by the psychological insight he has brought to the two figures—Ivan's son, whose life is slipping away, and Ivan himself, who, his fury gone, realizes what he has done. His face and hands covered with blood, he embraces the limp body of his son as his features are distorted in a frightful expression of regret and despair.

Next to Repin, two important members of the Society of the Wanderers were Vasili Surikov (1848–1916) and Ivan Kramskoy (1837–1887). Surikov is famous for his enormous multi-figure history paintings that depict important events in Russian history. His *The Morning of the Streletsi's Execution* (FIG. 18-23) depicts the notorious moment in Russian history when Peter the Great ordered the execution of hundreds of Streltsy, members of a corps of musketeers from which the czar's bodyguard had traditionally been recruited. Peter the Great's distrust of the Streltsy was related to their undue political influence, which he intended to crush by having them exiled or put to death. Even today, tourists in Moscow are taken to the place, in front of St Basil's Church on Red Square, where the Streltsy were executed, suggesting that the event is etched deep into Russian historic consciousness.

Surikov's history paintings owe their impact to their epic proportions, their multi-figure compositions, and the meticulous care with which the setting and each figure in the scene have been depicted. His paintings seem to anticipate some of the huge film dramas of the twentieth century—*War and Peace*, most immediately, comes to mind—in the attention to historic truthfulness and the magnitude of their conception.

18-23 **Vasili Surikov,** *The Morning of the Streltsys' Execution*, 1881. Oil on canvas, 7'2" x 12'5" (2.18 x 3.79 m). State Tretyakov Gallery, Moscow.

18-24 **Ivan Kramskoy,** *Christ in the Wilderness,* 1872, 5'11" x 6'11" (1.8 x 2.1 m). State Tretyakov Gallery, Moscow.

Kramskoy's *Christ in the Wilderness* (FIG. 18-24) was a unique attempt at creating a modern Russian religious painting. Russian religious art had always taken the traditional form of icon painting. Icons, even in the nineteenth century, were painted in the Byzantine style, the origins of which went back to the Middle Ages. Most icons were painted by artists specializing in this genre, such as Ivan Bunakov, the earliest teacher of Repin. Kramskoy's preoccupation with the creation of a modern, Russian image of Christ was related to new attitudes towards religion among the Russian intelligentsia during the last decades of the nineteenth century. These attitudes, most clearly articulated by the writer Lev Tolstoy (1828–1910), are marked by a distrust of the Orthodox Church and its clergy and a new emphasis on personal faith. Christ, in this new belief context, was seen not in the first instance as a member of the Divine Trinity, but as a wise and moral being, who, during his life on earth, had followed his conscience and loved his fellow men.

Kramskoy's painting shows Christ as he is seated in the wilderness, having fasted for forty days and forty nights. According to the Bible, the devil came to tempt him, telling him to use his divine powers by commanding that the stones be turned into bread. But Christ answered: "Man shall not live by bread alone, but by every word that proceedeth out of the mouth of God" (Matthew 40:4). In Kramskoy's painting the emphasis is on the psychological struggle that goes on within Christ as he considers his options. Shall he give in to his hunger and change the stones into bread, or follow his mission, namely to live out his life on earth as a human being, according to God's will? The representation of Christ as a lone figure in a forlorn, deserted landscape exemplifies Kramskoy's view of the place of modern man in the world. Alone, living in a spiritual desert, he must follow his conscience even if it appears that no one cares or even pays attention.

The 1889 Exposition in Review

Naturalism and nationalism seem to have been the two driving forces that motivated most of the artists whose works were exhibited at the exposition of 1889 in Paris. Naturalism was an international style that gave a common denominator to works from different countries. Nationalism, by contrast, led to differences in subject matter as well as in style (the "tonal style" of the Hague school, for example). In the 1889 exhibition, we see some artists taking new approaches to subjects derived from ordinary life. Léon Frédéric, for example, was one of several artists at the end of the nineteenth century who imbued his Naturalist works with symbolism. Finally, nationalism led some artists, beginning with Bastien-Lepage (*Joan of Arc*) and continuing with such artists as von Uhde, Repin, and Kramskoy, to return to historic and religious painting in an attempt to imbue both with a new spirit that was both chauvinistic and modern.

Chapter Nineteen
France during *La Belle Époque*

The French refer to the last decade of the nineteenth century and the first of the twentieth as *La belle époque*, the "beautiful era," a period that ended once and for all with the outbreak of World War I in 1914. This was, indeed, a glorious time when the arts, music, and literature flourished and life was full of diverse pleasures for the rich and the super-rich.

The famous actress Sarah Bernhardt (1844–1923) embodied the glamour of the period. Although she had been acting since the 1860s, her real, international fame began in the 1880s, when she performed a series of roles especially written for her by Victorien Sardou (1831–1908). In many of these she played a *femme fatale* ("fatal woman"), a beautiful but ruthless woman who loves and destroys with equal passion. In the 1890s, at the peak of her career, Bernhardt toured the world performing in major cities in western and eastern Europe, North Africa, the United States, South America, and Australia.

A legend during her lifetime, Bernhardt owed much of her reputation to the expatriate Czech artist Alphonse Mucha (1860–1939). From the mid-1890s he designed her costumes and jewelry, as well as posters and promotional materials for her plays. FIG. 19-1 illustrates one of Mucha's most popular images of Sarah, one that was used and reused for posters, magazine illustrations, and postcards. It shows the actress as a combination queen/goddess, complete with a bejewelled tiara (designed by Mucha) and a golden halo. The image speaks of

19-1 **Alphonse Mucha,** *Journée Sarah (La Plume)*, 1896. Color lithograph, 27 x 20″ (69 x 50.8 cm). Private Collection.

19-2 **Théophile-Alexandre Steinlen,** *The Wretched Man,* cover illustration for *Gil Blas,* November 19, 1897. Color photorelief. Bibliothèque Nationale, Paris.

enjoyed the luxury life, many people lived dreary lives at or below the poverty level. Théophile-Alexandre Steinlen (1859–1923), an illustrator with socialist, even anarchist sympathies, drew attention to these people in illustrations drawn for left-wing newspapers. His drawing for a story called "The Wretched Man" (FIG. 19-2) was published on the cover of the paper *Gil Blas.* It depicts a social outcast, peering angrily through a restaurant window, behind which an overweight patron is eating a lavish meal.

To those most sensitive to the decade's political divisions and social inequalities, the 1890s seemed not so much a *belle époque* as a period of decadence, an ominous time that spelled the beginning of the end of western civilization. Many felt that the excessive luxury of the period was a sign of moral decay. The term *fin de siècle*, or "end of the century," which is also used for this period, alludes to a feeling of world-weariness, anxiety, and even despair that was shared by many intellectuals and artists of the time. The high rate of alcoholism, insanity, and suicide among this group is indicative of this phenomenon. Camille Claudel (1864–1943), Paul Gauguin, Vincent van Gogh, Edvard Munch (1863–1944), and Henri de Toulouse-Lautrec (1864–1901) are just a few examples of artists who appear to have been unable to cope with the tensions of the time.

It is not coincidental that the *fin de siècle* witnessed the rapid development of psychiatry. In the late 1880s and early 1890s the Parisian clinic of the neurologist-psychiatrist Jean-Martin Charcot (1825–1893) was one of the most famous in Europe, attracting patients from across the continent. Charcot became a master teacher of psychiatry. Among his many students was the Viennese Sigmund Freud (1856–1939), who became fascinated by Charcot's use of hypnosis to cure hysteria. Freud would eventually give a name to the fears and anxieties of his contemporaries, calling them neuroses, and he would develop a way to heal them through dream analysis and talking cures.

In addition to psychiatry, religion also offered solace to those whose nerves were frayed by the pressure of the period. During the 1890s there was a revival of Roman Catholic piety and several esoteric sects, such as Rosicrucianism, grew up. New philosophies of life, such as theosophy, that offered alternative modes of thinking and living, including vegetarianism, meditation, naturism, and so on, also arose.

Transport of Soul and Body: Sacré Coeur and the Metro

Two major architectural projects of the 1890s are indicative of the contradictions of the period. The first was the gigantic church that was built in the outer district of Montmartre, a recently urbanized area of Paris that was inhabited by working-class people and young artists, writers, and actors who were attracted by its low rents. Built between 1876 and 1914, the Church of the Sacré Coeur

beauty, power, wealth, and success—the attributes of Bernhardt that made people both admire and envy her.

Not all was beautiful, however, in *the belle époque.* Politically, France experienced a series of crises that threatened the survival of the Third Republic. Most serious among these was the so-called Dreyfus affair. In 1894 Alfred Dreyfus, an army officer of Jewish origin, was charged and convicted of selling military secrets to the Germans. While he was serving a lifelong sentence in France's penal colony on Devil's Island, information surfaced to suggest that he had been falsely accused. France became bitterly divided over the case. Radical republicans and socialists were convinced of his innocence, while conservatives called him guilty. Moderate republicans, at first, tried not to get involved but eventually split in the middle over the issue. The Dreyfus Affair deepened and sharpened political divisions in France and awakened a latent anti-Semitism.

France's political divisions reflected, and were a response to, grave social and economic inequities. The *belle époque* was beautiful, indeed, to those who could afford opera and theatre, elegant restaurants, luxury travel on steamers and trains, and expensive clothing. But while a chosen few

19-3 **Paul Abadie and others,** Church of the Sacred Heart (Sacré Coeur), 1876–1914. Paris.

was by the architect Paul Abadie (1812–1884), who had once worked on the restoration of Notre Dame under the supervision of Viollet-le-Duc (see page 262). Like Viollet-le-Duc, Abadie was fascinated with medieval architecture, although his interest was in early medieval ("Romanesque") rather than late medieval ("Gothic") buildings. His design for Sacré Coeur was inspired by the Romanesque churches in southern France that he had restored at the beginning of his career.

The Sacré Coeur represents a glorious end to the architectural revivalism that marked most of the nineteenth century. From the late eighteenth century onward, architects had imitated historical models—Classical, medieval, or Baroque—either straightforwardly ("architectural historicism") or by mixing elements of different styles and periods ("eclecticism"). The neo-Romanesque style of the Sacré Coeur was the latest of the major nineteenth-century revival styles, which had included neo-Classical, neo-Gothic, neo-Renaissance, and neo-Baroque, roughly in that order. With its associations of medieval piety and spirituality it was an apt response to a deep-felt need, at the turn of the century, for religious transport and even mysticism.

In addition to the Sacré Coeur, the second major construction project that was carried out in Paris at the end of the century was a network of tunnels, hallways, and stations for an underground train. Following the example of London, which had built its first "tube" in 1860, the French began the construction of the metro (short for Metropolitan Railroad of Paris) in 1898. The first 6.25 miles were opened in 1900.

In 1896 a competition was organized for the design of the metro entrances. Although the young architect

or Sacred Heart (FIG. 19-3) is today the second major landmark of Paris after the Eiffel Tower. The church was the result of a vow, made by a group of religious conservatives, to build a church to thank God for delivering France from the Prussians and the Commune. The original design

19-4 **Hector Guimard,** Metro Entrance at the Louvre station, 1899–1905. Paris.

Hector Guimard (1867–1942) did not win the competition, he nevertheless received the commission and designed several different entrances. The metro entrance at the Louvre station (FIG. 19-4) represents one of his standard designs. It comprises a railing surrounding the staircase and a monumental sign above the entrance illuminated by two tall lanterns. Even a cursory look at Guimard's metro entrance makes it clear that it represents something new in nineteenth-century architecture. Its design is based not on historical models but on natural forms. The two lanterns, for example, look like giant lily stems about to blossom into flowers. The use of materials such as green-tinted cast-iron stalks and yellow light fixtures contribute to this botanical impression. The irregular, organic form of the lanterns is echoed in the other lines of the entrance, which are mostly curved and asymmetrical.

Guimard's design for the Paris metro entrances is representative of what the French call *art nouveau* or new art, an innovative approach to design marked by the rejection of revivalism and eclecticism, and the search for new forms inspired by plants, marine life, and other natural forms. The mass production of these forms, sinuous, irregular, and often quite intricate, was made possible by the use of new materials, notably cast iron and molded glass. In addition, the modular design of the stations enabled many dozens to be put up in a period of only a few years.

Together, the Sacré Coeur and Guimard's metro stations sum up at once the conservative, backward-looking attitudes and the modernist, forward-looking attitudes of the *fin-de-siècle* period. They embody the contradictory character of a time that both rekindled such ancient practices and beliefs as alchemy, occultism, and spiritualism, and witnessed the introduction of electrical light, the automobile, and the phonograph.

Art Nouveau, Siegfried Bing, and the Concept of Decoration

Art Nouveau, to a greater or lesser extent, pervaded all the arts, although it was most prominent in architecture and the decorative arts. Although the terms "new art" (*art nouveau*) and "new style" (*style nouveau*) were in circulation from at least the late 1880s, *art nouveau* acquired a more specific meaning in the mid-1890s with the establishment of a store and showroom called La Maison de l'Art Nouveau (The House of New Art) by Siegfried Bing (1838–1905). This German-born art dealer, critic, and

19-5 **Henri van de Velde and George Lemmen,** Smoking Room designed for Siegfried Bing, 1895. Contemporary photograph.

entrepreneur had made a fortune importing Japanese arts and crafts; he also took an interest in contemporary design. In 1894 he traveled to North America, where he admired both the artistry and the business acumen of Louis Comfort Tiffany (1848–1933). A year later he opened a store and showroom of contemporary design in Paris. His purpose was to bring together several artists whom he admired and to have them develop a new decorative style. Thus Bing took the lead in the movement towards design reform that had been initiated by a French government agency, the Central Union of the Decorative Arts, but which needed his money and energy to succeed.

Since the middle of the nineteenth century, interiors had generally been cluttered with an eclectic mixture of objects in different period styles. To achieve more styliztic unity, Bing began commissioning entire interiors from one or two designers. The inaugural exhibition of the Maison de l'Art Nouveau included six such rooms, which were remarkable at the time for their unity and relative simplicity. Unfortunately, none of the six rooms was preserved, but contemporary photographs give us an idea of what they looked like. The Smoking Room (FIG. 19-5), designed by the Belgian designers Henri van de Velde (1863–1957) and George Lemmen (1865–1916), shows how the two artists used the theme of smoke as the guiding design principle for the room. The billowing forms of the wall paneling, with its built-in windows, mirrors, and shelves, create a comfortable feeling, suitable for a gentleman's leisurely after-dinner smoke.

On several occasions Bing commissioned "fine" artists rather than interior designers or architects to design rooms. In so doing, he hoped to erase the boundaries between the fine and the decorative arts. In his mind, all artists should be equally concerned with the creation of interior spaces of beauty. Bing was not alone in this conviction; there was a common sense in the 1890s that the artist's primary role was "decoration," that is, to create domestic environments inside which people could find relief from the pressures and ugliness they encountered in the outside world.

The Sources of Art Nouveau

Although the term *Art Nouveau* would seem to suggest that this type of art was entirely new and unprecedented, in fact it had several sources. One of these was British design of the second half of the nineteenth century. William Morris, as early as the 1860s, had found inspiration in natural forms (see page 347), admiring them for their complexity and irregularity. Like Bing, he also firmly believed that the fine and decorative arts should be united.

A second source of art nouveau was Rococo design, which was similarly inspired by forms of nature. The sinuous lines, asymmetrical forms, and playful character of Art Nouveau had much in common with the architecture and decorative arts of the first half of the eighteenth century. Interest in the Rococo period was rekindled in the late nineteenth century by the brothers Edmond (1822–1896) and Jules (1830–1870) de Goncourt. In their serial publication, *Eighteenth-Century Art* (1859–75), as well as in several books on famous eighteenth-century women, they interpreted the Rococo period as one of grace, imagination, and creativity.

Artists of the end of the nineteenth century looked upon the arts of the first half of the eighteenth century as a model, not to be imitated—as the Rococo revivalists of earlier decades had done—but to be adapted to a modern aesthetic. The delicate wooden screen designed by the well-known French designer Emile Gallé (1846–1904) is a case in point (FIG. 19-6). Like Rococo furniture, it is elegant and shows irregular contours. It is simpler and lighter than most Rococo designs, however, and less abundantly decorated.

19-6 **Emile Gallé,** Screen, 1900. Ashwood, carved and inlaid with various woods, height 3'6" (1.07 m). Victoria and Albert Museum, London.

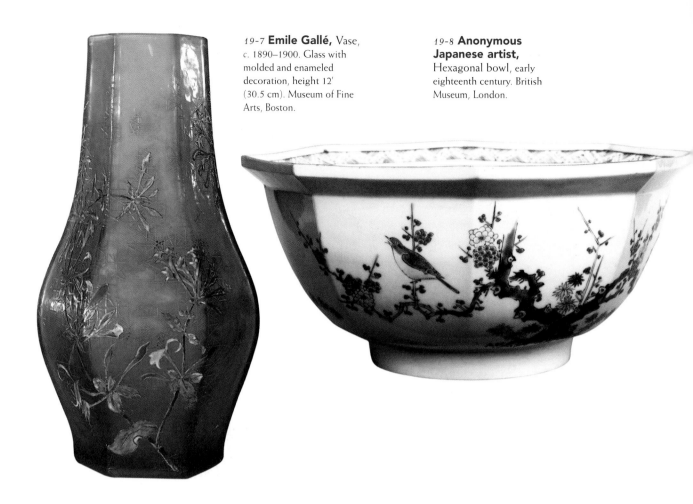

Japanese prints and decorative arts were a third important inspiration for Art Nouveau. Since the Universal Exposition of 1867 (see pages 356–7), when Japanese craft objects were first exhibited, Japanese art had become fashionable. In France, Bing himself had contributed greatly towards cultivating a taste for all things Japanese. Before opening La Maison de l'Art Nouveau in 1895, he had owned a store selling Japanese crafts and had founded a monthly periodical, *Le Japon artistique* (Artistic Japan). Even after the close of his store, Bing's private collection of Japanese prints and ceramics attracted numerous artists.

While to us, today, it would appear that the taste for Japanese and Rococo art are mutually exclusive, in the nineteenth century this was not so. The Goncourts, major proponents of the Rococo style, were also avid collectors of Japanese prints and decorative art pieces. Similarly, designers such as Gallé studied both Rococo furniture and Japanese art objects to find inspiration for their designs. Gallé's hexagonal glass vase with molded glass and enamel applications (FIG. 19-7) is reminiscent of Japanese porcelains not only in its shape but also in its decoration (FIG. 19-8). Gallé did not imitate Japanese art in a slavish manner. Instead, he adapted the general characteristics of Japanese decoration, namely asymmetry and freedom, to his art.

Henri de Toulouse-Lautrec and the Art Nouveau Poster

The impact of Japanese art was, perhaps, most clearly visible in the new commercial art form of the picture poster (see *Posters*, opposite). Posters called for striking yet simple images that would be easily recognized from afar. No wonder that many poster artists were inspired by Japanese woodblock prints, whose simple flowing contours, bright, unmodulated colors, and unusual compositions seemed appropriate models.

That was certainly true for Henri de Toulouse-Lautrec, perhaps the greatest poster designer of the *fin-de-siècle* period. Born into an aristocratic family, Toulouse-Lautrec had left his parental château in southern France to become an artist. As a student, he was drawn to the nightlife that was just then developing in Montmartre, in the area where the Sacré Coeur was being built. In the nightclubs, cabarets, and brothels of the area, he not only found the subjects of his art, but also patrons—the owners of the various night establishments who asked him to design promotional posters for their businesses.

Toulouse-Lautrec's poster for Le Divan Japonais (Japanese love seat; FIG. 19-9), one of the numerous nightclubs in Montmartre, stands out for its unusual conception and composition. Unlike earlier representations of dance or cabaret performances by artists such as Degas and Seurat

19.1-1 **Leonetto Cappiello,** *Stenodactyle La Faurie.* Color lithographic poster, 26 x 29" (66 x 73.7 cm). Library of Congress, Washington, DC.

The sudden development of picture posters, in the 1870s, was the result of a combination of factors. The constantly increasing manufacture of consumer products made advertising a growing necessity. Producers became dissatisfied with the small text posters that had been used to promote consumer goods. A more attractive, pictorial mode of advertising was sought and it was provided by the lithographed color poster.

By the late 1870s the lithographic process (see page 207) had been improved and refined so that it could be used to print images in many colors. In addition, large presses had been developed that made it possible to print on sizable sheets of paper. By the mid-1880s posters were seen covering the walls of urban buildings or mounted on carts that were riding through the streets. By 1889 they were considered such a uniquely modern phenomenon that a special exhibition of posters was mounted at the International Exposition in the Palace of Liberal Arts. That same year, poster exhibitions were held in several other cities in France.

Posters soon became collectors' items. As early as 1891, a commercial gallery organized an exhibition of posters for sale to interested buyers. Before long, poster production became split between posters that were made primarily for outdoor advertising use and posters that were made for collectors. The latter, frequently made to advertise theatrical or musical performances, might be mounted

indoors for brief periods of time but soon found their way into galleries or collectors' apartments.

The poster that Leonetto Cappiello (1875–1942) for a stenographic machine (FIG. 19.1-1) belongs to the first category. It advertises a new secretarial tool that allowed the user to type 150 words a minute. The poster not only shows the machine in use, but it also contains the address where one could buy it and the name of the school—the Women's Professional Institute—where one could take lessons on how to use it. It is both informative and attractive to look at.

The posters of Jules Chéret (1836–1932) belong to the second group. In their time they were in great demand among collectors. His poster for a performance of Loïe Fuller (1862–1928; FIG. 19.1-2), in the well-known nightclub Folies Bergère, is all about image and contains only a minimal amount of text. The poster shows the famous American dancer in one of her spectacular "serpentine" dances, in which she dressed in billowing folds of silk that she whirled around under carefully controlled light effects. Chéret's posters are marked by large areas of color in single hues— the green of the background, the flesh color of the face and arms, the light green of the legs. Only the whirling silks show two, or sometimes even three hues to suggest the effects of light on the shimmering silks. This reduction of colors and hues is, of course, inherent to the print medium. But it was eminently suitable for poster art, which was meant to be seen from afar, at a glance, and must make an immediate impression.

19.1-2 **Jules Chéret,** *Loïé Fuller at the Folies Bergère,* 1893. Color lithographic poster, 48¹³/₁₆ x 34⁵/₈" (1.24 m x 88 cm). Bibliothèque Nationale, Paris.

19-9 Henri de Toulouse-Lautrec, *Le Divan Japonais,* 1892–3. Color lithographic poster, 31 x 23⅝″ (80 x 60 cm). Bibliothèque Nationale, Paris.

19-10 **Henri de Toulouse-Lautrec,** *May Milton,* 1895. Color lithographic poster, 31 x 23" (78.7 x 59.6 cm). Milwaukee Art Museum.

(see FIGS. 16-34 and 17-5), the emphasis here is not on the performers but on the spectators. The poster shows a beautiful redhead, wearing a tight-fitting black coat and an enormous black hat with an ostrich feather. Behind her sits her companion, a middle-aged gentleman sporting a cane and a monocle. He leans over as if to whisper something into her ear. She, however, remains focused on the stage, where a headless female performer with long black gloves sings, accompanied by a small pit orchestra. The waving hands of the conductor and the necks of the double basses form an exotic, ghostlike backdrop to the main figures.

Toulouse-Lautrec's contemporaries, if they were familiar with Montmartre nightlife at all, would have known immediately that the singer on stage was Yvette Guilbert, a tall skinny woman who was famous for her very expressive performances of sentimental songs. They would also have known that the female spectator was Jane Avril, also called Mélinite, herself an accomplished singer and dancer. The poster derives its power both from its startling composition and from the radical simplification of the forms. The streamlined black silhouette of Jane Avril's slender, sexy body immediately attracts viewers' eyes and draws them into the space in which she and her companion are seated. Only gradually do we become aware of their surroundings and of the poster's text—which provides the name of the cabaret, its address, and the name of its director.

When we compare the Divan Japonais poster with a print by Utamaro (see FIG. 17-30) we can see that the juxtaposition of large areas of unmodulated color is directly related to Japanese prints. The startling composition may also have been inspired by Japanese art. The famous print series *Thirty-six Views of Mount Fuji* by the Japanese printmaker Katshushika Hokusai (1760–1849) contains a print called *The Great Wave* in which Mount Fuji is all but hidden behind several enormous waves and a fishing boat that appears to cut the mountain sheer in half. In the Divan Japonais poster we encounter a similar situation because the main spectacle—the singer on the stage—is moved all the way to the rear and cut off both at the top and the bottom to be dominated by the spectators in front who, in the normal order of things, should be secondary to the performer.

In Toulouse-Lautrec's late posters, the tendency towards simplification and capturing the essence of his subject is carried to the limit. His poster advertising the art of the British dancer May Milton (FIG. 19-10) is little more than a large yellow form against a solid black background, interrupted only by the letters of the dancer's name. Compared with contemporary posters such as Jules Chéret's for the dancer Loïe Fuller, Toulouse-Lautrec's poster is minimalist. His colors are entirely unmodulated and there is no attempt at suggesting depth or three-dimensionality. Instead, contour plays an important role. The abstraction (i.e. pulling

Toulouse-Lautrec, the Painter

Toulouse-Lautrec's paintings and drawings frequently show subjects similar to those of his posters—actors on stage or the public of dance halls and cabarets. An exception must be made for his brothel scenes, which are common in his paintings and drawings but, for obvious reasons, absent from his poster designs. Toulouse-Lautrec was not the first artist to find inspiration in brothels. Degas, as well as other late nineteenth-century artists, had drawn and painted prostitutes, either walking the streets, waiting for clients, or simply resting or chatting. But Toulouse-Lautrec, more than any other artist, was able to paint the brothel "from the inside."

Deformed by a childhood accident that had stopped the growth of his legs, Toulouse-Lautrec often felt pitied by the women in his own social circle. For this reason, he preferred liaisons with prostitutes, which were "strictly business." In the early 1890s, in particular, he spent much time in brothels, becoming familiar with the prostitutes and their daily lives. Eventually, according to his friend Thadée Natanson, he "ceased to be a client and became a member of the household." This familiarity with the daily life of prostitutes enabled him to paint them in a way that no other artist had—both honestly and sympathetically.

Between 1892 and 1895 Toulouse-Lautrec completed more than fifty paintings of brothel scenes, the most important of which was *In the Salon of the Brothel of the Rue des Moulins* (FIG. 19-12). The painting brings one inside the gaudy salon of one of the most expensive brothels in Paris. On the red velvet couches, amidst mirrors and gilded columns, five jaded prostitutes sit and wait. A sixth paces back and forth, her skirt pulled up unselfconsciously. With their high henna hair and their faces smeared with lead-white, rouge, and lipstick, they seem at once grotesque and pathetic. With their countenances forced into professional smiles, they look as if they are wearing masks. Toulouse-Lautrec has powerfully characterized the atmosphere of false gaiety in the brothel, where love is not freely given but sold to those who cannot otherwise find it.

In the Salon of the Brothel of the Rue des Moulins is painted in a style and technique all Toulouse-Lautrec's own. The artist often sketched the outlines of the figures in bright blue or green. Rather than concealing the sketch lines in the painting process, he allowed them to show through the final paint layers. The colors themselves are applied in rapid, loose strokes, which rarely completely cover the primed (or even unprimed) canvas. In addition, Toulouse-Lautrec often mixed the oils with a great deal of turpentine, which made them look like pastels when they dried. All this gave to his works, even such "finished" ones as *In the Salon of the Brothel of the Rue des Moulins*, the appearance of sketches.

Toulouse-Lautrec's technique exemplifies the new artistic liberty that many young artists felt in the wake of Impressionism. Like Seurat, Cézanne and van Gogh

19-11 **Katsukawa Shunsho,** *The Actor Ichikawa Danjuro V in Shibaraku Role,* 1782. Print, approximately 10 x 15" (25 x 38 cm). Victoria and Albert Museum, London.

away from reality) was something that would be greatly admired by young artists in the early twentieth century. No less an artist than the young Pablo Picasso (1881–1973) is known to have had a copy of the May Milton poster in his room in Barcelona. At the same time, Toulouse-Lautrec's poster resembles some of the most daring examples of Japanese printmaking such as Katsukawa Shunsho's (1726–1792) image of the actor Ichikawa Danjuro V on stage (FIG. 19-11).

(see chapter 18), he felt entirely free to develop techniques that would suit his subject matter and temperament. Like them, too, he felt justified to exaggerate or distort forms found in reality, if it was in the interest of achieving his artistic goals.

Paul Gauguin and Emile Breton: Cloisonnism and Synthesism

The innovative technique and formal liberation found in the paintings of Toulouse-Lautrec also mark the work of Paul Gauguin (1848–1903). Born in Peru, the native country of his mother, Gauguin moved to France at the age of seven. Orphaned at the age of seventeen, he came under the tutelage of Gustave Arosa, a wealthy financier and art collector who helped him to get a job as a stockbroker and also exposed him to art. Financially secure, in 1873 Gauguin married Mette-Sophie Gad, a young Danish woman, with whom he had five children in rapid succession.

Over the course of the 1870s Gauguin became increasingly interested in art, not only as a collector but also as a practitioner. It started as a hobby, but in due course it took over his life. His meeting with Camille Pissarro (see page 380), who became both his teacher and mentor, was of crucial importance for his development as a painter. Pissarro brought Gauguin into the circle of the Impressionists, helping him to get some of his early works admitted to the Impressionist exhibitions.

In the stock market crash of 1882 Gauguin lost his bank job and decided to try to make a career as an artist. While his wife and children moved in with his parents-in-law in Denmark, Gauguin struggled alone to make ends meet. Trying to find an inexpensive place to live, he was drawn to the French province of Brittany. Economically and culturally backward, Brittany had become a refuge for young artists who found cheap room and board in the small villages, and a less stressful environment than in Paris.

During a second stay in Brittany in 1888 Gauguin, now aged 40, met a 20-year-old painter called Emile Bernard (1868–1941). Bernard was experimenting with a new mode of painting that he called "Cloisonnism," after cloisonné enameling, a technique in which thin bands of gold or silver are used to outline areas filled with brightly colored enamel pastes. Cloisonnism, analogously, was a mode of painting in which dark contours outlined areas of flat, unbroken color. Like enamels or, for that matter, stained-glass windows or Japanese prints, Cloisonnist paintings did not offer an illusion of three-dimensional reality. Instead, they were intended as expressions, through form and color, of the inner poetry and mystery of reality.

Interested in Bernard's ideas, which he helped to flesh out and develop, Gauguin painted a number of paintings of Breton themes that exemplify the new tendency towards abstraction (or, what he himself called, "style"), that is, the movement away from illusionist naturalism towards an art of synthesis and expression. Most important among these paintings is *Vision after the Sermon* (FIG. 19-13), completed in September 1888. A revolutionary work, it shows a group of Breton peasant women, dressed in the exotic white caps of the region, who appear to experience a vision inspired by the impassioned sermon of the priest. Kneeling in a half circle, in the shade of a tree, they "see" the struggle between Jacob and the Angel, as it is told in the biblical book of Genesis (32:24–32).

Compositionally the painting is striking for the radical way in which it is partitioned by the diagonal trunk of an apple tree, darkly silhouetted against the red background. This seems to separate the earthly from the heavenly realm, an impression that is heightened by the fact that the peasant women are painted in subdued colors—white, dark blue, and black—while Jacob and the Angel are ultramarine blue, green, and chrome yellow. Clearly, Gauguin no longer aimed at illusionism in this painting, but at conveying, through form and color, his own experience of the simple, unshakable faith of the Breton peasant women.

Emile Bernard, resentful that Gauguin was taking the lead in the development of a new art that he had pioneered, responded to his *Vision after the Sermon* by painting *Breton Women in a Prairie* (FIG. 19-14). Bernard's work was inspired by a recent pardon (see page 435) that he had witnessed in Pont-Aven. Bernard, in his own words, "deliberately painted a sunlit field, illuminated with Breton bonnets and blue-black groups" to contrast his work with Gauguin's dark and mysterious scene. It is interesting to compare both artists' works, with their simplified forms and bright, "flat" (i.e. unmodulated) colors, to the *Brittany Pardon* (see FIG. 18-7) by Dagnan-Bouveret, painted just three years earlier. Comparing the three, one readily sees the divergent directions in which artists were moving at the end of the nineteenth century. From the vantage point of the twenty-first century, one is inclined to see the difference between Dagnan-Bouveret's *Brittany Pardon* and the Breton scenes by Gauguin and Bernard in simple terms of traditional versus modern. It is noteworthy that, in his own time, Dagnan-Bouveret was not seen as a reactionary but as an innovative artist, and indeed he was. Yet his innovations led him in a "photo-realist" direction that was the exact opposite of the movement towards abstraction.

While Dagnan-Bouveret's *Brittany Pardon* was hailed as a modern masterpiece at the Universal Exposition of 1889 (see page 429), Gauguin exhibited seventeen paintings, mostly of Breton scenes, in a café located close to the exhibition grounds. The owner of the Café Volpini had "lent" his walls to Gauguin and seven like-minded artists so that they could mount a "protest" exhibition, similar in spirit to those that Courbet had organized in 1855 and 1867 (see page 256). Called the "Exhibition of the Impressionist and Synthetist Group," the Café Volpini exhibition inspired

19-12 **Henri de Toulouse-Lautrec,**
In the Salon of the Brothel of the Rue des Moulins,
1894. Oil on canvas, 43 x 52″ (1.11 x 1.32 m).
Musée Toulouse-Lautrec, Albi.

19-13 **Paul Gauguin,** *Vision after the Sermon*
(Jacob Wrestling with the Angel), 1888. Oil on
canvas, 28 x 36″ (73 x 92 cm). National Galleries
of Scotland, Edinburgh.

19-14 **Emile Bernard,** *Breton Women in a Prairie,* 1888. Oil on canvas, 29 x 36" (74 x 92 cm). Private Collection, Saint-Germaine-en-Laye.

the term "Synthetism," coined by Gauguin to distinguish his art from Bernard's "Cloisonnism." Derived from the French verb *synthétiser,* to synthesize, Synthetism denotes a three-fold artistic endeavor aimed at conveying to the viewer something about the real appearance of the subject; expressing the poetry the artist sees within it; and creating works that have a "decorative" quality. By the latter term, Gauguin meant a kind of painting in which form (lines, colors, and shapes) took precedence over subject matter. Perhaps the best characterizations of the spirit of Synthetism was provided by the youg Maurice Denis (1870–1943), one of Gauguin's fellow exhibitors, who in 1890 wrote the now famous line, "It is well to remember that a picture before being a battle horse, a nude woman, or some anecdote, is essentially a flat surface covered with colors assembled in a certain order." Denis thus launched an idea that would become very important in the twentieth century, namely that the form of a work of art is more important than its content. Nineteenth-century artists, however, were not quite ready to abandon subject matter altogether.

Paul Gauguin: The Passion for Non-Western Culture

In his struggle to make a living from art, Gauguin received some help from Theo van Gogh, a progressive art dealer in Paris. Theo van Gogh introduced Gauguin to his brother Vincent and, in 1889, lent him some money to visit the latter in Arles. The few months the two artists spent together were tumultuous, ending in the famous incident in which Vincent cut off part of his ear. During long and heated discussions Gauguin and van Gogh argued whether it was better to work from the motif or from memory, and whether artists should paint only what they had seen, or whether they could work from imagination.

Not long after his return from Arles to Brittany, Gauguin painted *Christ in the Garden of Olives* (FIG. 19-15) representing Christ's momentary anxiety, at Gethsemane, in the face of his suffering and death. It was a subject that had also been treated by Emile Bernard and by van Gogh, although the latter destroyed both of his attempts at

19-15 **Paul Gauguin,** *Christ in the Garden of Olives,* 1889. Oil on canvas, 28 x 35⅞" (73 x 92 cm). Norton Gallery of Art, West Palm Beach.

painting this biblical scene. Vincent wrote to his brother Theo that he could not paint without models. Thus while van Gogh remained true to the Realist and Impressionist precept that artists should only paint what they could see, Gauguin and Bernard asserted the importance of the imagination.

The interest of all three artists in the subject of Christ in the Garden of Olives was related to the contemporary view of him as a model of moral courage and intellectual independence. Ernest Renan, in *The Life of Jesus* (1863), had referred to Christ in the Gardens of Olives as "the man who has sacrificed a peaceful existence and the legitimate awards of life to a grand idea. . . [and who] experiences a moment of sad introspection when the image of death represents itself to him for the first time and seeks to persuade him that it is all in vain." This was a man with whom van Gogh, Gauguin, and Bernard all identified. No wonder that Gauguin gave Christ his own traits, thus equating his own suffering as a misunderstood genius with the passion of Christ.

To Gauguin, the way out of Gethsemane, that is, the uncaring, materialist world of "civilized" Europe, was suggested by the Universal Exposition of 1889. Viewing the displays of Pacific cultures, he began to explore the possibility of leaving France for a place as far away as possible from civilization as he knew it. Eventually he chose the Polynesian island of Tahiti, which had been a French protectorate since 1842 and a colony since 1880. There, as he wrote to his wife, he hoped to find a life of "ecstasy, calm, and art." There, "far from the European struggle for money," he expected to live a life in harmony with nature, much like the life that Adam and Eve had led in Paradise.

The Tahiti that Gauguin found on his arrival, by steamship, in the capital of Papeete, was far removed from his paradisiacal dreams. As he wrote in *Noa Noa* (1897), the semi-fictional account of his Tahitian stay, "It was Europe—the Europe which I had thought to shake off—and that under the aggravating circumstances of colonial snobbism, and the imitation, grotesque even to the point of caricature, of our customs, fashions, vices, and absurdities of

civilization." His move to the Tahitian countryside brought him a little closer to his dreams though even there European "civilization," in its varied manifestations of Christianity, alcoholism, and venereal disease, had made its inroads. But Gauguin was determined to get back to the unspoiled origins of Tahitian culture. Like an anthropologist doing fieldwork, he tried to get as close as possible to the native Polynesian population (even living with young Tahitian women), learned some of their language, and surrounded himself with their objects. In addition, he read the available literature on Tahiti, written by early European travelers who had visited the island before it was transformed by colonization. In so doing, Gauguin created for himself an ideal of pre-colonial Tahitian life that he made the subject of his paintings.

Tahitian Women: On the Beach (FIG. 19-16), painted shortly after his arrival in Tahiti, is still a relatively straightforward representation of a scene that Gauguin may have seen in the village where he lived. Two women are seated on a yellow plank. The one on the left is dressed in a white shirt tucked into a native *pareu*, the one on the right in a pink "missionary dress." Native and Western dress were worn side by side in Tahiti, much to the chagrin of the missionaries, who would have liked to outlaw Polynesian dress, which left too much of the body exposed (the *pareu* was traditionally worn without a shirt). The dress is not the only sign of Westernization in this painting. The woman on the right, who appears to be making a hat out of strips of palm leaf, is engaged in productive work. Such hats were made both for domestic use and for export to France, and Tahitian women had turned their production into a small home industry.

How faithful Gauguin's painting was to the reality of Tahiti is clear from its resemblance to contemporary photographs by other French colonials living on the island. The photograph of *Young Tahitians Making Straw Hats* (FIG. 19-17) was made only a few years after Gauguin's painting by Henry Lemasson (1870–1956), the French director of the postal services in Tahiti. An amateur photographer as well as a writer, Lemasson used his free time in Tahiti to write articles on the island which, together with his photographs, would be featured at the World's Fair of 1900 and the Colonial Exhibition of 1906. Lemasson's photograph and Gauguin's painting show

19-16 **Paul Gauguin,** *Tahitian Women: On the Beach,* 1891. Oil on fine-weave canvas, 26⅞ x 35" (69 x 91 cm). Musée d'Orsay, Paris.

19-17 **Henry Lemasson,** *Young Tahitians Making Straw Hats,* 1896. Photograph, 5¼ x 4″ (13.5 x 10 cm). Archives Nationales d'Outre-mer, Aix-en-Provence.

19-18 **Paul Gauguin,** *Fatata te miti (Tahitian for "Near the Sea"),* 1892. Oil on canvas, 26 x 35⅞″ (68 x 92 cm). National Gallery of Art, Chester Dale Collection, Washington, DC.

a striking similarity of vision—that of recently arrived colonials who have carefully posed some willing natives to create images that have a semblance of authenticity. Apparently, both Gauguin and Lemasson were struck by the juxtaposition of native and Western dress; both were also interested in recording a native craft—the weaving of palm leaves in baskets and hats—one that was closely associated with Tahiti and "primitive" cultures in general.

Gauguin's later Tahitian paintings, such as *Fatata te miti* (Near the Sea; FIG. 19-18), bring us closer to the artist's ideal vision of pre-colonial Tahiti, the earthly paradise of his dreams. In this painting, two women go bathing in the sea. One throws herself into the waves, while the other unwraps her *pareu*. In the background, a male bather stands in the waves. The impression created here is one of a culture that knows no shame, for people live so close to nature that nudity is accepted and normal. (If this had ever been true in Tahiti, it certainly was no longer so in Gauguin's time. Ironically, the artist was fined for public indecency when caught swimming in the nude near the village where he lived.)

In *Fatata te miti* the sense of an earthly Eden seems confirmed by the richly colored foreground of the painting. Gauguin shows a pink and purple beach covered with clusters of orange and yellow leaves, separated from the water by the dark silhouette of a tree branch. One can hardly speak of a very realistic representation of landscape here, since colors and lines seem to have taken on a life of their own. Together they form a rich, abstract pattern with irregularly curved lines, somewhat reminiscent of art nouveau decorations.

To Gauguin, this was the "musical" part of his painting, which corresponded to the "literal" part in the background. This division was based on the idea that there are two worlds—a visual and a spiritual one—which correspond to one another. The decorative area in the foreground was a way of representing the spiritual world which, to Gauguin, was best imagined as music or abstract color patterns. Gauguin's ideas about the correspondences between the real and spiritual worlds were neither new nor unique (see below, pages 470; "Symbolism"). They belonged to a long tradition of mystical thought that had enjoyed periodic revivals of interest throughout the nineteenth century.

19-19 **Paul Gauguin,** *Manao tupapau* (The Specter Watches over Her), 1892. Oil on canvas, 28 x 35⁷/₈" (73 x 92 cm). Albright-Knox Art Gallery, A. Conger Goodyear Collection, Buffalo, New York.

19-20 **Paul Gauguin,** *Where Do We Come From? Where Are We? Where Are We Going?*, 1897. Oil on canvas, 4'6" x 12'3" (1.39 x 3.75 m). Museum of Fine Arts, Tompkins Collection, Boston.

The juxtaposition of the physical and spiritual worlds was nowhere more obvious than in *Manao tupapau* (The Specter Watches over Her; FIG. 19-19). The painting presumably represents Gauguin's teenage mistress (or *vahine*), Tehamana, caught in a moment of panic as she is home alone at night and imagines herself surrounded by ghosts. In *Noa Noa* Gauguin describes the incident that inspired the painting. Returning from a trip to Papeete, he found his house completely dark inside. As he lit a match, he saw "Tehura (alternative name for Tehamana), immobile, naked, lying face downward flat on the bed with the eyes inordinately large with fear. She looked at me, and seemed not to recognize me ... A contagion emanated from the terror of Tehura. I had the illusion that a phosphorescent light was streaming from her staring eyes."

In *Manao tupapau* the spiritual world is embodied in *tupapau*, the ghost, the little black figure behind Tehura that looks like a statue carved from wood. It is also made visible in the pink and purple background, which is punctuated by white flowery forms. Together they represent Tehura's vision, or, to use a clinical term, hallucination. Indeed, Gauguin's rendering of Tehura's vision may well have been inspired by the contemporary interest in hallucinations on the part of psychiatrists such as Charcot.

Manao tupapau is yet another example of the preoccupation, of mid- and late nineteenth-century artists, with

the subversion or even perversion of that hallowed old subject in Western painting, the reclining female nude. Like Cézanne in his *Modern Olympia* (see FIG. 17-19), Gauguin appears to have wanted to outdo Manet by flouting that artist's own subversion of the traditional reclining nude in *Olympia*. Gauguin went one step further than Cézanne. He replaced a white woman with a dark one, a member of what was then considered an "inferior" race. He also substituted a young, underage girl for a mature woman. Finally, he painted the figure lying on her stomach rather than her back, so that her breasts and sex are invisible. In so doing he created a highly ambiguous image that at first seems more chaste than *Olympia* but ultimately may be more scandalous.

Towards the end of his life, Gauguin became increasingly interested in making his art the vehicle for the articulation of his views on life and the world. This is best seen in the artist's monumental *Where Do We Come From? Where Are We? Where Are We Going?* (FIG. 19-20). Gauguin's artistic and spiritual testament to the world, this work was painted during his second stay in Tahiti, between 1895 and 1901. It is a mural-size canvas that was intended as a visual articulation of the artist's philosophy of human life and civilization. In several letters to friends and critics Gauguin compared the painting with the allegorical murals of Puvis de Chavannes, with which its size

and suffering. "I was so bent on putting all my energy into it before dying, such painful passion amid terrible circumstances, and such a clear vision without corrections, that the hastiness of it disappears and life bursts from it."

Gauguin also distinguished himself from Puvis by the way in which he delivered his message. Puvis, he argued, had used standard, even trite allegorical imagery, while he himself had developed a personal symbolism that was less easily understood but more imaginative and poetic. Indeed, the symbolism of Gauguin is so personal that it is difficult to gain a complete understanding of each aspect of his painting, even though its general meaning is clear. The painting evokes the cycle of life, the voyage from birth to death, as well as its main episodic activities—work, caring for one another, religious worship. On the right we see birth, embodied by the infant accompanied by three adult figures. In the center a figure picking fruits from a tree and the child eating them suggest that humankind's role on earth is to guarantee its survival. On the left the dark, crouched figure, looking much like an Australian mummy (see FIG. 19-27), may represent death. In the rear a statue of an unidentified deity suggests the importance of religion and religious worship in human life. The figures, many of them genderless, are set in a rich and luxurious landscape, perhaps suggesting that they live in the lost paradise that existed before evil and sin made their entrance into the world.

In 1901 Gauguin moved to the distant island of Hivaoa, where he built his last home and studio, which he called the "House of Pleasure." He had always taken an active interest in the places in which he lived, remodeling native dwellings or building new houses after the example of local architecture. The House of Pleasure was a two-storey house, built of wood and bamboo, with earthen floors. On the second floor he had his bedroom, which led into his studio. The door to the bedroom was surrounded by an elaborately carved and colored wooden frame

and even certain aspects of its composition are in common (see FIG. 19-21). While comparing himself with Puvis, however, Gauguin stressed that his own work was different and in many ways better. While Puvis's murals were the result of extensive planning and preliminary studies, Gauguin admitted that his own work was "terribly unpolished." To him, that was a sign of its superiority. His work did not "stink of models, professionalism, and the so-called rules." Instead, it spoke of energy, passion,

19-21 **Pierre Puvis de Chavannes,** *Between Arts and Nature,* 1890. Oil on canvas, 9'8" x 27'3" (2.95 x 8.3 m). Musée des Beaux-Arts, Rouen.

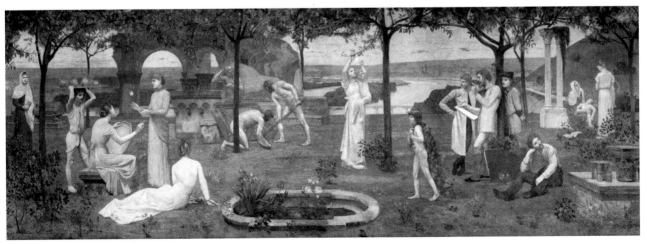

19-22 **Paul Gauguin,** *Maison du Jouir* (House of Pleasure), 1902. Redwood, carved and painted, right jamb, 62 x 15⅝" (1.59 m x 39.7 cm); left jamb, 6'6" x 15⅝" (2 m x 39.7 cm); right base, 6'8" x 15⅝" (2.05 m x 39.7 cm). Musée d'Orsay, Paris.

(FIG. 19-22). On the lintel, the words *Maison du Jouir* (House of Pleasure) were framed by stylized plants, birds, and human heads. On the two sides two nude women stood among plants and animals. And at the bottom two horizontal reliefs carved with human heads featured the words *soyez mystérieuses* ([women,] be mysterious) and *soyez amoureuses et vous serez heureuses* ([women,] be in love and you will be happy).

Gauguin had worked in three dimensions since the start of his career. He had made marble sculptures and woodcarvings since 1880, and pottery and ceramic heads since the mid-1880s. While still in France, he had made individual reliefs that were loosely based on Polynesian and south-east Asian sculptures, which he had come to know through photographic reproductions in books and magazine articles. The elaborate ensemble of carvings that he made for his house in Hivaoa, however, was unprecedented. These reliefs were part of an artistic environment that included architecture, sculpture, and probably also painting. Gauguin's interest in a complete artistic environment may be linked to his admiration for Polynesian and Maori art, such as the carved Maori meetinghouses that he had seen and drawn during a short trip to New Zealand. Yet it may also be related to the contemporary Western interest in creating integrated interiors, an interest that, as we have seen, was typical of Art Nouveau (see page 455). With their plant motifs that wind their way among text, human figures, and animals, these wooden reliefs do have something in common with Art Nouveau. Yet their deliberate folk crudeness sets them apart from the refined consumer products of Guimard and Gallé.

Symbolism

Gauguin's *Where Do We Come From? Where Are We? Where Are We Going?,* as well as his relief sculptures for his house in Hivaoa, are far removed from the Impressionism of the artist's early years or even the Synthetism that he had practiced in Brittany. For these works, observation of reality is no longer the initial point of departure. Instead, their origin is in the world of ideas. This change in Gauguin's art, already noticeable in several of his earlier works, links it closely to a late nineteenth-century movement in literature and art called Symbolism.

In 1886 the Greek-born French poet Jean Moréas published an article in the well-known French paper *Le Figaro* entitled "Symbolism." The article served as a sort of manifesto (i.e. a statement of tenets and goals) for a new literary movement that was based on two related convictions. The first was that the material reality of the physical world hid another, more meaningful spiritual reality. The second was that the essence of that invisible reality could be communicated only through art. The Symbolists believed that art was the supreme form of expression and knowledge. In Symbolist art, as Moréas put it, "all the concrete phenomena would not manifest themselves; they are but appearances perceptible to the senses destined to represent their esoteric affinities with primordial ideas."

While Moréas in his manifesto focused primarily on literature, his ideas were extended to the visual arts by the critic Albert Aurier. In a magazine article called "The Symbolists" (1892), Aurier defined symbolism as the "painting of ideas." Already earlier, in 1890 and 1891 respectively,

he had referred to Vincent van Gogh and Gauguin as "symbolists," that is, artists whose works were like "dense, fleshy, physical envelopes" that contained an idea. According to Aurier, that idea was "the essential substratum of the work."

Symbolism and Romanticism: Gustave Moreau and Odilon Redon

By rejecting materialism and realism and emphasizing spirituality and the imagination, Symbolism recalled Romanticism. It is not surprising, therefore, that, in the 1880s, several belated Romantics suddenly found themselves propelled into the position of precursors of Symbolism. In the influential early Symbolist novel *A rebours* (Against the Grain), published in 1884 by Joris Karl Huysmans (1848–1907), the central character, plagued by a severe case of Baudelairean *ennui* (see page 218), withdraws into a private domestic world and surrounds himself with the works of Gustave Moreau (1826–1898) and Odilon Redon (1840–1916). Thanks in large part to Huysmans's novel, these two artists, already middle-aged in the 1880s, experienced a sudden upsurge of public interest. In Gustave Moreau's *Salome Dancing before Herod* (FIG. 19-23), which had been exhibited at the Salon of 1876, Huysmans saw more than a romanticized and imaginative rendering of a biblical story. The painting represents Salome, stepdaughter of the Galilean ruler Herod Antipas, who has agreed to dance for him in return for the head of John the Baptist (Mark 6: 14–29 and Matthew 14: 1–12). To Huysmans, however, she was not "merely the dancing-girl who extorts a cry of lust and concupiscence from an old man by the lascivious contortions of her body." She was, in fact, the embodiment of the *femme fatale*: "the curse of beauty supreme above all other beauties … a monstrous Beast of the Apocalypse, indifferent, irresponsible, insensible, poisoning."

The symbolism that Huysmans saw in Moreau's painting was, of course, quite different from the symbolism that Aurier saw in those of van Gogh and Gauguin. Moreau's was in the first instance a literary symbolism—one whose underlying meaning was inherent in its subject matter, derived from the Bible or mythology. Moreau, however, managed to give to his subjects (which did not differ from those of academic history painters) a new and unprecedented form. "His talent," as Zola wrote, "lies in taking subjects which have already been treated by other artists and recasting them in a different, more ingenious way." In Moreau's paintings, meaning is conveyed not only through the composition, the gestures and facial expressions of the figures, but through color and *chiaroscuro*. The entire paint surface has been mobilized to suggest the bewitching eroticism of Salome's dance, which leaves everyone in Herod's palace hall spellbound.

This perfect juncture between subject matter and form was especially obvious in Moreau's last major work, *Jupiter*

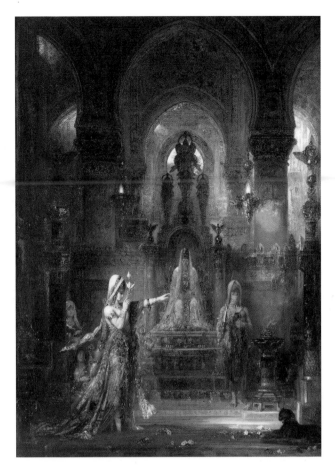

19-23 **Gustave Moreau,** *Salome Dancing before Herod,* 1876. Oil on canvas, 57 x 41" (1.45 x 1.04 m). Armand Hammer Museum of Art and Cultural Center, Armand Hammer Collection, Los Angeles.

and Semele (FIG. 19-24), which the artist considered his artistic testament. The painting was based on the Classical myth about the love between Jupiter, king of the gods, and the beautiful Semele. Prompted by Jupiter's jealous wife Juno, Semele asks Jupiter to make love to her in his full divine splendor. Jupiter, unable to refuse Semele anything, obeys her wish, even though he knows that she will be consumed by the radiance and lightning that are part of his sublimity.

In *Jupiter and Semele* Moreau explored the age-old dream of man's union with the divine, an ecstatic union that inevitably calls for death. The myth illuminates the Christian belief that death transports the faithful to heaven, where they are united with God, as well as similar beliefs in other religions, such as Buddhism and Islam. Moreau wrote two lengthy essays to explain the painting, in which he wrote: "… the God so often invoked appears in his still veiled splendor; and Semele, penetrated by the divine effluvia, regenerated and purified by the Sacred, is struck down and dies … Then, under this spell and this sacred exorcism, all is transformed, purified, idealized. Immortality begins, the Divine pervades everything …"

In Moreau's painting, the body of Semele is resting on the giant knee of Jupiter, in an attitude that suggests at

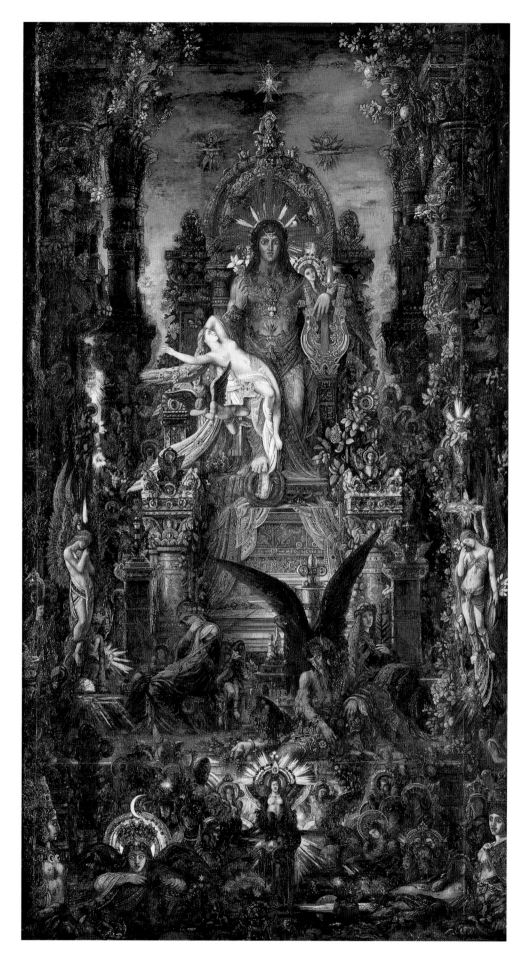

19-24 **Gustave Moreau,**
Jupiter and Semele, 1890–95.
Oil on canvas, 83 x 46"
(2.12 x 1.18 m).
Gustave Moreau Museum,
Paris.

once surrender and awe, desire and vulnerability. Pale and smoothly painted, like an academic nude, it forms a sharp contrast with the picture as a whole, which shows a mass of figures and forms, painted in rich, thickly encrusted colors. Moreau has masterfully evoked the idea of man's union with the divine by engulfing the small form of Semele in an ocean of forms, colors, and surface texture.

While Moreau looked for Moréas's "primordial ideas" in Classical mythology and the Bible, Odilon Redon, anticipating Surrealism by some fifty years, pursued them via the avenues of fantasy and free association. Huysmans, in *A rebours*, repeatedly used the words "nightmare" and "dream" to refer to the charcoal drawings and lithographs of the artist he called a "mad and morbid genius." Redon, however, was far from mad but an artist with a fertile imagination who, finding inspiration in literature as well as a wide array

of visual sources, created an entirely new and highly personal imagery. Slow to venture into the public artistic arena, Redon did not launch his career until 1879, when he published, at his own expense, an album of ten lithographs entitled *In the Dream. Vision* (FIG. 19-25), the eighth print in the series, is typical of Redon's work, which often shows eyeballs or disembodied heads floating in space. In this print a man and a woman, wandering through a colossal architectural space, come upon a huge eyeball hovering between two columns. What makes the print intriguing is that it appears to suggest the occurrence of an intensifying series of visual experiences that seem to come ever closer to an "ultimate" vision that, itself, remains invisible. It begins with the viewer, who is looking at the print. Then there is the vision of the couple, obviously startled by the apparition they see in front of them; and finally there is

19-25 **Odilon Redon,** *Vision,* plate 8 of *In the Dream,* 1879. Lithograph, 10⅞ x 7⅞" (27.6 x 19.9 cm). Art Institute of Chicago.

the vision of the eye which, directed towards the sky, appears to catch a glimpse of something so glorious and bright that it causes it to be aglow in a halo of light. While Redon leaves it up to the viewer to imagine what the eye is looking at, it is clear that his print is rooted in Christian imagery, most notably in Baroque paintings of visionary saints, their eyes opened wide as they catch a glimpse of the divine. At the same time, however, the unattached eye may be related to nineteenth-century popular illustrations, such as *Venus at the Opera* by Grandville (see FIG. 10-34). Redon's hovering eyes and heads have also been associated with the contemporary fascination with hot air balloons as well as the popularization of astronomy manifested in numerous illustrated articles in family and children's magazines.

In the wake of the publication of *In the Dream*, Redon organized several exhibitions of charcoal drawings in which he developed further his dreamlike imagery. As his range of sources widened, his imagery became ever more varied

and fantastic. *The Convict* (FIG. 19-26), a charcoal drawing about twice the size of his earlier prints, shows a figure behind bars, crouched in an embryonic position. Between the figure's drawn-up knees and oversize head, a small hand points accusingly at the spectator. Redon's figure has been linked to an illustration in the popular French magazine *La Nature*, representing a Maori mummy found in New Zealand (FIG. 19-27). Illustrations such as this fascinated Redon and, in fact, link the artist to Gauguin, who had likewise found inspiration in popular anthropological illustrations.

The search for the multifarious sources of Redon's art is important not because it shows that the artist had no imagination of his own, but rather because it demonstrates the very aim of Symbolist art—to find a spiritual reality behind the material reality of the physical world. Redon's works are an attempt to do precisely that. The artist often stressed that the wellspring of all his art was the observation and copying of reality. "After making an effort to copy

19-26 **Odilon Redon,** *The Convict,* 1881. Charcoal, 21 x 14⁵/₈" (53.3 x 37.2 cm). Museum of Modern Art, New York.

19-27 **Smeeton Tilly after Albert Tissandier,** *Australian Mummy Found in a Tree (Brisbane, Queensland)* from *La Nature,* December 4, 1875, p. 16. Wood engraving after a photograph. Art Institute of Chicago.

in minute detail a pebble, a blade of grass, a hand, a pro-
file, or any other element, organic or inorganic, I feel a
mental stimulus that makes me want to create, to allow
myself to represent the imaginary."

Symbolist Cult Groups: Rosicrucians and Nabis

Given that van Gogh, Gauguin, Moreau, and Redon could
all be called Symbolists in their time, it is clear that the
term "Symbolism" was extremely flexible. It could apply
to paintings, such as van Gogh's, that depicted figures,
objects, or landscape scenes observed in reality but "trans-
formed" to a greater or lesser degree. It could apply to the
works of Moreau, which offered imaginative interpreta-
tions of literary (biblical, mythological) subjects; it could
apply to the works of Gauguin, for whom the observation
of reality was often a point of departure to create semi-
imaginary scenes; and it could apply to the works of Redon,
who used popular visual culture as the raw material for his
nightmarish scenes. Clearly Symbolism was not an artis-
tic style or even an artistic movement. Perhaps it is better
defined as a state of mind, marked by a desire to find mean-
ing in the commonplace and to find answers to the great
questions of life in the inner recesses of the soul.

Understanding Symbolism as a state of mind explains
the often cultlike character that the movement assumed
at the end of the nineteenth century. Two groups, in par-
ticular, must be mentioned in this regard. One was a circle
of artists who gathered around Joséphin Péladan (1858–1918),
a self-styled prophet who abhorred the materialism of the
time and called for the rebirth of Roman Catholic mysti-
cism. Péladan thought of art as an "initiatory rite" to religious
revelation. Conversely, he felt that art "elevates itself or
falls into decline as it nears or draws further from God."

To promote the mystic Catholic art that he envisioned,
Péladan organized a series of exhibitions that he referred
to as Salons of the Rose + Croix (Rose + Cross), after the
occult–religious Rosicrucian brotherhood that he helped
to revive. Five exhibitions in all were held between 1892
and 1897. For the most part, the works exhibited showed
innovative interpretations of traditional religious subjects,
but not many formal innovations. Indeed, the artists
who showed their work at Péladon's Salons practiced con-
servative styles derived from mid-nineteenth-century
academic painting and Naturalism. Perhaps not surpris-
ingly, Péladan's Salons attracted many non-French artists,
happy to have found an outlet in Paris for more traditional
art (see below, Chapter 20).

Next to the followers of Joséphin Péladan, another artist
cult group were the so-called Nabis. Calling themselves
"prophets" after the Hebrew word *nabi*, they saw them-
selves as initiators of a highly subjective art deeply rooted
in the soul of the artist. Gauguin was the absent father of
the movement, which had as its "talisman" or charm a small

19-28 **Paul Sérusier,** *Landscape:The Bois d'Amour* (The Talisman),
1888. Oil on panel (the lid of a cigar box), 10⁵/₈ x 8⁵/₈" (27 x 22 cm).
Denis Family Collection, St-Germain-en-Laye.

landscape sketch by its founder, Paul Sérusier (1864–1927),
painted in 1888 under the direct guidance of Gauguin
(FIG. 19-28). Gauguin had encouraged Sérusier to approach
nature subjectively. To help him free himself from
the desire to render nature as he knew it to be, he told him
not to mix his paints so as to match them carefully to
the hues in nature. Instead he advised him to use colors
straight from the tube. The result was a picture, scarcely
recognizable as a landscape, made up of irregular
areas of flat, boldly contrasting colors. The work resem-
bles some of Gauguin's paintings (such as *Fatata te miti*,
FIG. 19-18), but, on the whole, was considerably more
abstract than his own.

Beside their leader, Sérusier, the Nabi movement included
some twelve painters including Pierre Bonnard (1867–1947),
Maurice Denis (1810–1945), and Edouard Vuillard
(1868–1940). While the works of these artists differed in
subject matter, they had certain formal characteristics in
common. The Nabi believed that a painting was first and
foremost a harmonious ensemble of lines and colors. Their
paintings, like Gauguin's, have areas painted in a single
color or pattern, separated from one another by firm con-
tours. This does not mean, however, that all their works
looked alike. As Sérusier once wrote, "a certain number of
lines and colors constituting a harmony can be arranged

19-29 **Maurice Denis,** *Climbing Mount Calvary,* 1889. Oil on canvas, 16 x 12″ (41 x 32.5 cm). Musée d'Orsay, Paris.

19-30 **Edouard Vuillard,** *Women in Blue with Child,* 1899. Oil on cardboard, 19 x 22″ (48.6 x 56.5 cm). Glasgow Art Gallery and Museum.

infinite ways." To the Nabis it was precisely in the arrangement of the lines and colors that the subjectivity and personality of the artist manifested itself.

The Nabi painter Maurice Denis, a devout Roman Catholic, specialized in religious painting. His *Climbing Mount Calvary* (FIG. 19-29) is a highly personal and very moving representation of Christ carrying the Cross, mourned and consoled by a group of nuns. The painting resembles Gauguin's *Vision after the Sermon* in that it seems to represent a rapturous vision in which a group of nuns imagine that they actually see and touch the living Christ. Denis has masterfully contrasted the group of dark earthbound nuns with the light, ethereal figure of Christ, who kneels in a flowering meadow—traditional symbol of Paradise. Moreover, in the daring, diagonal composition of the painting, one feels something of the soul striving upward to God.

The paintings and prints of Bonnard and Vuillard, by contrast, depict contemporary themes. Like van Gogh, these two artists found truth and meaning in the simple things and scenes of daily life. Indeed, the two artists have been referred to as *intimistes,* which may be translated as "artists interested in private scenes of daily life." But there is more to intimism than a particular choice of subject matter. In their paintings, which frequently represent domestic interiors, Vuillard and Bonnard express something of the inner life of the people who inhabit them. Thus the interiors become metaphors for the "interiority" of the figures within.

Vuillard's *Women in Blue with Child* (FIG. 19-30) is characteristic of this artist's work in its bold juxtapositions of different patterns—bedspread, wallpaper, dress, tablecloth,

pictures, and so on. Together they create a striking collage-like effect that, at first glance, seems almost confusing. Indeed, the viewer needs a few seconds to "decipher" the painting and appreciate this scene of happy intimacy between mother and child. Vuillard's paintings, which are surprisingly accurate representations of late nineteenth-century interiors (see FIG. 19-31), express something about the duality of late nineteenth-century women's lives. For while his interiors exude a sense of coziness, and intimacy, they also have a claustrophobic quality—conveying the message that a woman's role as a mother and homemaker can be experienced as restricting.

Bonnard's *Man and Woman* (FIG. 19-32) expresses an anxiety of a different kind. The painting shows the interior of a bedroom with a naked woman seated on a bed and a naked man, in the foreground, putting on a dressing gown. The figures are separated by a screen. While the woman on the left side of the screen is brightly lit, the man is a dark figure on the right. The interior is filled with sexual tension. Perhaps the couple has had a row, or else, as has been suggested, the man is suffering the shame of

19-32 **Pierre Bonnard,** *Man and Woman,* 1900. Oil on canvas, 45 x 28" (115 x 72.5 cm). Musée d'Orsay, Paris.

temporary impotence. Whatever the case may be, the interior space, with the screen all but cutting it in half, becomes a sign for the ruptured relationship between the two people inhabiting it.

Fin-de-Siècle Sculpture

The work of the greatest French sculptor of the nineteenth century, Auguste Rodin, has sometimes been called Symbolist. It is true that several of the artist's works, especially those made at the turn of the century, are Symbolist in so far as they seem the result of his attempt to express the spiritual in the commonplace. At the same time, however, Rodin may be called a Naturalist, particularly during the early part of his career, when his works were often remarkable for their verisimilitude.

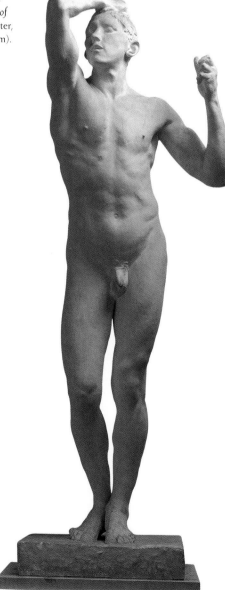

19-33 **Auguste Rodin,** *The Age of Bronze,* 1877. Plaster, height 68″ (1.73 m). State Hermitage Museum, St Petersburg.

We have seen in Chapter 16 (page 363) how, in 1879, Rodin entered the public contest for a monument to commemorate the Franco-Prussian war. Rodin lost that contest, even though he was not entirely unknown at the time. Two years earlier, he had drawn a great deal of attention with a plaster study of a standing male nude entitled *The Age of Bronze* (FIG. 19-33). Rodin had not used a professional model for this work but a young soldier, whose body he rendered with such scrupulous care that he was accused of having cast the figure from life. Just as some Naturalist painters (for example, Bastien-Lepage in France and Uhde in Germany; see pages 372 and 443) had painted extremely realistic figures to represent historical or biblical scenes, so Rodin presented his figure as an allegory. By calling it *The Age of Bronze,* he referred to the dawning of civilization, when early man had first invented bronze.

The Age of Bronze was as widely criticized as it was admired but eventually it was bought by the French State and Rodin was honored with a major commission. In 1880 the government asked him to design a set of bronze doors for a yet to be built Museum of Decorative Arts. Free to choose his own theme, he decided to draw on the *Divine Comedy* by the Italians medieval poet Dante Alighieri (1265–1321). In Dante's lengthy poem, an ordinary man, presumably Dante himself, is allowed to visit the souls in hell, purgatory, and paradise. During this extraordinary voyage, he has two guides, the Classical poet Virgil, who leads

19-34 **Auguste Rodin,** *The Gates of Hell,* 1880–1917. Plaster, high relief, height 17′ (5.2 m). Musée d'Orsay, Paris.

19-35 **Auguste Rodin,** detail from the *Gates of Hell.*

him through hell and purgatory, and the beautiful Beatrice, who introduces him to paradise. For the doors, Rodin decided to focus on the section of the poem that dealt with hell.

Work on the so-called *The Gates of Hell* (FIG. 19-34) occupied Rodin throughout the remainder of his career. In 1885 he announced that the doors were ready to be cast but he was told that the plans for the museum were cancelled. That gave him the opportunity to resume work on the doors. In 1900 the plaster model for the gates was shown to the public in a private exhibition organized by Rodin to coincide with the Universal Exposition of that year. Not until after his death were a number of bronze versions cast from Rodin's plaster model (*The Techniques of Sculpture*, opposite). Two of these ended up in the United States, one in the Rodin Museum in Philadelphia, the other on the campus of Stanford University in California.

The *Gates of Hell* contains dozens of figures which crowd the doors and spill over on their frame (see detail in FIG. 19-35). Compositionally, the work has been compared with Michelangelo's *Last Judgment* in the Sistine Chapel, as well as with Delacroix's *Death of Sardanapalus* (see FIG. 9-18), which likewise show a multitude of bodies, closely packed together. In Dante's *Inferno*, hell has a number of circles that are inhabited by different sinners. Rodin was particularly fascinated by the second circle, in which carnal sinners, that is, those too much given to sex, were tossed about by furious winds. It provided him with the opportunity to do a series of figures in passionate embraces. A counterpoint to these lustful figures are the sufferers, whose poses and gestures suggest pain and remorse.

Rodin made models for almost all the figures in the *Gates of Hell* and many of these were eventually modified to become independent sculptures. *Fugit Amor* (Fleeting Love; FIG. 19-36) is an example of such a work. Carved in marble (see techniques, opposite), it was one of several interpretations of Dante's sinners Paolo and Francesca. Francesca, married to the deformed Gianciotto, fell in love with Giancotto's handsome younger brother Paolo. As they kissed each other for the first time, Giancotto saw them and stabbed them both to death. By the strict morality of the Middle Ages, they belonged in hell for their

19-36 **Auguste Rodin,** *Fugit Amor*, 1887. Bronze, height 15" (38 cm). Musée Rodin, Paris.

adulterous behavior. In *Fugit Amor* Rodin has tried to express the tragedy of Paolo and Francesca's unconsummated love. The sculpture shows a male and a female, their reclining bodies closely entangled. As he turns away, she tries desperately to hold on, reaching out her arms in a vain attempt at an embrace. The sculpture is unusual not only in that the figures are lying down rather than standing, but also for the unconventional poses of the body. Equally unprecedented is the relation between the sculptures and their support. Traditionally sculptures in the round were entirely self-contained and independent from their support. Here, the body of Paolo emerges from the marble block that serves as the couple's support. Thus we are reminded of its "sculptural-ness," the fact that these figures owe their existence to the genius of the artist who wrested them from the coarse and resistant marble.

Although the subject of the *The Gates of Hell* was inspired by Dante, many of the individual sinners were derived from other literary sources. *The Old Courtesan* (FIG. 19-37) or *She Who Was Once the Helmet Maker's Beautiful Wife* is a figure inspired by the poetry of François Villon, a well-known French medieval poet. In Villon's lengthy poem *Grand Testament*, the once beautiful wife of a helmet maker laments the ravages that time has caused her body: "This is what human beauty comes to/The arms short, the hand shriveled/the shoulders all hunched up/The breasts? Shrunk in again/The buttocks gone the way of the tits . . . As for the thighs/They aren't thighs now but sticks/Speckled all over like sausages." By placing this figure in *Inferno*, Rodin seems to have wanted to show that the worst punishment

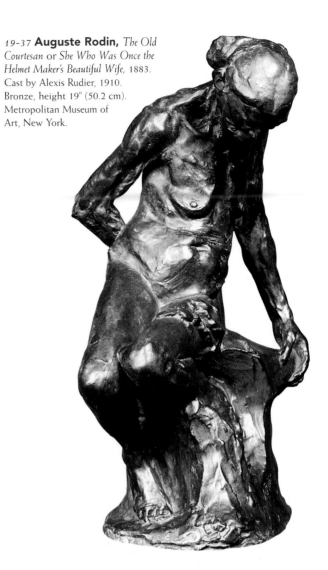

19-37 **Auguste Rodin,** *The Old Courtesan* or *She Who Was Once the Helmet Maker's Beautiful Wife,* 1883. Cast by Alexis Rudier, 1910. Bronze, height 19" (50.2 cm). Metropolitan Museum of Art, New York.

The Techniques of Sculpture

In the nineteenth century, as in the Classical period and the Renaissance, most sculptures were made of marble or bronze. The two materials required different techniques and procedures. To make a marble sculpture, the artist would use hammer and chisels to chip away at a block of fine marble until the desired form had been obtained ('subtractive' process). Then the work was polished to eliminate the chisel marks and create the desired surface texture.

To make a bronze figure, a sculptor would first make a clay model, building from a core of clay or a wire frame ("additive" process). Once the clay model had hardened and/or was baked (terra cotta), it was used to make a (negative) mold from which a plaster positive was cast. Plaster casts were not merely for the artist's own use, but were frequently exhibited. Bronze casting was very expensive and most artists would rather wait for a patron to pay for it than have their figures cast in bronze and run the risk of not selling them. Many sculptures were never cast in bronze at all, or not during the artist's life time (see page 410).

Once an artist was famous, nothing prevented him/her from casting numerous bronzes of a single mold to make multiple sales. But most artists kept the number artificially small to maintain the sense of rarity and uniqueness of their works. Some even ordered the molds to be destroyed after the desired number of casts had been made. If they did not do that, it could happen (and it often did) that unscrupulous dealers would buy the molds in the studio sale or from a founder and cast numerous additional copies. This has happened to the works of many sculptors, including Rodin. Such unauthorized copies, although they are often hard to distinguish from authorized casts, have lesser value in the art market.

It is important to note that the making of bronze sculptures did not directly involve the artist as the casting was done in a foundry. This distinguished it from marble sculpture, which was traditionally done by the sculptor himself. From the late eighteenth century onwards, however, sculptors increasingly hired professional carvers, known as 'practicians,' to carve their marble figures. They would provide a clay model, which the practicians would faithfully reproduce, using three-dimensional grids and plumb lines as well as pointing machines to achieve the greatest possible accuracy.

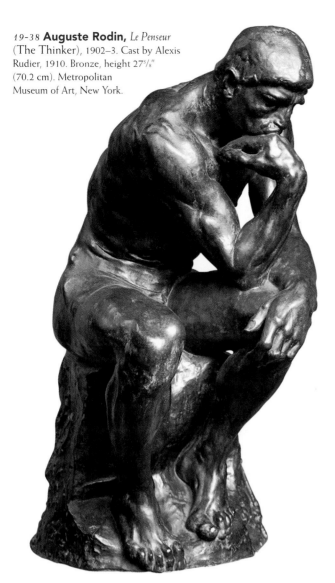

19-38 **Auguste Rodin,** *Le Penseur* (The Thinker), 1902–3. Cast by Alexis Rudier, 1910. Bronze, height 27⅝" (70.2 cm). Metropolitan Museum of Art, New York.

commissioned by a French literary society but ultimately rejected. Active during the early part of the nineteenth century, Honoré de Balzac (1799–1850) had become one of the stars of French literature. He had written an impressive number of novels, loosely grouped together as the *La Comédie humaine* (Human Comedy), because in them he had tried to record all the tragic and comical aspects of human life in his own time.

Unfortunately for Rodin, Balzac had been short and fat, with tiny legs and a large potbelly. This made it difficult to create a sculpture that would be both majestic and realistic. After numerous experiments that included some grotesque nude Balzacs, Rodin decided to represent the writer in the famous monk's robe that he was known to have worn when he was writing. Rather than dressing the figure in the robe and girding it around his bulging waist, Rodin draped it over his shoulders, to create the illusion of a cape or a classical toga. In that way, he lent to the figure a sense of Classical grandeur not dissimilar to ancient statuary (see FIG. 2-13).

In an interview, Rodin once said that he had tried, in the *Monument to Honoré de Balzac,* "to show a Balzac in his

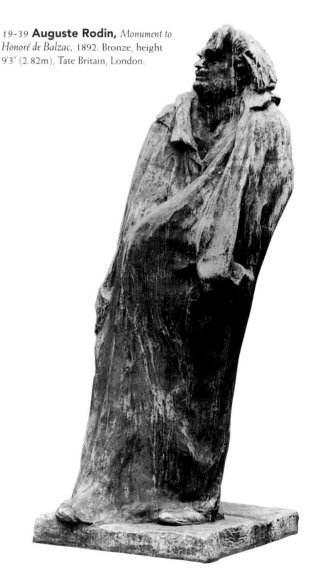

19-39 **Auguste Rodin,** *Monument to Honoré de Balzac,* 1892. Bronze, height 9'3" (2.82m), Tate Britain, London.

for a beautiful woman is not death but old age. *The Old Courtesan* is the image of an old woman, who regretfully contemplates the ruins of her body.

Rodin's plan for the *The Gates of Hell* included a rectangular area above the two doors. Equivalent to the tympanum above the entrance to a medieval church (see FIG. 12.2-1), this area is dominated by the famous *Le Penseur* (The Thinker; FIG. 19-38). The meaning of this figure is ambiguous. Does he represent Dante himself, meditating over what he has seen? Or is he, more generically, "thinking man," or else, an allegory of thought—including both creativity and conscience? Questions have arisen over the nudity and powerful build of the *Thinker,* which cause him to look more like a sports hero than a sage. It is possible that by lending to his *Thinker* such a superior physique, Rodin wished to express that thought is the highest form of being?

In addition to the *The Gates of Hell,* Rodin executed numerous other commissions, for public monuments as well as for portraits. Perhaps the most interesting among them was the *Monument to Honoré de Balzac* (FIG. 19-39),

study, breathless, hair in disorder, eyes lost in a dream, a genius who in his little room reconstructs piece by piece all of society in order to bring it into tumultuous life before his contemporaries and generations to come." His aim, in other words, had been to capture the moment of creative conception through the figure of Balzac.

The plaster for Balzac's monument was shown at the Salon of the Société Nationale des Beaux-Arts in 1898 and touched off a heated controversy between those who admired and those who hated it. The latter called the work a snowman, a seal, a penguin, an embryo, a sack of flour, and more. They ultimately prevailed and managed to convince the literary society that had commissioned the work not to accept it. The work, Rodin was told, lacked style, to which the sculptor responded that style was life itself. "My principle is to imitate not only form but also life," he wrote in a newspaper article in 1898. To him, as to the Symbolist, form was an envelope for an idea.

Camille Claudel

In the well-known French film *Camille Claudel* (1990) Rodin is portrayed as an arrogant, feverish creator, a man with no regard for anybody as he single-mindedly pursues his art. The movie's heroine, Camille Claudel (1864–1943), Rodin's student, model, and lover, is one of the numerous people who is consumed by his dual passion for art and love. The tragedy of Camille, the movie suggests, is that for her, a female artist, love comes before art, while for Rodin, male "genius" par excellence, art ultimately comes before love.

While that makes for an interesting movie theme, the facts do not entirely bear it out. Camille Claudel was one of a considerable group of female artists at the end of the nineteenth century, who successfully broke free from the expectation that women should be lovers, wives, and homemakers first and artists second. (It was precisely this expectation that had traditionally forced women into the amateur artist category.) Although she was unable to attend the École des Beaux-Arts, Claudel studied at the Académie Colarossi (see page 506). Later, she studied with the sculptor Alfred Boucher (1850–1934), who introduced her to Rodin. As one of Rodin's numerous young assistants, she helped him to execute several major commissions, while also becoming his lover.

This did not prevent her, however, from having a successful career of her own. She exhibited regularly at the Salons, received numerous commissions, served on artistic juries and committees, and received prizes, including the Legion of Honor (1892). Her work, though at times close to Rodin's, often shows distinctive characteristics. *Waltz* of 1895 (FIG. 19-40), for example, resembles Rodin's *Fugit Amor* in its theme of a passionate embrace (see FIG. 19-36). Its mood, however, is more tender and less desperate. While the male figure is nude, the female wears a long, shapeless skirt over her naked body. It is an inventive motive that, by melding the two figures together, is suggestive of the fusion of two human beings in the act of lovemaking.

Claudel's importance is not primarily in her work, which is of modest talent. Nor does it reside in her relation with Rodin, even though she has commonly been portrayed as a female muse to this male "genius." Most importantly, Claudel exemplifies the strides that women artists had made in the course of the nineteenth century. A late nineteenth-century woman artist, she was no longer confined in her choice of medium or subject matter. Not only did she practice twhat was perceived as the eminently masculine art of sculpture, creating a number of large-scale works, but she was also equally comfortable with the female and the male nude, long taboo for female artists. By the time she was born, in 1864, professional women artists were still the exception. At the time of her death in 1943, they were a presence in the European art world.

19-40 **Camille Claudel,** *Waltz,* 1895. Bronze, height 17″ (43.2 cm). Musée Rodin, Paris.

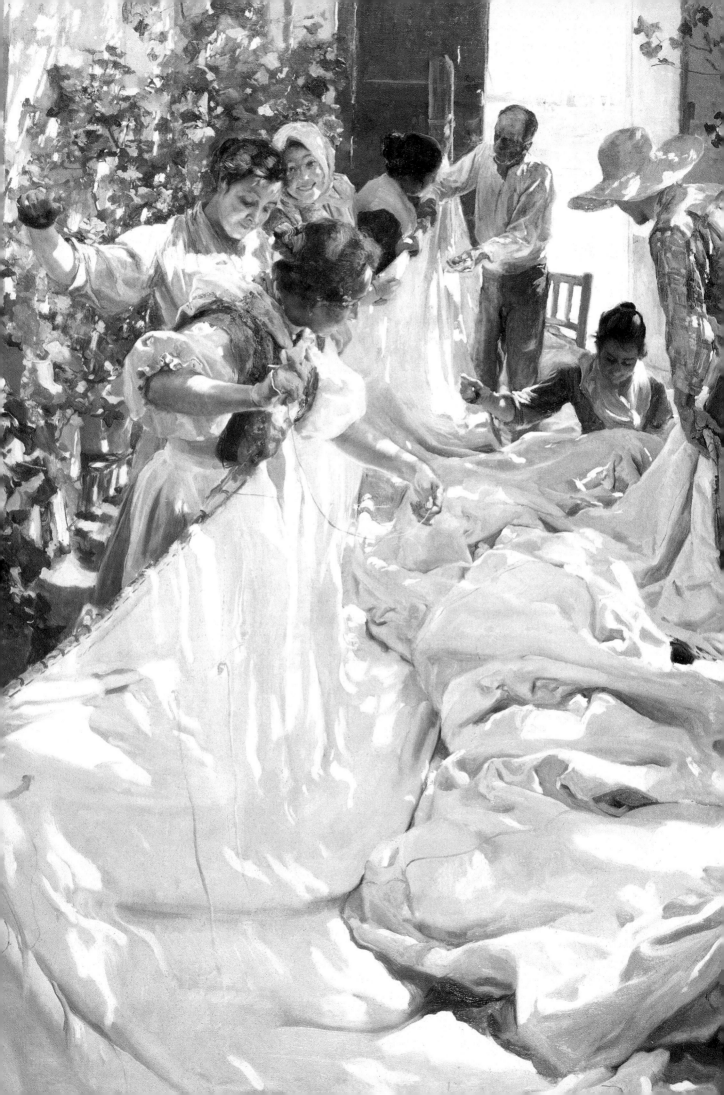

Chapter Twenty

International Trends c. 1900

As the nineteenth century drew to a close, the stage was set for a new age of mass communication and transportation. In 1876 the Scottish-born American Alexander Graham Bell (1847–1922) obtained a patent for a device to transmit sound through wires. Twenty years later, the telephone, as we know it, was widely used in offices as well as in the homes of the rich. Almost simultaneously, another mode of long distance communication was perfected by the Italian scientist Guglielmo Marconi (1874–1937). In 1896 he patented a system for wireless telegraphy that would soon lead to the development of the radio.

The internal combustion engine, the critical element of the modern car, was invented in the middle of the nineteenth century. By the late 1880s, Karl Benz (1844–1929) and Gottlieb Daimler (1834–1900) in Germany and Armand Peugeot (1849–1915) and the Renault brothers in France began to manufacture automobile (self-moving or "horse-less") carriages for an emerging market. By the end of the century, experiments were also underway to mount internal combustion engines on gliders in order to develop vehicles that could fly. In 1903 the brothers Wilbur (1867–1912) and Orville (1871–1948) Wright, bicycle manufacturers from Dayton Ohio, made the first successful manned flights at Kitty Hawk in North Carolina.

In 1900 even the staunchest believers in technology could not foresee the speed and breadth of the development of these inventions in the twentieth century. Nor did they anticipate their military potential. Did Benz and

Daimler suspect that automobiles would supplant the horse in war, because soldiers could be transported faster and in greater numbers by car? Did the Wright brothers ever think that airplanes would be used to drop bombs? Yet World War I (1914–18) would not have been "the war to end all wars" were it not for those new technologies. They caused more destruction of life and property than had been seen in any war in history. No wonder that, by 1918, people's view of technology had changed. The widely shared enthusiasm of the nineteenth century had given way to a more jaded, suspicious attitude towards technology and progress.

New Art Outside France

In the 1890s, however, the numerous advancements in technology were still capable of creating a powerful sense of optimism and faith in progress. The belief that a new and better era was imminent led to a call for a new art across Western Europe. While this call was heard throughout the art world, it was particularly powerful in architecture and design circles. Art Nouveau in France found its match in Belgian Art Nouveau, as well as in *Modernisme* in Spain, *Jugendstil* (Youth Style) in Germany, *Stile Floreale* (Flowery Style) in Italy, Glasgow Style in Scotland, and Secession Style in Austria. While these national and regional movements differed considerably, they all had in common a

desire for new architectural and decorative forms—forms that would no longer be steeped in styles of the past, either by way of imitation or by eclectic borrowing and adaptation. These new movements furthermore were based on the conviction that all forms of art had common roots and hence equal value. Thus the traditional distinction between fine arts and applied or decorative arts became increasingly blurred.

Art Nouveau in Belgium

Of all the "new art" movements in Europe, the one in Belgium was most closely aligned with contemporary developments in France (see page 454). Belgian Art Nouveau was dominated by two architects–designers, Victor Horta (1861–1947) and Henri van der Velde. Horta, the elder of the two, was among the first architects in Europe to develop a new, non-historical and non-eclectic

20-1 **Victor Horta,** Staircase in the Tassel residence (now Mexican Embassy, 1892–3, Brussels.

20-2 **Victor Horta,** *Maison du Peuple* (House of the People), 1897–99, Brussels (destroyed).

style, preceding even Hector Guimard in Paris by a few years. Early in his career, Horta specialized in the design of urban homes. In accordance with Art Nouveau philosophy, these houses, their interiors, and all their furniture were designed by Horta in order to create a stylistic unity that was the antithesis of the eclectic interiors of the previous era.

Horta's domestic designs are characterized by his use of exposed structural metal as well as his predilection for sinuous lines loosely derived from plant motifs. The Tassel residence, now the Mexican Embassy in Brussels, is characteristic of his style. It is built around a hall with a monumental open staircase (FIG. 20-1). The design centers on a metal column which branches out into curved metal supports that hold up the ceiling and landings. The stair's metal banister is filled with sinuous tendrils, a motif that is repeated in the mosaic floor and the painted decorations of the walls and ceiling.

Horta's interest in exposing the structural elements of his buildings can best be seen in his most advanced architectural design, the Maison du Peuple or "House of the People" (FIG. 20-2), the headquarters of the Socialist Party in Brussels. The building, unfortunately, has been destroyed but old photographs clearly show the modernity of its design and construction, which combined glass and iron, much like the Crystal Palace in London and the contemporary early skyscrapers of Louis Sullivan (1856–1924) in Chicago. The Maison du Peuple was built on an irregularly shaped plot, of which Horta took full advantage by creating an intricately curved and angled façade that is almost entirely made of glass, set for the most part in an exposed iron frame. This gives the building a modern look that anticipates twentieth-century architecture.

The architectural designs of Henri van der Velde have been discussed in Chapter 19, because this artist worked for some time in Paris, where he was recruited by Siegfried Bing. Van der Velde was a highly versatile artist, who was an architect and painter as well as an interior and graphic designer. The posters he designed for the health food manufacturer Tropon (FIG. 20-3) are among the most original

20-3 **Henri van der Velde,** Poster for a food concentrate manufactured by Tropon, 1899. Private Collection.

examples of late nineteenth-century graphic design. They differ from most French Art Nouveau posters in their use of a highly stylized, abstract ornamentation. The viewer is not invited to focus on a recognizable picture that conveys something about the product that is advertised (see Posters, page 457). Instead one is drawn into the poster by the upward striving, sinuous lines, vaguely resembling flower stems, that propel the glance upward towards the brand name, "Tropon." Van der Velde's posters precede twentieth-century non-representational art by more than a decade. Yet his impulse to develop natural forms into abstract ornamentation is not very different from the one that would drive the Russian-born artist Vasili Kandinsky (1866–1944), around 1910, to transform landscapes into non-objective compositions.

Antoni Gaudí and Spanish Modernisme

By far the most exuberant and idiosyncratic form of Art Nouveau was produced in Spain. Here the call for a "new art" was restricted largely to the Catalan city of Barcelona,

20-4 **Antoni Gaudí,** Casa Battló, 1905–7, Barcelona, Spain.

where it coalesced into a movement called *Modernisme*. Like art nouveau in France and Belgium, Spanish *Modernisme* developed as a reaction to the eclecticism that had dominated Spanish art and architecture for much of the nineteenth century. Antoni Gaudí (1852–1926), the most famous (though decidedly atypical) representative of *Modernisme*, himself started out as an eclectic architect. In his early buildings he borrowed extensively from various historical sources, such as Spanish medieval and Islamic art. Around 1900 he abandoned historicism to turn to nature for inspiration. His idea was not to imitate elements in nature but to transform them creatively into new, imaginative architectural forms.

The originality of Gaudí's new style is evident in the Casa Battló in Barcelona (FIG. 20-4), which the architect remodeled between 1905 and 1907. For this multi-story apartment building, he designed a softly undulating façade dribbled with colored splashes of cement. Above a ground floor articulated by five arches, a second-floor tribune, spanning the house, juts forward. Its irregularly curved, overhanging edge is supported by bone-shaped columns. The higher floors feature individual balconies for each room. Those of the top three floors have irregularly curved balustrades pierced with large round holes, giving them the appearance of masks. The house seems playful and whimsical, as if Gaudí deliberately set out to create a happy living environment. And indeed, the architect is quoted to have said that he wanted to create buildings in the "image of paradise."

Gaudí's life work was the church of the Sagrada Familia (FIG. 20-5) in Barcelona. The idea for this building had come from a local religious group which, as early as 1866,

20-5 **Antoni Gaudí and others,** *Façade of the Nativity of the Templo Expiatorio de la Sagrada Familia,* 1893–1930. Barcelona, Spain.

had begun to raise funds to build an expiatory chapel dedicated to St Joseph and the Holy Family. By the time that building began in the early 1880s, the scope of the design had become a cathedral-size church. When Gaudí took charge of the project in 1883 the Sagrada Familia had been under construction for more than a year, yet the building had not advanced beyond the sanctuary. Gaudí worked on the church until his death in 1926, becoming more deeply involved in the project as he became more intensely religious.

Although at first Gaudí followed the neo-Gothic design of his predecessor, he soon began to impose his own vision on the project. He overlaid the architectural framework with fluid sculptural decorations that made the building look like a living organism rather than a man-made structure. All straight lines and angles were replaced by serpentines and curves. This is especially visible in the façade of the Nativity, with its three portals devoted to Faith, Hope, and Love. Covered with an abundance of sculptural ornamentation, their tall neo-Gothic gables resemble a stalactite cave or a petrified forest.

Towering above the entrance are four tall spires, twice the number found in a traditional Gothic cathedral. Dedicated to SS Barnabas, Simon, Thaddeus and Matthew, all but one were completed after Gaudí's death. Starting from a square base, the spires turn to tubes as they reach the top of the portals. From there, they spiral upwards, tapering towards the top and ending with elaborate finials, designed by Gaudí's successor in the Cubist-inspired "Art Deco" style of the 1930s.

Art Nouveau in Glasgow

While in France, Belgium, and Spain, Art Nouveau was marked by irregular curves, often derived from organic forms, in Scotland a different "new art" developed that was more restrained and inspired more by Japanese design than by nature.

In 1893–4 two female and two male students of the Glasgow School of Art joined together to form a movement called "The Four." Chief among them was Charles Rennie Mackintosh (1868–1928), an architect, interior designer, and painter. Mackintosh became best known for his four Glasgow tearooms, which he designed for the local restaurant entrepreneur Catherine Cranston. Tearooms were popular at the turn of the century; like today's coffee shops, they were places where one spent leisure time and met friends. Their ambiance was important, so tearoom owners like Cranston tried to attract the best designers to create their decors. Inside the Willow Tearoom (FIG. 20-6), the only one of Mackintosh's that has

20-6 **Charles Rennie Mackintosh,** Salon de Luxe, Willow Tearoom, 1904. Sauchiehall Street, Glasgow.

20-7 **Charles Rennie Mackintosh,** Doors to the Salon de Luxe, Willow Tearoom, 1904. Sauchiehall Street, Glasgow.

been preserved intact, the Salon de Luxe epitomizes the "integrated" look that was so important at the turn of the century. In Mackintosh's design, the flourishing curves of French and Belgian Art Nouveau are substituted by straight lines and right angles and by a careful balancing of horizontals and verticals. This is exemplified in the contrast between the horizontal table surfaces and the vertical backs of the tall chairs. Mackintosh's style is seen at its best in the leaded glass doors that he designed for the Salon de Luxe (FIG. 20-7). In them, a basic grid of horizontal and vertical lines is enlivened by the addition of diagonal and slightly curved lines, as well as by small oval insets and two irregular roselike shapes that are the hallmark of many of Mackintosh's designs. The use of muted colors, such as pink, light blue, moss green, and mauve, is also characteristic of his work.

Art Nouveau and Symbolism

While the term Art Nouveau—as well as its regional variants, such as Glasgow School and *Modernisme*—are applied first and foremost to architecture and design innovations at the turn of the nineteenth century, these movements had important links with contemporary painting and sculpture. Many of the artists of the period were active both as designers and as painters or sculptors, and the characteristics of Art Nouveau—asymmetry, flowing serpentine lines, and irregular organic shapes—are frequently found throughout their entire artistic production. That fact notwithstanding, the term Art Nouveau is not often applied to painting and sculpture. Instead, these art forms, representational rather than decorative, are most often referred to as Symbolism (see page 470).

One could easily argue that the abstract forms in the foreground of Gauguin's *Fatata te miti* (see FIG. 19-18) are related to contemporary Art Nouveau. One might compare them, for example, with the architectural designs of Hector Guimard and the irregular curved forms found in the vases of Emile Gallé (see FIGS. 19-4 and 19-7). Yet we call the late art of Gauguin "Symbolist," because contemporary critics, interested in their content rather than their form, felt that their most outstanding characteristic was that they were "paintings of ideas." In sum, Art Nouveau and Symbolism must be considered as two closely interwoven artistic trends that are often difficult to separate from one another.

Today, the term "International Symbolism" is used for much of the painting and sculpture that were produced in Europe at the turn of the century. In their own time, however, the numerous associations of avant-garde artists that

20-8 **Fernand Khnopff,** *Caresses*, 1896. Oil on canvas, 19⅝ x 59″ (49.8 cm x 1.5 m). Musées Royaux des Beaux-Arts de Belgique, Brussels.

formed in different parts of Europe did not feel that they were part of an international movement. Instead, they thought of themselves as members of a local or national avant-garde association. It is noteworthy, however, that many of these groups were interconnected, because the exhibitions that they organized were increasingly international in scope.

Salons of the Rose + Croix

We have seen in Chapter 19 how the Salons of the Rose + Croix, organized by Joséphin Péladan, attracted a large international group of exhibitors. For the most part, their work was startling in subject matter but conservative in form. In their preoccupation with the fantastic and often the ghastly, many of the Rose + Croix artists may be called "neo-Romantic." Yet stylistically their art was far removed from truly Romantic artists such as Delacroix, and more closely aligned with late nineteenth-century academic painting.

Belgium was especially well represented at the Rose + Croix Salons. The Belgian painter Fernand Khnopff (1858–1921) was among Péladan's favorite artists. His *Caresses* (FIG. 20-8) shows a reclining leopard with a woman's head rubbing her cheek against the temple of a standing youth. The painting contains an obvious reference to the myth of Oedipus solving the riddle of the sphinx, which had inspired several older artists including Ingres (see FIG. 20-9). Yet while in Ingres's painting Oedipus is clearly the embodiment of human intelligence and moral strength, which triumph over evil, in Khnopff's painting the young man seems both seduced and confused by the leopard's advances. Indeed, the roles of man and woman-beast are clearly reversed here since the leopard is the embodiment of the *femme fatale*, the fatal woman who, it seems, will ultimately destroy the young man through her animal passion. Khnopff's painting anticipates the

writings of Freud in its allusion to the fears that accompany the awakening of male sexuality. Freud's theories about male castration anxiety, provoked by the young boy's first view of the female vagina, are suggested both by his anxious facial expression and by the movement of the leopard's claw, which seems to reach for his genitals.

Stylistically, Khnopff's painting is greatly indebted to Ingres, whose painting style had remained the model for

20-9 **Jean-Auguste-Dominique Ingres,** *Oedipus and the Sphinx*, 1808, reworked c.1827. Oil on canvas, 6′2″ x 4′9″ (1.89 x 1.44 m). Musée du Louvre, Paris.

academic painting for most of the nineteenth century. Where it differs most drastically from the older master, however, is in the naturalistic representation of the woman's head, which looks much like the portrait of a contemporary woman. The startling naturalism of her features in this otherwise imaginary and idealized work lends the painting a strange and disturbing quality.

Next to Khnopff, the Belgian artist Jean Delville (1867–1953) was a major exhibitor at Péladan's salons. *The Treasures of Satan* (FIG. 20-10) is one of his more outrageous works. Satan, an athletic male figure with fiery hair and octopus tentacles, leaps over a pile of sleeping (or dead) figures—mostly women—whose seductive, nude bodies are loosely tied together by strings of beads. The scene is set under water, amidst fantastic rock and coral formations populated by a variety of strange marine creatures. The entire picture is eerily lit by the fiery glow that Satan emits.

Although most of us, today, will probably look upon this painting as an elaborate sexual fantasy, to Delville it summed up the ideals he had set for himself in art: spiritual beauty, plastic beauty, and technical beauty. The painting's spiritual beauty resided in its condemnation of sexual excess (through the presence of the devil himself); its plastic beauty in the idealized representation of the bodies; and its technical beauty in the way in which the artist has rendered the submarine effect, as well as the strange and eerie illumination of the bodies.

20-10 **Jean Delville,** *The Treasures of Satan,* 1895. Oil on canvas, 8'6" x 8'9" (2.58 x 2.68 m). Musées Royaux des Beaux-arts de Belgique, Brussels.

Les XX or "The Group of Twenty"

While the Rose + Croix Salons featured works by stylistically conservative painters and sculptors, the exhibitions organized by "The Group of Twenty" (Les Vingt or Les XX) in Brussels attracted Symbolist artists interested in a formal renewal of art. Les XX was formed in 1883 as an avant-garde exhibition society, that is, a society whose aim it was to organize exhibitions of the works of its members and guests. Like the Impressionist shows in Paris during the 1870s and 1880s, the exhibitions of Les XX were a progressive alternative to the Brussels Salons, which were controlled by the Belgian Academy.

Between 1884 and 1893 Les XX organized nine annual exhibitions of works of members as well as invited artists. Many of them were foreigners, because Les XX were intent on giving an international dimension to their shows. By far the most original artist to exhibit with Les XX, however, was the Belgian James Ensor (1860–1949), one of the group's founding members. Ensor had started out as a Realist painter, but by the time he became involved with Les XX he had turned from real-life to imaginary subject matter and had become increasingly experimental in both style and technique.

In 1888 Ensor painted his most important work, *The Entry of Christ into Brussels* (FIG. 20-11). This painting is an adaptation of the traditional biblical theme of the entry of Christ into Jerusalem (see FIG. 10-7), transposed to the Brussels of Ensor's own time. In Ensor's work, the event has been turned into a political rally, complete with marching bands, banners ("Long live the Socialist State"), and officials on a viewing stand. Christ himself is hard to find within the crowd. Riding on a donkey behind the marching bank, he is greeted by a group of creatures whose hybridized animal heads resemble the papier mâché masks worn in Belgium at carnival times. Of course, they are not the only grotesque figures in the painting. All the men and women in the crowd seem to be hiding behind masks, peering out at the world through dark, empty eyeholes.

Ensor's attempt to transpose a biblical event to the Brussels of his own time may be seen as a throwback to the sixteenth-century painter Pieter Brueghel (c.1525–1569), one of the major figures in the history of Belgian art. Brueghel's *Christ Carrying the Cross* (FIG. 20-13) likewise shows a biblical scene set in the artist's own time and place. As in Ensor's *The Entry of Christ into Brussels*, Brueghel's figure of Christ is all but swallowed up by the crowd, which is composed of characters that match Ensor's in their grotesqueness. Like Brueghel's painting, Ensor's may have a moralizing aim—to remind us that we are all so busy trying to "be someone" in the world that we ignore or pay only lip service to what is truly important in life. Yet the *The Entry of Christ into Brussels* doubtless also had a political significance. Ensor had in common with several artists of his time a sympathy for the Belgian workers' movement. His painting was begun less than three years after the foundation of the Belgian Workers' Party, a socialist opposition

20-11 **James Ensor,** *The Entry of Christ into Brussels*, 1888. Oil on canvas, 8'15" x 12'5" (2.57 x 3.78 m). J. Paul Getty Museum, Los Angeles.

20-12 **James Ensor,** detail of *The Entry of Christ into Brussels*, 1888.

20-13 **Pieter Brueghel,** *Christ Carrying the Cross*, 1564. Oil on wood, 48³/₈ x 66³/₈" (1.23 x 1.69 m). Kunsthistorisches Museum, Vienna.

party whose aim was to counter the conservatism of the ruling Roman Catholic and liberal parties.

It is ironic that Ensor never exhibited his largest and most public work, perhaps for fear that it would be mis-understood. To his contemporaries, therefore, the artist was better known for his private and intimate paintings of studio interiors and still lifes. Many of these were based on the fantastic arrangements that Ensor made with the help of objects sold in his mother's souvenir shop or props found in his studio, such as skulls, brushes, and palettes. To Ensor, painting such arrangements was an escape from the hostile world into what he called a "solitary land of bantering mirth." *Skeletons Trying To Get Warm* (FIG. 20-14) may serve as an example of this aspect of Ensor's work. The painting shows a group of skeletons huddling around a wood stove, much as artists and models would warm themselves after a painting session. While the subject is morbid, the colorful outfits of the skeletons and their ubiquitous grin do give these paintings a "sense of mirth." Indeed, one of the striking qualities of Ensor's work is its ambiguity. This painting may be read at once as a macabre joke and as a serious work, reminding the viewer of the vanity of all earthly activities, including even art.

Vienna Secession

The Vienna Secession was the central European equivalent of Les XX in Belgium. In Vienna, in 1897, nineteen artists—painters, designers, architects—"seceded" or broke away from the existing (and dominating) association of Viennese artists to form their own exhibition society, called *Sezession*. Their first exhibition, in a rented locale, was such a success that the Secessionists decided to build their own exhibition building. They also began to publish a magazine called *Ver Sacrum* (Latin for sacred spring), a title that was suggestive of their intention to bring about a rebirth of the arts in Austria.

Between 1898 and 1905 twenty-three exhibitions took place in the new Secession building. Like Les XX, the Secessionists intended to help the public develop an appre-ciation for new and "modern" art. One of their aims was to bring foreign art to Vienna to awaken Austrian art from its sleepy provincialism. In the editorial of the first issue of *Ver Sacrum* they declared: "We want to bring foreign art to Vienna not just for the sake of artists, academics, and collectors, but in order to create a great mass of people receptive to art, to awaken the desire which lies dormant in the breast of every man for beauty and freedom of thought and feeling."

20-14 **James Ensor,** *Skeletons Trying to Get Warm,* 1889. Oil on canvas, 29 x 23⅝" (75 x 60 cm). Kimbell Art Museum, Fort Worth, Texas.

The Secessionists organized regular group shows of members and foreign artists, many of whom were named "corresponding members." They were also responsible for staging a number of special retrospective exhibitions, for example of the works of the French Impressionists (1903); some design exhibitions, such as the eighth Secessionist show (1900), which featured an entire Mackintosh room; and "theme" exhibitions. The famous Beethoven exhibition of 1902, for example, contained an installation of works by several of the Secession artists—something of a *Gesamtkunstwerk* (total work of art)—commemorating the 75th anniversary of the famous composer's death.

Gustav Klimt

The artist whose name is most closely associated with the Secession exhibitions is the Viennese painter Gustav Klimt (1862–1918), a founding member of the Secession group and its first president. Klimt caused a string of scandals apropos of three large paintings that he had made in response to a commission from the University of Vienna. Intended for the ceiling of the monumental entrance lobby or Aula of the university building, they were allegorical representations of Philosophy, Medicine, and Jurisprudence respectively.

Medicine (FIG. 20-15) shows an image of Hygeia (bottom center), the Greek goddess of health. A golden snake,

20-15 **Gustav Klimt,** *Medicine* (ceiling painting for the Aula of Vienna University), 1901. Oil on canvas, 14'2" x 9'10" (4.3 x 3 m), destroyed.

20-16 **Gustav Klimt,** *"Choir of Heavenly Angels"* from the Beethoven frieze, 1902. Plaster panel painted in carein colors, worked with charcoal, pencil and pastel, and decorated with inlaid stucco, gold and semi-precious stones; length 15′6″ (4.72 m), length of entire frieze 98′5″ (30 m). Österreichische Galerie, Vienna.

coiled around her right arm, is drinking from a glass dish held in her left hand. Her commanding presence suggests that she represents the power of medicine to heal. Behind her is a vertical chain of densely packed nude bodies, male and female, young and old. Her closed eyes as well as their unusual poses suggest that they are asleep. One young woman appears to have escaped the "pack." Isolated from the others but for one man who is reaching out to her, she seems to be floating in mid-air.

When exhibited in 1900, 1901, and 1903, in advance of their installation, Klimt's university paintings, and especially *Medicine*, were harshly criticized. They were branded as "strange" and "monstrous," and criticized for the unidealized way in which Klimt had rendered the human figure. Clearly he had not observed traditional propriety in his representation of the nude figure. The presence of body hair, on both male and female figures, was still very much frowned upon at the turn of the century and so was the representation of pregnant nudes (such as the one in *Medicine*). So vicious and relentless were the attacks that Klimt withdrew from the commission. The three paintings were brought by his friends but two, including *Medicine* and *Philosophy*, were destroyed in World War II.

In spite of the daringly realistic representation of the nudes, Klimt's *Medicine* is formally conservative. The work shows none of the modernist qualities of synthesis, flatness, and expressive color that we find in the works of Bernard or Gauguin, nor does it show the grotesque distortion for the sake of expression that we find in the work of van Gogh or Ensor. Instead, the work's originality lies in the artist's unusual interpretation of the subject he was commissioned to paint. Klimt's work thus may be related to that of the artists of the Rose + Croix group, who likewise focused on startling subjects rather than innovative form.

Not all of Klimt's works show such formal conservatism. In the Beethoven frieze painted for the Secession's special Beethoven exhibition of 1902, we encounter a quite different artist, more interested in the decorative aspect of his work and the expressionist possibilities of line, color, and pattern. The Beethoven exhibition was organized around a statue of the famous composer by the German artist Max Klinger (1857–1920). Klimt's "frieze"—a narrow horizontal wall painting extending the length of two walls—was conceived as a visual paraphrase of the *Ode to Joy*, the last movement of Beethoven's Ninth Symphony.

20-17 **Gustav Klimt,** *The Kiss,* 1908. Oil on canvas, 5'11" x 5'11" (1.8 x 1.8 m). Österreichische Galerie, Vienna.

Its final section, inspired by the line "Let me embrace you, O millions!/This kiss is for the whole world!," shows a chorus of women, who serve as a backdrop for a couple locked in a close embrace (FIG. 20-16). Watched by the sun and the moon, their bodies contained in a bubble-shaped halo, the couple epitomizes ecstasy, that supreme form of joy when the soul seems momentarily freed from the body.

In contrast to the university paintings, the Beethoven frieze is composed of simplified, stylized figures that lack even a hint of *chiaroscuro.* There is an emphasis on pattern—whether it is the dot and squiggle pattern of the singers' gowns or the flowery pattern of the meadow in which they stand. Against this patchwork of different patterns, the couple stands out. Drawn with a few sparing lines and painted in the lightest of flesh tones, their bodies seem almost transparent, suggesting the sensation of weightlessness and ethereality that ecstasy brings about.

The Beethoven frieze for the first time featured the theme of the kiss, which was to be a *leitmotiv* in Klimt's work for the next several years. It would find its final elaboration in the artist's famous painting *The Kiss* (FIG. 20-17), in which a man and a woman, dressed in ornately patterned gowns, kneel down in a flowered garden, holding one another in a close embrace. With its elaborate use of gold leaf, variously treated for different effects, Klimt's painting recalls Byzantine icons and medieval altarpieces. By stressing the analogy between this scene of sexual abandon and traditional religious painting, the artist may have wished to suggest the similarity between erotic and religious ecstasy.

Ferdinand Hodler

Another artist who made his reputation largely through the Secession exhibitions was Ferdinand Hodler (1853–1918). Swiss rather than Austrian, Hodler was not a regular member but a "correspondent." Much admired by young Austrian artists, including Klimt, his work was frequently represented in the Secession exhibitions.

Born in Bern and trained in Geneva, Hodler spent the first fifteen years of his career painting Naturalist landscapes, portraits, and genre scenes. Around 1890, however, he grew dissatisfied with faithfully representing the world around him, and became increasingly interested in art as an expression of existential truths. His monumental painting *Night* (FIG. 20-18), exhibited at the first Rose + Croix exhibition of 1892, was a turning point in his career. Not only did it mark Hodler's transition from Naturalism to Symbolism, but it also helped him to build a reputation as a new and innovative artist of international stature. To Hodler himself it was a work in which he revealed himself "in a new light."

Night shows seven men and women sleeping alone or in pairs on rocky ground. In the center, one man—Hodler himself—awakens with a start to find a figure wrapped in a black shroud straddling his naked body. In a handwritten note, Hodler explained the painting as follows:

It is not one night, but an ensemble of impressions of the night. The phantom of death … is there as a most intense nocturnal phenomenon. The coloration is symbolic; these sleeping beings are draped in black; the lighting is similar to an effect of the evening after sunset, which is an effect preliminary to the night. But what is most striking is the phantom of death. This way of representing the phantom, at once harmonious and sinister, envisions the unknown, the invisible.

Hodler's *Night* has been compared to *The Nightmare* by the early nineteenth-century Swiss painter, Henry Fuseli (see FIG. 3-7), which also shows blatant eroticism. While in Fuseli's work an incubus crouches on the chest of a young woman, in Hodler's *Night*, by contrast, the phantom of death seems to descend on the artist's genitals. In both cases the "attacker" seems to embody the two contrasting human drives that Sigmund Freud saw as the main motivating forces of the human psyche—*eros* (the sexual instinct, aimed at the continuation of life) and *thanatos* (the death instinct, aimed at ending life's stress and tension).

Hodler's *Night* was followed by several other Symbolist allegories, dealing with such existential topics as faith, life, truth, and love. The artist probably intended them as a series, for they all have a similar horizontal format and include several life-size figures in a landscape setting. A considerable number of these allegorical works were exhibited at the nineteenth Secession exhibition in 1904. There Hodler was represented with no less than thirty-one paintings, and his reputation was established once and for all.

In addition to monumental allegorical works, Hodler produced numerous landscape paintings. During his apprenticeship years he had assisted his teacher in painting views of alpine scenery for the tourist market. Later he returned to many of the same scenes, creating a series of original landscapes of great intensity. Hodler's view of nature was heavily influenced by German Romanticism. With German poets such as Goethe and Schiller (see page 199), he shared the conviction that the contemplation of nature brings the viewer closer to understanding the secret of life. A preliminary drawing for one of Hodler's early landscapes (FIG. 20-19) shows a woman "communing" with nature, much like the female figure in Caspar David Friedrich's *Woman Before the Setting Sun* (see FIG. 7-13). In the finished landscape, *Autumn Evening* (FIG. 20-20), Hodler left out the woman, confronting the viewer directly with the landscape and inviting him or her to commune with nature

20-18 **Ferdinand Hodler,** *Night,* 1890. Oil on canvas, 3'9" x 9'9" (1.16 x 2.99 m). Kunstmuseum, Bern.

20-19 **Ferdinand Hodler,**
sketch for *Autumn Evening*, 1892.
Lead pencil, watercolors,
gouache, oil, and varnish on
beige paper, 25⁷/₁₆ x 15⁷/₈" (64.5 x
40.2 cm). Musée d'Art d'Histoire,
Geneva.

20-20 **Ferdinand Hodler,**
Autumn Evening, 1892. Oil on
canvas, 39³/₈ x 51" (1 x 1.3 m).
Musée d'Art et d'Histoire,
Neuchâtel.

20-21 **Ferdinand Hodler,** *Lake Silvaplana,* 1907. Oil on canvas, 28 x 36³/₈" (71.1 x 92.4 cm). Kunsthaus, Zürich.

without the intermediary of a painted figure. Through the dramatic way in which Hodler has handled the perspective, the eye is forcefully drawn into the landscape, to be met at the horizon by the red streaks of the setting sun. Like Hodler's *Night,* but in a different way, *Autumn Evening* seems to be a meditation on death. The painting evokes thoughts of loss and decay as well as of peace and eternity.

The symmetrical ordering of *Autumn Evening* and its limited color scheme anticipate Hodler's later landscapes, such as *Lake Silvaplana* (FIG. 20-21). Hodler painted this picture during a stay in the Engadin region of Switzerland, where he became fascinated with this particular view of the Alps across the lake. In his painting, the reddish-brown mountains, dotted with trees and patches of snow, are perfectly reflected in the mirror-like surface of the lake. Hodler has emphasized the double symmetry of the landscape, both along a vertical and a horizontal axis. Details are minimized and so is the color scheme. By these means, Hodler has imposed a certain order on nature that enables us to appreciate its underlying structure. Ten years earlier, he had stated that he saw it as his "mission" to "express the

eternal elements of nature, … to bring out nature's essential beauty." The artist, he felt, needed to exalt nature, to show "an aggrandized nature, a nature that has been simplified, freed from all insignificant detail." Clearly, Hodler advocated a new form of idealism along Platonic lines (see Chapter 2). Indeed, the artist cited Plato as he claimed: "Art is the gesture of beauty Plato's definition of 'beauty as the resplendence of truth' means that we must open our eyes and look at nature."

Berlin Secession

The Vienna Secession was one of a number of secession movements that swept across central Europe at the turn of the nineteenth century. In major cities, such as Berlin, Munich, Dresden, Leipzig, Prague, and Kraków, groups of young artists seceded from academies or other hegemonic art associations to develop their own exhibition societies. Most secession movements were the result of tensions that had developed between successful older artists

who controlled official exhibition policies and younger artists who were unable to break into the art market, because their works were consistently excluded.

Next to the Vienna Secession, the most important secession movement in the German-speaking world was in Berlin. Formed in 1898, the Berlin Secession resulted from a series of incidents in which the exhibition initiatives of young artists were blocked by the Academy. In 1892, like the Vienna Secession, the Berlin Secession was in the first instance an exhibition society. It organized two "salons" each year, a spring show for paintings, and a fall show for drawings and prints.

Edvard Munch

Compared with the Vienna Secession exhibitions, those of the Berlin Secession were conservative. Under the leadership of Max Liebermann (see page 441), the Berlin Secession above all promoted German Naturalism and Impressionism, although it did expose the Berlin public to more avant-garde, mostly non-German, art. Perhaps the boldest exhibition organized by the Secession in its early years was the spring exhibition of 1902, which featured a series of twenty-two paintings by Edvard Munch (1863–1944).

A Norwegian by birth, Munch had received his early training as an artist in Christiania, present-day Oslo. At the age of 23, he received a scholarship to study in Paris, where he arrived just in time for the Universal Exposition of 1889. While in Paris, Munch's father died, which sent him into a deep depression. He became obsessed with death and its opposites, life and love. These issues would inform all his subsequent works. During the 1890s Munch spent much time in Berlin, where he acquired a certain reputation after a controversial exhibition of his work in 1892. It was during this decade that he prepared many of the paintings that comprise *The Frieze of Life*, his most important artistic statement to date. In its initial form, called *Love*, this series of twenty-two paintings, unified by a common landscape setting as well as a common theme, was exhibited at the Berlin Secession exhibition of 1902.

Dance of Life (FIG. 20-22), a crucial painting in the cycle, demonstrates Munch's belief in sexuality—act of love and procreation—as the ultimate defense against human mortality. Five couples are dancing in a meadow. Behind them, the sun is setting over a deep blue sea. In the foreground two single women, one dressed in a flowery white dress, the other in black, flank a dancing couple. The bright red dress of the dancing woman seems to signify passion, just as the white dress of the woman on the left suggests

20-22 **Edvard Munch,** *Dance of Life,* 1899–1900. Oil on canvas, 4'1" x 6'3" (1.25 x 1.9 m). Nasjonalgalleriet, Oslo.

20-23 **Edvard Munch,** *The Scream,* 1893. Tempera and pastel on board, 35⁷/₈ x 29″ (91 x 73.5 cm). Nasjonalgalleriet, Oslo.

innocence and the black dress of the woman on the right experience. Together, the three women may be read as the three stages of life—youth, maturity, and old age—while the dance itself represents the libidinous energy that keeps death at bay. Munch's simplified forms, somewhat akin to the work of the French Synthetists, force the viewer to focus on the meaning of the picture rather than get lost in pictorial details.

In addition to such paintings as the *Dance of Life*, which attempt to answer existential questions as to the nature and meaning of life and death, Munch also painted pictures that express the anxiety that such questions provoke. *The Scream* of 1893 (FIG. 20-23) is a powerful image of existential *angst* or primal fear before the immensity of nature. The painting was based on a personal experience, which he described in this autobiographical prose poem:

> I was walking along the road with two friends.
> The sun was setting. I felt a breath of melancholy
> —Suddenly the sky turned blood-red. I stopped,
> and leaned against the railing, deathly tired—
> looking out across the flaming clouds that hung
> like blood and a sword over the blue-black fjord
> and town. My friends walked on—I stood there,
> trembling with fear. And I sensed a great, infinite
> scream pass through nature.

Munch's painting corresponds closely to this text, although it seems as if the figure is not merely "sensing" but producing the scream. The reverberation of the sound throughout the vast landscape is suggested by the long curving strokes, reminiscent at once of Art Nouveau decorations and of contemporary scientific images of sound waves.

Munch was one of several Symbolist artists who were seriously interested in printmaking. Gauguin, Bernard, and the artists of the Nabi group all produced prints, which could be sold more easily than paintings because their ease of reproduction enabled artists to charge lower prices. In addition, printmaking made it possible for artists to experiment with different techniques and materials in order to achieve innovative visual effects. The woodcut, especially, was favored by the Symbolists. Since its introduction in the fourteenth century, the use of this technique had been limited almost exclusively to the realm of folk and popular art. But by the end of the nineteenth century it experienced something of a revival among artists and graphic designers. The contemporary vogue of Japanese woodblock prints no doubt had something to do with the renewed interest in the woodcut, as did the expressive possibilities of the medium and its perception as a "popular" art form.

Munch's *The Kiss* (FIG. 20-24), like his painting of *The Scream*, has become something of an icon in popular culture today. The print is the graphic elaboration of a theme that

20-24 **Edvard Munch,** *The Kiss*, 1902. Color woodcut print (version D), 18 x 18⅝" (47 x 47.3 cm). Private Collection.

he had earlier treated in paintings. Like Klimt, Munch was obsessed with the theme of the embrace, which he had treated in several paintings, drawings, and etchings. The print seen here is a reduction of the theme to its essentials. Against a gray background, the linear pattern of which is obtained by the impression of the exposed grain of the woodblock, stands the silhouette of an embracing couple. Their bodies and faces have become one in this highly simplified, almost embryonic shape. Only the hands and the arms are sufficiently defined so that we can "recognize" the subject of the print. Like Klimt, but in a very different way, Munch conveyed the fusion of two people in love, that moment of sexual union when, for a brief moment, they become one. Early on in his career, Munch had described the theme of the embrace as "sacred," as one before which "people take off their hats, as if in church." To him, the embrace was related to life, hope, future, and immortality. "The man and woman ... [are] not themselves; they ... [constitute] a link in the interminable chain linking one generation to the next."

The Paris International Exposition of 1900

Like the Roman god Janus, who had two faces so that he could look at past and future simultaneously, the International Exposition of 1900 was both a retrospective and a prophetic event. In his opening speech, the French President Emile Loubet referred to the exhibition as a summation of the "noble" nineteenth century as well as the manifestation of a "continuing and lively faith in progress." Its main purpose, according to Loubet, was to offer "a brilliant contribution to the coming understanding among nations."

More than forty countries and their colonies were represented at the exhibition, which covered some 277 acres on either side of the Seine river. The Eiffel Tower, built for the exposition of 1889, was incorporated in the new exhibition but, surrounded by new buildings, it was no longer the premier attraction. Instead, other technological marvels, such as the phantasmagoric Palace of Electricity (FIG. 20-25), lit up at night by 5,700 incandescent light bulbs, and the moving sidewalk drew most public attention. Visitors were also impressed by Paris's brand new subway, with its striking Art Nouveau entrances by Hector Guimard (see FIG. 19-4).

Art was featured in three main exhibitions held in the newly built Petit Palais (Little Palace) and Grand Palais (Large Palace). The Petit Palais held a retrospective of French art from the Middle Ages to the year 1800. In the Grand Palais, the Centennial Exposition presented works by French artists since 1800. By contrast, the Decennial Exposition was an international exhibition featuring works from 1890 to 1900. Including France, twenty-eight countries participated in this exposition, which featured paintings, sculptures, works on paper, and architectural drawings. As in previous exhibitions, the entries for each country had been selected by a national jury.

Although the Decennial Exposition was still largely dominated by white male artists, it did include a small percentage of works by women. During the final decades of the nineteenth century feminist groups had fought hard for representation in international exhibitions. In the Philadelphia Centennial Exhibition of 1876 and the Chicago Columbian Exhibition of 1892, American women had managed to have a special Women's Pavilion, highlighting the achievements of women in all areas—fine arts, decorative arts, humanities, and sciences. In Europe, it would take until 1908 before women's pavilions became a part of international expositions.

Yet even before then women had made slow but steady progress in getting represented in the fine arts exhibition. Indeed, women artists not only showed their works, they were also among the prizewinners. In the exhibition of 1900, the American painter Cecilia Beaux (1855–1942) received a gold medal for her entry of three large portraits, including *Mother and Son* of 1896 (FIG. 20-26). Beaux had been trained in the academies of Julian and Colarossi in Paris, as had many other women artists whose works were represented in the exhibition.

20-25 Palace of Electricity, 1900. Postcard. Private Collection.

20-26 **Cecilia Beaux,** *Mother and Son,* 1896. Oil on canvas, 57 x 40″ (1.45 x 1.02 m). Amon Carter Museum, Fort Worth, Texas.

20-27 **Henry Ossawa Tanner,** *The Annunciation,* 1898. Oil on canvas, 57 x 71" (1.45 x 1.81 m). Philadelphia Museum of Art, W. P. Wilstach Collection.

The Decennial Exposition also included a number of works by non-white artists. In the American section, visitors could admire *Daniel in the Lions' Den* by the African-American painter Henry Ossawa Tanner (1859–1937). Tanner, like so many other American artists of this period, was an expatriate who had spent the better part of his career in Paris. Trained at the Académie Julian, like Cecilia Beaux, he produced works that, with some notable exceptions, were indistinguishable from those of his French colleagues. His *Daniel in the Lions' Den* is now lost, but a contemporary work, *The Annunciation* (FIG. 20-27), shows that Tanner's works resembled the works of several Naturalist painters who had turned to religious subject matter (Bastien-Lepage in France, Uhde in Germany), as well as the Pre-Raphaelites in England.

Most non-white artists whose works were shown at the 1900 exhibition were Japanese. Japan was well represented in the Decennial Exposition, ranking fifth in the numbers of works exhibited (269 paintings and sculptures by 174 artists). Most of the Japanese paintings shown were painted in ink on paper or silk, in the traditional *Nihonga* manner. A small number of works, however, represented the new *Yoga* or Western style of oil painting that had been recently adopted in Japan. Some of these artists had been trained in Paris, others in the "Western division" of the Tokyo

University of Fine Arts. Ichiro Yuasa's *Fishermen Returning Late in the Evening* (FIG. 20-28) may serve as an example of the *Yoga* style works that were shown at the exhibition. A naturalistic representation of a scene of Japanese low class life, it may be compared, in style and subject matter, with paintings produced by Naturalist artists across Europe and the United States.

Like the Universal Exposition of 1889, the exhibition of 1900 was virtually closed to modernist trends in art. Not even the works of the Impressionists, already well-known and financially successful in 1900, were included in the Decennial Exhibition (though some could be seen in the Centennial show). Works by Post-Impressionist and Symbolist artists were altogether excluded, except for those by stylistically conservative Symbolists such as Jean Delville and Fernand Khnopff.

As in 1889, Naturalism was the dominant trend, particularly the brand of Naturalism touched by Impressionism that was pioneered by Liebermann and Zorn (see FIGS. 18-15 and 18-13). One of the stars at the exhibition was the Spanish painter Joaquin Sorolla y Bastida (1863–1923), the winner of a first-class medal and one of the outstanding representatives of the virtuoso, *plein-air* Naturalism that triumphed around 1900. Sorolla's *Sewing the Sail* (FIG. 20-29) represents a veranda opening up on the Mediterranean

20-28 **Ichiro Yuasa,** *Fishermen Returning Late in the Evening,* 1898. Oil on canvas, 4'7" x 6'7" (1.39 x 2 m). Tokyo National University of Fine Arts and Music.

20-29 **Joaquin Sorolla y Bastida,** *Sewing the Sail,* 1896. Oil on canvas, 7'2" x 9'11" (2.2 x 3.02 m). Galleria Internazionale d'Arte Moderna di Ca'Pesaro, Venice.

20-30 **John Singer Sargent,** *Portrait of Mrs. Carl Meyer and her Children,* 1895. Oil on canvas, 6'7" x 4'5" (2.02 x 1.36 m). Private Collection.

shore. Among rows of flowering plants, five women and two men are busy repairing an enormous canvas sail, one side of which is suspended between two posts while the rest is heaped on the ground. The sail's huge folds alternately absorb and reflect the bright summer light, which has adopted the blue and green tones of its surroundings. Sorolla has thus transformed the inert lumpy canvas into a seemingly liquid, shimmering mass that becomes the center of this light-filled scene.

The American expatriate painter John Singer Sargent (1856–1925) was another representative of this flamboyant, light-filled Naturalism. His *Portrait of Mrs. Carl Meyer and her Children* (FIG. 20-30) is remarkable for the way the artist has suggested the play of light across the cascade of pink satin of Mrs. Meyer's skirt. There is more than a hint here of the Rococo style. And, indeed, this style made its influence felt not only in the serpentine forms of Art Nouveau design, but also in turn-of-the-century painting and sculpture.

To compare Sargent's work with the near contemporary *Portrait of Pedro Mañach* (FIG. 20-31), painted by the young Spanish painter Pablo Picasso (1881–1973), is to see just how great, by 1900, the distance had become between fashionable and avant-garde art. Picasso visited Paris in 1900 to see the International Exposition, where one of his more traditional paintings (now destroyed) was shown. His *Portrait of Pedro Mañach* was painted shortly after this trip, in his studio in Barcelona. Its simplified forms, bold contours, and saturated primary colors demonstrate that Picasso was familiar with the latest trends in French painting—Cloisonnism, Synthetism, and Symbolism.

If Sargent's portrait exemplifies the culmination of nineteenth-century Naturalism, Picasso's sets the tone for twentieth-century Abstraction. Together with other early twentieth-century artists, he would soon assert the authority of the artist to reinvent nature and even invent his or her own reality. While this would seem to be a radical departure from the nineteenth-century emphasis on "matching" reality in art, it was, of course, not an altogether new phenomenon. Indeed, the roots of Abstraction went back far into the nineteenth century—to the bodily distortions of Ingres' *Odalisque*, to the flattened form of Manet's *Olympia*, or, more recently, to the simplified or exaggerated forms of the Post-Impressionists and the visual fantasies of the Symbolists. "It is well to remember that a picture before being a battle horse, a nude woman, or some anecdote, is essentially a flat surface covered with colors assembled in a certain order," Maurice Denis had written in 1890. Some twenty years later, painters such as the Russian Vasili Kandinsky, the Czech Frantisek Kupka (1871–1957), and the French Robert Delaunay (1885–1941) carried this idea to its ultimate consequence and produced paintings that no longer showed any resemblance to the reality of everyday life.

20-31 **Pablo Picasso,** *Portrait of Pedro Mañach,* 1901. Oil on canvas, 41 x 27" (1 m x 67 cm). National Gallery of Art, Chester Dale Collection, Washington, DC.

TIMELINE 1750–1900

	Historical Events	**Science and Technology**
1751–1760	1756 Beginning of the Seven Years' War—the last war before the French Revolution in which all major European powers were involved 1759 Accession to the Spanish throne of Carlos (Charles) III (1759–1788) 1760 Accession to the English throne of George III (1760–1820)	1753 Linnaeus (Carl Linné), *Species plantarum* (binomir classification of plants in terms of genus and speci
1761–1770	1762 Accession to the Russian throne of Catherine the Great (1762–1796) 1763 Treaty of Paris marks the end of the Seven Years' War 1763 End of the French and Indian War	1769 James Watt patents the first effective steam engir
1771–1780	1772 First partition of Poland by Austria, Russia, and Prussia 1773 Boston Tea Party 1774 Death of Louis XV; beginning of the reign of Louis XVI and Marie Antoinette 1776 American Declaration of Independence	1774 Franz Anton Mesmer first practices "animal magnetism," an early form of hypnotism, for psychotherapeutic purposes
1781–1790	1784 Treaty of Paris ends American Revolution 1784 Russia annexes the Crimea 1788 Accession to the Spanish throne of Carlos IV (1788–1808) 1789 French Revolution begins with the storming of the Bastille (July 14) followed by the *Declaration of the Rights of Man and of the Citizen* (August)	1783 The Montgolfier brothers invent the first practical air balloon
1791–1800	1793 Execution of Louis XVI and Marie Antoinette 1794 Execution of the Jacobin leader Robespierre 1798 Napoleon's Egyptian campaign 1799 Napoleon becomes First Consul 1800 Napoleon's army conquers Italy	1794 Foundation of the École Polytechnique (Paris), the first advanced technical school of the modern worl 1794 Eli Whitney patents the cotton gin, a machine tha combs and deseeds raw cotton 1798 Edward Jenner develops vaccine against smallpo>> 1799 Discovery of the Rosetta Stone, the key to deciphering Egyptian hieroglyphics
1801–1810	1801 The *Concordat* between Napoleon and Pope Pius VII defines the relationship between the Catholic Church and the French State 1801 Accession to the throne of Tsar Alexander I 1803 US purchases Louisiana from France 1804 Napoleon crowns himself Emperor 1806 Resignation of Francis II, the last Holy Roman Emperor 1808 Spanish rise against French rule	1801 Karl Friedrich Gauss, *Disquisitions arithmeticae* (foundational work of modern mathematics)
1811–1820	1812 Napoleon invades Russia 1813 Battle of the Nations at Leipzig forces Napoleon's retreat 1814 Congress of Vienna 1815 Napoleon returns to France and remobilizes the army but is defeated by the allied forces at Waterloo 1816 Sinking of the French frigate *Medusa*	
1821–1830	1821 Beginning of the Greek War of Independence from the Ottoman Turks 1821 Coronation of George IV of England 1822 Brazil declares its independence from Portugal 1824 Charles X becomes king of France 1830 Louis Philippe d'Orléans becomes King of the French after the July Revolution 1830 Beginning of France's colonization in North Africa	1820s Improved gaslight burner makes more effective a safer lighting 1826–27 First photograph is made in France by Joseph Nicéphore Niepce

Philosophy, Literature, Music	Art and Architecture Events	Art and Architecture Works

Philosophy, Literature, Music

Publication of Bach's *Art of the Fugue*, one year after the composer's death
Voltaire, *Candide*

Rousseau, *The Social Contract*
2–63 James Macpherson publishes works ascribed to Ossian, *Fingal* and *Temora*
Horace Walpole, *The Castle of Otranto*

Johann Wolfgang von Goethe, *The Sorrows of Young Werther*
Edward Gibbon, first volume of *History of the Decline and Fall of the Roman Empire*
David Hume, *Dialogues Concerning Natural Religion*
Completion of the *Encyclopédie*

Choderlos de Laclos, *Dangerous Liaisons*
2–89 Rousseau, *Confessions*
William Thomas Beckford, *Vathek*
Wolfgang Amadeus Mozart, *Don Giovanni*
Jeremy Bentham, *An Introduction to the Principles of Morals and Legislation*

Marquis de Sade, *Justine or The Misfortunes of Virtue*
Mozart, *The Magic Flute*
James Boswell, *Life of Samual Johnson*
Thomas Robert Malthus, *Essay on the Principle of Population*
William Wordsworth, *Lyrical Ballads*
Friedrich Schiller, *Maria Stuart*

Chateaubriand, *Attala*
Franz Joseph Haydn, *The Seasons*
Ludwig van Beethoven, the *Eroica* Symphony
Madame de Staël, *De L'Allemagne* (Germany)

First publication of the Grimm brothers' *Fairytales*
Jane Austen, *Pride and Prejudice*
Gioacchino Rossini, *The Barber of Seville*
Mary Shelley, *Frankenstein*
Walter Scott, *Ivanhoe*

Byron, *Sardanapalus*
Beethoven completes the Ninth Symphony
James Fenimore Cooper, *The Last of the Mohicans*
Franz Schubert, "Unfinished Symphony"
Stendhal, *Le Rouge et le noir* (Scarlet and Black), the author's most famous novel.
Victor Hugo, *Hernani*

Art and Architecture Events

1754 Establishment of Copenhagen Art Academy
1755 Johann Winckelmann, *Reflections on the Imitation of Greek Works in Painting and Sculpture*
1757 Establishment of St. Petersburg Art Academy
1757 Edmund Burke, *Philosophical Enquiry into the Origin of our Ideas of the Sublime and the Beautiful*
1759 Opening of the British Museum in London

1762 Stuart and Revett, *Antiquities of Athens*
1765 Diderot, *Essay on Painting* (published in 1796)
1766 Gotthold Ephraim Lessing, *Laocoön: On the Limits of Painting and Poetry*
1768 Foundation of the British Royal Academy

1772 Opening of the Pio-Clementino Museum of antiquities, now part of the Vatican Museums
1773 Goethe, *On German Architecture*
1775–78 Johann Kaspar Lavater, *Essays on Physiognomy*

1785 Opening of the Prado Museum in Madrid
1790 Immanuel Kant, *Critique of Aesthetic Judgment*

1793 Opening of the Louvre in Paris
1797 Publication of Joshua Reynolds' *Discourses* (delivered to the Royal Academy between 1769 and 1790)
1797 Wilhelm Heinrich Wackenroder, *Outpourings from the Heart of an Art-Loving Monk*
1799 Lithography patented by Senefelder
1798–1800 Schlegel Brothers publish the *Athenäum*, the chief organ of early Romanticism

1802 Vivant Denon, *Travels in Lower and Upper Egypt*
1805 Foundation of the British Institution for the Promotion of the Arts
1810 Goethe, *Farbenlehre* (Color Theory)

1816 Lord Elgin sells the Parthenon marbles to the British nation

1824 Foundation of the British National Gallery by John Julius Angerstein

Art and Architecture Works

1754 Completion of the Wieskirche
1754 François Boucher, *Mars and Venus Surprised by Vulcan*
1755 Quentin de la Tour, *Portrait of Madame de Pompadour*
1760–61 Anton Raphael Mengs, *Parnassus*

1763 Joseph-Marie Vien, *Seller of Cupids*
1765 Publication of Piranesi, *Della magnificenza dell'architettura dei Romani*
1768 Benjamin West, *Agrippina Landing at Brundisium*

1771 West, *Death of General Wolfe*
1771–73 Jean Honoré Fragonard, *Progress of Love* series
1779–81 John Singleton Copley, *Death of the Earl of Chatham*

1781 Henry Fuseli, *The Nightmare*
1781–83 Antonio Canova, *Theseus and the Minotaur*
1782 Etienne Maurice Falconet, inauguration of *Equestrian Statue of Peter the Great*
1785 Jacques Louis David, *Oath of the Horatii*
1789 David, *The Lictors Returning to Brutus the Bodies of his Sons for Burial*
1789 William Blake, *Songs of Innocence*
1790–91 David, *The Oath in the Tennis Court*

1793 Anne-Louise Girodet-Trioson, exhibits *Sleep of Endymion*
1793 David, *Death of Marat*
1799 Francisco Goya y Lucientes, *Los Caprichos*
1799 David, *The Sabine Women*
1800–1801 Goya, *Family of Carlos IV*

1804 Antoine Jean Gros, *Bonaparte Visiting the Plague House at Jaffa*
1804–1808 Canova, *Paolina Borghese as Venus Victrix*
1805–1806 Phillip Otto Runge, *Rest on the Flight into Egypt*
1806 Ingres, *Napoleon on his Imperial Throne*
1807–1808 Caspar David Friedrich, *The Cross in the Mountains*
1806–11 *Vendôme Column*
1808 David, *Coronation of Napoleon* shown at the Salon

1811 Franz Pforr, *Shulamit and Mary*
1812 J. M. W. Turner, *Snow Storm—Hannibal Crossing the Alps*
1812–15 Goya, *Los Desastres de la Guerra*
1814 Publication of first volume of Hokusai's *Manga*
1814 Goya, *Execution of the Rebels on the Third of May, 1808*
1814 Jean-Auguste-Dominique Ingres, *Grand Odalisque*
1817 West, *Death on a Pale Horse*
1819 Théodore Géricault, *Raft of the Medusa*

1821 John Constable, *The Hay Wain*
1822 Eugène Delacroix, *Dante and Virgil*
1824 Delacroix, *Massacre at Chios*
1824 Ingres, *The Vow of Louis XIII*
1827 Delacroix, *Death of Sardanapalus*

	Historical Events	Science and Technology
1831–1840	1831 The *Risorgimento* movement in Italy, aimed at creating an Italian nation-state takes on new life 1833 Slavery abolished in British colonies 1837 Coronation of Queen Victoria (1837–1901) 1839 Britain starts first Opium War (1839–42) against China 1840 Queen Victoria marries Prince Albert	1833 Invention of the sewing machine by Walter Hunt 1835 Samuel Colt patents revolver in France and Engla[nd] 1839 New photographic process invented by Louis-Jacques-Mendé Daguerre (Daguerreotype) annou[nced] at the French Academy of Sciences 1839 Goodyear develops process to vulcanize rubber 1839 First bicycle made by Kirkpatrick Macmillan
1841–1850	1845 Irish potato famine 1848 Revolutions across Europe; in France, Louis Napoléon is elected president of the Second Republic. 1848 Karl Marx, *The Communist Manifesto*	1841 Patenting of photographic *calotype* process by William Talbot 1844 Samuel F. B. Morse introduces the "electric telegraph" 1850 Michael Faraday publishes his theory of electromagnetism
1851–1860	1852 Proclamation of Second Empire in France; Louis Napoléon renames himself Napoléon III 1853–56 Crimean War 1853 The American Commodore Perry opens up Japan to Western trade 1858 The French invade Vietnam and eight years later create the colony of Cochinchina	1851 Crystal Palace Exhibition with some 14,000 exhib[its] featuring new products and manufacturing proces[ses] 1856 Hermann von Helmholtz, publication of first volur[ne] of *Handbook of Physiological Optics*, book that changed the way people understood vision 1856 Discovery of Neanderthal man 1859 Charles Darwin, *On the Origin of Species* 1860 Florence Nightingale establishes the first school o[f] nursing in London
1861–1870	1861 Abolition of serfdom in Russia 1861 Proclamation of Italian kingdom under Victor Emmanuel II (r. 1861–1878) 1861 Beginning of American Civil War 1864 The "First International" founded in London 1867 Establishment of Austro-Hungarian dual monarchy 1870 Outbreak of the Franco-Prussian War	1863 First subway track constructed in London 1865 Publication of Gregor Mendel's research on hered[ity] 1869 Heinrich Schliemann begins his archeological que[st] for ancient Troy 1869 Opening of the Suez Canal
1871–1880	1871 Commune of Paris, established in March, is repressed by government forces in May 1871 Proclamation of German Empire under King William I of Prussia 1877 Queen Victoria becomes Empress of India 1877–78 Russo-Turkish War	1871 Francis Stanley finds David Livingstone in Ujiji on Lake Tanganyika, Africa 1871 Darwin, *The Descent of Man* 1871 Publication of final version of the periodic table o[f] elements by Dmitry Mendeleev 1876 Patent of the telephone by Alexander Graham Be[ll] 1877 Invention of the phonograph by Thomas Alva Edi[son] 1879 Invention of the light bulb by Edison
1881–1890	1881 Beginning of the Boer War 1881 Assassination of Russian Tsar Alexander II 1883 Marxist party founded in Russia 1884–85 At the Berlin West Africa Conference, European nations decide the future of the Congo River Basin	1881–89 First, failed attempt at creating the Panama Ca[nal] 1883 Gottlieb Daimler patents gasoline combustion eng[ine] 1885 Louis Pasteur finds vaccine against rabies 1888 George Eastman introduces the portable Kodak b[ox] camera 1889 Eiffel Tower
1891–1900	1892 Beginning of Dreyfus affair in France 1893 Franco-Russian Alliance 1894 Nicholas II becomes Tsar of Russia	1896 Henry Ford develops his first gasoline-powered vehicle, the "Quadricycle"

Philosophy, Literature, Music	Art and Architecture Events	Art and Architecture Works
Hugo, *The Hunchback of Notre Dame* Alexander Sergeyevich Pushkin, *Boris Gudonov* Vincenzo Bellini, *Norma* Hector Berlioz, *Symphonie Fantastique* Hegel, *The Philosophy of History* (posthumous) Honoré de Balzac conceives idea of *La Comédie Humaine* First book of fairytales by H. C. Anderson Charles Dickens, *Oliver Twist*	1836 Establishment of the Alte Pinakothek in Munich 1839 Michel Eugène Chevreul, *De la loi du contraste simultané des couleurs* (The Law of the Simultaneous Contrast of Colors) 1840 Invention of the metal paint tube by John Rand	1831 Delacroix, *Liberty Leading the People* 1831 Honoré Daumier, *Gargantua* 1833 Edwin Landseer, *Hunted Stag* 1834 Daumier, *Rue Transnonain* 1835 Jean-Baptiste-Camille Corot, *Hagar in the Wilderness* 1840 Turner, *Slavers Throwing Overboard the Dead and Dying*
Edgar Allan Poe, *The Murders in the Rue Morgue* Auguste Comte, *Course of Positive Philosophy* Felix Mendelssohn, *A Midsummer Night's Dream* Alexandre Dumas, *The Count of Monte Cristo* George Sand, *La Mare au diable* Charlotte Brontë, *Jane Eyre* Emily Brontë, *Wuthering Heights*		1844 Turner, *Rain, Steam, and Speed* 1847 Thomas Couture, *Romans of the Decadence* 1848 Ingres, *Venus Anadyomene* 1849–50 Gustave Courbet, *A Burial at Ornans* 1849–50 John Everett Millais, *Christ in the Carpenter's Shop* 1849–50 Dante Gabriel Rossetti, *Ecce Ancilla Domini*
Herman Melville, Moby Dick –53 John Ruskin, *Stones of Venice* Harriet Beecher Stowe, *Uncle Tom's Cabin* Giuseppe Verdi, *La Traviata* Walt Whitman, *Leaves* Charles Baudelaire, *Flowers of Evil* Gustave Flaubert, *Madame Bovary*	1852 Opening of the Hermitage Museum in St Petersburg, Russia 1852 Foundation of the Victoria and Albert Museum in London 1852 Baron Haussmann becomes Prefect of the Seine Department and begins the rebuilding of Paris 1855 International Exposition, Paris; first one to include an international art exhibition	1851–53 William Holman Hunt, *Light of the World* 1852 Ford Madox Brown, *Work* 1852 Adolph Menzel, *The Flute Concert of Frederick the Great at Sancoussi* 1853 Rosa Bonheur, *The Horse Fair* 1855 Courbet, *The Painter's Atelier* 1855 Karl Theodor Piloty, *Seni before the Corpse of Wallenstein* 1857 Jean-François Millet, *The Gleaners* 1859 Millet, *Angelus*
2 Hugo, *Les Misérables* 3 Ernest Renan, *Life of Jesus* 3 John Stuart Mill, *Utilitarianism* 5 Lewis Carroll, *Alice's Adventures in Wonderland* 6 Fyodor Dostoevsky, *Crime and Punishment* 7 Publication of first volume of Marx's *Das Kapital* 3 Richard Wagner, *Die Meistersinger von Nürnberg* 9 Leo Tolstoy, *War and Peace*	1861 Foundation of the firm of Morris, Marshall, Faulkner and Co 1863 Salon des refusés	1863 Alexander Cabanel, *Birth of Venus* 1863 Edouard Manet, *Déjeuner sur l'herbe* 1865 Manet, *Olympia* 1866 Vasily Perov, *Troika* 1866–67 Claude Monet, *Women in the Garden* 1870–73 Ilya Repin, *Barge Haulers on the Volga*
1 George Elliott, *Middlemarch* 1 Verdi, *Aïda* 2 Friedrich Nietzsche, *The Birth of Tragedy* 3 Jules Verne, *Around the World in Eighty Days* 4 Verdi, *Requiem* 4 Completion of *Der Ring des Nibelungen* by Wagner 5 Mark Twain, *The Adventures of Tom Sawyer* 5 Georges Bizet, *Carmen* 7 Tolstoy, *Anna Karenina* 8 Henry James, *The Europeans* 9 First performance of Brahms' violin concerto by Joseph Joachim 0 Dostoevsky, *The Brothers Karamazov* 0 Emile Zola, *Nana*	1871 Destruction of the Vendôme Column; the artist Courbet is involved 1873 Walter Pater, *Studies in the History of the Renaissance* 1874 First Impressionist Exhibition 1875 Goncourt Brothers, *Art of the Eighteenth Century* 1878 Universal Exposition in Paris 1880 Hippolyte Taine, *Philosophy of Art*	1872 Monet, *Impression Sunrise* 1872 Berthe Morisot, *The Cradle* 1872 Ivan Kramskoy, *Christ in the Wilderness* 1872–75 Menzel, *Iron Rolling Mill* 1875 Completion of the Paris Opéra 1875 James Abbott McNeill Whistler, *Nocturne in Black and Gold: The Falling Rocket* 1876 Pierre-Auguste Renoir, *Ball at the Moulin de la Galette* 1876 Gustave Moreau, *Salome Dancing before Herod* 1877 Gustave Caillebotte, *Paris Street, Rainy Weather* 1877 Auguste Rodin, *Age of Bronze* 1879 Jules Bastien-Lepage, *Joan of Arc Listening to Voices* 1880 Rodin receives commission for *Gates of Hell*
2 Piotr Ilyich Tchaikovsky, "1812 Ouverture" 3 Robert Louis Stevenson, *Treasure Island* 4 Mark Twain, *The Adventures of Huckleberry Finn* 5 Zola, *Germinal* 0 Gabriel Fauré, *Requiem*	1884 Joris Karl Huysmans, *A Rebours* (Against the Grain) 1886 Zola, *L'Oeuvre* (The Masterpiece) 1886 Eighth and last Impressionist Exhibition 1886 "Manifesto" of the Symbolist movement published by Jean Moréas in the *Figaro* 1889 Universal Exposition, Paris 1890 Oscar Wilde, *The Picture of Dorian Gray* 1890 Ferdinand Hodler, *Night*	1881 Edgar Degas, *Little Dancer of Fourteen Years Old* 1881–82 Manet, *A Bar at the Folies-Bergères* 1884 Jules Breton, *Song of the Lark* 1885 Vincent Van Gogh, *Potato Eaters* 1886 Dedication of Frédéric-Auguste Bartholdi's *Statue of Liberty* 1886 Georges Seurat, *A Sunday Afternoon at La Grande Jatte* 1886 Degas, *The Tub* 1887 Renoir, *The Bathers* 1888 Paul Gauguin, *Vision after the Sermon* 1888 James Ensor, *Entry of Christ into Brussels* 1889 Jules Dalou, *Triumph of the Republic* 1889 Van Gogh, *Starry Night*
1 Arthur Conan Doyle, *Adventures of Sherlock Holmes* 2 Tchaikovsky, *The Nutcracker* 4 Claude Debussy, *L'Après-midi d'un faune* 5 Friedrich Nietzsche, *The Anti-Christ* 6 Giacomo Puccini, *La Bohème* 7 Anton Chekhov, *Uncle Vanya* 7 Edmond Rostand, *Cyrano de Bergerac* 0 Sigmund Freud, *The Interpretation of Dreams* 0 Puccini, *Tosca*	1900 Paris International Exposition	1890 Gaudí becomes chief architect of the Sagrada Familia 1890–95 Moreau, *Jupiter and Semele* 1892 Gauguin, *Manao tupapau* 1893 Edvard Munch, *The Scream* 1893 Rodin, *Monument to Honoré de Balzac* 1894 Toulouse Lautrec, *In the Salon of the Brothel of the Rue des Moulins* 1895 Camille Claudel, *The Waltz* 1897 Gauguin, *Where Do We Come From? Where Are We? Where Are We Going?* 1899–1900 Munch, *Dance of Life*

Philosophy, Literature, Music **Art and Architecture Events** **Art and Architecture Works**

Glossary

Abstract Derived from the Latin verb *abstrahere*, to draw away. In the context of art, "abstract" refers to an artist's departure, in painting or sculpture, from the lifelike representation of observed reality. "Abstract" art does not represent reality convincingly but simplifies or distorts it. In its most extreme form, abstract art becomes "non-objective" or "non-representational," which means that it no longer has any visual correspondence with reality.

Academy An academy is a school. The term may also refer to a selected group of scholars or artists who have no teaching duties but whose accomplishments qualify them as masters in their field. An art academy is a school where the fundamentals of painting and sculpture are taught. The first European art academies were founded in the sixteenth and seventeenth centuries. Here students received an education that was different from the traditional apprenticeship training that had been standard practice within the guilds. While the latter was focused on practice and technique, the former emphasized theory and aesthetics.

One of the most influential early art academies in Europe was the Royal Academy of Painting and Sculpture in Paris, founded in 1648 under Louis XIV. This academy was composed of a selected group of professional artists who also had teaching responsibilities. Students at the French Academy followed a rigorous course of systematic study centered on the human figure, drawing first from casts of Classical sculptures, then from the live model. Drawing, centered on line and **chiaroscuro**, was considered the intellectual scaffold of art at the Academy. Painting, which owed its effect to color, was considered its sensual envelope; it did not become part of the curriculum in Paris until 1863. In addition to drawing training, the Academy provided courses in anatomy, history, perspective, and geometry, among others. The French Academy also provided exhibition opportunities for its members and, later, to select non-members as well (see **Salon**). Most European and American academies of the seventeenth, eighteenth, and nineteenth centuries were modeled after the French example.

Academic Refers to an artist who received his or her training at an academy, particularly the Academy in Paris, and who produced art following the principles taught there. As the academy privileged historical subjects, "academic" paintings and sculptures generally depict scenes from the Bible, ancient history, or Classical mythology. Figures tend to be modeled after the ideal examples of Classical sculpture. Academic paintings, moreover, are marked by crisply outlined forms and smooth paint surfaces.

Aesthetic Term coined in the mid-eighteenth century by the German philosopher Alexander Gottlieb Baumgarten (1714–1762). Having established that there are two forms of cognition, sensory and intellectual, Baumgarten advocated the foundation of a new science of sensory perception, which he called *aesthetics* (after the Greek word *aisthesis*, meaning perception or sensation), in analogy to the existing science of the intellect, logic. Aesthetics is that branch of philosophy that focuses on questions of beauty and ugliness, just as ethics focuses on questions of good and evil.

Allegory In literature, an allegory or parable is a (usually) fictitious story that illustrates a moral truth. An allegorical painting may depict such a story. Allegorical figures, in painting and especially in sculpture, are human, most often female personifications of abstract ideas such as liberty, justice, truth, and vanity. The meaning of allegorical figures is contained in their attributes, that is, objects that they hold, or in the way they are dressed. Allegories of justice usually are blindfolded and carry a scale; allegories of truth generally are nude; allegories of vanity hold a mirror, and so on.

Androgynous A figure that combines male and female physical characteristics.

Anecdotal Depiction of a scene in a way that suggests a story, usually of a private and trivial nature (anecdotal painting, anecdotal detail).

Anxiety of influence Phrase coined in 1973 by the American critic Harold Bloom (b. 1930) to describe the uneasiness that poets feel when confronted with the works of their famous predecessors. Like sons rebelling against their fathers (for reasons formulated most powerfully by Sigmund Freud), poets mutiny against their artistic forebears by a deliberate misreading and re-writing of their poetry. Bloom's theory, which transformed the way literary scholars thought about the term "artistic influence," has been successfully applied to the fine arts as well.

Arabesque An interlaced or intertwined design made up of geometric patterns, human figures, animals, etc.

Assumption The entrance of the Virgin Mary into heaven, body and soul. Although not mentioned in the New Testament, the Assumption is part of Roman Catholic and Eastern Orthodox doctrine.

Attribute see **Allegory**.

Avant-Garde French term that refers to the troops moving at the head of the army. It was first used as a cultural term in 1910, to refer to writers or artists on the literary or artistic forefront. Today the term is applied as well to earlier artists and groups of artists who were "ahead" of their contemporaries.

Beaux-Arts Architecture A late nineteenth- and early twentieth-century style of architecture, found especially in France and the United States, that was strongly influenced by the academic teaching of the **École des Beaux-Arts** in Paris. Beaux-Arts architecture is characterized by formal planning, the use of Classical elements, and abundant decoration.

Cartoon A full-scale preparatory drawing for a fresco or a tapestry.

Chiaroscuro Contrast between light and dark in a painting or drawing. Its primary aim is the suggestion of three-dimensionality. Yet *chiaroscuro* can also enhance the overall effect of a work, lending it a sense of drama or mystery.

Colors, complementary Colors that are on the opposite side of the color wheel. The complementary of a primary color is always the mixture of the other two primaries. Thus red is the complementary of green; yellow, of purple; and blue, of orange. Complementary colors present the optimum color contrast.

Colors, local The basic color of an object in natural daylight, free from shadows. The local color of an object is the color we "know" it to be, such as green for grass, black or brown for dirt, etc.

Colors, primary Colors that cannot be achieved by mixing: red, blue, and yellow.

Colors, secondary Colors that are achieved by mixing primary colors (purple, green, and orange).

Crypt A room or chamber, partly or entirely underground. In a church, the crypt is usually under the choir section and may contain the remains of a saint or a ruler.

Decorative From the Latin *decus*, that which adorns or beautifies. When applied to art, the term often has a negative ring because it refers to painting or sculpture that is devoid of meaning and therefore neither edifies nor moves the spectator. At the end of the nineteenth century, however, the term *decoration*, for a time, acquired a positive meaning, since the aesthetic enhancement of human environments, public or private, was at that time seen as the highest purpose of art.

Diptych A painting consisting of two panels that are hinged together. A format used for medieval devotional pictures, it was revived by some nineteenth-century artists.

Eclecticism Method of selecting what appears to be best in various doctrines, methods, or styles. The theoretical foundation of eclecticism was laid by the French philosopher Victor Cousin (1792–1867). The term (historical) eclecticism is often used for the nineteenth-century revival of various historical styles in architecture and decorative arts.

École des Beaux-Arts French for "School of Fine Arts." The teaching body that resulted from the division of the Royal Academy of Painting and Sculpture in Paris in 1793 into an administrative body (Académie des Beaux-Arts or Academy of Fine Arts) and a school. The Académie hired teachers, supervised competitions, including the **Rome Prize**, formed the juries of the Salons, and examined the *envois* sent from students in Rome. In 1863 the government took control of the École and the French Academy in Rome and the curriculum began to include practical training in painting, sculpture, and architecture. The École's influence on the standards of artistic training declined by the end of the nineteenth century.

Emblem A form or figure used as an identifying mark. The *fleur-de-lis* (a stylized lily flower) was the emblem of the French royal family; the bee that of Napoleon.

Envoi A work of art sent yearly by a student at the French Academy in Rome to the Academy in Paris as proof of progress.

Ephebe A term used for a youth between 18 and 20 years old in ancient Greece.

Eros The spirit of love in Greek mythology, which is equivalent to the Roman Cupid. In art, Eros is generally represented as a winged young male figure.

Equestrian statue A statue of a rider on a horse.

Exemplum virtutis Literally, an example of virtue. During the Neoclassical period, art's main purpose was to educate and edify. Paintings and sculptures often represented historical role models whose virtuous deeds were presented as an example to the public.

Expiatory chapel A chapel built in atonement for the sins of a person or a group of people.

Expression From the Latin verb *exprimere*, to press or squeeze out. "Expression" refers to the communication, in words, acts, or body language, of an inner state. With reference to art, the term may connote the artist's expression of his feelings through the work. It may also refer to the facial and body language of the figures who are represented in the work. And it may be used to suggest the capacity of

a work to arouse feelings in the beholder. It is, therefore, a complex and confused term that should be used with caution.

Façade The front or entrance side of a building. For urban structures it is usually the side that faces the street.

Facture French term that refers to the brushwork in a painting.

Fascis (plural fasces) A bundle of rods tied together with straps, carried by the *lictores*, the principal attendants of ancient Roman magistrates. Fasces consequently signify authority, but they may also symbolize unity. Until the use of the *fascis* as a symbol by Benito Mussolini (1883–1945) in the early twentieth century, it did not have a negative connotation.

Foreshortening In painting, a method of perspective that calls for the shortening of a figure or other form to suggest its placement perpendicular to the picture plane.

Fresco see **Mural (painting)**.

Friendship picture A painting or drawing, often a portrait, made by an artist for exchange with another artist, as a token of admiration and affection.

Genre French term, the literal meaning of which is type or sort. In art, a subject category in painting. See **Hierarchy of genres**.

Genre painting Painting of a scene of daily life.

Gesamtkunstwerk Term coined by the German composer Richard Wagner (1813–1883) in 1849 to describe his concept of a stage presentation in which art, music, literature, and architecture would all be made to work together to express a single powerful idea. Today the term is used more broadly, to refer to any artistic projects in which several art forms are combined to achieve a totalizing effect.

Girder A strong horizontal beam, usually of iron or steel, that provides the main support for a bridge or building.

Grande Machine Literally, a big contraption. An artists' slang term for a large history painting intended for the Salon.

Hierarchy of genres Within the academy, the different painting **genres**—history painting, landscape, portrait, **genre painting**, and still life—were ranked in order of importance. While history painting was always at the top of the scale and still life always at the bottom, the positions of the other three genres tended to shift.

Hieratic In art history, this term refers to a highly stylized, formal way of representing the human figure, usually found in religious art.

Historic genre painting Representation of imagined scenes from everyday life in the past.

Hue Gradation of a color, depending on the amount of white that has been added to it. A saturated color is one to which no white has been added. It represents the highest intensity of the color.

Icon, iconic From the Greek *eikon* or image. An icon, traditionally, is an image of a holy figure, such as Christ, the Virgin, or a saint. Such images are usually **hieratic** and still—unmoving and lacking in **expression**. An iconic painting or sculpture is one that is non-narrative, static, and non-expressive. Napoleon's portrait by Ingres (FIG. 5-17) is an **iconic** portrait.

Iconography, iconology Art-historical pursuits aimed at the study of subjects and themes in works of art. Strictly speaking, iconography focuses on the classification of subjects and themes while iconology is concerned with their explanation. In practice, the term **iconography** is often used for both of these pursuits.

Idealism In artistic representation, the practice of "improving" upon reality to reach a state of perfection that does not exist in nature.

Illusionist(ic) Form of representation that creates an especially strong illusion of reality.

Impasto Heavy application of oil paint to a canvas or panel so that it stands out in relief and retains the marks of the brush or palette knife.

Lattice Interwoven strips of metal or wood, usually in a criss-cross pattern with spaces in between.

Leitmotiv Literally, leading motif. Term used in music to refer to a musical phrase that returns again and again in a composition. In art, it generally refers to a subject, figure, or formal motif that recurs repeatedly in an artist's work.

Local color see **Color, local**.

Manifesto A statement of policy and purpose, usually in a political sense, such as the *Communist Manifesto* (1848) of Karl Marx. As a statement of artistic purpose, the term was first used in the twentieth century. Today it is occasionally applied anachronistically to statements by nineteenth-century artists or artists' groups.

Mausoleum A large tomb. The term derives from the colossal tomb of the Persian satrap Mausolus (ruled 377/376 to 353 BCE), which was considered one of the Seven Wonders of the World.

Modular construction Form of construction in which the whole is built of prefabricated, standardized parts or modules.

Monolithic Made of a single stone.

Mural (painting) Painting done on a wall. Mural paintings may be painted *a secco*, on the dry plaster wall; or al *fresco*, on fresh plaster, before it has dried. The latter technique has the advantage of durability, because the pigments bind with the plaster of the wall, but it is technically difficult. Nineteenth-century artists sometimes painted mural paintings on canvases, which were later mounted on a wall (*marouflage*).

Narrative Used as an adjective, this work means "storytelling." A narrative painting is one that tells a story, usually derived from literature—the Bible, Classical myths, historical writing, or fiction.

Naturalism This term usually refers to all art that represents figures and objects in accordance with its appearance in reality. Naturalism can take different forms, most importantly **idealism** and **realism**. Specifically, Naturalism is a movement of the late nineteenth century that aims at photographic resemblance.

Odalisque From the Turkish word *odalik*, harem woman.

Orientalism In art history, Orientalism refers to the representation, by Western artists, of subjects from the Orient, an umbrella term that denotes both the Near East and the north coast of Africa. As Edward Said pointed out in

his well-known book *Orientalism*, the Orient was largely a Western construct, at the core of which was a Western fascination with the "other" and the exotic.

Oeuvre French word meaning "work." With reference to art, "oeuvre" refers to the collective work of an artist.

Palette A board, usually oval, with a thumbhole on which an artist mixes colors; by extension, the range of colors used by an artist or typical for a particular artist.

Palette knife Tool used by an artist to scrape paint off the **palette**. It is sometimes used as a painting tool by artists who favor a heavy **impasto**.

Panorama Literally, "complete sight." In the visual arts, a landscape or narrative scene painted on a long stretch of canvas that is mounted on a curved wall so that it surrounds the viewer. Sometimes panoramas are not mounted but slowly unrolled before the viewer. In that case one speaks of a cyclorama. Panoramas and cycloramas were popular in the late eighteenth and nineteenth centuries, when nearly every major city had a special panorama building.

Pathetic Fallacy Term coined by the British critic John Ruskin in *Modern Painters* (1856) to comment negatively on the habit of poets to attribute human feelings to nature (such as angry storms, sad rains). Analogous to literature, paintings often display parallels between the state of mind of figures and the conditions of nature. This is especially true for Romantic art.

Pendant A work that forms a pair with another, for example, portraits of a husband and wife.

Perspective From the Latin verb *perspicere*, to look through. A method for suggesting three-dimensionality in painting. The correct application of perspective creates the illusion that one is looking not *at* a flat surface covered with paints but *through* it into a three-dimensional space with forms and figures that have substance and bulk.

Phrygian cap A soft, red cap with a rounded peak that was worn by freed slaves in ancient Rome. The cap became a symbol of freedom during the French Revolution, when it was also called the *bonnet rouge*.

Plein-air painting Painting done outdoors rather than inside the studio.

Polychromy The coloring of sculpture or architecture, by means of painting or the use of differently colored materials.

Popular culture Culture that is shared by several social classes, though usually not by all. In the latter case, we generally speak of "mass culture."

Primary colors see Colors, primary.

Primitivism In art, a trend to take art back to its origins. Primitivism stems from a desire to start again from the beginning, to forget the history of art, and, in so doing, to remake contact with elemental forms of conceiving and making art.

Prix de Rome see Rome Prize.

Profile In portraiture, the side view of the face (as opposed to a frontal or three-quarter view).

Putto (plural, Putti) Naked infant boy, with or without wings, representing a pagan spirit (such as **Eros** or Cupid, the spirit of love) or an angel.

Relief In sculpture, a form or figure that stands out from a surrounding flat surface. In low relief, the figure emerges only slightly from the surface (as George Washington's head does in a quarter). In high relief, the figure comes forward more dramatically.

Repoussoir A pictorial formula used by landscape painters that involves the use of foreground elements, such as trees or buildings, to frame the composition and suggest the distance of the landscape behind them.

Rome Prize Grand prize awarded by the Academy in Paris, which enabled the winner to study at the French Academy in Rome for three to five years, all expenses paid. The grueling competition involved three parts: an oil sketch of a specific topic, a painting of a nude male from a live figure, and a history painting (each student had to paint the same subject). In the third part, the final ten competitors were confined to their small studios for seventy-two days to complete the history painting, with no access to models, props, or sketches. Once in Rome, the student was expected to learn from ancient and Renaissance works of art and was obligated to send back a yearly **envoi**. Upon return to Paris, the prizewinner was practically guaranteed a successful career.

Rückenfigur A figure seen from the back. Such figures are especially common in the art of Caspar David Friedrich (1774–1840).

Sarcophagus Large coffin, generally made of stone, that is placed above ground in a church or chapel, rather than buried in a grave.

Satire A work of art or literature that holds up human follies and vices for ridicule and contempt. Depending on its focus, satire can be political or social. In art, it is found most often in prints.

Scatology Treatment or depiction in literature or art of bodily functions, especially urination and defecation.

Still life A painting of a grouping of objects, natural or man-made. There are many kind of still lifes, such as flower pieces, food still lifes, and *vanitas* still lives. (The latter are centered on objects that symbolize death.)

Stylized In art, stylized refers to a mode of representation that follows a pattern or style rather than imitating nature.

Symbol Something (usually concrete) that stands for something else (usually abstract), for reasons of association or convention. Bread and wine are symbols of the Body and Blood of Christ; the dog is a symbol of faithfulness.

Symbolic Realism Term used for the art of the Pre-Raphaelites, who believed that realism and symbolism were inseparable. Every detail of the work was considered to be meaningful.

Tableau French word for a painting. In the nineteenth century the word *tableau* meant a finished painting, meant for exhibition, in contrast to *esquisse*, which referred to a sketch.

Tableaux vivants Literally, "living pictures." A parlor game, popular in the nineteenth century, whereby people, usually in small groups, dressed up and adopted poses so that they resembled an existing or imaginary painting.

Tactile Refers to a quality in art, especially in painting, that appeals to the sense of touch. The word tactile may be applied to the actual surface of a work; yet it may also refer to the way the artist has suggested various surface textures, such as satin, wood, or silver, in a painting.

Tempera Paint in which the pigments are mixed with water, after having been "tempered," or brought to a desired consistency with the help of a binder. The most common binding material is egg yolk, but other materials such as gum and wax are also used. Tempera was a common paint medium used by artists in the late Middle Ages and early Renaissance. During the fifteenth century, however, it was gradually replaced by oil paint. In the nineteenth century some artists, such as William Blake (1757–1827), sought to revive the tempera technique.

Tonal painting Painting in which color is subordinated to tone. Grey or brown often predominate in tonal paintings, which are aimed more at suggesting effects of light and dark than at the representation of local colors. In the nineteenth century tonal painting was practiced mostly by landscape painters, such as Camille Corot (1796–1875) in France and the painters of The Hague school in the Netherlands.

Triptych A painting composed of three separate panels that are (usually) connected with hinges. Although the triptych form is typical of late medieval religious painting, it experienced a revival at the end of the nineteenth century.

Varnishing day The opening day of an exhibition, when painters put a final layer of varnish on their pictures. The French refer to it as *vernissage*.

Verisimilitude A term used to describe the appearance of being real.

Version A copy or paraphrase of a painting or sculpture, executed by the artist himself. In the nineteenth century, it was not uncommon for artists to paint or sculpt several versions of the same work to meet the demands of more than one client. Sometimes artists also made several versions of a painting to try out different pictorial possibilities. Such versions generally show slight variations.

Zeitgeist The spirit of the time. Term coined by the German philosopher of history, Georg Wilhelm Friedrich Hegel (1770–1831), who, in his *Lectures on Aesthetics*, claimed that each art form is the expression of a particular *Zeitgeist* that permeates the entire culture. The transition from one style to the next, therefore, is always a symptom of a larger historical transformation in which all aspects of the culture are engaged.

Bibliography

General

BLÜHM, ANDREAS, and LOUISE LIPP INCOTT. *Light: The Industrial Age, 1750–1900.* London: Thames and Hudson, 2001.

EISENMAN, STEPHEN. *Nineteenth-Century Art: A Critical History.* New York: Thames and Hudson, 1994.

EITNER, LORENZ. *An Outline of 19th-Century European Painting: From David to Cézanne.* 2 vols. New York: Harper & Row, 1987.

FRASCINA, FRANCES, and CHARLES HARRISON, eds. *Modern Art and Modernism: A Critical Anthology.* New York: Harper & Row, 1982.

HAUSER, ARNOLD. *A Social History of Art.* Vols. 3 and 4. New York: Routledge, 1999.

JANSON, H.W. *19th-Century Sculpture.* New York: Harry N. Abrams, 1985.

ROSENBLUM, ROBERT, and H.W. JANSON. *Art of the Nineteenth Century: Painting and Sculpture.* London: Thames and Hudson, 1984.

TAYLOR, J.C. *Nineteenth-Century Theories of Art.* Berkeley, Los Angeles, and London: University of California Press, 1987.

TOMLINSON, JANIS. *Readings in Nineteenth-Century Art.* Upper Saddle River, New Jersey: Prentice Hall, 1996.

VAUGHAN, WILLIAM, ed. *Arts of the Nineteenth Century.* 2 vols. New York: Abrams, 1998–99.

YELDHAM, CHARLOTTE. *Women Artists in Nineteenth-Century France and England.* 2 vols. New York: Garland, 1984.

Primary Sources

HARRISON, CHARLES, PAUL WOOD, and JASON GAIGER, eds. *Art in Theory, 1815–1900: An Anthology of Changing Ideas.* Malden, Massachusetts: Blackwell, 1998.
Art in Theory, 1648–1815: An Anthology of Changing Ideas. Malden, Massachusetts: Blackwell, 2001.

HOLT, ELIZABETH GILMORE, ed. *From the Classicists to the Impressionists.* New Haven: Yale University Press, 1986.

Introduction

CALINESCU, MATEI. *Five Faces of Modernity.* Durham: Duke University Press, 1987.

GAY, PETER. *The Bourgeois Experience: Victoria to Freud. 4 vols: Education of the Senses; The Tender Passion; The Cultivation of Hatred; The Naked Heart.* New York: Oxford University Press, 1984–95

HOBSBAWM, ERIC J. *Birth of the Industrial Revolution.* Edited by Chris Wrigley. New York: New Press, 1999.

KOLCHIN, PETER. *Unfree Labor: American Slavery and Russian Serfdom.* Cambridge, Massachusetts: Belknap Press of Harvard University Press, 1987.

LOUBERE, LEO A. *Nineteenth-Century Europe: The Revolution of Life.* Englewood Cliffs: Prentice Hall, 1993.

SCHAMA, SIMON, *Citizens: A Chronicle of the French Revolution.* New York: Knopf, 1989.

CHAPTER 1

BAILEY, COLIN. *The Loves of the Gods: Mythological Painting from Watteau to David.* Exhibition catalog. New York: Rizzoli, 1992.

BARKER-BENFIELD, G.J. *The Culture of Sensibility: Sex and Society in Eighteenth-Century Britain.* Chicago and London: University of Chicago Press, 1992.

BOIME, ALBERT. *Art in the Age of Revolution, 1750–1800.* Chicago and London: University of Chicago Press, 1987.

BRAHAM, ALLEN. *The Architecture of the French Enlightenment.* Berkeley: University of California Press, 1980.

BRYSON, NORMAN. *Word and Image: French Painting of the "Ancien Régime."* Cambridge, Massachusetts: Harvard University Press, 1981.

CONISBEE, PHILIP. *Painting in Eighteenth-Century France.* Oxford, 1981.

CRASKE, MATTHEW. *Art in Europe, 1700–1830.* New York: Oxford University Press, 1997.

CROOK, J. MORDAUNT. *The Greek Revival: Neo-classical Attitudes in British Architecture, 1760–1870.* 1972. Rev. ed., London: John Murray, 1995.

CROW, THOMAS. *Painters and Public Life in Eighteenth-Century Paris.* New Haven: Yale University Press, 1985.

FRIED, MICHAEL. *Absorption and Theatricality: Painting and the Beholder in the Age of Diderot.* Berkeley: University of California Press, 1980.

GAY, PETER. *The Enlightenment: An Interpretation.* 2 vols. New York: Knopf, 1966–69.
Age of Enlightenment: A Comprehensive Anthology. New York: Simon & Schuster, 1973.

MCCLELLAN, ANDREW. *Inventing the Louvre: Art, Politics, and the Origins of the Modern Museum in Eighteenth-Century Paris.* Berkeley, London, and Los Angeles: University of California Press, 1994.

MICALE, MARK S., and ROBERT L. DIETLE. *Enlightenment, Passion, Modernity: Historical Essays in European Thought and Culture.* Stanford, California: Stanford University Press, 2000.

PERRY, GILLIAN, and COLIN CUNNINGHAM, eds. *Academies, Museums and Canons of Art.* New Haven: Yale University Press, 1999.

PORTER, ROY, and MIKULÁS TEICH, eds. *The Enlightenment in National Context.* New York: Cambridge University Press, 1981.

SOLKIN, DAVID H. *Painting for Money: The Visual Arts and the Public Sphere in Eighteenth Century England.* New Haven: Yale University Press, 1993.

WAKEFIELD, DAVID. *French Eighteenth-Century Painting.* London: Gordon Fraser, 1984.

WATKIN, DAVID, and TILMAN MELLINGHOFF. *German Architects and the Classical Ideal, 1740–1840.* Cambridge: MIT Press, 1987.

WOLOCH, ISSER. *Eighteenth Century Europe: Tradition and Progress, 1715–1789.* New York: Norton, 1982.

Primary Sources

DIDEROT, DENIS. *Salons (1759–81).* Edited by Jean Adhémar and Jean Seznec. 4 vols. Oxford: Clarendon Press, 1957–67. Rev. 1983.
Selected Writings on Art and Literature. Translated and introduction by Geoffrey Bremmer. London: Penguin, 1994.

EITNER, LORENZ. *Neoclassicism and Romanticism 1750–1850,* vol. 1: *Enlightenment and Revolution.* Englewood Cliffs: Prentice Hall, 1970.

GOODMAN, J., and THOMAS CROW, eds. *Diderot on Art.* 2 vols. New Haven: Yale University Press, 1995.

REYNOLDS, SIR JOSHUA. *Discourses on Art.* London, 1778. Edited by Pat Rogers, New York: Penguin, 1992. Edited by Robert Wark, New Haven: Yale University Press, 1997.

Monographs and Catalogs
Boucher:
BRUNEL, GEORGES. *François Boucher.* London: Trefoil Books, 1986.

Chardin:
CONISBEE, PHILIP. *Chardin.* Lewisburg, Pennsylvania: Bucknell University Press, 1985.

ROSENBERG, PIERRE. *Chardin, 1699–1779.* Exhibition catalog. Cleveland: Cleveland Museum of Art; Bloomington: Indiana University Press, 1979.

Falconet:
LEVITINE, GEORGE. *The Sculpture of Falconet.* Greenwich, Connecticut: New York Graphic Society, 1972.

Fragonard:
CUZIN, JEAN-PIERRE. *Jean-Honoré Fragonard: Life and Work.* New York: Abrams, 1988.

SHERIFF, MARY D. *Fragonard: Art and Eroticism.* Chicago and London: Chicago University Press, 1990.

Gainsborough:
BERMINGHAM, ANN. *Landscape and Ideology: The English Rustic Tradition, 1740–1860.* Berkeley, Los Angeles, and London: University of California Press, 1986.

HAYES, JOHN T. *The Landscape Paintings of Thomas Gainsborough.* 2 vols. Ithaca, New York: Cornell University Press, 1982.

Greuze:
BROOKNER, ANITA. *Greuze: The Rise and Fall of an Eighteenth-Century Phenomenon.* Greenwich, Connecticut: New York Graphic Society, 1972.

MUNHALL, EDGAR. *Jean-Baptiste Greuze, 1725–1805.* Exhibition catalog. Hartford: Wadsworth Atheneum, 1976.

Hogarth:

BINDMAN, DAVID, and SCOTT WILCOX, eds. *"Among the Whores and Thieves": William Hogarth and* The Beggar's Opera. Exhibition catalog. New Haven: Yale Center for British Art, The Lewis Walpole Library, 1997.

EINBERG, ELIZABETH. *Manners and Morals: Hogarth and British Painting, 1700–1760.* Exhibition catalog. London: Tate Gallery, 1987.

PAULSON, RONALD. *Hogarth.* 3 vols. New Brunswick and Cambridge: Rutgers University Press, 1991–93.

Houdon:

ARNASON, H. HARVARD. *The Sculptures of Houdon.* New York: Oxford University Press, 1975.

Quentin de la Tour:

BURY, ADRIAN. *Maurice Quentin de la Tour: The Greatest Pastel Portraitist.* London: Skilton, 1971.

Reynolds:

PESTLE, MARTIN. *Sir Joshua Reynolds: The Subject Pictures.* New York: Cambridge University Press, 1995.

WATERHOUSE, ELLIS K. *Reynolds.* London: Phaidon, 1973.

WENDORF, RICHARD. *Sir Joshua Reynolds: The Painter in Society.* Cambridge, Massachusetts: Harvard University Press, 1996.

Saint-Aubin:

Prints and Drawings by Gabriel de Saint-Aubin, 1724–1780. Exhibition catalog. Middletown, Connecticut: Davison Art Center, Wesleyan University, 1975.

Tiepolo:

LEVEY, MICHAEL. *Giambattista Tiepolo: His Life and Art.* New Haven: Yale University Press, 1986.

MORASSI, ANTONIO. *A Complete Catalog of the Paintings of G.B. Tiepolo.* London: Phaidon, 1962.

Zimmermann:

HITCHCOCK, HENRY RUSSELL. *The German Rococo: The Zimmermann Brothers.* Baltimore: Penguin, 1968.

Films and Videos

"An Age of Reason, an Age of Passion." *Art of the Western World.* Videocassette. Santa Barbara, California: Intellimation, 1989. (30 minutes).

Classical Sculpture and the Enlightenment. Dir. Robert Philip. Videocassette. Ho-Ho-Kus, New Jersey: The Roland Collection, 1995. (25 minutes).

Dangerous Liaisons. Dir. Stephen Frears. Perf. Glenn Close, John Malkovich, Michelle Pfeiffer, Uma Thurman. Videocassette. Burbank, California: Warner Home Video, 1988. (119 minutes) [Based on the novel *Dangerous Liaisons* (1782) by Choderlos de Laclos].

Hogarth's Marriage-à-la-Mode. Narrated by Alan Bennett. Videocassette. Chicago: Home Vision, 1997. (40 minutes).

Hogarth's Progress. Videocassette. Chicago: Home Vision, 1997. (50 minutes).

Valmont. Dir. Milos Forman. Perf. Annette Bening, Colin Firth, Meg Tilly. Videocassette. New York: Orion Home Video. 1989. (130 minutes) [Based on the novel *Dangerous Liaisons* (1782) by Choderlos de Laclos].

Text References

p. 6: The quote by Dubos is from his *Réflexions critiques sur la poésie et sur la peinture* or *Critical Reflections on Poetry, Painting, and Music.* First published in 1719, this book was reprinted in numerous editions and translated into several languages, including English and German.

p. 14: Lafont's letter was published as *Lettre de lauteur des Réflexions sur la peinture … (Letter from the Author of the Reflections on Painting).* Paris, 1747.

pp. 16–17: Diderot's quotations are from Diderot 1983, *passim.*

pp. 19–20: For Reynolds's citation, see Reynolds 1992, p. 112.

CHAPTER 2

General

The Age of Neoclassicism. Exhibition catalog. London: Royal Academy and Victoria and Albert Museum, 1972.

ANTAL, FREDERICK. *Neoclassicism and Romanticism.* New York: Basic Books, 1966.

BURGESS, ANTHONY, and FRANCIS HASKELL. *The Age of the Grand Tour.* New York: Crown, 1967.

CROOK, J. MORDAUNT. *Greek Revival: Neo-classical Attitudes in British Architecture, 1760–1870.* London: J. Murray, 1995.

HASKELL, FRANCIS, and NICHOLAS PENNY. *Taste and the Antique: The Lure of Classical Sculpture, 1500–1900.* New Haven: Yale University Press, 1981.

HONOUR, HUGH. *Neo-classicism.* New York: Penguin, 1968.

IRWIN, DAVID. *English Neoclassical Art: Studies in Inspiration and Taste.* London: Faber and Faber, 1966.

—. *Neoclassicism.* London: Phaidon, 1997.

LEITH, JAMES A. *The Idea of Art as Propaganda in France, 1750–1799: A Study in the History of Ideas.* Toronto: Toronto University Press, 1965.

MIDDLETON, ROBIN, and DAVID WATKIN. *Neo-classical and 19th-Century Architecture.* New York: Abrams, 1980.

POTTS, ALEX. *Flesh and the Ideal: Winckelmann and the Origins of Art History.* New Haven: Yale University Press, 1994.

PRAZ, MARIO. *On Neoclassicism.* Translated by Angus Davidson. Evanston: Northwestern University Press, 1969.

ROSENBERG, PIERRE. *The Age of Louis XV: French Painting, 1710–1774.* Exhibition catalog. Toledo: Toledo Museum of Art, 1975.

ROSENBLUM, ROBERT. *Transformations in Late Eighteenth-Century Art.* Princeton: Princeton University Press, 1967.

STILLMAN, DAMIE. *English Neo-classical Architecture.* 2 vols. New York: Sotheby's, 1988.

Primary Sources

EITNER, LORENZ. *Neoclassicism and Romanticism, 1750–1850, vol. 1: Enlightenment and Revolution.* Englewood Cliffs: Prentice Hall, 1970.

HOLT, ELIZABETH GILMORE, ed., *The Triumph of Art for the Public: The Emerging Role of Exhibitions and Critics.* Washington: Decatur House Press, 1980.

KANT, IMMANUEL. *Observations on the Feeling of the Beautiful and Sublime.* Translated by John T. Goldthwait. Berkeley: University of California Press, 1960.

WINCKELMANN, JOHANN JOACHIM. *Writings on Art.* Edited by David Irwin. London: Phaidon, 1972.

Reflections on the Imitation of Greek Works in Painting and Sculpture. Translated and edited by Elfriede Heyer and Roger C. Norton. La Salle, IL: Open Court, c. 1987.

Monographs and Catalogs

Adam:

BRYANT, J. *Robert Adam 1728–92: Architect of Genius.* London: English Heritage in association with the National Library of Scotland, 1992.

KING, DAVID N. *The Complete Works of Robert and James Adam.* Oxford: Butterworth Architecture, 1991.

PARISSIEN, STEVEN. *Adam Style.* London: Phaidon, 1992.

Batoni:

CLARK, ANTHONY M. *Pompeo Batoni: A Complete Catalog of his Works with an Introductory Text.* Edited by E.P. Bowron. New York: New York University Press, 1985.

Canova:

JOHNS, CHRISTOPHER M.S. *Antonio Canova and the Politics of Patronage in Revolutionary and Napoleonic Europe.* Berkeley: University of California Press, 1998.

LICHT, FRED. *Canova.* New York: Abbeville Press, 1983.

PAVANELLO, GIUSEPPE, and GIANDOMENICO ROMANELLI, eds. *Canova.* Exhibition catalog. Translated by David Bryant et al. New York: Rizzoli, 1992.

David:

BROOKNER, ANITA. *Jacques-Louis David.* London: Thames and Hudson, 1980.

JOHNSON, DOROTHY. *Jacques-Louis David: Art in Metamorphosis.* Princeton: Princeton University Press, 1993.

MONNERET, SOPHIE. *David and Neo-classicism.* Translated by Chris Miller and Robert Snowdon. Paris: Terrail, 1999.

Flaxman:

BINDMAN, DAVID. *John Flaxman.* London: Thames and Hudson, 1979.

IRWIN, DAVID G. *John Flaxman, 1755–1826: Sculptor, Illustrator, Designer.* New York: Rizzoli, and London: Christie's, 1979.

SYMMONS, SARAH. *Flaxman and Europe: The Outline Illustrations and their Influence.* New York: Garland, 1984.

Kauffman:

HARTCUP, ADELINE. *Angelica: The Portrait of an Eighteenth-Century Artist.* London: W. Heinemann, 1954.

MANNERS, LADY VICTORIA, and G.C. WILLIAMSON. *Angelica Kauffmann, RA: Her Life and Works.* 1924. New York: Hacker Art Books, 1976.

ROWORTH, WENDY WASSYNG, ed. *Angelica Kauffman: A Continental Artist in Georgian England.* Exhibition catalog. Seattle: University of Washington Press, 1992.

Ledoux:

VIDLER, ANTHONY. *Claude-Nicolas Ledoux: Architecture and Social Reform at the End of the Ancien Régime.* Cambridge: MIT Press, 1990.

Mengs:

PELZEL, THOMAS O. *Anton Raphael Mengs and Neoclassicism: His Art, his Influence and his Reputation.* Dissertation. Princeton University, 1968. Ann Arbor: UMI, 1981.

ROETTGEN, STEFFI. *Anton Raphael Mengs 1728–1779 and his British Patrons.* London: Zwemmer, 1993.

Piranesi:

WILTON-ELY, JOHN. *Piranesi as Architect and Designer.* New Haven: Yale University Press, 1993.

Stuart and Revett:

SYKES, CHRISTOPHER SIMON. *Private Palaces: Life in the Great London Houses*. London: Chatto and Windus, 1985.

WATKIN, DAVID. *Athenian Stuart, Pioneer of the Greek Revival*. Boston and London: Allen and Unwin, 1982.

West:

ERFFA, HELMUT VON, and ALLEN STALEY. *The Paintings of Benjamin West*. New Haven: Yale University Press, 1986.

STALEY, ALLEN. *Benjamin West: American Painter at the English Court*. Exhibition catalog. Baltimore: Baltimore Museum of Art, 1989

Wright of Derby:

DANIELS, STEPHEN. *Joseph Wright*. London: Tate Gallery, 1999.

EGERTON, JUDY. *Wright of Derby*. Exhibition catalog. London: Tate Gallery, 1990.

Films and Videos

Neoclassicism and Romanticism and Realism. Videocassette. Glenview, Illinois: Crystal Productions, 1987. (44 minutes).

Text References

pp. 2–3: The quotations from Winckelmann are from Winckelmann 1987, *passim*.

p. 4: Mengs's line comes from his *Gedanken über die Schönheit und über den Geschmack in der Malerei* (*Thoughts about Beauty and Taste in Painting*), published in 1762. English translation in Honour 1968, 105. For Reynolds's citation, see Reynolds 1992, 107.

pp. 5–6: Hamilton's catalogs were published as *The Collection of Etruscan, Greek and Roman Antiquities from the Cabinet of the Honble Wm Hamilton* (4 vols., 1766–77) and the *Collection of Engravings from Ancient Vases Mostly of Pure Greek Workmanship Discovered in Sepulchres in the Kingdom of the Two Sicilies* (3 vols., Naples, 1791–95).

p. 8: The English translation of Winckelmann's famous description of the *Apollo Belvedere* is from Eitner 1970, 18–19.

p. 13: The positive critique of Vien's *Seller of Cupids* is found in an anonymous publication entitled *Description des Tableaux exposés au Sallon* [sic] *du Louvre*, Paris 1763, 58–59. English translation in Rosenblum 1967, 5. Diderot's critique of Vien's painting is cited in Jean Seznec and Jean Adhémar, eds. *Diderot Salons* (Oxford: Oxford University Press, 1957), vol. 1, 210. Author's translation.

p. 16: The assessment of Kauffman's art appeared in a review in the *London Chronicle* of 1777. Quoted in Roworth 1992, 86. David's pronouncement about the Antique is cited in Antoine Schnapper, *Jacques-Louis David, 1748–1825* (Paris: Réunion des musées nationaux, 1989), 41. Author's translation.

p. 18: An English translation of Tischbein's review of David's *Oath of the Horatii* is found in Holt 1980, 16–24.

p. 21: The English translation of the citation from Diderot's *De la poésie dramatique* is from Brookner 1980, 84.

CHAPTER 3

General

ALDRICH, MEGAN. *Gothic Revival*. London: Phaidon, 1994.

CLARK, KENNETH. *The Gothic Revival: An Essay in the History of Taste*. 3rd ed. London: John Murray, 1995.

DAVIS, TERENCE. *The Gothick Taste*. Rutherford, New Jersey: Fairleigh Dickinson University Press, 1975.

FRIEDMAN, WINIFRED H. *Boydell's Shakespeare Gallery*. New York: Garland, 1976.

MACAULAY, JAMES. *The Gothic Revival, 1745–1845*. Glasgow: Blackie, 1975.

MCCARTHY, M. *The Origins of the Gothic Revival*. New Haven: Yale University Press, 1987.

POINTON, MARCIA. *Strategies for Showing: Women, Possession and Representation in English Visual Culture 1665–1800*. New York: Oxford University Press, 1997.

Primary Sources

BLAKE, WILLIAM. *The Complete Writings of William Blake*. Edited by Geoffrey Keynes. New York: Random House, 1957.
The Letters of William Blake. Edited by Geoffrey Keynes. 3rd ed. Oxford: Clarendon Press, 1980.
The Complete Poetry and Prose of William Blake. Edited by David V. Erdman. 2nd ed. Berkeley: University of California Press, 1982.
Blake's Illuminated Books. 6 vols. London: Tate Gallery, William Blake Trust; Princeton: Princeton University Press, 1991–95.

BURKE, EDMOND. *A Philosophical Enquiry into the Origin of our Ideas of the Sublime and Beautiful*. Edited by Adam Philips. Oxford and New York: Oxford University Press, 1990.

EASTLAKE, CHARLES L. *A History of the Gothic Revival*. 1872. Edited by J. Mordaunt Crook, New York: Humanities Press, 1970.

MCPHERSON, JAMES. *Ossian's Fingal*. 1792. New York: Woodstock Books, 1996.

SHELLEY, MARY WOLLSTONECRAFT. *Frankenstein*. Boston: Bedford and St Martin: 2000.

WALPOLE, HORACE. *The Yale Edition of Horace Walpole's Correspondence*. Edited by W.S. Lewis. 48 vols. New Haven: Yale University Press, 1937–83.
The Castle of Otranto: A Gothic Story. Edited by W.S. Lewis. New York: Oxford University Press, 1996.

Monographs and Catalogs

Barry:

PRESSLY, WILLIAM L. *The Life and Art of James Barry*. New Haven: Yale University Press, 1981.
James Barry: The Artist as Hero. Exhibition catalog. London: Tate Gallery, 1983.

Beckford:

OSTERGARD, DEREK E. *William Beckford, 1760–1844: An Eye for the Magnificent*. New Haven: Yale University Press, 2001.

Blake:

BINDMAN, DAVID. *Blake as an Artist*. New York: E.P. Dutton, 1977.

DAMON, SAMUEL FORSTER. *A Blake Dictionary: The Ideas and Symbols of William Blake*. Providence, RI: Brown University Press, 1988.

ERDMAN, DAVID V., ed. *The Illuminated Blake: William Blake's Complete Illuminated Works with a Plate-by-Plate Commentary*. New York: Dover, 1992.

HAMLYN, ROBIN, and MICHAEL PHILLIPS. *William Blake*. Exhibition catalog. New York: Metropolitan Museum of Art, 2001.

MITCHELL, W.J.T. *Blake's Composite Art*. Princeton: Princeton University Press, 1978.

VAUGHAN, WILLIAM. *William Blake*. Princeton: Princeton University Press, 1999.

Copley:

FLEXNER, JAMES THOMAS. *John Singleton Copley*. New York: Fordham University Press, 1993.

NEFF, EMILY BALLEW. *John Singleton Copley in England*. Exhibition catalog. Houston: Museum of Fine Arts, 1995.

Fuseli:

MYRONE, PARTIN, *Henry Fuseli*. Princeton: Princeton University Press, 2001.

TOMORY, PETER. *The Life and Art of Henry Fuseli*. New York: Praeger, 1972.

Lawrence:

GARLICK, KENNETH. *Sir Thomas Lawrence: A Complete Catalog of the Oil Paintings*. Oxford: Phaidon, 1989.

Walpole:

FOTHERGILL, BRIAN. *The Strawberry Hill Set: Horace Walpole and his Circle*. Boston: Faber and Faber, 1983.

SABOR, PETER. *Horace Walpole: A Reference Guide*. Boston: G.K. Hall, 1984.

Films and Videos

Frankenstein. Dir. James Whale. Perf. Boris Karloff, Colin Clive. Videocassette. Universal City, California: MCA Home Video. 1991. (70 minutes) [Release of restored picture from 1931].

Frankenstein. Dir. David Wickes. Perf. Randy Quaid, Patrick Bergin. Videocassette. Atlanta, Georgia: Turner Home Entertainment. 1993. (117 minutes) [Based on the novel *Frankenstein* (1818) by Mary Shelley].

William Blake. Videocassette. Botsford, Connecticut: Filmic Archives. 1998. (30 minutes).

Text References

pp. 2–3: Burke's pronouncements on the sublime are found in Burke 1990, 36, 71, and 83.

p. 7: Reynolds's citation is from his Sixth Discourse (Reynolds 1992, 168).

p. 8: The precise biblical text on which West's *Death on the Pale Horse* is based is Revelation 6: 8.

p. 16: The text of Blake's catalog is found in Blake 1957, 565.

p. 17: George III's criticism of West's *Death of General Wolfe* and West's defense of his art are quoted in Erffa and Staley 1986, 213.

CHAPTER 4

General

BOIME, ALBERT. *Art in an Age of Revolution, 1750–1800*. Chicago: University of Chicago Press, 1987.

CROW, THOMAS. *Emulation: Making Artists for Revolutionary France*. New Haven: Yale University Press, 1995.

FRIEDLÄNDER, WALTER. *David to Delacroix*. Translated by Robert Goldwater. Cambridge: Harvard University Press, 1966.

French Caricature and the French Revolution. Exhibition catalog. Chicago: Chicago University Press, 1988.

GAMBONI, DARIO. *The Destruction of Art: Iconoclasm and Vandalism since the French Revolution*. London: Reaktion, 1997.

LEITH, JAMES, and ANDREA JOYCE. *Face à Face: French and English Caricatures of the French Revolution and its Aftermath*. Exhibition catalog. Toronto: Art Gallery of Ontario, 1989.

OZOUF, MONA. *Festivals and the French Revolution.* Translated by Alan Sheridan. Cambridge, Massachusetts: Harvard University Press, 1988.

ROBERTS, WARREN. *Jacques-Louis David and Jean-Louis Prieur, Revolutionary Artists: The Public, the Populace and Images of the French Revolution.* Albany: State University of New York Press, 2000.

WARNER, MARINA. *Monuments and Maidens: The Allegory of the Female Form.* New York: Atheneum, 1985.

Primary Sources

BERKIN, CAROL R., and CLARA M. LOVETT, eds. *Women, War and Revolution.* New York: Holmes & Meier, 1980.

VIGÉE-LEBRUN, ELISABETH. *Memoirs of Elisabeth Vigée-Le Brun.* Translated by Lionel Strachey. New York: George Braziller, 1989.

Monographs and Catalogs
David:

HERBERT, ROBERT. *David, Voltaire, Brutus and the French Revolution: An Essay in Art and Politics.* New York: Viking Press, 1972.

LAJER-BURCHARTH, EWA. *Necklines: The Art of Jacques-Louis David after the Terror.* New Haven: Yale University Press, 1999.

MONNERET, SOPHIE. *David and Neo-classicism.* Translated by Chris Miller and Peter Snowden. Paris: Terrail, 1999.

ROBERTS, WARREN E. *Jacques-Louis David: Revolutionary Artist: Art, Politics and the French Revolution.* Chapel Hill: University of North Carolina Press, 1989.

VAUGHAN, WILLIAM, and HELEN WESTON, eds. *Jacques-Louis David's Marat.* New York: Cambridge University Press, 2000.

Prud'hon:

ELDERFIELD, JOHN. *The Language of the Body: Drawings by Pierre Paul Prud'hon.* New York: Harry Abrams, 1996.

LAVEISSIÈRE, SYLVAIN. *Pierre Paul Prud'hon.* Exhibition catalog. New York: Metropolitan Museum of Art, 1998.

Quatremère de Quincy:

LAVIN, SYLVIA. *Quatremère de Quincy and the Invention of a Modern Language of Architecture.* Cambridge: MIT Press, 1992.

Robert:

CARLSON, VICTOR. *Hubert Robert: Drawings and Watercolours.* Exhibition catalog. Washington, DC: National Gallery of Art, 1978.

RADISICH, PAULA REA. *Hubert Robert: Painted Spaces of the Enlightenment.* New York: Cambridge University Press, 1998.

Vigée-Lebrun:

BAILLIO, JOSEPH. *Elisabeth Louise Vigée-Le Brun, 1755–1842.* Exhibition catalog. Fort Worth: Kimball Art Museum, 1982.

SHERIFF, MARY D. *The Exceptional Woman: Elisabeth Vigée-Lebrun and the Culture Politics of Art.* Chicago: Chicago University Press, 1996.

Films and Videos

Danton. Dir. Andrzej Wajda. Perf. Gerard Depardieu. Videocassette. Culver City, California: Columbia Tristar Home Video. 1982. In French with English subtitles. (138 minutes) [Subjects: Georges-Jacques Danton (1759–1794), Maximilien Robespierre (1758–1794), The Terror].

Jefferson in Paris. Dir. James Ivory. Perf. Nick Nolte, Greta Scacchi, Thandie Newton, Gwyneth Paltrow. Videocassette. Buena Vista Home Entertainment, 1995. (139 minutes) [Drama/romance about Jefferson's years as ambassador to France on the eve of the French Revolution; his friendship with artist Maria Cosway; and his changing relationship with his 15-year-old slave Sally Hemings].

"The French Revolution: Impacts and Sources." *An Introduction to the Humanities.* Videocassette. Ho-Ho-Kus, NJ: The Roland Collection. (24 minutes).

"The Passing Show: Jacques-Louis David." *Portrait of an Artist.* Dir. Leslie Megahey. Videocassette. Chicago: Home Vision, 1986. (50 minutes).

Text References

p. 3: Burke's quote is from Edmund Burke, *Reflections on the Revolution in France.* Edited by J.C.D. Clark Stanford: Stanford University Press, 2001.

p. 4: For Plutarch's quote, see *Plutarch's Lives,* translated by Bernadotte Perrin (Cambridge: Harvard University Press, 1914), vol. 1, 515 ("Life of Publicola").

p. 5: For the 1791 critique of David's *Brutus,* see Herbert 1972, 129–30.

p. 8: David's reminiscence of his visit to Marat is cited in Monneret 1999, 111.

CHAPTER 5

General

The Age of Neoclassicism. Exhibition catalog. London: Royal Academy and Victoria and Albert Museum, 1972.

BOIME, ALBERT. *Art in the Age of Bonapartism, 1800–1815.* Chicago: Chicago University Press, 1990.

French Painting, 1774–1830: The Age of Revolution. Exhibition catalog. New York: Metropolitan Museum of Art, 1974.

HARGROVE, JUNE. *The Statues of Paris: An Open Air Pantheon.* New York: Rizzoli, 1989.

LEVITINE, GEORGE. *The Dawn of Bohemianism: The Barbu Rebellion and Primitivism in Neoclassical France.* University Park, Pennsylvania: Pennsylvania State University Press, 1978.

PORTERFIELD, TODD. *The Allure of Empire: Art in the Service of French Imperialism, 1798–1836.* Princeton: Princeton University Press, 1998.

PRENDERGAST, CHRISTOPHER. *Napoleon and History Painting.* New York: Oxford University Press, 1997.

TSCHERNY, NADIA, and GUY STAIR SAINTY. *Romance and Chivalry: History and Literature Reflected in Nineteenth-Century French Painting.* New York: Stair Sainty Mattiesen, 1996.

WILSON-SMITH, TIMOTHY. *Napoleon and his Artists.* London: Constable, 1996.

Primary Sources

MENEVAL, BARON CLAUDE-FRANÇOIS, PROCTOR JONES, and CHARLES-OTTO ZIESENISS. *Napoleon: An Intimate Account of the Years of Supremacy, 1800–1814.* New York: Random House, 1992.

Monographs and Catalogs
Girodet:

LEVITINE, GEORGE. *Girodet-Trioson: An Iconographical Study.* New York: Garland, 1978.

Gros:

Baron Antoine-Jean Gros, 1771–1835: Painter of Battles, the First Romantic Painter. Exhibition catalog. New York, Jacques Seligmann, 1955.

PRENDERGAST, CHRISTOPHER. *Napoleon and History Painting: Antoine-Jean Gros's La Bataille d'Eylau.* New York: Oxford University Press, 1997.

Ingres:

CONDON, PATRICIA, MARJORIE B. COHN, and AGNES MONGAN. *In Pursuit of Perfection: The Art of J.-A.-D. Ingres.* Ed. by Debra Edelstein. Exhibition catalog. Louisville: J.B. Speed Museum; Bloomington: Indiana University Press, 1983.

OCKMAN, CAROL. *Ingres' Eroticized Bodies: Retracing the Serpentine Line.* New Haven: Yale University Press, 1995.

ROSENBLUM, ROBERT. *Jean-August-Dominique Ingres.* 1967. New York: Harry N. Abrams, 1985.

VIGNE, GEORGES. *Ingres.* Trans. by John Goodman. New York: Abbeville Press, 1995.

Valenciennes:

RADISICH, PAULA REA. *Eighteenth-Century Landscape Theory and the Work of Pierre Henri de Valenciennes.* Dissertation. University of California Los Angles, 1977. Ann Arbor: UMI, 1979.

Films and Videos

Desirée. Dir. Henry Koster. Perf. Marlon Brando, Merle Oberon, Jean Simmons. Videocassette. Beverly Hills, California: CBS/Fox Video Image Entertainment. 1954. (110 minutes) [Drama/romance about Napoleon Bonaparte. Note Jacques-Louis David's *Coronation of Napoleon*].

"Ingres: Slaves of Fashion." *Portrait of an Artist.* Videocassette. Chicago: Home Vision, 1982. (52 minutes).

Napoléon. Dir. Abel Gance. Perf. Paul Amiot, Antonin Artaud. Videocassette. Universal City, California: MCA Home Video, 1981. (235 minutes) [Release of a silent, but vivid, film from 1927].

Napoleon. Videocassette. Wynnewood, Pennsylvania: Library Video Co. 1997. (61 minutes).

Portraits by Ingres. Videocassette. Chicago: Home Vision. 1999. (25 minutes).

Text References

p. 9: Napoleon's instructions to David are quoted in Monneret 1999, 158.

pp. 17–18: Girodet's letter to his guardian Benoît-François Trioson is cited in Crow 1995, 134.

CHAPTER 6

General

HELSTON, MICHAEL. *Painting in Spain during the Later 18th Century.* Exhibition catalog. London: National Gallery, 1989.

KASL, RONDA, and SUZANNE L. STRATTON. *Painting in Spain in the Age of Enlightenment: Goya and his Contemporaries.* Exhibition catalog. Indianapolis: Indianapolis Museum of Art; New York: Spanish Institute, 1997.

SANCHEZ, ALFONSO PEREZ, and ELEANOR A. SAYRE. *Goya and the Spirit of Enlightenment.* Exhibition catalog. Boston: Museum of Fine Arts; Boston: Little, Brown, 1989.

Primary Sources

GOYA, FRANCISCO. *Letters of Love and Friendship in Translation.* Lewiston: Edwin Mellen Press, c. 1997.

Monographs and Catalogs
Goya:
GASSIER, PIERRE. *The Life and Complete Work of Francisco Goya.* New York: Harrison House, 1981.
Licht, Fred. *Goya.* New York: Abbeville, 2001.
LOPEZ-REY, JOSE. *Goya's Caprichos: Beauty, Reason and Caricature.* 2 vols. Princeton: Princeton University Press, 1953.
TOMLINSON, JANIS A. *Goya in the Twilight of Enlightenment.* New Haven: Yale University Press, 1992.
 Francisco Goya y Lucientes. London: Phaidon, 1994.

Films and Videos
Etching. Dir. Gavin Nettleton. Videocassette. Ho-Ho-Kus, New Jersey: The Roland Collection, 1992. (40 minutes).
"Goya." *Museum Without Walls.* Videocassette. Greenwich, Connecticut: Arts America, 1970. (54 minutes).
"Goya." *Art Awareness Collection.* Videocassette. Long Beach, California: Pioneer Entertainment. 1975. (7 minutes).
Goya en su tiempo [*Goya, His Life and Art*]. Dir. Jesus Fernandez Santos. Videocassette. Princeton: Films for the Humanities, 1981. In English. (45 minutes).
The Naked Maja. Dir. Henry Koster. Perf. Ava Gardner, Anthony Franciosa. Videocassette. Santa Monica, California: MGM Home Entertainment, 1959. (111 minutes) [Romance between Francisco Goya and the Spanish duchess].
"Romantics and Realists: Goya." *The Great Artists.* Videocassette. West Long Branch, New Jersey: Kultur Films, 2000. (50 minutes).

Text References
pp. 7–8: The English translation of Goya's advertisement of *Los Caprichos* is from Lopez-Rey 1953, 78–79.

CHAPTER 7

ANDREWS, KEITH. *The Nazarenes: A Brotherhood of German Painters in Rome.* Oxford: Oxford University Press, 1964. New York: Hacker Art Books, 1988.
BLÜHM, ANDREAS, ed. *Philipp Otto Runge, Caspar David Friedrich: The Passage of Time.* Translated by Rachel Esner. Amsterdam: Van Gogh Museum; Zwolle: Uitgeverij Waanders bv, 1996.
BROWN, DAVID BLAYNEY. *Romanticism.* London: Phaidon, 2001.
 German Masters of the Nineteenth Century: Paintings and Drawings from the Federal Republic of Germany. New York: Metropolitan Museum of Art, 1981.
HARTLEY, KEITH, ET AL, eds. *The Romantic Spirit in German Art, 1790–1890.* Exhibition catalog. London: Thames and Hudson, 1994.
MITCHELL, TIMOTHY. *Philipp Otto Runge and Caspar David Friedrich: A Comparison of their Art and Theory.* Bloomington: Indiana University Press, 1977.
 Art and Science in German Landscape Painting, 1770–1840. New York: Oxford University Press, 1993.
ROSENBLUM, ROBERT. *Modern Painting and the Northern Romantic Tradition.* New York: Harper & Row, 1975.
 The Romantic Child: From Runge to Sendak. New York: Thames and Hudson, 1988.

VAUGHAN, WILLIAM. *German Romantic Painting.* New Haven: Yale University Press, 1980.

Primary Sources
GOETHE, JOHANN WOLFGANG VON. *Goethe on Art.* Edited and translted by John Gage. London: Scolar Press, 1980.
SCHIFF, GERT, ed. *German Essays on Art History.* New York: Continuum Publishing, 1988. [See essays by Schlegel, Goethe, Wackenroder].
WACKENRODER, WILHELM HEINRICH, and LUDWIG TIECK. *Confessions and Phantasies.* Translated by Mary Hurst Schubert of *Herzensergiessungen eines kuntsliebenden Klosterbruders* and *Phantasien über die Kunst, für Freunde der Kunst.* University Park: Pennsylvania University Press, 1971.

Monographs and Catalogs
Friedrich:
BÖRSCH-SUPAN, HELMUT. *Caspar David Friedrich.* Translated by Sarah Twohig. New York: George Braziller, 1974.
KOERNER, JOSEPH LEO. *Caspar David Friedrich and the Subject of Landscape.* New Haven: Yale University Press, 1990.
SCHMIED, WIELAND. *Caspar David Friedrich.* New York: Harry N. Abrams, 1995.
Runge:
BISANZ, RUDOLF M. *German Romanticism and Philipp Otto Runge: A Study in Nineteenth-Century Art Theory and Iconography.* Dekalb: Northern Illinois University Press, 1970.

Films and Videos
Caspar David Friedrich. Presented by William Vaughan. Videocassette. Ho-Ho-Kus, New Jersey: The Roland Collection, 1992. (25 minutes).
Caspar David Friedrich: Landscape as Language. Dir. Walter Koch. Videocassette. Ho-Ho-Kus, New Jersey: The Roland Collection, 1977. (18 minutes).
"Romantics and Realists: Friedrich." *The Great Artists.* Videocassette. West Long Branch, New Jersey: Kultur Films, 2000. (50 minutes).

Text References
p. 3: Schlegel's definition of Romantic poetry is found in a series of aphorisms in the inaugural issue of *Athenäum*, a literary magazine he started with his brother August Wilhelm in 1798. Translation in Kuno Francke, ed. *The German Classics* (New York: German Publication Society, 1913), vol. 4, 177–78.
p. 4: Pforr's characterization of sixteenth-century German art is quoted in Vaughan 1980, 170.
p. 5: For Wackenroder's quote, see Wackenroder 1971, 108. English translation of Overbeck's letter cited in *German Masters of the Nineteenth Century* 1981, 176.
p. 12: For the quotation from Boehme, see Jacob Boehme, *The Way to Christ*, translated by Peter Erb (New York, Ramsey, and Toronto: Paulist Press, 1978), 213.
pp. 16–17: Kosegarten's lines are cited, in English, in Koerner 1990, 78.
p. 18: Friedrich's commentary on the *Cross in the Mountains* and details of its exhibition in his studio are found in Koerner 1990, 48.
pp. 18–19: A translation of Ramdohr's review is found in Holt 1980, 152–65.
pp. 19–20: For Friedrich's defense against Ramdohr's attack, see Sigrid Hinz, ed. *Caspar*

David Friedrich in Briefen und Bekenntnissen (Berlin: Henschelverlag, 1984), 156–57. Author's translation.

CHAPTER 8
General
BAETJER, KATHARINE. *Glorious Nature: British Landscape Painting, 1750–1850.* Exhibition catalog. Denver: Denver Art Museum; New York: Hudson Hills Press, 1993.
BARRELL, JOHN. *The Dark Side of the Landscape: The Rural Poor in English Painting, 1730–1840.* Cambridge: Cambridge University Press, 1980.
BERMINGHAM, ANN. *Landscape and Ideology: The English Rustic Tradition, 1740–1860.* Berkeley: University of California Press, 1986.
COFFIN, DAVID R. *The English Garden: Meditation and Memorial.* Princeton: Princeton University Press, 1994.
COPLEY, STEPHEN, and PETER GARSIDE, eds. *The Politics of the Picturesque: Literature Landscape and Aesthetics since 1770.* New York: Cambridge University Press, 1994.
DANIELS, STEPHEN. *Fields of Vision: Landscape Imagery and National Identity in England and the United States.* Cambridge: Polity Press, 1993.
HUNT, JOHN DIXON. *Studies in the History of Landscape Architecture.* Cambridge, Massachusetts, and London: MIT Press, 1992.
KLINGENDER, FRANCIS. *Art and the Industrial Revolution.* London: Carrington, 1947, 72.
PAULSON, RONALD. *Literary Landscape: Turner and Constable.* New Haven: Yale University Press, 1982.
ROSENTHAL, MICHAEL. *British Landscape Painting.* Ithaca: Cornell University Press, 1982.

Primary Sources
CONSTABLE, JOHN. *Correspondence.* Edited and introduction by R.B. Beckett. 6 vols. Great Britain: Royal Commission on Historical Manuscripts Suffolk Records Society; London: HM Stationery Office, 1962–68.
 John Constable's Discourses. Edited by R.B. Beckett. Ipswich: Suffolk Records Society, 1970.
GILPIN, WILLIAM. *Three Essays: On Picturesque Beauty; On Picturesque Travel; and On Sketching Landscape: To Which is Added a Poem on Landscape Painting.* Reprint of 1794 edition. Farnborough: Gregg, 1972
TURNER, J.M.W. (John Mallord William). *The Sunset Ship: The Poems of J.M.W. Turner.* Edited by Jack Lindsay. Lowestoft: Scorpion Press; London: Evelyn, 1966.
 The Collected Correspondence of J.M.W. Turner. Edited by John Gage. New York: Oxford University Press, 1980.
WILLIAM WORDSWORTH, *Selections.* Edited by Stephen C. Gill. Oxford and New York: Oxford University Press, 1984.

Monographs and Catalogs
Constable:
CORMACK, MALCOLM. *Constable.* Oxford: Phaidon, 1986.
PARKINSON, RONALD. *John Constable: The Man and his Art.* London: V&A Publications, 1998.
ROSENTHAL, MICHAEL. *Constable: The Painter and his Landscape.* 2nd ed. New Haven: Yale University Press, 1986.
 Constable. London: Thames and Hudson, 1987.

Cotman:

HOLCOMB, ADELE M. *John Sell Cotman*. London: British Museum Publications, 1978.

RAJNAI, MIKLOS, ed. *John Sell Cotman, 1782–1842*. London: Herbert Press, 1982.

Girtin:

GIRTIN, THOMAS, and DAVID LOSHAK. *The Art of Thomas Girtin*. London: A. and C. Black, 1954.

MORRIS, SUSAN. *Thomas Girtin, 1775–1802*. Exhibition catalog. New Haven: Yale Center for British Art, 1986.

Turner:

BAILEY, ANTHONY. *Standing in the Sun: A Life of J.M.W. Turner*. New York: Harper Collins, 1997.

GAGE, JOHN. *J.M.W. Turner: "A Wonderful Range of Mind."* New Haven: Yale University Press, 1987.

HAMILTON, JAMES. *Turner: A Life*. London: Hodder and Stoughton, 1997.

LINDSAY, JACK. *Turner: The Man and his Art*. New York: Granada, 1986.

RODNER, WILLIAM S. *J.M.W. Turner: Romantic Painter of the Industrial Revolution*. Berkeley: University of California Press, 1997.

WILTON, ANDREW. *Turner in his Time*. London: Thames and Hudson, 1987.

Films and Videos

Constable: The Changing Face of Nature. Presented by Leslie Parris. Videocassette. Chicago: Home Vision, 1991. (25 minutes).

"Joseph Mallord William Turner." *Art Awareness Collection*. Long Beach, California: Pioneer Entertainment. 1975. (7 minutes).

Turner. Dir. Anthony Roland. Videocassette. Ho-Ho-Kus, NJ: The Roland Collection. 1964. (12 minutes).

"The Worship of Nature." *Civilization*. Prod. Michael Gill and Peter Montagnon. Narr. Kenneth Clark. Videocassette. Chicago: Home Vision, 1993. (50 minutes) [Turner, Constable, Goethe, Rousseau].

Text References

p. 2: Blake's famous line about the "dark Satanic mills" is found in a poem that forms part of the preface to his *Milton* (1808). See Blake 1957, 480–81. Seward's poem is cited in Klingender 1947, 72.

pp. 2–3: Wordsworth's words are from his well-known poem "Lines." For the full poem, see Wordsworth 1984, 54–55.

pp. 3–4: Brown's letter to the Earl of Scarborough is quoted in Hunt 1992, 128. Wordsworth's poem *The Brothers* is found in Wordsworth 1984, 155.

p. 12: Constable used the term "natural painture" in a letter to his friend John Dunthorne of May 29, 1802. Quoted in Bermingham 1986, 117.

CHAPTER 9

ATHANASSOGLOU-KALLMYER, NINA M. *French Images from the Greek War of Independence, 1821–1830: Art and Politics under the Restoration*. New Haven: Yale University Press, 1989.

BOIME, ALBERT. *The Academy and French Painting in the Nineteenth Century*. London: Phaidon, 1971.

French Painting 1774–1830: The Age of Revolution. Exhibition catalog. New York: Metropolitan Museum of Art, 1975.

WRIGHT, BETH SEGAL. *Painting and History during the French Restoration: Abandoned by the Past*. New York: Cambridge University Press, 1997.

Primary Sources

DELACROIX, EUGÈNE. *The Journal of Eugène Delacroix*. Translated by Walter Pach. New York: Viking Press, 1972. (Earlier editions by Crown Publishers.)

The Journal of Eugène Delacroix. Translated by Lucy Norton. Edited by Hubert Wellington. Ithaca, New York: Cornell University Press, 1980. (Earlier and later editions published by Phaidon.)

EITNER, LORENZ. *Neoclassicism and Romanticism 1750–1850*, vol. 2: *Restoration/Twilight of Humanism*. Englewood Cliffs: Prentice Hall, 1970.

WAKEFIELD, DAVID, ed. *Stendhal and the Arts*. London: Phaidon, 1973.

Monographs and Catalogs

Delacroix:

JOBERT, BARTHÉLÉMY. *Delacroix*. Translated by Terry Grabar and Alexandra Bonfante-Warren. Princeton: Princeton University Press, 1998.

JOHNSON, LEE. *The Paintings of Eugène Delacroix: A Critical Catalog*. 6 vols. New York: Oxford University Press, 1981–89.

SPECTER, JACK. *Delacroix: The Death of Sardanapalus*. New York: Viking Press, 1974.

Géricault:

EITNER, LORENZ. *Gericault's Raft of the Medusa*. London: Phaidon, 1892.

Géricault: His Life and Work. London: Orbis, 1983.

Films and Videos

Delacroix. Dir. Anthony Roland. Videocassette. Ho-Ho-Kus, New Jersey: The Roland Collection, 1962. (13 minutes).

"The Fallacies of Hope." *Civilization*. Prod. Michael Gill and Peter Montagonon. Narr. Kenneth Clark. Videocassette. Chicago: Home Vision, 1993. (50 minutes) [Napoleon, Romanticism, Delacroix, Byron, Rodin].

Géricault: The Raft of the "Medusa." Dir. Adrien Touboul. Videocassette. Ho-Ho-Kus, New Jersey: The Roland Collection, 1968. (21 minutes).

The Glorious Romantics. Dir. Richard M. Russell, Marshall Jamison. Videocassette. Thousand Oaks, California: Monterey Home Video, 1993. (90 minutes) [Poetry of Byron, Keats, Shelley].

Impromptu. Dir. James Lapine. Writer: Sarah Kernochan. Perf. Julia Davis, Hugh Grant, Emma Thompson, Julian Sands. Videocassette. St Paul, Minnesota: Videocatalog Movies Unlimited. 1991. (108 minutes) [Romantic comedy set in 1830s France; features the pianist and composer Frédéric Chopin and George Sand].

"The Restless Eye: Eugène Delacroix." *Portrait of an Artist*. Dir. Colin Nears. Videocassette. Chicago: Home Vision, 1980. (65 minutes).

"Romantics and Realists: Delacroix." *The Great Artists*. Videocassette. West Long Branch, New Jersey: Kultur Films, 2000. (50 minutes).

Text References

pp. 6–7: The quote from Madame de Staël is from Germaine de Staël, *De L'Allemagne* (Paris: Garnier, 1968), 214. Author's translation.

pp. 7–8: All Stendhal quotes are from Wakefield 1973, pp. 101 and 120, respectively.

p. 16: Quotes of Delacroix are from Delacroix 1980, 338, 397, and 356, respectively.

p. 17: Stendhal's critique of Delacroix's *Massacres at Chios* is from Wakefield 1973, 107.

p. 19: The English translation of Delacroix's "storyboard" for *Death of Sardanapalus* is found in Specter 1974, 67–68. For the definition of Romantics as artists who departed "from the beaten path," see Johnson 1981–89, vol. 1, 88.

p. 22: Ingres's words on drawing are found in Henri Delaborde, *Ingres: Sa vie, ses travaux, sa doctrine* (Paris: Henri Plon, 1870), 123. Author's translation.

p. 23: For Stendhal's criticism of *The Vow of Louis XIII*, see Wakefield 1973, 114.

CHAPTER 10

General

The Art of the July Monarchy, France 1830–1848. Exhibition catalog. Columbia, Missouri: Museum of Art and Archaeology, University of Missouri, 1989.

BOURET, JEAN. *The Barbizon School and 19th-Century French Landscape Painting*. Greenwich, Connecticut: New York Graphic Society, 1973.

CHU, PETRA TEN-DOESSCHATE, and GABRIEL WEISBERG, eds. *The Popularization of Images: Visual Culture under the July Monarchy*. Princeton: Princeton University Press, 1994.

FARWELL, BEATRICE. *The Charged Image: French Lithographic Caricature, 1816–1848*. Exhibition catalog. Santa Barbara, California: Santa Barbara Museum of Art, 1989.

GERNSHEIM, HELMUT. *The Origins of Photography*. London: Thames and Hudson, 1982.

JANSON, H.W., and PETER FUSCO, eds. *The Romantics to Rodin*. Exhibition catalog. Los Angeles: Los Angeles County Museum of Art; New York: George Braziller, 1980.

LEMAGNY, JEAN-CLAUDE, and ANDRÉ ROUILLÉ, eds. *A History of Photography: Social and Cultural Perspectives*. Translated by Janet Lloyd. New York: Cambridge University Press, 1987.

MARRINAN, MICHAEL. *Painting Politics for Louis-Philippe: Art and Ideology in Orléanist France, 1830–1848*. New Haven: Yale University Press, 1988.

NEWHALL, BEAUMONT. *The History of Photography from 1839 to the Present*. 5th ed. New York: Museum of Modern Art, 1982.

ROSENBLUM, NAOMI. *A World History of Photography*. 2nd ed. New York: Abbeville Press, 1989.

WECHSLER, JUDITH. *A Human Comedy: Physiognomy and Caricature in Nineteenth-Century Paris*. Chicago: University of Chicago Press, 1982.

Primary Sources

BAUDELAIRE, CHARLES. *The Mirror of Art: Critical Studies by Charles Baudelaire*. Edited and translated by Jonathan Mayne. Garden City, New York: Doubleday, 1956.

Art in Paris, 1845–1862. Edited and translated by Jonathan Mayne. London: Phaidon, 1965.

Monographs and Catalogs

Bonington:

CORMACK, MALCOLM. *Bonington*. Oxford: Phaidon, 1989.

NOON, PATRICK J. *Richard Parkes Bonington: On the Pleasure of Painting*. New Haven: Yale Center for British Art, 1991.

POINTON, MARCIA R. *The Bonington Circle: English Watercolour and Anglo-French Landscape, 1790–1855*. Brighton, Sussex: Hendon Press, 1985.

Corot:

CONISBEE, PHILIP, SARAH FAUNCE, and JEREMY STRICK. *In the Light of Italy: Corot and Early Open-air Painting*. Exhibition catalog. Washington, DC: National Gallery of Art; New Haven: Yale University Press, 1996.

GALASSI, P. *Corot in Italy*. New Haven: Yale University Press, 1991.

TINTEROW, GARY, Michael Pantazzi, and Vincent Pomarède. *Corot*. Exhibition catalog. New York: Metropolitan Museum of Art, 1996.

Daumier:

LAUGHTON, BRUCE. *The Drawings of Daumier and Millet*. New Haven: Yale University Press, 1991.
Honoré Daumier. New Haven: Yale University Press, 1996.

LOYRETTE, HENRI, ET AL. *Honoré Daumier*. Exhibition catalog. Washington, DC: The Phillips Collection; Paris: Réunion des musées nationaux, 1999.

TOCQUEVILLE, ALEXIS DE. *The Old Regime and the Revolution*. 1856. Edited by Françoise Mélonio and François Furet. Translated by Alan S. Kahan. Chicago: Chicago University Press, 1998.

REY, ROBERT. *Honoré Daumier*. Translated by Norbert Guterman. New York: Harry N. Abrams, 1985.

Daguerre:

GERNSHEIM, ALISON, and HELMUT GERNSHEIM. *L.J.M. Daguerre: The History of the Diorama and Daguerreotype*. London: Seckler and Warburg, 1956. Rev. 1968.
L.J.M. Daguerre (1787–1851): The World's First Photographer. Cleveland: World Publishing, 1956.

D'Angers:

DE CASO, JACQUES. *David d'Angers: Sculptural Communication in the Age of Romanticism*. Translated by Dorothy Johnson and Jacques de Caso. Princeton: Princeton University Press, 1992.

Delaroche:

BANN, STEPHEN. *Paul Delaroche: History Painted*. Princeton: Princeton University Press, 1997.

ZIFF, NORMAN D. *Paul Delaroche: A Study in French Nineteenth-Century History Painting*. New York: Garland Publishing, 1977.

Dupré:

MILKOVICH, MICHAEL. *Jules Dupré, 1811–1889*. Exhibition catalog. Memphis, Tennessee: The Gallery, 1979.

Gavarni:

STAMM, THERESE DOLAN. *Gavarni and the Critics*. Ann Arbor: UMI Research Press, 1981.

Rousseau:

THOMAS, GREG M. *Art and Ecology in Nineteenth-Century France: The Landscapes of Théodore Rousseau*. Princeton: Princeton University Press, 2000.

Visconti:

DRISKEL, MICHAEL PAUL. *As Befits a Legend: Building a Tomb for Napoleon, 1840–1861*. Kent, Ohio: Kent State University Press, 1993.

Films and Videos

Corot. Dir. Roger Leenhardt. Videocassette. Ho-Ho-Kus, NJ: The Roland Collection. 1968. (18 minutes).

Daumier. Dir. Roger Leenhardt, Henry Sarrade. Ho-Ho-Kus, NJ: The Roland Collection. 1968. (15 minutes).

Ivanhoe. Dir. Richard Thorpe. Perf. Robert Taylor, Elizabeth Taylor, Joan Fontaine. Videocassette. Santa Monica, California: MGM Home Entertainment. 1952. (107 minutes) [Based on the novel by Sir Walter Scott].

Ivanhoe. Dir. Douglas Camfield. Perf. James Mason, Anthony Andrews, Sam Neill. Videocassette. Culver City, California: Columbia Tristar Home Video. 1982. (142 minutes) [Based on the novel by Sir Walter Scott; remake of the 1952 version].

Les Misérables. Dir. Richard Boleslawski. Perf. Fredric March, Charles Laughton. Videocassette. Beverly Hills, California: CBS/Fox Video, 1935. (108 minutes) [Based on the novel *Les Misérables* (1862) by Victor Hugo].

Les Misérables. Dir. Perf. Liam Neeson, Uma Thurman. Videocassette. Culver City, California: Columbia Tristar Home Video, 1997. (159 minutes) [Based on the novel *Les Misérables* (1862) by Victor Hugo].

Lithography. Dir. Gavin Nettleton. Videocassette. Ho-Ho-Kus, New Jersey: The Roland Collection, 1994. (39 minutes).

Text References

p. 1: The observation that Delacroix's *Liberty* showed "a new allegorical language" is by the well-known critic Théophile Thoré. Cited, in English, in Jobert 1997, 12.

p. 8: Delacroix's assessment of Flandrin's murals as "Gothic Smears" is found in Delacroix 1972, 266.

p. 13: The praise of Corot's painting is by the critic Charles Lenormant. Cited, in English, in Tinterow et al. 1996, 156.

p. 16: Thoré's review of the Salon of 1844 was published in the journal *L'Artiste*. For an English translation of the *Letter to Rousseau*, see Harrison et al 1998, 221–24.

CHAPTER 11

CLARK, T.J. *The Absolute Bourgeois: Artists and Politics in France, 1848–51*. Princeton: Princeton University Press, 1982 (reprint of 1973 edition published by New York Graphic Society).

MCWILLIAM, NEIL. *Dreams of Happiness: Social Art and the French Left*. Princeton: Princeton University Press, 1993.

NEEDHAM, GERALD. *19th-Century Realist Art*. New York: Harper & Row, 1988.

NOCHLIN, LINDA. *Realism*. New York: Penguin, 1971.

ROSEN, CHARLES, and HENRI ZERNER. *Romanticism and Realism: The Mythology of Nineteenth-Century Art*. New York: Viking Press, 1984.

THOMPSON, JAMES. *The Peasant in French 19th-Century Art*. Exhibition catalog. Dublin: Douglas Hyde Gallery, Trinity College, 1980.

WEINBERG, BERNARD. *French Realism: The Critical Reaction, 1830–1870*. New York: Modern Language Association of America, 1937.

WEISBERG, GABRIEL P., and PETRA TEN-DOESSCHATE CHU. *The Realist Tradition: French Painting and Drawing, 1830–1900*. Exhibition catalog. Cleveland, Ohio: Cleveland Museum of Art, 1980.

Primary Sources

COURBET, GUSTAVE. *The Letters of Gustave Courbet*. Edited and translated by Petra ten-Doesschate

Chu. Chicago and London: University of Chicago Press, 1992.

NOCHLIN, LINDA, ed. *Realism and Tradition in Art, 1848–1900: Sources and Documents*. Englewood Cliffs: Prentice Hall, 1966.

Monographs and Catalogs

Courbet:

CHU, PETRA TEN-DOESSCHATE, ed. *Courbet in Perspective*. New York: Prentice Hall, 1977.

CLARK, T.J. *Image of the People: Gustave Courbet and the 1848 Revolution*. London: Thames and Hudson, 1973.

FAUNCE, SARAH. *Gustave Courbet*. New York: Abrams, 1993.

FRIED, MICHAEL. *Courbet's Realism*. Chicago: Chicago University Press, 1990.

RUBIN, JAMES H. *Gustave Courbet*. London: Phaidon, 1997.
Gustave Courbet: Realist and Visionary. London: Phaidon, 1995.

Couture:

BOIME, ALBERT. *Thomas Couture and the Eclectic Vision*. New Haven: Yale University Press, 1980.

Meissonier:

GOTLIEB, MARC. *The Plight of Emulation: Ernest Meissonier and French Salon Painting*. Princeton: Princeton University Press, 1996.

HUNGERFORD, CONSTANCE. *Ernest Meissonier and Art for the French Bourgeoisie*. New York: Cambridge University Press, 1995.
Ernest Meissonier: Master in his Genre. New York: Cambridge University Press, 1999.

Millet:

MURPHY, ALEXANDRA R. *Jean-François Millet*. Exhibition catalog. Boston: Boston Museum of Fine Art, 1984.

MURPHY, ALEXANDRA R., ET AL. *Jean-François Millet: Drawn into the Light*. Exhibition catalog. Williamstown, Massachusetts: Sterling and Francine Clark Institute; New Haven: Yale University Press, 1999.

Films and Videos

"Romantics and Realists: Courbet." *The Great Artists*. Videocassette. West Long Branch, New Jersey: Kultur Films, 2000. (50 minutes).

Text References

p. 3: Meissonier's reminiscence of the Revolution of 1848 is quoted in Clark 1982, 27.

p. 4: For the English translation of Baudelaire's review of the Salon of 1846, and particularly for the section *On the Heroism of Modern Life*, see Baudelaire 1965, 116–19.

p. 7: For Courbet's remarks on art, see Courbet 1992, 203–04.

p. 8: For Courbet on *The Stonebreakers*, see Courbet 1992, 88.

CHAPTER 12

ADAMS, STEVEN. *The Barbizon School and the Origins of Impressionism*. London: Phaidon, 1994.

CLARK, T.J. *The Painting of Modern Life: Paris in the Art of Manet and his Followers*. Princeton: Princeton University Press, 1984.

DREXLER, ARTHUR, ed. *The Architecture of the École des Beaux-Arts*. Exhibition catalog. New York: Museum of Modern Art; Cambridge: MIT Press, 1977.

HUGHES, PETER. *Eighteenth-Century France and the East.* London: Trustees of the Wallace Collection, 1981.

JORDAN, DAVID P. *Transforming Paris: The Life and Labors of Baron Haussmann.* Chicago: University of Chicago Press, 1996.

JULLIAN, PHILIPPE. *The Orientalists: European Painters of Eastern Scenes.* Translated by Helga and Dinah Harrison. Oxford: Phaidon, 1977.

LOUER, FRANÇOIS. *Paris Nineteenth Century: Architecture and Urbanism.* Translated by Charles Lynn Clark. New York: Abbeville Press, 1988.

MAINARDI, PATRICIA. *Art and Politics of the Second Empire: The Universal Expositions of 1855 and 1867.* New Haven: Yale University Press, 1987.

McPHERSON, HEATHER. *The Modern Portrait in Nineteenth-Century France.* New York: Cambridge University Press, 2001.

MIDDLETON, ROBIN, ed. *The Beaux-Arts and 19th-Century French Architecture.* Cambridge: MIT Press, 1982.

OLSEN, DONALD J. *The City as a Work of Art: London, Paris, Vienna.* New Haven: Yale University Press, 1986.

PINCKNEY, DAVID H. *Napoleon III and the Rebuilding of Paris.* Princeton: Princeton University Press, 1958.

ROOS, JANE MAYO. *Early Impressionism and the French State (1866–1874).* New York: Cambridge University Press, 1996.

ROSEN, CHARLES, and HENRI ZERNER. *Romanticism and Realism: The Mythology of Nineteenth-Century Art.* New York: Viking Press, 1984.

ROSENTHAL, DONALD A. *Orientalism: The Near East in French Painting, 1800–1880.* Exhibition catalog. Rochester, New York: Memorial Art Gallery of the University of Rochester, 1982.

RUBIN, JAMES H. *Impressionism.* London: Phaidon, 1999.

SAALMAN, HOWARD. *Haussmann: Paris Transformed.* New York: George Braziller, 1971.

SAID, EDWARD. *Orientalism.* New York: Penguin, 1995.

The Second Empire 1852–1870: Art in France under Napoleon III. Exhibition catalog. Philadelphia: Philadelphia Museum of Art, 1978.

THORNTON, LYNNE. *The Orientalists: Painter-Travellers, 1828–1908.* Paris: ACR, 1983.

VAN ZANTEN, DAVID. *Building Paris: Architectural Institutions and the Transformation of the French Capital, 1830–1870.* Cambridge, Massachusetts: Harvard University Press, 1994.

VERRIER, MICHELLE. *The Orientalists.* New York: Rizzoli, 1979.

WEISBERG, GABRIEL P., ed. *The Realist Tradition.* Exhibition catalog. Cleveland, Ohio: Cleveland Museum of Art, 1980.

Primary Sources

BAUDELAIRE, CHARLES. *The Painter of Modern Life and Other Essays.* Edited and translated by Jonathan Mayne. London: Phaidon; Greenwich, Connecticut: New York Graphic Society, 1964.

GONCOURT, EDMOND, and JULES DE. *The Goncourt Journals 1851–1870.* Edited and translated by Lewis Galentière. New York: Doubleday Anchor, 1958.

KLUMPKE, ANNA. *Rosa Bonheur: The Artist's (Auto)biography.* Translated by Gretchen van Slyke. Ann Arbor: University of Michigan, 1997.

Monographs and Catalogs
Bonheur:

ASHTON, DORE, and D. BROWN HARE. *Rosa Bonheur:*

A Life and a Legend. New York: Viking, 1981.

Rosa Bonheur: All Nature's Children. Exhibition catalog. New York: Dahesh Museum, 1998.

Breton:

STURGES, HOLLISTER. *Jules Breton and the French Rural Tradition.* Exhibition catalog. Omaha: Joslyn Art Museum; New York: Arts Publisher, 1982.

Carpeaux:

WAGNER, ANNE MIDDLETON. *Jean-Baptiste Carpeaux: Sculptor of the Second Empire.* New Haven: Yale University Press, 1986.

Garnier:

MEAD, CHRISTOPHER. *Charles Garnier's Paris Opéra: Architectural Empathy and the Renaissance of French Classicism.* New York: New York Architectural History Foundation; Cambridge: MIT Press, 1991.

Gérôme:

ACKERMAN, GERALD M. *The Life and Work of Jean-Léon Gérôme.* New York: Sotheby's, 1986.

Gérôme and Goupil: Art and Enterprise. Exhibition catalog. Translated by Isabel Ollivier. New York: Dahesh Museum of Art, 2000.

Manet:

ADLER, KATHLEEN. *Manet.* Oxford: Phaidon, 1986.

BROMBERT, BETH ARCHER. *Edouard Manet: Rebel in a Frock Coat.* Chicago: University of Chicago Press, 1997.

FARWELL, BEATRICE. *Manet and the Nude: A Study of Iconography in the Second Empire.* New York: Garland, 1981

HANSON, ANNE COFFIN. *Manet and the Modern Tradition.* New Haven: Yale University Press, 1977

TUCKER, PAUL HAYES, ed. *Manet's Le Déjeuner sur l'herbe.* Cambridge and New York: Cambridge University Press, 1998, 12.

Nadar:

GOSLING, NIGEL. *Nadar.* London: Secker and Warburg, 1976.

HAMBURG, MARIA MORRIS, ET AL. *Nadar.* Exhibition catalog. New York: Metropolitan Museum of Art; New York; Harry N. Abrams, 1995.

Films and Videos

Art in the Making: Impressionism. Prod. Jacquie Footer. Videocassette. Ho-Ho-Kus, New Jersey: The Roland Collection, 1992. (22 minutes) [Renoir, Monet, Pissarro].

Edouard Manet: Painter of Modern Life. Dir. Judith Wechsler. Videocassette. Chicago: Home Vision, 1983. (27 minutes).

"A Fresh View: Impressionism and Post-Impressionism." *Art of the Western World.* Videocassette. Santa Barbara, California: Intellimation, 1989. (30 minutes).

Impressionism: Painting Quickly in France 1860–1890. Narrated by Kathleen Adler. Videocassette. Chicago: Home Vision, 1999. (25 minutes).

Juarez. Dir. William Dieterle. Perf. Paul Muni, Bette Davis. Videocassette. Santa Monica, California: MGM Home Entertainment, 1939. (132 minutes) [Life of Mexican statesman, Benito Pablo Juarez; Maximilien, Emperor of Mexico (1864–67), the Habsburgs].

The Life of Emile Zola. Dir. William Dieterle. Perf. Paul Muni. Culver City, California: MGM/UA Home Video, 1989; Warner Brothers Pictures, 1937. (116 minutes).

Madame Bovary. Dir. Vincente Minelli. Perf. James Mason, Jennifer Jones. Videocassette. Culver City, California: MGM/UA Home Video,

1949. (115 minutes) [Based on the 1857 novel by Gustave Flaubert].

"Manet" Modern Art and Modernism: Manet to Pollock. Prod. Nick Levinson. Videocassette. Ho-Ho-Kus, New Jersey: The Roland Collection, 1982. (25 minutes).

Text References

p. 1: Bentham's famous formulation, which became the cornerstone of Utilitarianism, is found in *An Introduction to the Principles of Morals and Legislation,* published in 1789.

p. 3: Marx made these comments in his address *Civil War in France* (1871). Quoted in Jordan 1996, 345.

p. 5: The critic's remarks on Carpeaux's *Dance* is cited in Wagner 1986, 238; the caricature of the same work is reproduced in ibid., p. 234, fig. 234.

p. 9: Baudelaire's remark about Meissonnier is quoted in Baudelaire, *Oeuvres complètes* (Paris: Gallimard, 1961), 951. Author's translation.

p. 11: Maxime Du Camp's album was published in Paris in 1852–54 as *Egypte, Nubie, Palestine et Syrie: Dessins photographiques recueillis pendant les années 1849, 1850, 1851, accompagnés d'un texte explicatif et précédés d'une introduction.*

p. 23: Antonin Proust's memoirs are quoted in Tucker 1998, 12.

p. 25: The selections from Zola's critique of Manet here cited are from Harrison et al. 1998, 555 and 560.

CHAPTER 13

General

HIMMELHEBER, GEORG. *Biedermeier 1815–1835: Architecture, Painting, Sculpture, Decorative Arts, Fashion.* Munich: Prestel, 1989.

LENMAN, ROBIN. *Artists and Society in Germany, 1850–1914.* New York: Manchester University Press, 1997.

NORMAN, GERALDINE. *Biedermeier Painting, 1815–1848: Reality Observed in Genre, Portrait, and Landscape.* London: Thames and Hudson, 1987.

NOVOTNY, FRITZ. *Painting and Sculpture in Europe, 1780–1880.* Baltimore: Penguin, 1960.

Spirit of an Age: Nineteenth-Century Paintings from the Nationalgalerie, Berlin. Exhibition catalog. London: National Gallery, 2001.

Monographs and Catalogs
Købke:

Schwartz, Sanford. *Christen Købke.* New York: Timken, 1992.

Leibl:

WEST, RICHARD V. *Munich and American Realism in the 19th Century.* Exhibition catalog. Sacramento, California: E.B. Crocker Art Gallery, 1978.

Menzel:

KEISCH, CLAUDE, and MARIE URSULA RIEMANN-REYHER, eds. *Adolph Menzel 1815–1905: Between Romanticism and Impressionism.* Translated by Michael Cunningham et al. Exhibition catalog. Washington, DC: National Gallery of Art; New Haven: Yale University Press, 1996.

Text References

p. 3: For the quote from *Werther,* see Johann Wolfgang von Goethe, *The Sorrows of Young Werther.* Translated by Catherine Hutter (New York: Penguin, 1962), 65.

CHAPTER 14

BENDINER, KENNETH. *An Introduction to Victorian Painting*. New Haven: Yale University Press, 1985.

DIXON, ROGER, and STEFAN MUTHESIUS. *Victorian Architecture*. New York: Oxford University Press, 1978.

DYOS, H.J., and MICHAEL WOLFF, eds. *The Victorian City: Images and Realities*. 2 vols. London and Boston: Routledge & Kegan Paul, 1973.

ERRINGTON, LINDSAY. *Social and Religious Themes in English Art: 1840–1860*. New York: Garland, 1984.

LAMBOURNE, LIONEL. *Victorian Painting*. London: Phaidon, 1999.

MAAS, JEREMY. *Victorian Painters*. New York: Abbeville Press, 1984.

MACLEOD, DIANNE SACHKO. *Art and the Victorian Middle Class*. New York: Cambridge University Press, 1997.

PARRIS, LESLIE, ed. *The Pre-Raphaelites*. London: Tate Gallery Publications, 1984.

PRETTEJOHN, ELIZABETH. *The Art of the Pre-Raphaelites*. Princeton: Princeton University Press, 2000.

READ, BENEDICT. *Victorian Sculpture*. New Haven: Yale University Press, 1982.

STALEY, ALLEN. *The Pre-Raphaelite Landscape*. 2nd ed. New Haven: Yale University Press, 2001.

TREUHERZ, JULIAN. *Hard Times: Social Realism in Victorian Art*. Exhibition catalog. Manchester: Manchester City Art Galleries, 1987.
Victorian Painting. London and New York: Thames and Hudson, 1993.

VAUGHAN, WILLIAM. *German Romanticism and English Art*. New Haven: Yale University Press, 1979.

WOOD, CHRISTOPHER. *The Pre-Raphaelites*. New York: Viking Press, 1981.

Primary Sources

BROWN, FORD MADOX. *The Diary of Ford Madox Brown*. Edited by Virginia Surtees. New Haven: Yale University Press, 1981.

BURNE-JONES, SIR EDWARD. *Letters to Katie from Edward Burne-Jones*. Introduction by John Christian. London: British Museum Publications, 1988.

The Germ: Thoughts Towards Nature in Poetry, Literature, and Art. 1850. Introduction by William Michael Rossetti. New York: AMS Press, 1965.

PATER, WALTER. *Three Major Texts*. Edited by William E. Buckler. New York and London: New York University Press, 1986.

ROSSETTI, DANTE GABRIEL. *The Essential Rossetti*. Edited by John Hollander. New York: Ecco Press, 1990.

RUSKIN, JOHN. *Stones of Venice*. Edited and introduction by Jan Morris. Boston: Little, Brown, 1981.
Modern Painters. Edited by David Barrie. New York: Alfred Knopf, 1987.
Seven Lamps of Architecture. New York: Dover, 1989.
Lectures on Art. Introduction by Bill Beckley. New York: Allworth Press; School of Visual Arts, 1996.
The Genius of John Ruskin: Selections from his Writings. Edited by John D. Rosenberg. Charlottesville, Virginia: University Press of Virginia, 1997.

WHISTLER, JAMES MCNEILL. *The Gentle Art of Making Enemies*. Introduction by Alfred Werner. New York: Dover, 1967.
Whistler on Art: Selected Letters and Writings of James McNeill Whistler. Edited by Nigel Thorp. Washington: Smithsonian Institution Press, 1994.

Monographs and Catalogs
Alma Tadema
BARROW, ROSEMARY. *Lawrence Alma Tadema*. London: Phaidon, 2001.

SWANSON, VERN G. *The Biography and Catalogue Raisonné of the Paintings of Sir Lawrence Alma Tadema*. London: Garton and Scolar, 1990.

Brown:
BENDINER, KENNETH. *The Art of Ford Madox Brown*. University Park: Pennsylvania State University Press, 1998.

NEWMAN, TERESA, and RAY WATKINSON. *Ford Madox Brown and the Pre-Raphaelite Circle*. London: Chatto and Windus, 1991.

Burne-Jones:
HARRISON, MARTIN, and BILL WATERS. *Burne-Jones*. 2nd ed. London: Barrie and Jenkins, 1989.

WILDMAN, STEPHEN, and JOHN CHRISTIAN. *Edward Burne-Jones: Victorian Artist-Dreamer*. Exhibition catalog. New York: Metropolitan Museum of Art; New York: Harry N. Abrams, 1998.

WOOD, CHRISTOPHER. *Burne-Jones: The Life and Works of Sir Edward Burne-Jones (1833–1898)*. London: Weidenfeld and Nicolson, 1998.

Cameron:
LUKITSH, JOANNE. *Cameron: Her Work and Career*. Exhibition catalog. Rochester, New York: International Museum of Photography at George Eastman House, 1986.

WEAVER, MIKE. *Whisper of the Muse: The Overstone Album and Other Photographs by Julia Margaret Cameron*. Exhibition catalog. Malibu: J. Paul Getty Museum, 1986.

Dadd:
ALLDERIDGE, PATRICIA. *The Late Richard Dadd, 1817–1886*. Exhibition catalog. London: Tate Gallery Publications, 1974.

GREYSMITH, DAVID. *Richard Dadd: The Rock and Castle of Seclusion*. London: Studio Vista, 1973.

Doré:
GOSLING, NIGEL. *Gustave Doré*. New York: Praeger, 1973.

MALAN, DAN. *Gustave Doré: Adrift on Dreams of Splendor*. St Louis, Missouri: Malan Classical Enterprises, 1995.

Dyce:
POINTON, MARCIA. *William Dyce, 1806–1864: A Critical Biography*. New York: Oxford University Press, 1979.

Fenton:
BALDWIN, GORDON. *Roger Fenton: Pasha and Bayadère*. Los Angeles: J. Paul Getty Museum, 1996.
Roger Fenton: Photographer of the 1850s. Exhibition catalog. London: South Bank Board, 1988.

Frith:
NOAKES, AUBREY. *William Frith, Extraordinary Victorian Painter: A Biographical and Critical Essay*. London: Jupiter, 1978.

Hunt:
LANDOW, GEORGE P. *William Holman Hunt and Typological Symbolism*. New Haven: Yale University Press, 1979.

Landseer:
BATTY, J., ed. *Landseer's Animal Illustrations*. Alton, Hampshire: Nimrod Press, 1990.

ORMOND, RICHARD. *Sir Edwin Landseer*. Exhibition catalog. New York: Rizzoli; Philadelphia, Pennsylvania: Philadelphia Museum of Art, 1981.

Leighton:
BARRINGER, T.J., and ELIZABETH PRETTEJOHN. *Frederic Leighton: Antiquity, Renaissance, Modernity*. New Haven and London: Yale University Press, 1999.

Martin:
FEAVER, WILLIAM. *The Art of John Martin*. Oxford: Clarendon Press, 1975.

Millais:
ASH, RUSSELL. *Sir John Everett Millais*. London: Pavilion Books, 1996.

MILLAIS, GEOFFREY. *Sir John Everett Millais*. New York: Rizzoli, 1979.

Paton:
IRWIN, FRANCINA, ed. *Noël-Paton, 1821–1901*. Edinburgh: Ramsay Head, 1990.

Pugin and Barry:
ATTERBURY, PAUL, and CLIVE WAINWRIGHT, eds. *Pugin: A Gothic Passion*. Exhibition catalog. London: Victoria and Albert Museum; New Haven: Yale University Press, 1994.

Redgrave:
CASTERAS, SUSAN P., and RONALD PARKINSON, eds. *Richard Redgrave 1804–88*. Exhibition catalog. London: Victoria and Albert Museum; New Haven: Yale University Press, 1988.

Robinson:
HANDY, ELLEN. *Pictorial Effect, Naturalistic Vision: The Photographs and Theories of Henry Peach Robinson and Peter Henry Emerson*. Exhibition catalog. Norfolk, Virginia: Chrysler Museum, 1994.

HARKER, MARGARET F. *Henry Peach Robinson: Master of Photographic Art, 1830–1901*. New York: B. Blackwell, 1988.

Rossetti:
GRIEVE, ALISTAIR IAN. *The Art of Dante Gabriel Rossetti*. 3 vols. Hingham and Norwich: Real World Publishing, 1973–78.

MARSH, JAN. *Dante Gabriel Rossetti: Painter and Poet*. London: Weidenfeld and Nicolson, 1999.

Whistler:
ANDERSON, RONALD, and ANNE KOVAL. *James McNeill Whistler: Beyond the Myth*. London: J. Murray, 1994.

DORMENT, RICHARD, and MARGARET F. MACDONALD. *James McNeill Whistler*. Exhibition catalog. London: Tate Gallery; New York: Harry N. Abrams, 1994.

KOVAL, ANNE. *Whistler in his Time*. Exhibition catalog. London: Tate Gallery, 1994.

MERRILL, LINDA. *A Pot of Paint: Aesthetics on Trial in Whistler v Ruskin*. Washington: Smithsonian Institution Press, 1992.

Wilkie:
ERRINGTON, LINDSAY. *David Wilkie, 1785–1841*. Edinburgh, Scotland: National Galleries of Scotland, 1988.
Sir David Wilkie of Scotland (1785–1841). Exhibition catalog. Raleigh: North Carolina Museum of Art, 1987.

Films and Videos
Dante's Inferno: The Life of Dante Gabriel Rossetti. Dir. Ken Russell. Perf. Oliver Reed, Derek Boshier, Clive Goodwin. Videocassette. Valencia, California: Tapeworm Video Distributors, 1969. (90 minutes).

"Romantics and Realists: Rossetti." *The Great Artists*. Videocassette. West Long Branch, New Jersey: Kultur Films, 2000. (50 minutes).

"Romantics and Realists: Whistler." *The Great Artists*. Videocassette. West Long Branch, New Jersey: Kultur Films, 2000. (50 minutes).

Victorian Painting: Country Life and Landscape. Dir. Edwin Mickleburgh. Hosted by Christopher Wood. Videocassette. Ho-Ho-Kus, New Jersey: The Roland Collection, 1993. (26 minutes).

Victorian Painting: Esthetes and Dreamers. Dir. Edwin Mickleburgh. Hosted by Christopher Wood. Videocassette. Ho-Ho-Kus, New Jersey: The Roland Collection. (26 minutes) [includes artists Alma-Tadema, Moore, F.E. Watts].

Victorian Painting: High and Low Life. Dir. Edwin Mickleburgh. Hosted by Christopher Wood. Videocassette. Ho-Ho-Kus, New Jersey: The Roland Collection. (26 minutes).

Victorian Painting: Modern Life. Dir. Edwin Mickleburgh. Hosted by Christopher Wood. Videocassette. Ho-Ho-Kus, New Jersey: The Roland Collection. (26 minutes).

Text References

p. 1: For Henry James on Victoria, see Leon Edel, *Henry James* (New York: Avon Books, 1972), vol. 5, 87.

pp. 10–11: For the quote from Hill, see Newhall 1964, 37.

pp. 14–15: Ruskin's contemptuous words about the Academy public are found in Ruskin 1987, 3.

p. 16: Dickens's scathing critique of Millais's *Christ in the Carpenter's Shop* appeared in *Household Words*, the popular magazine published by the author between 1850 and 1859. Cited in Wood 1981, 17.

p. 17: Hunt published a pamphlet, "An apology for the symbolism introduced into the picture called *The Light of the World*", to explain his painting. It is cited, in part, in Parris 1984, 119. Millais's letter to Hunt is cited in ibid.

p. 23: Pater's essay was published in *The Renaissance: Studies in Art and Poetry* (3rd ed., 1888). It is reprinted in Pater 1986. For the sections here quoted, see pp. 156–58.

p. 25: For Whistler's response to a critic, see Whistler 1967, 44–45.

CHAPTER 15

ALLWOOD, JOHN: *The Great Exhibitions.* London: Cassell and Collier MacMillan, 1977.

FINDLING, JOHN E., ed. *Historical Dictionary of World's Fairs and Expositions, 1851–1988.* New York: Greenwood Press, 1990.

GERE, CHARLOTTE, and MICHAEL WHITEWAY, *Nineteenth-Century Design from Pugin to Mackintosh.* New York: Harry N. Abrams, 1994.

GIEDION, SIEGFRIED. *Space, Time and Architecture: The Growth of a New Tradition.* Cambridge, Massachusetts: Harvard University Press, 1967.

GREENHALGH, PAUL. *Ephemeral Vistas: The Expositions Universelles, Great Exhibitions and World's Fairs, 1851–1939.* New York: St Martin's Press, 1988.

MAINARDI, PATRICIA. *Art and Politics of the Second Empire: The Universal Expositions of 1855 and 1867.* New Haven: Yale University Press, 1987.

MATTIE, ERIK. *World's Fairs.* New York: Princeton Architectural Press, 1998.

NEUBERG, HANS. *Conceptions of International Exhibitions.* Translaterd by Margery J. Scharer-Wynne. Zurich: ABC, 1969.

Primary Sources

The Crystal Palace Exhibition: Illustrated Catalog, London 1851. An unabridged republication of the *Art-journal* special issue, intro. by John Gloag. New York: Dover, 1970.

Holt, Elizabeth Gilmore, ed. *The Art of All Nations 1850–1873: The Emerging Role of Exhibitions and Critics.* Garden City, New York: Anchor-Doubleday, 1981.

Jones, Owen. *The Grammer of Ornament.* CD Rom. Octavo Corporation, 1998

Morris, William. *William Morris on Art and Design.* Edited by Christine Poulson. Sheffield: Sheffield Academic, 1996.

Monographs and Catalogs
Godwin:
E.W. Godwin: Aesthetic Movement Architect and Designer. Exhibition catalog. New York: Bard Graduate Center for Studies in the Decorative Arts. New Haven: Yale University Press, 1999.

Hokusai:
FORRER, MATTHI. *Hokusai.* New York: Rizzoli, 1988.
HILLIER, JACK RONALD. *Hokusai: Paintings, Drawings, and Woodcuts.* 3rd ed. New York: Dutton, 1978. *The Art of Hokusai in Book Illustration.* Berkeley: University of California Press, 1980.

Morris:
BORIS, EILEEN. *Art and Labor: Ruskin, Morris and the Craftsman Ideal in America.* Philadelphia: Temple University Press, 1986.
HARVEY, CHARLES, and JON PRESS. *William Morris: Design and Enterprise in Victorian Britain.* New York: New York University Press, 1991. *Art, Enterprise and Ethics: The Life and Works of William Morris.* Portland, Oregon: Frank Cass, 1996.
MACCARTHY, FIONA. *William Morris.* London: Faber and Faber, 1994.
NAYLOR, GILLIAN, ed. *William Morris by Himself: Designs and Writings.* London: MacDonald Orbis, 1988.
PARRY, LINDA, ed. *William Morris.* Exhibition catalog. New York: Harry N. Abrams, 1996.
STANSKY, PETER. *Redesigning the World: William Morris, the 1880s, and the Arts and Crafts.* Princeton: Princeton University Press, 1985.

Paxton:
MCKEAN, JOHN. *Crystal Palace: Joseph Paxton and Charles Fox.* London: Phaidon, 1994.

Webb:
LETHABY, W.R. *Phillip Webb and his Work.* London: Raven Oak Press, 1979.

Text References

p. 3: Cole's words are found in the introduction to the first issue of the *Journal of Design and Manufacture.*

p. 5: Bucher's words are cited in Giedon 1967, 252.

p. 7: Wornum's remarks are found in *The Crystal Palace Exhibition* 1970, V and XXII.

p. 12: Burges's remark is quoted in Gere and Whiteway 1994, 126.

pp. 17–18: For Courbet about *The Painter's Atelier,* see Courbet 1992, 131.

p. 23: The word "troika" literally means "trio" or "threesome." It is often used for a carriage drawn by three horses.

p. 24: John Leighton's remarks are found in an essay called "On Japanese Art: Illustrated by Native Examples" in *Notices of the Proceedings of the Meeting of the Members of the Royal Institution of Great Britain* 4 (1862–63): 99–108.

CHAPTER 16

BOIME, ALBERT. *Art and the French Commune: Imagining Paris after War and Revolution.* Princeton: Princeton University Press, 1995.

CALLEN, ANTHEA. *Techniques of the Impressionists.* London: Orbis, 1982.

CLARK, T.J. *The Painting of Modern Life: Paris in the Art of Manet and his Followers.* Princeton: Princeton University Press, 1984.

CLEMENT, RUSSELL T, ANNICK HOUZE, and CHRISTIANE ERBOLATO-RAMSEY. *The Women Impressionists: A Sourcebook.* Westport, Connecticut: Greenwood Press, 2000.

DENVIR, BERNARD, ed. *The Impressionists at First Hand.* London: Thames and Hudson, 1987.

HERBERT, ROBERT L. *Impressionism: Art, Leisure and Parisian Society.* New Haven: Yale University Press, 1988.

LEVIN, MIRIAM R. *Republican Art and Ideology in Late Nineteenth-Century France.* Ann Arbor: University Microfilms International Research Press, 1986.

LOYRETTE, HENRI, and GARY TINTEROW. *Origins of Impressionism.* Exhibition catalog. New York: Metropolitan Museum of Art, 1994.

MAINARDI, PATRICIA. *The End of the Salon.* New York: Cambridge University Press, 1993.

MILNER, JOHN. *The Studios of Paris: The Capital of Art in the Late Nineteenth Century.* New Haven: Yale University Press, 1988.

MORENO, BARRY. *The Statue of Liberty Encyclopedia.* New York: Simon and Schuster, 2000.

REWALD, JOHN. *Studies in Impressionism.* Edited by Irene Gordon and Frances Weitzenhofer. New York: Harry N. Abrams, 1986.

ROOS, JANE MAYO. *Early Impressionism and the French State (1866–1874).* Cambridge and New York: Cambridge University Press, 1996.

SCHAPIRO, MEYER. *Impressionism: Reflections and Perceptions.* New York: George Braziller, 1997.

WHITE, CYNTHIA, and HARRISON WHITE. *Canvases and Careers: Institutional Change in the French Painting World.* New York: Wiley, 1965.

Primary Sources

BERSON, RUTH. *The New Painting: Impressionism 1874–1886.* 2 vols. Seattle: University of Washington Press, 1996.

CASSATT, MARY. *Cassatt and her Circle: Selected Letters.* Edited by Nancy Mowll Mathews. New York: Abbeville Press, 1984. *Cassatt: A Retrospective.* Edited by Nancy Mowll Mathews. New York: H.L. Levin Associates, 1996.

CÉZANNE, PAUL. *Letters.* Edited by John Rewald. New York: Da Capo Press, 1995.

DEGAS, EDGAR. *Letters.* Oxford: B. Cassirer, 1947. *The Notebooks of Edgar Degas: A Catalog of the 38 Notebooks in the Bibliothèque Nationale and Other Collections.* Edited by Theodore Reff. Oxford: Clarendon Press, 1976.

HOLT, ELIZABETH GILMORE, ed. *Universal Expositions and State-Sponsored Fine Arts,* part 1 of *The Expanding World of Art, 1874–1902.* New Haven: Yale University Press, 1988.

MONET, CLAUDE. *Monet: A Retrospective.* Edited by Charles Stuckey. New York: Hugh L. Levin Associates, 1985.

MORISOT, BERTHE. *Berthe Morisot: The Correspondence with her Family and Friends, Manet, Puvis de Chavannes, Degas, Monet, Renoir and Mallarmé.* Mount Kisco: Moyer Bell, 1987.

PISSARRO, CAMILLE. *Letters to his Son Lucien.* Edited by John Rewald. Mamroneck, New York: P.P. Appel, 1972.

Monographs and Catalogs

Bazille:
CHAMPA, KERMIT. *Monet and Bazille: A Collaboration.* New York: Harry N. Abrams, 1999.
Frédéric Bazille and Early Impressionism. Exhibition catalog. Chicago: The Institute, 1978.
JOURDAN, ALETH, ET AL. *Frédéric Bazille: Prophet of Impressionism.* Exhibition catalog. Translated by John Goodman. Brooklyn, New York: Brooklyn Museum of Art, 1992.
PITMAN, DIANNE. *Bazille: Purity, Pose, and Painting in the 1860s.* University Park, Pennsylvania: Pennsylvania State University, 1998.

Boudin:
HAMILTON, VIVIEN. *Boudin at Trouville.* Exhibition catalog. London: John Murray, 1992.
SELZ, JEAN. *E. Boudin.* Translated by Shirley Jennings. New York: Crown, 1982.
SUTTON, PETER C. *Boudin: Impressionist Marine Paintings.* Exhibition catalog. Salem, Massachusetts: Peabody Museum of Salem, 1991.

Bouguereau:
ISAACSON, ROBERT. *William Adolphe Bouguereau.* Exhibition catalog. New York: The Center, 1975.
William Adolphe Bouguereau, 1825–1905. Exhibition catalog. Montreal: Montreal Museum of Arts, 1984.
WISSMAN, FRONIA E. *Bouguereau.* San Francisco: Pomegranate Artbooks, 1996.

Caillebotte:
DISTEL, ANNE, ET AL. *Gustave Caillebotte: Urban Impressionist.* Exhibition catalog. Chicago: Art Institute; New York: Abbeville Press, 1995.
VARNEDOE, KIRK. *Gustave Caillebotte.* New Haven: Yale University Press, 1987.

Cassatt:
MATHEWS, NANCY MOWLL. *Mary Cassatt: A Life.* New York: Villard Books, 1994.
POLLOCK, GRISELDA. *Mary Cassatt: Painter of Modern Women.* New York: Thames and Hudson, 1998.

Dalou:
HUNISAK, JOHN M. *The Sculptor Jules Dalou: Studies in his Style and Imagery.* New York: Garland, 1977.

Degas:
ARMSTRONG, CAROL. *Odd Man Out: Readings of the Work and Reputation of Edgar Degas.* Chicago: Chicago University Press, 1991.
REFF, THEODORE. *Degas: The Artist's Mind.* New York: Metropolitan Museum of Art, 1976.
SUTTON, DENYS. *Edgar Degas: Life and Work.* New York: Rizzoli, 1986.

Manet (works of the 1870s and 1880s):
BAREAU, JULIET WILSON. *Manet, Monet, and the Gare Saint-Lazare.* New Haven: Yale University Press, 1998.
COLLINS, BRADFORD R. *12 Views of Manet's Bar.* Princeton: Princeton University Press, 1996.
RAND, HARRY. *Manet's Contemplation at the Gare Saint-Lazare.* Berkeley: University of California Press, 1987.

Monet:
HOUSE, JOHN. *Monet: Nature into Art.* New Haven: Yale University Press, 1986.
SPATE, VIRGINIA. *Claude Monet: Life and Work.* New York: Rizzoli, 1992.
TUCKER, PAUL HAYES. *Claude Monet: Life and Art.* New Haven: Yale University Press, 1995.
WILDENSTEIN, DANIEL. *Monet.* Cologne: Taschen, 1996.

Morisot:
ADLER, KATHLEEN, and TAMAR GARB. *Berthe Morisot.* London: Phaidon, 1987.
HIGONNET, ANNE. *Berthe Morisot's Images of Women.* Cambridge: Harvard University Press, 1993.
SHENNAN, MARGARET. *Berthe Morisot: The First Lady of Impressionism.* Thrupp (UK): Sutton Publishing, 1996.

Pissarro:
ADLER, KATHLEEN. *Camille Pissarro: A Biography.* New York: St Martin's Press, 1977.
LLOYD, CHRISTOPHER. *Camille Pissarro.* Geneva: Skira; New York: Rizzoli, 1981. ed. *Studies on Camille Pissarro.* New York: Routledge, 1986.

Puvis de Chavannes:
PETRIE, BRIAN. *Puvis de Chavannes.* London: Ashgate, 1997.
SHAW, JENNIFER LAURIE. *Dream States: Puvis de Chavannes, Modernism, and the Fantasy of France.* New Haven: Yale University Press, 2002.

Renoir:
BAILEY, COLIN. *Renoir's Portraits: Impressions of an Age.* Exhibition catalog. New Haven: Yale University Press, 1997.
JOANNIDES, PAUL. *Renoir: Life and Works.* London: Cassell, 2000.
Renoir. Exhibition catalog. New York: Abrams, 1985.
WHITE, BARBARA EHRLICH. *Renoir: His Life, Art and Letters.* New York: Abrams, 1984.

Sisley:
SHONE, RICHARD. *Sisley.* London: Phaidon, 1992.
STEVENS, MARYANNE, ed. *Alfred Sisley.* Exhibition catalog. New Haven: Yale University Press, 1992.

Films and Videos
Berthe Morisot: An Interview with Kathleen Adler. Prod. Nick Levinson. Videocassette. Ho-Ho-Kus, New Jersey: The Roland Collection, 1992. (25 minutes).
Berthe Morisot: The Forgotten Impressionist. Videocassette. Amherst, Massachusetts: Electronic Filed Production Services. (32 minutes).
Degas. Videocassette. Long Beach, California: Pioneer Entertainment. 1988. (58 minutes).
"Degas." *Art Awareness Collection.* Videocassette. Long Beach, California: Pioneer Entertainment. (7 minutes).
Degas' Dancers. Dir. Anthony Roland. Videocassette. Ho-Ho-Kus, New Jersey: The Roland Collection, 1994. (13 minutes).
"Gustave Caillebotte, or the Adventures of the Gaze." *Portrait of an Artist.* Dir. Alain Jaubert. Videocassette. Chicago: Home Vision, 1994. (59 minutes).
Impressionism. Prod. Wayne Thiebaud. Videocassette. St Louis, Missouri: Phoenix/Coronet/BFA Films & Video, 1957. (7 minutes).
Impressionism: Shimmering Visions. Videocassette. Morris Plains, New Jersey: Lucerne Media, 1998. (23 minutes).
Impressionists on the Seine. Dir. Jackson Frost. Videocassette. Chicago: Home Vision, 1997. (30 minutes).
"Mary Cassatt: Impressionist from Philadelphia." *Portrait of an Artist.* Dir. Perry Miller Adato. Videocassette. Chicago: Home Vision, 1977. (30 minutes).
Monet. Dir. Tony Coe. Presented by Dr. Anthea Callen. Videocassette. Ho-Ho-Kus, New Jersey: The Roland Collection, 1993. (25 minutes).
Monet: Legacy of Light. Prod. Museum of Fine Arts, Boston. Videocassette. Chicago: Home Vision Cinema, 1990. (27 minutes).
Paris, Spectacle of Modernity. Dir. Nick Levinson. Presented by Francis Frascina, Tim Benton, and Hollis Clayson. Videocassette. Ho-Ho-Kus, New Jersey: The Roland Collection, 1995. (25 minutes).
Pissarro. Dir. Nick Levinson. Presented by T.J. Clark. Videocassette. Ho-Ho-Kus, New Jersey: The Roland Collection, 1993. (25 minutes).
Portrait of Gustave Caillebotte in the Country. Dir. Emmanuel Laurent. Videocassette. Glenview, IL: Crystal Productions, 1994. (25 minutes).
"Renoir." *Art Awareness Collection.* Videocassette. Long Beach, California: Pioneer Entertainment. (7 minutes).
Renoir. Narrated by Sir Anthony Quayle. Videocassette. Ho-Ho-Kus, New Jersey: The Roland Collection, 1994. (28 minutes).
Rodin. Prod. Nick Levinson. Videocassette. Ho-Ho-Kus, New Jersey: The Roland Collection, 1991. (25 minutes).

Text References
p. 7: Chennevières's remark is quoted in Petrie 1997, 94.
pp. 10–11: Comments on the Salon by Charles Blanc and Renoir are quoted in Mainardi 1993, 85.
pp. 15–16: For the critiques of Manet's *Railroad*, see Rand 1987, 12.
p. 18: For Leroy's critique of the Impressionists, see Berson 1996, 1, 25. Author's translation.
p. 24: Monet's remarks to Lilla Cabot Perry are quoted in Monet 1985, 183. Helmholtz's words are quoted in Paul C. Vitz and Arnold B. Glimcher, *Modern Art and Modern Science* (New York: Praeger, 1984), 73.
p. 26: Cézanne's letter to Zola is quoted in Cézanne 1995, 112–13.
p.27: Zola's review of Bazille is cited in Pitman 1998, 83.
pp. 32–33: Cited in Berson 1996, 1, 238. Author's translation.
pp. 35–36: The advice of Morisot's teacher is quoted in Shennan 1996, 151–52; Morisot's own remarks are found in Higonnet 1993, 146.

CHAPTER 17

HALPERIN, JOAN UNGERSMA. *Félix Fénéon: Aesthete and Anarchist in Fin-de-siècle Paris.* New Haven and London: Yale University Press, 1988.
HERBERT, ROBERT L. *Neo-Impressionism.* Exhibition catalog. New York: Solomon R. Guggenheim Foundation, 1968.
Post-Impressionism: Cross-currents in European Painting. Exhibition catalog. London: Royal Academy, 1979.
REWALD, JOHN. *Post-Impressionism: From van Gogh to Gauguin.* 3rd ed. New York: Museum of Modern Art; New York: New York Graphic Society, 1978.
SHIFF, RICHARD. *Cézanne and the End of Impressionism: A Study of the Theory, Technique, and Critical Evaluation of Modern Art.* Chicago: University of Chicago Press, 1984.
SUTTER, JEAN. *The Neo-Impressionists.* Translated by Chantal Deliss. Greenwich, Connecticut: New York Graphic Society, 1970.

WEISBERG, GABRIEL, ET AL. *Japonisme: Japanese Influence on French Art 1854–1910*. Exhibition catalog. Cleveland: Cleveland Museum of Art, 1975.

WICHMANN, SIEGFRIED. *Japonisme: The Japanese Influence on Western Art in the 19th and 20th Centuries*. Translated Mary Whittall et al. New York: Harmony Books, 1981.

Primary Sources

CÉZANNE, PAUL. *Letters*. Edited by John Rewald. 4th ed. New York: Hacker Art Books, 1976.
Conversations with Cézanne. Edited by Michael Doran and translated by Julie Lawrence Cochran. Berkeley, Los Angeles, and London: University of California Press, 2001.

HOLT, ELIZABETH GILMORE, ed. *The Expanding World of Art, 1874–1902: Universal Expositions and State-Sponsored Fine Arts Exhibitions*. New Haven: Yale University Press, 1988.

NOCHLIN, LINDA. *Impressionism and Post-Impressionism, 1874–1904: Sources and Documents*. Englewood Cliffs: Prentice Hall, 1966.

VAN GOGH, VINCENT. *The Complete Letters of Vincent van Gogh: With Reproductions of All the Drawings in the Correspondence*. 3 vols. Greenwich, Connecticut: New York Graphic Society, 1958.

Monographs and Catalogs

Cézanne:

CACHIN, FRANÇOISE, ET AL. *Cézanne*. Exhibition catalog. New York: Harry N. Abrams; Philadelphia Museum of Art, 1996.

LEWIS, MARY TOMKINS. *Cézanne*. London: Phaidon, 2000.

SCHAPIRO, MEYER. *Paul Cézanne*. New York: Harry N. Abrams, 1988.

Degas:

KENDALL, RICHARD, ed. *Degas and the Little Dancer*. New Haven: Yale University Press, 2001.

Seurat:

HERBERT, ROBERT. *Seurat: Drawings and Paintings*. New Haven: Yale University Press, 2001.

HOMER, WILLIAM INNES. *Seurat and the Science of Painting*. Rev. ed. Cambridge: MIT Press, 1978.

REWALD, JOHN. *Seurat: A Biography*. New York: Harry N. Abrams, 1990.

SMITH, PAUL. *Seurat and the Avant-Garde*. New Haven: Yale University Press, 1997.

ZIMMERMANN, MICHAEL F. *Seurat and the Art Theory of his Time*. Antwerp: Fonds Mercator, 1991.

Signac:

BOCQUILLON-FERRETTI, MARINA, ET AL. *Paul Signac*. Exhibition catalog. New York: Metropolitan Museum of Art, 2001.

CACHIN, FRANÇOISE. *Paul Signac*. Paris: Bibliothèque des arts, 1971.

RATLIFF, FLOYD. *Paul Signac and Color in Neo-Impressionism*. New York: Rockefeller University Press, 1992. (Includes translation of Signac's *D'Eugène Delacroix au néo-impressionisme*)

Van Gogh:

PICKVANCE, RONALD. *Van Gogh in Arles*. Exhibition catalog. New York: Metropolitan Museum of Art, 1984
Van Gogh in Saint-Rémy and Auvers. Exhibition catalog. New York: Metropolitan Museum of Art, 1986.

SILVERMAN, DEBORA. *Van Gogh and Gauguin: The Search for Sacred Art*. New York: Farrar, Straus and Giroux, 2000.

TILBORGH, LOUIS VAN, and MARIJE VELLEKOOP. *Vincent van Gogh Paintings*. Amsterdam: Van Gogh Museum; London: Lund Humphries Publishers, 1999.

WALTHER, INGO F. *Van Gogh: The Complete Paintings*. Cologne and New York: Taschen, 2001.

ZEMEL, CAROL. *Van Gogh's Progress*. Berkeley, Los Angeles, and London: University of California Press, 1997.

Films and Videos

In a Brilliant Light Light: Van Gogh in Arles. Prod. Metropolitan Museum of Art. Videocassette. Greenwich, Connecticut: Arts America, Knowledge Unlimited, Home Vision Cinema, 1987. (57 minutes).

Japonism, Part One. Dir. Guido De Bruyn. Videocassette. Ho-Ho-Kus, New Jersey: The Roland Collection, 1996. (30 minutes).

Lust for Life. Dir. Vincente Minnelli. Perf. Kirk Douglas. Videocassette. Culver City, California: MGM/UA Home Video, 1989. (122 minutes) [Drama about the life of Vincent van Gogh].

"Point Counterpoint: The Life and Work of Georges Seurat." *Portrait of an Artist*. Prod. Ann Turner. Videocassette. Chicago: Home Vision, 1979. (75 minutes).

"Seurat." *Modern Art and Modernism: Manet to Pollock*. Prod. Tony Coe. Videocassette. Ho-Ho-Kus, New Jersey: The Roland Collection, 1982. (24 minutes).

Seurat and the Bathers. Videocassette. London: National Gallery; Chicago: Home Vision, 1997. (30 minutes).

Van Gogh's Van Goghs. Dir. Jackson Frost. Videocassette. Chicago: Home Vision, 1999. (57 minutes).

Vincent & Theo. Dir. by Robert Altman. Perf. Tim Roth, Paul Rhys. Videocassette. St Paul, Minnesota: Video catalog, 1990. (138 minutes) [Drama about the life of Vincent van Gogh].

Text References

p. 3: Seurat's assessment of Puvis de Chavannes is cited in Smith 1997, 13.

pp. 3–4: For a discussion of Fénéon's article, see Halperin 1988, 81–85.

p. 4: Chevreul's theories are discussed concisely in Homer 1964, 20ff.

p. 5: Seurat's remark about wanting to "redo" the Panathenaic frieze are found in Smith 168.

p. 8: Signac's remarks about the *Gasholders at Clichy* were made in the anarchist journal *La Révolte*.

p. 12: On the terms, "absorption" and "theatricality," see Fried 1980.

pp. 13–14: On the various critiques that were leveled against Degas's *Little Dancer*, see Kendall 1998; Huysmans's critique is cited in Harrison et al. 1998.

pp. 14–15: For Renoir's remark on his trip to Italy, see White 1984, 114; Renoir's conversation with Vollard is cited in *Renoir* 1984 [Ehrlich 1984]., 114.

p. 15: On "anxiety of influence," see Harold Bloom, *The Anxiety of Influence: A Theory of Poetry* (New York: Oxford University Press, 1973).

p. 18: Cézanne's remark about renewing his art is cited in Cachin 1996, 17.

p. 19: Critiques of Cézanne's exhibit at the Impressionist exhibition of 1877 are found in Berson 1996, vol. 1, 123ff. Author's translation.

p. 20: Cézanne's definition of art as a "harmony parallel to nature" is quoted in Cachin 1996, 18.

p. 21: Cézanne's often-cited remark about Monet was reported by the art dealer Ambroise Vollard in his biography of Cézanne of 1914; his advice to a young artist in Cachin 1996, 18.

p. 22: Van Gogh's explanation of the *Potato Eaters* is found in Van Gogh 1958, 2, 370.

p. 24: For van Gogh on Hokusai, see Van Gogh 1968, vol. 3, 29.

pp. 25–26: On *the Night Café*, see Van Gogh 1986, vol. 3, 29–33.

CHAPTER 18

General

ÇELIK, ZEYNEP, *Displaying the Orient: Architecture of Islam at Nineteenth-Century World's Fairs*. Berkeley, California: University of California Press, 1992.

LEVIN, MIRIAM R. *When the Eiffel Tower was New: French Visions of Progress at the Centennial of the Revolution*. Amherst, Massachusetts: University of Massachusetts Press, 1989.

Tretyakov Gallery Guidebook. Moscow: State Tretyakov Gallery, 2000.

VALKENIER, ELIZABETH KRIDL. *Russian Realist Art: The State and Society: The Peredvizhniki and their Tradition*. Ann Arbor: Ardis, 1977 (reissued New York: Columbia University Press, 1989).

WEISBERG, GABRIEL P. *Beyond Impressionism: The Natural Impulse*. New York: Harry N. Abrams, 1992.

Primary Sources

TOLSTOY, LEO. *What Is Art?* Translated by Larissa Volokhonsky. Hammondsworth: Penguin, 1996.

Monographs and Catalogs

Dagnan-Bouveret:

WEISBERG, GABRIEL P. *Against the Modern: Dagnan-Bouveret and the Transformation of the Academic Tradition*. New Brunswick: Rutgers University Press, 2002

Repin:

PARKER, FAN. *Russia on Canvas: Ilya Repin*. University Park: Pennsylvania State University Press, 1980.

VALKENIER, ELIZABETH KRIDL. *Ilya Repin and the World of Russian Art*. New York: Columbia University Press, 1990.

Surikov:

KEMENOV, VLADIMIR. *Vasili Surikov: 1848–1916*. Bournemouth: Parkstone, c. 1997.

Zorn:

BOETHIUS, GERTA. *Anders Zorn, an International Swedish Artist: His Life and Work*. Stockholm: Nordisk rotogravyr, 1954.

HARBERT, MARGUERITE J. *Zorn: Paintings, Graphics, and Sculpture*. Exhibition catalog. Birmingham, Alabama: Birmingham Museum of Art, 1986.

Text References

p. 1: The title of this chapter is borrowed from the catalog of an exhibition held in the Mount Holyoke College Art Museum in 1989. See Levin 1989. For the citation of Lockroy, see Levin 1989, 22.

p. 3: On the History of Habitation street, see Çelik 1992, 70.

p. 7: The critique of Dagnan-Bouveret's work by André Michel paraphrased the words of Fromentin. Cited in Weisberg 1992, 436.

p. 16: For Dostoevsky's critique of Repin's *Barge Haulers*, see Fyodor Dostoevsky, *A Writer's Diary*

(Evanston, IL: Northwestern University Press, 1993), vol. 1, 213.

CHAPTER 19

ARWAS, VICTOR. *Belle Epoque Posters and Graphics.* New York: Rizzoli, 1978.

GERHARDUS, MALY, and DIETFRIED GERHARDUS. *Symbolism and Art Nouveau: Sense of Impending Crisis, Refinement of Sensibility, and Life Reborn in Beauty.* Translated by Alan Bailey. Oxford: Phaidon, 1979.

MATTHEWS, PATRICIA. *Passionate Discontent: Creativity, Gender, and French Symbolist Art.* Chicago: Chicago University Press, 1999.

MAUNER, GEORGE. *The Nabis: Their History and their Art, 1888–1896.* New York, 1978.

SILVERMAN, DEBORA. *Art Nouveau in Fin-de-siècle France: Politics, Psychology, and Style.* Berkeley: University of California Press, 1992.

SIMPSON, JULIET. *Aurier, Symbolism, and the Visual Arts.* Bern: Peter Lange, 1999.

WEISBERG, GABRIEL P. *Art Nouveau Bing: Paris Style 1900.* New York: Abrams, 1986.

Primary Sources

DORRA. HENRI. *Symbolist Art Theories.* Berkeley: University of California Press, 1994.

GAUGUIN, PAUL. *Paul Gauguin: Letters to his Wife and Friends.* Ed. by Maurice Malingue. Translated by Henry J. Stenning. Cleveland: World Publishing, 1949.
The Writings of a Savage. Edited by Daniel Guerin. Translated by Eleanor Levieux. New York: Da Capo Press, 1996.

GAUGUIN, PAUL. *Noa Noa.* Translated by O.F. Theis. San Francisco: Chronicle Books, 1994.

HUYSMANS, J.K. *Against the Grain.* New York: Random House, 1956.

MURRAY, GALE B. *Toulouse-Lautrec: A Retrospective.* New York: Macmillan, 1992.

Monographs and Catalogs

Bernard:

STEVENS, MARYANNE. *Emile Bernard, 1868–1941: A Pioneer of Modern Art.* Exhibition catalog. Translated by Connie Homburg et al. Zwolle: Waanders Publishers, 1990.

Bonnard:

FERMIGIER, ANTOINE. *Pierre Bonnard.* London: Thames and Hudson, 1987.

Chéret:

BROIDO, LUCY. *The Posters of Jules Chéret.* 2nd ed. New York: Dover, 1992.

Claudel:

PARIS, REINE-MARIE. *Camille: The Life of Camille Claudel, Rodin's Muse and Mistress.* Translated by Liliane Emery Tuck. New York: Seaver Books, 1988.

RIVIERE, ANNE, BRUNO GAUDICHON, and DANIELLE GHANASSIA. *Camille Claudel: Catalog raisonné.* Paris: Adam Biro, 1996.

Gallé:

DUNCAN, ALISTAIR, and GEORGES DE BARTHA. *Glass by Gallé.* New York: Harry N. Abrams, 1984.

GARNER, PHILIPPE. *Emile Gallé.* London: Academy Editions, 1990.

Gauguin:

BRETTELL, RICHARD, ET AL. *The Art of Paul Gauguin.* Exhibition catalog. Washington, DC, National Gallery of Art, 1988.

HOOG, MICHEL. *Paul Gauguin: Life and Work.* New York: Rizzoli, 1987.

Guimard:

CANTACUZINO, S. "Hector Guimard," *The Anti-Rationalists,* Edited by J.M. Richards and Nikolaus Pevsner. London: Architectural Press, 1973.

GRAHAM, F. LANIER. *Hector Guimard.* Exhibition catalog. New York: Museum of Modern Art, 1970.

NAYLOR, GILLIAN, and YVONNE BRUNHAMMER. *Hector Guimard.* New York: Rizzoli, 1978.

Lalique:

BAYER, PATRICIA, and MARK WALLER. *The Art of René Lalique.* London: Quintet, 1988.

DAWES, NICHOLAS M. *Lalique Glass.* New York: Crown, 1986.

Moreau:

LACAMBRE, GENEVIÈVE, ET AL. *Gustave Moreau: Between Epic and Dream.* Exhibition catalog. Chicago: Art Institute; Princeton: Princeton University Press, 1999.

MATHIEU, PIERRE-LOUIS. *Gustave Moreau.* Boston: New York Graphic Society, 1976.
Gustave Moreau. Translated by Tamara Blondel, Louise Guiney, Mark Hutchinson. New York: Flammarion, 1995.

Mucha:

ARWAS, VICTOR, ET AL. *Alphonse Mucha: The Spirit of Art Nouveau.* New Haven: Yale University Press, 1998.

ELLRIDGE, ARTHUR. *Mucha: The Triumph of Art Nouveau.* Paris: Terrail, 1994.

MUCHA, JIRI. *Alphonse Maria Mucha: His Life and Art.* New York: Rizzoli, 1989.

Redon:

DRUICK, DOUGLAS W., ed. *Odilon Redon: Prince of Dreams, 1840–1916.* Exhibition catalog. Chicago: Chicago Art Institute; New York: Harry N. Abrams, 1994.

EISENMAN, STEPHEN. *The Temptation of Saint Redon: Biography, Ideology and Style in the Noirs of Odilon Redon.* Chicago: Chicago University Press, 1992.

Rodin:

BUTLER, RUTH. *The Shape of Genius.* New Haven: Yale University Press, 1993.

ELSEN, ALBERT E. *The Gates of Hell by Auguste Rodin.* Stanford: Stanford University Press, 1985.

GRUNFELD, FREDERIC V. *Rodin: A Biography.* New York: Holt, 1987.
Rodin and Balzac. Exhibition catalogue, Stanford University Art Museum, 1973.

Sérusier:

BOYLE-TURNER, CAROLINE. *Paul Sérusier.* Ann Arbor: UMI Research Press, 1983.

Steinlen:

CATE, PHILLIP DENNIS, AND SUSAN GILL. *Theophile-Alexandre Steinlen.* Salt Lake City: G.M. Smith, 1982.

Toulouse-Lautrec:

DENVIR, BERNARD. *Toulouse-Lautrec.* New York: Thames and Hudson, 1991.

FREY, JULIA BLOCH. *Toulouse-Lautrec: A Life.* New York: Viking, 1994.

THOMSON, RICHARD, ET AL. *Toulouse-Lautrec.* Exhibition catalog. New Haven: Yale University Press, 1991.

Vuillard:

GROOM, GLORIA. *Edouard Vuillard: Painter-Decorator, Patrons and Projects, 1892–1912.* New Haven: Yale University Press, 1993.

THOMSON, BELINDA. *Vuillard.* Oxford: Phaidon, 1988.

Films and Videos

Camille Claudel. Dir. Perf. Isabelle Adjani and Gérard Depardieu. Dir. Bruno Nutten. Videocassette. Orion Home Video, 1989. In French with English subtitles. (159 minutes).

"In Search of Pure Color: Pierre Bonnard." *Portrait of an Artist.* Dir. Didier Baussy. Videocassette. Chicago: Home Vision, 1984. (55 minutes).

La Belle Epoque 1890–1914. Narrated by Douglas Fairbanks, Jr. Videocassette. Chicago: Home Vision. (63 minutes).

Moon and Sixpence. Dir. Albert Lewin. Perf. George Sanders, Herbert Marshall. Videocassette. Santa Monica, California: MGM Home Entertainment, 1943. (89 minutes) [Based on the novel of the same name by Somerset Maugham, inspired by the life of Gauguin].

Moulin Rouge. Dir. John Huston. Perf. José Ferrer, Zsa Zsa Gabor. Videocassette. Culver City, California: MGM/UA Home Video, 1952. (119 minutes) [Fictional account of the life of Toulouse-Lautrec].

Paul Gauguin: The Savage Dream. Dir. Michael Gill. Videocassette. Greenwich, Connecticut: Arts America, Home Vision Cinema, 1988. (45 minutes).

Rodin. Dir. Nick Levinson. Videocassette. Ho-Ho-Kus, New Jersey: The Roland Collection, 1995. (25 minutes).

Toulouse-Lautrec. Dir. Jacques Berthier. Videocassette. Ho-Ho-Kus, New Jersey: The Roland Collection, 1968. (14 minutes).

Wolf at the Door. Dir. Henning Carlsen. Perf. Donald Sutherland, Jean Yanne. Videocassette. Beverly Hills, California: CBS/Fox Video, 1987. (94 minutes) [Story of the middle period of Gauguin's life].

Text References

p. 11: For Natanson's remark about Toulouse-Lautrec's relation to prostitutes, see Murray 1992, 178.

p. 13: For Breton's remark on his *Breton Women in a Prairie,* see Brettell et al., 103.

pp. 14–15: Maurice Denis's famous line is quoted in Dorra 1994, 235.

p. 16: Gauguin's utopian vision of Tahiti and his reality check are all clearly expressed in Gauguin 1994.

pp. 18–19: For Gauguin's description of Tehura, see Gauguin 1994, 73.

pp. 19–20: Many of Gauguin's ideas about *Where Do We Come From?* are found in a letter to his friend Daniel de Monfreid. Cited, in English, in Guérin 1978, 159–60.

p. 22: A partial translation of Moréas's article is found in Dorra 1994. The line here quoted is cited on p. 223. A partial translation of Aurier's article is found in Dorra 1994. The line here quoted is cited on p. 223.

p. 23: Huysmans's quote is from Huysmans 1956, 59.

p. 24: Moreau's essay on *Jupiter and Semele* is cited in Mathieu 1976.

p. 25: For Huysman's view of Redon, see Huysmans 1956, 68.

p. 26: Redon's observation was made in his diary *A Soi-même (To Himself).* Cited in Dorra 1994, 54.

p.27: For Péladan's line on art, see Dorra 1994, 264.

p. 28: Sérusier is quoted in Dorra 1994, 237.

p. 32: The translation of Villon's poem is from Galway Kinnell, translated and edited, *The Poems of François Villon* (Boston: Houghton Mifflin, 1977), 59.

pp. 33–34: Rodin's interview is cited in *Rodin and Balzac* 1973, 13.

CHAPTER 20

ESCRITT, STEPHEN. *Art Nouveau*. London: Phaidon, 2000.

GARB, TAMAR. *Sisters of the Brush: Women's Artistic Culture in Late Nineteenth-Century Paris*. New Haven: Yale University Press, 1994.

GERE, CHARLOTTE, and MICHAEL WHITEWAY. *Nineteenth-Century Design from Pugin to Mackintosh*. New York: Harry N. Abrams, 1993.

HASLAM, MALCOLM. *In the Nouveau Style*. Boston: Little, Brown, 1989.

HOWARD, JEREMY. *Art Nouveau: International and National Styles in Europe*. Manchester and New York: Manchester University Press, 1996.

LUCIE-SMITH, EDWARD. *Symbolist Art*. New York: Oxford University Press, 1972.

ROSENBLUM, ROBERT, MARYANNE STEVENS, and ANN DUMAS. *1900: Art at the Crossroads*. Exhibition catalog. London: Royal Academy of Arts, 2000.

TROY, NANCY J. *Modernism and the Decorative Arts in France*. New Haven: Yale University Press, 1991.

VERGO, PETER. *Art in Vienna: 1898–1918*. Ithaca: Cornell University Press, 1981.

Weber, Eugen. *France: Fin-de-siècle*. Cambridge, Massachusetts: Belknap Press, 1986.

WEISBERG, GABRIEL P., and JANE R. BECKER, *Overcoming All Obstacles: Women of the Académie Julian*. New Brunswick: Rutgers University Press, 2000.

Primary Sources

BEAUX, CECILIA. *Background with Figures*. Boston: Houghton Mifflin, 1930

Monographs and Catalogs

Beaux:

Cecilia Beaux: Portrait of an Artist. Exhibition catalog. Philadelphia: Pennsylvania Academy of Fine Arts, 1974.

TAPPERT, TARA LEIGH. *Cecilia Beaux and the Art of Portraiture*. Exhibition catalog. Washington, DC: Smithsonian Institution Press, 1995.

Ensor:

LESKO, DIANE. *James Ensor: The Creative Years*. Princeton: Princeton University Press, 1985.

TRICOT, XAVIER. *James Ensor: Catalog Raisonné of the Paintings*. New York: Rizzoli, 1992.

VAN GINDERTAEL, ROGER. *Ensor*. Boston: New York Graphic Society, 1975.

Gaudí:

BERGÓS, JUAN. *Gaudí: The Man and his Work*. Translated by Gerardo Denis. Boston: Little, Brown, 1999.

NONELL, JUAN BASSEGODA. *Antonio Gaudí: Master Architect*. New York: Abbeville Press, 2000.

MASINI, LARA VINCA. *Gaudí*. London: Hamlyn, n.d.

Hodler:

HIRSH, SHARON L. *Ferdinand Hodler*. New York: Braziller, 1982.

Horta:

BORSI, FRANCO, and PAOLO PROTOGHESI. *Victor Horta*. Translated by Marie-Hélène Agüeros. London: Academy Editions, 1991.

LOYER, FRANÇOIS, and JEAN DELHAYE. *Victor Horta: Hôtel Tassel, 1893–1895*. Translated by Susan Day. Brussels: Archives d'architecture moderne, 1996.

Klimt:

FLIEDL, GOTTFRIED. *Gustave Klimt, 1862–1918: The World in Female Form*. New York: Taschen, 1998.

NEBEHAY, CHRISTIAN M. *Gustav Klimt: From Drawing to Painting*. Translated by Renée Nebehay-King. London: Thames and Hudson, 1994.

VERGO, PETER. *Art in Vienna, 1898–1918: Klimt, Kokoschka, Schiele and their Contemporaries*. London: Phaidon, 1993.

WHITFORD, FRANK. *Gustave Klimt*. London: Collins & Brown, 1993.

Mackintosh:

CRAWFORD, ALAN. *Charles Rennie Mackintosh*. London: Thames and Hudson, 1995.

Munch:

HELLER, REINHOLD. *Edvard Munch: The Scream*. New York: Viking, 1972.
Munch: His Life and Work. Chicago: Chicago University Press, 1984.

Sargent:

FAIRBROTHER, TREVOR J. *John Singer Sargent*. New York: Abrams, 1994.

ORMOND, RICHARD, and ELAINE KILMURRAY. *John Singer Sargent: Complete Paintings*. New Haven: Yale University Press, 1998.

RATCLIFF, CARTER. *John Singer Sargent*. New York: Abbeville Press, 1982.

SIMPSON, MARC, RICH ORMOND, and H. BARBARA WEINBERG. *Uncanny Spectacle: The Public Career of the Young John Singer Sargent*. New Haven: Yale University Press, 1997.

Sorolla y Bastida:

PEEL, EDMUND, ed. *The Painter, Joaquín Sorolla y Bastida*. Exhibition catalog. San Diego, California: San Diego Museum of Art, 1989.

Tanner:

MATHEWS, MARCIA M. *Henry Ossawa Tanner: American Artist*. Chicago: University of Chicago Press, 1969.

MOSBY, DEWEY F. *Across Continents and Cultures: The Art and Life of Henry Ossawa Tanner*. Exhibition catalog. Kansas City, Missouri: Nelson-Atkins Museum of Art, 1995.

Films and Videos

Art Nouveau. Dir. Maurice Rheims, Monique Lepeuve. Videocassette. Ho-Ho-Kus, New Jersey: The Roland Collection, 1987. (14 minutes).

Art Nouveau. Dir. Folco Quilici. Videocassette. Ho-Ho-Kus, NJ: The Roland Collection, 1996. (60 minutes).

Art Nouveau: 1890–1914. Dir. Carroll Moore. Videocassette. Chicago: Home Vision, 2000. (30 minutes).

Charles Rennie Mackintosh. Dir. W. Thomson. Videocassette. Ho-Ho-Kus, NJ: The Roland Collection, 1968. (22 minutes).

Edvard Munch. Dir. Peter Watkins. Perf. Geir Westby, Gro Fraas. Videocassette. New York: New Yorker Video, 1974. In Norwegian with English subtitles. (167 minutes).

Edvard Munch. Prod. Deutsche Welle. Videocassette. Princeton: Films for Humanities and Science, 1998. (30 minutes).

Edvard Munch: The Frieze of Life. Dir. Jonathan Wright Miller. Videocassette. Ho-Ho-Kus, New Jersey: The Roland Collection, 1993. (24 minutes).

The Enlightened Bourgeois. Dir. Folco Quilici. Videocassette. Ho-Ho-Kus, New Jersey: The Roland Collection, 1996. (60 minutes) [Horta, Hoffmann, Ohlbrich, Klimt, Schiele, van der Velde].

The Fall and Rise of Mackintosh. Dir. Murray Grigor. Videocassette. Ho-Ho-Kus, New Jersey: The Roland Collection, 1993. (52 minutes).

Gaudí. Videocassette. New York: Academic Entertainment, 1992. (25 minutes).

Henry Ossawa Tanner (1859–1937). Dir. Casey King. Prod. Philadelphia Museum of Art. Tanner Film Group, 1991. (16 minutes).

"I'm Mad, I'm Foolish, I'm Nasty". Dir. Luc de Heush. Videocassette. Ho-Ho-Kus, New Jersey: The Roland Collection, 1995. (55 minutes) [Self-portrait of James Ensor].

John Singer Sargent: Outside the Frame. Dir. Jackson Frost. Chicago: Home Vision, 2000. (57 minutes).

Modernism in Barcelona. Dir. Joan Mallarach. Videocassette. Ho-Ho-Kus, New Jersey: The Roland Collection, 1993. (25 minutes) [General overview of the *fin-de-siècle* in Spain].

Munch and Ensor: Fathers of Expressionism. Videocassette. Olathe, Kansas: RMI Productions, 1994. (21 minutes).

The Universal International Exhibition, Paris 1900. Dir. Nick Levinson. Videocassette. Ho-Ho-Kus, New Jersey: The Roland Collection, 1975. (25 minutes).

Vienna 1900. Videocassette. Ho-Ho-Kus, New Jersey: The Roland Collection, 1993. (18 minutes) [Gustave Klimt].

Text References

p. 5: Gaudí's remark is cited in Masini n.d., 40.

p. 11: Ensor is quoted in Van Gindertael 1975, 111. The editorial of *Ver Sacrum*'s first issue (1898) is cited in Vergo 1981, 26.

p. 13: For a complete text of Beethoven's *Ode of Joy*, a loose rearrangement of Friedrich von Schiller's poem of 1785, see http://www.scholacantorum.org/9803ninth.html (last accessed March 13, 2001).

p. 15: Hodler's note, about *Night*, is cited in Hirsh 1982, 74.

p. 17: For Hodler's ideas about the mission of the artist, see Dorra 1994, 247.

p. 19: Munch's description of the experience underlying *The Scream* is cited in Heller 1972, 107.

p. 20: For Munch's view of the theme of the embrace, see Dorra 1994, 244.

Picture Credits

Index